PAINTING RELIGION

IN PUBLIC

PAINTING RELIGION

IN PUBLIC

———

John Singer Sargent's *Triumph of Religion*

at the Boston Public Library

SALLY M. PROMEY

PRINCETON UNIVERSITY PRESS
PRINCETON, NEW JERSEY

Details used on divider pages: Introduction, *Israelites Oppressed* (fig. 6); Chapter 1, *Frieze of Prophets,* east wall (fig. 9); Chapter 2, *Dogma of the Redemption* (fig. 10); Chapter 3, *Israel and the Law* (fig. 27); Chapter 4, *Preliminary Sketch for Sermon on the Mount* (fig. 25); Chapter 5, *Synagogue* (fig. 17); Chapter 6, *Church* (fig. 18); Chapter 7, YWCA pageant, Silver Bay, New York (fig. 156); Epilogue, *Oil Study for East Wall* (fig. 24)

Published by Princeton University Press, 41 William Street, Princeton, New Jersey 08540
In the UK: Princeton University Press, 3 Market Place, Woodstock, Oxfordshire OX20 1SY
www.pup.princeton.edu

Second printing, and first paperback printing, 2001
Paperback ISBN 0-691-08950-7

Publication of this book has been aided by a grant from the Millard Meiss Publication Fund of the College Art Association of America

MM

Publication of the paperback edition has been made possible in part by a subvention from the Department of Art History and Archaeology, University of Maryland

Designed by Jean Wilcox
Composed in Bembo and Meta with Copperplate display by dix!, Syracuse, New York
Printed by CS Graphics, Singapore
10 9 8 7 6 5 4 3 2

The Library of Congress has catalogued the cloth edition of this book as follows
Promey, Sally M., 1953–
 Painting religion in public : John Singer Sargent's Triumph of
 religion at the Boston Public Library / Sally M. Promey.
 p. cm.
 Includes bibliographical references and index.
 ISBN 0-691-01565-1 (cl. : alk. paper)
 1. Sargent, John Singer, 1856–1925. Triumph of religion.
 2. Protestantism in art. 3. Mural painting and decoration—
 Massachusetts—Boston. 4. Boston Public Library. I. Boston
 Public Library. II. Title.
 ND237.S3A77 1999
 759.13—dc21 99-12158
 CIP

To my teachers—and especially
John W. Cook,
Neil Harris,
Martin E. Marty,
Pamela Mayencourt,
S. Thomas Niccolls,
Paul Rochford,
Linda Seidel,
Marie Smith, and
David Tracy

CONTENTS

⊕

✳

ACKNOWLEDGMENTS

This book's framing idea on the public representation of religion and its connections to John Singer Sargent's public library murals began to take early shape at the University of Chicago in the spring of 1985 in a graduate seminar on "Public Religion and Public Theology" taught by Martin E. Marty and David Tracy. To these teachers—and to others named and unnamed—I dedicate this book. There is much more to be said on religion's public display in the United States; a second, more synthetic and broadly historical, treatment of the subject will follow, and complement, the case study approach presented here.

Writing this book was an intensely collaborative activity. A substantial part of the effort's pleasures accrued from the community of people assembled around the subject in its various aspects over time. I am deeply grateful to all contributors who gave so freely of their knowledge, insight, resources, and skills.

A National Endowment for the Humanities Fellowship for University Teachers in 1997–98 funded a year's release from the immediate interests and commitments of teaching and service; the liberal research leave policies of the College of Arts and Humanities at the University of Maryland made it possible for me to accept the fellowship. As this project developed over time, research support at different stages came from the American Council of Learned Societies, the Department of Art History and Archaeology at the University of Maryland, the General Research Board of the Graduate School at the University of Maryland, and the Louisville Institute as well as the National Endowment for the Humanities. Generous publication subventions from the Henry Luce Foundation, the Millard Meiss Publication Fund, and the Department of Art History and Archaeology, University of Maryland, provided for the book's current form.

Many institutions made available to me their considerable holdings in subjects addressed here. For kindnesses large and small I owe special thanks to the professional staffs of numerous archives, museums, galleries, and religious organizations, including: Adelson Galleries, Inc.; the American Cathedral in Paris; American Jewish Archives, Hebrew Union College; the American Jewish Historical Society; the Archives of American Art; the Art and Architecture Libraries, University of Maryland; the Bancroft Library, University of California, Berkeley; the Boston Athenaeum; the Boston Public Library; Boston University School of Theology; Cabell Library, Virginia Commonwealth University; Center Church, Hartford; Church of the Advent, Boston; Congregation Adath Israel Brith Sholom, Louisville, Kentucky; Congregation Emanu-El of the City of New York; Dartmouth College Library; the Edward Lee McClain High School, Greenfield, Ohio; the Fogg Art Museum, Harvard University Art Museums;

George Eastman House; Houghton Library, Harvard University; the Imperial War Museum, London; the Isabella Stewart Gardner Museum; the Jewish Community Center, Rochester; Jewish Theological Seminary; the Library of Congress; the Massachusetts Council of Churches; the Massachusetts Historical Society; McKeldin Library, University of Maryland; the Metropolitan Museum of Art; Miller Library, Colby College; the Museum of Fine Arts, Boston; the Museum of Modern Art; the National Gallery of Art; the National Museum of American Art; the National Portrait Gallery; the New York Public Library; Silver Bay Conference Center; the Society of St. John the Evangelist, Cambridge; Sotheby's; Syracuse University Library; Temple Israel, Boston; Temple Sholom, Chicago; Trinity Church, Boston; and the YWCA of the USA, New York.

Individuals at a number of these institutions helped me repeatedly over the years. They deserve particular mention. To say that without John Dorsey (Special Library Assistant in the Research Library Office at the Boston Public Library) this book would not have been written is only the slightest exaggeration. His efficiency, unflagging thoughtfulness, reservoir of information, and careful attention to detail made my frequent contacts with that institution an adventure and a delight. At the public library, I also owe an unusual debt to Janice Chadbourne, Katherine Dibble, Jody Eldredge, Aaron Schmidt, Karen Smith Shafts, R. Eugene Zepp, and Roberta Zonghi. At the Fogg Art Museum, Harvard University Art Museums, Miriam Stewart likewise dedicated an extraordinary share of time, energy, and expertise to my study of Sargent drawings and other materials in the Fogg's collections. The contributions of Stephen Nonack at the Boston Athenaeum; Marcia Hertzman at Congregation Adath Israel Brith Sholom, Louisville, Kentucky; Elizabeth Gombosi, Teri Hensick, and Abigail Smith at the Fogg Art Museum; Patrick McMahon and Lowell Bassett at the Isabella Stewart Gardner Museum; Phyllis Kasdin at the Jewish Community Center, Rochester; Peter Drummey and Virginia Smith at the Massachusetts Historical Society; and Erica Hirschler, Shelley Langdale, and Karen Otis at the Museum of Fine Arts, Boston, also warrant separate note.

Among those who read this manuscript in its various parts and stages, I am especially grateful to Leigh Culver, John Davis, Jane Dini, David Morgan, Richard Murray, and Ellen Smith for their critical and creative advice and for their professional and personal encouragement. For the latter, I want to express my appreciation to Jill Pearlman as well. Elizabeth Ives Hunter made her spirited assistance and multiple kindnesses—in terms of time and energy as well as archival resources—unstintingly available. Sargent scholars both new and seasoned— Leigh Culver, Jane Dini, Trevor Fairbrother, Anne Helmreich, Stephanie Her-

drich, Patricia Hills, Erica Hirschler, Elaine Kilmurray, Richard Ormond, Elizabeth Oustinoff, Marc Simpson, and John Thomas—shared generously from their own research. And Sargent descendants Richard Ormond (again) and John Ormond provided materials with respect to family history and items in John Sargent's library.

In addition, for both intellectual engagement and material assistance, I also thank Helen Barton, Edward Bleiberg, Cynthia Bird, Jeri Bothamley, Betsy Brinson, Roger Bruce, Anita Carrico, Christopher Coble, Adam Cohen, Anthony Colantuono, Dan Crusie, Don Denny, Elka Deitsch, Erika Doss, John B. Fox, Jr., Robert A. Fradkin, Sharon Gerstel, Meredith Gill, Louise Greene, Michael Hager, June Hargrove, Catherine Hays, Michelle Jenney, Pamela Jones, Mary Kergall, Bill Kipp, Liza Kirwin, Genevra Kornbluth, Jennifer Krzyminski, Melinda Linderer, Yelena Luckert, Patricia Lynagh, Dorothy Lynch, Alan McLean, Merl Moore, Elizabeth Norris, Thai Nguyen, Samuel D. Perry, William Pressly, Kevin Proffitt, Kathy Rivas, Bruce Ronda, Herbert Roth, Jonathan Sarna, Terry Sayler, Kristin Schwain, Kerry Schauber, Donna Schulze, Dan Strain, Jennifer Strychasz, Roger Tolson, Malcolm Varon, Marjorie Venit, Melanie Wisner, and Lynne Woodruff.

Working with Princeton University Press has been a satisfying experience from start to finish. When the College Art Association convened in Boston in 1996, then associate art editor Timothy Wardell met me in Sargent Hall with *Triumph of Religion* around and before us to discuss the project. Since then this book has benefited immensely from the insights of the informed and discerning readers solicited by the press and from the guidance of art editor Patricia Fidler, editorial assistant Elizabeth Pohland, production coordinator Elizabeth Steiner, and production editor Curtis Scott. Virginia Wageman's expert copyediting was an art historian's dream, Kathleen Friello brought interdisciplinary expertise to the task of indexing, and Jean Wilcox designed a book likely to make Sargent proud. Earlier drafts of some materials presented in this book were published by William B. Eerdmans, *Art Bulletin,* and *Art Journal.* I am grateful to the editors for their initial support and for permission to publish revised versions.

Finally, it is to my husband Roger Fallot and our daughter Anna that I am most profoundly indebted. Their sweet company, patience, and good and wise counsel have made this a better book and me a better person. It was Anna, too, whose persistent desire for a pet brought Alex, the Labrador retriever, into our household where she kept a place by my chair while I wrote and lured me outside for walks at all the most appropriate moments.

PAINTING RELIGION

IN PUBLIC

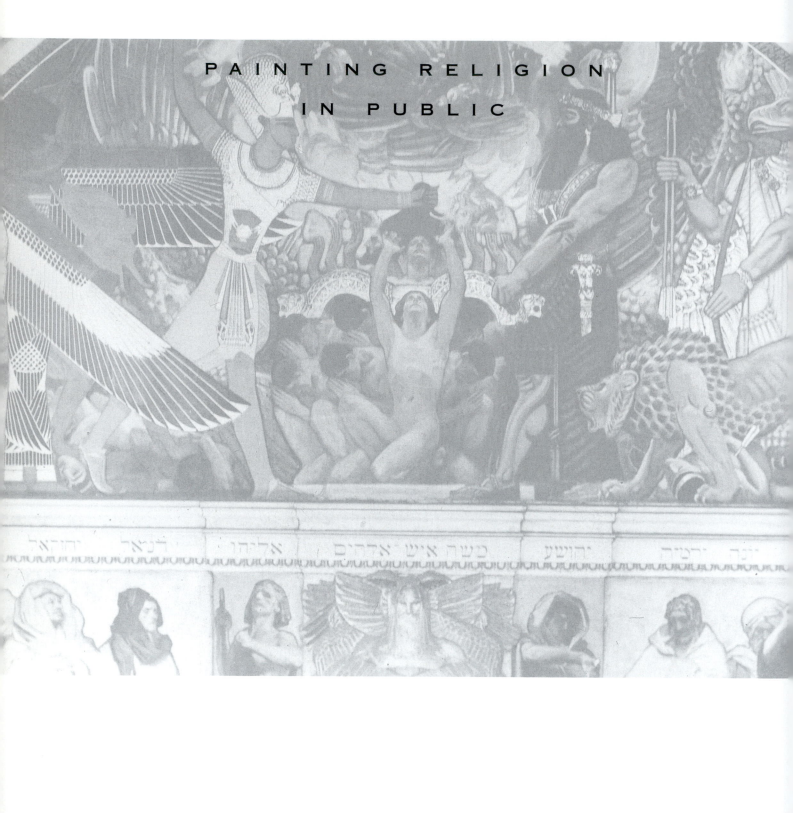

PAINTING RELIGION
IN PUBLIC

⊕

The distinction between "public" and "private" has been a central and characteristic occupation of Western thought since classical antiquity, and has long served as a point of entry into many of the key issues of social and political analysis, of moral and political debate, and of the ordering of everyday life.

—JEFF WEINTRAUB, *"The Theory and Politics of the Public/Private Distinction"* (1998)

*

This book investigates a major monument of American art and that monument's integral and multilayered connections to American religion. It is the story of an artist of international stature; a complex and consuming but meagerly remembered work; a public controversy invoking relations among art, religion, and politics; a large unfinished culminating panel; and numerous "afterlives" in various media of reproduction. In the strictest sense my inquiry focuses on a single artistic product: the Boston Public Library mural cycle that John Singer Sargent titled *Triumph of Religion*. Just as important, however, the program of paintings at the center of my study animates broader cultural and political exchanges concerning the representation of religious content in the American public sphere. Sargent's library decoration—in the original and in reproduction—engaged the attention of multiple audiences and raised the profile of contemporary debates about class, race, art, and religion.

Triumph of Religion is one of the more comprehensive cycles of religious iconography produced by an American artist. Despite its title and subject, however, *Triumph of Religion* does not embellish the walls of a religious institution. It occupies, instead, the third-floor staircase hall of the public library on Copley Square in Boston, Massachusetts. Sargent planned and executed his paintings between 1890 and 1919, making four trips to Boston (the first in 1895) to install different portions of the series. The artist intended his selection and treatment of subject to endorse an advanced spirituality, characteristic, he believed, of enlightened and educated citizens in a modern secular republic. Little known or studied today, in the early twentieth century *Triumph of Religion* was a highly celebrated and widely discussed project in a preeminent public building.[1] Few would contest Sargent's status as a brilliant painter of society portraits. That he spent a substantial part of three decades at the height of his active career executing a religious decoration for a public library may come as a surprise. Even more curious, an artist contemporaries acknowledged as "America's greatest living painter" considered these murals to be his most important work.[2]

Religious experience in the United States has been a multivariate proposition from the earliest days of nationhood.[3] This pluralistic configuration, however, has not always been apparent to the majority of citizens, and it has been especially opaque to many, past and present, who represented Protestant hegemony. Interestingly for our purposes, Sargent painted his *Triumph of Religion* at just the time when social and political events suggest broadening *awareness* of pluralism in American experience; this conceptual shift from Protestant America to pluralist America informed reception of the public library murals.[4] In a grand gesture toward the beginning of Sargent's project, the library trustees could still appropriate a long-standing Christian triumphalist construction in their equation of the mu-

rals' appreciative audiences with "Christendom."[5] By the time the artist installed his fourth set of mural panels in 1919, however, many had to acknowledge that "Christendom" (or its primary New England expressions) no longer constituted, if indeed it ever had, the only or even the most significant frame of reference.

Just six years earlier and a few short miles away, Harvard professor and philosopher George Santayana offered his now classic observation: "The civilization characteristic of Christendom has not yet disappeared, yet another civilization has begun to take its place. We still understand the value of religious faith; . . . on the other hand, the shell of Christendom is broken."[6] Consciously and unconsciously, Sargent's Boston audiences brought experience of the religious and cultural transition Santayana sensed to understandings of the artist's enterprise. Sargent himself never overtly endorsed the trustees' monolithic conception of the library's public as "Christendom." Furthermore, the idea at the core of his mural cycle acknowledged some important implications of religious pluralism in the United States. Still, *Triumph of Religion* is perhaps best described as issuing from a relatively progressive and nonsectarian late-nineteenth-century version of liberal Protestant Christianity. By the end of the second decade of the twentieth century, this perspective would prove not inconsequential for Sargent's murals. A controversy surrounding one of the panels installed in 1919 brought this fact into sharp focus.

In part because of the murals' subject and content, in part because of their particular place in time and space, Sargent's paintings illuminate a frequently heated conversation in American culture over acceptable roles of religious images in public places. While this book is, first, a careful examination of the commission, design, content, and reception of one significant American mural program, a broader set of questions about the representation of religious content in the public sphere generated the research and has framed the conceptualization of the manuscript. The body of the book addresses this second issue from a strictly historical perspective, asking *Triumph of Religion,* in content and contexts, to serve as a case study; the epilogue engages the issue, thematically and theoretically, in relation to later-twentieth-century concerns. At a time in American cultural and political history when art and religion again seem to maintain troubled relations, this book considers aspects of religious pluralism's complex connections to public visual expression.[7]

Both historically and in present practice, the public/private distinction has been singled out as a way of approaching the problem of imagining religious action in a pluralistic culture.[8] Recent scholarship has demonstrated the extent to which "public," and its presumed opposite, "private," lack the neutrality as concepts that they are frequently assigned.[9] In specific cases, "public" and "private" are cast into (or constructed by) any number of social, legal, and political al-

liances. In addition to this problem of valuation, public and private maintain relatively fluid definitional boundaries with respect to each other. Sociohistorically and typologically, the binary opposition of public and private can be demarcated in multiple related but also sometimes self-contradictory ways: for example, the "public" domain of social life (including the market economy) is set off against the "private" domain of family and intimate relations; the "public" domain of interaction with other individuals or groups (including family) against the interior "privacy" of the self; and the "public" domain of state or governmental administration against the "private" or nongovernmental operation of the market economy.[10] It is easy to see how the terms become confusing when analysis merges two or more of these definitions. In the three examples immediately above, the market economy and the family are at once public and private. "The public/private distinction, in short, is not unitary, but protean," argues social and political theorist Jeff Weintraub. "It comprises not a single paired opposition, but a complex family of them, neither mutually reducible nor wholly unrelated."[11]

While the terms under consideration have a much longer history (traceable to ancient Greece and Rome), the modern notion of a personal private sphere (the "things we are able or entitled [or required] to keep hidden, sheltered, or withdrawn from others") operating in relation and opposition to an impersonal public sphere is substantially a development of the late eighteenth and nineteenth centuries.[12] As Weintraub suggests, two sorts of imagery are most generally associated with this pair of contrasting terms: the one having to do with degree of visibility (as in the private "hidden" versus the public "accessible") and the other with degree of collectivity (as in the individual versus the group or the particular versus the collective).[13] Both constructions of "public" (in terms of visibility and collectivity) are relevant to the subject of my book. Here "public" implies access and relative inclusion, a "means of signifying that which is generally available for common inspection," *and* it implies a sphere of social exchange beyond the individual.[14] In the former sense, especially, the word has its greatest applicability as an adjective, as in, for example, public space, public art, or public expression.

While I deem public spaces to be relatively more open and inclusive than private ones, no rhetorically all-inclusive "public" stands behind my argument. By comparison with the adjectival employment of public, the nominal usage (as in "the public") seems to carry greater potential for naturalizing dominant power relations—which public? on whose behalf? and with what authority? ought to be a constant refrain—but within certain limitations the notion of a "public" is still a viable construct.[15] In my text, the most important qualification of the noun is its use in the plural: not public but publics, multiple audiences, individuals and groups, who interpret and appropriate Sargent's mural cycle or one of its constituent parts. In fact, this book is about both painting religion in *public,* that is, in

public spaces and as part of a public conversation, and painting religion in *publics,* that is, in a context that invites many different audiences to respond. These publics are plural not only in any given moment, but also in the sense that each public changes over time and new publics emerge. Furthermore, some of *Triumph*'s audiences saw Sargent's cycle, or more frequently individual elements of it, only in reproduction in various, usually photomechanical, media. In a significant number of instances, the murals' reiterations in different media and places created new semipermanent local cultures of display with new material and social conditions. Finally, any number of relatively discrete publics may aggregate to constitute a larger public—as in the alliance of Jews, liberal Protestants, and Catholics during the five-year controversy generated in 1919 by one of Sargent's mural panels—or disintegrate into smaller units. To discuss *Triumph*'s publics, then, is to deal with configurations both dynamic and partial. Combinations of publics differ in different aggregates, and the composition of the aggregates themselves is fluid. The product of this activity by no means represents a single, static, normative or fully representative entity.

In addition to "public," and its ever-present companion "private," a second paired set of concepts will concern us throughout this book. Like public and private, "sacred" and "secular" are relative and dynamic terms. Rather than simple opposites, they are, writes Robert A. White, interdependent "dualities that are the enabling conditions for each other."[16] The shared boundaries that define the two are mutable; sacred and secular are constantly in the process of formation and reformation. Along the spectrum that charts the two, the advance and retreat of one is always relative to the other. Here too qualifying questions pertain: not just sacred or secular but how? and to what degree? and when? and for whom? For different contemporary audiences and over time, *Triumph of Religion* has sustained interpretations that moved it from one category to the other and back again. But according to Sargent at the Boston Public Library, as I will demonstrate, in the modern world, religion (as a category of sacred experience) could be appropriately public only when it was private. Ultimately *Triumph of Religion* represents Sargent's public recommendation of the privacy of modern religious experience. His post-Enlightenment solution to the puzzle of religious and cultural pluralism in a democratic society was one well suited to the European paradigm of secularization: Sargent recast religion as spirituality, he disconnected it from institutions and dogma, and he interiorized the "spiritual" as a matter of personal subjectivity. The quality that Sargent's critics recognized in *Triumph* as the "spiritualization of the world" derived from Sargent's privatization of religion.[17]

My own interests in interpreting the content of *Triumph* and in considering Sargent's public privileging of religious privacy have led me to focus my discussion at various points in the book on three sets of images: *Frieze of Prophets;*

Synagogue and *Church;* and the never-completed Sermon on the Mount in tandem with the finished lunette above, the pivotal *Israel and the Law.* Apart from a handful of revealing "official" pronouncements and about as many scattered references in his personal correspondence, over the course of Sargent's work at the Boston Public Library, he was characteristically silent about his specific intentions. This reticence on Sargent's part challenges the historian to construct a plausible and responsible interpretation, not from one clear and authoritative central source but from a fabric of reinforcing and corroborating associations, both literary/textual (as in chapter 1) and visual/pictorial (as in chapters 2, 3, and 6).

The opening chapter of my book examines Sargent's historical configuration of private religion for a public space and his association of this idea with the progress of Western (especially American) civilization.[18] This section considers the terms and conditions of Sargent's commission, the artist's decision to "paint religion," and the contexts that make sense of the selection. It engages the murals themselves, in terms of narrative content and style, especially as these relate to Sargent's principal literary sources. On the basis of surviving evidence, I reconstruct Sargent's declared intentions for the final, never-completed, image in the series, a painting that would have pictured the artist's modern interpretation of the Sermon on the Mount.

In chapter 2 I am principally concerned with the ritualized organization of space and performance that informs spectatorship in the Special Collections Hall of the Boston Public Library, a structure one critic aptly called the city's "shrine of letters."[19] Building on the spatial and choreographic meanings discussed in chapter 2, chapter 3 examines Sargent's uses of the history of art, the visual sources of his iconography, his sophisticated modification of these sources, and their relation to the content of *Triumph of Religion.* Though the emphasis varies from chapter to chapter, each considers at least three loci of agency with respect to the murals' significance: the artist, the various viewing publics, and the library.[20] Chapter 4 attends most specifically to the last, investigating the institution's educational and democratic mission and rhetoric as they pertain to the politics of class and immigration in turn-of-the-century Boston as well as to *Triumph of Religion* itself. Sargent acknowledged the library's cultural educational resonance in his deliberate configuration of the library hall as educational rather than devotional space.

Jews, Protestants, and Catholics in Boston, reacting almost immediately to the fourth installation of panels in 1919, objected to the historical falsehood they perceived in Sargent's allegorical representation of the *Synagogue* as a broken and decrepit old woman, in contrast to a youthful, forward-looking *Church.* The resulting controversy over the public representation of religion is the subject of chapter 5. The conflict surrounding *Synagogue* and *Church* involved open hear-

ings, state legislation, and iconoclastic vandalism. Complaints were confined neither to the Boston area nor to Jewish individuals and groups. Objections to these subsidiary, flanking images, I argue, account for the fact that Sargent never executed the final, central mural, the composition he called the "keynote" of the program, the all-important Sermon on the Mount destined for the large expanse of wall between *Synagogue* and *Church*. This late alteration redirected the cycle's narrative energies and introduced new readings that stood in dramatic contrast to the privatizing idea Sargent proposed. Both the reaction in Boston and the artist's uncomprehending dismay make sense if viewed from the perspectives of the city's social and political history and Sargent's personal convictions and experience. Chapter 6 presents a close visual and cultural interpretation of the problematic Sargent *Synagogue* and its companion, *Church*. Locating Sargent in relation to contemporary personal and international events—and especially to the material and psychological devastation of the First World War—substantially moderates perceptions of the artist's investment in these two paintings.

In distinct contrast to significant but chronologically fairly circumscribed (1919–24) negative religious criticisms, over the years and in reproduction Sargent's *Triumph of Religion,* and especially his *Frieze of Prophets,* has received wide popular acclaim among multiple publics of diverse religious and cultural backgrounds. Representatives of various institutions have hailed particular portions of the cycle as indicative of the strength of their own religious and/or aesthetic convictions. It is here that I place the emphasis of chapter 7. In reproduction, many panels of this unfinished and hotly contested mural program have appealed to some of the very constituencies who found the 1919 installation so problematic. Protestants, Catholics, and Jews have requested permission to reproduce different panels of the series in religious educational and periodical literature, on the covers of worship bulletins, in stained glass, in wall decorations, and even in public pageantry. Arts institutions, too, have promoted the use of reproductions, especially in the schools; here much of the primary literature suggests a religio-political agenda in which Sargent's Hebrew prophets have assumed a public identity as representatives of American democratic individualism.

In the book's epilogue, I return to the important question of the public representation of religion in the United States. In the late twentieth century, the increasingly public character of pluralism presents a significantly altered interpretive context for Sargent's decision to paint modern religion as an essentially private phenomenon at the Boston Public Library.

In general, the black-and-white photographs of Sargent Hall in this book date to the murals' installation. More recent color images (1977 and 1999), while indicating the extravagance of Sargent's palette, also document layers of accumulated dirt and damage suffered in early attempts to clean the room's multimedia surfaces.

THE SUBJECTIVITY OF MODERN RELIGION

⊕

Of the portions already completed and which form the beginning of the series, a ceiling, a lunette and a frieze, the subjects are respectively polytheism, monotheism, and the Law and the prophets. The ceiling is the first in order as it is the most primitive form of belief represented.

(It will be noticed that, parallel with the progress of belief towards a more spiritual ideal, the material and formulated character of symbolic treatment gives place to a less conventional artistic expression. Thus the ceiling is entirely composed of archaic and definite emblems, the lunette departs somewhat from them to express a more personal relation between the godhead and humanity, and in the third part with the prophets in whom religion became subjective, formulas are almost entirely abandoned. The future portions of the decoration will follow historically this aspect of the expression of religion in art.)

—JOHN SINGER SARGENT,

"The Triumph of Religion" (1895)

*

For Sargent, the critical moment in the "progress" of religion, the movement in relation to which all subsequent developments (progressive and regressive) were to be understood, occurred when "religion became subjective" in the relation of the Hebrew prophets to the divine. This the artist made clear in the most formal and complete description he ever penned regarding *Triumph of Religion* (or any of his murals), a one-and-one-half-page typescript about the 1895 installation, including a few prognostic sentences regarding his intentions for the rest of the cycle. Here Sargent demonstrated his explicit interest in the "subjective" dimension of religion, a quality he associated with the "progress of belief towards a more spiritual ideal," a "more personal relation between the godhead and humanity." "Subjectivity" is a rather imprecise term, one that, historically, has been made to carry a range of diverse meanings. Sargent employed it to characterize the "advanced" mode of spiritual experience he would recommend to contemporaries in Boston and elsewhere. The quality of subjectivity, the artist maintained, he had already invested in his *Frieze of Prophets.* When his mural cycle was complete, Sermon on the Mount would serve as subjectivity's "keynote." He would narrate the story of religion's progress toward this "more spiritual ideal" using a variety of artistic and intellectual resources. The challenge he set himself was substantial: to represent, visually and publicly, matters he understood to be intrinsically inward, personal, private, subjective—and therefore presumably invisible, or at least partially hidden from external scrutiny.

THE COMMISSION AND DESCRIPTION OF THE CYCLE

On 18 January 1893 John Singer Sargent and the city of Boston, through the trustees of the public library in its new McKim, Mead and White building (fig. 1), entered into a contractual agreement regarding mural decorations for the gallery of the special collections floor at the top of the library's principal staircase.[1] Serious conversations with the artist had begun several years earlier in 1890; the 1893 written document specifically acknowledged the verbal agreement of the prior date and all work already accomplished.[2] Though Charles Follen McKim, the building's chief architect, and Stanford White, his partner, had both personally campaigned for Sargent's selection as muralist, a letter dated 18 November 1890 suggests that it was probably Isabella Stewart Gardner who finally secured the highly desired commission for Sargent.[3] Conceived as a premier monument of the artistic impulse subsequently named the American Renaissance, the Boston Public Library, as a building project, supported an elaborate artistic program and an aesthetic ideal dedicated to the unity of architecture, sculpture, and painting.[4] Though Sargent's murals would occupy a room assigned solely to his decoration,

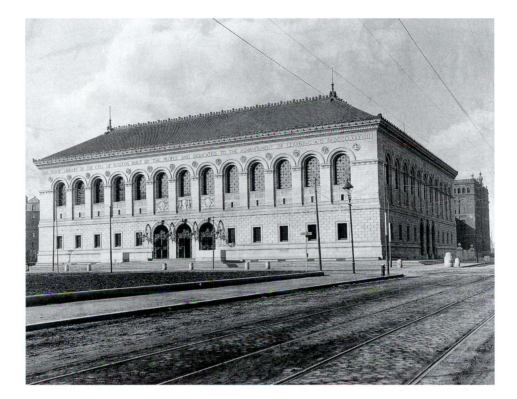

Fig. 1

McKim, Mead and White, Boston Public Library, Copley Square façade, 1887–95.
Trustees of the Boston Public Library

the library trustees commissioned other prominent artists to adorn different parts of the building, its ceilings, walls, and public spaces. Paintings by the French Pierre-Cécile Puvis de Chavannes, acclaimed by many of the library's promoters as the greatest living muralist of any nationality, would cover the walls of the grand staircase and the second-floor corridor, just below the gallery reserved for Sargent. Expatriate American painter Edwin Austin Abbey, Sargent's friend and colleague, contracted with the library for the decoration of the book delivery room on the second floor; Abbey and Sargent would share a studio, organized to accommodate large-scale canvases, early in the course of their respective library cycles.

The space Sargent selected for his work was a long vaulted hall with no windows on the library's uppermost floor (fig. 2).[5] Skylights in the barrel vault illuminated the room, which measured eighty-four feet long, twenty-three feet wide, and twenty-six feet high at the peak of the vault. Along the east wall ran a balustraded stairwell; doors leading to special collections rooms punctuated the two end walls to the north and south and the west wall opposite the stairwell. Ac-

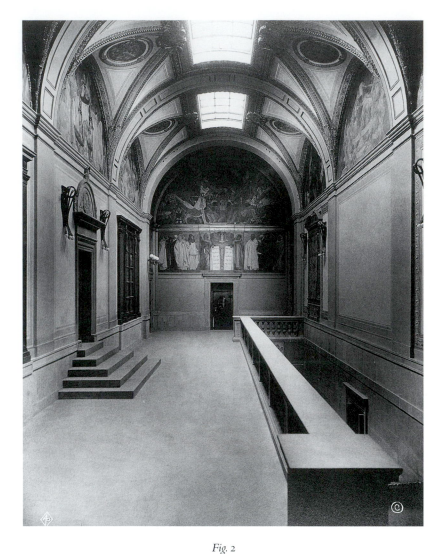

Fig. 2

Boston Public Library, Special Collections Hall, looking north, c. 1916. Trustees of the Boston Public Library

cording to the terms of the 1893 agreement, for the sum of fifteen thousand dollars (in five three-thousand-dollar payments), Sargent was to make and position "a series of mural decorative paintings for the space above the height of the door at the two ends [north and south] of the Special Library Hall of the new Public Library building in Copley Square in Boston including the whole of the two ends of the Hall and the Side walls and barrel vault to the first Pilasters, a distance of about eight feet four inches."[6]

Subject only to consultation with McKim, Sargent would "have the greatest possible freedom in the design and execution of his work."[7] In 1893, by

the time this agreement was committed to writing, however, Sargent's project was already well under way, and all of the principal parties knew the ambitious idea he had outlined. Initially, in the spring of 1890, Sargent had considered depicting themes from Spanish literature. Six months later when he shared his excitement over the recently confirmed verbal contract with his friend and distant cousin Ralph Curtis, the artist had changed his focus and settled instead on a subject representing a specific idea in relation to the history of religion.[8] In 1895, in official correspondence with the library, he called the cycle "Triumph of Religion—a mural decoration illustrating certain stages of Jewish and Christian religious history."[9] He gave it this title, he indicated, because he wanted to "avoid such names as the 'Religions of the World' and others" that might be considered more "comprehensive" than he intended his program to be.[10] He was painting an idea, not a catalogue of religions.

By 28 September 1893, only eight months after signing the first contract, the artist wrote to Charles McKim requesting allowance to elaborate his conception of the room's decoration. At this point, it appears, Sargent had in mind a relatively clear sense of the unified narrative fabric he desired. He could not move ahead with his design, however, until he had the library's permission (and a source of funding) to expand his scheme to the east wall; without this allowance the south wall would have to constitute the cycle's end point. In his letter to McKim, he asked the architect to secure approval from the library trustees for his "plans of doing three large panels along [the east staircase] wall . . . the subject being Christ preaching to the multitudes. . . . I am anxious to know whether I can carry this out for it would affect my treatment of the other end [the south wall]."[11] Later in the same letter, Sargent summed up his request in a manner that indicated its urgency to him: "Please think over the question of the decorations of the *lateral* wall—I am very anxious to do it and will do it for very little money. . . . it will complete the room and be the keynote of my affair."[12] Sargent's bid for the project's expansion was successful, and he signed a second agreement dated 5 December 1895. This time, however, he contracted not with the city of Boston but with Edward W. Hooper, Augustus Hemenway, and Samuel D. Warren, the designated "trustees of a fund subscribed by the citizens of Boston and others, for the purpose of enabling said Sargent to complete his scheme of decoration." Thus, while the city had budgeted public funds for the murals specified in the first contract, this "Committee of Citizens" raised moneys by private subscription for the paintings described in the second.[13]

The language of the 1895 agreement bears careful consideration. Again, as in the 1893 contract, those concerned wished to give the artist the greatest possible latitude in "design and execution" as well as in "choice or character of the subjects"; by this time, of course, they had seen the first installation and they

knew the subject Sargent planned for the east wall. Again, the artist would receive fifteen thousand dollars for his work—here in three five-thousand-dollar increments. For this sum Sargent would produce a "mural painting or series of mural paintings, to cover the three [east wall] panels above the staircase." The contract also indicates that, in December 1895, Sargent and the committee's trustees believed the decoration of the three lunettes above the east wall panels to be both a legal part of the agreement and a likely aesthetic necessity. The document contained a further provision for the *possible* decoration (by mutual agreement of Sargent and the three other signatories or their successors and with no further remuneration) of all or some of the three opposing lunettes on the west, but these were recognized "to be in excess of" the contract. In addition, although the east lunettes were an explicit part of the agreement, some other course might be followed pursuant to a "conference" between Sargent, McKim, and the trustees of the committee. The import of all these allowances was to fix the 1895 arrangement around the necessary treatment of the east wall and to specify that everything else was subsidiary and negotiable.

As the project developed, Sargent's murals would require installation in four parts, spanning a period of twenty-four years, from 1895 to 1919. The artist painted all of the panels on canvas in England, accompanying them, after completion, to the United States to orchestrate and supervise their placement. The fully projected scheme (fig. 3) was far more ambitious, more conceptually and stylistically complex, than anything the artist attempted in subsequent mural commissions: Ralph Curtis called *Triumph of Religion* Sargent's "labor of Hercules," his "Boston pièce de résistance."[14] As Sargent noted in 1914 to Josiah H. Benton, president of the library's board of trustees, the task was also a more demanding challenge than his inexperience in the decorative field had led him to anticipate.[15]

In 1895 Sargent installed the first murals at the north end of the gallery. The north ceiling vault he covered with a panel representing (west to east) the "false" or so-called pagan gods Baal or Moloch (fig. 4) and Astarte (fig. 5) arranged over the central "black silhouette of the goddess Neith," described by Sargent as "the vault of heaven, the origin of things, the Mother of gods . . . who spans the entire arch, touching the horizon with her hands and with her feet as on Egyptian ceilings and zodiacs."[16] On the lunette directly below this ceiling vault, the artist depicted the Israelites (fig. 6) afflicted and oppressed by an Egyptian pharaoh and an Assyrian king and their attendants. Elevated somewhat above the chaos of this scene, but still within the lunette, Sargent painted the Hebrew deity, his face covered by clouds and by the wings of cherubim, intervening on behalf of the children of Israel. *Frieze of Prophets* (figs. 7–9) completed this first set of panels.

Not until 1903 did Sargent travel to Boston to hang the second installment in the mural cycle.[17] This set of images, intended for the south wall of the

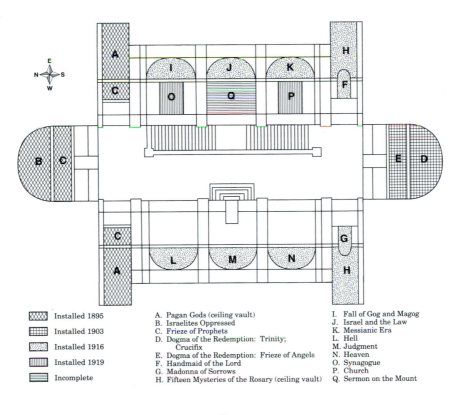

Installed 1895
Installed 1903
Installed 1916
Installed 1919
Incomplete

A. Pagan Gods (ceiling vault)
B. Israelites Oppressed
C. Frieze of Prophets
D. Dogma of the Redemption: Trinity; Crucifix
E. Dogma of the Redemption: Frieze of Angels
F. Handmaid of the Lord
G. Madonna of Sorrows
H. Fifteen Mysteries of the Rosary (ceiling vault)

I. Fall of Gog and Magog
J. Israel and the Law
K. Messianic Era
L. Hell
M. Judgment
N. Heaven
O. Synagogue
P. Church
Q. Sermon on the Mount

Fig. 3

**Diagram of John Singer Sargent's mural program *Triumph of Religion* (1895–1919)
for the Boston Public Library, showing location of images and order of installation**

gallery, Sargent called *Dogma of the Redemption* (fig. 10). In the lunette, the three persons of the Christian Trinity appear as three crowned men sharing one cope and one throne. Below the lunette, *Frieze of Angels* contains eight figures holding instruments of the Passion of Christ. The two central figures (whose garments Sargent decorated with eucharistic symbols) support the base of a very high relief Crucifix that extends upward, visually uniting lunette and frieze. In this conception, Adam and Eve, bound by a single cloth to Christ's body and cross, elevate eucharistic chalices to catch the blood from the Christian Savior's pierced hands.

With the third installation in 1916, Sargent completed the south ceiling vault and the corresponding niches flanking the south wall. In the niche to the east he represented *Handmaid of the Lord* (fig. 11), balanced on the west by *Madonna of Sorrows* (fig. 12). Above, on the ceiling, Sargent painted Fifteen Mysteries of the Rosary, with the *Joyful Mysteries* (fig. 13) adjacent to *Handmaid,* the *Sorrowful Mysteries* (fig. 14) adjacent to *Madonna of Sorrows,* and the *Glorious Mysteries* in gilt relief (fig. 15), crowning the vault. Thus, by 1916, more than a quar-

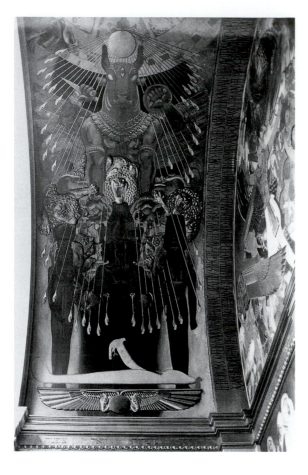 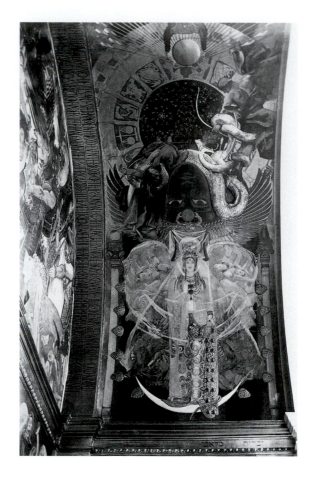

Fig. 4

John Singer Sargent (American, 1856–1925), *Pagan Gods: Moloch,* north ceiling vault, west side, installed 1895. Oil on canvas with relief elements of gilded papier-mâché and plaster, entire vault is approx. 8 ft. 4 in. (254 cm) wide. Trustees of the Boston Public Library

Fig. 5

John Singer Sargent, *Pagan Gods: Astarte,* north ceiling vault, east side, installed 1895. Oil on canvas with relief elements of gilded papier-mâché and plaster, entire vault is approx. 8 ft. 4 in. (254 cm) wide. Trustees of the Boston Public Library

Fig. 6

Opposite: John Singer Sargent, *Israelites Oppressed,* north wall lunette, installed 1895. Oil on canvas with relief elements of gilded papier-mâché and plaster, approx. 22 ft. 1 in. (673 cm) wide. Trustees of the Boston Public Library

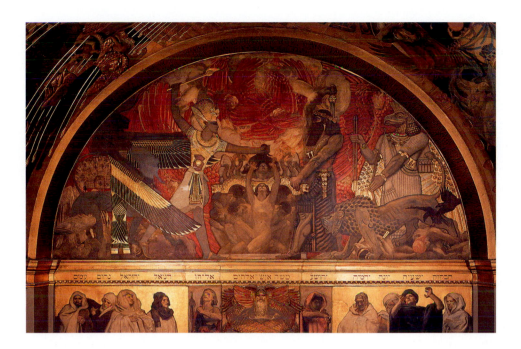

ter century after the initial conception of the project, the north and south ends of the hall—friezes, lunettes, and ceiling vaults—had been installed. This completed the decorations specified in the first contract.

Sargent included in the 1916 installation a series of lunettes for the three vaults along the east and west walls of the gallery (fig. 16; and figs. 26, 27, 31, 56, 61, and 62), with accompanying ceiling decorations in relief. These aspects of the installation belonged to the second contract. Beginning at the north corner of the east wall and moving south, the artist painted *Armageddon* or *Fall of Gog and Magog,* the figure of Israel sheltered under Jehovah's mantle (in an image titled *Israel and the Law*), and *Messianic Era* depicted as the fulfillment of prophecies written in the Book of Isaiah. On the west wall, beginning at the northwest end, Sargent depicted *Hell* as a voracious green monster in a fiery lair. In *Judgment,* the central lunette, an angel weighs souls in a balance and consigns them to hell or to heaven, the celestial subject of the third panel, *Passing of Souls into Heaven,* located at the southwest end of the gallery.

Sargent contributed once more to his mural cycle in 1919 when he added personified representations of *Synagogue* (fig. 17) and *Church* (fig. 18) to the east wall above the stairwell on either side of the central space reserved for Jesus preaching the Sermon on the Mount. In order to maintain the internal logic of his decorative program, Sargent placed *Synagogue* in closest proximity to the "Jewish" north wall and *Church* nearest the "Christian" south wall, inverting the convention of locating Synagogue on the left of Christ and Church on the right.

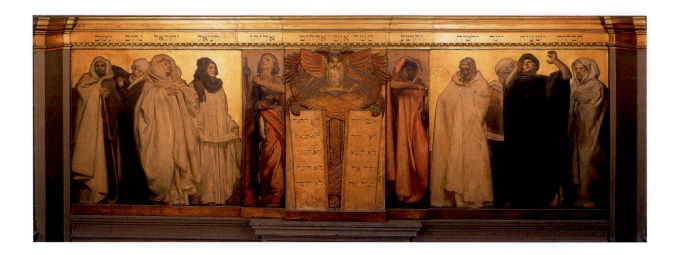

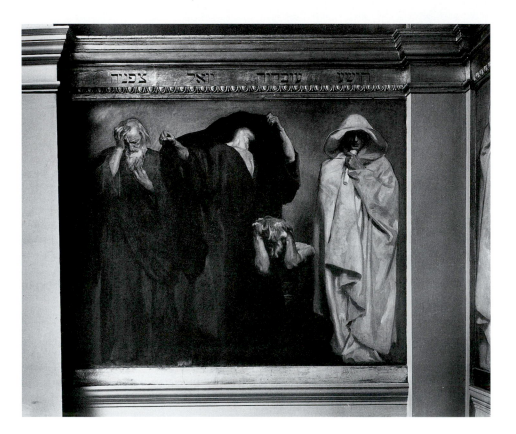

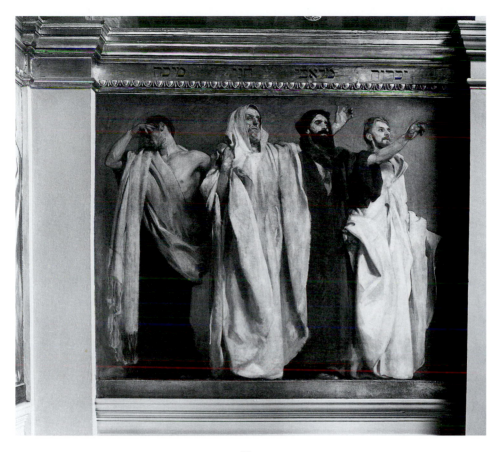

Fig. 7

Opposite, top: John Singer Sargent, *Frieze of Prophets,* north wall, installed 1895. Oil on canvas with central panel relief elements of gilded and painted plaster and papier-mâché, approx. 7 ft. x 21 ft. 1 in. (213 x 673 cm). Trustees of the Boston Public Library. *From left to right:* Amos, Nahum, Ezekiel, Daniel, Elijah, Moses, Joshua, Jeremiah, Jonah, Isaiah, Habakkuk

Fig. 8

Opposite, bottom: John Singer Sargent, *Frieze of Prophets,* north end of west wall, installed 1895. Oil on canvas, approx. 7 ft. x 8 ft. 4 in. (213 x 254 cm). Trustees of the Boston Public Library. *From left to right:* Zephaniah, Joel, Obadiah, Hosea

Fig. 9

John Singer Sargent, *Frieze of Prophets,* north end of east wall, installed 1895. Oil on canvas, approx. 7 ft. x 8 ft. 4 in. (213 x 254 cm). Trustees of the Boston Public Library. *From left to right:* Micah, Haggai, Malachi, Zechariah

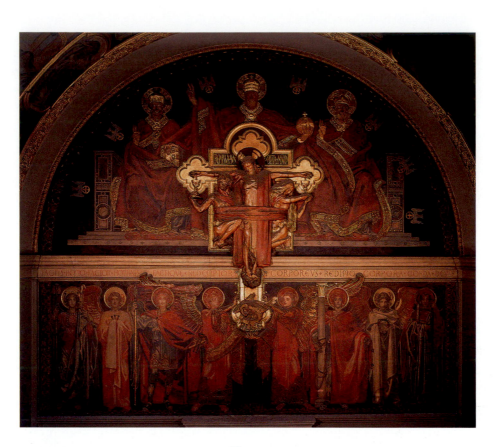

Fig. 10

John Singer Sargent, ***Dogma of the Redemption,*** **south wall lunette and frieze, installed 1903. Oil on canvas with relief elements of gilded papier-mâché and plaster; high-relief Crucifix of gilded and painted wood and metal, approx. 22 ft. 1 in. (673 cm) wide. Trustees of the Boston Public Library**

Fig. 11

Opposite, left: **John Singer Sargent,** ***Handmaid of the Lord,*** **south end, east wall, installed 1916. Oil on canvas with relief elements of gilded plaster or papier-mâché(?), approx. 9 ft. 6 in. x 4 ft. 6 in. (290 x 137 cm). Trustees of the Boston Public Library**

Fig. 12

Opposite, right: **John Singer Sargent,** ***Madonna of Sorrows,*** **south end, west wall, installed 1916. Oil on canvas with relief elements of gilded papier-mâché, plaster, and wax composition, approx. 9 ft. 6 in. x 4 ft. 6 in. (290 x 137 cm). Trustees of the Boston Public Library**

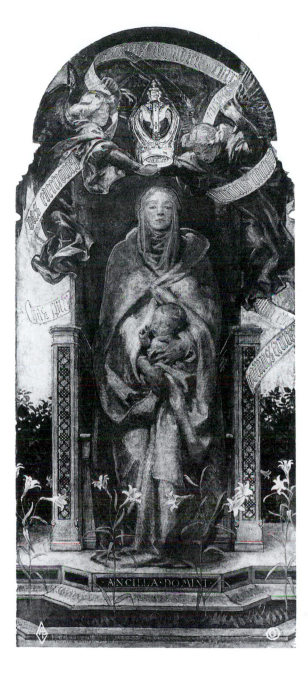

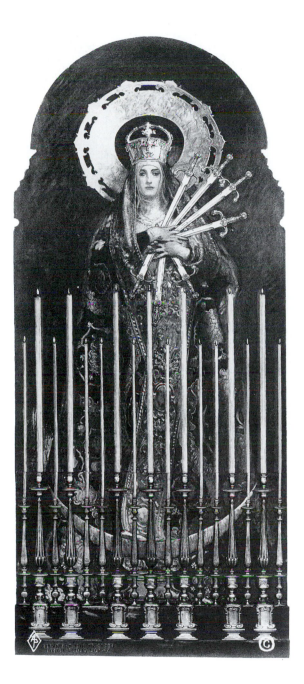

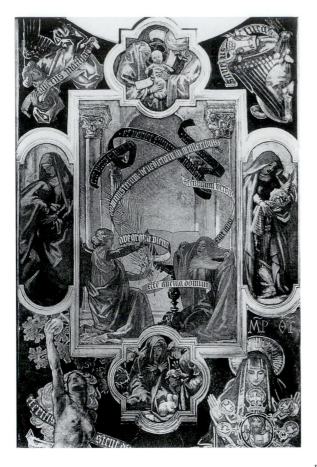 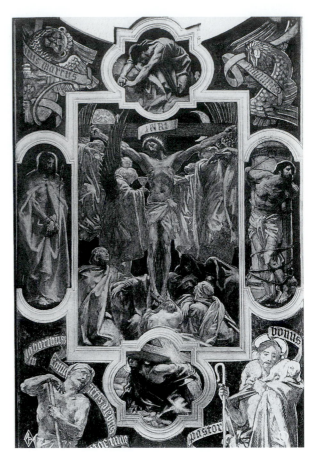

Fig. 13

John Singer Sargent, *Joyful Mysteries of the Rosary,* south ceiling vault, east side, installed 1916. Oil and papier-mâché on canvas, approx. 8 ft. 4 in. (254 cm) wide. Trustees of the Boston Public Library

Fig. 14

John Singer Sargent, *Sorrowful Mysteries of the Rosary,* south ceiling vault, west side, installed 1916. Oil on canvas, approx. 8 ft. 4 in. (254 cm) wide. Trustees of the Boston Public Library

Fig. 15

Opposite, top: John Singer Sargent, *Glorious Mysteries of the Rosary,* south ceiling vault, center, installed 1916. Gilded plaster, approx. 8 ft. 4 in. (254 cm) diam. Trustees of the Boston Public Library

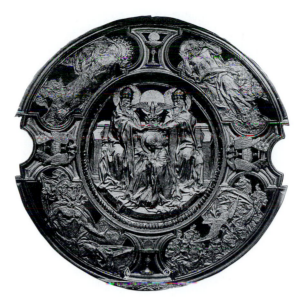

Fig. 16

Below: **John Singer Sargent, photo-board of penultimate studies for *(top)* west wall and *(bottom)* east wall lunettes, prior to 1916 installation of final versions. Each row appears as in the Special Collections Hall, assuming the viewer is facing the respective wall. West wall, from left to right: *Passing of Souls into Heaven, Judgment, Hell;* east wall, from left to right: *Fall of Gog and Magog, Israel and the Law, Messianic Era.* Trustees of the Boston Public Library**

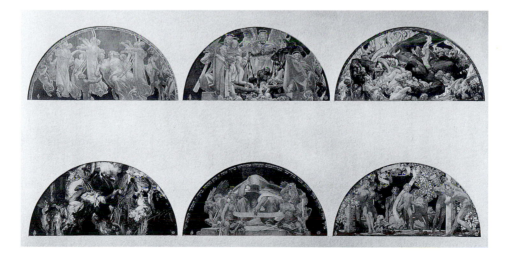

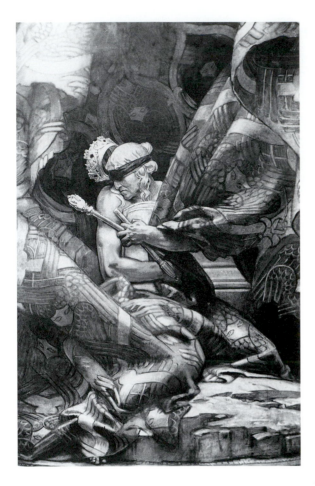

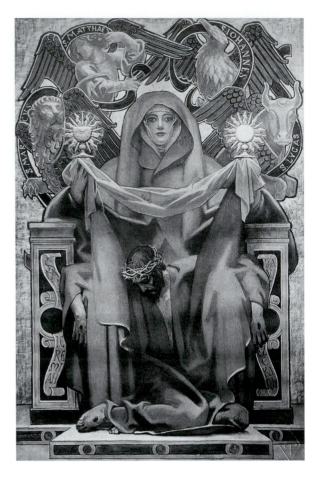

Fig. 17

John Singer Sargent, *Synagogue,* east wall, north of center, installed 1919. Oil on canvas, approx. 64 1/2 in. (164 cm) wide. Trustees of the Boston Public Library

Fig. 18

John Singer Sargent, *Church,* east wall, south of center, installed 1919. Oil and gilded plaster or papier-mâché(?) on canvas, approx. 64 1/2 in. (164 cm) wide. Trustees of the Boston Public Library

SARGENT AND RELIGION

Religion may strike the late-twentieth-century observer as not just a peculiar theme for Sargent, but also an unusual and perhaps inappropriate subject for a public facility. The latter would not necessarily have been the case in 1890. The decoration of the new Library of Congress, for example, represented an almost exactly contemporary project. There a number of artists treated religion as both a

stage in the "scientific" evolution of civilization and an essential body of human knowledge suited to depiction in a library—and to decoration in a government institution. Architecturally and spatially, the most exalted work of art in the new Library of Congress was muralist Edwin Blashfield's *Evolution of Civilization* (1896) on the reading room dome. In this sequential painting and in the language of the time, religion, "typified" by a personified "Judea," delineated the contribution of an early stage of human cultural development and understanding.[18]

My interest in this book has explicitly to do not with the specific character of Sargent's personal religious convictions (or the lack thereof) but with judgments on the part of Sargent and his audiences regarding the appropriate *public* expression of religion. My interpretation rests, in other words, not on whether or not Sargent was himself religious, but on the character of his representation of religion at the Boston Public Library and on the public attitudes (the artist's and his audiences') that informed response to it. To the extent, however, that the private illuminates the public, and considering that private and public exist in dynamic relation to each other, a discussion of the surviving evidence for Sargent's "own" religion seems appropriate.

Based on their assumptions about Sargent's religious disposition as well as his artistic practice, contemporaries expressed amazement over his selection of a "religious subject."[19] The artist's personal history provides no obvious reason for his decision to paint religion rather than Spanish literature. In fact, his background would seem to distance Sargent from religion rather than involving him in its practice. Sargent was born in Florence of American parents committed to a rather constant state of movement from one Continental city or country to another; he trained in Paris and later settled in London. His father (Fitzwilliam) and mother (Mary Newbold Singer) numbered Massachusetts Bay Colony Puritans and Lancaster (Pennsylvania) Moravian Brethren among their ancestors. Sargent's paternal grandfather was secretary of foreign missions for the Presbyterian Board of Publication, and one of Fitzwilliam's brothers was a minister.[20] As a child, Sargent went with his family to church, generally to Episcopal services (his father belonged at one point to the American Church at Nice).[21] His family's nomadic lifestyle, however, precluded settled participation in the activities of any one church or faith community. During the artist's childhood, his father, who apparently valued the content of Christianity over its form, made a point of allowing Sargent and his sisters a degree of latitude and flexibility in religious training. In a letter to his own parents, Fitzwilliam wrote:

We keep them all (the children) supplied with nice little books of Bible stories, so that they are pretty well posted-up in their theology. I have not taught them the Catechism, as someone told me I should, I can't imagine anything more dull and doleful to a little

child, than to be regularly taught the Catechism. . . . And so Emily and Johnny I believe, can give the substance of everything in the Catechism important for them to know, as yet, or which they can, as yet, to any good degree comprehend, without inspiring them with a dislike to books in general by making them "go through" the Catechism. I confess (and I hope you will not be hurt) that I am not myself able to give the exact replies to the questions of the Catechism. To me it is the dreariest of all books.[22]

In part through his father's supply of "nice little books of Bible stories," John Sargent was acquainted in his youth with the Bible but, as he later told a family friend, "not so *very* much."[23] He was confirmed, at age eighteen, in the year he began his Paris art studies, by the bishop of Maine at the American Cathedral in Paris (Holy Trinity Episcopal Church); Emily, his sister and his junior by only one year, participated in the rite of confirmation at the same time. No other mention of Sargent or his family appears in the cathedral's records until his youngest sister Violet's upcoming marriage to Louis Francis Ormond was entered on the books on 11 September 1890. Neither bride nor groom appears to have been well known to the rector, the Reverend Dr. J. B. Morgan, who misspelled both names in the parish registry.[24] While, over time, Sargent's mother and sisters retained a closer connection to institutional religion, there is no evidence that the mature John Sargent ever attended church regularly; his own accounts of his weekly calendar, the absence of his name in schedules of pew rentals, and the testimony of acquaintances indicate that he did not. In Boston he belonged to neither of the two Episcopal congregations most likely to attract his presence (Trinity Church and the Church of the Advent); archivists at both institutions have concluded, on the basis of the absence of any mention of the prominent artist in church records, that it is unlikely that he worshipped there even occasionally.[25] Throughout his correspondence, even in letters written to close friends on the days of Christmas and Easter, he did not refer to church services or Christian observances.

Of the mature painter's religious life, author, critic, and Sargent's childhood friend, agnostic Vernon Lee expressed the opinion that Sargent was "quite emancipated from all religious ideas."[26] Nicola D'Inverno, the artist's model and then valet and household manager for twenty-five years, called him a "freethinker" who "did not 'go in' for religion."[27] Richard Ormond, art historian and grandnephew of the artist, has suggested that "Sargent was not in the least religious, and his objective and historical approach precluded any personal statement of faith."[28] While it is true that, over the course of a lifetime, many people undergo substantial change in degree and character of religious conviction, Vernon Lee's comment was made in 1881 and Nicola D'Inverno (who could speak with some authority about the period from 1892 through 1917) registered his opinion in 1926. In sum, when it

came to *institutional* religion, it seems that Sargent was more an interested spectator than a devoted participant. Though his experiences and attitudes were heavily informed by Western Christianity and its symbols, religion was an idea to which the artist more or less subscribed, not a practice or a community to which he committed himself. If Sargent was not an orthodox believer, however, he was certainly a fascinated and not entirely disinterested onlooker. His personal library contained a large percentage of volumes most appropriately categorized if not as "religious" then as "about religion." Some of these books Sargent acquired as source material for the murals after he had selected the library's subject; his acquisition of other books, as we will shortly see in this chapter and in the third, predated his library work and informed his choice of subject.

 "Freethinking," applied to Sargent, seems to have meant precisely that. It was not that he had no opinions, but rather that he was generally willing to consider, at least initially, a range of intellectual possibilities—and he was more inclined than most to remain deliberately outside the fray when disagreement arose (see chapters 5 and 6). He was "devoted to" Voltaire throughout his adult life, but he also read and enjoyed Decadent and Catholic convert Joris-Karl Huysmans, at least in those instances when he judged the author "not too irritatingly devout."[29] He seemed to be especially attracted to the intellectual consideration of censored or otherwise proscribed and reviled ideas in past or contemporary writers on the history of Christianity; this attraction marked his interest in, for example, Ernest Renan, Leo Tolstoy, and Voltaire. It also touched his engagement with James George Frazer's *The Golden Bough: A Study in Magic and Religion,* a book he apparently delighted in applying to social circumstances as well as to his thinking about religion. On one occasion he reported his pleasure at having "horrified" a guest of Emily's by offering Frazer's interpretation of the "primitive" origins of contemporary mourning rituals.[30] Sargent's friend George Percy Jacomb-Hood specifically connected to the Boston Public Library murals both his own speculations on Sargent's religious predisposition and Sargent's reading of Frazer's *Golden Bough:* "He treated it [the reference here is to the representation of religion at the Boston Public Library] more, one imagines, from the historical and scientific side than from that of the supernatural. His mind dealt with ethics rather than with religion, and he was tremendously interested in the speculations and evidence of 'The Golden Bough' and other works which he read widely, finding them an engrossing study. If he had religious beliefs, they were broad and simple like his character."[31]

 As Jacomb-Hood may have guessed, freethinking in Sargent's case did not amount to the rejection of all religious ideas; his was not unbelief but a modern way of believing. The artist's dismissal of the supernatural Jesus and his focus on what he called the "subjective" in religion seem never to have extended to

atheism or even open agnosticism. Sargent was, moreover, disinclined to advocate any one of an available range of contemporary options for characterizing Jesus as a charlatan. Though he did not object, in his reading of *The Brook Kerith,* to George Moore's representation of Jesus surviving the Crucifixion, he rejected the split in Moore's novelistic depiction of Jesus as a man in possession of a violent and manipulative temper in the years before the Crucifixion who was then abruptly humbled and repentant of the sins of his pretensions to messiahship afterward. "Oh the tame pastoral, and the homilies! And the absence of any identity between Christ before and after his death—and the patronising view he takes of his past career when he has become an absolute dolt and looks upon his past 'crimes.'" Sargent wrote these words to his good friend Mary Hunter who admired Moore and played some small part in Moore's decision to rewrite the biblical narrative. "If the book has come up to your expectations, I wish you would say in what way," the artist concluded.[32]

When everything is considered, Sargent apparently believed in the existence of a generalized and universalized God and in a noble and idealized though very human Jesus. Furthermore, while significant similarities between Sargent's exoticism and concurrent tendencies in Symbolist art have been often remarked, he was not a believer in the occult or in esoteric religion. He once told a family friend and fellow artist who had briefly entertained inclinations in that direction that he believed adoption of the sort of esoteric and densely symbolic religious thought expressed in *The Perfect Way, or, The Finding of Christ* (by Anna Bonus Kingsford and Edward Maitland) would spell the end of art.[33] Both art and "free-thinking" required that the creative individual be constrained neither by a set of ideas too rigidly defined nor by symbols too severely identified with secret or hidden meanings, in this case with syncretic, gnostic, and hermetic significance.

THE ARTIST AS SCHOLAR

Given the absence of conventionally expressed religious conviction in Sargent's adult life, recent historians, like the artist's contemporaries, have puzzled over his decision to paint a religious subject at the Boston Public Library rather than the Spanish literary theme he had originally selected. Since the impressive George Ticknor collection of Spanish literature was bound for one of the special collections rooms adjacent to the hall to be occupied by Sargent's murals, the Spanish theme might have seemed contextually more obvious.[34] But Sargent had another, more ambitious, agenda in mind, one suited to both the library's special collections holdings (the Theodore Parker Library with its wealth of volumes on the history of religions, for example) and to cultural reference on a grander scale. His

idea would emerge from an interpretation of the accumulated knowledge of civilized culture: *Triumph of Religion* would narrate the movement of Western civilization from "primitive" and "materialistic" superstition that located power in external objects to a more "advanced" and "subjective" spirituality according to which power resided with individual selves. As early as 1893 critics in Boston and London anticipated noble designs from Sargent on the subject of the "evolution of religion from superstition."[35] At the public library, through the medium of books (and images), this body of knowledge was placed on deposit for public consumption in Boston. The artist's decoration, initially so puzzling in terms of subject matter, perfectly suited this larger concept. The Boston Public Library was, after all, not a Catholic chapel or a Protestant church, but, largely because of the wealth of its special collections on the third floor, a preeminent American "shrine of letters," the "Mecca of American scholarship," the "Valhalla of Learning."[36] The three contemporary critical appellations served to sacralize the sort of intellectual endeavor represented by a public library as the open and free repository of knowledge and culture. Sargent's murals, decorating the walls of the special collections gallery, marked the principal entrance to these collections.

Sargent had a particular and rather personal investment in a project of just this sort. Marc Simpson has recently demonstrated Sargent's early and consistent interest in literally "making" his public reputation, and Sarah Burns has described the library commission as an eagerly seized opportunity to reinvent public perceptions of his art.[37] In 1890, at the inception of the library undertaking, the artist's technical facility was widely admired; his reputation for creative depth as distinct from dash was less secure.[38] Six years earlier he had written to Vernon Lee expressing his conviction that true genius in the arts could be attained only through the rare combination of these two qualities; the "idealistic" and the "artistic," he called them.[39] Sargent's initial descriptions of his Boston Public Library work indicate his sensitivity to critical perceptions that he was "more talented than intelligent."[40] The library murals, with Sermon on the Mount as their capstone, would establish the painter's intellectual credentials. Thomas Fox, Sargent's younger contemporary and assistant (though neither he nor Sargent would use the term, in some later work we might even call Fox a collaborator) at the Boston Public Library, recorded Sargent's evaluation of mural painting and its significance relative to the other genres in which he worked: "It can be definitely set down that he felt that portraiture was, as he many times said, a comparatively low form of the art of painting. . . . Next in the ascending scale he placed figure compositions and landscapes, and above them, and at the top, the work of Decoration."[41]

With *Triumph of Religion* Sargent would move from society portraitist to serious artist; he would use religious content to secure his reputation as an artist of

substance, a new "old master," a rank that the magazine *Punch* (following others) granted him in 1923 (fig. 19). For a while Sargent apparently believed he could accomplish this transition while still building his clientele for portraits. In fact, he accepted the Boston Public Library commission just as his reputation as a portraitist seemed assured in the United States and during the year in which he began to win sound approval in England. By 1907, however, he would mount a determined though only partially successful effort to put portraiture behind him and to focus on the priorities Fox recounted: "figure compositions and landscapes" and, most of all, "Decoration." Having painted over forty oil portraits in just nine months in 1890, he produced fewer than thirty between 1907 and 1925. In 1914 he complained to Edward Robinson, then director of the Metropolitan Museum of Art, that portraiture constituted "too great an interruption," an interruption he did not wish to sustain.[42]

From the perspective of the artist and his high culture contemporaries, *Triumph of Religion* would literally embody the much touted "evolution" of American visual culture from simple to complex, from modest easel painting to a monumental civic art.[43] Decoration "afforded a much broader field of activity than that of portraiture or landscape" alone, wrote Fox; it presented a greater and more comprehensive technical and intellectual challenge.[44] In an interview with Gutzon Borglum, Sargent reportedly commented: "What a fine thing it is to have some big work on hand which calls for continued labor and all one's ability! . . . It [decoration] is so much better [than portraits]. It is an artist's work. *You can study on and on,* and crowd your life into it. The portrait means an attack that lasts a week or a month and then it's over."[45] Many, including Sargent, agreed with muralist Edwin Blashfield: "Mural painting may safely be called the most exacting as it is certainly the most complicated, form of painting; its scope includes figure, landscape, and portrait; *its practice demands the widest education, the most varied forms of knowledge,* the most assured experience." Recalling to his readers' minds the glories of European (and especially Italian Renaissance) mural painting, Blashfield predicated the "future of modern art" in the United States on the success of the mural movement.[46]

Critic and historian Ernest F. Fenollosa explicitly remarked on the "test of intellectual power" Sargent encountered at the Boston Public Library (and, according to Fenollosa, at which the artist excelled). In the 1895 installation, Fenollosa continued, Sargent demonstrated art's "capacity to marshal into a single illumination truths which Science or History would require many unreadable volumes coldly to demonstrate." Here the artist "condenses for us into a single mental appeal the essences of Egyptian, Assyrian, Phoenician, and Hebrew thought, and that in the tragedy of their relation to the civilization and spiritual-

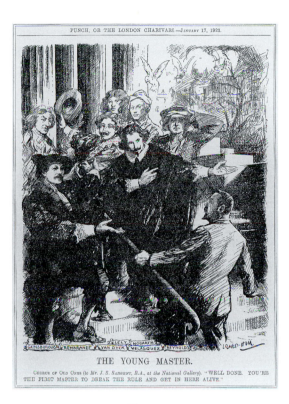

Fig. 19

The Young Master. From *Punch*, 17 January 1923. Boston Public Library Fine Arts Clippings File. Trustees of the Boston Public Library

ization of the world."[47] Both Blashfield and Fenollosa looked to mural painting for evidence of superior intellectual accomplishment, and both believed they found it in Sargent's murals. Publicist Sylvester Baxter agreed: "This work furnishes the first example on a grand scale of a truly modern interpretation of such a theme; the artistic employment of all the means which scientific investigations have placed at the disposal of the worker in the wonderful fruits of archaeological and historical research. It is notable even as a scholarly achievement and one receives a profound impression of the intellectual quality of the artist."[48]

A group of nineteen Boston artists commended Sargent's "scientific design," "high intellectual qualities," and "scholarly effort."[49] The hyperbolic language of the Boston and New York critics sounds so exaggerated to late-twentieth-century ears as to partially mitigate its effect. It stands, however, as a useful marker of contemporary opinion and excitement among supporters and promoters of the genre. The periodical literature of the time is full of similar encomia. By the printing of the 1895 *Handbook* of the Boston Public Library, in a

tribute to the artist repeated neither for Abbey nor Puvis, the room Sargent's decoration adorned had become "Sargent Hall." As Sargent acknowledged on more than one occasion, this project represented a tremendous intellectual and imaginative departure for him. In 1892, when he was hard at work on the "Library exclusively," he wrote to a Boston friend noting modestly that the work was "getting on very slowly as it need must—and requires more brain work than is good for a would-be impressionist."[50]

In equipping Sargent Hall to accommodate the visual and cultural meanings he desired, Sargent pursued a number of activities appropriately characterized as "scholarly": he traveled, he observed and sketched, he read. In fact, travel was among Sargent's earliest responses to the mural commission. Before the year was over he set out for Alexandria, Cairo, and other Egyptian sites, Athens, Olympia, Delphi, and Constantinople. Soon he would also spend time in Spain. Later, in preparation for the 1903 installation, he not only returned to Spain, but also traveled to Ravenna and to Palermo, Sicily, as well as paying repeat visits to Rome and Florence.[51] And after 1903 he continued his researches in Syria and Palestine (visiting, among other places, Nazareth, Mount Tabor, the Plains of Esdralon, and Jerusalem). In Italy he went again to some favorite sites, Venice, Rome, and Florence among them. Another visit to Spain took him to Seville, Granada, and Majorca. That he understood this sort of travel as professional study rather than simple tourism is apparent in his correspondence. "Cramming hard for my library" was the way, in a letter of 1 February 1891, he described his current itinerary.[52]

In order to guarantee the objectivity and authenticity of his narrative, Sargent conducted extensive research. He not only traveled widely to look at artistic and religious monuments firsthand, assembling a large reserve of sketches and visual memories as he went, he also accumulated and consulted an impressive personal library of relevant books and materials. Baxter framed this acquisition of printed matter (a "remarkable library of religious and archaeological lore") in direct relation to the Boston murals.[53] In a memorial tribute, Evan Charteris summarized his friend's literary habits in this context as well: "His range was wide, his knowledge inexhaustible, his reading deep and varied. In literature he trod no narrow track—travel, adventure, experiences that were personal and strange, these had an invariable appeal for him. He liked writing which could conjure up images and portraits. . . . For his work in the library at Boston there was no detail which he had not verified by his reading. He was in all things thorough, not, indeed, consciously, but rather by reason of his immense and natural sincerity, his zest for the absolute truth in expression and representation."[54]

Fox agreed but added more: "The books to be seen on the shelves of even his temporary abode were of unexpected and exceeding interest, and

showed a range rarely found outside the quarters of a true bibliophile or the enthusiast in things unusual, but never abnormal. Books of travel were numerous and the file of a geographical magazine, primarily for the pictures, was kept intact so far as possible. But in addition to these were always to be found not only the standard fiction of foreign tongues, but also the works of the biographer, philosopher and poet."[55] A careful perusal of extant tabulations of the books owned by Sargent would augment these lists of Sargent's reading interests with such categories as art, architecture, design, religion, literature (classical and contemporary), and history, especially of the places Sargent had lived or to which he traveled with any frequency.

There is ample evidence to suggest that Sargent was a dedicated collector of books well before the beginning of his experiences as a muralist. Lists of the items in his personal library, collated from various sources including an important estate sale catalogue, include many selections both rare and old as well as a significant number of first editions.[56] Sargent's correspondence with family and friends also indicates that books were a favored gift on birthdays and holidays.[57] His sister Emily, in particular, indulged her brother's love for books in the presents she chose for him. With Henry James and Edmund Gosse as close friends and many other writers among his warm acquaintances, he moved easily and frequently in bibliophilic circles. It was as one already established in the habits of avid reading, book collecting, and support of contemporary literature that Sargent conceived *Triumph of Religion*. His collecting habits were so well set that, on a visit to an army hospital in 1918 during his months as a war artist, he was more inclined to stop at all the relevant local establishments than to eat. His escort commented: "He wanted to roam all over every book shop and antique shop but took himself firmly, slapped himself on the wrist, and came to lunch."[58] Martin Birnbaum, who met Sargent at a dinner party in 1917 and was sketched by him in charcoal in 1922, described the artist's consistent display of "youthful greediness [Sargent was in his mid-sixties by this time] for the wealth of wisdom that books contain . . . his rapid mind retained its readiness to absorb everything."[59] Sargent's library, as well as his travel itineraries, tends to indicate that he often linked religion with travel (and therefore with distance). He was, in other words, fascinated by other people's religion. He recommended to his friend, musician Charles Loeffler, for example, Ferdinand Ossendowski's "very remarkable" tale of adventure and Asian religions, *Beasts, Men, and Gods,* and he provided illustrations—some of them "religious"—for Alma Strettell's primitivizing book on Spanish folk songs.[60]

What we know about Sargent's library and reading habits we owe to the estate sale catalogue, lists of public and private collections, and his own correspondence.[61] The fact that Sargent was a book collector as well as a reader, however, increases the level of caution that must be exercised with respect to gauging

the significance of any particular volume in his library. That he owned a book tells us little about his sense of its content; even if we know that he read the book, it may have represented to him a collector's prize rather than a scholar's resource.[62] On the other hand, a number of factors facilitate responsible documentation and assessment of Sargent's reading habits. Several partial collections of his books exist intact. Here we see the varied possibilities for the different volumes he owned: some remain uncut; some are inscribed as gifts (often from family and close friends but also from distant admirers eager to share their own literary productions with a renowned contemporary); others are well worn and annotated in his own hand—some annotations directly connected to his Boston Public Library project. In addition to the evidence of the books themselves, the estate sale catalogue for printed materials from his Boston and London studios and some of the private lists too contain rather precise notations regarding inscriptions, condition, and in some instances even suggestions of use. Finally, because Sargent was so fully engaged in the culture of books, his own reviews and recommendations appear with some frequency in letters to family and friends and in the records his acquaintances kept of various exchanges with the artist.

Boston artist R. H. Ives Gammell accurately assessed the Sargent who painted *Triumph of Religion* as, first and foremost, the "cultivated reader," the scholar meticulously recording in his mural panels images elicited during hours of study in his private library: "These pictures seem to give pictorial shape to the thoughts of a man comfortably ensconced in the security of nineteenth-century scholarship, pondering over the dreams of earlier ages."[63] Such an "intellectual" undertaking would surely refute complaints regarding the supposed superficiality of Sargent's facile "French" brush. From Sargent's perspective, *Triumph of Religion,* when completed, would represent an intellectual endorsement of spiritual subjectivity conceived not to sanction religion per se but as an analogue for enlightened human achievement (his own and that of Western civilization). This message hinged on the style and content of two paintings: *Frieze of Prophets* at the north end of the hall and the "keynote" Sermon on the Mount, planned for the long east wall above the staircase.[64] In these panels Sargent would equate his naturalistic signature style with a "modern" freedom from external and institutionally determined authority. Here *Triumph* owed much to Sargent's principal textual sources, and especially to Ernest Renan's *Life of Jesus* and five-volume *History of the People of Israel.*[65]

SARGENT AND RENAN

Sargent's move from the Spanish subject to *Triumph of Religion* was not simply a move from a literary subject to a religious one but from one literary subject to another. His conception of the public library decoration was heavily informed by his own wide reading habits—and by Renan in particular. In *Triumph of Religion* Sargent expanded upon both his specific understanding of Renan's scholarly thought and his sense of Renan's contemporary reputation. Sargent's murals invoked the content of Renan's texts, first and most importantly, in the artist's endorsement of a progressive evolutionary scheme that appropriated the history of Western religion to recommend, as characteristic of civilization's pinnacle, the values of subjectivity and individualism. Second, in this cycle at least, Sargent agreed with Renan's identification of the specific pivotal episodes (the Hebrew prophets and Sermon on the Mount) upon which the narrative construction of human "progress" would turn. In addition to the content of Renan's texts themselves, Sargent's conception of *Triumph of Religion* depended upon the cultural and political character of historical reception of the French author's work. Especially in Sargent's earliest idea of his program, he counted on the tendency of his contemporaries to read the skeptic Renan as both subversive and scientific: subversive, in fact, because he was so "scientific" in his approach to the biography of Jesus. Renan's texts had disconcerted the institutional church in France; Sargent anticipated that his Boston library murals, too, would be a "surprise to the community."[66] He also believed that his cycle would be understood in relation to contemporary advances in the scholarship of biblical criticism and archaeology, a body of knowledge represented by Renan's biography of Jesus and histories of religion.

Though *Life of Jesus* was initially published in Paris in 1863, twenty-seven years before Sargent conceived his *Triumph of Religion,* the French historian's five-volume *History of the People of Israel* was completed to much fanfare between 1887 and 1893 (with the last two volumes published posthumously). *Life of Jesus,* too, continued to maintain a high cultural profile. Over sixty thousand copies of Renan's *Life of Jesus* had been sold in the first five months after publication (it went through eight editions in three months); the text was translated into thirteen languages. Dora Bierer's research on Renan and his cultural interpreters indicates that in nineteenth-century France, *Life of Jesus* might justifiably be called a "best seller," its sales superseded, apparently, by only one book: the Bible itself.[67] Owen Chadwick concurs that Renan's book was the "most famous book written in France during the nineteenth century and until about 1900 its author was the most famous of French writers."[68] Whereas Gustave Flaubert's *Madame Bovary*

went through twenty-three printings in different French editions between 1857 and the end of the century, *Life of Jesus* went through at least one hundred printings between 1863 and 1900.[69] Undoubtedly Renan's clear and readable style of writing, his straightforward thesis, and the resonance of poetry and romance that attended his brand of positivism all contributed to the book's appeal. Here was an expert of established academic repute who communicated comfortably with the general reading public as well as his professional peers.

By 1891 Sargent was well aware of Renan's reputation as a scientific rationalist and a skeptic. This is especially apparent in an August entry for that year in the diary of Lucia Fairchild, an art student and Sargent family friend. It is due chiefly to Fairchild, and to her accounting of the day on which Sargent recommended Renan's *Life of Jesus* to her consideration, that we know Sargent had this text on his mind as he formed the plan for his Boston Public Library mural cycle. According to Fairchild's diary, after a visit to the Church of St. Mary, Fairford, Gloucestershire, to look at medieval stained-glass windows depicting Hebrew prophets (windows that Sargent judged to be of very fine quality as stained glass but not very helpful in their treatment of draperies and characterization of the subject for his purposes in Boston), the older artist encouraged the unchurched Fairchild to read the Hebrew Scriptures for their excitement and their "stories of adventure perfectly plainly told." He also promoted the Christian Scriptures for their beauty "from a literary point of view" and asked Fairchild about her degree of acquaintance with Renan's 1863 text: "Have you ever read Renan's 'Life of Christ' [*sic*]? Oh that you ought to read—that's a fine book."[70] Fairchild secures for us Sargent's familiarity with *Life of Jesus* and his general approval of its content.

A letter from Sargent to his friend and promoter Henry James demonstrates his explicit interest in a later set of works by Renan, the author's five-volume *History of the People of Israel*. James held Renan in highest esteem. Earlier, in 1876, he had asserted, "if he is not the first of French writers, I don't know who may claim the title." Within a few years of Renan's death in 1892, James deplored the fact that now, as he saw it, "the great historians are dead—the last of them went with Renan."[71] Clearly Sargent knew of James's admiration for and familiarity with Renan, for the artist wrote James, in the early stages of the library murals' production, to inquire whether the fourth volume of Renan's *History of the People of Israel* had yet appeared: "I wish you could find the time to run down here some day. We would all be so delighted. I should like to have your suggestions about my work [on *Triumph of Religion*] and about the subject of it which seems to me bigger and bigger and more difficult to put into a straight jacket. I am still at work on the designs, and not yet on the big canvases. Do you know if the 4th volume of Renan's Peuple d'Israel has come out?"[72] Records of

Sargent's personal library indicate, furthermore, that he owned a first and complete edition of *History of the People of Israel* as well as the eight-volume set of Renan's *History of the Origins of Christianity* (including *Life of Jesus*).[73] Later in life, Sargent's response to an admirer's inquiry explicitly acknowledged the influence of this author and historian on *Triumph of Religion*.[74]

Taken together, the James and Fairchild references establish for us Sargent's engagement of both *History of the People of Israel* and *Life of Jesus* at just the time of the conception and planning of *Triumph of Religion*. Fairchild's account is particularly revealing, for it is in her diary that the reader most clearly discerns the interpretation of Renan that informs the Boston decorations. In Fairchild's diary, in the sentences that follow Sargent's hearty endorsement of *Life of Jesus,* the artist added a cautious qualifying note. It was only because Fairchild had none of "that conventional feeling to start with" that the painter's recommendation of Renan could pass as appropriate. Renan's text was, after all, a "book that most young people are not allowed to see. It's considered awfully sacrilegious. . . . Raising doubts—taking away a young creature's faith etc etc."[75] In Fairchild's rendering, Sargent understood *Life of Jesus,* with its emphatically human conception of the Christian messiah, its rationalist debunking of miracles, and its reliance on German biblical criticism, as a challenge to conventional late-nineteenth-century Christianity. In short, the artist was attracted by the subversive agenda he read in Renan.

RENAN'S REPUTATION

There was plenty of basis for this reading of Renan on Sargent's part. Despite Renan's scholarly credentials and intentions, his biography of Jesus had provoked an immediate scandal. In Europe and in the United States, churchmen and women moved vigorously to counteract his influence. The proportions of this reaction were amplified, surely, by the fact that Renan's principal "target" was neither Jesus nor God—though he did sever the ontological and orthodox connection between the two, claiming that Jesus was not God but simply the closest thing to divinity (in terms of intimacy and quality of relation with the divine) that humanity had yet produced.[76] While Renan's was a distinctly revisionist history of the Christian messiah, he reserved his condemnation for the institutional church as the source of stultifying dogmatic pronouncements and structures. Writing thirty years later, at precisely the time that Sargent was working on the north end of the library hall, Emile Zola recalled the ecclesiastical furor following the publication of *Life of Jesus:*

Suddenly, overnight [Renan's] face rose above France, with the terrifying profile of Antichrist. It was a sacrilege shaking Jesus on his cross. Renan was represented, like Satan, with two horns and a tail. The fright was immense, mainly among the clergy.

. . . Devout women crossed themselves and scared naughty little girls by threatening them with M. Renan, while the freethinkers grew interested in this audacious mind and liked to attribute gigantic proportions to him. He became the giant of negation, he symbolized science killing faith. If one adds that he was considered a defrocked priest, one completes the portrait of this rebellious archangel, a modern Satan, a victor over God, eliminating God with the weapon of the century.[77]

The official response of the Catholic Church was swift. From its perspective, Renan's book exemplified recent and dangerous scientific critical tendencies in historical and religious scholarship; such literature generally supported liberalism, challenged the church's political power, and encouraged rationalism and skepticism. Judged to constitute just the sort of "pestilential errors" and "pernicious fallacies" that Pius IX had recently proscribed (June 1862), *Life of Jesus* by 24 August 1863 had earned a secure place in the church's *Index* of censured works. A little over a year later, though naming neither text nor author, those for whom the message was intended could clearly see that the *Syllabus of Errors* condemned Renan and his book.[78] Among the hundreds of reviews and pamphlets (some with titles like "Long Live Jesus! An Appeal to the People against the Deicide Manifesto of M. Renan") that appeared in Europe and the United States, many attacks were written by individuals who, since the *Index* prohibited observant Catholics from ever actually seeing the text, had not read the book. Some of the most vehement detractors went so far as to suggest that *Life of Jesus* represented a conspiracy by Renan and his Jewish publisher (Calmann-Lévy) to destroy the Catholic faith.[79]

Renan remained a prominent figure in the French press throughout the rest of the nineteenth century and a favored enemy of the Catholic Church until well after his death. During the period of Sargent's student days and early career years (1874–84) in Paris as well as during the time of *Triumph of Religion*'s initial conception (1890–94), the French historian's name appeared in the news in ways that might well have attracted Sargent's attention. It would have been difficult to avoid knowledge of Renan's reputation; he had become the perennial symbolic adversary of the French Catholic Church and its political allies. In 1878 Renan received significant coverage for his connection to another of Sargent's literary heroes: Voltaire. On the occasion of the centenary of Voltaire's death, Renan, Victor Hugo, M. P. F. Littré, and other intellectuals organized a widely publicized celebratory event. The government refused to take part (Voltaire's name—not unlike Renan's, incidentally—having well before this time acquired a kind of

symbolic usage in French politics). In language sounding like that used to de-
nounce Renan, one devout and disgusted English observer commented that the
huge crowd, representing "no inconsiderable portion" of France's population,
"exalted the memory of the most inveterate enemy of Christianity and its
founder."[80] In the first decades of the twentieth century, the French church and
prominent Catholic authors including Jacques Maritain and Paul Bourget con-
strued the return to the church of Renan's grandson (Ernest Psichari) as a vindi-
cation of Catholic Christianity and as revenge for Renan's blasphemy.[81]

RENAN AND SUBJECTIVITY IN *TRIUMPH OF RELIGION*

Renan's *Life of Jesus* did more than suggest a subject to Sargent and set the scien-
tific and anti-institutional tone for his "religious" decoration. It also charted a
standard nineteenth-century progressive evolutionary course from "paganism" to
Christianity, a movement Renan described as the basis for Western civilization.[82]
Perhaps most important for the organization of Sargent's murals, Renan's book
extolled two moments of greatest consequence in the story that told these des-
tinies: first, "the introduction of morality into religion" in the lives and words of
the Hebrew prophets and, second, the flowering of the prophets' message in
Jesus' Sermon on the Mount.[83] For Renan, Jesus was, in fact, "the last of the
Prophets," the one who "sets the seal upon the work of Israel."[84] From this time
forward, "whatever may be the transformations of dogma, Jesus will remain in
religion the creator of its pure sentiment: the Sermon on the Mount will never be
surpassed."[85] Renan's celebration of this "pure sentiment" Sargent reiterated in
his sense of the development of "subjective" spirituality. For Renan, this sort of
subjectivity constituted a new beatitude for contemporary life. Alluding in his
own selection of words and organization of sentences to the language and struc-
ture of the biblical Sermon on the Mount, Renan provided this emphatic sum-
mary: "more blessed still would Jesus tell us, [is] he who, disenthralled from all
illusions, shall reproduce *in himself* the heavenly advent, and, with no millennial
dream, with no chimerical paradise, with no signs in the heavens, [but] by the
righteousness of his will and the poesy of his soul, shall create anew *in his heart* the
true kingdom of God!"[86]

According to Renan, the ideal religion, the religion founded by Jesus and
expressed most fundamentally in the Sermon on the Mount, was anti-institutional
and democratic; it was "the everlasting religion of humanity, the religion of the
spirit liberated from everything belonging to the priesthood, to ceremonial and to
ritual, accessible to every caste."[87] Renan's "pure worship" represented "a reli-
gion without priests and external practices, resting entirely upon the feelings of

the heart, upon the imitation of God, [and] upon the immediate communion of the conscience with the heavenly Father."[88] Renan insisted, further, that much of the religious sentiment of the Sermon on the Mount could be traced to the Hebrew prophets, "defenders of the ancient democratic spirit, enemies of the rich, opposed to all political organizations," conveyors of the highest moral and spiritual imagination. It was, in fact, the subordination of the priesthood to the individual inspiration of the prophets that accounted for Judaism's early religious superiority.[89] Subjectivity, of the sort endorsed by Sargent and defined as an immediate, intimate, experiential, and private relation to God (a relation characterized as the divine "kingdom" or domain within the individual), was the cornerstone of authentic religion as Renan understood and recommended it.[90] For Renan, the prophets signaled the beginning of the story of genuine religious subjectivity, just as the Sermon on the Mount signaled its distilled expression.

THE STAIRCASE WALL AND SARGENT'S
SERMON ON THE MOUNT

In official correspondence dated as early as 1893 (when Sargent was hard at work on his *Prophets*) and as late as 1918, the artist maintained that Sermon on the Mount was essential to his conception of *Triumph of Religion*.[91] His desire to paint this image on the east wall panels was fundamental to his request for the second contract—and it determined his treatment of the south end of the hall. Furthermore, Sargent clearly understood Sermon not just as one more equally important piece of the whole, but as the "central idea," the "culmination," the "keynote of my affair."[92] Without Sermon, *Triumph of Religion* would not narrate the idea he had in mind. The second contract specifically subordinated the east and west lunettes to the east wall panels in terms of the expected order of completion as well as significance. In keeping with his qualitatively "evolutionary" pattern or sequence of installation, however, Sargent began the lunettes first. Presumably in the interest of emphasis, he decided, sometime before 1913 when he told Edward Robinson of his plans, to leave "the three large panels [of the lateral staircase wall] to be finished last of all."[93] This course of action also offered the distinct advantage of visually pulling together the two ends of the room before showcasing the program's climax.

In the two years or so leading up to the 1916 installation, Sargent redesigned the moldings and the punctuation of the ceiling and the east and west walls with his three large panels in mind. Until this time he had envisioned a continuous single-subject composition, covering all three panels of the wall surface. A surviving sketch reflects this idea (fig. 20).[94] Except when viewed from the

Fig. 20

John Singer Sargent, *Study for Sermon on the Mount*. Graphite on cream wove paper, 10 5/16 x 16 3/16 in. (26.2 by 41.1 cm). Fogg Art Museum, Harvard University Art Museums, Gift of Miss Emily Sargent and Mrs. Francis Ormond (through Thomas A. Fox, Esq.), 1933.46 recto

north and south ends of the room, it would have enveloped the viewer's entire range of vision and continued beyond. In this rendering and in the relatively narrow space of Sargent Hall, Sermon would have assumed panoramic proportions. While this treatment would have underscored the contemporaneity and importance of the theme, the possibility that the piece would seem entirely out of scale with the rest of the cycle, and that it might reinforce the "monotony of that long wall," apparently dissuaded Sargent from pursuing this course, as he indicated to Josiah Benton in a letter of 8 October 1915 reporting the modification of his plans. The letter not only reiterated the significance of Sargent's Sermon panel as his story's climax, the "end" of the painted sequence, but also noted the addition of flanking "allegorical" figures of Synagogue and Church. These two figures, Sargent declared, he would treat in a manner "totally different" from the Sermon, in part by containing the images in architectural frames (or "shrines" as he called them). In this letter, too, Sargent provided his straightforward explanation for reducing the lateral expanse of the Sermon panel: "My original intention was to cover the three large spaces over the staircase and below the impost with one continuous composi-

tion of the Sermon on the Mount—but I find that impracticable—one could not stand far enough away to see such an extended composition—and have come to the conclusion to limit that subject to the middle space."[95]

Based on the presumed distance required to view the very large composition as initially conceived, Sargent's explanation accounts for the more emphatic division of the three panels but not for the addition of new subject matter. Sargent pursued his revised conception of the east wall in a sketch (fig. 21) that shows him moving from the tripartite landscape he first penciled in to an overdrawing of Synagogue and Church in architectural frames. The framing devices altered the visual phrasing of the wall, shrinking the spaces now to be occupied by *Synagogue* and *Church* and "expanding" by comparison the central area intended to hold the new single-panel conception of Sermon. The focus on Sermon Sargent would maintain in that panel's relative scale and lateral orientation.[96]

Sargent's earliest design for *Synagogue* and *Church,* worked out before his decision to modify the east wall and probably while he was considering the iconography for the west lunettes, demonstrates that the artist had initially envisioned the allegorical pair as part of the cycle's relief decoration (fig. 22). In this

Fig. 22

John Singer Sargent, *Study for Lunettes and Relief Sculpture,* top, west wall; bottom, east wall, from sketchbook labeled "Lat[e]ish Decoration." Graphite on off-white wove paper, 10 1/4 x 14 3/4 in. (26 by 37.5 cm). Fogg Art Museum, Harvard University Art Museums, Gift of Mrs. Francis Ormond, 1937.7.31 folio 4 verso

phase of his thinking, Sargent sketched relief figures of apocalyptic angels for the west side of the room flanking the central lunette of *Judgment* and relief figures of Synagogue and Church (reversed north to south from their final configuration) for the east side flanking *Israel and the Law.* The sketch in which the artist superimposed his architectural shrines on the landscape (fig. 21) he probably executed in the two years or so prior to his 1915 letter to Benton, after moving Synagogue and Church from elevated relief pendants adjacent to the lunettes and locating them within the painted scheme for the east wall but before he had reached his final conception of the two figures. As in all the earlier sketches, Synagogue and Church here retain a more conventional iconography and opposition than in the final design.[97]

The London scale model (fig. 23), which Sargent had photographed in 1915 to demonstrate to Josiah Benton and Thomas Fox the changes he desired in the moldings and treatment of the ceiling, showed an early conception of *Church* in place and a preliminary sketching out of the central Sermon panel. An oil study (fig. 24), now at the Boston Public Library, provides an even better sense of

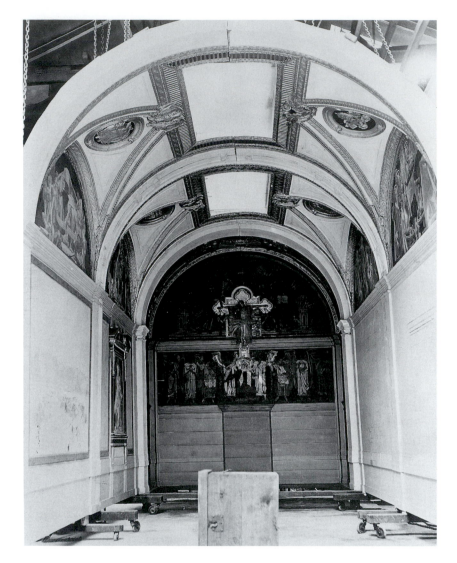

Fig. 23

John Singer Sargent, studio model for Special Collections Hall, three bays from center of room to south end. Fogg Art Museum, Harvard University Art Museums, Registrar's Files, refers to 1933.45

this stage of Sargent's thinking about the staircase wall. Here he retained the landscape features of the central horizontally oriented panel and indicated the relational scale he desired between *Sermon* and the smaller, vertically oriented *Synagogue* and *Church*. Another preliminary sketch (fig. 25) has the artist working out the figural composition of *Sermon* with a crowd of people inclined toward the central figure of Jesus, whose left hand rests on the head of a child. The wall of upright bodies in the middle ground cuts off the sweep of the landscape of ear-

lier studies and represents a more intimate view, into which the viewer is drawn by the disposition of the foreground figures.

Considering the east wall as a whole, the new, more segmented treatment featured a higher degree of thematic consistency with the lunettes above. Sargent's *Synagogue* would be placed under the apocalyptic destruction of *Gog and Magog;* his *Church* under *Messianic Era* (fig. 26), with the young anointed one, above, striding out confidently over Church's shoulders; and Sermon itself would appear below the figure of a youthful Israel sheltered by Jehovah's Law (fig. 27), marking the descent of authority from the Jewish God to the Christian Jesus. Despite the changes in scale and iconography that accompanied Sargent's east wall modifications (1913–16), the artist and his critics remained sharply focused on the projected climax in the Sermon.

Sargent never intended the latecomers, *Synagogue* and *Church,* to stand at the apex of his cultural evolutionary scheme. Rather, like Renan, he understood both institutions to represent premodern dimensions of religion. The artist endorsed a conception of the two that eventuated in the library's labeling them the "Medieval Contrast." "Medieval" here, in relation to recent developments in the organization and periodization of history, signified not just chronology but also the superstitious, primitive, and archaic.[98] *Synagogue* and *Church* represented the institutional religious framework that Sargent saw progress discarding as it approached the "more personal relation" of individual will and imagination to the divine that Sermon signified. In Sargent's panels, implicit in the conventional opposition set up between *Synagogue* and *Church* was an even more dramatic dichotomy between the pair of "medieval" images and Sermon's "modernism." In terms perhaps especially appealing to an artist, Renan had made his position on religious institutions clear; unlike the Church with its "limited" and "temporary" creeds, the expansive and "pure" worship of Jesus rested on a different foundation: "His symbols [creeds] are not fixed dogmas, but *images susceptible of indefinite interpretations.* We should seek vainly in the gospel for a theological proposition. All professions of faith are disguises of the idea of Jesus."[99]

At the *Boston Evening Transcript,* art critic William Howe Downes articulated the opinion of many that Sargent had, in fact, organized *Synagogue* and *Church* to showcase the all-important Sermon on the Mount. According to Downes, the "extremely quiet tone" of the two allegorical panels was "deliberately premeditated" to emphasize, by comparison, the "brilliancy of the central wall panel." In the painting that would fill the "important space" between *Synagogue* and *Church,* Sargent would "delineate the climax of the evolution of the Christian religion, up to which all the rest of the mural painting in the corridor leads by successive stages in its development."[100]

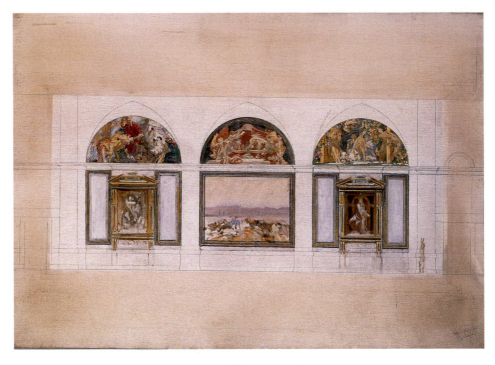

Fig. 24

John Singer Sargent, *Oil Study for East Wall,* c. 1915–16. Oil and graphite on canvas, 44 x 62 1/4 in. (111.8 x 158.1 cm). Trustees of the Boston Public Library, Gift of the late Grace Nichols Strong

Fig. 25

Opposite, top: John Singer Sargent, *Preliminary Sketch for Sermon on the Mount,* recto. Graphite on cream wove paper, 10 x 13 in. (25.4 x 33 cm). Boston Public Library, Print Department, Gift of Miss Emily Sargent and Mrs. Francis Ormond. Trustees of the Boston Public Library

Fig. 26

Opposite, bottom: John Singer Sargent, *Messianic Era,* east wall lunette, south end, installed 1916. Oil and gilded or painted Lincrustra Walton on canvas, approx. 16 ft. 10 in. (513 cm) wide. Trustees of the Boston Public Library

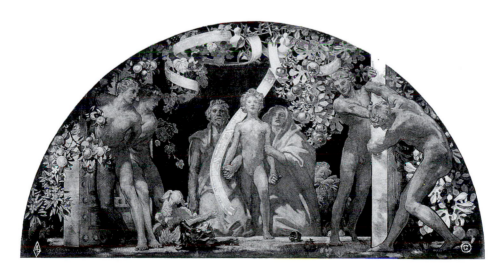

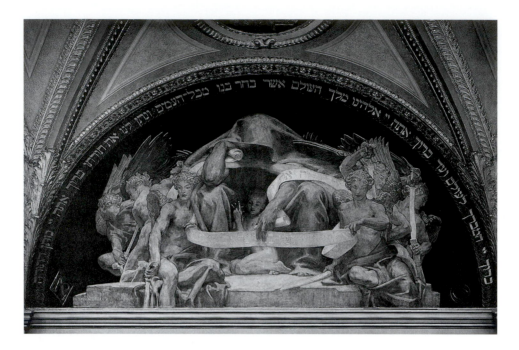

Fig. 27

John Singer Sargent, *Israel and the Law,* east wall lunette, center, exhibited at Royal Academy 1909, installed 1916. Oil and gilded or painted Lincrusta Walton on canvas, approx. 16 ft. 10 in. (513 cm) wide. Trustees of the Boston Public Library

In Sargent's rendering, as in Renan's, both *Synagogue* and *Church* had been superseded by the still emphatically Christian but also emphatically more expansive Sermon on the Mount. The sources Sargent cited for *Synagogue* and *Church* (Reims, Strasbourg, Notre-Dame in Paris) suggest the weighting that the artist claimed he intended; the sculptural programs of the medieval cathedrals placed the allegorical figures in supporting roles, directing the spectator to the primary gospel scene or narrative. Like Renan, Sargent anticipated a religion free of external forms and institutions. Like Renan, he positioned the Sermon on the Mount as religion's pinnacle, as the foundation for all future expressions. The fact that Sermon technically represented an event chronologically prior to the doctrinal crystallizations of the Middle Ages and Counter-Reformation was inconsequential. Sargent's plan freed Sermon from historical sequence and recast it in subjective, experiential, and spiritualized terms. The Sermon on the Mount now represented the summation of a revolutionary religion of the heart.

An 1893 conversation with Sargent recalled in 1922 by George Santayana suggests the degree to which Sargent's idea superseded any rigidly linear chronology and accentuated individual subjectivity. According to Santayana, Sargent had considered, at least in passing, the possibility of painting the Protestant Reforma-

tion on the west wall across the room from Sermon on the Mount.[101] The Reformation postdated by many centuries the historical event that Sermon would recount, but late-nineteenth-century evolutionary theories of religion generally had the Protestant "event" stand in for the revitalization of unmediated religious individualism (some specifically said "subjectivity").[102] No other evidence suggests that Sargent actually thought of painting the Protestant Reformation in the library; that he would have discussed Sermon on the Mount with Santayana in terms of the Protestant Reformation, however, is consistent with the idea the painter pursued.

SUBJECTIVITY AND THE PRIVACY OF RELIGION

I have spent significant time elaborating on selections from the writings of Renan because when we consider, in relation to the evidence of Sargent's attraction to Renan at precisely the time of the library murals' conceptualization, the artist's few direct statements on his interests and intentions at the Boston Public Library, it is Renan, and Sargent's reading of him, that provides the most revealing and compelling correlation with Sargent's words and with the images he painted in the library. "Images susceptible of indefinite interpretations": this was a suggestively visual Christianity and one that might have excited particular enthusiasm from a painter. But Renan was not the only author Sargent read, and surely Renan's appeal was enhanced by the fact that his ideas were philosophically consistent, in significant respects, with those expressed in other literary sources Sargent favored.[103] Voltaire, for example, would have endorsed the rejection of institutions and superstitions inherent in Renan's argument. Voltaire was, in fact, a source for Renan's own expression of these themes, and Sargent's lifelong interest in Voltaire likely prepared him for receptivity to Renan's biblical archaeological histories. In Voltaire's famous call to arms, "écrasez l'infâme" ("crush the infamous thing"), the "infamous thing" was Catholic (and Protestant) orthodoxy in its institutional and doctrinal forms. For Voltaire, the sort of irrational and superstitious thinking inherent in the institutional Christian church led straight to fanaticism, which, in turn, was the principal source of human misery.[104] From an Enlightenment perspective, truth required just the sort of "inner freedom and rational insight" promoted in the visual and literary arrangements of Sargent and Renan. It was dogma, not doubt, that constituted the most dire threat to knowledge and truth.[105]

Sargent's interest in Leo Tolstoy we can date somewhat less securely to the years of *Triumph*'s conception. We do know, however, that the artist owned a copy of Tolstoy's *My Religion* (1884; also translated as *What I Believe*) in an edi-

tion that was published in the 1890s and that Tolstoy was immensely popular among artists and intellectuals in France and England beginning in the mid-1880s.[106] What we also have in Tolstoy's writings, and in *My Religion* in particular, is substantial correlation on significant dimensions with Sargent's interpretation of Renan. Tolstoy's Christian stance was decidedly anti-institutional; he advocated as the only appropriate guide for moral action a subjective reliance on an indwelling and interior divine principle; his focus was on a human Jesus, who was best represented in the Sermon on the Mount, which in turn maintained an essential opposition to and nullification of all creeds; and, finally, Tolstoy's work was judged subversive and censored by church and state in Russia.[107]

If for Sargent and many of his contemporaries, religion had ceased to be "materialistic" dogma or institution, what remained was "subjective" experience. From this perspective, the external trappings of religion gave way to a privacy predicated on interior imagination and will. As T. J. Jackson Lears suggests in *No Place of Grace,* the cultivation of these qualities constituted one significant adjustment to the late-nineteenth-century crisis of religious and cultural authority.[108] Taking his lead over the years of the project from Renan, Voltaire, Tolstoy, William James, and others, Sargent relocated and reaffirmed a sense of the ultimate in the individual's inner relationship with an invisible spirit. The "subjectivity" Sargent sought was not simply the quality of interior relation of the self to the self but the quality of interior relation of the self to the divine. In the public arena of Boston's library, John Singer Sargent's *Triumph of Religion* represented an endorsement of the privacy of individual deliberation and conviction. Belief appropriately organized and focused adhered in this configuration not to external structures like institutions and doctrines but to the interior authority of moral and aesthetic imagination.

The categories of spirituality, subjectivity, individualism, and privacy generally pertain to different spheres of reference (religious, psychological, political, and social). In *Triumph of Religion,* the four came together in ways that make sense of Sargent painting religion in public in the United States between 1890 and 1919. Though each had in this case its own particular content with particular national, municipal, institutional, and personal associations, the linking of "spiritualization" with "privatization" was by no means unique to Sargent and his named literary and artistic sources. The removal of religion from the public sphere and its location in the private (of which Voltaire was a relatively early and more decisively anticlerical exponent and Renan a relatively late representative) was one major aspect of the Enlightenment project of secularization.

In the case of the "realist" Sargent, as of the "positivist" Renan—and also the "pragmatist" William James—it may seem a bit curious to have so much at-

tention focused on subjectivity and imagination. The appearance of inconsistency here, however, arises from late-twentieth-century assumptions about the character of "scientific" investigation and empirical scholarly "objectivity." According to this later view, what is true is that which is verifiable by multiple observers, predictably replicative (i.e., given the same conditions, the same thing happens over and over again), and rooted in the consensus of a shared external perspective. In the late nineteenth century, however, as "scientific" psychology began to emerge as a discipline and to separate itself from departments of philosophy (a process that received a major boost in Boston and Cambridge), the object of this new science was human consciousness, and the practice of the new field relied heavily on the individual's capacity for self-observation. William James, a Bostonian whose personal and social circles overlapped frequently and substantially with Sargent's, encouraged his contemporaries to take their own minds as objects of study, attending to the "stream of consciousness," the flow of thoughts and ideas. From this perspective, James and, in a different way, Renan reconciled (or rather, never construed at odds) a commitment to objectivity with an endorsement of subjective experience.[109] Both reason and faith, James argued, could be construed as "instances of truth."[110] This recommendation describes a very different "science" from one that takes as its object of study only those aspects of experience on which external observers can agree. But it is a recommendation that better suits Sargent's own intellectual account of the advance of subjectivity, his application of empiricist techniques to individual imagination, will, and belief.

In a memorial essay written four months after Sargent's death, Vernon Lee characterized Sargent as possessed of a "double nature"—at once expressive and puritan; imaginative and realist.[111] Years earlier, in a critical response to the 1895 installation, she had recognized that the appeal the positivist Renan held for Sargent was not simply archaeological. In fact, she astutely suggested, Renan offered Sargent the perfect combination of archaeology and imagination. Renan's scholarly works made subjectivity "scientific," providing apparently objective documentation of a movement toward the authority of the subjective in modern religious experience.[112]

NATURALISM AND PROGRESSIVE SUBJECTIVITY

Sargent organized his *Triumph of Religion* as a visual counterpart to Renan's *Life of Jesus* and *History of the People of Israel*. *Triumph of Religion* was, however, by no means a literal transcription of the French historian's words. Unlike Renan, and taking advantage of his own visual medium and its sources in a highly sophisticated fashion, Sargent invested significance in a "progressive" vocabulary of

style.[113] In May 1895, describing the three parts of the first installation, Sargent wrote: "It will be noticed that, parallel with the progress of belief towards a more spiritual ideal, the material and formulated character of symbolic treatment gives place to a less conventional artistic expression. Thus the ceiling is entirely composed of archaic and definite emblems, the lunette departs somewhat from them to express a more personal relation between the godhead and humanity, and in the third part with the prophets in whom religion became subjective, formulas are almost entirely abandoned. The future portions of the decoration will follow historically this aspect of the expression of religion in art."[114] In other words, the movement Sargent desired toward a "more spiritual ideal," toward greater subjectivity in belief, toward the interiorization of religion, he marked by a movement toward less "conventional," less hieratic stylistic emphasis. The story as underscored by style, however, did not roll forward unimpeded in one ever more naturalistic movement. It proceeded by fits and starts with formulaic renderings of Egyptian and Assyrian thought giving way to psychological individuation and naturalism in the Hebrew prophets, in turn succeeded by the ritualized conventions of Byzantine, medieval, and early Renaissance doctrines and institutions (see figs. 4–15).

This sort of periodization represented a relatively recent development in art historical thinking, a development that allowed Sargent to use "period" style to represent coherent intellectual and cultural units.[115] Rather than literally copying ancient styles, Sargent produced his own "modern" versions from a well-established stylistic lexicon. In the artist's own words and from his first descriptions of the murals, he contrasted "material," "formulated," "conventional," "allegorical," "abstract," "primitive," "symbolic," "archaic," "severely decorative," and "definite" renderings with an assumed stylistic opposite corresponding to the "spiritual," the "subjective," the "more personal."[116] This change in style he understood to manifest a change in substance. From Sargent's perspective, the emblematic mode codified and objectified religious experience, restraining interpretive possibilities. His formulaic language of representation functioned in Sargent Hall to underscore the "pastness," the otherness, the *distance* in time and space between what was depicted and the freedom of "modern" experience for the artist and, by extension, the city of Boston. The pagan, the primitive, and the dogmatic made possible for Sargent a rhetorical contemporary opposite: the subjective, the personal, the spiritual. Sargent likened the abandonment of formulas, which he approached in his *Prophets* and intended to attain fully in the "keynote" of Sermon on the Mount, to a freedom from external and institutionally determined religious authority. He was not interested simply in a chronological historical accounting but (as his title indicated) in qualitative change as well,

in a movement from the material to the spiritual, from the dogmatic to the expe-riential, from objective to subjective, and from externally generated theological prescription to voluntary, interiorized, and private moral choice.

The meaning Sargent assigned to style in *Triumph of Religion* may repre-sent a late manifestation of a visual discourse Michael Paul Driskel claims was as-sumed in France during the years of the artist's training in the Paris studio of Emile Carolus-Duran. In *Representing Belief: Religion, Art, and Society in Nineteenth-Century France,* Driskel has mapped in nineteenth-century French religious art an ideological opposition between naturalism and the "hieratic mode," correspond-ing to progressive and traditionalist religious positions respectively.[117] In this case, the hieratic mode, characterized by such qualities as "frontality, stasis, severity, and an emphatic reduction of pictorial illusionism," was the principal constituent of the aesthetics of ultramontanism. It represented a visual response to and de-fense against just the sort of secular scientific enterprise signified by the work of Ernest Renan. Naturalism, characterized by a more relaxed individualized ren-dering and direct observation of the visible universe, could be considered "an ad-junct of the ideology of progress"; this mode of representation was preferred by those in search of the historical (as opposed to the supernatural) Jesus.[118] The style, of course, did not actually correspond to the "real" any more than the hier-atic/iconic mode corresponded to the "transcendent."[119] But Sargent and many of his late-nineteenth-century audiences maintained that naturalism was "con-temporary" and "scientific," and thus, by implication, "real."[120] Driskel argues further that Renan's application of the basic principles of positivism to the sacred story of Jewish and Christian scripture and history hovered behind the emer-gence of a naturalist aesthetic in France after 1850.[121] By the end of the century, when Sargent was painting his public library murals, the hieratic mode was no longer tied to any single ideological position within institutional Christianity in France (not to mention London or Boston). However, its association with a con-servative authoritarian Catholic expression in the Paris of Sargent's own student days might have informed the painter's selective appropriation of the style, even more likely given Sargent's interest in Renan.[122]

Sargent's adoption of a narrative suggested by Renan and a somewhat outdated stylistic hierarchy informed by French painting theory explains some of the visual peculiarities of *Triumph of Religion,* for example, the oddly petrified treatment of Moses (fig. 28). In volume 1 of his *History of the People of Israel,* Renan commented on the antiquity of Moses: "Moses, at the distance [in time] at which he stands, has the appearance of a shapeless column, like the pillar of salt which represents Lot's wife."[123] According to Sargent's schema, of the figures represented in *Frieze of Prophets,* Moses, as the most "primitive," is the most styl-

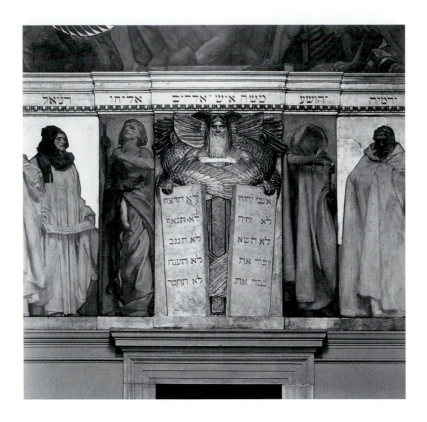

ized. Rather than representing an actual human presence, his Moses, "still surrounded by the [winged] divine presence" shown staying the hand of the oppressor in the lunette above, has the function of making "manifest the law of God."[124] That this stylistic setting apart of Moses was a deliberate strategy on Sargent's part is clear not only in the artist's own statement that he retained in this central frieze panel alone "an element of the abstraction of the preceding portions [i.e., the ceiling and the lunette]" but also in a surviving oil study (fig. 29).[125] In the study, Sargent treated Moses in a manner more consistent with his "living and realistic" treatment of the four major and twelve minor prophets, a manner subsequently rejected by the artist in favor of the sort of formulaic differentiation we see in the finished Hebrew lawgiver.[126] Another early oil study, this one of the north end of the hall (fig. 30), demonstrates that as Sargent's conception of his Moses changed, so did his conception of the overall organization of *Frieze of Prophets.* In the preliminary study of the hall's north end, columns isolated and contained the individual figures of the prophets. As Moses moved toward the final "great conventionality" described by the library's 1895 *Handbook,* the visual orchestration of the *Frieze* moved from an earlier more regimented appearance toward a freer, more pronounced naturalism.[127]

Fig. 28

Opposite: John Singer Sargent, *Frieze of Prophets,* north wall, central panel. Oil on canvas with relief elements of gilded and painted papier-mâché and plaster. Trustees of the Boston Public Library

Fig. 29

John Singer Sargent, *Study for Moses,* c. 1892–94. Oil on canvas, 31 3/4 x 23 in. (80.7 x 58.4 cm). Sheldon Memorial Art Gallery, University of Nebraska–Lincoln, Nebraska Art Association, Gift of Mr. and Mrs. Louis Sosland, 1968.N-234

In *Triumph of Religion* Sargent used a range of comparatively hieratic historical modes of representation as a mechanism of establishing distance between the image and the beholder. In other words, in the process of conceiving, organizing, and executing his murals, Sargent understood the activity of seeing these hieratic and conventional modes of religion as a kind of "not believing." He adopted the perspective of a spectator, an outside observer, a scholar. He painted these images not to endorse belief but to stimulate thought. With full knowledge that most of his pictures did not depict Boston's religion(s), he counted on that

fact to enhance the murals' impact. This was not modern religion with its natural residence in educated personhood (in experience and intellect), but archaic religion, religion as described by Frazer in *The Golden Bough,* religion that invested magic in material objects. As one London critic noted in 1894 when Sargent exhibited his pre-installation north-end lunette and ceiling (but not the *Frieze of Prophets*) at the Royal Academy: "It is astonishing to see how this brilliant master of realistic style, this mirror of natural character, turns himself away from true light and living fact, and reflects a sort of mystic procession of archaic types and forgotten civilizations."[128]

That Sargent had distanced himself from the religious traditions represented in most of *Triumph* was obvious in the murals themselves and in the response of critics (laudatory and otherwise) to his work. In 1903 admiring critics reproved those who might have concluded that Sargent recommended *Dogma of the Redemption* (fig. 10) as a model for contemporary practice or experience. On the contrary, "a modern man does not use archaic terms to express modern thoughts." The Christian south wall articulated historical ideas with the same degree of critical "detachment," the same "dispassionate spirit of the historian, scholar, and decorator" that Sargent had "exhibited in representing the cruel, treacherous, false gods of the primitive peoples."[129] This artist was an "onlooker" and not a devotee.[130] His cycle represented an abstract *idea,* the course of religious thought, not a confession of personal belief. "The thoughts here summoned up," Russell Sturgis claimed of the Byzantinizing and medievalizing Christian subjects installed in 1903, "are not the exclusive property of the devout, of believers, even of the religiously inclined."[131] Many concurred with Henry Van Dyke, prominent Presbyterian minister and author of *The Gospel for an Age of Doubt,* that the "fixed and formal lines," the "petrifications" of Byzantine art, "hide the face of

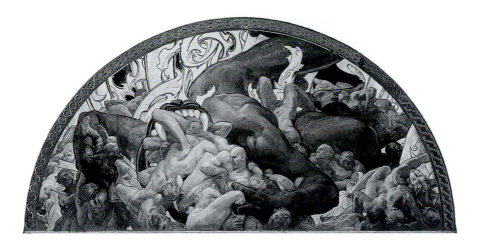

Fig. 30

**Opposite: John Singer Sargent, *Study for North End of Special Collections Hall,*
c. 1890–91. Oil on canvas, 24 3/4 x 33 3/8 in. (62.9 x 84.8 cm). Fogg Art Museum,
Harvard University Art Museums, Gift of Mrs. Francis Ormond, 1937.213**

Fig. 31

**John Singer Sargent, *Hell,* west wall lunette, north end, installed 1916. Oil and
gilded or painted Lincrusta Walton on canvas, approx. 16 ft. 10 in. (513 cm) wide.
Trustees of the Boston Public Library**

Jesus." "Every feature of naturalness is obliterated . . . the man Christ Jesus has
vanished."[132] Writing in 1917, G. Stanley Hall assigned differential value to dif-
ferent stylistic tendencies in Christian art. For Hall, the hieratic "stereotyping" of
the Byzantine period was "so severely controlled" that it became "a thing of
tricks and mannerisms, benumbingly conventional and ascetic. . . . for clericalism
had checked all spontaneity of genius and made art utterly servile."[133]

Sargent was not alone among his British contemporaries in using similar
techniques (impassive facial expression; artificiality of represented light; stylized,
flattened, patterned, or compartmentalized spaces; tightly contained contours;
strict frontality; application of relief decoration) to distance images, to communi-
cate the collectible nature of their otherness, to suggest indeed that faith itself
might now be construed as an appealing but distant quality of the medieval
past.[134] Though the generally Renaissance-derived mode of the 1916 installation
refers to a period of greater naturalism in art, in religion, from the perspective of
Sargent's evolutionary narrative, Renaissance spiritual progress was still somewhat
retarded by orthodox Catholic and Counter-Reformation dogma and religious

institution. Sargent addressed this qualitative gap between the "progress" of art and relative stasis of religion by using relief passages and decorative motifs to contain and partially defuse the naturalism of his Renaissance and Baroque sources. In the library images note, for example, the strongly accented relief elements of *Madonna of Sorrows* (fig. 12), the delicate decoration of *Handmaid of the Lord* (fig. 11), and, especially, Sargent's rendering of *Hell* (fig. 31), a part of the Last Judgment sequence on the west wall, where extremely stylized flames, deliberately accentuated contours, and understated differentiation of individual features control a naturalism that might otherwise rival that of *Prophets* and, ultimately, Sermon.[135] On the south ceiling, furthermore, Sargent appropriated the conventions of popular biblical images to restrain the "Renaissance" style of his panels.[136] Even many of those who did not like these southern panels, those who decried his "cold and soulless eclecticism," his "bewildering, crowded rotten world of dogmas, distress, and medievalism," saw right to the point of Sargent's hieratic and archaic symbols.[137] They read his style, as he had hoped they would, as a secularizing representation of historical religion, but they did not endorse the conclusions he assumed. These detractors took exception to his characterization of their own beliefs as the fossilized ornamental accessories of an age of religious faith and practice long past.

In direct contrast to his formulaic renderings of past religious expression, for the sort of interiorized and democratic version of consensual spirituality he recommended to his contemporaries, Sargent pursued a more free-flowing, naturalistic style that minimized the distance between image and beholder. Sargent would use this treatment of style to link *Frieze of Prophets* with the person of Jesus in Sermon on the Mount. According to the artist, what distinguished his prophets, stylistically, was their "living and realistic" character.[138] Sargent's own words, the expectations of admirers and critics, and the preliminary sketches and oil studies for the Sermon panel all indicate that Sermon would have been even more spontaneously rendered than *Frieze of Prophets*. We have seen Sargent's 1895 claim that all subsequent parts of the project would follow the stylistic trajectory set up at the north end. Contemporary critics too not only acknowledged this use of style and its meaning, they also recognized the stylistic necessity of the anticipated climax in Sermon on the Mount.[139] In 1903 the cycle's authorized publicist, Sylvester Baxter, tracked the stylistic progression he anticipated from the "chaos" of the pagan gods to doctrinal "formulation" to the "freedom" of the yet-to-be-completed east wall.[140] Yale-educated artist and writer Samuel Isham traced the movement from the free and "more human faith" represented in the style of *Prophets* to the "rigid bonds" of dogmatic "compression" on the south wall, and then to the open, "simple tenderness" he believed Sargent would employ in rep-

resenting Sermon.[141] Unlike the "splendid mental detachment from the things and life of today" that Frank Fowler observed in *Dogma of the Redemption,* Sermon, with its absence of architectural framing devices and the eager inward inclination of the foreground figures, would depict a *lived* relationship.[142] This was the part of the story in which the contemporary audience was presumed to participate. This was the expression of a vital religion for modern life. The principal axis of Sargent Hall (as of the library) was not the north and south, secured by Moses and the Crucifix, but the east and west, with its visual focus on Sermon.

In Sermon on the Mount, Sargent would place his art and his belief at the pinnacle of civilization. Equating artistic freedom and spontaneity with a spiritual parallel, the artist would endorse his own artistic enterprise (which traditionalist critic and painter Kenyon Cox labeled "modern naturalism") as well as his own noninstitutional, interiorized brand of spirituality in a panel many claimed would be his "masterpiece."[143] Here Sargent would recommend not irreligion or areligion but a modernized version of religious expression based on the same broad principles as contemporary American democracy: individualism, voluntarism, personal freedom, privacy, and enlightenment. Sermon would build on links to Sargent's oeuvre noted in earlier critical discussions of *Frieze of Prophets.* Reviewers of the 1895 installation remarked on similarities between the style of *Frieze* and Sargent's portrait style. Critic and painter William A. Coffin maintained in an article of 1896 that the figures of the prophets, in their careful differentiation of personality, demonstrated Sargent's own most characteristic accomplishments.[144] Some years later, Royal Cortissoz insisted that "the strongest elements in [the murals] are elements of portraiture—the powerful characterization and varied handling of forms in the now famous Frieze of Prophets. . . . It is as a portrait-painter that he stands head and shoulders above all his contemporaries."[145] By 1903 the critical literature explicitly linked Sargent's personal style (and belief) to Sermon as well as *Prophets.* The final panel of the cycle would be, Baxter wrote, "as free as its spirit, purely an expression of the painter's art."[146] In the "climax" of the cycle, said an unidentified critic, the artist would abandon the "attitude of the outside historian and commentator" and communicate instead a "more personal, a more ardent note, a closer expression of [his] own temperament." Indeed, this writer concluded, Sargent "has yet to show us what he himself deems most godlike: the best is reserved for the last."[147]

RITUAL

PERFORMANCES

⊕

The main entrance to the Boston Public Library used to face Copley Square across Dartmouth Street. There was a broad exterior stairway and inside there was a beautiful marble staircase leading up to the main reading room with carved lions and high-domed ceilings. It was always a pleasure to go there. It felt like a library and looked like a library, and even when I was going in there to look up Duke Snider's lifetime batting average, I used to feel like a scholar.

—ROBERT PARKER, *Looking for Rachel Wallace (1980)*

✳

That *Triumph of Religion* should be painted in Boston's "shrine of letters," its "temple of civilization," is no mere happenstance. Sargent's personal experiences as an international traveler and an alert reader would have suggested to him that the "scientific" gods of modern Western culture could be induced to reside there. Contemporary critical descriptions of the Boston Public Library—with its vast collections of books and its intellectual riches on the third floor especially— underscored the appeal of this sort of sacralizing metaphorical understanding.[1] In the Special Collections Hall, in his final choice of subject matter, in his careful, even staged, contrivance of space and light, and in the ritualized sequential choreography of his conception, Sargent would assent to and thoughtfully evoke the notion of the library as a shrine of Western culture.

 Triumph of Religion (a project the artist later also called *Pageant of Religion*) would be neither the first nor the last work of art that Sargent conceived as a sort of performance.[2] Given his many personal interests in and professional connections to music, theater, opera, and dance this was a subject on which Sargent was knowledgeable. It was a connection his friends and critics discerned as well.[3] Though Gammell interpreted the process of creating the murals on Sargent's part as a scholarly activity, he compared the experience of spectatorship in Sargent Hall to that of watching a theatrical presentation: "He [Sargent] gives us a series of *tableaux,* not unlike those carried on the floats of the medieval masques, each representing a concept in which at some time men found an explanation of the riddle of their destiny. The painter seems as detached as if he were viewing them from his seat in a darkened auditorium. The spectator is stirred by the variety of the spectacle, by the ideas it evokes and by the emotional impact of the subject, much as he might be moved by a fine stage production."[4]

 In 1916 Sargent explicitly accentuated the performative aspects of staging and movement through the room when he covered the shrines that would soon surround *Synagogue* and *Church* with tapestries or heavy curtains of his own design (figs. 32 and 33). Like the framing devices that continued Sargent's stylistic appropriations from the art of the past in their "Romanesque" and "Gothic" broken pediments, the curtains were purposely designed by Sargent to suggest the specific Jewish and Christian content that would ultimately fill these spaces. The draperies added an element of theatricality, underscoring the public's expectation that completion would be imminent, dramatic, and climactic.[5] Two sets of actors were invoked in the notion of performance in Sargent Hall: Sargent, as the artist, performed and, at Sargent's visual direction, so did the spectator. The visitor to the hall was thus both an observer of Sargent's display and a participant in the cultural ritual staged in the room. It is on the latter of these two (related) performances that this chapter focuses.

Fig. 32

John Singer Sargent, architectural frame and curtain for *Synagogue*, c. 1916. Trustees of the Boston Public Library

Fig. 33

John Singer Sargent, architectural frame and curtain for *Church*, c. 1916. Trustees of the Boston Public Library

SARGENT HALL AS RITUAL SPACE

In a building people generally visited to read and to study, Sargent Hall was a particular kind of space, an "empty" space, a space to pass through, a space in which to pause and think. In 1924 a journalist commented on the room's employ: "Many of the people who use this floor (the third) are students who draw or write at tables in the rooms that open from the [north] end of the corridor, just beyond the balustrade. Others come to study in the music room that opens off the center of the corridor [on the west] and others come to see the exhibitions in the art gallery at the head of the stairway [south]. Many people come up especially to see the Sargent decorations."[6] Unlike the Delivery Room with its

Abbey murals, Sargent Hall did not accommodate the overt business of the library. The bookcases Sargent designed and set into the room's west wall functioned symbolically and formally rather than practically: they were there to underscore the "distinctive library note" of the room and to balance and punctuate the murals on the east, not to hold books for readers.[7] Unlike the great staircase hall with its Puvis paintings, the third-floor hall was self-contained room as well as corridor. For some of its spectators, those who came just to see the pictures, the room was literally a gallery. Sargent Hall provided its audiences with time and space apart from the ordinary business of the library.

For the actual patrons of the library, however, this was also time and space of preparation, time and space on the way to the building's most serious and exalted activity: study among the intellectual treasures of the special collections rooms.[8] Entry to the Barton-Ticknor Library, housing the "rarest treasures of the institution," could be gained through the door in the center of the room's north wall, to the Music Library through the central penetration of the west wall, and to the Division of Fine Arts (and its intervening exhibition space) through the door at the south.[9] The decoration of Sargent's third-floor gallery acknowledged the status of the hall as the principal route of access to these inner sancta of the library; Sargent constructed the gallery itself as a kind of "shrine" within a "shrine," as a container for a particular assembly of cultural relics.[10] I will take up the question of the character of this collection and its content in another chapter. Just as important (and this is my subject here), the artist organized his collection and the space it occupied in order to structure the viewer's encounter with his art and, ultimately, with the scholarly apparatus of the library.[11] In a public entrance hall, already "consecrated" by the selection of a religious subject and by the historical resonance of art with things sacred, Sargent invited the library's "pilgrims" (as some contemporary critics indeed labeled visitors) to practice a kind of ritual performance in Sargent Hall.[12]

That the artist adopted a working method that would accommodate attention to the orchestration of vision and movement in the room as a whole is suggested in his consistent recourse to the one-third scale model (fig. 23) provided by McKim early in the project. As early as 1891 Sargent informed the architect of important modifications to the model. Throughout his work on the library murals the artist developed this visual and spatial tool, keeping it current, installing scale versions of his paintings and of the room's decorative elements, and reworking the model to suggest his changes in the interior architecture. Late in 1915 he had the structure photographed to show Benton and Fox the emendations he recommended for the ceiling. He even offered to ship the model to them if necessary. It could be disassembled along seams in the pilasters; the photographs that survive document three full bays of the five bays in Sargent Hall.[13]

Chapter 1, with its focus on Sargent's intellectual concerns and the organizing idea of subjectivity, framed *Triumph of Religion* in relation to a set of predominantly literary parameters. If viewed from this perspective alone, the cycle seems almost too closely to approximate a metaphorical translation of Sargent's own "library," accommodating his personal reading interests in the unconventional and exotic, in travel literature and adventure, in religious history and symbol, in the history and theory of art. This view, while not arbitrary, is surely only partial. As Gammell pointed out and as Sargent's practice demonstrates, even in the context of his intellectual ambitions, he mined his library for mental *images* and *visual* ideas, he looked to religion's past for the pictures it would surrender. His use of travel, his visits to museums and exhibitions, even his frequent recourse to books, were largely pictorial and also decidedly spatial. For Sargent did not imagine *Triumph of Religion* as a series of isolated panel paintings—or even a series of paintings elaborated with sculptural relief elements. In 1891 when he instructed McKim with respect to the moldings and pilasters at the north (and south) ends, he indicated his conception of the room as a decorated *space*.[14] A New York critic, writing just after the 1916 installation, emphasized this aspect of Sargent's work:

To consider any part of the wall as a detached unit would be an offense against the artist's strictly sustained idea which marvelously has lost none of its integrity in the twenty-one years between the placing of the decorations at the north end of the hall and the placing of the recently completed lunettes. Mr. Sargent's own protest against a fragmentary impression of his decoration, diversified as it is and charged with intricate meanings expressed in numerous episodes, is embodied in the plastic ornament which holds together with rhythms of form and direction the separate lunettes and panels and emphasizes their relations of color and spacing.[15]

In suggesting an interpretation of *Triumph of Religion* in terms of ritual performance, I adopt a definition of the process of ritualization proposed by Catherine Bell. According to Bell, ritual practice deploys "a way of acting that is designed and orchestrated to distinguish and privilege what is being done in comparison to other, usually more quotidian, activities."[16] Bell's definition is useful here because it emphasizes not a set of essential or universalizing features in relation to sacred contexts, but rather a process of differentiating one form of practice from another. If the cultural experience of Sargent Hall can be meaningfully described as ritualistic in this sense, as I believe it can, then its meaningful separation from the "usual," its design, distinction, and privilege, involved two signal features: a pattern or script of movement "orchestrated" by Sargent and the artist's recommendation of a particular kind of exalted social activity (study in the li-

brary) widely believed to transform, or at least refine, the devotee.[17] First, what were the visual and spatial mechanics of this ritual movement? How was the room organized and set apart visually? When people looked at Sargent's murals, how did they know where to direct their attention and when and how? Pictorial and architectural organization (including lighting, color, style, relief work, interior modification of the room's molding and material punctuation, and the internal chronologies of the images' historical subjects) played a significant part. As we have seen in chapter 1, furthermore, the cycle in Sargent Hall grew by the slow, even protracted, accretion of images and meanings. For contemporary audiences, then, the artist's practice of sequential installation, necessitated by the demands of time but organized according to an internal "evolutionary" chronology, suggested a permanent conduct of encounter, an order that described and reinforced the appropriate habit of spectatorship in this place.

PATTERNS OF MOVEMENT: ARCHITECTURE AND CULTURAL GEOGRAPHY

In understanding the pattern of ritual movement associated with Sargent Hall, it is important to consider first not just Sargent Hall as an isolated unit, but also its placement in the library's literal and cultural geography and its relation to the building's urban site. That Sargent was himself interested in these issues is suggested, most explicitly, in his deliberate selection of this particular room as the arena for his decoration; in at least one surviving sketch demonstrating his concern with the placement of the Puvis murals in the space directly below *Triumph* (fig. 34); and in the visual disposition of the room itself.[18] The fact that Sargent's preferred Boston residence early in the project was the luxurious Hotel Vendôme at Commonwealth and Dartmouth, a few short blocks from the library, and then, from 1917 on, the Copley Plaza, built on the old Museum of Fine Arts site after the museum moved out Huntington Avenue late in 1909, meant that the artist was intimately familiar with the square and its cultural traffic.[19]

Until 1972 when the Boylston Street entrance of the Philip Johnson addition supplanted the original pattern of pedestrian traffic, most visitors entered the Boston Public Library through its main ceremonial portal on the Dartmouth Street façade.[20] Elevated on a granite pedestal, broad and low, the building commanded an impressive aspect on Boston's Copley Square (fig. 35) in the elite new Back Bay neighborhood, constructed on landfill in the second half of the nineteenth century. Known earlier as Art Square, likely because of its selection as the site for the first Museum of Fine Arts building, the square was renamed in 1883 to honor Boston artist John Singleton Copley.[21] By 1895 Copley Square enjoyed a

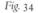

Fig. 34

John Singer Sargent, *Sketch for Staircase Hall,* **showing location of Puvis murals. Charcoal on paper, 10 1/4 x 16 1/8 in. (26 x 41 cm). Museum of Fine Arts, Boston, The Sargent Collection, Gift of Miss Emily Sargent and Mrs. Violet Ormond in memory of their brother, John Singer Sargent, 28.717**

reputation as the city's newest cultural center, a fact attested to not only in print, but also in the numerous commercial photographs, and especially in panoramic images that attempted to capture the square's cultural monuments in a single shot (fig. 36) for both local and tourist markets. Described in idealizing rhetoric that generally ignored the seasonal realities of urban life under construction (contrast fig. 37), the square's recent architectural landmarks (Trinity Church, 1872–77; New Old South Church, 1875; the Museum of Fine Arts, 1876; and the Boston Public Library, 1887–95) together formed a civic constellation of religion, culture, and knowledge. This was a fitting location indeed for Sargent's summation of sanctified human achievement.[22]

Approaching the library from some distance across the square, contemporary viewers reported being struck first by the building's "simplicity of outline" and lightness of tone. The contrast between the library and its closest neighbors was significant, with the Renaissance revival structure set off against the Romanesque features of Henry Hobson Richardson's Trinity Church and the ornate Victorian Gothic of New Old South Church and the Sturgis and Brigham Museum of Fine Arts. Moving closer (fig. 38), a solid lower story was crowned by a lighter, elegant upper story, its band of tall arched windows punctuating the façade and providing the vertical counterpoint (in conversation with the New Old South tower) to the building's horizontal mass.[23] The triple portals of the impressive entryway reiterated the arched windows above. Beyond this threshold, the patron passed through a vestibule into a vaulted entry hall (fig. 39),

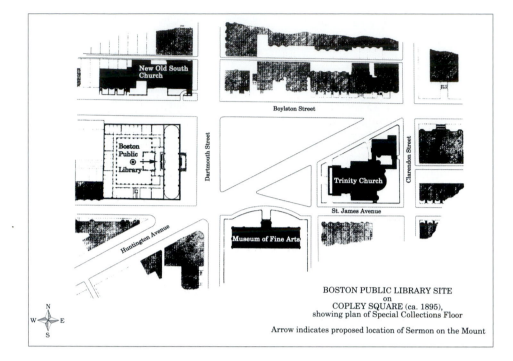

Fig. 35

Boston Public Library site on Copley Square, c. 1895 (adapted from illustration in *American Architect and Building News* 23, no. 648 [26 May 1888], special illustration section)

Fig. 36

Opposite, top: Panorama of Copley Square, photograph by T. E. Marr, c. 1900. Trustees of the Boston Public Library

Fig. 37

Opposite, middle: Copley Square, from southeast corner of the library looking toward Trinity Church, photograph by Charles H. Currier, c. 1897. Trustees of the Boston Public Library

Fig. 38

Opposite, bottom: Postcard, "Boston, Mass. Public Library," c. 1906. Collection of Virginia C. Raguin

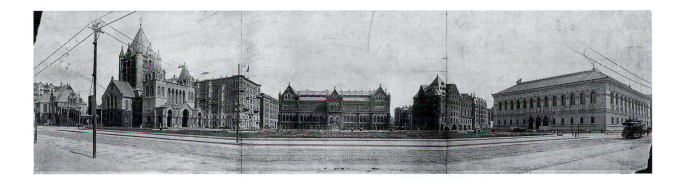

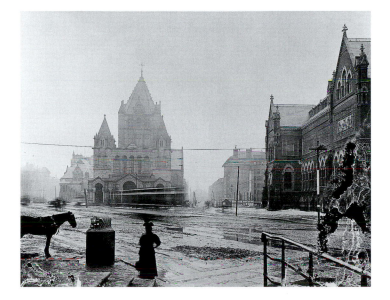

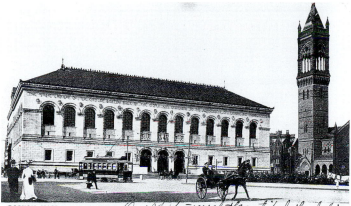

BOSTON, MASS. PUBLIC LIBRARY *One of the most beautiful buildings in America. Am sorry I did not see you when I was home. H.S.B.*

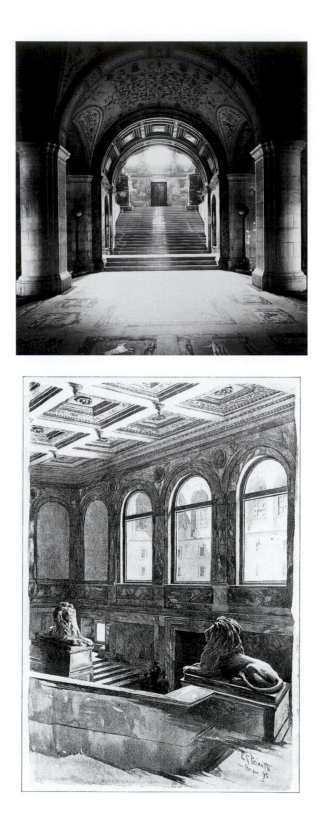

Fig. 39

Opposite, top: Main entrance hall and staircase, Boston Public Library, photograph by Charles Pollock, 1895. Trustees of the Boston Public Library

Fig. 40

Opposite, bottom: Ernest C. Peixotto (American, 1869–1940), *The Main Staircase, Looking Down*, 1895. Illustration for *Scribner's Magazine* 19 (January 1896): 87

Fig. 41

Ernest C. Peixotto, *Gallery of the Staircase Hall*, 1895. Illustration for *Scribner's Magazine* 19 (January 1896): 89

Roman in design, decorated with "mosaics of delicate tints and graceful patterns."[24] The entry level accommodated many aspects of the library's day-to-day operation of business; the regular patron of the facility might gain access to a variety of services by turning north or south off the main axis from the entry hall. In terms of the building's semiotic orchestration of traffic, however, it was the east-west axis that mattered; the flood of light from the wall of large windows (fig. 40) situated above the first landing of the main staircase and facing onto the interior courtyard beckoned the viewer to ascend. Opening up to the full height of the second story, the staircase, lined in warm, almost luminous, golden yellow

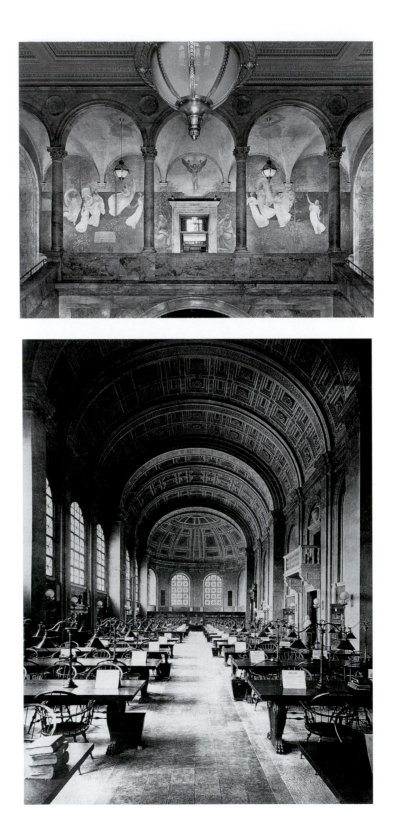

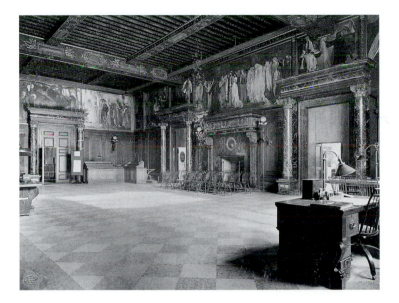

Fig. 42

Opposite, top: **Second-floor staircase corridor, with Pierre-Cécile Puvis de Chavannes (French, 1824–1898),** *Muses of Inspiration Acclaim Genius, Messenger of Enlightenment,* **1895, photograph by Richard Cheek, c. 1977**

Fig. 43

Opposite, bottom: **Bates Hall, c. 1896. Windows on left overlook Copley Square, access to balcony on right gained from landing on main staircase to Special Collections Hall. Trustees of the Boston Public Library**

Fig. 44

Delivery Room, with Edwin Austin Abbey (American, 1852–1911), *Quest and Achievement of the Holy Grail,* **installed 1895 and 1901, photograph c. 1902. Trustees of the Boston Public Library**

Siena marble, structured conduct to the first landing where this "glowing stairway" divided and doubled back, presenting, in the process of navigating this reversal, impressive views of the Puvis murals that decorated three walls of the main staircase hall. The muted, soft palette employed by the French painter undoubtedly contributed to T. R. Sullivan's sense, in 1896, that "the whole place seems staged in sunshine, and the library motto, 'Lux Omnium Civium,' is borne in upon our minds at every step that brings us nearer to the light's true source."[25]

Having climbed the main staircase to the second-floor landing (fig. 41), the patron stood directly in front of the celebrated Bates Hall, the library's princi-

pal reading room. Puvis's *Muses of Inspiration Acclaim Genius, Messenger of Enlightenment* (1895; fig. 42) on the entry wall faced the viewer.[26] At the central door into Bates Hall, the prospective reader, flanked on either side by Puvis's allegorical figures of Study (left) and Contemplation (right), stood immediately below the artist's *Messenger of Enlightenment*, its soaring ascent providing a sort of frontispiece to the two-story elevation of the light-filled Bates Hall and marking a similar "ascending" trajectory for the patron engaged in the acquisition of knowledge. Bates Hall (fig. 43), the largest room in the library, with its "quiet, well-subdued surroundings," spanned the entire width of the building across the Dartmouth Street façade.[27] From the second-floor landing in front of Bates Hall, the visitor could turn right (south) and proceed through the "Pompeian lobby" to the book delivery room (fig. 44) decorated by Abbey's *Quest and Achievement of the Holy Grail*. The other option, a left turn, would provide access, through the "Venetian lobby," to the Children's Room, the Patents Room, and the Newspaper Reading Room, all situated along the north end of the library's Dartmouth Street façade.[28]

And thus library patrons and art seekers alike approached the principal point of entry to Sargent Hall.[29] In order to continue upward beyond the Puvis murals on the second-floor landing, as Puvis's *Messenger of Enlightenment* seemed to direct, the spectator, having once headed to the left (north) toward the Children's Room, jogged right at the Venetian lobby. Immediately turning to the right again, and having now accomplished a 180-degree reversion, the prospective viewer of the Sargent murals proceeded up a stairway that ascended north to south along the opposite face of the wall adorned by Puvis's *Muses of Inspiration*. Though the staircase was actually wide and adequately illuminated, stepping into it from the open, light-filled second-floor landing, with its Puvis murals toned to harmonize with the warm yellows of the marble, created the initial impression of mounting a dark and, by comparison with what preceded it, narrow flight to a rather dimly lighted space. The length of the staircase, moreover, necessitated a slow, deliberate ascent, with the first measured view of the room probably a survey of the south wall taken during a pause at the first landing approximately halfway up the staircase.

Sargent likely counted on the circumnavigations of the principal route up and into the hall to increase the surprise at the top of the stairs. Indeed, with respect to selection of the special collections gallery, Thomas Fox assures us that Sargent "fully appreciated in advance the conditions of light and all other circumstances, and intended his finished work to be seen in connection with them."[30] Located along the most logical pedestrian pathway into the building, Sargent Hall was readily accessible from the main entrance. The orchestration of spaces leading to the hall and the hall's situation in the third story of a building with a two-story

façade, however, made it seem remote, elevated, and even otherworldly with respect to the library as a whole and the urban activity of Dartmouth Street. If ritual space is space set apart by some degree of qualitative distinction, then Sargent Hall, at the highest point of the library's principal route of entry, certainly met the requirement. As one contemporary Boston newspaper told its readers: "It is no mere metaphor to say that it is overpowering. Coming up the stairway and into this hall is like coming into another world—a world that awes and overwhelms the mind."[31]

PATTERNS OF MOVEMENT: THE SPECIAL COLLECTIONS GALLERY, INITIAL CONSIDERATIONS

Beginning in 1895, just after the first installation of images, when the north end was the only place to look and the rest of the room appeared all the more barren for the contrast, the library began printing descriptions of the decoration, principally keys to its iconography, that helped to chart the viewer's engagement with the images. The descriptive brochures that survive are abridgments of a set of sequential essays written by publicist Sylvester Baxter for various periodicals and editions of the library handbook.[32] In 1893 Baxter had married the former Lucia Allen Millet, sister of Francis (Frank) Davis Millet, both of whom (along with Frank's wife, Lily) were Sargent's good friends from the Broadway village (Worcestershire, England) days of the mid-1880s to the early 1890s; the publicist was apparently the only individual whose work on the library murals was explicitly "authorized" by the artist. Baxter no doubt gained Sargent's trust through the personal connection at Broadway as well as through Baxter's first article on the Boston Public Library decorations, an essay written in 1895 for *Harper's Weekly*. Sargent wrote to Baxter shortly after the piece appeared: "Allow me to say how much gratified I was by your article in Harper's Weekly, which was, both in the broad view and in the minor points, excellent (if I may say so of anything so flattering)."[33] While Baxter's descriptions of *Triumph*'s content and its use of style seem reliable (in relation to other surviving evidence), he was so interested in the sequence of installation and its attendant amplification of iconography that the *precise* pattern of movement varies somewhat in different accounts.

At this point in the narrative an interruption is in order. My intrusion here serves as a reminder—to me and to the reader—that what follows is an interpretation based on two categories of information: my own observations of the room and my reading of the range of extant textual and illustrative materials on Sargent Hall. That I have resorted to combining different sorts of evidence perhaps too seamlessly reflects the inadequacy, for my purposes here, of either body

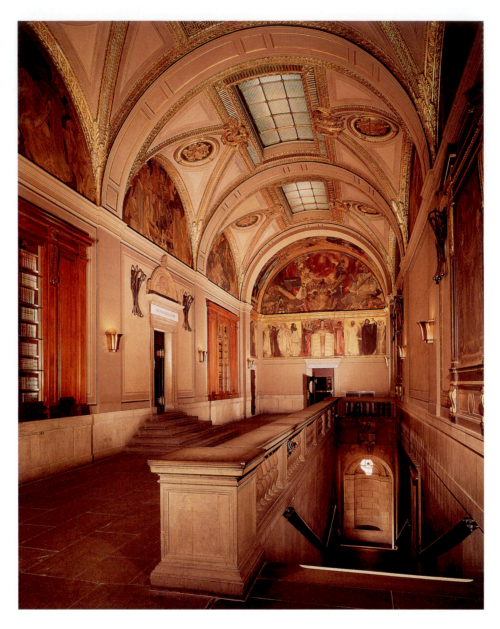

Fig. 45

Special Collections Hall, looking northwest, photograph by Richard Cheek, c. 1977

of material alone. The spectator in Sargent Hall in the 1990s sees only a partial version of the artist's intentions for the space. Since Sargent's death, substantial changes have occurred in the library room that bears his name. The skylights have been covered over and replaced with electric lights, the lighting has been otherwise altered as well (compare fig. 2 and fig. 45), and a zealous cleaning in

1953 by all accounts modified the color scheme and damaged the surface of the paintings—especially the low-relief and collage elements.[34] This situation compromises current readings of the room in its present condition.

Descriptions contemporary with Sargent, including Baxter's important work, constitute a second body of evidence. These do indeed assert the general scripted character of navigating Sargent Hall. The descriptions (even those that bring a part of the room's traffic up the small, slow elevator at the southwest) begin consistently at the north and then move to the south, sometimes with visual assistance from the east and west lunettes, before returning to some aspect of the central portions of the room (east and west lunettes, ceiling decoration, east wall). They are, furthermore, generally clear about the cycle's intended climax and the ultimately subsidiary roles played by other images. Nonetheless, after the 1916 installation, though a significant degree of consensus remains, there is some disagreement—and even confusion—about viewing order. In part this resulted from the fact that, especially with the 1916 installation, Sargent introduced a range of visual cross-references and counterpoints within the program. Most obviously, however, the fact that Sargent never completed the cycle's "keynote" left many observers (past and present) wondering where to look next. These two factors—incompletion and the complexities of the 1916 installation—actually reinforced one another in terms of visual impact. Without the culminating scene, the possibilities for multidirectionality underscored in 1916, rather than suggesting a complex network of interlocking visual references and comparisons that ultimately drew the viewer to the central panel on the east wall, instead scattered the beholder's attention, offering competing possibilities in terms of the resolution of the cycle's narrative structure. Following contemporary descriptions closely, but deviating from them to the extent that my description imagines Sargent's "keynote" in place, this chapter will chart the room as a progression from north to south and then from west to east.

PATTERNS OF MOVEMENT: THE SPECIAL COLLECTIONS GALLERY, LOOKING NORTH

From the top of the stairs, the shape and orientation of the room and the visual phrasing of the murals themselves directed the circulation of movement. Upon entering Sargent Hall on this trajectory, the patron—whose curiosity had already been piqued on the first landing—was immediately confronted by the visually sumptuous but emotively distant *Dogma of the Redemption* (fig. 46 and fig. 10) with its high-relief Crucifix of gilded and painted wood.[35] Sargent surely counted on this initial pause before the south wall to announce the historical character of the cycle. As contem-

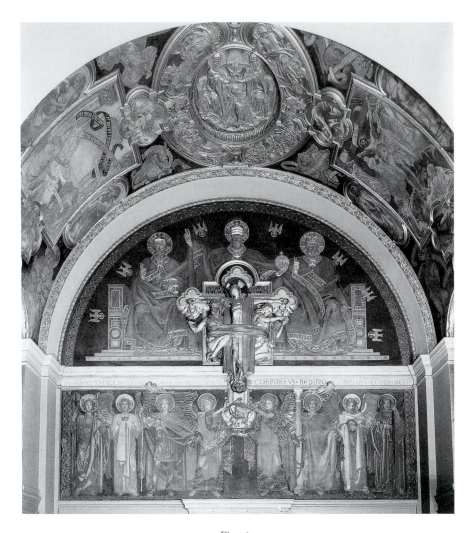

Fig. 46

Dogma of the Redemption, photograph by Richard Cheek, c. 1977

poraries readily acknowledged, this was clearly a "symbolic delineation" of "ancient" and "archaic" Christian dogma, not an expression of religion as practiced in the modern era in the United States of America.[36] The organization of the hall itself, with its relatively cramped space between the upper landing of the staircase and the south wall, its comparatively high ceilings (the room is higher than it is wide), its skylights distributed across the three central bays of the north-south axis, and the long barrel vault of the gallery extending back to the north toward the chambers beyond, which housed the rarest special collections of the library, soon rerouted the spectator's gaze in a northern direction.[37]

At the north end of the room, the high-relief Moses with the tablets of the Law (fig. 28) established the initial focal point. In two letters to McKim in December 1891 Sargent indicated his firm commitment to giving Moses sufficient "prominence" on the north wall and providing him with a sort of visual "pedestal." Following an example he saw "used in a Pinturicchio fresco," he asked McKim to build out the moldings above and below Moses, thereby securing for that figure a "real plane in relief." The painter would himself "paint a false architectural relief" for the two flanking figures (whom Sargent named as Joshua and Deborah here, though the finished *Frieze* substituted Elijah for Deborah).[38] The articulation of the cornice line above the three figures would further secure both the real projection of Moses and the illusory projection of the central block of three with respect to the rest of *Frieze of Prophets*.[39]

Sargent's composition allowed the eye to rest here momentarily with Moses, then pulled it upward along the strong vertical axis initiated by the figure of Moses above the central feature of the north door and leading upward through the kneeling figure of the foremost of Sargent's Israelites oppressed by the stylized leaders and gods of Egypt and Assyria (fig. 6). The loosely symmetrical arrangement of figures in the lunette and the orientation of their bodies punctuated the vertical as did Sargent's use of strong reds along this axis, in the garments of Elijah and Joshua who flank Moses and in the red wings of the cherubim embracing Moses and hiding the face of God at the top of the lunette, above. This compositional channel through the center of the lunette Sargent further accentuated by his naturalistic treatment of the Israelites and the formulaic treatment of other figures whose appearance approximates more closely the art historical objects they reference than actual beings. The inscription, excerpted from Psalm 106, on the rib at the juncture of lunette and ceiling vault, informed the diligent viewer that the formulaic images of strange beings in the ceiling (figs. 4 and 5) represented the "idols of Canaan" in whose pursuit the children of Israel had strayed from the truth. Here Sargent arranged the body of Neith, as he had seen her in Egyptian temples and papyrus, with limbs extended so that her fingers touched down just below Astarte's crescent moon and her toes behind the "Egyptian trinity" of Isis, Osiris, and Horus on the west.[40] The span of Neith's body is evident in Sargent's oil studies (figs. 47 and 48) where her toes (at west) and fingers (at east) are more clearly seen than in photographs of the final versions in the library. Combined with the judicious use of rich reds, blues, and gold, the disposition of the goddess ensured that the beholder took in the extravagance of images on the ceiling. The visual arrangement of the elements and the deliberate contrast of the initially confusing profusion of the ceiling and lunette with the simplicity of the prophets below, however, especially once a sense of the narrative chronology

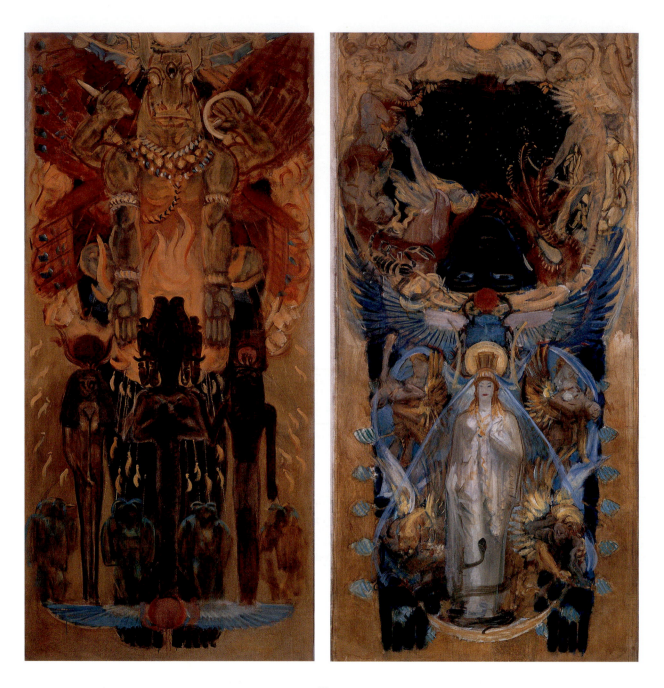

Fig. 47

John Singer Sargent, *Study for Moloch,* 1892–93. Oil and graphite on canvas, 83 3/4 x 44 5/8 in. (212.7 x 113.4 cm). Trustees of the Boston Public Library

Fig. 48

John Singer Sargent, *Study for Astarte,* 1892–93. Oil and graphite on canvas, 79 x 40 1/2 in. (200.7 x 102.9 cm). Trustees of the Boston Public Library

emerged, drew the eye back down the central axis to consider *Frieze of Prophets* (figs. 7–9).

Though Sargent later claimed that *Frieze of Prophets* had become his least favorite element in *Triumph,* he worked the row of figures to excellent effect in his design.[41] Relying on a keen sense of such visual cues as gesture, color, and the use of shallow dimensionality, Sargent organized the nineteen represented individuals to accomplish two simultaneously operative results. First, his distribution of prophets, with the dominant central Moses flanked by the prominent Ezekiel and Isaiah (the three singled out by Renan as well), articulated the significance of the north wall as an independent unit. And, second, some of the same elements also established the overall visual movement of *Frieze* (comprising panels across the north ends of the west and east walls as well as the north wall itself) as a subtle but certain eastward progression. Both Ezekiel and Isaiah, for example, the former in voluminous white drapery (fig. 49), the latter robed in heavy blue, stand to the east of center in their respective panels. Preliminary sketches and studies for the prophets (figs. 50 and 51) indicate the degree to which the artist considered a large range of possibilities in terms of gesture and the positioning of hands, faces, and draperies before settling on the final design with its elaborate choreography.[42] In an early sketch (fig. 52) now at the Fogg, for example, Micah assumes a posture similar to that adopted by Jonah in the completed frieze. In the single panel of four (as shown in Sargent's sketch), this posture served to anchor the gestures of the other three figures. In the full composition of nineteen prophets, however, Micah had to respond, across the room, to Joel as well. Generated by the point and counterpoint of Sargent's deliberate figural arrangements and by the brilliant interplay of hue, value, and saturation, the chain of figures weaves its way across the shallow space. This line of movement culminates in the three southernmost figures (Haggai, Malachi, and Zechariah; fig. 9), whose gestures lead the viewer to the east wall.

The ceiling vault too played a role in the gestural dance toward the east; Sargent reversed the conventional mythological disposition of Neith's body so that the Egyptian sky goddess's fingers would touch down on the east, thus reinforcing the directional sense of the prophets.[43] Even in 1895, when only the north end images were in place, the artist's direction of attention to the east was evident to library patrons, as an early print by Ernest C. Peixotto demonstrates (fig. 53). In this illustration for *Scribner's Magazine,* of the seven spectators depicted in Sargent Hall, three look toward the north wall segments of the *Frieze of Prophets,* one gazes up and slightly to the left, likely taking in the western portion of the north wall lunette, and three look toward the east wall segment of the *Frieze,* the so-called Prophets of Hope, who, like Peixotto, direct their attention (and ours) to the empty east wall panels that would ultimately contain *Triumph's* focus.

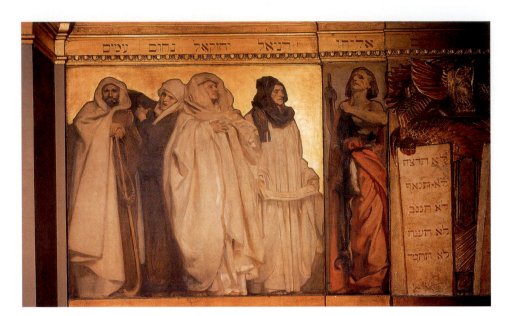

Fig. 49

John Singer Sargent, *Frieze of Prophets,* panel at west end of north wall, installed 1895. Oil and gilding on canvas. Trustees of the Boston Public Library

Fig. 50

Opposite, top left: John Singer Sargent, *Study for the Prophet Joel,* c. 1891–94. Charcoal on cream wove paper, 14 3/8 x 9 15/16 in. (36.6 x 25.3 cm). Fogg Art Museum, Harvard University Art Museums, Gift of Mrs. Francis Ormond, 1937.7.32 folio 3 recto

Fig. 51

Opposite, top right: John Singer Sargent, *Study for Frieze of Prophets, West Wall Panel,* c. 1891–94. Graphite on cream wove paper, 9 15/16 x 14 3/8 in. (25.3 x 36.6 cm). Fogg Art Museum, Harvard University Art Museums, Gift of Mrs. Francis Ormond, 1937.7.32 folio 12 recto

Fig. 52

Opposite, bottom: John Singer Sargent, *Study for Frieze of Prophets, East Wall Panel,* c. 1891–94. Graphite and charcoal on off-white wove paper, 10 x 14 1/2 in. (25.4 x 36.8 cm). Fogg Art Museum, Harvard University Art Museums, Gift of Mrs. Francis Ormond, 1937.7.32 folio 10 verso

Writing somewhat later, Ives Gammell applauded Sargent's careful balancing of different elements in the frieze, noting especially the "architectural stability" established through the "vertical lines of draperies" and the "friezelike quality . . . maintained by the interlacing horizontals of outstretched arms."[44] Though each figure is represented as an individual, a man of interior vision communing with or inspired by his own particular image of God, compositionally

Fig. 53

Ernest C. Peixotto, *The Sargent Decoration in the Staircase Hall,* 1895. Illustration for *Scribner's Magazine* 19 (January 1896): 91

none is isolated and each figure depends on the others. Haggai, Malachi, and Zechariah are balanced not only by the adjacent figure of Micah who turns back into the northeast corner of the room and shields his eyes, but also by the relatively distant figure of Joel, second from the far end of the west wall panel, whose extended right arm effectively offsets the east-panel gestures at the same time that the orientation of his body provides the initial impetus for the eye's movement to the east. The "twinning" of Joel and Malachi, in terms of the color and cut of their garments (blue-black headgear and brown robes with a distinct V shape at the neckline), stabilizes the frieze as do the dark notes in Nahum and Isaiah, while the predominance of white and its judicious distribution across the wall surfaces underscores the eastward pull.[45] In 1916, a critic for the *New York Times* noted:

Anyone accustomed to following the patterns of direction in a color composition will rejoice in the superb precision with which the color game is played, blue flung across to blue, red echoing red, the dominant blue carried down into the plain borderings and ac-

cents of the wall. And the color is also used to emphasize the architectural character of the decoration, much of the flesh color having the warm gray of the marble. The blue rises to silvery pallors as in the veil of Astarte and sinks to dusky profundities as in the background of one of the lunettes. The reds are dark fires or roseleaf pinks. The variety gained by sensitive modifications of a few simple hues is eloquent of a mind steeped in artistic feeling. Every inch of the large spaces is made interesting by its color as well as by its spacing and linear design.[46]

PATTERNS OF MOVEMENT: THE SPECIAL COLLECTIONS GALLERY, BACK TOWARD THE SOUTH

Several visual and narrative factors combined to accomplish the movement from the north wall to the south (figs. 54 and 55). Directed by *Frieze of Prophets* to the east wall, the viewer's progress was measured in intervals marked out along the way by pilasters punctuating the bays of the barrel-vaulted room. Sargent himself arranged for the elaboration of the interior architectural features that accounted for this effect.[47] The heavy stone banister guarding the stairwell further accentuated this north to south movement along the east wall, as did the ideal progression of the east wall lunettes, proceeding from the "general overthrow of all the heathen world" in the *Fall of Gog and Magog* (fig. 56), to the prospective maturation of Israel under the guidance of divine Law (fig. 27), to the dawning of the *Messianic Era* (fig. 26) as prophesied in the Book of Isaiah—and thence to the south wall (figs. 10, 46, and 55) and the Byzantine and medieval crystallization, even fossilization, of Isaiah's prophecies in the doctrines and dogmas of the Christian church.[48]

The strongest visual factor in our sequential movement to the south wall is also the feature that most vigorously maintains the east wall's status as "central" point of culmination for the cycle: the close visual pairing of the two ends of the hall (north and south) that would flank the east wall's Sermon on the Mount. This "mirroring" was accomplished in the similarity of architectural features, in the figural treatment of *Frieze of Prophets* and *Frieze of Angels,* in the formulaic styling of the two end wall lunettes, and in the similar keying of color at the two ends of the hall. That Sargent was fully aware of this dynamic is apparent in his adjustments to *Frieze of Prophets* during the installation of *Frieze of Angels.* At that time the artist gilded the two prophet panels (see, e.g., fig. 49) on either side of the central Elijah-Moses-Joshua panel in order to bring the two friezes into greater visual harmony. Prior to 1903, the background of all the panels of the prophets frieze had been the same gray we now see in the center panel as well as on the east and west wall panels of the frieze. The use of relief elements (espe-

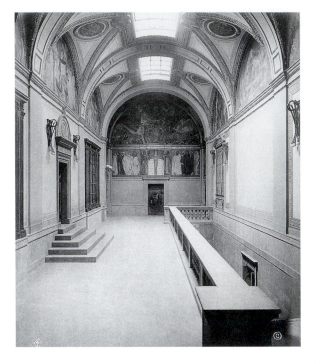 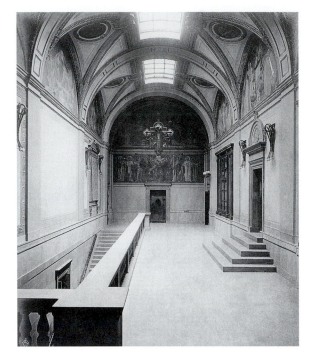

Fig. 54

Special Collections Hall, looking north, c. 1916. Trustees of the Boston Public Library

Fig. 55

Special Collections Hall, looking south, c. 1916. Trustees of the Boston Public Library

cially gilded relief) and the red and gold of Moses and Christ at the two ends of
the hall, moreover, further underscore the pairing of the two walls. And the red
wings of the angels (south) answer to the red wings of the cherubim that sur-
round both Moses and the Hebrew deity (north).

While the north and south bays are distinctly parallel, however, they are
also distinctly sequential with respect to treatment as well as narrative chronology.
From the perspective of Western visual conventions, the tendency of eye and
brain to read height of relief progressively reinforces the north to south sequenc-
ing. And, in terms of placement, the elevation of the very high relief (almost
sculpture in the round) Crucifix with respect to Moses and the tablets of the Law
is consistent with this pattern. Once we have moved back to the south wall, the
wall we faced as we climbed the stairs into the room, the carefully balanced, even
near symmetrical, composition locates us along the central vertical axis, marked
out by the visual focus of the polychrome Crucifix.[49] Despite the strong visual
pull of Crucifix, Sargent's "archaic style" and "archaeological temper" restrict the
degree of viewer identification with *Dogma of the Redemption* and function to re-

tain the desired relation to the room as a whole.[50] Sketches (e.g., fig. 57) as well as the scale model (fig. 58) for this wall indicate Sargent's interest in the use of relief pattern and line to suggest the appropriate emphasis. Here the message, communicated in the frontality of the figures, the lack of individuation of features (in either the Trinity with its three faces cast in the same mold or in *Frieze of Angels* with its similarly visaged hieratic groupings), and the strong emphasis on the abstract patterns produced by gilded relief, was one of stasis.

That Sargent set up the north and south walls of the room to refer to each other and to frame the all-important east wall is particularly clear in the disposition of the north and south ceiling vaults and south niches. At both ends of the hall, in the ceiling vaults, Sargent juxtaposed a variation on the theme of fertility and love (on the eastern ends of the vault in the images of the goddess Astarte [fig. 5] and the Virgin of the Joyful Mysteries [figs. 11 and 13]) with the representation of violence and pain (on the western ends of the vault with Moloch [fig. 4] and the Virgin of the Sorrowful Mysteries [figs. 12 and 14]). The ceiling vaults, with their gendered themes of generation and destruction, then, reflect back on each other. They also reflect back on themselves, for Sargent's contrasts are not absolute. In each case he modulates the effect by introducing minor notes of sorrow or despair (the instruments of the Passion clutched in the hands of the angels of the nativity, for example, and the visual pairing of Astarte and the Madonna of Sorrows) into his representations of joy and hope and vice versa.[51]

The two ends of the hall were tied together as well in Sargent's thinking about their content. Of the images installed in 1916, Sargent had at one point announced that his Madonnas were to be as much "idols" as the images on the north ceiling vault; both ends of the hall (with the exception of *Frieze of Prophets*) represented the idolatry of ages past, the "essentially materialistic and virtually obsolete ideas" of an earlier stage of civilization.[52] The *Madonna of Sorrows* was, here, a kind of Christian *Astarte;* Sargent gave each her own crescent moon and located the two female figures diagonally across the room from one another in roughly similar positions. After the artist's death, a prominent one-time Bostonian and passing acquaintance of Sargent's recalled a conversation with the artist regarding the intimate connection between the goddess Astarte and Spanish representations of the Madonna.[53] In preparation for an unpublished book on Sargent's murals, Ives Gammell collected reproductions of images similar to those he believed Sargent had in mind when he painted *Madonna of Sorrows*. Gammell's file included a Spanish Catholic Madonna (fig. 59) that he clipped from a contemporary magazine.[54] Thomas Van Ness, pastor of New Old South Church, reportedly remarked to a responsive Sargent that such images, often with "thin veil, stars, crescent moon, pose, and all," were "simply Astarte baptized, as it were, into Christianity."[55] The language of even the negative criticism acknowledged the narrative yoking of the north

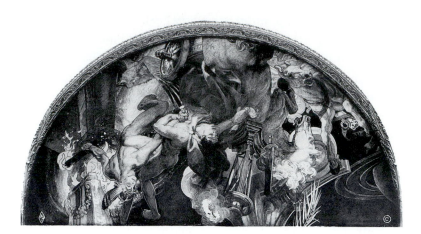

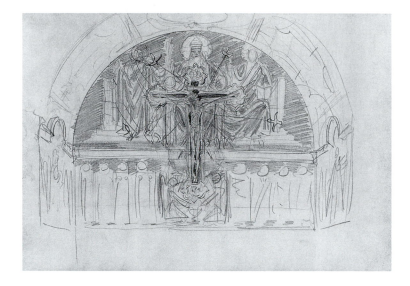

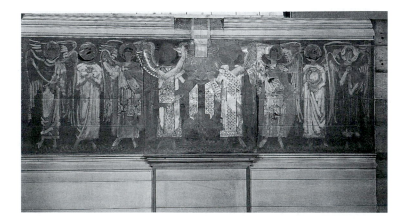

Fig. 56

Opposite, top: John Singer Sargent, *Fall of Gog and Magog,* east wall lunette, north end, installed 1916. Oil and gilded or painted Lincrustra Walton on canvas, approx. 16 ft. 10 in. (513 cm) wide. Trustees of the Boston Public Library

Fig. 57

Opposite, middle: John Singer Sargent, *Sketch after a Crucifix,* from an undated portfolio. Graphite on cream wove paper, 10 x 14 1/4 in. (25.3 x 36.3 cm). The Metropolitan Museum of Art, New York, Gift of Mrs. Francis Ormond, 1950, 50.130.143t

Fig. 58

Opposite, bottom: John Singer Sargent, fragment of dismantled studio model for Special Collections Hall, *Study for Frieze of Angels,* c. 1895–1903. Oil and gilded plaster and papier-mâché on wood panel. Fogg Art Museum, Harvard University Art Museums, Gift of Miss Emily Sargent and Mrs. Francis Ormond (through Thomas A. Fox, Esq.), 1933.45B

Fig. 59

Above: Spanish Madonna, magazine clipping collected c. 1950 by R. H. Ives Gammell (American, 1893–1981) in relation to Sargent's *Madonna of Sorrows.* Collection of Elizabeth Ives Hunter

and south ends of the room. Critic Forbes Watson complained of the "decadent ec-clesiasticism" of the *Madonna of Sorrows* and of Sargent's "cold and soulless eclecti-cism" in general.[56] This was not the practice of religion but the study of someone else's religion, religion that was long ago or far away.

PATTERNS OF MOVEMENT: THE SPECIAL COLLECTIONS GALLERY, WEST AND EAST

The lunettes installed in 1916 (fig. 16) on the east and west walls assisted move-ment in the room. On both lateral walls, though to a greater degree on the west, a subtle visual ascension across each set of three compositions reads north to south, suggesting this vector as an appropriate direction of vision. Sketches for the lunettes indicate the care with which Sargent considered the choreography of movement across their surfaces (cf. figs. 60 and 61). Thomas Fox tells us that Sar-gent was concerned, in the treatment of the ceiling and the east and west lunettes, to unite the two ends of the room. As other contemporary critics pointed out, however, the west wall could also be read as a single composition of the Last Judgment, beginning in the central lunette (fig. 62) with the act of judgment itself and moving in either direction, to hell (north; fig. 31) or to heaven (south; fig. 61). As the 1920 library *Handbook* observed: "Unlike the Judaic subjects the two companion lunettes are in continuity with the central picture, thus forming in ef-fect one panoramic composition" (see top register of fig. 16).[57] Further, "in the Christian trilogy there is a continuity of theme and a corresponding unity in composition; the Jewish trilogy is made up of three detached phases of tradition and doctrine, although related by the fact that disregard of the Divine Law leads to the final destruction of the material world represented by 'Gog and Magog' (a subject terribly suggestive of the present world conflict [World War I]), while the return of the race to compliance with the Law brings the Messiah to lead it into the Golden Age of a restored Eden."[58] The fit between the central (west) *Judg-ment* panel and the room's architectural features (fig. 63)—the steps into the music room, the music room door with its heavy cornice, relief decoration, and the flanking light fixtures and bookcases (all designed by Sargent)—helped to fix this directional scripting of the west wall.

A number of factors, including the centralized reading of the triple-lunette Last Judgment, the overarching treatment of the ceiling ribs and mold-ings, and the visual and conceptual relation between each pair of lunettes across the space of the hall (*Gog and Magog* and *Hell; Israel and the Law* and *Judgment; Mes-sianic Era* and *Passing of Souls into Heaven*), directed the spectator to turn his or her attention from the west wall to the east. In addition to the incentives just listed,

contemporary critics noted the pull of the warmer tones of the east wall lunettes: "The general tone of the lunettes in the Jewish series [on the east] is warm and ruddy. The Christian series [on the west] shows a predominance of blues and greens." Also remarked upon was the fact that the east wall lunettes were more substantial and complex iconographically and compositionally, and especially that they represented greater interest in volume than the west.[59] Further, if the part of the wall that extends down into the open stairwell is taken into account, the east wall surface suggests a two-story elevation. It is, then, both visually and literally the largest wall surface in Sargent Hall. As Sargent designed it, it would, furthermore, represent the largest painted surface in the room.[60]

Like the west wall lunettes, which read either north to south, in terms of visual ascension, or from the center out in both directions, thematically and in terms of shared motifs, the east wall lunettes allow a degree of multidirectionality as well. We have seen, for example, that they are calibrated, in terms of progress toward an ideal, to read north to south. They can also be read from the center out, as a sort of "Jewish" counterpart to the west wall's Christian Last Judgment. They are most compellingly understood, however, in terms of their separate and individual punctuation of the vertical (in the falling figures of *Gog and Magog,* the ascending youth of *Messianic Era,* and the stability around the vertical axis of all three), calling the viewer's attention to what is below each of them: to the architecturally framed *Synagogue* and *Church* and to the large central panel reserved for Sermon on the Mount (see fig. 24). Of all the painted elements in the room, these three would appear nearest eye level. In the oil study (fig. 24), the lightly rendered figure at lower right suggests Sargent's interest in the spectator's proximity to these paintings. If we imagine, for a moment, something like Sargent's most complete Sermon sketch (fig. 25) occupying the sizable space in the middle, we get a sense of the degree of visual emphasis that painting would have attained here.

Sargent communicated the singular significance of the central panel in the pains he took to establish his treatment of *Synagogue* and *Church* as visually and conceptually subsidiary, as "totally different" in treatment. *Synagogue* and *Church* would be proportionately smaller than Sermon, filling only part of the available space of the wall within the bay. While the paired set of allegorical figures would employ the same general color scheme as the rest of the hall, the saturation of the color would be lower, designed to recede by comparison with Sermon and with the lunettes above. In his first queries to the architectural advisors with respect to the feasibility of constructing and installing the architectural frames he envisioned for *Synagogue* and *Church,* Sargent insisted that, while some details were negotiable, the upright proportions were an essential aspect of his plan to differentiate the two panels from Sermon: "Please let me know what changes you think advisable in the pedimented panels. The one thing I must stick to is the upright measurements of the picture. I cannot possibly have it square."[61]

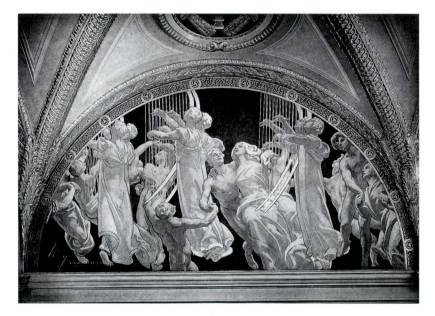

Fig. 60

John Singer Sargent, *Sketch for Passing of Souls into Heaven*. Graphite on paper,
10 1/4 x 16 1/8 in. (26 x 41 cm). Museum of Fine Arts, Boston, The Sargent Collection,
Gift of Miss Emily Sargent and Mrs. Violet Ormond in memory of their brother, John
Singer Sargent, 28.815

Fig. 61

John Singer Sargent, *Passing of Souls into Heaven*, west wall lunette, south end,
installed 1916. Oil and gilded or painted Lincrusta Walton on canvas, approx. 16 ft.
10 in. (513 cm) wide. Trustees of the Boston Public Library

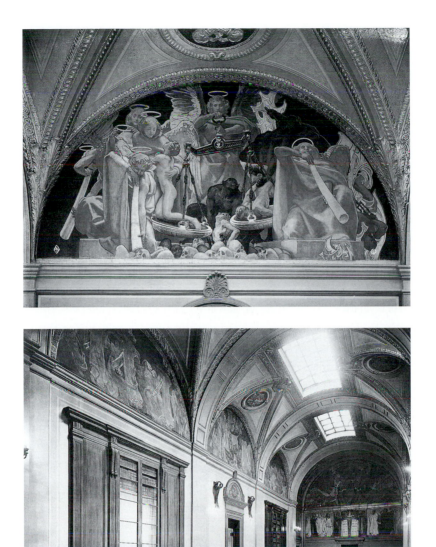

Fig. 62

John Singer Sargent, *Judgment,* west wall lunette, center, installed 1916. Oil and gilded or painted Lincrustra Walton on canvas, approx. 16 ft. 10 in. (513 cm) wide. Trustees of the Boston Public Library

Fig. 63

Sargent Hall, looking northwest, c. 1919. Trustees of the Boston Public Library

In addition to the inclusion in *Synagogue* and *Church* of numerous visual markers of their secondary importance, Sargent established the east wall's central bay as the uncontested (to his mind) focus of *Triumph of Religion*. In accomplishing this task, the volumetric stability of the central lunette (fig. 27) on the east played a major role. As an image this painting is, in significant ways, the most fully three-dimensional form present in the room, Moses and Crucifix notwithstanding.[62] Sargent, in fact, demonstrated his commitment to treatment of the figure in the round by producing a small bronze model (fig. 64) that indicated his conception of the picture as a three-dimensional block.[63] In the painting, the wing feathers included behind God's shoulders, suggesting the presence of additional unseen warrior angels, invite the viewer to visually circumnavigate the image. *Israel and the Law* was the first of the six wall lunettes that Sargent painted; he exhibited it in 1909 at the Royal Academy in London. From the artist's first settled configuration of the library gallery's east wall, he conceived *Israel and the Law* in direct relation to his idea of Sermon. Many critics selected this lunette (second only to *Frieze of Prophets*) as among the most successful of the finished paintings in the hall.[64] It was a composition to which Sargent returned in his variant at the Museum of Fine Arts, *Unveiling of Truth* (fig. 65).

In *Israel and the Law,* Sargent mindfully placed the child Israel in a central three-dimensional void created by the disposition of the Hebrew God's powerful limbs and by the red tent of Jehovah's heavy drapery, a garment that both veils and shelters. The volume of the image is measured and bounded, further, by the scroll of the Law, one rolled end held loosely by the thumb and last two fingers of Jehovah's left hand (fig. 66). With the first two fingers of the same hand, Jehovah steadies the scroll for the child to read. Winged guardians on either side assist. The other end of the scroll Jehovah grasps in his powerful right hand. This visually stunning movement of the scroll through space Sargent answered in reverse by the organization of God's massive body. Accentuating the image's three-dimensionality, the child Israel reads from one side of the scroll, while the viewer reads what is written on the other side. The sculptural treatment of the lunette, grounded in a stable pyramidal composition and weighted by its painted architectural stone base, created what one critic of Sargent's time labeled an "area of pause."[65] The fact that Sargent moved in his studies for *Israel and the Law* from an earlier conception of Jehovah holding small stone tablets of the Law (fig. 67) to the final version with the interweaving, enveloping, and double-sided scroll of the Law, further indicates his interest in the "pause" created by this compositional organization around an oval form registered in depth.

In the large central panel directly below this "area of pause," Sargent would have painted his cycle's "keynote" Sermon on the Mount. These two im-

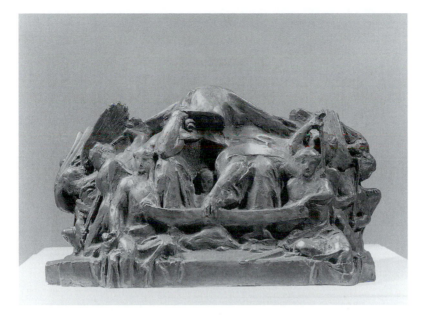

Fig. 64

John Singer Sargent, *Israel and the Law.* Bronze, 7 5/8 x 10 3/4 x 5 1/2 in. (19.4 x 27.3 x 14 cm). Formerly in the collection of the Hirshhorn Museum and Sculpture Garden, Smithsonian Institution, Washington, D.C., current location unknown

Fig. 65

John Singer Sargent, *Unveiling of Truth,* part of mural program for Museum of Fine Arts, Boston, installed over library door, Huntington Avenue entrance, 1921–25. Oil on canvas, 79 x 91 in. (200.7 x 231.1 cm). Museum of Fine Arts, Boston, Francis Bartlett Donation of 1912, 25.638

Fig. 66

John Singer Sargent, *Study for Israel and the Law* (detail), c. 1909. Oil and graphite on canvas. Trustees of the Boston Public Library

Fig. 67

***Opposite:* John Singer Sargent, *Study for Israel and the Law,* from an album of 107 studies for *Israel and the Law*. Charcoal on faded greenish blue laid paper, 18 3/8 x 24 1/4 in. (46.8 x 61.5 cm). Fogg Art Museum, Harvard University Art Museums, Gift of Mrs. Francis Ormond, 1937.11 folio 2**

ages together (Sermon and *Israel and the Law*) would establish a strong vertical axis in the center of the east wall.[66] This axis and the dominant visual focus it created for the room would have been underscored by Sargent's placement of the two paintings and their principal figures immediately above the balcony door on the first landing of the main staircase into the room and its balanced relation to the punctuating feature of the music room entrance, opposite on the west wall (see fig. 2).

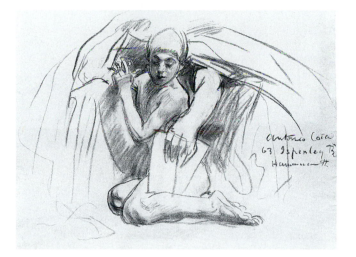

In his treatment of the ceiling moldings and decoration too, the artist marked the focus on Sermon and the central east-west axis of the room. Photographs taken of the hall in 1895 (fig. 68), just after the first installation and before the 1916 completion of the architectural modifications Sargent desired, reveal the extent to which the painter reshaped the room to meet the needs of his decoration. Over time, he instructed the architects to "carry the band of pilasters" that marked out the five bays of the barrel vault "right across" the ceiling. Furthermore, the two bands that separated the north and south ends of the room from the other three bays he made more substantial than the others so that they visually distinguish the north and south ends in relation to the central portion of the hall.[67] With the three central bays already larger and more extensively articulated in terms of moldings and relief medallions, Sargent reserved the most elaborate decoration, a double band of moldings, for the central bay itself: "For the sake of variety and of making the middle division of the ceiling richer than the two others, I have made two parallel bands of ornaments outlined by the penetrations . . . this has a good effect on the model" (compare, for example, the double band in fig. 27 with the single band in fig. 61).[68]

The degree to which the room organizes and structures our engagement with the space Sermon would occupy becomes immediately apparent when the daytime lighting of the room is taken into account. Before the room's illumination was modified and the skylights closed over and electrified, most of the natural light came from these ceiling apertures in the three central bays of the hall. Given the heavier bands of pilasters at north and south, the paintings at the ends of the hall, then, and especially the images on the north and south ceiling vaults, were shielded from direct natural light. Illuminated only by low electric lights (also designed by Sargent), the ceiling vaults and the upper portions of the north

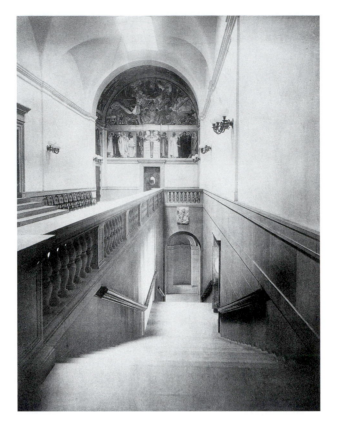

Fig. 68

Special Collections Hall, 1895, before Sargent's interior architectural modifications. From Newton W. Elwell, *The Boston Public Library* (Boston: G. H. Polley and Company, 1896)

and south wall lunettes were shrouded in semidarkness, the glint of light on gilded relief picking out the forms as the eye adapted to the dimness.[69] The skylights, however, especially on bright days, brought significant amounts of light into the central bays of the room, illuminating most clearly the bay reserved for *Israel and the Law* and Sermon on the east and *Judgment* on the west.[70] Photographs taken of the room just after the 1916 installation demonstrate this scheme (see figs. 54 and 55). On days when the doors to the music room with its bank of windows onto the courtyard or the balcony doors overlooking Bates Hall were open, the large central panel of the central bay was even more dramatically set apart as the culminating feature of the program.

PATTERNS OF BEHAVIOR

Though *Triumph of Religion* includes numerous references and cross-references that generate alternative paths for the viewer's consideration, Sargent's decoration just as securely manifests a specific and dominant pattern of movement through the room, first north, then south, then west, and finally east. Returning to the idea of ritual process outlined at the beginning of this chapter, we can see that Sargent Hall's ritual character accrued, in part, from its status as a particular and distinctive kind of space, a space in which the performance of beholding was carefully structured. The specific location, orientation, and use of Sargent Hall within the library, Sargent's orchestration of the hall's visual and architectural features, and the consequent sequential pacing of movement through the space all contributed to the room's ritual functioning. But the room's ritual character, its privileged separateness from the usual, depended as well on the murals' social activity, on the sort of behavior the room and its decoration recommended to visitors. It was not, after all, simply a *pattern* of movement that the hall required (go here, then there, then there), but also a *quality* of movement. T. R. Sullivan described the ascent to Sargent Hall this way:

From the [Venetian alcove] . . . a staircase ascends to the third story, and the door on the first landing leads into a stone balcony, overhanging Bates Hall above its main entrance. . . . At this point a fine view may be obtained, not only of the hall itself and its silent company of readers, but also through the great façade windows, out across the open square, where the Romanesque towers of Trinity Church rise grandly in the distance. All the stir and hubbub of the city are shut out. Standing in this clear light, one is doubly impressed by the fitness of the place for study, and the voice sinks with a natural impulse to a whisper, lest, through inadvertence, the study should be interrupted.[71]

From the pause for breath and for the view (of readers studying in Bates Hall) from the balcony on the first landing (fig. 69), to the surprise of Crucifix at the top of the stairs, Sargent Hall, in particular, functioned to quiet voices and to slow down the pace of the library patron in motion. A reviewer for the *Congregationalist and Christian World* noted the demeanor of the spectators who viewed *Dogma of the Redemption* shortly after its installation: "Day after day, and all day long, the hall is thronged with men, women and children gazing at the great picture. They speak to one another in subdued voices, and come and go in silence."[72] This modulation of sound, the "natural impulse" by which patrons lowered their voices to a whisper, linked the social effect of the library to that of churches, museums, schools, and other spaces built to contain similar cultural performances.

The religious subject and the dim lighting, as well as the juxtapositions and contrasts across a diverse range of symbols, required from the patron a reflective attitude, a willingness to look and to think, to read the brochure, and to look and think again. Merely glancing at the images would not suffice. In an important sense *Triumph,* by its sheer complexity as well as its content, induced its audiences to reiterate just the sort of behavior appropriate to a library. Sargent's articulation of the hall sacralized the scholarly work of the institution, an operation that was, after all, largely a solitary enterprise of individual will and imagination, a private activity, conducive to whispers.

Because most of the hall represented, for Sargent, the religious experience of the past, he construed the room as a sort of "dramatic arena" for viewing the religious experience of "others" and for contrasting that with the contemporary subject he would recommend in Sermon.[73] Though not everyone read the murals as Sargent did, the paintings, the sculptural relief, and the architectural ornamentation all provided props for rehearsing an activity of cerebration. Sylvester Baxter's first article on *Triumph,* the one Sargent pronounced excellent, celebrated the artist's "truly modern interpretation," his use of ideas formed in relation to "scientific investigations" and "archaeological and historical research." Baxter also described the ideal demeanor for understanding the cycle: "One is clearly impressed at a glance by the main idea, and is also made to feel the underlying immensity, the vast mystery behind it which slowly unfolds its meanings, its component elements revealing themselves as in a gradual dissolution of veil after veil beneath the calm gaze and the contemplative mind."[74] The set-apartness of ritual, from this perspective, involved the opportunity to consider, and even to dwell temporarily in, alternative worlds of thought and belief, worlds of "pagan" superstition, of Catholic doctrinal hierarchies, of fossilized institutions. Here the religious "other" could be contemplated as an object of study without the obligation of crossing over real religious and political boundaries in an actual world.[75] Important cultural work took place in this third-floor gallery, work that sacralized the activity of reading, studying, researching in the rooms beyond. From this perspective, Sargent Hall was a "stage well-equipped for certain kinds of performances which its [patrons] came to enact."[76] The general presence in the hall of unknown others seen to be engaged in precisely the same activity elevated the level of significance attached to participatory spectatorship in this space. This was a collective performance of private intellectual and imaginative activity. *Triumph's* audiences not only performed, they saw others performing, and they saw and imagined others observing them perform. This collective validation of the individual's private intellectual activity was an important aspect of the public experience of Sargent Hall.[77] Here Sargent's audiences had the opportunity to

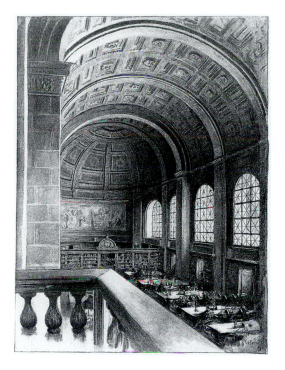

Fig. 69

Ernest C. Peixotto, *The Reading Room*, 1895, overlooking Bates Hall from balcony off
first staircase landing, directly below space reserved for Sargent's Sermon on the
Mount (mural shown at end of Bates Hall was to have been executed by James Mc-
Neill Whistler; the panel never moved beyond Whistler's first preparatory sketch).
Illustration for *Scribner's Magazine* 19 (January 1896): 88

"privately" consider religion in public with "strangers," with others who might
think and believe differently. The style of most of the murals not only asserted
the artist's critically "objective" position in relation to what he represented, it of-
fered his audiences a similar mechanism of distancing. Sargent counted on the
contextual capacity of the library, a secular depository of knowledge and culture,
to moderate and reframe the significance of his religious subject matter. Sargent
Hall was both its own discrete space structured by the artist for a particular kind
of intellectual/aesthetic absorption *and* it was the space in which the viewer
might be prepared, even schooled, for the intellectual performance required of li-
brary patrons (and especially those who visited the Boston Public Library's trea-
sured special collections in the rooms adjacent to Sargent's gallery). This
orchestrated preparation for privileged intellectual activity was the core ritual
function of Sargent Hall.

CULTURAL SELECTIONS

⊕

Only Abbey, Sargent, Saint-Gaudens and McKim, Mead, and White were present. After dinner, the plans of the Library were spread out and the mural possibilities of the walls and ceilings of the halls and galleries forming the special library collections discussed. . . . The interest of the occasion was much enhanced by the presence of several hundreds of carbon prints from the Masters covering the whole period of the Renaissance!

—CHARLES F. MCKIM TO SAMUEL ABBOTT (9 MAY 1890)

*

A critical part of what distinguished the space of Sargent Hall and moved the viewer so slowly through it was a sense of the richness, depth, and diversity of what Sargent had collected and assembled there.[1] While the long-term "study" necessary for mural decoration, by comparison with the short-term "attack" required for the production of portraits, was a new working method for Sargent, the activity of collecting was one to which he had become accustomed (even habituated) in his childhood and youth on the move.[2] In light of his family's commitments to frequent migrations from one European country to another, Sargent surely learned early the skill of organizing and reorganizing the "stuff" of his life. He was, furthermore (as we shall see more clearly in chapter 6), connected to the people, practices, and objects that moved with him rather more than to local (or even national) events of his temporary "homes." Collecting was an activity that allowed Sargent to standardize, organize, and control at least the material elements of his peripatetic existence.[3]

In part, the practice of collecting as an activity is about selective acquisition, containment, and organization—and public libraries, like museums, are grand civic collections of texts and images. Both sorts of institutions are involved in the acquisition of representative objects and in the organization of human experience and knowledge; both aspire to incorporate some essential aspect of the whole through a process of selection and ordering of constituent parts. Though eclectic and eccentric, the collection, at any one time a closed system, pretends to, suggests to its audiences, a kind of transcendence and comprehensiveness communicated in the title Sargent selected for his program: *Triumph of Religion*.[4]

Simultaneously, however, the collection is also intensely personal; it belongs to the individual(s) and/or institution(s) who articulate its boundaries. The audiences for Sargent Hall attended to the grand overarching and even universalizing idea of the artist's representation, but they just as certainly acknowledged it as *Sargent's* idea, as Sargent's collection.[5] Now assembled at the Boston Public Library, each of the individual elements of the cycle had come from somewhere else and in the opinion of contemporary critics retained at least a faint trace of the original contexts. But the issue of principal significance here was the new idea, Sargent's idea, to which the elements were now connected and in relation to which they had been reshaped and reconfigured. In selecting his sources for use in this new context, Sargent had dismantled them, filtered them through his own expectations and aesthetic, and reassembled his collection—one might almost call it a pastiche—in Boston.[6]

PASTICHE WITH A PURPOSE

Pressed to define Sargent's working method in a single sentence, Ives Gammell said that it "consisted in seeking for suggestions in the repertory of European art and then . . . of giving [the source] a new and highly personal character by an original treatment." In 1919 Sargent himself revealed that the "point of view of iconography" had been his "object throughout the painting of the Library."[7] In *Triumph of Religion* the artist collated motifs from a number of different cultural preserves (historical sites, museums, print publications), pursuing a collectible religious and artistic past, the raw materials for his mural cycle. Sargent's personal and professional travels (to places and in books) yielded not simply souvenirs to be relegated to a cultural attic (though, oddly, over the course of its history Sargent Hall perhaps became that too), but a new synthesis of materials deliberately chosen in relation to an idea, recast, and then assembled for public display.

The artist used the material and visual past in two qualitatively different ways. From some sources he garnered isolated images or motifs that underscored or illustrated a particular aspect of the theme already in place. Other sources he relied upon even more fundamentally. Art historical monuments in the latter category functioned as the basic building blocks of Sargent's concept; they helped him construct the idea itself, and they defined its contours. It is this second group of sources with which this book is most essentially concerned.

First, a brief survey of the former category is in order. This category comprised, for example, the Assyrian and Egyptian objects assembled at the north end of the room, the Byzantine and medieval sources of *Dogma,* and the Catholic revivalist images of James Tissot as well as the Spanish "primitives" for the south ceiling and west niche. Discussion of several specific instances of this type of appropriation will provide a sketch of Sargent's general approach to his material. So richly layered were his collecting habits that an exhaustive study of these sources would require its own text. Setting early the pattern he would follow throughout his work on *Triumph of Religion,* Sargent acquired his Egyptian and Assyrian images from a combination of travel (going as far up the Nile as Dendera, Luxor, and Karnak), visits to museums (especially the British Museum's Nimrud and Nineveh galleries, the Assyrian Saloon, and the Southern Egyptian Gallery, all in close proximity on the main floor of the building), and recourse to illustrated books in his personal library.[8]

The composition of the north wall lunette (fig. 6) owed most to a common Egyptian iconography for the representation of a pharaoh vanquishing enemy nations. Thanks to Evan Charteris, it is possible to reconstruct Sargent's trip up the Nile with some degree of certainty. Charteris tells us that the artist,

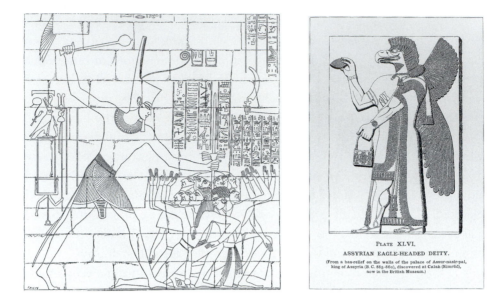

Fig. 70

Seti I, striking prisoners of war with his mace. As in John Singer Sargent's copy of Georges Perrot and Charles Chipiez, *History of Art in Ancient Egypt,* **trans. Walter Armstrong (London: Chapman and Hall, 1883), vol. 1, fig. 85**

Fig. 71

Assyrian Eagle-Headed Deity. From John Singer Sargent's copy of *Helps to the Study of the Bible* **(London: Oxford University Press, 1880). Trustees of the Boston Public Library**

after spending one month in Cairo, took "one of Gage's steamers" up the Nile to Luxor and Philae and that he also visited Fayoum. Tourist routes, and especially steamer ports, in this vicinity were well established; Baedeker's outlined the pre-scribed course.[9] Sargent could have seen a version of his pharaoh image in at least five different places on his itinerary. This iconographic theme was widely pub-lished so he probably also consulted designs for the image in one or more of the many texts he owned on Egyptian art (fig. 70). In 1893 the artist acknowledged that he had conflated several different versions in his lunette. "The motive of the pharaoh about to immolate his victims will be treated in a somewhat similar way to that in which it is seen on many Egyptian temples," Sargent claimed. His would thus be a "synthetic treatment of the subject."[10] Regardless of the specific source, the conventional Egyptian image accounts for the organization of Sargent's lunette, the central disposition of the figures of the Israelites oppressed,

the upstretched hands in the middle ground, and pharaoh's grasp, by the hair, of one of the victims along the central vertical axis. The gilded yoke held by the opposing Assyrian king appears to be Sargent's own addition, a visual exegetical remark on the text of Psalm 106 on the rib above.

The forms of the Assyrian lion and the eagle-headed deity whose protective magic oversees the deeds of the Assyrian king on the right side of the north wall lunette, Sargent appropriated from sculptural reliefs in the collections of the British Museum. The lion he adapted from a relief cycle, taken from the Palace of Ashurbanipal at Nineveh, depicting a lion hunt; the figure with the eagle's head came from the Palace of Ashurnasirpal II at Nimrud. In addition to viewing the original antiquities at the British Museum, Sargent consulted reproductions of the eagle-headed deity (fig. 71), for example, in his copy of *Helps to the Study of the Bible*.[11] For the ceiling vault, Sargent had sketched the sky goddess Neith from the temple at Dendera during his visit there. He likely also saw other variations on this iconography at the British Museum and at the Louvre; each institution owned a Book of the Dead that included prominent representations of the goddess. The British Museum exhibited extracts from its copy in the Southern Egyptian Gallery, where it also displayed the celebrated Rosetta Stone.[12]

For the north ceiling vault, the literary sources for the treatment of Astarte and Moloch have been well established. Sargent consulted both John Milton's *Paradise Lost* and Flaubert's *Salammbô;* the 1895 edition of the Boston Public Library *Handbook* mentions both texts, and we know from the artist's correspondence with Vernon Lee that he read *Paradise Lost* for the first time at the age of fourteen.[13] The principal visual source for Moloch's bull head was an Assyrian capital in the collection of the Louvre; for the figure of Astarte a recently excavated "polychromatic statue," a Kore figure that Sargent saw in Athens.[14] While Astarte and Moloch seem today to be arcane and obscure references, they were more easily recognized by name in 1895. Scores of biblical dictionaries and encyclopedias, products of the new biblical critical scholarship and of its detractors, flooded the market. Entries on Astarte (or Ashtoreth) and Moloch (or Baal) appeared in almost all of them, often with illustrations. In the context of this large and popular literature, the two stood in for the superstition and ignorance of pagan idolatry; as Sargent put it, the ceiling represented "the host of false gods, idols, graven images, and symbols of the superstitions of the neighboring heathen nations whose worship was the principal cause of God's displeasure and the theme of the prophets' remonstrances."[15] In order to emphasize this content, Sargent excerpted for his molding inscription those verses of Psalm 106 that most explicitly make this point.

Sargent's 1903 and 1916 installations represented similarly dense pastiches. The 1903 installation drew heavily on Sargent's travels; *Frieze of Angels* owed much

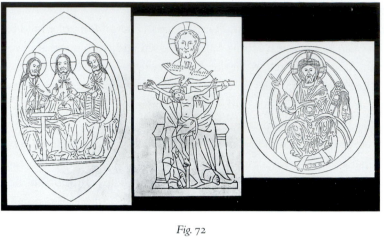

Fig. 72

Possible sources for *Dogma of the Redemption*, assembled c. 1950 by R. H. Ives Gammell. Collection of Elizabeth Ives Hunter

to similarly hieratic figures of winged messengers that he saw at San Apollinare Nuovo filtered through Sandro Botticelli and then scores of late-nineteenth-century painted and sculpted angels, including Augustus Saint-Gaudens's *Amor Caritas*.[16] For the sake of symmetry, the seven archangels conventionally understood to have functioned as attendants at the Crucifixion here number eight.[17] In terms of the books the artist consulted, Adolphe Napoleon Didron was especially influential. Gammell recognized *Dogma* as pastiche, and he collected and photographed (fig. 72) the sorts of images he believed Sargent used in the south wall Trinity. Gammell's own source for his array of pictures is not clear, but he could have assembled a nearly identical grouping from Didron.[18]

This first category of sources provided Sargent with raw materials for his assemblage. Taken cumulatively, his citations established a sort of encyclopedia of Western visual cultural literacy. The Boston spectator could have tracked a similar stylistic rhetoric of progress at the Museum of Fine Arts diagonally across Dartmouth Street. Assimilating and remaking the art historical past, Sargent's murals offered the perfect rejoinder to, and simultaneous reinforcement of, contemporary perceptions that cultural refinement originated on the European side of the Atlantic Ocean.

A second category of artistic sources, likewise handled as pastiche, participated directly in the definition of Sargent's theme. What did Sargent include in this second and most influential group of objects? What Western cultural relics actually provided the foundation for *Triumph of Religion?* How did Sargent use them? And what significance did his composition hold in Boston? Sargent began his work at the public library at a major threshold in his career. He had departed

Paris in 1884 shortly after the scandal over his portrait of Virginie Gautreau and had not yet hit his stride in the London art world. The market for his portraiture in the United States promised to turn the tide, but that promise had just begun to be realized. What better way to establish a lasting reputation than to undertake, in a public project of high visibility, a task no American artist, expatriate or otherwise, had yet accomplished: to synthesize the European art historical tradition in a new way in Boston for an American audience.

Triumph of Religion, in this light, represents Sargent's visual commentary on the history of Western art and especially his pictorial response to precisely those works his contemporaries viewed as the quintessential mural cycles of Western art, the visual representatives of modernity's advent. Baedeker's popular *Handbook for Travellers* outlined the alternatives: "Whether the ceiling of the Sistine Chapel, or the Stanze of Raphael are to be regarded as the culminating effort of modern art, has long been a subject of controversy."[19] Sargent's *Triumph* would assimilate and substantially rework aspects of each. Adding Pinturicchio's decoration of the Borgia apartments as well as the Sistine Chapel wall paintings of the rediscovered "Italian primitives" to the list of works that stimulated the process of conceptualization for *Triumph,* Sargent set up Rome, and the Vatican in particular (fig. 73), as the artistic and religious foil for his Boston enterprise.[20]

A number of sources confirm the degree of Sargent's acquaintance, from early in his life, with the Vatican and its art. Family correspondence and the recollections of Vernon Lee are especially helpful on this point. The artist's childhood sketchbooks too (one now at the Harvard University Art Museums, in particular) demonstrate that he drew from antique sculpture in the Vatican collections as early as 1868 and 1869.[21] Vernon Lee, who spent the winter of 1868–69 in Rome in the company of the Sargents, recalled "scamperings, barely restrained by responsible elders, through icy miles of Vatican galleries."[22] Lee described her own family's more passive mode of travel in order to set off by contrast the intensive sightseeing directed by Mary Sargent, that "most favoured inspired votary of the Spirit of Localities." In her own household, Lee "had been brought up to despise persons who travelled in order to 'sight-see.' *We* never saw any sights. We moved ourselves and our luggage regularly, . . . obeying some mysterious financial or educational ebb and flow, backwards and forwards between the same two places, and every now and then between a new couple of places in a different part of the globe. But we were careful to see nothing on the way."[23]

The Sargents, on the other hand, Lee explained, not only *saw* the sights, but discussed them, read about them, and discussed them some more. Furthermore, in the evenings Mary Sargent would paint verbal pictures for the three children (Vernon Lee, John, and Emily), thrilling Lee with "dim outlines of other parts of the world, with magic Alhambras and Tempes of Paestum and

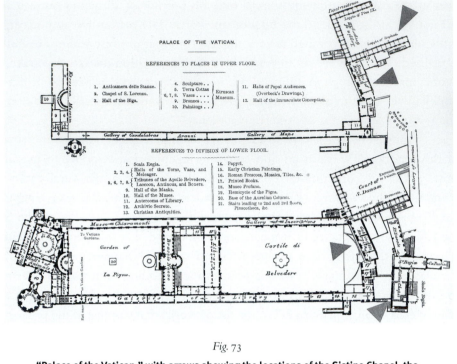

Fig. 73

"Palace of the Vatican," with arrows showing the locations of the Sistine Chapel, the Borgia apartments, the Stanza della Segnatura, and the Logge of Raphael. From John Murray, *Handbook of Rome and Its Environs* (London: John Murray, 1873)

Alpine forests." [24] Like Nathaniel Hawthorne, whose *Marble Faun* Sargent and Lee read together, the Sargents were fully occupied with the "sight-seeing of Rome." [25] Lee provides a colorful description of the sort of active tourism in which Sargent's mother engaged herself and her children. In addition, Lee's words, along with those of Fitzwilliam Sargent in a letter to a Philadelphia relative, indicate John Sargent's diligent use of John Murray's *Handbook of Rome and Its Environs.* [26] Lee says of the artist: "In his quiet, grave way he was, of course, extremely interested in Rome, with the kind of interest displayed already in the accurate descriptions and dates and measurements [that he provided in his early correspondence with friends] . . . together we spent hours over Murray's 'Guide Book' and Smith's 'Smaller Dictionary of Antiquities.' " [27]

RAPHAEL'S "TRIUMPH OF RELIGION"

Contemporary reception of Raphael's *Disputation of the Holy Sacrament* (or *Disputa*) framed an essential aspect of Sargent's conceptual pastiche. From Murray's

Handbook the young Sargent would have known that the "prevailing idea" of the Vatican Stanze was the "establishment and triumph of the Church," with the Logge representing the connected theme of "types of the history of the Savior and of the rise and progress of the Church." He would have read, furthermore, that Raphael's "Disputation on the Sacrament" had been "suggested by the 'Triumphs' of Petrarch."[28] Had Sargent consulted an edition of Baedeker's during the time he was at work on his own *Triumph,* he would have seen that the name of that Raphael painting, the *Disputa,* was "based on a misunderstanding and error . . . the scene is rather to be defined as the 'Glorification of the Christian Faith.'"[29] With a well-established lineage and roots in the Petrarchan Triumphs, by the late nineteenth and early twentieth centuries the notion of the "triumph" was so much a part of the common, even ubiquitous, vocabulary of Western art that Edwin Blashfield could casually refer to the Carolus-Duran ceiling decoration now at the Louvre (a project in which Sargent, a Carolus-Duran student, had participated early in his career) as a "'Triumph' of something or other."[30] Perhaps because its content was so well suited to expressing the ideology of progress, this titular construction found a popular following in the economy of nineteenth-century art.

What is significant for the purposes of this argument is that, by the time Sargent selected his subject for the Boston Public Library, Raphael's painting had been repeatedly cast as a "triumph" of religion or more specifically, of Christianity or the Church. Visually, of course, Sargent's *Triumph of Religion* looked nothing like Raphael's *Disputa.* In Sargent's case, he responded not to the form of Raphael's mural but to the idea of religion's triumph as represented by this "most famous and most beloved name in modern art."[31] Raphael's *Disputa* operated, I am suggesting, as the backdrop for Sargent's own selection of a subject (and title) of some cultural magnitude.

Though Sargent had, in all probability, known Raphael's Stanza della Segnatura since childhood, his recourse to the *Disputa* (fig. 74) in 1890 would surely have been filtered through the work of other nineteenth-century artists. Sargent's admiration for J.-A.-D. Ingres, and Sargent's as well as Ingres's for Raphael, has been well established.[32] When guiding Lucia Fairchild through the Louvre in 1891, Sargent selected the Ingres and Raphaels for special comment. Fairchild described Sargent's particular attachment to Ingres's *Apotheosis of Homer,* a reconceptualization and secularization of the *Disputa* as well as the *Parnassus* and the *School of Athens.*[33]

It was likely the connection to Petrarch's Triumphs (remarked by such a popular source as Murray) and appropriation of the *Disputa* by yet another nineteenth-century painter, the Nazarene Johann Friedrich Overbeck, as the principal source for his own *Triumph of Religion in the Arts* that accounted for the

Fig. 74

Raphael (Raffaello Sanzio, Italian, 1483–1520), *Disputation of the Holy Sacrament,*
1509. Fresco. Stanza della Segnatura, Vatican, Rome

tendency, by the late nineteenth century, to refer to the *Disputa* as the *Triumph of Religion.*[34] Overbeck began his painting in 1833 in Rome and completed it in 1840, exhibiting it for some time in the Italian city before delivering it to the patron, the Städelsches Kunstinstitut Frankfurt.[35] Overbeck's *Triumph* derived from his conviction that truly great art can be produced only when it proceeds from Christian (for him, Catholic) doctrine. The Nazarene's painting thus elevated Raphael but assigned a somewhat inferior position to the "pagan" Michelangelo.[36] It is not clear whether Overbeck participated in an already accepted alternative habit of naming for the *Disputa* or whether he initiated this usage himself. In the absence of any explicit statement by Sargent or his close acquaintances, it is, furthermore, difficult to establish whether the American expatriate knew the Overbeck image. Given the extent of the French and English influence of Overbeck's art, and given that Overbeck drawings of the life of Christ were exhibited at the Vatican throughout the years of Sargent's visits to Rome, it is not likely that Sargent was unaware of the German painter's work.[37]

Raphael's painting, in the most "official" real estate of Catholic Rome, celebrated the authority of the Church as mediator between divinity and humanity.[38] The elements of the Renaissance painter's composition converged in the exaltation of the Eucharist.[39] As Kenyon Cox noted in his essay (republished in 1914) on Raphael, "The hosts of heaven and the church on earth seem to gather

about the altar with its sacred wafer—the tiny circle which is the focus of the great composition and the inevitable goal of all regards, as it is the central mystery of Catholic dogma."[40] The wall, and some might argue the room itself, turned on the exposition of the Sacrament.[41] Whereas Raphael and his papal patrons made humanism Christian and Catholic, Sargent (and Renan) made Christianity humanist.[42] Sargent employed a triumphalist rhetoric similar to that of Raphael, but he turned it on its head. For Raphael, the "triumph" of religion was in the institution and sacramental doctrine of the Christian Church.[43] The perspectival system of Raphael's *Disputa* assigned a colossal stature to the human viewer, but it was Pope Julius II and his ecclesiastical associates to whom the paintings in the room granted this favor. For Sargent, religion's "triumph" resided in the kind of unmediated experience he saw represented in the person of Jesus. Since this experience was ideally available to anyone who desired it, "stature" at the Boston Public Library was established in a different way; the cycle's content granted authority only to individual subjectivities. Sargent's "triumph" was the triumph of human ingenuity and spiritual interiority over religion dogmatically and doctrinally expressed. In this sense, his *Triumph* ("truly a Raphaelesque conception," according to one critic) would seem to respond to Overbeck as well as to Raphael.[44]

Similarities as well as differences exist between Raphael's *Disputa* and Sargent's *Triumph*. Sargent's mural cycle was not a rejection of Raphael but a tribute to him, a reinterpretation of Raphael's subject for a more recent modernity and for Boston. In addition to representing papal Rome and its institutions, Raphael—and especially Raphael in Rome—represented also Renaissance individualism and selfhood. By the time Sargent painted *Triumph of Religion,* intellectuals like Jules Michelet, John Addington Symonds, and Walter Pater had resuscitated High Renaissance Rome (in response to attacks by, for example, Augustus Welby Pugin and John Ruskin).[45] Raphael's Stanza della Segnatura used secular images as well as religious ones to set out his ultimately ecclesiastical cycle. Painting in an era when the separation of religious subject matter from religious content had become possible, Sargent appropriated the language of religion to project a predominantly secularizing content.[46]

An additional connection existed between the Stanza della Segnatura and Sargent Hall. John Shearman has demonstrated that, as early as 1872, German historians suggested that the Stanza della Segnatura had been originally designed as Julius II's private library and that the room had come, only somewhat later, to be used also as the papal tribunal. The Austrian Franz Wickhoff presented a most compelling version of this argument in 1893.[47] Regardless of whether or not this information was available to Sargent, each artist, for his own library decoration, produced a program that depended on and represented both a way of knowing and

the organization of a system of knowledge.[48] While it is not clear that Sargent knew the literature on Stanza della Segnatura as Julius II's library, he certainly would have known that Pinturicchio's Borgia apartments, located on the first level directly beneath Raphael's Stanze, had been used as part of the Vatican Library, for that was their function during the years of Sargent's own early Roman experiences.[49] According to a contemporary edition of Murray's guide, the apartments contained "printed books, illustrated works, the library on the history of the Fine Arts formed by Cicognara, and that of the late Cardinal Mai, purchased by Pius IX: the sculptures which were formerly here have been moved to the Vatican Museum. These chambers were built by Alexander VI, from whom they derive their name; they are well worth visiting for the paintings on the vaults and walls, and will be shown *if desired* by the person who accompanies strangers over the library. They are preceded by some smaller rooms, also filled with printed books."[50]

Some of Pinturicchio's paintings (those decorating the Hall of Guards) had been covered over and were only restored by Leo XIII beginning in 1891. At this time the library moved out of the space, and by 1897 the whole of the apartments were once again accessible and all the paintings had been uncovered and restored. Though Sargent himself cited the Borgia apartment decorations with their ornamental moldings and relief medallions as the source for his north wall moldings and his ceiling treatment, an inventory of Pinturicchio's subjects (Sibyls and Prophets, Creed, Liberal Arts, Saints, Joyful and Sorrowful Mysteries of the Virgin) in the five rooms where the images were open to scrutiny between 1868–69 and 1891 (and then again after 1897) makes clear their potential impact on Sargent's conception.[51] Pinturicchio included images of Isis, Osiris, and Apis on the ceiling of the room of the saints, blending "pagan," "Jewish" (the prophets), and Christian subjects in the papal apartments. Sargent likely owed his use of scrolls and scroll-like motifs to contain inscriptions, as in *Frieze of Prophets, Dogma of the Redemption,* and *Israel and the Law,* for example, to Pinturicchio's similar usage.

THE SISTINE CHAPEL IN BOSTON

In 1896 Ernest Fenollosa celebrated the first installation in Sargent Hall in terms that both match this book's speculation regarding Sargent's calculated interest in mural painting and reflect a commonly shared hierarchy of artistic genres. He wrote:

In spite of his fame as a portrait-painter, what would Sargent, or the future reputation and influence of Sargent have been, had he not dared, Columbus-like, to discover this new

world? What were the painter Michelangelo without the Sistine Chapel? . . . It is proba-
ble that geniuses are born in every age and clime; but as seeds wither in an unreclaimed
desert, so do they in an ungenial atmosphere. This wonderful experiment of Sargent's
must penetrate American opinion like an irrigating flood, and stimulate directly and indi-
rectly a long series of splendid native works; so that, some day, when its walls are filled by
his epoch-making achievement, this gallery shall have become, like of old the Brancacci
chapel at Florence, a shrine for the pilgrimage of artists.[52]

Fenollosa was not the only contemporary of Sargent's to stand before *Triumph of
Religion* and think of Michelangelo, though here Fenollosa did so in terms that
also recalled Masaccio and thus set up the murals in Sargent Hall—"like of old the
Brancacci chapel at Florence"—as a first and exalted example of an art form he
hoped would thenceforth thrive on American shores. In the Boston library's Spe-
cial Collections Hall, claimed Fenollosa, future artists would come to learn at the
feet of this "early" master. In the course of his essay, however, Fenollosa ex-
tended his comparison between Sargent and Michelangelo to specific works of art
as well. When the Boston critic noted in *Frieze of Prophets* the "Michelangelesque
figure of Moses and His Law," he surely intended to link (broadly) Sargent's im-
pressive relief Moses with Michelangelo's monumental sculpture for the tomb of
Julius II (a cast of which could be seen just across the street at the Museum of
Fine Arts).[53]

 Twenty years later, when critic Frederick William Coburn named Sar-
gent Hall an "American Sistine Chapel," he made more specific the reference to
Michelangelo in general and to the chapel at the Vatican in particular.[54] Perhaps
the 1916 placement of the "panoramic" Last Judgment lunettes on the west wall
in Boston brought to Coburn's mind the *Last Judgment* on the west wall (there
liturgical east) of the chapel in Rome, or perhaps it was the resemblance (in body
type and posture) between Sargent's Jehovah in the central east wall lunette and
Michelangelo's Sistine sibyls and prophets—especially his Jeremiah (fig. 75, and
cf. fig. 76). Michelangelo's *Cumaean Sibyl* (fig. 77), furthermore, would serve as
Sargent's inspiration for the final design of *Synagogue* (fig. 17; see chapter 6), but
this panel would not be completed until 1919. In that year too Sargent would in-
stall *Synagogue*'s pendant, *Church* (fig. 18), with its reference to a Michelangelo
drawing of the *Pietà* (fig. 78) in Isabella Stewart Gardner's collection.[55] Other dis-
tinct references to Michelangelo also appeared in both sketches and final versions
for a number of library panels. As drawings now at the Museum of Fine Arts,
Boston, demonstrate, early designs for the central *Judgment* panel on the west wall
looked to Michelangelo's *Dying Slave;* in both the preliminary studies and the
final version, *Fall of Gog and Magog* borrowed rather directly from Michelangelo's
drawings of the *Fall of Phaëthon*.

Fig. 75

Opposite, top: Michelangelo Buonarroti (Italian, 1475–1564), *Prophet Jeremiah*, 1509–10. Fresco. Sistine Ceiling, Vatican, Rome

Fig. 76

Opposite, bottom: John Singer Sargent, *Study for Israel and the Law,* from album of 107 studies for *Israel and the Law.* Charcoal on off-white laid paper, 18 1/2 x 24 3/8 in. (47 x 62 cm). Fogg Art Museum, Harvard University Art Museums, Gift of Mrs. Francis Ormond, 1937.11 folio 21

Fig. 77

Michelangelo Buonarroti, *Cumaean Sibyl,* 1510. Fresco. Sistine Ceiling, Vatican, Rome

Fig. 78

Michelangelo Buonarroti, *Pietà*, n.d. Black chalk on hand-laid paper, 11 3/8 x 7 1/2 in. (29 x 19 cm). Isabella Stewart Gardner Museum, Boston, 1.2.0.16

Fig. 79

***Opposite, top:* John Singer Sargent, *Tyrolese Interior*, 1915. Oil on canvas, 28 1/8 x 22 in. (71.4 x 55.9 cm). The Metropolitan Museum of Art, New York, George A. Hearn Fund, 1915**

Fig. 80

***Opposite, bottom:* Sistine Chapel, Vatican, Rome. View toward altar, with Cosimo Rosselli's *Giving of the Law* at left and *Sermon on the Mount* at right**

Sargent's mining of the Sistine Chapel went beyond his appropriations from Michelangelo (which themselves went beyond the Sistine Chapel) to affirm his own substantial interest in the so-called Italian primitives of the fifteenth century (and earlier) whose reputations, by the middle of the nineteenth century, were in the process of revitalization.[56] Beginning earlier in the century, artists and historians alike contributed to revised and now positive appraisals of these works. Sargent registered his opinion on the subject in his high esteem for Botticelli, in periodic travel to visit Alpine, Italian, and Spanish sites known for their "primitive" art (e.g., fig. 79), and in his intense interest in exhibitions that included "primitive" works. In a letter to Ariana Curtis in 1907, for example, the artist described his delight in an exhibition in Perugia of "charming primitives, and of magnificent church treasures in the way of stuffs [fabric], crosses, ciboires, etc.— so much to see."[57]

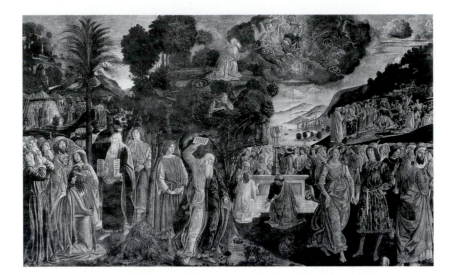

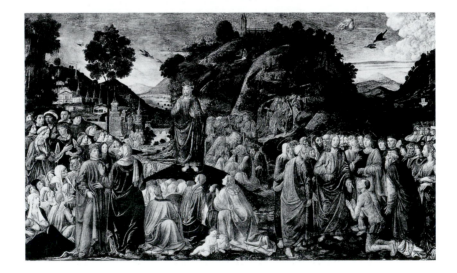

Fig. 81

Cosimo Rosselli (Italian, 1439–1507), *Giving of the Law and Adoration of the Golden Calf*, 1481–83. Fresco. Sistine Chapel, Vatican, Rome

Fig. 82

Cosimo Rosselli, *Sermon on the Mount and Healing of the Leper*, 1481–83. Fresco. Sistine Chapel, Vatican, Rome

By the fourth quarter of the nineteenth century, all the major guide-books for travelers to Rome included lengthy descriptions of the paintings on the Sistine Chapel walls (fig. 80), that "series of remarkable frescoes by eminent artists of the fifteenth century [including works by Luca Signorelli, Sandro Botticelli, Cosimo Rosselli, Perugino, and Domenico Ghirlandaio], whom the pope employed to decorate the chapel."[58] The text of Murray's guide, appealing, as it continued from the foregoing quotation, to an expert's authority, provides a glimpse into Sargent's use of the earlier Sistine imagery: " 'It was designed,' says Lanzi, 'to give a representation of some passages from the life of Moses on one side of the chapel, and from the life of Christ on the other, so that the Old Law might be confronted by the New, the type by the person typified.' "[59]

Sargent Hall reiterated this pairing of Moses and Christ on its north and south walls, the links between the two accentuated by their execution in relief.[60] In contrast to the Sistine Chapel, Sargent narrated the parallelism of the two not in the events of their biblical and apocryphal stories but in their representation of two different forms of the codification of religion: Law and Dogma. In contrast to each of the other prophets for whom Sargent's Hebrew inscriptions on the cornice recorded simply their names, above Moses' head the artist wrote: "Moses and the *Law.*" On the south wall, furthermore, Sargent painted not Redemption but the "*Dogma* of the Redemption." That Sargent turned, for a significant element in the visual composition of *Dogma,* to the Concordance window at St. Denis, with its insistence on this typology of old and new, is further evidence of this content.[61]

In Sargent Hall as in the Sistine Chapel, Moses and Christ faced one another across the north-south axis of the room. At the public library this was the long dimension of the room; at the Vatican it was the short dimension. While the Sistine Chapel, furthermore, was not oriented meteorologically, Sargent "corrected" for this in Boston, restoring to the Christian iconography its conventional southern positioning. This reorientation placed Moses and the tablets of the Law above the entry to the principal repository of special collections: the patron gained access to the Barton-Ticknor Library by passing under the prominent divinely inspired "special" text inscribed on the tablets held by the first prophet. In the Sistine Chapel, Cosimo Rosselli's *Giving of the Law* (fig. 81) faced the same artist's *Sermon on the Mount* (fig. 82) across the short dimension of the chapel—the "Old Law" faced the "New Law." Sargent reconstrued the character and function of *Sermon* in his cycle, making it the capstone of the program and repositioning "liturgical east," which is here also meteorological east, to the long wall of the library gallery.[62] Here Sargent would paint the image that, for him, represented the only genuine "modern" basis for discernment (the "medieval" version of which appeared in *Judgment* on the wall opposite). Like Walter Pater (whose

Fig. 83

"Morning Service for Sabbaths and Festivals." From John Singer Sargent's copy of *Authorized Daily Prayer Book of the United Hebrew Congregations of the British Empire* (London: Spottiswoode, 1904), 148, with annotations by the artist. Trustees of the Boston Public Library

Fig. 84

Opposite, top: Raphael, *Moses Receiving the Tablets of the Law*, c. 1517–19. Fresco. Bay 9, Vatican Logge, Rome

Fig. 85

Opposite, bottom: Julius Schnorr von Carolsfeld (German, 1794–1872), *Moses Receiving the Tablets of the Law.* Wood engraving. From *Die Bibel in Bildern* (Leipzig: Georg Wigland Verlag, [1870?])

early work we know Sargent read and generally liked), the artist's interest lay in tracking the breakdown of "those limits which the religious system of the middle ages imposed on the heart and the imagination."[63] Sargent's Sermon would constitute a distinct alternative to Law and to Dogma as represented on the north and south walls, something altogether new, a quality that suited religion's translation from Rome to Boston and from the fifteenth and sixteenth centuries to the twentieth.

Outside of the configuration of the two end walls, perhaps the most striking visual evidence of Sargent's desire to pair Moses and Christ in typological

fashion on the north and south, and then to discard that conventional typology for something different, appears in his excision of the two biblical figures from their usual positions in the iconography of the Giving of the Law on Sinai and the Last Judgment. The evidence for this excision is strong and resides, with respect to Moses, in both the inscription and the pictorial sources for *Israel and the Law.* In Sargent's painting, Jehovah holds before the child Israel a portion of the scroll of the Law. Sargent excerpted the text for this part of the inscription from his copy of the *Authorized Daily Prayer Book of the United Hebrew Congregations of the British Empire.*[64] On page 148 of the book (fig. 83) Sargent's annotations indicated his se-

lection of verses. The text in full in the prayer book reads: "And this is the Law which Moses set before the children of Israel." But Sargent used red pencil (barely visible at middle right in the photographic reproduction) to cross out the Hebrew words "which Moses set." The words on this part of the scroll in the completed painting thus say: "And this is the Law before the children of Israel."[65] Sargent has thereby carefully extracted Moses from the text for *Israel and the Law* and has placed him instead on the north wall where he faces the crucified and lifeless body of Christ in apparently typological fashion.

This literal setting aside of Moses Sargent reiterated in his consideration of visual sources for his iconography. Though the figure of Jehovah himself came from Michelangelo, Sargent surely took the basic conception of his figural grouping from Rosselli's Sistine *Giving of the Law* (fig. 81)—especially from Rosselli as that artist had been modified by Raphael in the Vatican Logge *Moses Receiving the Tablets of the Law* (fig. 84) and, subsequently, by Julius Schnorr von Carolsfeld in his wood engraving of the same title (fig. 85) for the well-known *Die Bibel in Bildern*.[66] In each of the three earlier pictures, Moses is the object of Jehovah's attentions; in each, the depicted or implied narrative has Moses receiving the Law from Jehovah and Moses subsequently presenting the Law to the people of Israel (see esp. fig. 81). On the east wall of the Special Collections Hall, Sargent substituted the child Israel for Moses and altered the figure's relation to God. Interestingly, on the west wall of his library gallery, Sargent also excerpted Christ from the depiction of the *Last Judgment* and, instead, located him crucified in *Dogma of the Redemption* (again as the pendant to Moses at the north). This shifting and recalibration of images necessitated an alteration in the inscription Sargent appropriated for his south wall from the cathedral at Cefalù: "judico" as the action of Christ in the original, Sargent changed to "redemo." In Sargent Hall, the north wall's Moses (fig. 28), with his Ten Commandments on massive tablets of stone, represented a "primitive" and rigidly contained version of the divine code, a suitable match for the fossilized, hieratic Christian images to the south and an "earlier" variation of the more fluid and embracing Law from which Israel reads in the lunette (fig. 27).

On the east wall, instead of Moses receiving the Ten Commandments or setting the Law before Israel, Sargent depicted Jehovah himself teaching Israel, with Jehovah represented in intimate and direct proximity to the allegorical child. Notably, a passage in Renan's *History of the People of Israel* expresses a preference for the Jewish Jehovah over the Christian trinitarian God in terms strikingly suggestive of Sargent's painting: "The fashion in which a pious Christian addresses God would not assume such tender accents if behind the God, in three persons, there were not a more tangible God who has carried his tribe in his bosom like a nurse, has caressed it, and spoken to it as though to a child."[67] In

Sargent's painting, the text that the viewer sees on the face of the scroll announces the lunette's subject: the Law set before Israel. The child in the image is fully engaged in learning the commandments "written" for his edification on the other side of the scroll. The inscription that appears on the small strip of the scroll draped over Jehovah's left arm is not, technically, the first commandment (as Baxter suggests) but the statement prefatory to the entire Law: "I am the Lord, your God."[68] *This* was the whole "law" set before the children of Israel. Its recitation here pointed to the nature and identity of the deity and indicated the comprehensive subject of Israel's education. In a preliminary sketch for this band of the scroll, Sargent worked out the lettering for the first commandment itself, the declaration that rejected pagan gods and required Israel's monotheism: "You shall have no other gods before me." In the final painting, he modified the inscription to express the more inclusive content.

In his representation, Sargent accentuated the mysterious humanity of one who claimed all genuine divinity for himself. The lunette's Jehovah, though veiled, attracts by his combination of tenderness and power.[69] Despite the Hebrew God's immense hidden frame, the toes of his left foot are exposed (like those of Israel's right foot), while the toes of Israel's left foot curl into and perhaps under Jehovah's robe (cf. fig. 86). One of Sargent's few personal references to divinity suggests the balance he sought here. While at work on this painting, the artist sent an unusually revealing message to his friend Ralph Curtis. Describing the current focus of his artistic attentions, Sargent wrote: "I am winding up my worldly affairs in that line [portraiture] and now I shall be able to paint nothing but Jehovah in Fulham Road [his London studio]. His friends all call him Jah, Whereas may you and the Dogaressa [Curtis's wife] and the children merit and receive his fatherly attention and flourish under his care."[70] Given the tone of the rest of the letter, these words were surely written in a mildly jocular moment (Curtis shared Sargent's reservations about conventional religion, and the two frequently exchanged witty remarks about weighty subjects). In these sentences, however, Sargent seemed also to communicate a rare but sincere religious sentiment—one that assigned humanity to divinity and divinity to relationship—at just the time that Sargent was painting the intimacy shared between God and the child Israel.

Just below *Israel and the Law,* instead of recommending the Christ of *Dogma*'s Crucifix, Sargent's Jesus of Sermon on the Mount would teach Boston's "multitudes" the "divinity" of full humanity. As the most finished extant pencil sketch (fig. 25) for this central panel suggests, Sermon's Jesus, like the God above, would appear in tender and immediate proximity to a child. Here promise and fulfillment appeared not across the room from each other as in Rome but on the same axis, diminishing, in the Jewish case, the activity of an intermediary and an-

Fig. 86

John Singer Sargent, *Study for Israel and the Law,* from an album of 107 studies for *Israel and the Law.* Charcoal on off-white laid paper, 24 13/16 x 18 1/8 in. (63 x 46). Fogg Art Museum, Harvard University Art Museums, Gift of Mrs. Francis Ormond, 1937.11 folio 23

nulling it altogether in the Christian one.[71] Given Sargent's reference in his Jehovah to Michelangelo's *Jeremiah,* it is interesting to note that one of the most widely quoted passages of Jeremiah's prophecy (Jeremiah 31:31–33) stressed the advent of a "new covenant" of an entirely different character, written not on stone but on the human heart. This time, God says, "I will put my law in their inward parts, and write it in their hearts; and I will be their God, and they shall be my people."[72] Sargent brought this version of the Jewish God into unusually close alignment with the activity of the Christian Savior. If, as the library *Handbook* maintained, *Synagogue* would represent the "medieval" idea of the fate of the Jewish religion, *Israel and the Law* represented a more "modern" idea. While Israel learned from the text of the Law held before him, Jehovah himself (not Moses) supported the scroll. Furthermore, the substitution of the Torah scroll for the tablets of the Law that appeared in the Renaissance precedents, in Sargent's *Moses,* and in the early sketches for this lunette, suggested a more comprehensive, direct, and transparent tissue of mediation than the conventional stone. The relationship of the Jewish lunette to the Christian keynote was one of continuity

rather than antithesis; this was not Luigi Lanzi's Sistine "confrontation." Movement from one to the other was evolutionary rather than strictly typological.

Sargent thus used the resources of art history conceptually as well as iconographically and stylistically. *Triumph of Religion* represented for Sargent a contemporary American reconfiguration of prominent works in the Vatican complex, especially the Sistine Chapel and the *Disputa*. In addition, while paying special homage to Michelangelo and Raphael, Sargent's appropriations for *Triumph* acknowledged the work of scores of other artists as well. *Triumph* was truly a "shrine" of Western culture, its individual "relics" not copied but interpreted with respect to Sargent's idea and then reworked to suit new circumstances of modernity and nationality. *Triumph of Religion* was, in this sense, "American Renaissance" with a vengeance, using the "best" of the past to design and affirm the artist's notion of progress in the present.[73]

A "SERMON" FOR BOSTON

Sermon on the Mount can, and has, meant many things to many people. For Cosimo Rosselli (fig. 82), it participated in the typological scheme of the Sistine Chapel, conveying the relationship of promise and fulfillment: as Moses mediated the Old Law, Christ mediated the New. Rosselli's Christ of *Sermon on the Mount* appeared on an eminence, wearing a halo, with hands positioned in a gesture that signified the act of exhortation or preaching. His disciples, also haloed (and whom he had just called to service in the previous panel by Ghirlandaio), gathered behind him at the foot of the hillock. The multitudes arranged themselves before him. Rosselli also included, in this painting, a vignette, in the right foreground, representing one of the miracles of Jesus, the Healing of the Leper, traditionally judged to demonstrate Christ's divinity and his priestly function.[74] Rosselli gives us *Sermon on the Mount,* then, as a sort of charter for the Roman Church.[75]

Sargent, on the other hand, composed his Sermon in a time and place committed to the search for the "real" Jesus, the "historical" Jesus, the one whose true character had been obscured, according to Renan, Tolstoy, and Voltaire, among others, by precisely the sort of churchly dogma and orthodoxy celebrated by Rosselli. The "real" Jesus thus stood in need of liberation.[76] In this quest, Protestant liberalism rejected or rationalized the scriptural stories of miraculous events and actions, like the Healing of the Leper. In addition, Protestant liberalism emphasized a kingdom of God that was within the individual or that existed as the social ideal toward which history advanced, or both.

The Reverend Lyman Abbott's widely consulted *Dictionary of Religious Knowledge for Popular and Professional Use* presented an interpretation of Sermon on the Mount that sounds strikingly similar to Sargent's 1895 outline of the idea behind *Triumph:* the progress from "material to spiritual," the movement by which "religion becomes subjective." Abbott was pastor of the prestigious Plymouth Church in Brooklyn, editor in chief of *Outlook,* and a frequent speaker in Boston and Cambridge. Abbott's analysis, working from a position he claimed was "generally considered by modern scholars," divided Jesus' sermon into four parts. From the minister's perspective, the first part of Sermon defined the kingdom as "spiritual" rather than "material or political." The second part contrasted Sermon with Mosaic Law; Sermon's emphasis was on the reconstruction of the heart as well as the regeneration of conduct. The third part of Sermon on the Mount, according to Abbott, set out the difference between a "religion of a pure heart" and one of "rigid ceremonialism." The fourth demonstrated that this kingdom could only be won by an interior disposition—in Abbott's explicitly religious terms, by "faith."[77] Two decades later, liberal Protestant professor of psychology and Clark University president G. Stanley Hall discerned in Sermon on the Mount the "most essential teachings of Jesus" and renamed Sermon's Beatitudes as "the great inwardizations."[78] Hall declared the "death of the old objective God, and his resorption and inwardization in man. So, too, the incarnation stands for a great movement of pragmatism in the religious domain. The day of the old transcendentalities of faith ended with the loud and clear call of the Baptist to realize everything here, now and within, to which Jesus added, 'and in myself.' Man must no longer eject, evict, or extradite his ideal self and project it upon the clouds but factualize it within his own soul."[79]

Apart from providing some insight into his literary sources, Sargent actually had very little directly to say about Sermon and his particular conception of it. In 1891 he made some revealing remarks to Lucia Fairchild regarding his personal assessment of the subject: he associated his beloved sister Emily, he said, with the exalted and unexpected qualities (what Hall would later call the "great inwardizations") recommended in the Beatitudes. Sermon on the Mount was, furthermore, not like the "Epistles, etc.," which more closely approximated the "ordinary kind" of sermon that Sargent found "awfully tiresome."[80] But aside from his official 1895 description of the first installation, including his comments regarding the material to spiritual direction of the cycle (with its "subjective" outcome favoring a "more personal relation"), he summarized his own thoughts in print only a handful of times. In his 1893 letter to McKim requesting the second contract, he proposed the "keynote" of "Christ preaching to the multitudes or words to that effect." In a newspaper interview in 1903, he maintained that the

cycle's "central idea is that in the teachings of Christ to his followers, the religious thought of the world found its culmination."[81] And in 1915, when he wrote to Josiah Benton regarding the changes in his conception of the east wall, he simply referred to the central east wall panel by its subject title, "Sermon on the Mount." We also have Sargent's comments in 1895 and 1903 that "each part will be in sequence of the preceding" and Sylvester Baxter's conviction, in a 1917 statement "authorized" by Sargent, that (in keeping with the stylistic "progress" of this sequencing) Boston could count on a "freer" treatment in the culminating panel on the east.[82] When divorced from knowledge of his literary sources, then, Sargent's words about his Sermon tell us relatively little. The conception of the subject takes on much more specificity when we turn to his sketches for the painting, and especially when we consider them in relation to depictions of the same subject by other artists. As we will soon see, Sargent's most finished sketch (fig. 25) for the central Sermon, in fact, demonstrates a particular and unique variation on the iconography of Sermon on the Mount.

At least seven variables register the significance of the choices Sargent made in his sketch: the geography of the site; Jesus' location in it; Jesus' relation to the crowd; the size of the crowd; the constituency of those gathered; the gestures assigned to Jesus; and the presence and position of the child at Jesus' side. First, in each of the extant pencil sketches (figs. 20, 21, 25, and 112) for Sermon and in the oil study for the east wall (fig. 24), Sargent represented consistently the geography of the place where Sermon on the Mount occurred.[83] In keeping with the latest biblical scholarship, he would paint neither a mountain (as in Matthew's account) nor a plain (as in Luke's account) but the harmonization of the two that contemporary critical readings recommended. Speculating that a third common source lay behind the Matthean and Lukan versions of the story, those versed in comparative biblical literatures located Sermon on a plateau in the hill country.[84] This description fits the scene as Sargent represented it and also suggests both the extent and liberal direction of Sargent's study of the subject.

Two of the most obvious variables in the range of possibilities for representation are the precise location of Jesus within the scene and the relationship of Jesus to those around him suggested by his pose and location. Sargent placed Jesus in the center of the crowd, in immediate proximity to those gathered to hear him. Jesus stands on ground that is level with that occupied by "the multitudes," his upright figure unusually close to the picture plane by comparison with compositions of Sermon executed by other artists. In a sampling of two dozen other Sermon images, all of them, by contrast, elevated or otherwise separated Jesus, sitting or standing, above the crowd on a high place, a large rock, or promontory. These artists, furthermore, generally located Jesus in the middle register or even

the upper third of the image. Both were true, for example, of Sermon on the Mount as depicted by Gustave Doré (fig. 87) and Julius Schnorr von Carolsfeld (fig. 88). James Tissot (fig. 89) presents perhaps the most striking contrast to Sargent's image. Robed and hooded in white, Jesus stands, to the right of center and in the upper register of the picture, on a rocky mountain outcropping. His arms raised, he preaches to the crowd below. In Tissot's vertically oriented composition, Jesus' left side is toward the beholder, his gaze directed down toward the crowd and his face shielded from view by the garment he wears. The Catholic revivalist Tissot painted the priestly Christ, elevated above and removed from the multitudes, speaking from a lofty pulpit. This is Christ the preacher and Christ the founder of the Church.

Both Doré's image and one published in 1866 by Currier and Ives (fig. 90) represent a specific passage from Matthew's version of Sermon on the Mount: "consider the lilies of the field, how they grow . . ." (Matthew 6:28–29). Doré's engraving raised Jesus above the crowd with the composition arranged to accent his position at the apex of the pyramid upon which the design rests. In the Currier and Ives print, Jesus appears almost level with the crowd in order to emphasize his relation to the lilies of his object lesson, but the figural composition falls into three vertical zones across the surface, effectively cutting Jesus off from direct contact with the people who stand on the same ground.

When we return to Sargent to consider his Sermon in relation to the fourth and fifth variables identified above, the size and constituency of the crowd, another brief detour to the biblical critical literature is helpful. Lyman Abbott pointed out how the Matthean version of the story suggested that Jesus probably delivered this sermon only to the disciples, whereas in the Lukan version the audience was construed as a multitude. The likelihood, Abbott concluded, was that in the earlier "common" text, Jesus assembled his disciples and then accompanied them to the place, whereupon a multitude also came out to hear him. Painted and print versions of Sermon on the Mount did not wait for modern biblical scholarship to draw this harmonizing conclusion; almost all images of Sermon, beginning as early as Cosimo Rosselli's, included some combination of the disciples and the crowd. Claude Lorrain's solution (fig. 91) to the integration of the two accounts was particularly inventive. He painted Jesus with his disciples arranged around him on a substantial rocky hill or small mountain jutting up in the midst of a landscape. On the plains below the "mount," at more remove from the person of Jesus, Claude accommodated a second audience, the multitudes. According to Anna Jameson, Claude's *Sermon on the Mount* was exhibited with other old masters in the late 1880s in the Grosvenor Gallery in London where Sargent in all likelihood would have seen it.[85] Over time the multitudes played a more and more prominent role in compositions of Sermon on the Mount, and

the disciples' presence was diminished by contrast. The Sargent sketch (fig. 25) follows this pattern. It is possible that the artist might have intended to arrange a cluster of disciples behind Jesus, but in this pencil drawing, and in the detail on its reverse (fig. 92), it is with the crowd—and a sizable crowd at that—that he is most concerned. Sargent's multitude, in fact, takes up almost all available space across fully two-thirds of the sketch's surface. There are so many figures that their bodies overlap and a sea of heads obscures the feet of Jesus. The foreground figures break the lower frame and move into the space of the room to include the beholder.

The range of gestures assigned to the figure of Jesus in representations of Sermon on the Mount is relatively narrow and can be categorized with reference to the height of the arms in relation to the waist, to the position of the hands (open or closed, palms up or palms down), to the degree of hierarchical separation implied in the gesture and stance, and to the activity suggested by both. In depictions that focus attention on the preaching role of Jesus, the arms are elevated above the waist and often extended outward with palms down (e.g., fig. 89). These pictures also generally present Jesus in some elevated position or include other significant indicators of difference that set Jesus apart from those around him. Just across Copley Square at Trinity Church, Sargent could have seen two representations of the figure of Christ in the stained-glass windows at the east and west ends of the nave, on the building's main axis. While neither one of these images represents Sermon on the Mount, Sargent must surely have considered their depictions of a similar iconography. In its pictorial inclusion of an audience for Jesus' words, the central chancel window (installed 1877–78; fig. 93) at Trinity, representing Christ preaching in the *Exhortation at the Feast of Tabernacles* (John 7:37), is perhaps most similar to the Sargent sketch. The resemblance stops with the audience, however. The window's designers, the English firm of Clayton and Bell, gave this Jesus a halo and enshrined him under an arched banner containing the words of the scriptural text ("If any man thirst, let him come unto me and drink") held by two haloed angels. The alternate title for this window was *The Preacher,* but the arrangement of Christ's body here, with outstretched arms raised above waist level, hands palm upward, in a position similar to the one conventionally adopted for the displaying of the stigmata, suggests that the preaching Christ is also the "crucified and risen Lord."[86] Unlike Matthew's premessianic Jesus of Sermon on the Mount, John's Jesus of the Feast of Tabernacles has assumed the mantle of messiahship.[87]

At the other end of Trinity's nave, closest to the library, John La Farge's *Christ in Majesty* (fig. 94), a design influenced by the Beau Dieu at Amiens and by the mosaics of San Vitale, stands above and behind the congregation, facing the preacher (literal and represented) in the chancel. La Farge designed this window

CHRIST'S SERMON ON THE MOUNT,
THE PARABLE OF THE LILY.

Consider the lilies of the field, how they grow, they toil not neither do they spin, and yet I say unto you, That even Solomon in all his glory was not arrayed like one of these. ST. MATT. VI. 28-29.

Fig. 87

Page 134, top: **Gustave Doré (French, 1832–1883),** *Sermon on the Mount.* **Wood engraving. From** *Bible Gallery* **(London, Paris, and New York: Cassell, Petter, Galpin, and Company, 1880)**

Fig. 88

Page 134, bottom: **Julius Schnorr von Carolsfeld,** *Sermon on the Mount.* **Wood engraving. From** *Die Bibel in Bildern* **(Leipzig: Georg Wigland Verlag, [1870?])**

Fig. 89

Page 135, top: **James Tissot (French, 1836–1902),** *Sermon on the Mount.* **Gouache on paper. From** *Life of Our Saviour Jesus Christ* **(London: Sampson Low, Marston and Company, 1897), vol. 1**

Fig. 90

Page 135, bottom: **Nathaniel Currier (American, 1813–1888) and James Merritt Ives (American, 1824–1895),** *Christ's Sermon on the Mount,* **1866. Lithograph. Library of Congress, Washington, D.C.**

Fig. 91

Above: **Claude Lorrain (Claude Gellée, French, 1600–1682),** *Sermon on the Mount,* **1656. Oil on canvas, 67 1/2 x 102 1/4 in. (171.4 x 259.7 cm). The Frick Collection, New York, 60.1.162**

for Trinity's famous "Preacher," Phillips Brooks. La Farge's Christ (also haloed) assumes the hieratic stance and gesture of blessing.[88] Sargent's Jesus, in a position spatially parallel to the Trinity chancel's preaching Christ (that is, on the east, facing west), offers, in terms of its specific iconography, a distinct alternative. In fact, Sargent's Jesus (completed and installed) would literally turn his back to both of Trinity's Christs; Sargent's Jesus would be neither Trinity's quintessential preacher nor its iconic and hieratic *Christ in Majesty.*

In contrast to representations of Christ preaching, the picture of *Christ's Sermon on the Mount* (a steel engraving by Henry Warren after John Rogers; fig. 95) in John Fleetwood's popular *Life of Christ* specifies in the accompanying text that it represents the opening verses of the Sermon on the Mount in the Matthean account: "And he opened his mouth and taught them." This, then, is Jesus the teacher. Anna Jameson's two-volume set on the iconography of religion in art (a set of books that Sargent owned) indicated Jameson's reading of Sermon's Jesus in her categorization of the image under the heading "Christ as Teacher."[89] Sargent's Jesus holds his right arm slightly raised, just below waist level, his hand with palm open toward the picture plane and the viewer; his left hand he rests gently (also palm open) on the head of a child. His stance is one of accessibility and vulnerability but also confidence and power. This Jesus is an approachable man of the people (he was Renan's "personification of the people"), speaking directly to each individual gathered here.[90] Like Sargent's depiction, Fleetwood's teaching Jesus composes the central figure with outstretched arms and with hands elevated only to the height of the waist.

Gesture alone, however, seems insufficient here as the determining mark of the teaching Christ by comparison with, for example, the preaching Christ. Preaching and teaching are two closely related activities from the perspective of Sermon on the Mount; in many cases, the difference seems a matter of degree rather than kind. But gesture, supported by the potentially leveling implications of the other variables elaborated here and augmented by the elements of Sargent's composition that belong to him alone, secures this identification. Sargent's Sermon on the Mount is, to my knowledge, a unique variation on the iconography of the subject. In composing this image, Sargent conflated the subject of Sermon on the Mount with that of Christ Blessing the Children. An iconography invented during the Protestant Reformation, Christ Blessing the Children had seen its most frequent use, beginning in the middle of the nineteenth century and continuing into the twentieth, in relation to religious education and Sunday schools.[91] The combination of Sermon and Christ Blessing allowed Sargent (from the perspective of composition and movement by visual relation) to place Sermon's Jesus, in physical contact with a child, directly below God (in *Israel and the Law*), in similar contact with a child. But, even considered as a combination of

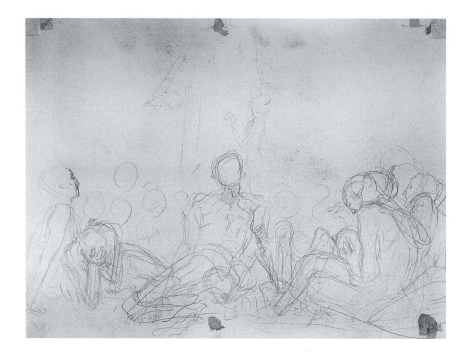

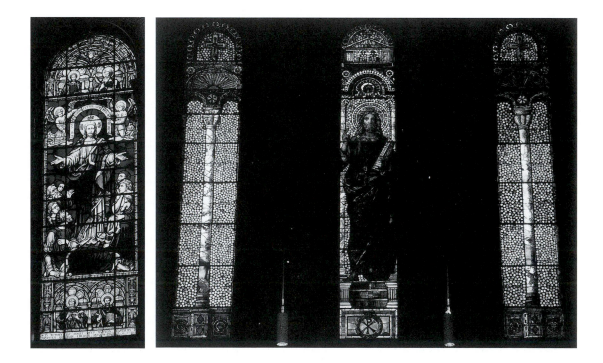

Fig. 92

Opposite, top: John Singer Sargent, *Preliminary Sketch for Sermon on the Mount,* verso. Graphite on cream wove paper, 10 x 13 in. (25.4 x 33 cm). Boston Public Library, Print Department, Gift of Miss Emily Sargent and Mrs. Francis Ormond. Trustees of the Boston Public Library

Fig. 93

Opposite, bottom left: Clayton and Bell, *Exhortation at the Feast of Tabernacles,* central chancel window, Trinity Church, Boston, installed 1877–78. Stained glass. Trinity Church, Boston

Fig. 94

Opposite, bottom right: John La Farge (American, 1835–1910), *Christ in Majesty,* west nave windows, Trinity Church, Boston, installed 1883. Stained glass. Trinity Church, Boston

Fig. 95

Above: Henry Warren after John Rogers, *Christ's Sermon on the Mount.* Steel engraving. From John Fleetwood, *Life of Christ,* part 5 (New York: Virtue and Yorston, [1861?]), frontispiece. American Antiquarian Society, Worcester, Massachusetts

the two iconographies (Sermon and Christ Blessing), Sargent's representation is a bit unusual.

In most conventional depictions of Christ Blessing (see, for example, figs. 96 and 97), multiple children appear (as in the scriptural texts in Matthew, Mark, and Luke), often with their mothers—and sometimes also with the rebuked disciples ("Suffer the children . . . and forbid them not . . .").[92] Christ's attention in these images, furthermore, is usually directed toward a child and/or a small group of children, and his hand (and this aspect *is* consistent with Sargent's representation) hovers over one child in a gesture of blessing or rests gently on his or her head (see Matthew 19:15a). There is another scriptural iconography (fig. 98) that includes Jesus and a child: the story of the dispute among the disciples about greatness in the kingdom. Here the child appears in a scene representing an educative function. In Matthew (18:1–6) these verses, in which Jesus teaches humility through a child, are located a chapter before the Blessing of the Children and ten chapters after the conclusion of Sermon on the Mount. Matthew's Jesus here addresses only his disciples, and the child becomes an object lesson, a demonstration that the world's measures of perfection (outward characteristics and wealth) do not constitute magnitude before God.[93] Sargent's sketch—with its one central child (though there appear to be others in the crowd), its gesture of tenderness toward the child, and its direction of Jesus' attention toward a multitude that likely includes but is by no means limited to mothers and disciples—accommodates aspects, then, of three different iconographies from Christian scripture. Despite this fact, however, the artist uniformly referred to the central panel as a representation of the Sermon on the Mount.

Granting Sermon on the Mount precedence over the other scriptural possibilities suggested by his sketch, Sargent essentially introduced the figure of a child into each of two well-established and often typologically paired iconographies, two iconographies that generally excluded children as principal figures: Sermon on the Mount and Moses Receiving the Law. Sargent altered Sermon on the Mount by its conflation with elements of both Christ Blessing the Children and the Lesson on Greatness; Moses Receiving the Law, in Sargent's rendition and by its alternate title, became Israel *Learning* the Law. We have already seen how Sargent removed Moses from the image of the Law (in the central east lunette) and Christ from *Judgment* (on the west) to locate the typological opposition between the two on the north and south walls instead. The effect of this extraction on the cycle's climax, however, depended on the fact that the process was also an additive one. On the east wall's central axis, the single most important feature of the iconography's modification was the introduction of the child. The child on the east carried the cycle's narrative thread. Specifically, the child accomplished two significant things for *Triumph of Religion*. First, it stood in as a fig-

ure of subjectivity (a topic already outlined in chapter 1 in terms of its significance for Sargent's *Triumph of Religion*), and, second, it participated in the library's sacralization of the intellectual activity of education (a subject taken up in chapter 4). The child's presence in *Triumph* thus focused the emphasis of the central images on both the spiritualized content of Jesus' teaching *and* on the idea of teaching and learning itself.

T. J. Jackson Lears connects the late-nineteenth-century popularity of the image of the child to a "liberal Protestant nostalgia for innocent sincerity and a primitivizing veneration for vitality [and immediacy] . . . the innocent child was a vision of psychic wholeness, a 'simple, genuine self' in a world where self-hood had become problematic and sincerity seemed obsolete."[94] G. Stanley Hall, educator and child study exponent as well as psychologist, expressed aspects of this "liberal Protestant nostalgia" in his conception of the childhood of the individual as a recapitulation of the "childhood of the race." He wrote in 1900: "These children feel and understand more than we are wont to think. Their nature is generic and universal. There is a sense in which growing to maturity is a limitation, and the 'shades of the prison house' restrict the all-sidedness of early years. The child lives nearer to and is a larger representative of the entire race than the man or woman, and of it can be said more truly than of the adult that nothing human is foreign to it."[95] When it concerned teaching the capacity for attending to what was "written on the heart," children did not suffer the "limitations" of maturity and might serve as signifiers of immediacy and subjective awareness.[96] Childlike sincerity and spontaneity offered an ideal and "spiritual" alternative to perceptions of adult artifice in the commercial and material world of a capitalist economy. In this context, the child represented, furthermore, a "secular cult of inner experience," a cult that placed its faith in the autonomy of the individual.[97]

Of particular interest in the privilege granted by Sargent's adoption of the figure of the child, Renan devoted several pages of *Life of Jesus* to a discussion of the child's significance in the liberated "pure religion" of Jesus. He wrote: "The infant religion was . . . in many respects a movement of women and children. These last formed about Jesus, as it were, a young guard in the inauguration of his innocent royalty. . . . It was childhood, indeed, in its divine spontaneity, in its innocent sparkles of joy, which was taking possession of the earth."[98] What is perhaps most striking about the pages in Renan that directly pertain to children is the fact that Renan brought together—and discussed seamlessly—the scriptural accounts of Christ Blessing the Children and of Jesus' insistence on the child as model for the practice of humility. Furthermore, he concluded his thoughts on this subject with his own modern interpolation of the Sermon on the Mount, a "subjective" Beatitude interiorized for his own time (and for Sargent's).[99]

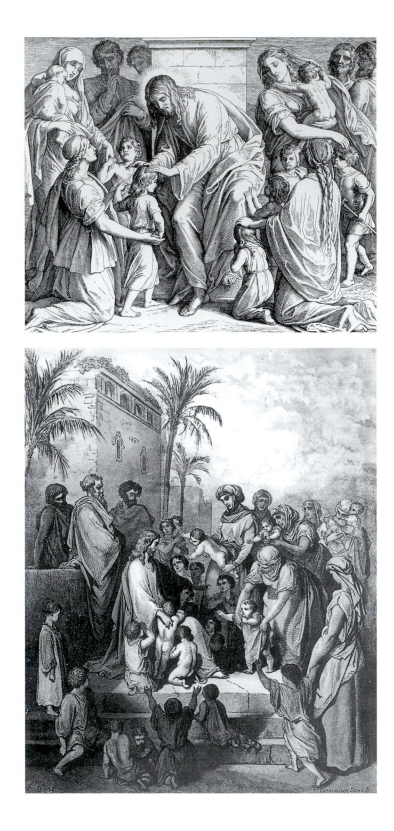

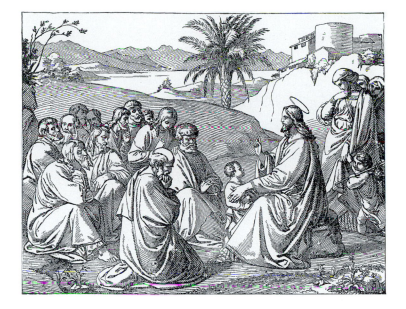

Fig. 96

Opposite, top: Julius Schnorr von Carolsfeld, *Christ Blessing the Children*. Wood engraving. From *Die Bibel in Bildern* (Leipzig: Georg Wigland Verlag, [1870?])

Fig. 97

Opposite, bottom: Gustave Doré, *Christ Blessing the Children*. Wood engraving. From *Bible Gallery* (London, Paris, and New York: Cassell, Petter, Galpin, and Company, 1880)

Fig. 98

Jesus Teaching Humility through a Child, 1846. Wood engraving. From *The New Testament: A Pictorial Archive from Nineteenth-Century Sources*, ed. Don Rice (New York: Dover Publications, 1986)

Sargent's *Triumph of Religion* ultimately represents a visual and conceptual pastiche of images and decorations, with the foundational motifs derived principally from the Vatican in Rome. The product approximated Walter Pater's notion of "ideas gathering themselves a visible presence out of historic fact."[100] This reworking of the old and invention of the new served to foreground both Sargent's celebration of "sacred" intellectual labor in the context of the library's mission and the contrast between historical varieties of religious expression and Sargent's version of subjective spirituality.

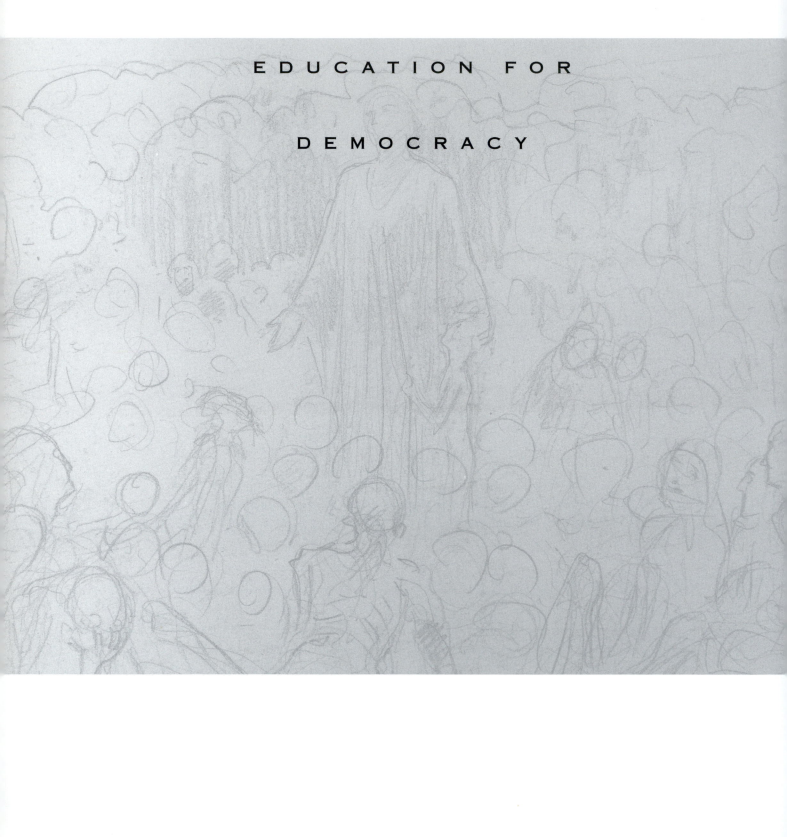

EDUCATION FOR

DEMOCRACY

⊕

[*Triumph of Religion*] is . . . an inspiration to all and particularly to the young, who, as they ascend the stairways to the halls of learning will reflect the brightness and glory of these idealistic paintings in the enthusiasm and achievement of their eager minds.

—"CHRISTIANITY IN MURAL DECORATIONS,"
 American Review of Reviews (1917)

*

What could the confluence of religion, education, and art mean at the Boston Public Library? Here a brief return to Sargent's literary sources provides useful context. Renan and, earlier, Voltaire explicitly connected to education as well as to individual discernment the sort of social, political, and ethical enlightenment they imagined as an essential characteristic of the ideal society. In some cases they seemed to view education and enlightenment as synonyms; ignorance was their polar opposite. What education then gained for society was the cultivation of individuals capable of a responsible and rational subjectivity. "Irrational" superstition and, for Voltaire, the fanaticism it produced, could be vanquished by knowledge, truth, enlightenment.[1] James George Frazer, furthermore, based the method of his voluminous *Golden Bough* on his own conviction that superstition (a quality he wished to study in "primitive" communities) and literacy were virtually incompatible. Education of the sort based on literacy was the requisite ingredient of social and cultural progress. In the preface to volume 1, part 1 (1890), of his *Golden Bough,* Frazer described relations among religion, literacy, and progress in a way that clarifies the advance of civilization as conceived in *Triumph.* Frazer maintained that he could study "primitive religion" in an "unevolved" state by simply looking to the "popular customs and superstitions" of a nonliterate "peasantry" in modern Europe:

For literature accelerates the advance of thought at a rate which leaves the slow progress of opinion by word of mouth at an immeasurable distance behind. Two or three generations of literature may do more to change thought than two to three thousand years of traditional life. But the mass of people who do not read books remain unaffected by the mental revolution wrought by literature; and so it has come about that in Europe at the present day the superstitious beliefs and practices which have been handed down by word of mouth are generally of a far more archaic type than the religion depicted in the most ancient literature.[2]

That Sargent granted credence to Frazer's popular argument is evident in the sources he explored, principally in Italy, Spain, and Switzerland, for the "primitive" images at the south end of the special collections gallery.[3] The movement from material to spiritual in *Triumph of Religion* is also a move from superstition to reason and from ignorance to enlightenment. In the context of the Boston Public Library as a whole, in fact (if not for Sargent in particular), the relationship of education and cultural enlightenment is the prior and generating theme—a theme made explicit in a wide scholarship on the evolution of religion and the progress of civilization at the time. For prominent liberal Protestants, like Henry Frederick Cope and Josiah Strong, education was the definitive mechanism of

progressive evolution. "Self-realization" rather than salvation was the goal toward which civilized society tended.[4]

Thus far in the pages of this book two closely related yet also distinct emphases have emerged with respect to *Triumph*'s focus. The first grants priority to the unmediated, subjective experience of the individual, and thus to the idea of insight or discernment based on an interior relation of the self to the divine or the self to the self. The second, and the subject to which this chapter turns, gives preference to the intellectual and scholarly activity deemed to provide the basis for such discernment, to prepare the individual, in modern democratic civilization at any rate, for the experience of insight: the activity, that is, of education.

While it is possible, and indeed necessary, to discuss these two emphases separately, at the library education and responsible subjective individualism of the sort Sargent recommended were inextricably bound together. An official 1914 report of the library's operation made this clear. Josiah Benton, president of the board of trustees from 1908 to 1917 (and a board member beginning in 1894), wrote:

In the aggregate of all its services, the Boston Public Library should be and I believe is a system of education for all and free to all.

The distinguishing characteristic of the education given by a public library is that it is not imposed upon the person who has it. The education of the schools is to a greater or less extent imposed upon those who receive it, and it is necessarily general in its character, without regard, to any great extent, to the individual needs of the persons who receive it. The schools must educate persons in classes and upon general lines of knowledge. The Library, however, educates only in response to individual wants and demands. Everything that is done by it is done in response to requests from individuals who ask for that which they each want most.[5]

One content of the library, then, very closely approximated changing nineteenth-century expectations of the ideal citizen: "exemplary members of democratic society [were] those who educate[d] themselves through individualized experience, which [was] different for each person but available to all."[6] The consumption and assimilation of knowledge, past and present, allowed the individual to act responsibly while acting freely. The spread of education was the basis for the advancement of civilization. Study produced discernment and dispelled ignorance. Education provided the key to inspired subjectivity. This constellation of ideas informed the enlightenment basis for liberal education in the United States.

SPACE FOR EDUCATION

That Sargent respected the educational aspects of the library's cultural content we have already seen in his own approach to and expectations for the project and in the particular aspect of the Jesus' life he would represent in Sermon on the Mount. For a nation many still judged wanting in the elevating knowledge of Europe's artistic treasures, Sargent's ambitious pastiche would literally bring cultural education to Boston. This use of the high artifacts of human history to suggest (if not establish) the emergent cultural eminence of the United States had strong American Renaissance antecedents by 1890—and was an approach fully endorsed and promoted by the library's architects and especially by Charles McKim.[7]

In *Triumph of Religion* Sargent indicated his commitment to the contemporary ideal of education in multiple ways: style, narrative flow, selection and manipulation of sources. Most dramatically, however, his contrivance of space in the special collections gallery and his specific conception of his cycle's keynote illuminated this content. The visual emphasis in Sargent Hall on the panel that would accommodate Sermon on the Mount, in fact, did more than establish that painting as the narrative "end" of the story Sargent wished to tell. The content and design of *Triumph of Religion* depended upon Sargent's deliberate reorientation, along the building's principal east-west axis, of the third-floor Special Collections Hall. Critics who knew the artist well later speculated that he might have selected this room for his design precisely because of its barrel-vaulted evocation of traditional spaces of Christian worship. Sylvester Baxter was among those who commented: "In its dimensions, long, narrow, and with a barrel-arched ceiling, the hall resembles one of the superbly decorated chapels often to be seen in European churches and palaces."[8] Sargent had enhanced this resemblance to a chapel by locating *Dogma* (fig. 46) on the south wall at the top of the stairs; thus the first aspect that greeted most visitors was *Dogma*'s high-relief gilt Crucifix with all its associations with ornate Byzantine and medieval altar walls.

In his conception and design of *Triumph* as a whole, however, the artist wrenched the room off the long north-south axis and redirected the beholder to the east. In other words, Sargent remade his chapel as something else: he converted it into a space with a different experiential and semiotic potential and a different set of historical and material referents.[9] In terms of one familiar architectural vocabulary regarding such long (or broad) rectangular spaces, he recast his church for secular audiences: instead of a church he designed a schoolroom or lecture hall. The proper "forward" orientation of the body would now require the beholder to face the wide east wall across the short dimension of the room rather than the comparatively narrow south wall across the long one. As Kenyon

Cox acknowledged, Raphael's triumphant *Disputa* had "transform[ed] the flat wall of the [Stanza della Segnatura] into the apse of a Cathedral."[10] Sargent's *Triumph*, conversely, remade a "sacred" shape to emphasize an educational rather than a devotional or sacramental content. Like other lecture halls, this was "public" space, a space to which many (regardless of specific religious affiliation) had access. While Sargent's message was essentially a lesson in religious and intellectual privacy—a fully human Jesus modeling an interior form of "spirituality"— Sermon on the Mount's Jesus represented, like Jehovah above him, the ideal teacher, the teacher who was himself the message.

Along the principal east-west axis of the building, then, the library's educative function (explicitly announced in the sculptural decoration and inscriptions surrounding the main entrance) and the artist's bid for intellectual respectability literally converged in a painting that represented Jesus in the role of teacher at the front of a schoolroom. In addition to the liberal Protestant connections of the biblical iconography with religious subjectivity, for this same group and on the strength of its opening verses in the longer and preferred Matthean version ("And he opened his mouth and taught them . . ."), Sermon on the Mount had long been associated with education. This was a "secular" function that the library not only endorsed but fully shared and publicly proclaimed. The city's residents did not require the substantial official literature to identify the library as an "educational institution"; the architecture itself incorporated the message.[11] The large inscription on the principal façade advertised the building's dedication to the "Advancement of Learning." One entered through the main doors, flanked by the sculptural figures of Science and Art and passing beneath the bust of Minerva, mounted above the central outer door. The center pair of the six-paneled bronze vestibule doors (by Daniel Chester French) depicted personifications of Knowledge and Wisdom. The lateral alignment of Sermon, on a wall directly above the building's main entrance and set back across the symbolic space of Bates Hall from it, the central figure of Jesus "in line" with the entryway's scripting of the library's educational commitments, would underscore the significance of this orientation.

As representations of teaching and learning, the two paintings that would occupy the central axis on the east wall of Sargent Hall (*Israel and the Law* and Sermon on the Mount) thus participated in the sacralization of education. The public library was also the public school or lecture hall, endowed, as another of its three façade inscriptions announced, "for the Education of the People." Edwin Blashfield claimed that the strongest appeal that could be made for "public and municipal art" (and he felt this was a compelling claim indeed) was its role as a "public and municipal educator." "All over the antique and medieval world," the artist had been a "schoolmaster," and "his school . . . the public building." Ex-

plicitly identifying "the decorated building as a teacher," Blashfield made the new ornamented structures of the American Mural Movement literally personify the linkage he sought between public art and public education.[12] The architects and artists who worked on the Boston Public Library would use the "voice of art" to "reinforce" the "voice of books" in pursuit of educational goals.[13]

LIGHT AND CULTURAL ENLIGHTENMENT

This educational content the building's architects and the artists they employed would emphasize through the use of light in the building and a metaphorical as well as practical association between light and mental and spiritual enlightenment. This was certainly the case along the main east-west axis of entry where the building's fenestration and electrical fixtures controlled and modulated the amount of light in relation to its symbolic source in the knowledge available to all in Bates Hall—and to a presumably smaller self-selected group of students and scholars in the special collections rooms above the great reading room. As Thomas Fox had maintained, and as the material evidence testifies, Sargent was fully aware of the artistic and symbolic potential of light in the special collections gallery. Here the artist carefully reserved the most fully illuminated panel of the room for his keynote image. He also respected the panel's organizational relation to Puvis's representation of the "messenger," or spirit, of enlightenment immediately below (see fig. 42). The mental and spiritual illumination of great books and great art (what library critic T. R. Sullivan called the building's "true light"), then, charted the ascent from the Dartmouth Street entrance to the third-floor gallery and *Triumph of Religion*.

Oliver Wendell Holmes left no doubt about Boston's appreciation of light's significance. "Let in the light!" he urged three times (two of them as quoted here) in the poem he wrote—and read—for the November 1888 exercises at New Old South Church officially celebrating the ceremonial laying of the library's cornerstone:

> Let in the light! from every age
> Some gleams of garnered wisdom pour,
> And, fixed on thought's electric page,
> Wait all their radiance to restore.
> Let in the light! on diamond mines
> Their gems invite the hand that delves,—
> So learning's treasured jewels shine,
> Ranged on the alcove's ordered shelves.

Holmes's poem in its entirety established, further, the secular sacrality of Boston as liberty's "virgin home," its "Bethlehem" cradle, and the Boston Public Library as a source of knowledge necessary to liberty's perpetuation. Education's "holy" democratic privilege sanctified the library's premises:

These chosen precincts, set apart
 For learned toil and holy shrines,
Yield willing homes to every art
 That trains or strengthens or refines.

Finally, as is already apparent in the "refinement" elevated in the immediately preceding quotations, Holmes also suggested the relation of this particular notion of enlightenment to class and culture:

Beyond the ever-open gate
 No pikes shall fence a crumbling throne,
No lackeys cringe, no courtiers wait,—
 This palace is the people's own![14]

Historians of class and social structure generally agree that "culture" as well as economics, and to an unusual degree, informed the conscious self-understanding of Boston's upper class. Late in the nineteenth century, in response to both immigrant and newly rich rivals for economic and political power, this elite had cast its lot with culture, endorsing the popular characterization of Boston as representative of intellectual pursuits by comparison with the vitality of New York's now uncontested commercial leadership.[15] Largely on the strength of Boston's libraries, schools, and museums, *King's Handbook* of 1881 proclaimed the metropolis a cultural and educational leader and exemplar, the "most desirable centre in the American continent for the scholar and the student."[16] Social and economic historian Ronald Story emphasizes the "singular cultural sheen" that was understood to distinguish Boston from New York or Philadelphia.[17] "Culture" for this group and time had a rather specific content, referring to a "particular part of the heritage of the European past, including polite manners, respect for traditional learning, appreciation of the arts." Culture, thus defined and according to its enthusiastic promoters, was a necessary component of democracy and was available to anyone who would work and study to acquire it. So, on the ground of education was this battle joined.[18] The "light" in the library's motto, "The Light of All Citizens," and in Holmes's poem too, was not simply a warm and passive glow but an active force: enlightenment.[19] In the sacralizing rhetoric of high culture at the time, and from the perspective of

Boston's cultured elite, mental illumination was sacred, in fact, precisely because it would "train" and "strengthen" and "refine."

Sometime around the years of the Civil War, the term "Brahmin" entered the lexicon as a synonym for prominent, generally highly educated Bostonians. By 1870, Ronald Story suggests, the word "meant the rich and well-born as well as the cultivated; was used interchangeably with 'upper class'; and was a sign, accordingly, of distinctiveness as well as attainment, the achievement of a degree of security, cultivation, and arrogance that struck observers as noteworthy if not unique."[20] A combination of wealth and culture exemplified this class, and it was through the coalescence of the two that the social constellation exerted its influence. By the late nineteenth century, in part because of the shared sense that the commercial world now revolved around New York, the reputation of Boston's upper class was "essentially cultural"; the city's cultural institutions, furthermore (Harvard University, the Lowell Institute, the Boston Athenaeum, the Massachusetts Historical Society, and the American Academy of Arts and Sciences—and, somewhat later, the Museum of Fine Arts and the Boston Symphony Orchestra), played a significant role as "agents of class development or class maintenance."[21] During the post–Civil War decades, Paul DiMaggio argues,

The distinction between high and popular culture advanced further and faster in Boston than in any of its sister cities. . . . Threatened from without by upstate populists who sought to wrest control of Harvard and other patrician institutions, and from within, so they thought, by Irish immigrants and urban disorder . . . [Boston's elite] created institutions that would give life to the classification high/popular. The process took forty years, beginning with the creation of stable nonprofit institutions (above all the Museum of Fine Art and the Boston Symphony Orchestra) and culminating in purges of "impure" art from the museum's collection and the orchestra's repertoire and in the construction of ritual and organizational boundaries separating artist from audience, culture from commerce, the tasteful from the tasteless.[22]

The question, then, of who would define and "own" American "culture" was a matter of some consequence, and various groups in Boston in the 1890s conducted cultural skirmishes not unlike those of the so-called culture wars of the 1990s.

In her excellent history of the Carnegie libraries, Abigail Van Slyck has pointed out the consistent "tension between the [Boston] library's public function and its role in preserving an elite view of culture."[23] The institution's urban geography expressed this tension. Between 1895 and 1920 Copley Square was the new cultural center of the residential enclave in recently reclaimed Back Bay.[24] Here Boston's upper class consolidated cultural heritage and authority just as their political and economic privileges were slipping away, challenged by large-

scale immigration and the increasing ethnic and religious pluralism of the city.[25] Zoning barriers and building codes restricted many kinds of access and ensured relative homogeneity; Back Bay, claims Whitehill, "developed in splendid isolation."[26] Of all Copley Square's cultural institutions, the Boston Public Library was the place most explicitly scripted as "Free to All"—open, presumably, to Harvard scholar and newly arrived immigrant alike. Beneath the cornice line of the building, the Dartmouth Street inscription read: "The Public Library of the City of Boston Built By the People and Dedicated to the Advancement of Learning." The Boylston Street inscription, however, rather more cautiously announced: "The Commonwealth Requires the Education of the People as the Safeguard of Order and Liberty."[27] Despite, or perhaps in part because of, its commitments to public education, the library, in its controlled and strongly class-differentiated Back Bay location, represented carefully contained meanings regarding the constituents of *real* culture.[28]

EDUCATION AND LIMINALITY

The consideration of class and culture in relation to education brings us back to the subject of ritual functioning in relation to the Boston Public Library. Both those who funded Sargent's second contract at the library (the 1895 subscription list reads like a who's who of cultured Boston) *and* those who came to see the murals associated the images with a set of expectations shaped by their sense of the murals' institutional home.[29] An essential, perhaps paramount, aspect of the library's significance concerned education. And education, especially in a period of social upheaval characterized by high levels of immigration, accrued to itself a ritual content derived from its association with liminal experience (sacred and secular). The sort of enlightenment that the library made its business described and assumed a process of change in those who came to read and study. The Boston Public Library, and Sargent Hall in particular, generated a set of social rituals, then, not merely in their architectural and artistic orchestration as privileged spaces apart (chapter 2), but also in their cultural identification as liminal space, as space in which transformation in the status of individuals was presumed to occur.[30] Sargent gave the prophet Daniel a transitive position in his *Frieze of Prophets* (between Elijah and Ezekiel). In the descriptive text that would accompany its reproductions of *Frieze,* a contemporary Boston-area picture company provided its sense of Daniel's social liminality: "Next in the Frieze stands Daniel, who rose from a slave to the ruler of a kingdom by his own wisdom and goodness. Inscribed in Hebrew, on the parchment which he carries, are the words, 'They that be wise shall shine.' "[31] From this perspective, the liminality of educa-

tion resided in its characterization as the ideal means of transcending class (and "foreign" nationality) at a time in Boston when the city's Brahmin elite privileged "spiritual" culture and intellect over "material" commerce as a demonstration of accomplishment. Cultural historian Jonathan Freedman writes: "Instruction in the touchstones of Western civilization—classical music, literature, high art, with their ostensibly universal subjects and timeless significance—was seen by those in power as a means of keeping social order, and by those aspiring to power as a means of achieving middle class security."[32] Cultural and intellectual Boston was spiritual Boston—and the local significance, in just these terms, of the New England metropolis was the subject of contemporary fiction and nonfiction alike.[33]

The benefits of culture were not automatic but required the conscious effort of study and appropriate comportment; as Abbey suggested in his mural cycle for the Delivery Room, culture was a quest to be achieved. Its acquisition marked a sort of rite of passage in the individual.[34] The power of literacy in the United States to signify the most basic level of competence was demonstrated, over the course of the nineteenth century, in the rhetoric of New England–generated Protestant literacy campaigns and the more broadly public literacy campaigns that followed.[35] The degree and kind of liminality associated with education, and especially cultural education, furthermore, had much to do with class. While the student and the scholar represented major constituencies for the library, its "primary purpose" was to "give the use of good books and other educational library materials to persons who might not otherwise enjoy such use."[36] In this context, the library ostensibly and self-consciously offered the same resources to everyone (serving the monolithic "people" of the façade inscription). In practice, however, the institution made different things available to different people and expected different outcomes of them. The library's message for the individual patron differed depending on the patron's relation to high culture. For those who had already achieved it, their familiarity with the library's treasures of art and culture bestowed approval on their valuable acquisition; for those still on the way, the puzzle of the unfamiliar text, the unrecognized object or item, set out the challenge and recommended the individual effort necessary to acquisition.

The library's cultural narratives thus reiterated and reinforced the social and semiotic position of upper-class Boston, suggesting that a kind of benevolent stasis rather than active movement would assure that elite individuals maintained the position they had already achieved. The gradual refinement understood as appropriate to middle-class Americans of the third and fourth generation stood in some degree of contrast to the Brahmin establishment. But both upper-class maintenance and middle-class refinement exhibited the highest level of contrast with the rapid and more complete transformation (or "Americanization") ex-

pected of the working-class immigrant. As early as 1852 Boston library records specified concern for the "influx of ignorance" attending immigration and its "remedy" in education: "The founders of our Republic have left on record their testimony that the perpetuity of our institutions depends upon the intelligence of the people."[37] Democracy required not just an educated upper class, but the informed citizenship of the population as a whole. The terms of education's content would be set by the prevailing understanding of culture and its acquisition.

SARGENT, CLASS, AND BOSTON BRAHMINISM

Despite claims that the crowds on opening day (estimates placed the numbers at around ten thousand) "were of all races, and creeds, and conditions," the definition of democracy that pertained most directly to the Boston Public Library was related first to class and culture and then, secondarily and more abstractly, to race and religion. The library as the place where "prince and pauper met on common ground" was the library Boston imagined it now possessed.[38] It was the range of occupations represented that interested both the library's amateur statisticians and the local newspapers: "Nothing is too good for the people when the people wish to read in Boston; the mason, the minister, the milliner and the millionaire, the lawyer and the laborer, the artist and the anglo-maniac, clubmen and carmen are all of the people as they move before the thrones of Bates Hall or the delivery desk."[39] The pairing of the artist and the "anglo-maniac" in this newspaper item is a telling detail—especially since this is the only couplet that does not represent an obvious economic and social opposition—and the only one that introduces the contemporary politics of nationality and race. Both Ronald Story and T. J. Jackson Lears have documented the anglomania of cultured ("artistic") Boston.[40] Henry James apparently believed distinctions between England and the United States were so inconsequential that the two amounted to a "big Anglo-Saxon total."[41] This disposition may have contributed to the elite's open welcome of Sargent who was, despite his French training, an "American" artist coming to them from London.

When Sargent accepted the commission for the Boston Public Library murals, he had recently established a solid patronage base in Boston and he enjoyed the company, in Europe and the United States, of numerous Bostonians. From the perspective of many in Brahmin Boston, in fact, Sargent would have been one of their own, and the "true" spirituality of the completed *Triumph* (modern, democratic, individualistic, voluntary, privatizing, subjective) would not be "other" but "us."[42] Historian of Boston class and culture E. Digby Baltzell has fixed the artist Sargent in relation to a distinguished New England genealogy

("the Sargent's . . . were surely one of the most distinguished Brahmin families, with ten members in the DAB").[43] In the social clubs he frequented and in his connections to Harvard University (where he received an honorary degree, painted two university presidents, produced a set of murals for the Widener Memorial Library, and sustained friendships with faculty and alumni), Sargent strengthened his Brahmin ties.[44] And the artist's repeated references to his own "New England conscience" suggest that he thought of Boston, at least tangentially and historically, as part of his own family's cultural and religious economy. This expression ("my New England conscience," by which he meant his own recourse to internalized moral restraint) appeared most frequently during the war years, when it stood in for the sense of responsibility he felt for family and to country.[45] Decades later, Sargent's nephew Guillaume Francis Ormond wrote that his uncle "had a great feeling for the family and indeed within the last years of his life, commissioned his cousins, Winthrop and Charles Sprague Sargent to provide him with a genealogy of his forbears."[46] The amount of time Sargent spent in Boston, accumulating over his adult life at least eight full years in residence, with the longest stays during his later years, led some journalists to refer to his "return" to "his ancestral New England" and to claim him as a "Bostonian."[47] Sargent, of course, was not a Bostonian, but he did not dispute the label—and his letters reveal an increasing attachment to the city.[48]

The artist's biographical and cultural genealogy was consistent with Sargent's characterization as a Massachusetts "Puritan." As his friend and early biographer Evan Charteris contended: "It is . . . to a Puritan stock that John Sargent traces his origin, to a family which, when the call came 'for the church to fly into the wilderness,' joined those devout and ardent spirits, who, with John Winthrop at their head, migrated to the colony of Massachusetts in order to practice with greater freedom the austerities of their religion. . . . The ancestry of John Sargent had been domiciled in America on the paternal side since 1630, and on his mother's side since 1730—the one originating in Devonshire, the other in Yorkshire."[49]

Acknowledging Sargent's familial Boston connections, Vernon Lee observed a kind of duplexity (a "double nature") in the artist's character. For Lee, this double nature was rooted in his father's "Puritanism" (the presumed source of what Sargent called his "New England conscience") and his mother's expressive spontaneity. Taken together, and when "harmoniously blended" rather than "self-conflicting," these produced an artist of both "supreme facility and of restless, indomitable passion for the difficult."[50] It was Sargent's Puritanism, Lee maintained, that led him to accept the challenging public library commission in the first place.[51] Lee's understanding of "Puritan," a definition already developed before she applied the word in print to Sargent, is especially revealing in relation

to the content of *Triumph of Religion*. For Lee there was a "bad" Puritanism and a "good" Puritanism—the former, obviously, to be rejected, the latter embraced, the former a set of externally administered "tables of permissions and prohibitions," the latter a practice of habits of good so internalized as to constitute "subjective" response, rendering external codes both unnecessary and irrelevant. According to Lee: "The splendid work of Puritanism is the training, nay, the conception, of real individuality, the habit of self-dominion, of postponing, foregoing the immediate, momentary and temporal for the sake of the distant, permanent, and, inasmuch as intellectually recognised, spiritual something. . . . If individualism is to triumph . . . it will be by an increase rather than a diminution of the healthy Puritan element. It is, after all, the Puritans in temper who have done all successful rebellion against items of Puritan codes."[52]

This "advanced" "Puritan" internalization and interiorization of ethics closely approximated Sargent's interpretation of Sermon on the Mount with its recommendation of the Law "written on the heart" rather than on tablets of stone.[53] If we accept Baltzell's characterization of early-twentieth-century Bostonian high culture as a kind of "secular puritanism," then perhaps the special collections gallery, with the spatial reorientation the artist specified (and in contrast to the Catholic chapel that the room's shape initially suggested), was Puritan meeting house as well as lecture hall. Though there is no evidence to suggest what Sargent would have known of early New England meeting houses, the possibility that he considered the Protestant Reformation in direct relation to his Sermon on the Mount was suggested by George Santayana (see chapter 1). Associations (on the artist's or viewer's part) with these mixed-use Protestant structures could have served the negation of ecclesial hierarchy and reinforced the notion of unmediated teaching and learning of a "sacred" message. Interestingly, Sargent's library decoration coincided with a revival, in late-nineteenth-century liberal Protestant architecture, of more integrated multiuse spaces. The auditorium-style church (a variation of which was erected in Back Bay in 1895, with a 1906 extension, as the Christian Science "Mother Church"), combined educational, religious, and performative functions: it was assembly room, theater, and lecture hall as well as church.[54]

CULTURE, CLASS, AND THE BOSTON LIBRARY

The institutional history of the Boston Public Library suggests that from its very beginnings it had been an institution that represented both popular and elitist impulses. The institution (not the building) had been conceived at midcentury in the midst of struggle over the very idea of a free circulating *public* library in contrast to the private "gentlemen's" establishment of the Boston Athenaeum with

its hereditary shares passed on from generation to generation.[55] The failure of George Ticknor's repeated attempts to convince the privately endowed Athenaeum (of which he was also a proprietor) to unite with the city in the foundation of a public library finally led to a plan endorsed by Ticknor and by Unitarian minister, scholar, and statesman Edward Everett. Ticknor was certainly one of Boston's elite citizens and he moved comfortably among the city's "aristocracy," but he also insisted that the opportunity to read "ought to be furnished to all, as a matter of public policy and duty, on the same principle that we furnish free education, and in fact, as a part, and a most important part, of the education of all."[56] This rhetorical linking of education and democracy formed a fundamental aspect of the library's intra-institutional image and conception. As Holmes's poem had asked, "Can freedom breathe if ignorance reign?"

Diverse expectations about the relation of this public institution to class in Boston came to the fore in the controversy surrounding the library's opening reception, essentially a party given by McKim, Mead and White for Sargent and Abbey at the time of the unveiling of the works installed in 1895. One partygoer recorded the festivities in his journal; his words suggest both his own class-based expectations concerning the library's use and his reading of Sargent Hall in relationship to enlightenment:

April 25. The architects, McKim, Mead and White, gave a reception this evening in their beautiful public Library to Abbey and Sargent, the painters, whose decorative work was unveiled for the first time. There were two hundred guests, men and women, forty of whom came over from New York for the night. It was a splendid affair of brilliant jewels and costumes which can never be repeated, for the building now becomes the People's Palace, making further fashionable exclusion there impossible. An orchestra played on the landing of the marble staircase, up and down which the pretty women strolled in all their glory of satin, lace, and diamonds. It happened to be a very warm night, and through the open windows of the court the fountain flashed and sparkled, throwing its tallest jet almost to the roof. The Abbey and Sargent pictures overwhelmed us all. . . Sargent chose for his subject "The World's Religions," [*sic*] and has put up one niched end of the Hall leading to the Special Libraries. . . . The scheme is tremendously ambitious, and to be understood must be studied carefully. It is a powerful and most original work, which will hold its own with any decorative masterpiece of modern times. The prophets are superb figures. . . . The group on the left despairs; that on the right looks toward the light with outstretched arms.[57]

Two Boston newspapers (the *Traveler* and the *Journal*) immediately voiced their objections to the use of a public building for a private party characterized by "fashionable exclusion."[58] The ensuing debate, the latest in a long string of wran-

glings over the library's mission and organization, in relation to class in particular, led director Samuel Abbott to resign his position in disgust.[59] This tension, implicit in the inscriptions on the building itself, was everywhere evident in contemporary descriptions of the library. Celebrating, on the one hand, the fact that "Boston has always been in the van[guard] in the matter of free libraries, and was the first city in the world to permit the free taking home of books," a journalist added, several sentences later, that the "range and scope of the Boston Library go very much beyond the gratuitous circulation of literature. They aim at the general culture of the people, and the raising of the standard of artistic feeling of the entire town." This "fine" institution, this "refining influence," would be "signal proof to all the world that democratic and iconoclastic are not convertible expressions."[60] The degree to which the library's perceived role in enforcing particular standards of genteel behavior (as well as cultural values and ideals) entered the consciousness of the time is apparent in the patronizing tone of the *Evening Transcript* journalist who wrote this often repeated anecdote on the subject, celebrating the library's potential to transform the manners (and grammar) of the working class:

A striking example of the effect of environment was noted in the new library this morning. A reader, seeking the registration room, asked one of the stately policemen adorning opening day, "Which way shall I go to the desk where we are to take out books?" He replied affably, "I ain't had no instructions yet." Then the academic atmosphere of the place swept over his spirit and he stood corrected before himself. "I haven't had no instructions yet," he called softly after the vanishing reader, with an accent of exquisite content. It was testimony to the influence of the library which words cannot express.[61]

The Boston Public Library, according to Henry James, was entirely too "Free to All." This democratic openness had produced an architectural organization not suited to serious study. The library needed more remote spaces in which the scholar could find privacy and quiet. The provision in a library's interior for an adequate number of such rooms, rooms that James called "penetralia," was a critical indicator of the building's status as a "great library." From James's perspective, the Boston library did not make the cut. This library without "penetralia" was like a "temple without altars." James was concerned as well with the democratic spirit of the place with respect to age and maturity. The Children's Room (in the building's plan and for many years after its opening) was located near Bates Hall; James found the energetic presence of children unsettling. The whole place struck him as a "railway-station" and he despaired of the "vain quest" for the "deeper depths aforesaid, some part should be sufficiently *within* some other part, sufficiently withdrawn and consecrated, not to constitute a thoroughfare."[62]

EDUCATION AND IMMIGRATION

In a November 1895 article on the library's "Ideals and Working Conditions," Lindsay Swift, a longtime employee of the library, worried in print about the public implications of a closed stack system and the potentially conflicting needs of the scholar, the general reader, and the spectator. In an open letter published five months earlier he had made clear his commitment to a library "frequented by all classes of citizens."[63] In November Swift was most concerned, however, about the potentially deleterious effects of immigration on the operation of the library. His anxieties were directly related to the increasing heterogeneity of Boston. He wrote: "This library is in good faith administered for the people. Freedom of access to its treasures is granted to a degree which has excited the fears of those who predict the necessity, in the near future, of a circumspection and restriction approaching in severity to that of European libraries. Pressure of a population fast passing from the homogeneity of an earlier American type may ultimately render it imperative that the library, except in the case of the most usual and inexpensive books, shall cease to be a medium of distributing literature among the homes of Boston."[64]

While some worried that a new and heterogeneous body of patrons would tax the library's services by increasing the numbers of lost and stolen volumes, others calculated the need for additional resources in more positive ways. Writing in 1905, librarian Horace Wadlin presented a series of compelling arguments for retaining and augmenting foreign language materials. His arguments related not to the needs of scholars but to the civic responsibilities of the library with respect to a large immigrant population:

It is comparatively easy to attract the children of foreign-born parents, and to lead them by progressive stages into the world of English literature, particularly since the elementary schools are also opening the way; but many of the adults never master the new language so as to read it easily. If the Public Library is to serve all classes, these must not be overlooked. Another phase of this demand is reflected in the remark of a young Bulgarian to the custodian of one of our reading rooms: "I read French and German and am learning English; but unless I can read a Bulgarian book once in a while, I forget my native tongue." . . . There is a duty resting upon us of extending the influence of the library, as a civic institution, toward enlarging the life and broadening the intellectual outlook of those who have recently entered the ranks of American citizenship without preliminary training in the English tongue.[65]

Though Swift, James, and Wadlin differed in emphasis, for all three notions of the library's appropriate function and use were complicated by recent patterns of immigration, largely composed, it seemed, of "foreigners" of working-class or

poor backgrounds. For these three men and many of their contemporaries, not only were public libraries explicitly linked to education, but education and its attendant secularized version of liminality were explicitly connected with immigration. This was especially clear in the common and generally positive conception (among both native and foreign-born residents) of public libraries and public schools as agents of assimilation.[66]

Education and immigration maintained legislative connections as well as ritualistic and symbolic ones. It was precisely in response to increasing numbers of immigrants and changing patterns of immigration that compulsory education laws were enacted in the post–Civil War years. Between 1880 and 1920 "Americanism" entered the literature as a subject of critical educational importance. Contemporary rhetoric linked "Americanism" and democracy as sacred constituents of the nation's culture. In 1909, in the thirty-seven largest urban centers in the United States, 57.8 percent of public school children had foreign-born parents. Educators, politicians, journalists, and social observers charged the public schools with "Americanizing" this population.[67] In an article on the city of New York, published in *Century Magazine* in 1897, Mariana Griswold Van Rensselaer (who also wrote on Sargent's art) had this to say about the city's schools:

If one takes any interest in the future of our extraordinary town, none of its places should be thought more interesting than its public schools. . . . Whatever else may be well or ill taught in these schools, they are fruitful and potent nurseries of Americanism. The good they do in this direction far outranks all that can be done by all other agencies and influences put together. . . . Inevitably, by gathering all kinds of children together, the public school teaches that all men are brothers under our flag; and deliberately it teaches reverence for that flag. Unconsciously it breaks down the barriers which separate race from race, and so quickly that little children speak fluent English, and broken German or Italian, whose parents cannot speak English at all; and consciously it teaches a new patriotism to these children whom our census calls foreigners. As a result the foreign child is apt to be more American—more keenly aware and more proud of the fact—than most of those who can trace their Americanism for generations.[68]

Of those quoted in the pages of this book, Van Rensselaer states most explicitly her expectations regarding the liminality of education and its ability to transform experience and identity, to function, in the terms of the time, as a "melting pot." The conceptual and legal connection among libraries, education, and immigration was expanded in 1917 when Congress (over President Woodrow Wilson's veto) made literacy the test for admission to the United States (see fig. 99).[69] Especially in a culture obsessed with "Americanizing" large numbers of recent immigrants, the sacralization of education and intellectual en-

Fig. 99

Raymond O. Evans, *The Americanese Wall*. From Puck 79 (25 March 1916). Library of Congress, Washington, D.C.

deavor was enhanced by the conviction of education as a transformative or limi- nal experience. This was, incidentally, the content represented in a large, three- panel sequence of murals exhibited at the Boston Art Club at Newberry and Dartmouth, one block from the library and in Sargent's own Copley Plaza neigh- borhood. The Boston Art Club displayed the paintings in 1918, 1919, and 1920, as Boston artist Vesper Lincoln George completed each of the three and before he installed them in the Ohio public high school (see chapter 7 and fig. 154) for which they were commissioned. In service of cultural and economic assimilation, education would "Americanize" immigrants who, upon arrival in America (in George's version), laid their own substantial cultural gifts at her feet. In the first panel, *The Melting Pot,* George took his central motif of a personified America and three immigrant gift givers from old master compositions of the Adoration of the Magi. The *Evening Transcript* reported: "Chronologically as planned by the artist, the arrangement is as follows: 1. 'The Melting Pot.' 2. 'The Apotheosis of Education.' 3. 'Progress and Prosperity.' Thus the series illustrates in proper se- quence the coming of the immigrants to America, their gradual Americanization through education, and the beneficial social results of sane education."[70]

Through the first quarter of the twentieth century at least, the upper ad- ministration of the Boston Public Library continued to rest primarily in the hands of the cultured elite, with its day-to-day operations overseen by a similarly educated managerial-professional group. The library's actual patronage was largely middle

class.[71] But its "ideal" public included the new immigrant as well as the (well-behaved and quiet) child and the student. Mary Antin's autobiographical *Promised Land* (1912) enshrined the Boston library and the public school as the two acculturating havens of her childhood as a Russian Jewish immigrant in the New England metropolis. Each day after school Antin would go to the Boston Public Library. She described these visits in a chapter titled "A Kingdom in the Slums":

It was my habit to go very slowly up the low, broad steps to the palace entrance, pleasing my eye with the majestic lines of the building, and lingering to read again the carved inscriptions: *Public Library—Built by the People—Free to All.*

Did I not say it was my palace? Mine, because I was a citizen; mine, though I was born an alien; mine, though I lived on Dover Street. My palace—*mine!*

I loved to lean against a pillar in the entrance hall, watching the people go in and out. Groups of children hushed their chatter at the entrance, and skipped, whispering and giggling in their fists, up the grand stairway, patting the great stone lions at the top, with an eye on the aged policeman down below. Spectacled scholars came slowly down the stairs, loaded with books, heedless of the lofty arches that echoed their steps. Visitors from out of town lingered long in the entrance hall, studying the inscriptions and symbols on the marble floor. And I loved to stand in the midst of all this, and remind myself that I was there, that I had a right to be there, that I was at home there. All these eager children, all these fine-browed women, all these scholars going home to write learned books—I and they had this glorious thing in common, this noble treasure house of learning. It was wonderful to say, *This is mine;* it was thrilling to say, *This is ours.*

I visited every part of the building that was open to the public. I spent rapt hours studying the Abbey pictures. I repeated to myself lines from Tennyson's poem before the glowing scenes of the Holy Grail. Before the "prophets" in the gallery above I was mute, but echoes of the Hebrew Psalms I had long forgotten throbbed somewhere in the depths of my consciousness. . . .

Bates Hall was the place where I spent my longest hours in the library. I chose a seat far at one end, so that looking up from my books I would get the full effect of the vast reading-room. I felt the grand spaces under the soaring arches as a personal attribute of my being.

The courtyard was my sky-roofed chamber of dreams. . . . Here was where I liked to remind myself of Polotzk. . . . That I who was born in the prison of the Pale should roam at will in the land of freedom was a marvel that it did me good to realize. . . . That an outcast should become a privileged citizen, that a beggar should dwell in a palace—this was a romance more thrilling than poet had ever sung.[72]

Even contemporary reviewers scrambled to acknowledge that Antin's experience could not be expected to be "typical." Nevertheless, it did chart reassuringly the

main components of the prevailing ritual ideal (and some of the reality) of public schools and public libraries.[73] And it located the paintings in Sargent Hall in relation to the rhetoric of education for democracy.

As both Mary Antin and Henry James indicated, it was, in fact, the very strength of the rhetorical understanding of the Boston Public Library *as* a quintessentially democratic institution that thrust it into the midst of these debates about the gap between its real and ideal clientele in the first place. The popular and elitist versions of the library's purpose existed side by side; the one impulse did not cancel out the other, and it was in this larger context that Sargent Hall represented the hierarchically distributed cultural functions of "maintenance," "refinement," and "transformation" as well as democratic egalitarianism. Frederick Coburn's full description of Sargent Hall as an "American Sistine Chapel, enshrined within a palace of democratic learning" suggested precisely this civic coalescence of Western high culture, art, and religion with education and public opportunity.[74]

The immediately foregoing pages have more to do with the library in general than with Sargent Hall in particular. Returning now to Sargent Hall, it seems appropriate to ask how the content of that room related to the larger cultural narrative of the library. We have already examined the strategies by which Sargent organized his east wall to elevate education as a sacred ideal; both God and Jesus would appear there as teachers. If Sargent used predominantly European literary and visual sources in conceiving his *Triumph of Religion,* he just as certainly reshaped and reconfigured them to fit his sense of the requirements of an American context. As schoolroom/lecture hall (or as "secular puritan" meeting house), Sargent Hall embodied a set of values that, like Sargent himself, could be and were construed as modern, cultivated, democratic, and liberal Protestant—and therefore American and even explicitly Bostonian.[75] In Sargent's representation, it was the "democratic" nature of *Frieze of Prophets* and Sermon on the Mount that would allow the two to represent the characteristics most exalted in the cycle.

SARGENT HALL AND THE LIBRARY'S DEMOCRATIC NARRATIVE: THE HEBREW PROPHETS

Though his classification was predominantly visual rather than textual, the painter was by no means alone in ranking the Hebrew visionaries among civilization's first democrats. In 1915 John Cournos, writing in the pages of *The Forum,* described the prophets, Sargent's in particular, as the "great democratic figures of ancient Judea."[76] Renan and other Western European thinkers had promoted this link as well. In Renan's *Life of Jesus* and in *History of the People of Israel* too, Sargent would

have read extended descriptions of the prophets in terms that defined their democratic stance.[77] In large part, two features earned the prophets this designation: their solidarity with the poor and the oppressed and their literary rendering as individuals. Renan's Hosea, for example, was a "man of the people."[78] But it was the representation of the prophets as individuals and as free in their own individuality from all external spiritual and intellectual coercion that seemed most to appeal to Sargent and that received the most attention and praise in the contemporary literature. In 1922 the artist made explicit this particular interest in Renan: "The only author I have read that throws any light on the individuality of the prophets and the part they played is Renan's 'History of the People of Israel.' This is well worth reading. I only wish my representations embodied more of his ideas."[79]

Not surprisingly, the idea of the democratic individualism of the Hebrew prophets, introduced by Higher Biblical Criticism and its popularizers, attracted an immediate following in the United States. Here the tradition of religious individualism—tracing its lineage to Thomas Jefferson and Benjamin Franklin and, even earlier, to Massachusetts Puritans—was strongly connected to the founding of the nation itself. Many in the United States were thus already committed to an idea of authentic religion as a subjective and private affair rather than an ecclesiastical or doctrinal one. In 1880 the Reverend Henry Ward Beecher congratulated the country for putting away earlier sectarian divisiveness by learning well the lesson that religious conviction belongs "to the heart."[80] Only two months after Sargent installed his north wall paintings (including *Frieze of Prophets*), *Century Magazine* (which also documented Sargent's progress at the library) printed an essay called "The New Old Testament." Its author, Newman Smyth, described the beneficial aspects of the new biblical criticism, chief among them the restoration of a "vivid reality" and a decisive individualism to the agents of social and political change in the "great age of the Hebrew Prophets."[81] Ives Gammell congratulated Sargent, in his rendering of the prophets, on the attention he had paid to the scholarship of modern biblical criticism: "He [Sargent] has differentiated and characterized them in accordance with modern scholarship."[82]

Lyman Abbott titled his 1899 multipart *Outlook* series "Hebrew Prophets and American Problems." Directly connecting Sargent's rendering with his own ideas, this widely known and influential Protestant clergyman illustrated his entries on Hosea and Ezekiel with the appropriate photographic excerpts from Sargent's *Frieze.* In his series of articles, Abbott described Micah as the "prophet of fraternity and equality" and Jeremiah as the seer in whom "moral individualism was born," the one whose "first message" was the "message of individualism." "Jeremiah would not write 'God' in the Constitution of the United States to make a nation pious; he would write God in the heart of the individual," Abbott wrote. He continued with a contemporary American exegesis of Jeremiah

31:31–33 (the scriptural passage that likely led Sargent to think of Michelangelo's Jeremiah as an appropriate source for his own Jehovah):

Jeremiah would not write "prohibition" in the constitution of a State to make the nation temperate; he would write temperance in the instincts of the individual. Jeremiah would not think that a nation could be made great by institutions; he would think the institutions must be made great by the individuals who make the nation. If Jeremiah were in the senate of the United States, he would not vote for a resolution declaring that the Philippines are and of right ought to be free and independent; he would say: Let us have a public school system and a free church that the people may become free and independent. For never are a people truly free, never are they really independent, until they are intelligent and until they are just. The public-school system and the free gospel run their roots back to Jeremiah. And although he was lacking in what Renan calls the greatest virtue of our century—courtesy—and although he was bitter in his invective . . . he taught some principles which the United States needs to relearn even to-day.

Throughout his series on the prophets, Abbott established individual characters for all of his subjects and associated each one of the Jewish seers with American democracy. Malachi and Joel he described as "Puritan Prophets," Isaiah was a "Prophet-Statesman" like Abraham Lincoln.[83]

Sargent's interest in the individualism of the prophets was apparent in his use of sources for *Frieze*. In 1891 he went with Lucia Fairchild to see the famous Fairford stained-glass windows, some of them depicting prophets, at the Church of St. Mary. From these he probably took the idea of phrasing his own prophets in groups of four—but he did not like the way their garments were depicted, judging them "too extraordinary and various." Here he apparently responded negatively to the manner in which the designer(s) rendered the clothing of individual figures anachronistically ("too extraordinary") or with no regard for the chronological relation of the figures (too "various"). He also directly criticized the absence of appropriate individual characterization. It was precisely the lack of individualism and historical veracity that led Sargent to comment that they "would not help him much."[84] The most obvious visual referent for *Frieze of Prophets,* Auguste Rodin's nearly contemporary *Burghers of Calais* (1884–95), underscored Sargent's interest in heroic moral individualism and the sort of interiorized involvements and resolve that it required. There is a remarkable similarity between the French sculptor's first maquette (fig. 100) for his monument (dated 1884) and an early oil study for *Frieze of Prophets* (c. 1892–94; fig. 101). Sargent visited Rodin and did a portrait study of him in 1884; the younger artist may have seen the maquette at this time.[85] Rodin's monument too was understood by critics as modern, egalitarian, and democratic, highlighting just the connections Sar-

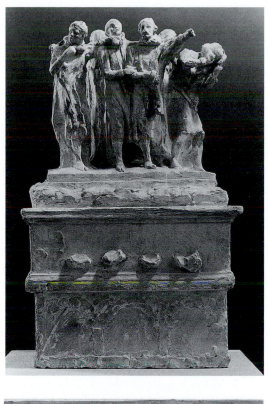

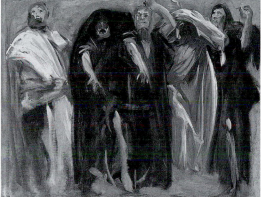

Fig. 100

**Auguste Rodin (French, 1840–1917), first maquette (1884) for *Burghers of Calais*.
Plaster, 24 x 14 15/16 x 12 5/16 in. (61 x 38 x 31.2 cm). Musée Rodin, Paris**

Fig. 101

**John Singer Sargent, *Study for Frieze of Prophets*, c. 1892–94. Oil on canvas, 22 x 28
in. (55.9 x 71.1 cm). Museum of Fine Arts, Boston, Gift of Mrs. Francis Ormond, 37.45**

gent desired between modernity, democracy, and his own prophets. Rodin's sculpture corroborated Sargent's sense of expressive naturalism in relation to modern style.[86]

That Sargent himself entertained a more personal and "individual" connection to his "living and realistic" prophets than to other completed elements in his *Triumph of Religion* is indicated not just in their rendition in an approximation of his own signature style but also in the inclusion in *Frieze* of recognizable "characterizations" of several of his friends. The artist suggested Coventry Patmore's features in Ezekiel and George Roller's in Hosea. The term "characterization" is Edwin Blashfield's. According to Herbert Small, Blashfield used it around 1896 of the figures in his Library of Congress murals in order to distinguish his inclusion of "resemblance[s] more or less distinct to the features of some real person" from the genre of "portraiture."[87] Sargent pursued a similar course in *Frieze of Prophets.* In practice and though many commented on *Frieze*'s tendency to remind them of Sargent's work as a portraitist, none of his references to contemporary individuals was so precise as to actually constitute a "portrait."

Though the Patmore and Roller identifications are sure, naming the other figures presents significant challenges. Some past observers have claimed, for example, that George Roller appeared as Isaiah and Nahum as well as Hosea.[88] Since reliable historical evidence indicates that Roller did pose for more than one prophet, and since Isaiah shares, broadly at least, Hosea's visage, that pairing is likely. The prophet Nahum's face, however, seems to belong to a different individual. If Roller did pose for this prophet too, he was more probably the model for the draperies, stance, or gestures than for the facial features.[89] In addition, Joshua's physiognomy approximates that of Nicola D'Inverno, Sargent's model (beginning in 1892 as the artist started work on *Frieze*) and his valet and then domestic manager for many years. That the boxer Nicola D'Inverno should stand in for the warrior Joshua and the Catholic poet Coventry Patmore for the priestly Ezekiel seems strangely appropriate. Yet the link between Joshua and D'Inverno is perhaps less certain than the foregoing might suggest. On the one hand, in early reproductions of *Frieze of Prophets,* copyrighted by the library's Employee Benefits Association, Joshua's features are virtually identical to those of D'Inverno. In the original mural, on the other hand, Joshua's features are registered so indistinctly that the degree of resemblance is more difficult to gauge. Short of the two unlikely possibilities that Sargent might have retouched some reproductions himself or that the unknown producer of the prints knew the identities of Sargent's models and wished to clarify them for contemporaries, I cannot account for the reproduction's closer match to photographs of Nicola D'Inverno.

Finally, if we take as a guide the sort of individual references that Sargent pursued in the known *Frieze* "characterizations" of Patmore and Roller, then

Malachi similarly, though less precisely, resembles Sargent's 1892 self-portrait (fig. 102). The proximity of features is most distinct across the bridge of the nose, the brow, and the ear.[90] Malachi, one of Abbott's "Puritan Prophets" and the "last of the prophets" in terms of the Christian ordering of prophetic books, was also one of the east wall panel's Prophets of Hope. Of all Sargent's prophets, Malachi gestures most directly toward the cycle's intended point of culmination, the panel reserved for Sermon on the Mount. There is no historical evidence for this comparison of the artist and Malachi; I share the observation only in relation to Sargent's degree of personal and artistic connection to *Frieze of Prophets,* a disposition that stands secure without the addition of this intriguing but unsubstantiated and inexact visual association.

The democratic individualism of Sargent's prophets had to do, clearly, with his own idea of heroic subjectivity and with his critics' enthusiastic assent to this sort of pictorial interiority. "On the frieze . . . like pillars, stand the incarnations of the voice of God in the human soul—those captains of the seers, who have won for the race of Israel the spiritual hegemony of the West."[91] Not only did this content of *Triumph of Religion* fit the American cultural ethos perfectly, it also catered to Brahmin Protestantism and its strongly Unitarian, and, secondarily, Episcopalian and Congregational cohorts. Each would have found much to applaud in *Triumph*'s focus on the unmediated inspiration of the individual.

A significant part of the social and ideological coherence of Boston's upper class had to do with denominational coherence. As Story suggests:

Religion, to be sure, was a factor in the development of a culturally coherent Boston elite, which seems to have been so overwhelmingly "liberal" (Arminian until about 1815, Unitarian thereafter) in affiliation and outlook that contemporaries referred to Unitarianism as "the Boston religion." That they did so in the face of a far vaster increase in the number of area Methodists, Baptists, and Catholics only underscores the class dimension of this elite attachment to the "liberal" faith, an attachment which persisted . . . well into the twentieth century. . . . Like all classes seeking a devotional pattern consonant with their status and occupations, entrepreneurial families flocked readily to a creed which contained no otherworldly or antiegoisitic doctrines whatever.[92]

Theologically liberal and politically conservative Unitarians, not surprisingly, found much to recommend in Renan.[93] Unitarian pastors translated the French historian's work for American audiences; these and other translations of Renan's books in the United States often carried promotional excerpts from Unitarian periodicals and individuals. Furthermore, Renan's biblical writings, with their emphasis on the humanity of Jesus and their implicit demotion of the third person of the Trinity as well, communicated a message curiously parallel to Unitarian the-

Fig. 102

John Singer Sargent, *Self-Portrait*, 1892. Oil on canvas, 21 x 17 in. (53.3 x 43.2 cm).
National Academy, New York

ology and principles. At the Boston Public Library one observer castigated library officials for accepting Sylvester Baxter's "Arian" and "Unitarian" translations of the inscriptions for *Dogma of the Redemption*. Sargent would not have taken exception to Baxter's rendition.[94] The Unitarian influence, through leaders like Edward Everett and Theodore Parker, on the library's founding and development had been substantial. Parker's own personal library, including all of the books he assembled to write a comprehensive history of religion, he bequeathed to the Boston public institution; the Parker Library was one of the special collections to which Sargent Hall provided entry.[95] The Unitarian Ralph Waldo Emerson (whose writings Sargent also read) would have assented to Sargent's emphasis on anti-institutional individualism: the essence of religion could be found not in Law or in Dogma but in the interior orientation of the individual toward a moral and spiritual ideal represented in the fully human Jesus.[96]

SARGENT HALL AND THE LIBRARY'S DEMOCRATIC
NARRATIVE: SERMON ON THE MOUNT

American exegetes understood Matthew's Sermon on the Mount, like the books of the Hebrew prophets, as a fundamentally "democratic" subject. Sermon on the Mount earned this reputation, furthermore, on the same two bases: first, its emphasis on truth that is internal to the personal self (inscribed on the human heart) and dependent upon individual consent; and second, its representation of Jesus as a "man of the people." The first of these considerations has received attention in the preceding pages of this book. The second requires another brief look at Sargent's final sketch (fig. 25) for his Sermon on the Mount and at one additional contemporary source.

Taking the second consideration first, Sargent communicated the relative inclusiveness of his vision in the size of the crowd gathered to listen to Jesus and the range of individuals and conditions represented in even this rather hasty preliminary sketch. Those who people Sargent's image include young and old, male and female, the strong and the weak. At least one person in attendance (at the left margin in the middle distance) is so sick or frail as to require the physical assistance of another. At left, in the immediate foreground, one individual turns away from Jesus in an attitude of depression or despair. Here Sargent's depiction of the sick and the lame reworks Cosimo Rosselli's addition to the Sistine *Sermon* of the vignette depicting the healing of the leper. Rather than the miracle-working capacities of Jesus that Rosselli elaborates, Sargent emphasizes the inclusivity of the human Jesus' message and the efficacy of his subjective spirituality.[97]

Henry Ward Beecher and Lyman Abbott were certainly not the only contemporary preachers concerned with the "democratic" inclusivity of Sermon on the Mount. In 1925 Thomas Van Ness, Congregational pastor of New Old South Church, just across Boylston Street from the public library, recalled, in precisely these terms, a conversation with Sargent about his plans for Sermon on the Mount. Van Ness had apparently suggested to Sargent an alternative vision for his central Sermon panel, one that emphasized the "lilies of the field" verses recited by the Currier and Ives print examined in chapter 3 (fig. 90). In contrast, according to Van Ness, Sargent believed that the "most inspiring moment" in the story came when Jesus saw the multitude and taught them. For the *Sunday Herald,* Van Ness recounted Sargent's democratic description of the scene:

What a picture! In the distance, the green-blue water of the lake; nearer the verdure-clad hills of Galilee; on the level ground and the slope Palestinians of all grades and classes, "from Decapolis, from beyond Jordan, from Syria, from nearby Capernaum"—fishermen, farmers, elders, teachers of the law; idle villagers and curious bystanders. What motley

costumes! Reds, blues, greens, yellows! What different positions for an artist to depict! And then, there in the smiling spring country, this young man with his fresh and unconventional Gospel, speaking words so new, so exalted, that they seemed heaven-born and heaven-sent; words that now as Beatitudes we repeat over and over again as containing not only the highest wisdom but the highest comfort.[98]

The inclusivity of Sargent's vision followed from his conviction that true spirituality was, to use the phrasing Robert Bellah borrowed from Alexis de Toqueville (who applied it to American mores more generally speaking), a "habit of the heart."[99] This form of spirituality, tied strictly to individual lights and individual consent, seemed, at least theoretically, open to anyone and to any content. Like William James, Sargent seems to have concluded that, in the modern world James would describe in 1912 as a "pluralistic universe," the only attainable unity resided within the individual, in the "moral interior."[100] Only on this level was it possible to get chaos to yield to consensus; only on this level was it possible to produce "one" from "many."

That the emphatically apolitical Sargent might have explicitly considered the subject and value of religious freedom in relation to the United States in the years during which he worked on *Triumph* is suggested not only in Santayana's later recollection but also in Sargent's enthusiasm in 1896 for a painting Abbey produced as part of a Philadelphia civic competition. The subject Abbey selected was the "Spirit of Religious Liberty leading great ships across the sea to America, accompanied by her sisters, Faith and Hope." The competition went to Joseph Decamp but Sargent reportedly called Abbey's design "stunning," the "finest notion of a decoration" he had ever encountered."[101] Though Philadelphia rejected Abbey's decoration, he returned to it shortly after the turn of the century as one of the compositions for the state capitol of Pennsylvania at Harrisburg. The inscription Abbey selected for a painted medallion called *Religion* reiterated a critical aspect of Sargent's noninstitutional religious ideal. The inscription reads: "For religion, pure religion, I say, standeth not in wearing of a monk's cowl, but in righteousness, justice, and well doing."

Like Sargent's, Abbey's religious background was Episcopalian, and he was quick to correct a misinformed biographer who, based on Abbey's Pennsylvania heritage, had designated him a Quaker.[102] Significantly (though also characteristically for many Protestants of his time), when Abbey thought of religious liberty, he thought not so much of the world's many religions as of the many persecuted Christian sectarians who had found refuge in the United States. Sargent, too, though his narrative rested on a thesis about the process by which civilization advanced toward an enlightened individual freedom, conceived his subject from within an explicitly Christian mind-set outward. Abbey and Sargent

would have agreed that only "nonsectarian" religious expression was appropriate to public art in the United States. The simple fact was, however, that what counted as nonsectarian differed for Protestants (who used the term to signify interdenominational efforts within Protestantism itself), Catholics (for whom the Protestant majority represented the "sectarian" expression of Christianity and "nonsectarian" meant *Christian* cooperation), and Jews (who, standing outside Christianity, saw the bigger picture and labeled "sectarian" any religious expression of particularity, usually Christian). It was only from within the dominant Protestant perspective on sectarianism that the World's Parliament of Religions' Protestant leadership could recommend the recitation of the Lord's Prayer as the "*Universal* Prayer"—and this to an international and interfaith gathering of religious leaders in Chicago in 1893.[103] To return to *Triumph of Religion,* the likelihood that Sargent gave some degree of consideration to Abbey's concurrent project is suggested not only by his words of approval with respect to the design for the religious liberty panel, but also in the fact that, after Abbey's death, Sargent supervised completion of an unfinished painting for the Harrisburg decorations. This one too focused on the subject of American freedoms; Abbey called it *Reading of the Declaration of Independence.*[104]

Boston's art critical writers assigned terms like "shrine of letters" and "temple of civilization" to the library not because of its appropriation of religious subject matter but because they expected something important to happen there. Chapter 2 mapped the performative dimensions of ritual space in Sargent Hall. Chapter 4 has considered the important sense in which the special collections gallery served ritualized functions in its role as an arena for transformation in the status of the library's patrons, and by extension, of the community as a whole. In sacralizing education, *Triumph of Religion* sought to foster movement toward intellectual depth. In valuing cultural literacy, it asserted the importance of refined aesthetic sensibilities. In embodying enlightened spiritual subjectivity, it hoped to nurture the development of morally responsible individuals for a participatory democracy. Reflecting these key values of its Boston social and cultural sponsors, Sargent's mural cycle, when complete, would provide visual and conceptual access to the new "subjective" world wrought by "sacred," rational progress. Offering the possibility of transit across the divides of class and social standing, it would hold out images of education and cultural literacy apparently well-suited to its presumed Bostonian and American publics. But controversy forcefully demonstrated that Sargent had miscalculated the parameters of Boston's religious and cultural unity and diversity. The viewing audiences for *Triumph of Religion* turned out to be more various than he was prepared to imagine. "Nonsectarian" Christian was an insufficiently comprehensive category even for a cycle about the privatization of religious consent and belief. This is the subject of chapter 5.

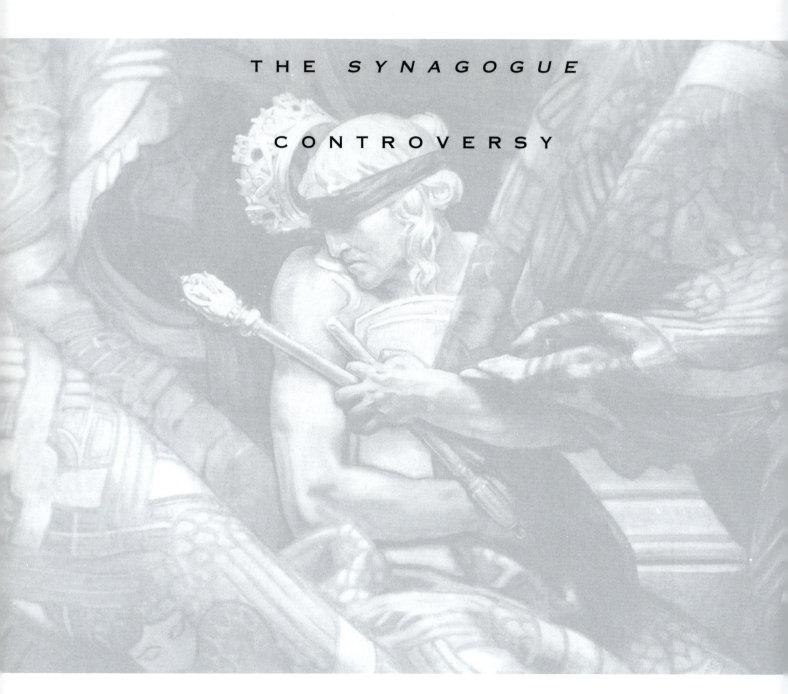

THE *SYNAGOGUE* CONTROVERSY

⊕

What mean you, master of the brush and tube?

Whence has your genius fled? You from whose brain

The rapt seraphic seers of Israel

Leaped on the canvas full grown into life.

Think you our youth will mutely close their lips

When you weave lies into your coloured text?

We are an ancient folk, sore-weighed with years;

Yet we are ever young; undying fire

Runs through our veins. Our bearded patriarchs

Still dream the dreams of God. Our warrior youth

See visions, and the Law from us still flows.

What mean you, master of the brush and tube;

Whence has your genius fled?

—LOUIS L. NORMAN (1919)

✳

Viewers of Sargent's *Triumph of Religion,* of course, understood themselves not only as individuals in a democratic society but as members of identifiable and significant social, cultural, racial, and religious groups. Social and political responses to the increasing pluralism of American culture represented striking crosscurrents of racism and antisemitism on the one hand and inclusivism and toleration on the other. Prejudice and the mobilization of individual and institutional resistance to it went hand in hand. Literacy and public education figured prominently in renewed conversations about American heterogeneity, and many viewed public libraries as essential civic components of assimilation, integration, and social transformation. Into this already charged climate came Sargent's depictions of *Synagogue* and *Church,* raising questions not only about the artist's beliefs and intentions but also about the role of religious expression in public (and especially public educational) spaces.

In addition to happy predictions about the yet-to-be-completed Sermon panel, Sargent's 1919 installation provoked immediate complaints about the sectarian and anti-Jewish character of the artist's conception of *Synagogue* and *Church.* Until 1919 Christian bias was more or less covert, unremarked, resident in the organization of the cycle, in the progressive scripting of Sargent's narrative, and not in the individual images themselves. In 1919, with the placement of the allegorical pendants, many who did not subscribe to the myth of Christian origins and destiny objectified in the murals took exception to the display of sectarian religion in a public institution they had encouraged and supported.

The Controversy over *Synagogue:* Beginnings

The five-year debate surrounding the image of *Synagogue* began within days of the 5 October unveiling. It is likely, in fact, that the anticipatory musings of two Boston art critics ignited the conflict. One, Frederick William Coburn, art critic for the *Boston Herald,* voiced his reservations on 14 September, three weeks before the critic or the Boston public could have seen the two paintings. Speculating on the subject of the installation (which the library had known since 1915) and on Sargent's medieval sources, Coburn inserted a cautionary note: "In the interest of racial and religious amenity in this community one hopes that Mr. Sargent has avoided the old middle-age bigotry in working out this perilous theme; as no doubt he has done."[1] On 6 October, the day after the installation opened for public viewing, the art critic for the *Boston Evening Transcript,* William Howe Downes, concluded his careful review of medieval precedents with this prescient comment: "No doubt there will be found theological controversialists who may object to the revival in our day, even in a modified form, of these obso-

lete suggestions of doctrinal differences."[2] Less than a week after Downes's article, in a column that was otherwise generally appreciative of Sargent's two new panels, Coburn sharpened his reservations about the subject matter: "If one were an orthodox Jew, a rabbi or a cantor, it might be a little distasteful to have this middle-age fashion of depreciating his ancient religion revived in a building supported by public taxation."[3]

THE CONTROVERSY OVER *SYNAGOGUE:* JEWISH VOICES

The surviving evidence indicates that organized opposition to Sargent's representation of *Synagogue* moved through three phases: first, in October 1919, an initial and apparently short-lived local campaign for signatures from individual citizens requesting removal of the painting; second, from October 1919 to April 1920, a series of resolutions and official actions promulgated by various national and regional organizations and then directed to the attention of the library's trustees, the city's mayor, and the governor of the state; and third, from November 1921 to April 1924, a sequence of legislative initiatives brought before the House and Senate of the Commonwealth of Massachusetts.[4] In each phase prominent Jewish individuals exercised primary leadership, but they found ready support among non-Jews in both political and religious spheres of activity.

Objections in Boston's local Jewish press began with an editorial in the *Jewish Advocate* on Thursday, 16 October 1919. Set off in large type and headed by a sizable reproduction of Sargent's *Synagogue,* this column is noteworthy for the comparatively measured tone of its judgments, for its interest in acknowledging the existence of supporters as well as detractors of the image, and for the author's inclination to yield to the opinion of an "unbiased" expert in the field of art. By the time *Jewish Advocate* editor and publisher Alexander Brin printed this 16 October editorial, Sargent's *Synagogue* was already "the subject of considerable controversy . . . in non-Jewish as well as Jewish circles." Brin's reference to a movement to have the panel removed dates the generation of the petition drive to sometime prior to his opinion piece (and probably after the 5 October unveiling of the image). To Brin's mind, however, no one who had yet expressed an opinion on "one side or the other" was "competent" to render judgment. Until knowledgeable persons with artistic credentials had assessed the situation to determine whether the painting "represent[s] a Synagogue or whether it misrepresents one," Brin advised "respectable" rather than "violent criticism."[5]

In an interview in the secular press, Brin suggested that his paper had already contacted a New York "art critic, high in his profession, to come to Boston and view the picture . . . that critic [Brin continued] is also a Jew. If he decides

that the painting is no affront, we shall let the matter rest." If, on the other hand, the critic decided otherwise, the *Jewish Advocate* would use its resources to support the petition for the painting's removal.[6] Though both Boston and New York journalists specified the intended recipients of the petition as the library's trustees and the mayor of Boston, the extant evidence identifies neither author nor agent for the document itself. Rabbi Menachem Max Eichler, director of the Zionist Bureau of New England, is a likely possibility. Brin quoted Eichler in his 16 October editorial, and one contemporary periodical identified him, in the early phase of the conflict, as "the leader of the protest."[7] The record, unfortunately, does not name the art critic whose opinion the *Jewish Advocate*'s editor valued so highly or report the critic's assessment of the image. Whether or not this individual ever came to see the painting, within days of Brin's editorial (and perhaps as the result of a decision that the aesthetic dimension was neither the only nor the most important one to be considered) the *Jewish Advocate* had apparently endorsed a different strategy. Subsequent articles did not promote either aesthetic judgments or the petition as preferred courses of action. It may be that the idea of the petition was simply abandoned; in any event, it moved sufficiently to the background that no significant evidence of the campaign's course or completion survives.[8]

Less than a week passed between the 16 October *Jewish Advocate* editorial and Sargent's response. In a characteristically brief letter to the editor, dated 21 October, the artist defended his painting by referring his challengers to the iconography's medieval sources; he mentioned the cathedrals at Reims and Strasbourg in particular. To Sargent's mind the "traditional" antecedents for *Synagogue* and *Church* "established an authoritative precedent."[9] On 23 October the *Jewish Advocate* printed the artist's letter and claimed that the paper would "seek a more explicit statement from Mr. Sargent."[10] The "more explicit statement" never materialized, though a representative of those who opposed the painting (probably either Henry Raphael Gold, rabbi from 1919 to 1925 of the largest Orthodox congregation in New England, Congregation Adath Jeshurun in Roxbury, Massachusetts, or Eichler, both of whom the *Jewish Advocate* had already cited) called on Sargent requesting an explanation.[11] It was in all likelihood the visit prompted by the Jewish weekly's concerns that Sargent rather peevishly described to Evan Charteris in a letter dated 24 October 1919: "I am in hot water with the Jews, who resent my 'Synagogue,' and want to have it removed—and tomorrow a 'prominent' member of the Jewish colony is coming to bully me about it and ask me to explain myself. I can only refer him to Rheims, Notre Dame, Strassburg and other Cathedrals, and dwell at length about the good old times. Fortunately the Library Trustees do not object, and propose to allow this painful work to stay."[12]

Between the more cautiously worded 16 October editorial and the 23 October article accompanying Sargent's letter to the editor, the *Jewish Advocate*

abandoned its initial position of relative neutrality to expose the historical fiction and cultural elitism of Sargent's representation.[13] Restricting his comments to a comparison of *Synagogue* and *Church,* the columnist pointed out that these two panels did not depict the progress of two vital, contemporary religions but the progress of Christianity at the expense of Judaism. Despite the panels' iconographic pedigree (and also in part because of it), this was not the triumph of religion but the "triumph of Christianity." After brief comments by the Jewish weekly's reporter, lengthy quotations from Rabbi Gold constituted the remainder of the text. Gold was now willing to speak with authority, though he and other leading Boston rabbis, including Temple Israel's Harry Levi, had earlier moderated their comments until they could see the painting for themselves. Occupied with observances of the Jewish holidays when the first news of *Synagogue* broke, Gold had since been to the library and felt it appropriate to render an opinion.[14] His principal objections concerned the panel's biased rendering of religious history and (especially) its placement in a public institution. Churches and cathedrals might legitimately harbor images like this allegorical pair. But how would Jewish students feel when happening upon this "calumny to their honor" in a public library? Jewish high school and college youth, Gold continued, regarded *Frieze of Prophets* "with a mixed feeling of highest admiration and gratitude; they felt happy that a great American devoted his genius to the beautiful representation of the heroes of Jewish antiquity." The *Synagogue* was a different matter entirely. In response to this unfortunate painting, Gold advocated a "strong organized protest to both the trustees and the artist."[15]

By 1 November the secular *Literary Digest* declared that "art and religion have seemed to prepare a battleground for themselves in the Boston Public Library."[16] The battleground very soon extended far beyond Boston. Reaction to Sargent's *Synagogue* came from Worcester, New York, Cleveland, Cincinnati, Detroit, Chicago, Pittsburgh, Baltimore, Louisville, and Nashville. As the local petition drive receded from view, a wider but more tightly organized effort, with Reform Judaism's Central Conference of American Rabbis as its principal catalyst, emerged. On 5 November Leo M. Franklin, president of the conference, and Felix A. Levy, its secretary, forwarded to the board of directors of the library a resolution adopted by the conference's executive board at its annual meetings. This resolution protested the representation of *Synagogue* as "contrary to fact and therefore unjust" and called for the removal of "anything with such a clear sectarian bias" in a public institution.[17] Later in the month, in a public address before his Detroit congregation, Franklin expanded on his earlier comments. Refuting the historicity of Sargent's images, the rabbi rejected the ancient and popular Christian chronicle of Judaism's demise recently appropriated in a medieval version by Sargent. Only the Church's propagandistic manipulation and distortion of

the prophetic texts of the Hebrew Scriptures, Franklin maintained, allowed the Christian institution "not merely to justify its own existence, but especially to prove to its followers and to men generally, that it had come into the world as the legitimate successor of the synagog which by that token, had outlived its purpose and was ready for the grave."[18] In April 1920 the Central Conference of American Rabbis followed up on its November initiative. On 20 April, four months after his initial letter, Franklin wrote, on behalf of the organization of Reform rabbis, to the trustees of the library, "asking for some definite word in the matter of the Sargent painting . . . also an opinion of the Corporation Counsel of the City of Boston as to the legal powers of the Trustees in relation to the same."[19]

The national scope of the *Synagogue* debate meant that many of Sargent's detractors had seen his library paintings, if at all, only in reproduction and never in context. Almost without exception and throughout the entire debate, however, they assiduously avoided impugning the artist's intentions or his art. To a person their objections seem to have been limited to subject matter, treatment, and sources, and to the relation of these three to "historical truth." Franklin had seen at least the first installation in situ. Nevertheless, with respect to the images under attack, Franklin's refusal to evaluate the "technical merits or defects of Sargent's work" was characteristic of the controversy as a whole.[20] Summarizing his argument toward the end of his sermon, Franklin concluded:

It is my deep-seated conviction that this presentation of Judaism as a broken faith, as a faith without a future, is untrue to fact and on this ground, rather than in contempt for the mind that conceived it, I maintain that this picture must not find a place in a public institution devoted to the spread of knowledge and to the dissemination of truth.

Anti-Semitism has found many a cruel weapon with which to fight its unholy battle, but surely the time has not come in America when even art may be prostituted to so base a purpose.[21]

In an editorial in Cleveland's *Jewish Review and Observer,* Louis Wolsey, a local Cleveland rabbi and member of the executive board of the Central Conference of American Rabbis, wryly contrasted "Puritan" Boston's earlier rejection of the nudity of Frederick MacMonnies's *Bacchante and Infant Faun* (1894) with its apparent acceptance of the "bigotry" of Sargent's *Synagogue:* "If the Bacchante is demoralizing to the eyes of the people how much the more [corrupting] is the representation of a bigoted interpretation of the Synagogue."[22] While a number of the debate's leaders (for example, Wolsey, Franklin, Levi, and Kaufmann Kohler) had direct connections to the Central Conference, other organizations (perhaps through the conference's influence) became involved as well. At its November 1919 annual board meeting in Nashville, the National Council of Jewish

Women, "representing many thousands of women from all parts of the country," unanimously passed a resolution charging that Sargent "grossly misrepresent[ed]" the Synagogue and condemning the "false impression" his image promoted. Arguing, further, against the un-Americanness of the painting's biases, the resolution framed a position that, along with the argument for historical veracity, informed much of the debate: "It is against the spirit of these particular times and against the spirit of America at all times to foster anything which can encourage discrimination against any part of its citizenship."[23] Like other associations that wrote to the library (including, in addition to the Central Conference of American Rabbis and the National Council of Jewish Women, the Young Women's Hebrew Association, the Young Men's Hebrew Association, and the Anti-Defamation League), the council vowed to send copies of its resolution to the mayor of Boston and to the governor of Massachusetts as well as to the head librarian and to pursue the issue until the panel was removed.

By early July 1920, as reported in the *Jewish Advocate* ("Jewish Girl's Medallion Refutes Sargent's 'Synagogue' "), painter and sculptor Rose Kohler had produced a "complete refutation" of Sargent's *Synagogue* in her large (forty-two-inch-diameter) bas-relief medallion of the same subject. Kohler was the granddaughter of Reform theologian David Einhorn and daughter of Kaufmann Kohler, successor as president of Hebrew Union College in Cincinnati to Reform pioneer Isaac Meyer Wise and honorary president of the Central Conference.[24] Rose Kohler likely became aware of the controversy over Sargent's *Synagogue* through her father's connections to both Hebrew Union College and the Central Conference of American Rabbis. This was a subject meaningfully suited, however, to her own interests and expertise. At age forty-seven in 1920, a mature and highly educated artist, trained at the Cincinnati Art Academy and the Art Students League, Kohler was hardly the "girl" of the *Jewish Advocate* headline.[25]

A brochure likely penned by the sculptor and designed to market twelve-inch (fig. 103) and three-inch bronze reproductions of her *Spirit of the Synagogue* described the work:

In the medallion the treatment is from the Jewish standpoint; the crown is firmly placed on the head of the allegorical central figure, whose sceptre is unbroken and whose eyes look into the future as she holds aloft the Scroll of the Law.

The upper group on the left indicates the Congregation; the children carrying books represent Instruction; the old man with covered head and praying shawl is blowing the ram's horn announcing the new era for humanity.

The Seven-Branched Candlestick on the right is symbolic of Light. The figure of the old man behind the pulpit with hands spread out in priestly benediction, the cantor chanting from an open scroll, the youth in the foreground reading from a prayerbook, are all expressive of worship.

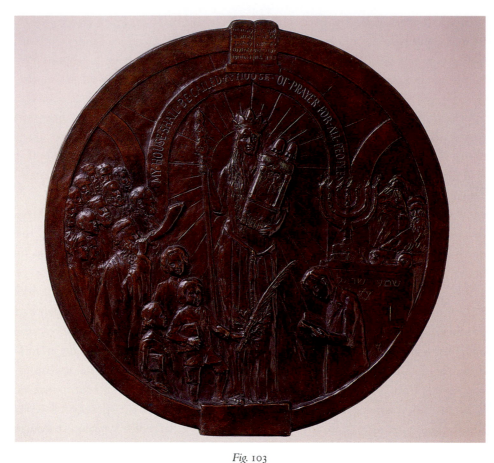

Fig. 103

Rose Kohler (American, 1873–1947), *Spirit of the Synagogue,* **small-scale reproduction, 1920. Bronze, 12 in. (30.5 cm) diam. Congregation Emanu-El, New York**

The whole composition is intended to stress the universalistic ideal of the Synagogue inscribed upon the central arch "My House shall be called a House of Prayer for all peoples."[26]

The three-and-one-half-foot original of Kohler's medallion was purchased for Congregation Adath Israel in Louisville, Kentucky, as a memorial to Mattie L. Tackau; the medallion itself is currently unlocated.[27] Of the bas-relief a columnist for the London *Jewish Guardian* had this to say on 4 February 1921: "I have now seen a capital photograph of Miss Rose Kohler's symbolical plaque, which may be regarded as a Jewish answer to Sargent's Boston libel. Allusion has already been made in this column to Miss Kohler's work, but a fresh word of praise may not be superfluous. The central figure is a dignified woman, crowned and bearing the Scroll of the Law in contrast to the conventional representation of the Syna-

gogue as dropping both crown and Law. . . . Altogether the work is a noble illustration of artistic skill applied with genuine spiritual significance."[28]

When the National Council of Jewish Women asked Kohler to address the subject of "Jewish Art, Its Origins and Development," Kohler deliberated about the implications of the title the organization had assigned to her subject:

Of course I am familiar with the movement fostered by those who are trying to impose upon the world today a Jewish art as part of a specific Jewish culture—as if this had not always been borrowed from the surrounding world, and like all culture, is international and universal. However, I accepted the invitation of the Council of Jewish Women, believing that by adding the word PURPOSE to the title, I could make it clear that art for Judaism was not an end in itself, that it was but a means—and could become a powerful one—of illustrating for Jew and non-Jew, Judaism's religious mission for humanity. The term JEWISH ART went against the grain, nevertheless, and before it was too late I changed my topic to ART AS RELATED TO JUDAISM.[29]

The National Council of Jewish Women published Kohler's substantial essay in 1922; but she first presented it before that body as an illustrated lecture (the lantern slide set numbered seventy slides). One contemporary subject of direct relevance for Kohler was Sargent's *Synagogue,* a painting she discussed in the context of its appropriation from medieval sources. Among the slides that accompanied her set of reflections in its initial spoken format were reproductions of medieval works from the cathedrals at Bamberg and Strasbourg as well as Sargent's panel and two Jewish alternatives (one of them her own). Because Sargent based his *Synagogue* on biased precedents, "objection has been raised to Sargent's painting . . . for it was felt that in this century and in America, we had advanced sufficiently to cast aside the notions and prejudices of the Dark Ages."[30] Interestingly, at the conclusion of her comments, the fundamental quality—universalism (in Kohler's words, "one God and one humanity")—claimed for contemporary Judaism was the same quality ascribed to the climax of *Triumph of Religion.* The one artist grounded her understanding of and plea for a humanistic universalism in Jewish scripture and tradition, the other in the privatized interpretation of a narrative from Christian scripture, Sermon on the Mount.

What is perhaps surprising is that while many took exception to Sargent's representation of *Synagogue* as old and broken, few objected to the evolutionary content of the cycle itself. The exceptions were notable—Henry Gold, Leo Franklin, and Rose Kohler—and bear examination. Rose Kohler and Leo Franklin had similar concerns about the Christian content of *Triumph of Religion.* As early as 1908, in a presentation before the Fifth Triennial Convention of the National Council of Jewish Women, Kohler promoted a collection of "pictures

for religious school use." She specified that she had decided not to include Sargent's "very popular 'Prophets' " because "their conception is decidedly christological. They are all made to appear—as is the Christian view of almost all the Old Testament heroes, to which we Jews cannot subscribe—as the forerunners of Jesus, and all point to the coming of the Christian Messiah."[31] Leo Franklin later concurred; it was the triumph of Christianity, sure to be depicted in the final panel, that disturbed him. In his 16 November 1919 sermon, Franklin pointed out that *Synagogue* and *Church* were "so placed as to leave between them, the largest and most prominent available panel for the final painting of the group, in which, it is presumed upon good authority, the artist proposes to make a portrayal of the triumphant progress of the Christian religion unto this date. The hypothesis that this is his purpose cannot be lost sight of in the discussion of the two panels under consideration."[32] Henry Gold's concerns about the evolutionary tracking of the cycle differed from those of Kohler and Franklin. Gold focused his attention on the threat of irreligion rather than sectarian religion. In the critical central (empty) space, Sargent would surely move from religious authority to an endorsement of scientific authority as the modern replacement.[33]

Outside of the well-placed reservations of these three individuals, however, most seemed to take *Triumph*'s sort of progressive scheme for granted. One of the principal grounds for Jewish-Christian understanding and dialogue during these years was the often repeated assertion of a common heritage; with striking frequency writers for the *Jewish Advocate* selected as their subject the status of Judaism as the progenitor of Christianity. Both the Orthodox Gold and the Reformer Harry Levi promoted this position in their own congregations and elsewhere. In 1924, speaking on the "Prophetic View of History" before Methodist seminarians at the Boston University School of Theology, Gold presented his case in terms that sound remarkably similar to the theses of Sargent and Renan: "The teachings of the prophets of Israel are the great fountain of inspiration for the leaders of Judaism and also Christianity. The fundamental idea of the prophets concerning history was the substitution of moral supervision in the course of events for the chaos of accidental possession of power, and this fills history with the joy of optimistic expectation."[34]

Recorded, like Gold's lecture, in the Boston *Jewish Advocate,* a 1921 article titled "The Judaic Beginnings of Christianity" by scholar Israel G. Einstein insisted:

The true personal religion of Jesus, the inward sacrifices of his spirit, his sense of prayer with God, his efforts to learn the divine will, and to guide his associates in the right way, his loyalty to duty, his fidelity to ideals, these things which gave meaning to his life can be seen only in the light of his Jewish heritage and environment. In the Jewish heritage

and environment is mirrored the pure perspective of his personal religion. Jesus was a Jew by birth and training. He was fully aware of the great stream of patriarchs and prophets of his race. He believed he was one of them.[35]

This Jewish narrative of civilization presented two equally vital modern religions, one of which (Christianity) postdated and originated in the other (Judaism). It was not the larger evolutionary premise of Sargent's cycle that came under attack but its apparently overt comment on the vitality of Judaism in relation to Christianity. The controversy focused attention on *Synagogue* and *Church,* not *Triumph of Religion;* not the whole but the construction of this particular episode in Sargent's story constituted the stumbling block. Completed according to his original plan, prior to the introduction of *Synagogue* and *Church,* the cycle would not have been without problems in both style and content. However, in the original scheme, the stylistic similarity between *Frieze of Prophets* and Sermon on the Mount and the thematic connections between *Israel and the Law* and Sermon would have made clear the deliberate association of two exalted moments and, while the evolutionary content would have remained fundamentally Christian (the "old" Israel still yielding sequentially to the "new" Israel), the cycle might not have found as many opponents in Boston. Without *Synagogue* and from the perspective of contemporary religious practice in Boston, Sargent's *Triumph of Religion* might have been read as a chronological account of religious inception and influence, as a recommendation of an expansive and interiorized religious ethic, if not an inclusive interreligious philosophy.

THE CONTROVERSY OVER *SYNAGOGUE*: LEGISLATIVE EFFORTS AND THE LIBRARY'S POSITION

In response to pleas for the removal of *Synagogue,* the library argued that its contracts with Sargent gave the artist complete freedom with regard to the subject and design of his work. Citing the precedent established early in 1919 in *Charles Eliot v. Trinity Church,* Arthur D. Hill, corporation counsel for the city of Boston, advised William F. Kenney, the president of the library's board of trustees from 1917 to 1920, that the board could not legally remove any part of the mural decoration. Sargent's paintings had been secured according to the terms of a charitable trust executed with the city of Boston by the private committee of citizens who contributed funds. The painting was part of the contract between the artist and the citizens. The contract represented not just the agreement of the library with the artist but also with the donors, the "Committee of Citizens," who thus also had legal rights with respect to the disposition of the cycle and its constituent

elements.[36] The trustees had "expressly approved" the contract; the artist had fulfilled the terms of the contract, "which gave him the widest possible discretion in his choice and treatment of the subject consistent with an honest effort on his part to achieve an artistic result." The city and the library's trustees were obligated to comply with those terms. As long as the conditions of the trust, as laid out in the contract and accepted by the trustees, had been met, the courts could not alter the agreement or its results. The painting must "have its place in Mr. Sargent's scheme of decoration of which it is an essential part."[37] This advice, from a letter dated 12 April 1920, shaped the library's public position throughout the controversy and promoted an attitude of relative passivity and disengagement from debate.

In the early phases of the conflict, the trustees' response had paralleled that offered by Sargent himself; they had maintained that "the picture is symbolical and is in harmony with the rules of art as pictured for centuries in Europe. . . . the present agitation against the picture is a 'tempest in a teapot' . . . Mr. Sargent would not willingly give offense."[38] After Hill's letter the trustees would refer queries directly and consistently to this opinion. Thus Kenney responded to Franklin's request of 20 April 1920 by sending him a copy of Hill's letter and of *Eliot v. Trinity Church*. Eight days later Franklin acknowledged receipt of the library's reply: "I note that in the opinion of the Corporation Counsel based upon the decision in the case mentioned, it will not be feasible for your Board to take any action in the matter of the Sargent picture. I shall report your findings to the Central Conference of American Rabbis in whose name our correspondence has been carried on and shall advise you of their further action in the matter."[39] This closed the second phase of the controversy, the "resolution" phase, in which the Central Conference played the critical role.

Over a year and a half later, the legislative phase of the conflict swung into full gear. In January 1922 Massachusetts State Representative Coleman Silbert introduced House Bill 1131 calling for removal of the *Synagogue* panel. The substance of the bill read: "The trustees of the public library of the city of Boston are hereby authorized and directed to remove the picture 'The *Synagogue*' from the Boston public library."[40] Soon thereafter, on the basis of *Eliot v. Trinity Church* and similar legal precedents, Attorney General J. J. Weston informed *Synagogue*'s detractors that any proposal urging outright removal of the painting would probably be deemed unconstitutional. In response, Silbert redrafted his original proposal. The revised version of the bill (House Bill 1749) called for removal of the painting by right of eminent domain for use in the Massachusetts public school system.

The state Judiciary Committee referred the legislation to the House Ways and Means Committee for a decision on its financial implications. A range of citizens spoke before the committee. The Reverend Dr. Doremus Scudder, executive secretary of the Greater Boston Federation of the Massachusetts Federation of

Churches, spoke on behalf of the federation's broad coalition of Protestant denominations ("Twenty-five Ecclesiastical Bodies of Fifteen Denominations Representing Twenty-three Thousand Churches"): "Anything which is looked upon as an insult to a church with such an historic past should be avoided. Protestants should sympathize with the Jews in their feeling toward this picture. It represents the Jewish faith as decadent. As Christians we are ashamed of what some Christians do."[41] Assistant Attorney General Lewis Goldberg spoke in favor of House 1749 on behalf of the Young Men's Hebrew Association of New England (of which he was president) and the Young Women's Hebrew Association of New England, representing together some twenty-four thousand members. State Representative George Louis Richards, who was chair of the Massachusetts Federation of Churches Legislation Committee; Leo J. Lyons, president of the Amos Lodge of B'nai B'rith; and Isadore Fox, chair of the New England chapter of the Anti-Defamation League of B'nai B'rith, also spoke for the bill. Silbert provided details on the action's rationale: "It is proposed to preserve the painting as a work of art and the production of a great artist. The State Board of Education can use the painting in connection with courses on art. It has the two-fold purpose of illustrating history and art, but when it is evident that its historical motive is wrong, then it should not be allowed to stand as teaching history. It is used improperly where it is now. It is hoped to put it to the proper use as a work of art."[42]

In continuing his comments, Silbert suggested that it would likely cost the commonwealth about five thousand dollars to take the panel by eminent domain. The journalist reporting on the session characterized Silbert as "not opposed to an artist depicting the supremacy of Christianity, but this ought not to depict the fall of Judaism."[43] The House Ways and Means Committee sent the matter forward to the state's Joint Judiciary Committee for a public hearing. Informed on 17 February 1922 that the hearing to consider both versions of the bill regarding the removal of *Synagogue* would be held before the Joint Judiciary Committee of the Commonwealth ten days later, the library trustees (including a Catholic priest, the Reverend Monsignor Arthur Theodore Connolly; a Protestant minister, the Reverend Dr. Alexander Mann; and a prominent Jewish businessman and philanthropist, Louis Edward Kirstein) voted "that the Corporation Counsel be informed that this Bill has been brought to the attention of the Trustees; and that the subject matter has never been discussed by them on its merits, they having been informed by the Corporation Counsel on a previous occasion that they had no power whatever in the premises."[44]

Sargent did not attend the 27 February 1922 hearing (he did not come to Boston until May). The artist's supporters were likewise conspicuous in their absence, or, at the very least, in their unwillingness to speak in his defense, falling back again, perhaps, on the claim that, in light of the legal precedent, they had

never discussed the substance of the charges. At least one member of the board of trustees may have had mixed sentiments; Alexander Mann had served on the board of directors of the Greater Boston Federation of Churches in 1919 and as president of that body in 1920; the federation had made its opposition to *Synagogue* clear.[45] Judge Michael Joseph Murray, apparently the only member of the library's board of trustees in attendance at the hearing, was presented by Silbert as an ally in the matter.[46] Murray's own position, as recorded in the minutes, is somewhat less conclusive on this count. Murray simply "explained the attitude of the Trustees, stating that they had never functioned in respect to the matter." After drawing the attention of the assembly to the similar "Phillips Brooks statue case" at Trinity Church, he concluded by assuring those present that he "personally did not wish to offend the religious sensibilities of any person, and he was sure that the other Trustees were with him in that respect."[47]

Those who spoke out at the hearing overwhelmingly favored seizure of the panel.[48] The minutes recorded the comments of many, Jew and Christian, that Sargent's *Synagogue* was "historically false" and "made justice subservient to art." At Silbert's request, the Central Conference of American Rabbis had appointed a local conference representative, Rabbi Harry Levi of Boston's Temple Israel. Levi read into the hearing's minutes the conference's earlier resolution on Sargent's *Synagogue* (as it had been sent to the library in November 1919).[49] Various politicians, religious leaders, and concerned citizens urged the state to "dispose of this ill-conceived picture," to take it, whitewash it, smear it over, wipe it out.[50] Only one person stood up to oppose the bill. The record of the meeting characterized him as "a young Jew who stated that while he did not like the picture, it was a work of creative art, and that it was altogether too big a fuss to make over so little a thing." In a conciliatory gesture, Samuel Silverman, the city assistant corporation counsel, who, like Silbert, was himself Jewish, recommended a meeting of the artist, the trustees, and the Committee of Citizens (who had contracted with Sargent for the east wall in 1895) "to see whether . . . the picture could not be removed without resorting to the right of eminent domain."[51] If such a meeting ever materialized, no record of it survives. The minutes concluded with a statement of the Joint Judiciary Committee's intentions to visit Sargent Hall to study *Synagogue* and *Church* themselves.[52]

In June 1922 Silbert's bill to remove the painting by right of eminent domain for use in the public school system came before the Massachusetts House and Senate. Sargent was in Boston from May to December 1922 but appears to have disassociated himself from the proceedings. As reported in *American Art News*: "John Singer Sargent, creator of the mural decorations in the Boston Museum of Fine Arts as well as those in the Public Library, returned to the United States a few weeks ago, but he has not appeared publicly since except to visit a

local artist's exhibition. One of the local papers asserts that Mr. Sargent, who is at the Copley-Plaza Hotel, 'made it known through a friend that no reflection on the Jewish race was intended' by his famous mural decoration, and the paper adds that the painter 'evidently is not disturbed by the legislative action.' "[53]

On 7 June, after Silbert's bill had passed the House and on the day of its passage in the Senate, Assistant Librarian Otto Fleischner, a Jewish man long on friendly terms with Sargent, wrote Sargent patron and supporter Isabella Stewart Gardner a tardy but urgent note. Adopting a tone that indicated his sense of topical concordance with Gardner, Fleischner recommended an immediate and "strong protest . . . either by letter or by telephone" to the proper state officials. This course of action alone, Fleischner believed, might prevent the otherwise inevitable passage of "that nonsensical 'Synagogue' bill."[54] Erratic summer schedules had frustrated the assistant librarian in his attempts to contact other friendly parties. The exasperated Fleischner still hoped at least to reach Augustus Hemenway, one of the influential individuals who had played a significant role in securing funding and contractual agreements for the Sargent decorations. Fleischner finally located Hemenway, and on 8 June—a day too late—Hemenway wrote to Governor Channing H. Cox asking Cox to use his influence to "have a resolution passed in the Senate referring the matter to the Supreme Court of the Commonwealth in reference to the constitutionality of the proposed law." In Hemenway's opinion, this was the only way to avert cultural disgrace and to avoid becoming the "laughing-stock of artistic people throughout the world."[55]

But, as the *Jewish Advocate* reported on the day of Hemenway's letter, the Senate, their hearing room "crowded" by Protestants, Catholics, and Jews who supported the measure, had already adopted "Silbert's Bill" the day before.[56] A subheading for the weekly's article noted that Silbert had argued his case from a "Broad American and Not Jewish Viewpoint"—and it would seem that, from a religious perspective at least, Silbert's support was broadly "American," confined neither to the Boston area nor to Jewish individuals and groups. While, like Silbert, the most outspoken proponents of seizure were Jewish, throughout the conflict's legislative phase prominent Protestants and Catholics publicly supported and expanded on the position taken by Jewish leaders. The Federation of Churches (on both state and municipal levels) played a particularly active part, as did the Young Men's Christian Association.[57]

As both Jews and Christians urged removal of the panel, so both Jews and Christians expressed their dismay over the "agitation." During the course of the protest, individuals of both faiths sent "private" letters to the library in sympathy with Sargent.[58] On 14 June 1922, lawyer James Garfield Moses wrote, "As a Jew, I resent the agitation which has resulted in this hypocritical measure. I should be very glad to subscribe to a fund to test the constitutionality of this law.

The action of the promoters of this proposition is calculated to foment rather than to lessen or remove race prejudice."[58] The *public* support the artist received throughout the controversy, however, came principally from the library (or those directly associated with it) and from other artists. The library's trustees, rather than engaging in discussions of substance, simply stated that they could not legally remove the panel. The one Jewish member of the board of trustees, Louis Edward Kirstein, after consulting Sargent directly, decided in favor of the artist's position, but seems to have expressed his support principally behind the scenes. Kirstein was impressed by Sargent's demeanor in the face of opposition. Lincoln Kirstein, Louis's son, in a memoir written later, described his family as essentially nonobservant in its Jewishness, though his father was active in Boston Jewish philanthropies and Lincoln was sent, for a time, to Saturday Bible school at Rabbi Harry Levi's Temple Israel. In the memoir, Lincoln recalled visiting his father at the library during the years of the *Synagogue* debate and reflected on his father's perspective on the subject: "He felt unequipped to render aesthetic, theological, or, what was probably primary, any political judgments. Steps were therefore begun to remove the murals, though Father was judiciously slow to comply with a public which had already forgotten its own protests against twin bare-assed boys supporting a civic seal [the Saint-Gaudens seal above the library's main entrance]. In the meantime, Sargent was invited to justify his work. My father was deeply impressed by the painter's professionalism, lack of vanity, historical logic. . . . Sargent's gravity, grace, lack of resentment, his acceptance of the world's Philistia, were convincing."[59]

The support of Sargent's fellow artists came early in the debate. In November 1919 the board of directors of the American Fine Art Society passed a resolution in Sargent's defense. On 23 November Sargent sent a letter expressing his gratitude.[60] A columnist for *American Art News* described the reaction of another group of artists, reiterating their opinion that "to remove the 'Synagogue' would destroy the unity of the great series devoted to Judaism and Christianity. . . . Sargent [has] chosen . . . a motive which was commonly used in the Christian architecture of the Middle Ages: the contrast between the 'Church Triumphant' and the 'Synagogue Defeated.' Whether judiciously chosen or not, the subject was historically correct. It belonged logically in the series."[61] On 18 May 1922 the Boston Art Commission voted that its chair, Thomas Allen, should write to the Massachusetts attorney general "on the subject of the proposed act of the legislature providing for the removal of a painting at the Boston Public Library by Sargent."[62]

The 7 June Senate vote, the *Jewish Advocate* optimistically maintained, "brought to an end" the "controversy over removal of Sargent's panel." On 14 June 1922, the day after Governor Cox signed the bill into law, Silbert wrote jubilantly to the Central Conference of American Rabbis: "May I at this time say

that the Conference may feel that it did yeoman service in this case, as the presentation of the case as set forth in the [conference] President's report in vol. XXX of your annual reports, was very effective in pointing out the injustice of the situation and in gaining adherents to our bill."[63] Celebration of the incident's conclusion, however, was decidedly premature.

While the bill passed the Massachusetts House and Senate and was signed into law by Governor Cox on 13 June, State Senator Monk of Watertown, having apparently reached the same conclusion as Hemenway and perhaps at his behest, introduced a measure calling for a state Supreme Court decision on the law's constitutionality.[64] This was the action the library had hoped for all along, possibly because the precedents seemed strongly to suggest a court opinion that would match their own desire to retain *Synagogue* and also because the judicial process guaranteed somewhat greater remove from the public arena of state politics. The courts, however, moved relatively slowly; evidently even before the judiciary had rendered an opinion (ultimately finding that the state had no legal right to take the painting), an alternate route to the conflict's abatement had been selected.[65]

On 21 October 1922 Corporation Counsel Hill wrote to Thomas Fox with questions regarding the material feasibility of removing *Synagogue*. Hill's letter makes it clear that he and Sargent had discussed the matter at least briefly and that Hill believed it impossible to remove the panel intact. Hill followed up this letter with one dated 30 October requesting another meeting with Fox on the subject of the "much vexed *Synagogue*."[66] The legal date for the actual taking of the painting, initially set for six months from the bill's passage, was subsequently extended to 1 July 1924 by House Bill 1012, dated January 1923. Francis J. Good, of the Massachusetts Department of Education (which had serious reservations about receiving the painting), pursued the extension. On 21 November 1923 Payson Smith, commissioner of education, wrote to Monsignor Arthur T. Connolly, president of the library's board of trustees from 1923 to 1924, expressing his conviction that they should work toward the repeal of the "original measure." In so doing, however, Smith wanted to avoid giving offense and to minimize friction over the issue. As a first step, Smith hoped to meet with the trustees or their representatives to discuss strategy.[67] On 30 November a recorder added a note to the bottom of Smith's letter specifying that the trustees took no official action but would informally consider Smith's gesture. In fact, any deliberations were so informal as to leave no paper trail. But Commissioner Smith's inclinations, which the trustees likely embraced, can be discerned from his annual set of recommendations to the state's general court.

As the eighth item in a list of eight, Smith constructed his rationale for repealing the bill that authorized the removal of *Synagogue* by right of eminent domain for educational purposes. Indeed, Smith claimed, the schools did not

want the image. For one thing, they had no practical use for it, it was "unsuited" to educational purposes, and they could not ensure the safety of such a costly work of art; for another, they feared the sort of sectarian and religious controversy it had aroused. The isolation of *Synagogue* "from the other paintings of whose general theme it is a part," the commissioner observed, would only serve to accentuate its problematic character and "significances as a religious interpretation."[68] Given Smith's 21 November letter to Connolly and his evident alliance with the library on this issue, and given, further, the likelihood that the controversial painting, once seized, might have been stored rather than exhibited, Smith's protest reads as a smoke screen designed to resolve the conflict on the library's terms but without unduly offending the image's detractors.[69]

On 10 March 1924 Leverett Saltonstall, acting for the Joint Judiciary Committee, reported to the state House of Representatives a bill originating with the state Department of Education and calling for the repeal of Silbert's *Synagogue* bill. A few days later, on 15 March, Hill informed Fox that the House had approved the act (House Bill 1398) repealing the earlier measure (House 1749) for removal of the panel:

Enclosed herewith please find copy of an Act repealing the law requiring the removal of the Sargent picture. It has passed the House, the only place there was likely to be any trouble, and is substantially certain to pass the Senate and be signed by the Governor within a few days. I think it eminently satisfactory, for the preamble really means nothing, and the whole matter is definitely put an end to, so that any fresh agitation will have to start from the ground up. Mr. Sargent, to whom I showed a copy of the Act, is very much pleased with it.[70]

The "preamble" to House 1398, dismissed so readily by Arthur Hill, may have been far more influential than he imagined. When considering the fact that Sargent ceased to work on Sermon on the Mount once the dispute began and apparently never returned to the painting, knowledge that Hill shared a copy of the act of repeal with Sargent is significant. In the preamble that Hill found so innocuous the artist would have read: "It is the sense of the general court that in the future no pictures involving possible religious discussions or controversies be removed to or otherwise placed in public buildings."[71] He would have seen, further, that the legislature had enacted House 1398 as an "emergency law" to ensure that this provision regarding the public representation of religion went into effect immediately. Perhaps Sargent decided that Sermon on the Mount was a picture "involving possible religious discussions or controversies."

By April 1924 the *Synagogue* bill had been repealed by both the House and Senate, and the repeal approved by Governor Cox. The final version of the

Fig. 104

Photograph showing damage to *Synagogue*. From Herbert Thompson to Josiah Belden, 25 February 1924, Boston Public Library, Department of Rare Books and Manuscripts. Trustees of the Boston Public Library

bill as amended by the Senate deleted the "emergency" designation and, interestingly, modified the wording of the preamble. The bill that the governor finally signed shifted the burden from "religion" to "race and class." While the terms of the repeal itself remained the same, the new preamble to the bill read: "It is the sense of the general court that works of art which by their nature and character reflect upon any race or class within our commonwealth should not be placed in public buildings."[72] (The Senate's new wording is worth note, not least because of contemporary tendencies of groups outside Judaism to define Jewishness in terms of race rather than religion, and also because the House version would have rendered problematic many other paintings already in situ in courthouses, libraries, and other public places around the city, state, and nation.) Two months before the repeal, as the likelihood that the panel would actually be removed diminished, an unidentified vandal splattered Sargent's *Synagogue* with ink (fig. 104). While most accounts downplayed the extremity of the situation, even poking fun at the ineptitude of the attack, one journalist underscored the undiminished ideological charge of the painting, noting that the library had stationed a

guard by the image, "the center of bitter feeling since it was placed" in 1919.[73] Sargent himself assisted the Museum of Fine Art's Herbert Thompson with the restoration; the physical damage to the mural was not permanent.[74]

THE CONTROVERSY OVER *SYNAGOGUE:* THE ARTIST'S RESPONSE TO CRITICISM

On more than one occasion, Sargent indicated bewilderment, annoyance, and frustration with the vehemence and duration of the objections to his *Synagogue.* For the most part, however, he avoided direct engagement with his accusers, communicating his feelings indirectly through friends and library officials. Sargent's frank antipathy to public speaking made any open exchange unlikely. As Thomas Fox intimated: "To be absolutely truthful, there was a trace of fear in Sargent's make-up, and it was manifest in at least two instances; one in anticipation of a formal interview with the representatives of the press, and the other when called upon unexpectedly to make an after-dinner speech."[75] While this "trace of fear" should not be mistaken for timidity (at age sixty this artist spent three weeks in a tent in the Canadian Rockies on a summer painting excursion), it should be considered a significant element in his public demeanor.

Frederick Coburn exaggerated when he selected a title for a lengthy article on Sargent: "John Singer Sargent Is Sphinx of Modern Celebrities: Boston's Giant of the Art World Makes Egypt's Symbol of Silence Seem Like a Chatterbox—Most Human of Men, Sargent Remains Uninterviewed and Uninterviewable." Coburn as much as admitted the hyperbole of the title in his inclusion in the essay (written in the early 1920s) of a description of a 1916 interview with Sargent. Though one might quibble with the journalist on technicalities, however, the experience he relayed hardly qualified as a "real" interview:

The Boston art critics . . . once had an interview with Mr. Sargent, or a chance to get one. It was a painful experience to them as well as to him. They fell down so badly that at least one of them [Coburn] made no effort at the time to get his impressions into print. There seemed to be no point in publishing a viewless interview.

That interview which ended in fiasco was quite properly arranged for the local press by the late Josiah H. Benton, chairman of the trustees of the public library. Mr. Sargent had just finished and installed the spandrel decorations and their accessories in the long gallery at the library . . . as Mr. Benton had explicitly asked him to meet the newspaper writers he graciously consented.

Then he wished he was dead.

He didn't say just this, of course, as with much ceremony the scribes were

brought forward and presented to him, but his face said it. . . . he was plainly undergoing an ordeal and while he spoke pleasantly enough and answered a few questions to the best of his ability, there was no real give and take in the interview. It, in fact, wasn't a real interview at all, and neither the scholarly persistence of Mr. Downes of the Transcript nor the trained persuasiveness of Mr. Philpott of the Globe could make it anything but a flat failure. The "story" that was to have gone to The Herald never reached the city desk.[76]

Sargent was particularly loathe to be interviewed about controversial subjects and privately expressed his sense of relief that the fact that he had not seen MacMonnies's *Bacchante* provided him with a good excuse for pleading ignorance when the *Boston Evening Transcript* asked him to comment.[77]

Sargent's response to a social invitation in 1916 was characteristic: because of the implied obligation to speak, he declined, citing his "constitutional blue funk of public dinners where the only decent alternative to *not* making a speech is to wear a false nose or commit hari kari—neither of which are customary—I know my blind staggers at the prospect of large gatherings are foolish and tiresome, and that there may be some pill that would cure them, but they are chronic, and I simply have to stay away."[78] In 1901 the artist had responded to a similar invitation, this one from William Rothenstein, in the same fashion: "My only misgiving is that if there are to be speeches . . . one might be expected from me, and I am utterly incapable of saying a word. I dare say this is a recognised fact by this time and I need not fear being asked."[79] No wonder he did not hurry to speak in his own defense at the hearing in February 1922.

While, as we have seen, messages designed for public consumption maintained that "the painter 'evidently is not disturbed by the legislative action,' "[80] an encounter at the height of the protest, recalled somewhat later by C. Lewis Hind, suggests the degree of Sargent's defensive vulnerability. Describing an hour's visit in the artist's apartment, Hind commented that he and his wife "saw and heard the real Sargent. We saw too how sensitive he was to criticism. . . . He showed me books to prove that his point of view was tenable."[81] Marc Simpson has demonstrated just how carefully Sargent constructed the professional parameters for reception of his work.[82] The artist just as deliberately avoided not only public speaking in general and public defense of his own positions, but also self-revelation of just about any kind. Henry McBride perhaps said it best: "Mr. Sargent succeeds in shunning the personal end of publicity more than anyone who has come into vogue since publicity was invented. He is never interviewed and nothing that he says or does ever leaks into the public press. . . . Gossip can do nothing with the silent Sargent."[83]

He could be relied upon to refuse to endorse any sort of biographical enterprise, even those undertaken by the most reputable firms and individuals. In

1917 he responded with humor to one inquiry: "As to biographical details there are none of the least interest to the public. I have left no diary and am vague about dates marking events in my artistic career. It strikes me, and may strike you, that I am advocating a posthumous volume! That indeed would suit me 'down to the ground.' "[84] To a similar proposal in 1921 by the Boston publishing firm Little, Brown and Company, Sargent replied with more impatience, "I can only repeat what I stated on a previous occasion, that I am entirely out of sympathy with the project."[85]

Fiercely protecting his own privacy, Sargent so conscientiously destroyed personal letters after answering them that he frequently found himself in the embarrassing situation of having to ask for clarification of the engagements arranged therein—or of missing some social event altogether. To Mrs. Fuller Maitland he wrote: "I have been out of town for a week and on returning I find in my blotter a kind invitation from you to lunch on the 21st last. And as I usually destroy notes on answering them, I am filled with misgivings as to whether this one was never acknowledged. . . . I sincerely hope I have not been guilty of such carelessness, and if so my apology and my regrets are ready to come forth at a sign."[86] Not only did Sargent destroy letters, discourage would-be biographers, and refuse speaking engagements and interviews, he also disposed of works of art that he judged, for one reason or another, to be expendable. Thomas Fox reported that "there were cleanings at various times, and radical ones at that, which consisted mostly of the absolute destruction and elimination of all works not destined to see the light outside the workshop. Very little—in point of fact almost absolutely nothing which was not complete as to its purpose was allowed to permanently escape whole through the outside door."[87]

With regard to the *Synagogue* debate, despite, or perhaps because of, his emotional response to the controversy, Sargent's behavior was consistent with patterns he had established earlier in his career. As a contemporary news item noted, Sargent "declined to comment on the discussion his painting the 'Synagogue' in the Boston Public Library has aroused."[88] He handled the conflict over *Synagogue* much as he had the stir caused by his portrait of Madame Pierre Gautreau (1884); he remained outside the public fray and he directed his artistic energies elsewhere. In the wake of the earlier conflict, Sargent moved his principal professional residence from Paris to London; the later one precipitated a similar renegotiation of territory, this time artistic rather than geographical. Commissioned in 1916 to decorate the rotunda of the new building for the Museum of Fine Arts (three years before the final public library installation), Sargent completed that task in 1921 and immediately undertook the decoration of the main staircase in the same building, a project he had finished but not yet installed at the time of his death. In 1921 Sargent also agreed to paint two murals for the

Widener Memorial Library at Harvard University; he completed this assignment in 1922. Throughout the controversy over *Synagogue,* then, other business in Boston occupied the artist's time.

Another aspect of Sargent's personal history likely magnified his distress at public opposition in 1919. During the first decade of the twentieth century, Sargent had decided, only partially successfully, to discard portraiture in favor of other artistic genres, largely because he was tired of subjects that talked back, that demanded revisions or adjustments of their features.[89] He wrote to Violet Maxse:

Please don't ask me to paint anybody! I have taken portraits . . . to such a degree that my principal employment in life is to dodge them when I see them describing a parabola in the air in my direction. You have given me a chance for which I am grateful, by not mentioning who it is who has this morbid wish to be painted—so there is nothing personal about my diving into my bombproof shelter—Please make it clear to the bomb and never tell me who it was. If I knew I should feel almost as bad as if he or she were in the hated category of future sitters.[90]

Reporting a 1918 conversation with the artist, Charles Knowles Bolton, who was sitting to the portraitist at the time, recalled a (strongly gendered) comment Sargent made to him: "I lost my nerve for portraits long ago when harassed by mothers, critical wives and sisters."[91] In addition to the opportunity to work in a more exalted (and masculine?) aesthetic arena, the public library mural project promised Sargent complete discretion relative to subject and treatment. Unlike the living and present subjects of his portraits, the historical subjects of his murals were unable to object to his conception of them.

But, to Sargent's chagrin, the shift in genre did not prevent the intrusion of "experts" (now predominantly male) with suggestions for improvement. Beginning shortly after the first installation, numerous Bostonians stepped forward to correct the artist in his representation of Western religious history. Especially eager were those specialists in biblical and ecclesiastical languages, who offered unsolicited, often condescending, corrections to the murals' inscriptions.[92] The controversy over *Synagogue,* then, did not represent the first contentious engagement over the "accuracy" of parts of the cycle. On at least two different occasions, alterations in some of the Hebrew and Latin inscriptions were rather rapidly executed. Usually Sargent learned of complaints when they were indecorously aired in the local papers; few correspondents addressed their concerns to the artist's attention alone.

An exception that proved the rule was Rabbi Charles Fleischer's letter to Otto Fleischner in February 1903. Fleischer offered to point out to Sargent (in person) some discrepancies in his Hebrew. Sargent responded courteously to this

sort of private intervention, and, though Fleischer's emendations reached back to the Ten Commandments of the 1895 installation, the artist apparently heeded the rabbi's advice. Somewhat later in 1903, Sargent produced a charcoal portrait of Fleischer, who preceded Harry Levi as rabbi of Temple Israel; the portrait sketch was executed at Fenway Court on Easter Sunday.[93]

More often, however, the exchange was more antagonistic. In 1903 Sargent wrote to Fox: "Some wiseacre has discovered a fault in prosody in my Latin inscription—it ought to be Corporeous Redimo instead of Redemo Corporeus—do you think it would be easy to make that alteration without its showing? If so I suppose it would be worthwhile—what do you think?"[94] In 1919, during the installation of *Church,* two of the evangelist symbols surrounding the allegorical figure were inadvertently switched so that the inscription for Luke was installed adjacent to Matthew's winged man and Matthew's inscription adjacent to Luke's ox. Since Sargent had already painted these symbols correctly in his south ceiling three years earlier, the mistake was not likely an indication of insufficient knowledge of religious iconography. Instead it probably represented an oversight in the process of installation. Sargent apparently noticed and corrected the inaccuracy immediately following the unveiling of the painting. Someone complained to the *Evening Transcript,* however, and an item that ran on 16 October printed an "erudite correspondent's" sarcastic comments. On 17 October the *Evening Transcript* noted the correction.[95] Given the tone of the missives that generally undertook to inform Sargent of his mistakes, the fact that he would take umbrage at the situation is not surprising. Further, such public and purportedly scholarly interrogations surely presented a challenge to the reputation for intellect and imagination Sargent wished to secure.

Outside of his letter to the *Jewish Advocate,* apparently Sargent's only overt and public response to the controversy was an artistic one. His own defensive vulnerability did not leave him entirely without resources. In 1922, at the height of Boston's legislative struggles over *Synagogue,* Sargent engaged in a bit of witty

Fig. 105

Opposite: John Singer Sargent, *Apollo in His Chariot with the Hours,* part of mural
program for Museum of Fine Arts, Boston, stairway, Huntington Avenue entrance,
1921–25. Oil on canvas, 129 x 302 in. (327.7 x 767.1 cm). Museum of Fine Arts, Boston,
Francis Bartlett Donation of 1912, 25.640

Fig. 106

John Singer Sargent, *Madame X (Madame Pierre Gautreau),* 1884. Oil on canvas,
82 1/8 x 43 1/4 in. (208.6 x 109.9 cm). The Metropolitan Museum of Art, New York,
Arthur H. Hearn Fund, 1916

and self-reflective prognostication in one of his murals for the Museum of Fine Arts. As Jane Dini has demonstrated, there, in *Apollo in his Chariot with the Hours* (fig. 105), a composition derived from Guido Reni's *Aurora,* Sargent replaced Reni's Aurora with his own Diana, a figure bearing the distinctive features, as well as the dark draperies, of Virginie Gautreau.[96] By this time Gautreau, who wore Diana's signature crescent moon in the 1884 portrait (fig. 106), was Sargent's most famous and notorious "triumph," a "scandalous" image, widely acknowledged as one of his most aesthetically successful paintings. In *Apollo in His Chariot,* Apollo, representing the fine arts, puts temporary controversy (Gautreau as Diana, goddess of night) to flight, alluding not just to the earlier episode with the portrait, but also to Sargent's current sense of embattlement at the library and to the mounting attacks of modernist critics like Roger Fry and Forbes Watson on his work as a muralist. Perhaps this reference to Gautreau represented Sargent's attempt to have the last word—or perhaps he merely took this opportunity to express his own conviction that truly great art will ultimately vanquish scandal, as it had in the case of Madame Gautreau. Gautreau's rendering at the Museum of Fine Arts related her rather directly to another prominent figure in the library murals. Early in his conception of *Triumph,* Sargent identified Astarte (fig. 5) with another fertility goddess, "Diana of Ephesus," whose cult image "had fallen from heaven," as his copy of *Helps to the Study of the Bible* (in the caption next to Diana's picture) would have reminded him.[97]

Hind's notation that Sargent showed him books to demonstrate the validity of his historical sources underscores the gap between Sargent's perception of his working method and the argument of *Synagogue*'s detractors. For Sargent, authority rested in cultural precedents, art historical and literary. He approached *Triumph of Religion* "from the point of view of iconography"; his idea rested on a modern interpretation communicated by means of reworking the religious iconography of the past.[98] For his critics, on the other hand, authority rested in *historical* accuracy rather than iconography and on a sense of democratic fairness. Rabbi Franklin demanded greater historical consciousness from someone in Sargent's position. To Sargent's iconographic explanation, Franklin responded, "to assert that pictures in the great cathedrals of Rheims and Strassburg have established a tradition in regard to the treatment of the Synagog is unworthy of a man of Sargent's standing, for does he not know under what stress those paintings [*sic*] were made?" Silbert spelled out the argument in terms Christian Boston might understand:

The objection to the painting is that it represents Judaism as downfallen or dead, which is far from the truth. But the action taken by the Legislature was not done especially for the Jewish people. We put it in a broader light, claiming that it did not depict history cor-

rectly. Suppose it was a painting portraying the advent of Martin Luther and the conse-
quent fall of the Roman Catholic Church, wouldn't there be objection? It is practically
the same as a picture would be showing Phillips Brooks instead of the woman in Sargent's
picture as symbolic of the Episcopal Church suffering downfall because of the growth of
Unitarianism. It is against the broad spirit of Americanism. That is what we object to.[99]

Earlier assertions of Sargent's objectivity reappeared insistently in the art
critical literature in response to the controversy over *Synagogue*. Before and after
the *Synagogue* debate, many noted the "impartiality" of his treatment: "You ap-
preciate the amount of thought and study which he has given to this decoration
when he shows that he is equally at home on the subject with the Catholic priest,
the Jewish Rabbi, or the Modern Agnostic"—and again: "The great artists who
attempted this sort of thing in the past were usually men of strong religious bias—
dogmatic in their attitude. Sargent has risen above that. He has visioned the
whole religious idea involved in the Jewish and Christian doctrines in a theme of
appalling grandeur."[100]

While Sargent's careful avoidance of verbal and literary self-revelation
and his personal monitoring of visual material (as suggested by Fox) shed light on
his emotional response to the fact of controversy over *Synagogue,* Sargent's refusal
to engage in debate had to do with conviction as well as personality. He had
adopted, almost as an ethical precept, and well before the *Synagogue* conflict, the
notion that the artist must remain apart from contemporary sectarian debates in
politics and religion. Consequently, from his own perspective at least, he ap-
proached *Triumph of Religion* in a nonsectarian and appropriately secular fashion.
The artist did not see that his murals perpetuated, perhaps even exacerbated, old
biases. He had not consciously intended insult. Though he found the unconven-
tional attractive, he was also highly committed to social decorum. He wanted to
be modern, innovative, and even startling, but he had no desire to offend.[101] For
Sargent, his selection of Synagogue and Church was authoritative because nu-
merous art historical precedents existed.

Those who opposed the paintings did not find Sargent's argument from
precedent compelling. They discerned a fundamental distinction between histor-
ical event and historical representation. Arguing that the artist's precedents had
been generated by an essentially Christian and blatantly anti-Jewish polemic and
were themselves biased, *Synagogue*'s detractors maintained that the source materi-
als of artists ought not supersede "what actually happened."[102] Judaism did not
die birthing Christianity; "historical truth" alone ought to constitute authority.
As Coburn maintained: "It is, of course, a fact that the Jewish religion is far from
being a dead one in Boston or anywhere else in Christendom. A few minutes
walk from the Public Library might convince any one of that fact. Synagogues of

the Back Bay and suburbs are as well attended and prosperous looking as any of the churches of this neighborhood."[103]

Sargent would have agreed, in fact, with his painting's accusers and with William Howe Downes that *Synagogue* and *Church* represented "obsolete suggestions of doctrinal differences." Both panels intended to flank *Sermon* indexed outmoded religious dispensations, the external and reified apparatus of historical institutions, not the subjective and spontaneous experience of the inspired individual that the artist wished to recommend.[104] Commentary on the current ideal direction of spirituality Sargent reserved for his final mural.

The five-year public controversy generated by the 1919 unveiling of *Synagogue* and *Church* at least temporarily shifted the principal context for critical discussion from one of aesthetic admiration to one of religious and political debate. From its installation, Sargent's *Synagogue* occupied a very tenuous position. On several occasions seizure of the painting ("this painful work" as the artist called it) seemed imminent.[105] No wonder that less than three months after the matter was finally settled in 1924 by the repeal of the bill to remove the image for educational use, the library's then director, Charles Belden, reported to art historian Rilla Jackman that Sargent was not "disposed" to complete the cycle.[106] In 1925, at the time of Sargent's death, the final panel had not advanced beyond the preliminary stage of broadly conceived sketches and studies. In a memorial address delivered to the Philadelphia Art Alliance on 27 April 1925, artist Violet Oakley expressed an opinion conveniently adopted by many: that it was the painter's death that had in fact prevented the completion of the final public library painting.[107] But the telling comment to Jackman from Belden suggests otherwise—as does the fact that, while as late as mid-May 1918 Sargent requested additional measurements from Fox specifically for *Sermon on the Mount*, no additional sketches or studies for that panel appear to have been finished after the controversy began.[108]

Some have suggested that Sargent ultimately decided his *Synagogue* and *Church* completed the cycle.[109] To the contrary, the artist apparently never sought to collect—and the library certainly never offered—the final payment for the murals contracted in 1895. After the painter's death, rather than transfer the reserved moneys to Sargent's estate, the Massachusetts Supreme Court ruled that the library could use the full amount of the final five thousand dollars intended to pay for the murals on the east wall to preserve the paintings already in Sargent Hall.[110] According to the stipulations of the 1895 contract, such a judgment could only have been made were the murals deemed substantially incomplete. The assault on *Synagogue* led Sargent to abandon *Sermon on the Mount*, dropping the very scene (see fig. 107) that, in concert with *Frieze of Prophets,* made formal and narrative sense of all the rest. As late as 1915 Sargent had contended that *Triumph of Re-*

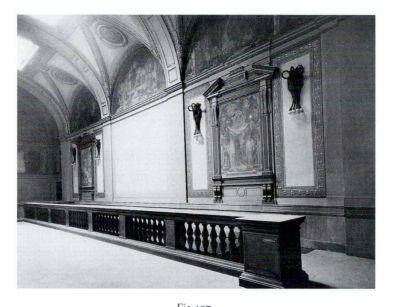

Fig. 107

Sargent Hall, looking toward the east wall from the south, c. 1919. Trustees of the Boston Public Library

ligion had a distinct beginning (first pagan, then Jewish) and end ("subjective" spirituality represented in Sermon); in May 1918 he anticipated additional work on the keynote panel.[111] The artist did not change his conception of the program's climax; he simply stopped working on the project.

OTHER COMPLICATIONS, DIGRESSIONS, AND SUBTEXTS

If Thomas Fox is a reliable witness, *Triumph of Religion,* including Sermon on the Mount, was the one artistic project by which Sargent most desired to be remembered.[112] Why would he abandon a project of this magnitude just one painting short of completion? Ultimately, a confluence of factors, religious and political, artistic and personal, apparently led the artist to this outcome. Most important, the 1919 installation generated a controversy with regional and even national ramifications. The political and social context of immigration restriction and the accompanying rise of ideological antisemitism; an underlying, widespread, and for the most part unexamined cultural ambivalence toward Jews and Jewishness; and the specific location of *Triumph of Religion* in a publicly funded institution all contributed to the volatility of Sargent's *Synagogue.*

The controversy, however, was neither the only nor the first hint of trouble. In fact, the religious conflict gathered steam at a time when the stylistic

shortcomings and artistic disunity of the 1916 and 1919 installations would have been apparent to the artist. This second set of circumstances exacerbated the impact on Sargent of the protracted *Synagogue* debates and diminished his resolve in the face of opposition. Visually, his paintings had not come together as strongly as he had hoped. With the panels installed in 1916 it became clear that at least two sometimes conflicting aesthetic commitments governed his work: Sargent's attraction to art historical referencing competed for attention with his calculated movement from hieratic abstraction to naturalism. Style, no longer tied so exclusively or at least so apparently to the artist's judgments about the evolutionary content of religious history, also communicated his fascination with the history of art. While the latter agenda was one shared by the entire cycle (we have already seen its presence in the cycle's conception and in the earlier panels), only with the 1916 installation did the one attachment come into conflict with the other. From the perspective of Sargent's aesthetic vocabulary, the issue was, quite simply, a problem of two differing chronologies of stylistic "development." Religion had "evolved" toward nondogmatic subjectivity somewhat more slowly than art had "evolved" toward naturalism. Renaissance and even Counter-Reformation *ecclesial hierarchies,* for both Renan and Sargent, still promoted, by comparison with more "advanced" modernity, a ritualized and "formulaic" institutional Christianity; the Renaissance and Baroque in *art,* conversely, adopted a more liberal humanism, reflected in a forward-looking style.

Though Sargent set out with a grand unitive scheme that linked style and meaning, and though he continuously claimed that the murals should be read as a single entity, over the long course of the project, he gradually lost stylistic momentum, and the individual parts ceased fully to cohere.[113] By the time he painted *Heaven* (fig. 61), around 1914, he was already experimenting with the weightless classicism that would characterize his Museum of Fine Arts and Widener murals (and, not incidentally, his *Church* panel).[114] Still, Sargent's "central idea" retained its edge through the 1919 installation. In recognition of the challenge to his theme represented in his Renaissance and Baroque stylistic appropriations, he used relief passages and decorative motifs to contain and partially defuse the naturalism of his sources. Note, for example, the strongly accented relief elements of *Madonna of Sorrows* (fig. 12), the delicate decoration of *Handmaid of the Lord* (fig. 11), and, especially, Sargent's rendering of *Hell* (fig. 31), a part of the Last Judgment sequence on the west wall, where extremely stylized flames, deliberately accentuated contours, and understated differentiation of individual features control a naturalism that might otherwise rival that of *Prophets* and, ultimately, Sermon.

In at least three additional ways, broad changes in stylistic climate may have figured in Sargent's hesitation: the first concerns expectations regarding mural painting in the United States; the second concerns the course of mod-

ernism; and the third concerns the visual representation of Jesus. In a sense, the American Mural Movement simply outran Sargent. He began *Triumph* before any consensus about the appropriate style for public murals had been reached; he painted *Synagogue* and *Church* well after opinion had jelled. By 1906 or so, American patrons and publics no longer wanted complex narrative schemes that required extensive guidebooks. In Sargent's murals for the Museum of Fine Arts, a decorative mode won out over narrative possibilities. In contrast, *Triumph of Religion,* by this time, struck some as overly intellectualized and even abstruse.[115] Furthermore, Sargent's trajectory from abstraction to naturalism depended on his audiences' readings of the two stylistic tendencies. In artistic circles by the end of the second decade of the twentieth century, abstraction (Sargent's mode for the ancient, the violent, the ritualistic) increasingly allied itself with the "modern" and "advanced," while late-nineteenth-century naturalism (Sargent's mode for the contemporary and "progressive") took on associations with the "conventional" and "traditional."[116] Finally, in the arena of the contemporary aesthetics of religion, Sargent may have been further dissuaded by vigorous and widespread concern with the person of Jesus and especially his representation. Who was the Christ for the modern age of doubt? How did he look? And must he necessarily be painted by an artist of faith? These were questions raised in scores of late-nineteenth- and early-twentieth-century books and periodicals. The challenge manifested itself around several specific issues (all relevant to Sargent's *Triumph*): the humanity of Jesus (with respect to the latest biblical critical scholarship); the masculinity of Jesus (with respect to anxious perceptions of the feminization of Protestant Christianity); the Jewishness of Jesus (with respect to the latest discoveries of biblical archaeology and the "scientific" study of scripture); and the disconnection of religious subject matter from religious content (with respect to broad agreement that a painting of Jesus no longer necessarily counted as a religious painting and that the religious convictions held personally by the artist mattered).[117]

The range of expectation and the vehemence of expression on these parameters was such that no artist could hope to satisfy more than a fraction of his or her audiences. Prompted by reactions to the 1899 New York exhibition of Tissot's *Life of Christ* at American Art Galleries (a collection of images that Sargent, a year later, successfully encouraged the Brooklyn Museum to acquire), Kate P. Hampton polled prominent religious leaders in New York City on the question: "Does the face of Christ, as depicted in ancient and modern art, realize your idea of a strong face?" Of the nineteen clergy who responded in print to her query, nine called themselves Protestant Episcopalian, three Presbyterian, two each Catholic and Unitarian, one Jewish (Reform), one Methodist, and one did not identify denomination. Most all agreed that the Christ represented in art was a "weak"

Christ; this weakness they saw constituted in diametrically opposed ways, however. Some found him too feminine, others thought the more feminine Christ to be the appropriate representation for contemporary life. Some believed art made Jesus look too human, some not human enough. Some saw the expression of Christ's Jewishness as a major strength, others took it as a weakness.[118] The range of opinion was at least as broad, from the art critical side of the equation, in the 1906 reviews of the New York exhibition of a series of paintings of Jesus commissioned a year earlier by the American Arts Company of Cleveland.[119]

The legal precedent to which the corporation counsel and the library trustees had turned in the *Synagogue* controversy, *Eliot v. Trinity Church,* represented a particular local Boston expression of the difficulties involved in imaging a "modern" Jesus. The statue in question, of Phillips Brooks by Augustus Saint-Gaudens, included, in addition to Brooks, a second full-scale figure: Jesus represented as an almost ghostly muse, authorizing and inspiring the famous Boston preacher. Negative response to this Jesus on the part of a large number of Trinity's members caused them to seek, unsuccessfully, to remove the statue and replace it with one commissioned from Bela Pratt. Mary Crawford Volk suggests that this local debate figured influentially in Sargent's decision to abandon Sermon on the Mount.[120] As one more demonstration, and this one close to home, of the difficulty of picturing Jesus without giving rise to attention of an unwanted sort, the impact of this case may have contributed to Sargent's sense of the difficulty of pursuing his religious theme. Yet, in the library cycle, Sargent had already represented Jesus several times with no significant negative response. The artist, furthermore, had no known direct connections to Trinity or to Brooks, and Saint-Gaudens was dead by this time. The Trinity case, however, was decided in favor of the Saint-Gaudens statue in the same year that the *Synagogue* controversy arose and with the same corporation counsel advising. Furthermore, as soon as Arthur Hill had communicated to the library his opinion establishing the Trinity case as the precedent for the library case, the two legal battles were linked in the news media. Hill surely shared a copy of the Trinity transcript with Sargent.

Personal considerations, too, hindered the artist. By nature Sargent was not a controversialist. The characterological inclinations discussed earlier in this chapter reinforced the tendency toward inertia produced in Sargent by increasing public opposition and decreasing artistic incentive. He managed somehow even to avoid any formal or official declaration regarding his "decision" to abandon *Triumph of Religion*. While no single factor accounted fully for the cessation of Sargent's labors at the Boston Public Library, the concurrence of social, artistic, and personal circumstances produced a situation in which religious controversy counted as the last straw—or maybe even the best excuse. Had it not been for the intense debate surrounding the *Synagogue* panel, Sargent in all probability—and

despite these other complications—would have painted Sermon on the Mount, completing his *Triumph of Religion.*

SARGENT AND ANTISEMITISM

The charges of antisemitism leveled at his *Synagogue* surprised and shocked Sargent's friends and acquaintances. It seemed curious and uncharacteristic to them that the artist would find opposition among Jews. In London, prominent Jews numbered among Sargent's friends and patrons: the Carl Meyer family, Maj. Sir Philip Sassoon and his sister Sybil (the Marchioness of Cholmondeley), the George Henry Lewises, Asher Wertheimer, his wife Flora Joseph, and their ten children. Sybil Sassoon's hands appeared in the Boston Public Library as the hands of the *Madonna of Sorrows;* Philip Sassoon was "the first caller at the Sargent home after the fact of the painter's death was known." [121] Sargent's portrait of Asher Wertheimer (fig. 108), with its appraising eye, eager poodle (Noble, the family pet), and especially its half-smoked cigar, has been cited as evidence of antisemitism on Sargent's part. [122] This possibility cannot be ruled out with certainty. Wertheimer himself, however, approved the portrait—and, as an art dealer, he had established his reputation on the basis of his powers of appraisal, a skill the artist surely admired. As for the cigar, Sargent, for at least the last twenty-five years of his career, repeatedly had himself professionally photographed, by Sarah Choate Sears (fig. 109), J. E. Purdy, and Havelock Pierce (fig. 110), for example, holding or smoking a similarly impressive cigar. Mr. and Mrs. Wertheimer willed to the British nation nine of the twelve Sargent portraits of family members, painted between 1898 and 1908, "as an expression of gratitude for the way in which the Jewish race is treated in England." [123] When anti-Jewish discussions in the House of Commons followed the gift, in relation to this subject Boston's *Jewish Advocate* presented Sargent as a friend of Jews and a number of the paintings as "undoubtedly among the world's art masterpieces." The article appeared in 1923 following Mrs. Wertheimer's death and during the course of the *Synagogue* controversy. [124] Sir Joseph Duveen was so convinced of the merit of Sargent's work, including his "Jewish" portraits, that he "supplied the funds for the Sargent Gallery" at what is now the Tate Gallery of Art. [125]

The problematic juxtaposition of *Synagogue* and *Church* in *Triumph of Religion* represented, on Sargent's part, not a unique personal prejudice against Jews but a largely unexamined appropriation of a wider cultural ambivalence. The equivocality in Sargent's attitudes and behaviors toward Jews and Judaism expressed a common duplexity in (Christian) America and England. [126] Human selves, like human cultures (including the works of art produced within them),

Fig. 108

John Singer Sargent, *Asher Wertheimer,* 1898. Oil on canvas, 58 x 38 1/2 in. (147.3 x 97.8 cm). Tate Gallery, London

Fig. 109

Opposite, left: John Singer Sargent drawing the actress Ethel Barrymore at Fenway Court. Photograph by Sarah Choate Sears, 1903. Private collection

Fig. 110

Opposite, right: John Singer Sargent. Photograph by Havelock Pierce, 1924. Private collection

sustain constellations of complicated, multiple, and sometimes conflicting commitments and inclinations. Without noting consciously the discrepancy in his attitudes, Sargent could simultaneously maintain long and close friendships with Jewish peers and patrons and, conversely, in the context of anticipated "bullying" by a Jewish critic, refer to more overtly prejudiced days (as well as to days when art's cultural authority presumably went unchallenged) as the "good old times."[127] The work of both Sargent and Renan reflected and promoted this pervasive cultural ambivalence; elements of both philosemitism and antisemitism can be found in artist, author, and their respective cultures.[128]

Abraham Geiger, the German rabbi and scholar of Judaism who mounted the first major Jewish critique of the search for the historical Jesus, applauded Renan for taking Geiger's own work into account, but also clarified the degree to which Renan's "scientific" scholarship, no matter how "positivist," how "secular" from the Catholic Church's perspective, actually endorsed a pervasive anti-Jewish Christian triumphalism.[129] Renan's philological definition of race, based on language rather than skin color, led him to conclude that the division between "Indo-European" or "Aryan" and "Semitic" races was substantial. In work published in the mid-1850s and reissued later in that decade and early in the next, he not only specified the existence of racial groups on the basis of lin-

guistic phenomena, he also argued the inherent inferiority of "Semites," including Jews. This position was, however, a view expressed most fully in Renan's earlier writings, a view he qualified rather rapidly and modified completely later in life.[130] By 1882, in a lecture at the Sorbonne on the components of nationality, Renan had rejected the conflation of race with language and nationality as well as biology (a position he had never endorsed himself) and suggested that the construction of race was itself historically contingent. He told his audience: "Race, as we historians understand it is then something that makes and unmakes itself. The study of race is of capital importance to the student who occupies himself with the history of mankind. It has no application in politics. The instinctive consciousness which presided over the construction of the map of Europe took no account of race; and the greatest European nations are nations of essentially mixed blood."[131] Discarding earlier ideas about race and nation, Renan called for an enlightened and educated humanism in politics, one that depended, ultimately and importantly, on the human will. This new position, while it promoted a substantially revised perspective on race, was yet consistent with other aspects of Renan's earlier thought and, significantly for our purposes, with the themes regarding individual spiritual autonomy and responsibility that Sargent drew from the author's biblical research.

Despite this qualification and revision of Renan's perspective on race, antisemites in France used his work without emendation. But philosemites used his work widely too. Those who knew Renan best maintained that, had he lived to witness the Dreyfus affair, he would have taken a Dreyfusard position in that most devastating case of public antisemitism in late-nineteenth-century France.[132] Henry James, Sargent's friend and one of Renan's greatest celebrators, was acquainted with Renan in the later years and had, in fact, met the scholar in Paris.[133] Generally reticent about speaking of personal politics in the public arena, James was known to have expressed explicitly political views in at least two historical situations: the Dreyfus case and the First World War.[134] The pairing of outspoken literary commitments to the work of Renan with a pro-Jewish position in the Dreyfus case, then, took place in the very person (Henry James) that Sargent consulted on the publication of the final volumes of Renan's *History of the People of Israel* and during the years of Sargent's work on the library murals. It also (and significantly for this discussion of the complexity of racial attitudes) took place in the very person (Henry James) who wrote disparagingly of Jews—and especially of lower-class immigrant Jews—in his own literary production.

Unlike James, however, Sargent never wrote or spoke publicly on Dreyfus though he certainly knew people on both sides of the political, military, and ideological battle. In Sargent's case, as in Renan's, differentiating and listing potentially pro- and anti-Jewish incidents or elements, in an attempt to discern con-

sistent patterns of behavior or, even more difficult, attitudes, seems a futile task. While many individual clues suggest what the artist's stance may have been, taken together they fail to yield a definitive direction. Historians and biographers have not yet discovered irrefutable evidence of either direct endorsement or explicit rejection of contemporary racist philosophies.

In terms of Sargent's literary habits, we know, for example, that he read Count Arthur de Gobineau, an early theorist of race and advocate of racism.[135] We do not know, however, which of Gobineau's books Sargent read. Given that the biographer who established this literary inclination on Sargent's part mentioned Gobineau in the context of William Beckford's *Vathek* and Sargent's preference for reading material that could "conjure up images and portraits," it is likely that the writer intended to signify the orientalist and art historical writings of Gobineau rather than the treatise on race. Since the count's works do not appear on Sargent's library listings, it is difficult to know what to make of this comment in passing by Evan Charteris—who certainly had no desire to present Sargent as a racist.[136] A book that does appear on the list for the London estate sale, however, is Hilaire Belloc's 1922 diatribe, *The Jews*. But the significance of the mere ownership of the book (especially since it was published after the completion and installation of *Synagogue* and *Church*) is not entirely clear. It is possible (and consistent with Belloc's eagerness to gain a wider readership) that the writer sent his book unsolicited to Sargent in the midst of the artist's legislative difficulties at the library. Belloc admired Sargent and referred to his library murals in a later work. There is no direct evidence connecting the two, but they did have friends and acquaintances in common. Most critics discussed Belloc's antisemitism in the context of his enthusiastic support for orthodox Catholic dogma, and this is a position Sargent would have found unattractive. On the other hand, the artist did not discard the book and a later (1923) edition of Belloc's poetry also found a place in the London book collection.

Finally, Sargent was an ardent exponent of the cult of Wagner—and Wagner's virulent antisemitism was widely acknowledged even in his own time. But Wagner was admired for many reasons, by many people, and his work was actively promoted in Sargent's lifetime by Jews as well as non-Jews. It is less likely that Sargent was attracted to Wagner's antisemitism than it is that the painter inclined toward the synthetic modernity of his aesthetic, his emphasis on the essential unity and universality of the arts, and his elevation of a "religion of art" in contradistinction to institutional religion. In the case of Wagner, the complication of reading too much into personal preferences in the absence of more definitive knowledge is revealed when Emile Zola's esteem for the impresario is taken into account. Zola's outspoken role as a catalyst in the public defense of Dreyfus is well known. But even Zola, who vigorously opposed antisemitism, shared and

expressed many contemporary biases about race and, like Henry James, adopted conventional anti-Jewish stereotypes in his writing.[137] In situations like this one, where scant evidence can be read in contradictory ways and attempts to discern personal inclinations and privately held views reveal little, it seems more prudent and productive to focus on the historical and cultural frame through which Sargent's audiences viewed *Triumph of Religion* and on the paintings themselves. One proviso remains to be added here, however, before turning to *Triumph's* Boston publics.

To say that in some cases, including the one under consideration, antisemitism is difficult to discern with certainty is not to claim that it was not present. Taken as a whole, Western Christianity has been (and still is in many cases) so inherently anti-Jewish that it often cannot even see its own bias. The Sermon on the Mount itself, in its scriptural form, represents a mixture of noble and ignoble sentiments in this respect. Jewish exegesis of Sermon on the Mount, undertaken while Sargent was at work in Boston (for example, Claude Montefiore's *Synoptic Gospels,* 1909, and Gerald Friedlander's *Jewish Sources of the Sermon on the Mount,* 1911), pointed this out and claimed Jewish origins for the more admirable aspects of Sermon. Abraham Geiger, writing somewhat earlier, criticized Renan for accepting the conventional Christian position on the character of Pharisaism as legalistic and dogmatic. From Geiger's perspective, Jesus *was* a Pharisee.[138] Renan's contrary position was consistent with contemporary Christian exegesis of Sermon on the Mount; Sargent too had "pharisaic legalism" in mind as the less enlightened religious experience that advanced civilization would replace with Sermon's subjective spirituality, "written on the heart."

RACE AND ANTISEMITISM IN BOSTON: A PUBLIC CONTEXT FOR *SYNAGOGUE* AND *CHURCH*

Events in Boston during the years in question provide a meaningful backdrop for sensitivity to sectarian subject matter at the public library. Sargent produced his *Synagogue* and *Church* as three decades of increasingly public bias, in the United States in general and in Boston in particular, reached a crescendo.[139] Even though Sargent's two paintings were understood by Sargent and some of his audiences to represent a "medieval point of view," Coburn's assessment of the situation was accurate: " 'The unveiling of these contrasting pictures of Christianity triumphant and Judaism defeated came at a time in the world's history and at a place a bit unfortunate for their acceptance as merely a great artist's playing with historical themes.' "[140] According to David Gerber, the 1910s and 1920s in America constituted a period of "extra-ordinary" or "ideological" antisemitism, during

which "significant sectors of society . . . [were] willing to articulate publicly prejudicial views" in aesthetic, political, or economic terms. These years saw the formation of organizations committed to combating antisemitism, for example, the American Jewish Committee (1906) and the Anti-Defamation League of B'nai B'rith (1913). They also witnessed the Leo Frank lynching in Georgia (1913), the reestablishment of the Ku Klux Klan (1915), the introduction of Jewish quotas in higher education (including the prominent example of Harvard University), the reinforcement of discriminatory barriers in hotels, clubs, and the commercial sector, the Sacco and Vanzetti case (1919–27), and, beginning in the spring of 1920, Henry Ford's dissemination of the fraudulent "Protocols of the Elders of Zion," alleging an international Jewish conspiracy, in his widely circulated personal newspaper, the *Dearborn Independent*.[141] These and other incidents and atrocities were reported in Boston's *Jewish Advocate*.

That these were also years of significant labor conflict further influenced contemporary perceptions of class and race. The months surrounding *Synagogue*'s installation saw major strikes of Boston's longshoremen and policemen, the latter resolved when President Woodrow Wilson intervened. On 15 October 1919, Sargent wrote to Mary Hunter of the coal strikes in London and of similar unrest in Boston: "We have had an attack of Bolshevism here—the police on strike and the mob looting shops and houses. All the smart young men were turned into amateur policemen and guarded the streets with bayonets to their guns, and they still regulate the traffic at street corners."[142]

Large-scale immigration of European Jews between 1880 and 1914 led to increasing agitation for quotas on immigration during the 1920s.[143] In 1890 census takers, enumerating immigrants of all nationalities and religious affiliations and their native-born children, counted as "foreign stock" a full 68 percent of Boston's population.[144] In terms of specifically Jewish immigration, one million Jews left Eastern Europe for the West between 1881 and 1905; over 80 percent of them settled in the United States. In Boston alone, while the total population doubled between 1880 and 1920, the Jewish population increased sixteenfold, from 4,000 or 5,000 in a total population of 363,000 in 1880 to 80,000 in a population of 745,000 in 1920. It was, in fact, in Boston and with the hearty endorsement and leadership of some members of Harvard's faculty and administration that the Immigration Restriction League was founded in 1894.[145] Immigration restrictionists argued their case principally on the grounds of "Anglo-Saxon superiority."[146] They also tended to characterize immigrants as part of an undifferentiated "mass," refusing to grant them the individuality ascribed to the "native" population.[147] After years of unsuccessful agitation on the part of the league, in 1921 and 1924, the years most immediately surrounding Sargent's legislative conflict over the *Synagogue* panel, immigration restrictions were im-

posed.[148] With the 1921 immigration legislation, "ethnic affiliation became the main determinant for admission to the United States."[149]

Beginning in the 1890s, the case for immigration restriction advanced two principal sorts of arguments, the first based on demonstrating the economic and social menace represented in the "new immigration" (coming from eastern and southern Europe rather than northern and western), the second on the development of a modified argument from race.[150] Because, for most purposes, race at the time meant color and because no uniformly observable differences in skin tone separated the new immigrants from the old, new race lines had to be manufactured.[151] John Higham argues that, bolstered by new theories of genetics early in the twentieth century, these "new race lines conformed not to national groups but to physical types," including the "Anglo-Saxons" of western Europe, the "Nordics" of northern Europe, the "Alpines" of central Europe, and the "Mediterraneans" of southern Europe.[152] The racial hierarchy created by this set of classifications granted racial superiority to "Anglo-Saxons" and to "Nordics." Building on Higham's argument, Gail Bederman points to the formation of a definition of race as a "seamless mix of biology and culture."[153] The coincidence of the emergence of the social sciences as academic disciplines with a new race obsession in American (and European) culture at least temporarily granted racial theorizing a kind of intellectual credence and respectability.[154] Racial categories hardened, and the vocabulary of race provided a popular mechanism for understanding culture. By the late 1920s virtually every popular scientific and social scientific rationale for late-nineteenth- and early-twentieth-century racial categorizations had been refuted, and large numbers of scholars and intellectuals publicly announced the reversal of their own earlier opinions on race.[155] During the years between 1890 and 1925, however, a consensus view, even among political liberals, was more difficult to identify, and thinking based on some degree of racial typing seemed almost ubiquitous. Sargent's project straddled this shift, and *Triumph*'s historical positioning was apparent in the responses of its various publics.

RELIGIOUS EXPRESSION IN PUBLIC EDUCATION

Given the explicit connections between public libraries and education and between education and immigration (outlined in chapter 4), it is not surprising that the library's public educative functions figured prominently in the *Synagogue* debate. Furthermore, the tendency to regard education as a dimension of experience with liminal potential, with the ability to transform both identity and social/cultural practice, provides another meaningful context for concerns about *Synagogue* at the Boston Public Library. Here a significant demographic factor in

the library's target audiences raised the level of apprehension. Particularly troubling to many, the *Jewish Advocate* reported, was the location of Sargent's pair of paintings in a library, a civic institution with multiple connections to "small children" and education.

While Henry James had complained about the presence of children in the library, this population had rapidly become one of the library's principal groups of readers. An innovative feature of the new Copley Square building (one not available at the old Boylston Street facility) was the Children's Room located just off Bates Hall on the second floor and easily accessible from the main staircase. Though the room already held its place in early plans for the library, Josiah Benton described its genesis in this way:

When the new building was opened children came in large numbers and there was space for them to run about. They soon began to say: "Please give me a book," "Please can I see a book?" and interfere more or less with the working of the Library for others. As an experiment a large round table was put in a vacant room off Bates Hall and filled with books suitable for children. It was soon surrounded by a fringe of small heads of all colors intently examining the books. . . . Six months after, the trustees spent about $3,000 in purchasing books for children, and placed them upon open shelves in this room. Since that time I think the room has been the most interesting part of the Library. Children of all nationalities use it, with perfect good order, and with a degree of attention to the books which many older persons might well emulate.[156]

With the opening of the McKim, Mead and White building in 1895, the Boston Public Library, as the "final step" in the city's educational system, also established new formal programs of cooperation with the Boston public schools; the library thus became the provider of large numbers of books, photographs, and "pictures of all different kinds" (including many fine-art prints) for use on rotating loan in the public schools. Both on its own premises and off, then, as Benton maintained, the Boston Public Library "supplements the work of our public schools."[157]

If public libraries represented a principal resource for children and youth, and especially for public school students, and if the library exercised a particular brand of transformative agency among Benton's "children of all nationalities" who used it, then what was the content of the "Americanism" that they would learn on the library walls? The question here was not just *what* but *who* was being taught: "There is no antipathy toward the painting itself as far as its artistic value is concerned: but it is felt that religious subjects should be painted on Cathedral or Church pediments or windows, rather than in a place where small children congregate."[158] The ritualization of space in Sargent Hall in particular, in terms of both the choreography of movement and the metamorphosis of chapel to lecture

hall, illuminates the reaction to *Synagogue*. *Synagogue*'s most ardent detractors would have happily embraced Sargent's overarching theme of individual autonomy and individual consent. Far fewer were pleased with a library picture that evoked antisemitic historical sources and that seemed to them manifestly anti-Jewish—and this on the wall the artist reserved for the cycle's climax.

Between 1890 and 1925 few in Boston—or elsewhere in the United States—would offer dissent to the notion that public schools (or public libraries) existed to "Americanize" new populations; many, however, especially toward the end of this period, would object to public school efforts to "Christianize" immigrants. Thus while tax-supported common schools in the United States had first been founded in the early nineteenth century in relation to a "non-sectarian" but explicitly Protestant religious agenda, with new vigor the first quarter of the twentieth century brought the concept of the separation of church and state to bear on the content of public education. This was, then, a critical historical moment in terms of church-state relations in the United States; it was so largely because of the increasing political organization and moral authority of minority religious groups. When critics decried *Synagogue* as "un-American," their argument rested, in large part, on convictions about sectarian expression in public places—and especially those public places with an educational motive and purpose. For the individuals most prominently involved in the *Synagogue* controversy, their activity with respect to Sargent Hall did not represent an isolated incident of social agitation but was part of a network of commitments in relation to religion, education, and immigration. Between 1905 and 1922, for example, the Committee on Church and State of the Central Conference of American Rabbis drew up a series of statements on religion in the public schools. In 1922 the conference published a substantial position paper titled "Why the Bible Should Not Be Read in the Public Schools."[159] In Boston itself, as careful reading of the *Jewish Advocate* makes clear, in the same months and years that they mounted sustained protests of *Synagogue,* Henry Gold, Harry Levi, Lewis Goldberg, Menachem Eichler, David Shohet, and Louis Hurwich expressed consistent political, religious, and educational ideals in many other forums.[160]

In the late teens and twenties, Jewish efforts in securing equal access to nonreligious public education had a specific target; these postwar years witnessed a significant increase in blatant expressions of Protestant cultural triumphalism. Religious pluralism and Protestant triumphalism came head to head, the latter in part a re-entrenchment of defensive posture with respect to the former. Of particular interest in relation to the *Synagogue* controversy is an incident of 1919 to which Leo Franklin—president of the Central Conference and the first Jewish leader to write in an official capacity to the library's trustees after *Synagogue*'s installation—responded. In this year, the Bureau of Christian Americanization of

the Protestant Episcopal Church issued a pronouncement on missionary activity among Jews. Since, it argued, the *New York Times* had reported that only 25 percent of Jews maintained synagogue affiliations, the bureau would begin missions efforts to convert the remaining ("unchurched") 75 percent. What seemed especially pernicious to Franklin was not the missionizing per se, but its characterization as a "patriotic" initiative, implying that Jews needed Christianity to be good citizens of the United States. In October 1919, the same month as *Synagogue*'s installation and one month before Franklin's letter to the library, leaders of the Central Conference met with the Episcopal board in an attempt to resolve the issue. Representatives of the church denied that they had made Americanization contingent upon Christianization—and claimed that they would resist doing so in the future. Despite the efforts of Franklin and the Central Conference and despite the promises of specific Christian denominations and organizations, similar proselytizing efforts were mounted by a number of establishment leaders in several denominations.[161]

BIGOTRY—AND GOOD WILL

While Sargent never publicly articulated his position on contemporary racist philosophies of history, it was through this cultural filter that he conceived and executed his mural cycle; through the same cultural filter, a wide audience responded to his oeuvre. Praising the artist for his "susceptibility to the impress of race characteristics," William A. Coffin, in 1896, described Sargent's "eager grasp of the picturesque, not only in foreign lands, but whenever he is met with anything markedly racial in subject for a picture at home."[162] A decade later Christian Brinton noted the artist's "keen sense of race distinctions and of the subtle variations of type or class."[163] In January 1923, reviewing the new Sargent murals at the Widener Memorial Library at Harvard, Frederick Coburn, indicating both his own preference for the *Death and Victory* panel and his skeptical position on "modern" racial anthropology, admitted that viewers preoccupied with race might favor the other Widener panel, *Soldiers of the Nation* (also called *Coming of the Americans*), where Sargent's "resolute Nordic young women and young men" constituted "symbols of racial complexes which in process of resolution through the ages have run the gamut from downright piracy to administration of social justice."[164]

The progressive Coburn was certainly not alone in his implied plea for racial and religious understanding. Just as American (and especially New English) xenophobia and ethnocentrism were on the rise in the years between 1890 and 1925, so too did toleration appear to be increasing in some quarters. Among those

intellectuals best known to Sargent, William James, after 1899, consistently advocated an anti-imperialism based on a rejection of "Anglo-Saxon arrogance and Caucasian bigotry." These and similar convictions, induced relatively late in his career by the Spanish-American War, led James to a position on the individual human will that was strikingly parallel to (though much more egalitarian than) that advanced by Renan. James's intellectual commitments to a "pluralistic universe" had social and political outcomes, involving him in a number of contemporary causes with respect to religious toleration and ethnic egalitarianism.[165] In the late 1920s Everett R. Clinchy, of the National Conference of Jews and Christians, suggested a typology of religious and cultural pluralism that looked toward Will Herberg's classic *Protestant, Catholic, Jew* (1955) in its observation of three equal American "culture groups." As early as 1915 Horace Kallen, Jewish educator and philosopher, and a student of William James, had attempted to popularize a similar set of ideas.[166]

As Benny Kraut suggests, the decade of the 1920s, generally characterized as an "isolationist age punctuated by ethnic and religious bigotry," was also an "age of goodwill," with the United States taking significant strides toward acknowledging a "new" religious pluralism. It would be inaccurate to speak of a single, unified "movement" of interreligious cooperation, and "religious" here was a term with limited application to three groups (Protestants, Catholics, and Jews). Nevertheless, a number of institutions and organizations (including the Federal Council of Churches of Christ, the National Conference of Jews and Christians, the Central Conference of American Rabbis, and the American Good Will Union) implemented programs for improved relations in these years.[167] In terms of Sargent's immediate audiences at the Boston Public Library, the most prominent figures of the *Synagogue* controversy, Jews, Protestants, and Catholics, were also among Bostonians most actively involved in promoting interreligious cooperation and supporting interreligious organizations.[168]

The response on the part of the Federal Council of Churches of Christ in America to the virulent antisemitic propaganda of the so-called Protocols of Zion, was swift. At its quadrennial meeting in Boston in 1920, the organization adopted a resolution castigating the spurious work, pledging itself to "unity and brotherhood," and admonishing member Christians to "express disapproval of all actions which are conducive to intolerance or tend to destruction of our natural unity through arousing racial divisions in our body politic."[169] Leo Franklin's role in the national politics of interreligious cooperation was especially strong. It was due to his initial request for support, as president of the Central Conference in 1919–20, that the Federal Council decisively rejected both Protestant missionary efforts among Jews and antisemitic expression and behavior.[170] In the Boston

area, Rabbi Harry Levi celebrated what he called the "rising tide of liberalism." During his years at Temple Israel, Levi organized a theater group that presented plays on the theme of interreligious respect and toleration. He sponsored a club of Protestant, Catholic, and Jewish youth who came together to discuss interfaith understanding. A biographical essay on Levi, written on the occasion of Temple Israel's centennial celebration, provides insight into the rabbi's multicultural and egalitarian commitments:

Throughout the rabbi's sermons ran the theme of fostering greater understanding—between businessmen and workers, Jews and Christians, natives and immigrants, Negroes and whites. . . . For two decades a New England radio audience listened to Harry Levi preach racial and religious understanding. . . . The rabbi defended with eloquence and without equivocation the heritage of the melting pot. America, he declared, was neither an Anglo-Saxon, nor a white, nor a Christian, nor a Protestant land. Rather it was a democratic way of life that claimed allegiance from persons of diverse ethnic, religious, and racial groups. . . . Characteristically, when invited to speak at the Community Church on "My Religion," he described not the uniqueness of Judaism but the essential and universal principle of all religions "to do justice and love mercy."[171]

The installation of *Synagogue* and *Church* in 1919 illuminated the cultural diversity of *Triumph*'s Boston publics. The politics of immigration and concurrent debates over the role of education in assimilating newcomers to an "American" (and, for some, a consequently "Christian") way of life turned up the contextual heat. While Sargent's location of the appropriate site of religious ideation in the individual will and imagination may have constituted his acknowledgment of an increasingly complex and pluralistic cultural identity for the United States, in the final analysis he did not accord to culture the same ultimately "subjective" and "private" constitution he allowed religion. The content of Rabbi Levi's public ministry celebrated variety in Boston in the 1910s and 1920s in terms that better match late-twentieth-century perspectives. Sargent's *Triumph of Religion,* by contrast, represented an idealistic but essentially monocultural (and liberal Christian) construction of the "best" that civilization had to offer.

AN ART OF "TYPE"

In its less troublesome aspect, Sargent's expertise at depicting "race characteristics" was rather benignly reflective of his more general attraction to and identification with exoticism and exotic "types."[172] Critics of the time agreed that

Sargent "disliked neutral faces."[173] More apparently unsettling, Sargent seems to have attended carefully to delineations of racial physiognomy in some key figures for the Boston Public Library. Historian Celia Betsky has examined the way late-nineteenth- and early-twentieth-century New Englanders, faced with the cultural possibilities and challenges of large-scale immigration, reshaped genealogy as a "new form of aesthetics." From the perspective of colonial revival, with its interest in American historical introspection and its consequent emphasis on "interior[s] and interiorization," "Puritan" could mean "pure stock."[174] For some, perhaps including Sargent, whose interest in his own Puritan background evidently increased around this time, the attraction of tracing familial lineage to Massachusetts Puritans hinged on a desire to establish their own Anglo-Saxon lineage. Just as Herbert Small, in describing the artistic decoration of the Library of Congress, could discern the "pre-eminence of the Caucasian races in the arts of civilization generally," Sargent's murals clearly associated "Anglo-Saxon," northern European features with a more evolved civilization or at least with an ideal physical type.[175] The artist's preliminary studies reveal his adjustment of the features of the child Israel (protected and instructed by God's Law, in the central panel over the space reserved for Sermon), moving from the Mediterranean model of his early sketches (fig. 111) to the final image of a fair, blond child (fig. 27).[176] This alteration accentuated the similarity between the obedient Israel, the child messiah in the adjacent lunette (also a fair blond, fig. 26), and the child who would have gazed longingly upward, fully absorbed in the words of Jesus, in the "keynote" Sermon panel (fig. 25). Sargent thus charted in attentiveness to the physical features of race as he understood them the descent of authority from his sheltering Jehovah of *Israel and the Law* to his Jesus of an interiorized spirituality.

The substitution of a child for the infant that Sargent depicted in an earlier sketch (fig. 112) for the Sermon panel underscored the narrative link between the three male children on the east wall. This constellation of children, arrayed near the conceptual center of Sargent's composition, reiterated a Christian scriptural admonition on the importance of a childlike demeanor and suggested the artist's agreement with Renan on the central symbolism of children in relation to the messianic "kingdom of God."[177] If there remained any doubt that the childhood of the individual was here meant to recapitulate the childhood of a human race "typified" by Sargent's blond youth, the 1920 Boston Public Library *Handbook,* in a paragraph presumably authorized by the artist, described *Messianic Era* in the terminology of contemporary racial anthropology: "The race, purified and perfected of soul . . . enters into a new paradise." This phrasing likely appealed to the literary Sylvester Baxter, author of the description, who excerpted and adapted it from Robert Browning's *Paracelsus,* in a passage that begins: "When all mankind is per-

Fig. III

John Singer Sargent, *Study for Israel and the Law,* from an album of 107 studies for *Israel and the Law*. Charcoal on blue laid paper, 24 3/16 x 18 1/8 in. (61.5 x 46 cm). Fogg Art Museum, Harvard University Art Museums, Gift of Mrs. Francis Ormond, 1937.11 folio 22

Fig. 112

John Singer Sargent, *Study for East Wall: Synagogue, Sermon, Church,* n.d. Graphite on cream wove paper, 10 5/16 x 16 3/16 in. (26.2 x 41.1 cm). Fogg Art Museum, Harvard University Art Museums, Gift of Miss Emily Sargent and Mrs. Francis Ormond in memory of their brother, John Singer Sargent, 1933.47 recto

fected, equal in full-blown powers—then, not till then, I say, begins man's general infancy." In the library's *Handbook,* Baxter expanded upon Browning's verses in relation to Sargent's painting: this is the "inspired boy—embodiment of the prophet race that leads humanity into the light." Despite the youth's blond hair, the "race" here represented was meant to signify those of Jewish descent; in Sargent's scheme this lunette belonged on the east wall, and thus the boy, like his younger "twin" in the adjacent lunette, was part of the "Jewish trilogy."[178] In either reading, however, with the figural ideal adopted in *Triumph of Religion,* Sargent established a religio-cultural pedigree for late-nineteenth-century Boston and, by extension, the United States. This cultural genealogy involved the artist in a set of contemporary debates about race and class.[179]

Critics representing a range of political and aesthetic perspectives applied the contemporary vocabulary of typing to Sargent's art, and typing was so much a part of the way Sargent approached human character that he even thought of the twenty-two British generals for an Imperial War Museum group portrait in terms of the different "types" they represented. Though he was not at all pleased with his group (the men had never actually been in a single place at any one time so he felt he was painting them "all standing up in a vacuum"), he wrote to Charteris to say that he found "each of them individually very interesting to do and the tremendous variety of types seems to give a promise of some sort of interest."[180] The pervasiveness of this vocabulary of typing complicates understandings of its use.[181] Typing was not necessarily stereotyping; though typing had its own set of problems, it generally offered a wider (and more positive) range of expressive possibilities than the more narrowly construed alternative. Art historian Linda Nochlin has recently urged attention to "representational ambiguity" in considerations of pictorial typing. Not every appeal to "type" participates to an equal degree in negative stereotypical imaging—and the same picture can be used in different ways by different audiences.[182] These complications come to the fore in recognition, for example, that while most of *Synagogue*'s Jewish detractors were concerned with the age and masculinity of Sargent's representation, some wanted the figure to "look" both more and less "Jewish." Menachem Eichler's principal complaint in this regard was that this woman did not represent a Jewish type: "The face of the woman is not that of a Jewess."[183] Typing, it appears, was neither static nor univocal during this period. Surely Asher Wertheimer, a highly discerning connoisseur of art, knew of Sargent's reputation for painting well "to type" before he selected him to paint the Wertheimer family portraits; perhaps Wertheimer even appreciated precisely this aspect of the painter's reputation.

I have argued in an earlier publication that Sargent introduced an apparently distinct stereotypical element to the racial subtext of his narrative in his de-

Fig. 113

John Singer Sargent, *Studies for Synagogue and Church,* n.d. Graphite on cream wove paper, 10 5/16 x 16 3/16 in. (26.2 x 41.1 cm). Fogg Art Museum, Harvard University Art Museums, Gift of Miss Emily Sargent and Mrs. Francis Ormond in memory of their brother, John Singer Sargent, 1933.46 verso

Fig. 114

John Singer Sargent, *Studies for Synagogue: Scepter and Partial Profile,* from sketchbook of studies, c. 1916–19. Graphite on off-white paper, 7 9/16 x 10 1/8 in. (19.2 x 25.7 cm). Fogg Art Museum, Harvard University Art Museums, Gift of Mrs. Francis Ormond, 1937.7.28 folio 4 recto

Fig. 115

Matt Morgan, *Unrestricted Immigration and Its Results*. From *Frank Leslie's Illustrated Newspaper*, 8 September 1888. Library of Congress, Washington, D.C.

liberate consideration of the dimensions of *Synagogue*'s nose (figs. 113 and 114).[184] Contemporary images and texts demonstrate that for Sargent's contemporaries in England and America, in signifying Jewishness a large nose was the marker most closely linked with Jewish "visibility."[185] Between 1885 and 1920 this exaggerated physiognomic feature appeared frequently in illustrated journals like *Harper's Weekly, Harper's Monthly, Puck, Leslie's Weekly,* and *Life* (see, for example, fig. 115).[186] It is surely significant that the first deliberately counterstereotypic Jewish cartoon character, introduced by a Jewish artist in 1914, had a small nose.[187] Writing on a subject not directly related to Sargent's artistic activity in Boston, historian Lisa Marcus claims that the year 1919 represented the height of the "political fiction of

Fig. 116

John Singer Sargent, *Sketch for Synagogue*, n.d.; note detail of face in upper-right corner. Graphite on paper, 10 1/4 x 16 1/8 in. (26 x 41 cm). Museum of Fine Arts, Boston, The Sargent Collection, Gift of Miss Emily Sargent and Mrs. Violet Ormond in memory of their brother, John Singer Sargent, 28.726 recto

the publicly recognizable Jew." Between 1918 and 1922 both Columbia University and Harvard University moved to cut Jewish enrollments. A significant element in the racial strategies of both institutions was the requirement of a photograph of the applicant as part of the admissions procedure. Jewish applicants, admissions officers presumed, could then be eliminated from the pool simply by reference to their pictures.[188] With respect to *Triumph of Religion,* in Sargent's earliest sketches Synagogue and Church are equally young, equally beautiful, and have comparably sized noses (e.g., fig. 116). As the artist refined his conception, however, he aged the figure of Synagogue and measurably enlarged her nose.

But the content of Sargent's consideration of Synagogue's nose changes rather considerably, evoking counterstereotypic as well as stereotypic impulses, if we take seriously into account, as Sargent requested, "the point of view of iconography" and its sources, and this is the subject of chapter 6.

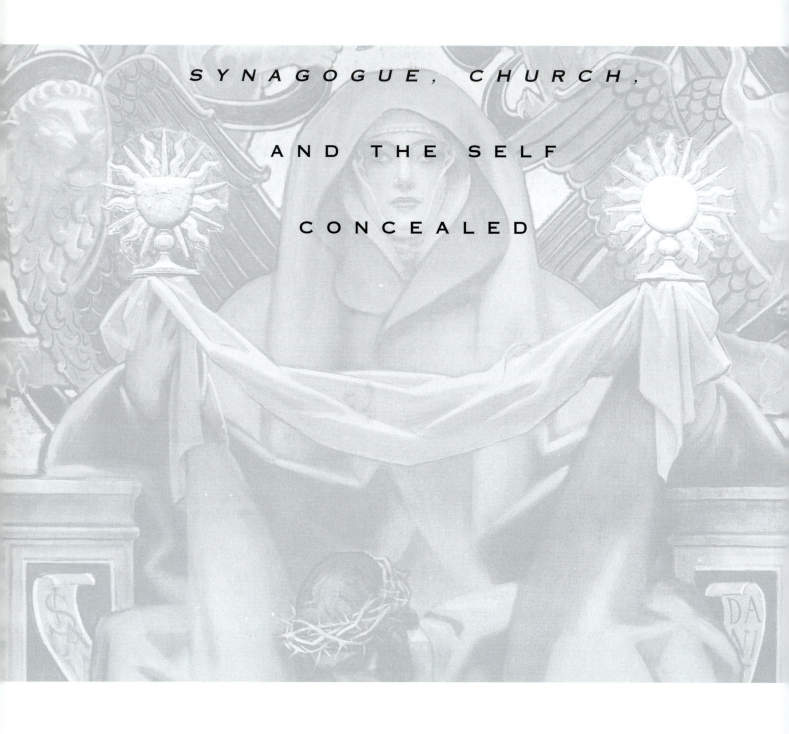

SYNAGOGUE, CHURCH,

AND THE SELF

CONCEALED

⊕

I would that they kept her without repair,

The church as she stands there empty and bare,

Her gaping wounds to the world arrayed,

Let no effort to close them be ever essayed.

—MIGUEL ZAMAÇOÏS, IN MAURICE LANDRIEUX,

The Cathedral of Reims (1920)

*

This chapter considers, in any degree of detail, only two of the many panels of *Triumph of Religion, Synagogue* (fig. 17) and *Church* (fig. 18), the last two paintings installed. This is perhaps a fitting way to approach the conclusion of this book's discussion of Sargent's cycle in the original at the Boston Public Library. I use the word *fitting* somewhat ironically since the *Synagogue* controversy effectively isolated *Synagogue* and *Church* from the rest of the cycle that Sargent argued "should be seen and judged only as a whole and not in parts."[1] Though this chapter focuses on these two images, its goal is to resuscitate them in relation to their role in *Triumph* and to the rest of Sargent's oeuvre.

Sargent pursued, in his composition of *Synagogue* and *Church,* the method of iconographic assembly he had practiced in earlier portions of *Triumph of Religion.* "Pastiche" is a label well-matched to his process of design. His avid interest in art historical referencing, in collecting and revising objects emblematic of art's "religious" history, in fact, surely contributed to his initial inclination to picture *Synagogue* and *Church* in Boston. When it came to the models for *Synagogue,* Sargent selected not just the medieval cathedral sculptures he cited in his own defense during the *Synagogue* controversy but also, and with deliberation, Michelangelo's *Cumaean Sibyl* (fig. 77). This art historically significant notation added new dimensions to *Synagogue*'s cultural meanings. On the one hand, from at least the early Middle Ages, the contrast of Synagogue and Church had formed an opposition basic to the structure of Christian triumphalism. On the other hand, though *Triumph of Religion,* with its projected culmination in Sermon on the Mount, remained a Christian "triumphalist" cycle, Sargent's specific configuration of the opposition between Synagogue and Church (a configuration that contained continuities as well as discontinuities) decisively reworked and "modernized" the conventional understanding of the pair.

In the public library cycle, and in relation to their medieval and Renaissance artistic sources, *Synagogue* and *Church* introduced three significant themes. First, they represented Sargent's conviction of the *twin* obsolescence, in an authentically spiritual world, of institutions embodying both law and doctrine; together they constituted equally the recessive frame for the keynote Sermon with its validation of subjective spirituality. In this sense, *Synagogue* and *Church* were essentially related, as a balanced pair, to the central progression from the material to the spiritual represented in *Triumph of Religion.* Second, *Synagogue* and *Church* interjected into the cycle Sargent's critical personal reflections on and reactions to World War I. And third, the artist's engagement with the blindfolded *Synagogue* and the stoically sighted but apparently unseeing *Church* allowed him to pursue a theme of concealment and revelation that had fascinated him for many years. Because Sargent's recourse to Michelangelo's *Cumaean Sibyl* is relevant in all three

cases, I will consider some of the implications of the historical and art historical reference before discussing the thematic contributions of *Synagogue* and *Church*.

THE CUMAEAN SIBYL

What most firmly secures this connection is not the finished *Synagogue* panel itself but a preliminary sketch executed, presumably, after the earlier range of beautifully visaged possibilities (fig. 116) and before the final design. Returning to this later sketch (fig. 114), we now see that Sargent did not simply trade a small, straight nose for a large, hooked one, he traded the earlier uniformly petite models that matched *Church* physiognomically for the profile of Michelangelo's *Cumaean Sibyl* (fig. 117). Perhaps the initial attraction was at least in part the size of the Sistine sibyl's nose—yet, in the oil painting, while retaining her grimace, Sargent closed the mouth, diminished (by comparison with Michelangelo) the nose, and straightened it. Viewed from this perspective, it is clear that if Sargent considered the visual stereotype, he refrained from exploiting it, perhaps commenting, in the process of tempering and moderating a potentially problematic profile, on cultural expectations in relation to stereotypic representation. Because of the modifications to the profile and the disposition of the body, in the finished version of *Synagogue* the association with Cumaea is perhaps most visibly established not by the profile but by the massiveness of *Synagogue*'s right arm as it reiterates the Cumaean sibyl's left arm.

Objections to Sargent's masculine "hag" sound more than vaguely like John Ruskin's complaint five decades earlier that Michelangelo's Cumaea, this "especially Italian prophetess" (so understood because Cumae was the "earliest colony on the Italian mainland"), was, inappropriately from his perspective, "an ugly crone with the arms of Goliath."[2] At least one of Sargent's younger contemporaries, Lincoln Kirstein, trustee president Louis Kirstein's son, recognized *Synagogue* as a "Sistine sibyl."[3] The "Jewishness" of this Cumaean sibyl Sargent secured not in the size of her nose but in elements of Cumaea's story and in his pastiche of details from both Michelangelo's Cumaea and his Julian *Moses,* a connection established—though with different content—by Michelangelo himself in his *Moses'* own reference to the *Cumaean Sibyl*. *Synagogue*'s right arm (fig. 118) associated her with *Moses* as well as the Sistine sibyl, and *Synagogue*'s left forearm and hand quoted *Moses* rather directly. Sargent knew the *Moses* well, not only in the original but also in one or more of its many reproductions. When, as an art student in Paris, he visited his family at St. Enogat, he described the room in which he slept: "My bedroom is the most beautiful interior I have ever seen in anything short of a palace or a castle. It is furnished throughout in the medieval

style. Its beamed ceiling and floor are of oak, its walls completely hung with stamped leathers and arras; the furniture is all antique and richly carved. . . . Then there is a great tapestried chimney piece, plenty of oil portraits, a few small choice casts such as a head of Goethe and a beautiful reduction of the Moses of Michel Angelo."[4]

Long before Sargent, stories of the Cumaean sibyl (called variously Cumaea or Cumana) had been collated from a wide variety of sources. Mid-nineteenth-century excavations of the site of her oracle reinvigorated interest in this sibyl in particular.[5] Sargent surely knew the basic outlines of the sibyl's tale; with his family he had visited the recently opened site in 1869. He recorded the trip in a letter to his boyhood friend, Ben del Castillo: "We . . . saw the caverns of the Cumaean sibyl, on the banks of Lake Avernus."[6] Anna Jameson and John La Farge could have filled in any gaps in the adult Sargent's knowledge of the sibyl. Both authors devoted a substantial number of pages in popular texts to discussion of sibyls in general and Cumaea in particular. La Farge, in his *Gospel Story in Art* (1913), a book widely available to Sargent's Boston audiences, mentioned numerous sources for Cumaea's legend, including Varro, Pausanius, and especially Virgil. Of these stories, the best known concerned both her relationship with Apollo—and thus her age and former beauty—and her encounters with Tarquin (Tarquinius Superbus) and the preservation of the Sibylline books.[7] With reference to the former, La Farge relayed how Cumaea, "Chief Sibyl of Roman History," beloved in her youth of Apollo, was also inspired by the god and assumed the role of his priestess. Apollo granted her years as plentiful as the grains of sand her hand could hold. When she spurned him, however, the god decreed that though she would live for many years, each one would tell in her body and face.[8] This story accounts for the aged appearance of Michelangelo's white-turbaned sibyl and, significantly in relation to complaints regarding *Synagogue*'s age, for the white hair and wrinkled face of Sargent's personification, which adopted these characteristics in reference to the Renaissance model.

In other sources, Cumaea's story was also associated with her books and with her vision of the secrets contained therein. Sargent's visit to Lake Avernus and his copy of Anna Jameson's *History of Our Lord as Exemplified in Works of Art* would have provided him with ample information on Cumaea's significance in this regard. With nine books of secret prophecies, the sibyl traveled to prerepublican Rome to offer the oracles to Tarquin for a large sum. He declined, whereupon she left, burned three of the books, and returned with six to sell at the same high price. He again refused the offer; she again burned three books and brought to Tarquin the three that remained. Having consulted his soothsayers in the interim, Tarquin now recognized the books' importance and purchased the three from the sibyl at the original price.[9] In Jameson's account, the "destinies of the

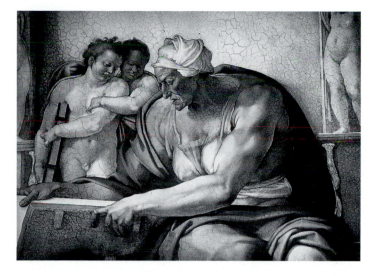

Fig. 117

Michelangelo Buonarroti, *Cumaean Sibyl* (detail), 1510. Fresco. Sistine Ceiling, Vatican, Rome

Fig. 118

John Singer Sargent, *Studies for Synagogue,* n.d. Charcoal on paper, 18 1/2 x 24 1/4 in. (47 x 61.6 cm). Museum of Fine Arts, Boston, The Sargent Collection, Gift of Miss Emily Sargent and Mrs. Violet Ormond in memory of their brother, John Singer Sargent, 28.614

world depended upon their preservation." Jameson continued her descriptive commentary:

The books were therefore purchased, for centuries preserved in the Capitol under the guardianship of an order of priests, and consulted on all national emergencies. At the destruction of the Capitol, during the wars of Marius and Scylla, these volumes perished. To repair the loss, messengers were sent all over the provinces of the empire to collect the scattered Sibylline leaves, and these, in turn, were guarded in the same way. The fate of this second edition would be impossible to tell; but, at all events, the idea entertained by the Roman people, and quoted by Tacitus and Suetonius, that out of Judea should come those who would be rulers of the world, is believed to have proceeded from the Sibylline remains.[10]

In Jameson's popular handbooks, the sibyl's symbolic connections to Roman (here "pagan") priests, to prophecies concerning Judea's destiny, and to war and its potential to destroy civilization came into focus. With respect to the latter motif, not only were her remaining original books destroyed in the Roman wars, but her prophecies contained repeated warnings of conflict: "I see wars, grisly wars and the Tiber foaming with much blood."[11]

In relation to other oracles, the Cumaean sibyl was distinguished by her function as "an official state institution," overseen by priests, and centered in Rome.[12] Thus she acquired significance not just as "Roman fortitude," as Ruskin related, but also as the "age and strength of the Roman Church."[13] The relationship of the Cumaean sibylline prophecy and the Christian church took some of its cues from a passage in Virgil's Fourth Eclogue. Jameson translated these verses in a manner that suggests the similarity between their content and not just Sargent's *Synagogue* but also his *Messianic Era* (fig. 26): "The last age of the Cumaean song now approaches; the great series of ages begins again: now returns the Virgin (Astraea), now return the Saturnine kingdoms; now a new progeny is sent from high heaven. Be but propitious, chaste Lucina, to the boy at his birth, through whom the iron age will first cease, and the golden age dawn on the whole world."[14] That Michelangelo recognized the connection between Cumaea and the Roman Church he signified in his placement of this Sistine sibyl next to his painting of the creation of Eve from Adam's side. The Sistine Chapel's High Renaissance occupants would have recognized here a well-established typology: as Eve was created from the side of Adam, so the Roman Church was created from the side of Christ.[15]

SYNAGOGUE, CHURCH, AND THE
OBSOLESCENCE OF LAW AND DOCTRINE

We return now to the three themes introduced by *Synagogue* and *Church* in *Triumph of Religion.* The relationship between Sargent's *Synagogue* and Michelangelo's Cumaea suggests the identity of the institutions of Synagogue and Church as well as their opposition: if *Synagogue* was Cumaean sibyl and Cumaean sibyl was Roman Church, then *Synagogue* was Roman Church. In Sargent's cycle, *Synagogue* and *Church,* as a pair and in relation to Sermon on the Mount, suggest not simply the medieval contrast but also a "modern" shift in awareness, the triumph of individualism and subjective spirituality and the obsolescence of both law and doctrine. Rabbi Henry Gold, on several occasions among the most astute of Sargent's critics, wondered how long it would be, in Sargent's scheme, before a new "religion of science" supplanted Christianity as well as Judaism. The artist, in his quest for a form of spiritual expression free from the constraints of orthodoxy and ecclesial authority, rejected Synagogue *and* Church as antique, "materialistic," convention-bound forms of religious expression. In *Triumph,* both Crucifix (with Adam, Eve, and Christ representing a "trinity of the flesh") and *Church* pictured the dead body of Christ rather than the "free spirit of Christianity," the material rather than the spiritual.[16] While Sargent's *Church,* by contrast with *Synagogue,* was certainly attractive in a standardized sort of way, she was hardly representative of far-seeing vision. Her expression a cold, impassive stare, she looked straight ahead but apparently without seeing. Her eyes were curiously empty and distant; she held conventionalized eucharistic symbols appropriated from her medieval counterparts at Reims and elsewhere—and she seemed entirely disengaged from the suffering of her son in her lap. The body of Christ, with its crown of thorns, red stigmata, and gray pallor, signified a particularly horrible death, but without appealing in any obvious way to the empathy of the beholder. While Michelangelo's drawing of the *Pietà* (fig. 78) in Isabella Stewart Gardner's collection was one important model for Sargent's panel, it by no means set the emotional tone for the painting.[17] It did, however, suggest the conflation of Mary with Ecclesia in Sargent's sources, in his own thinking, and for some of his critics.

Lincoln Kirstein was among the few who later recalled objections to *Church* as well as *Synagogue:* "A Jewish community was outraged at Israel's personification as a strongly musculated female derived from a Sistine sibyl. She was seen as desolate, mantled in the richly textured, riven veil of the Temple, clutching the Tablets of the Law. . . . And Roman Catholics were equally offended seeing a Blessed Virgin envisioned as a young woman, between whose majestic knees slumped an all-but-nude figure of an athletic Jesus, [who was virtually the

same age as] his Mother."[18] Because of the contiguity of the garment that covers the two, some imagined the adult figure of Jesus to be completely nude under his mother's cloak.[19] Louis Kirstein, by contrast, recognized the archaism of Sargent's representation of the Christian institution. The elder Kirstein accepted Sargent's connection of the painting with the early "Church Fathers" and with Chaucer. Lincoln later described his father's reaction:

As for interpreting Israel in decline, this was not far from Father's own personal opinion. And as far as Catholicism went, like everyone else he knew the Boston Irish ruled with more po-litical know-how in City Hall than did the Cardinal in his Bay State Road palace. Sargent explained to Dad that the Church Fathers of the [past] Christian apex held that Mary's essence in virginity stayed ageless, inviolate, unchanging. The Son died long before middle age. So Geoffrey Chaucer, in the Canterbury "Second Nonnes Tale," wrote: "Thow Mayde and Moder, doghter of thy Sonne, / Thow welle of mercy, synful soules cure."[20]

Synagogue and Church reiterated the obsolescence of law and doctrine al-ready signified in the gilt relief Moses with the tablets of the Law on the north wall and the similarly represented crucified Christ on the south. From the per-spective of Sargent's own time and in their architectural context, his paintings of Synagogue and Church would flank the representation of an expansive and progres-sive Protestantism. Jesus in Sermon on the Mount was neither the Christ of Sargent's Crucifix nor the doctrinally grounded institution of Church but the human individual who, in quality of relation to other human beings and to the divine, was the highest exemplar of enlightened citizenship. While Synagogue and Church certainly participated in an updated and recycled Christian triumphalism, here Church was obsolete too, and religion's "triumph" resided in a more spiritual and potentially "universal," extrainstitutional variety of Christianity. But separate from the rest of the program and viewed in isolation (a situation sequential instal-lation and controversy fostered), Church and Synagogue standing alone had a very different meaning from the two yielding jointly to Sermon.

SYNAGOGUE AND WAR

Strangely enough, though Henry Gold castigated the artist for his handling of the subject matter, this Jewish critic numbered among the first to discuss the *aesthetic* superiority of Synagogue and the stylistic disjunction between the neomedieval Baroque of Synagogue and the neomedieval beaux-arts classicism of Church.[21] Gold argued for Synagogue's "great intrinsic merit as a work of art." Church, by contrast with the "richer production" of Synagogue, Gold associated with the

Fig. 119

John Singer Sargent, *The Brook* (detail), c. 1907. Oil on canvas. Private collection, courtesy of Adelson Galleries, Inc., New York

"stiffness . . . of the illuminated manuscripts of the middle ages."[22] In the recent art historical literature, Trevor Fairbrother suggests that the stylistic disjunction between the two paintings is most convincingly accounted for as a result of Sargent's much documented penchant for the theatrical and the exotic.[23] Kathleen Adler proposes a highly personal dimension to this attraction to "otherness" on Sargent's part: at least to a degree Sargent identified with "otherness," she suggests, because he was himself (as a possibly homosexual Florentine-born American trained in Paris and living in London) a perpetual "outsider," an "other."[24] From this perspective, Sargent's own experience "matched" that of the Synagogue more closely than that of the Church.

The events of 1918 suggest an additional related impetus for aesthetic and affective differences between *Synagogue* and *Church*. In 1918, at precisely the time that Sargent's final version of *Synagogue* was nearing completion, the British War Memorials Committee commissioned the artist to produce a large painting of co-operation between British and American forces in World War I.[25] With friend and fellow artist Henry Tonks, under the custody of Sargent's longtime friend Major Sir Philip Sassoon, the artist spent nearly four months in the summer and fall of 1918, from early July to late October, close to the French and Belgian fronts, following British and American troops, alert for an appropriate subject.[26] During this time Sargent witnessed the aftermath of mustard gas shelling, which ultimately provided his scene.[27] Sargent's friend and biographer Evan Charteris reports Henry Tonks's account of this occasion:

One day we heard that the Guards Division were advancing so we motored towards them to find material for our subjects. We knew that a number of gassed men were being taken to a dressing station on the Doullens Road, so we went there in the evening. He [Sar-

Fig. 120

Opposite, left: John Singer Sargent, *Cashmere Shawl (Rose-Marie Ormond),* 1909–11. Watercolor over graphite, with wax resist, on paper, 19 3/4 x 11 3/4 in. (50.2 x 29.9 cm). Museum of Fine Arts, Boston, The Hayden Collection, Charles Henry Hayden Fund, 12.227

Fig. 121

Opposite, right: John Singer Sargent, *Reading,* 1911. Watercolor on paper, 20 x 14 in. (50.8 x 35.6 cm). The Hayden Collection, Museum of Fine Arts, Boston, 12.214

Fig. 122

Above: John Singer Sargent, *Rose-Marie Ormond,* 1912. Oil on canvas, 31 1/2 x 23 in. (80 x 58.4 cm). Private collection, courtesy of Adelson Galleries, Inc., New York

gent] immediately began making sketches and a little later asked me if I would mind his making this essentially medical subject his, and I told him I did not in the least mind. He worked hard and made a number of pencil and pen sketches which formed the basis of the oil painting known as *Gassed* now in the War Museum.[28]

Sargent experienced an intimate engagement with gas victims when he succumbed to influenza in late September and spent a week in a hospital tent surrounded, as he wrote to Gardner, by the "groans of wounded and the chokings and coughings of gassed men, which was a nightmare. It always seemed strange on opening one's eyes to see the level cots and the dimly lit long tent looking so calm, when one was dozing in pandemonium."[29]

Charteris wrote that Sargent seemed to maintain his "habitual reserve" in the most nightmarish of wartime situations, but a description of Sargent's visit, in the company of a British officer, to a United States Army base hospital in July 1918 suggests the limits of his "reserve." As an American medical officer noted in a letter to Thomas Fox: "Apparently J.S.S. is out on a painting mission and some wise guy thought he (J.S.S.), would be interested in painting those terrible faces that have been shot away and then good men build up but they look like nothing human. That was too much for Sargent. Of course I had to telephone that he was dead or the light was bad or any damn thing but he couldn't come."[30]

Even a professional spectator like Sargent, a person widely known for his cultivation of the role of close observer, was not prepared to experience all of the war's visual possibilities. For Sargent, the disjunction between his actual intended subject and the ideal performative "epic" representation he felt was required by "art" had never been greater than during the First World War and especially during 1918. To Charteris, again, he wrote of the baffling predicament that modern trench warfare presented to one prepared to paint a "heroic" battle scene:

The programme of "British and American troops working together," has sat heavily upon me for though historically and sentimentally the thing happens, the naked eye cannot catch it in the act, nor have I, so far, forged the Vulcan's net in which the act can be imprisoned and gaily looked upon. How can there be anything flagrant enough for a picture when Mars and Venus are miles apart whether in camps or front trenches. And the farther forward one goes the more scattered and meagre everything is. The nearer to danger the fewer and more hidden the men—the more dramatic the situation the more it becomes an empty landscape. The Ministry of Information expects an epic—and how can one do an epic without masses of men?[31]

Another personal confrontation with war, earlier in 1918, had touched the artist even more deeply than his own exposure to unknown maimed victims or

even his proximity to young casualties of gas.[32] On 29 March 1918 Sargent's twenty-four-year-old niece Rose-Marie Ormond André-Michel (1893–1918) was killed in Paris in the bombing of the Roman Catholic church of Saint-Gervais in place Lobau.[33] Rose-Marie, herself an Episcopalian, was the middle daughter and second child of Sargent's younger sister Violet. Again and again Rose-Marie was the model in paintings that included members of Sargent's own family, in, for example, *The Brook,* (1908; fig. 119); *Cashmere Shawl* (1909–11; fig. 120); *Reading* (1911; fig. 121); and *Rose-Marie Ormond* (1912; fig. 122). So frequently did she appear that she can fairly be judged an integral part of Sargent's sense of artmaking.

In correspondence written over the course of the war and to many different recipients, Sargent expressed a high degree of concern for the welfare of his sisters and for Violet's six children. Always close to family, especially in the years after his mother's death (1906), Sargent spent significant time with Emily and Violet and Violet's daughters and sons. A letter from Jane de Glehn to her own mother, penned shortly after Mary Sargent's death, gives some indication of the private impact on the artist of this and presumably other familial deprivations. Jane wrote that Wilfrid, her husband and Sargent's friend and assistant, "saw poor Sargent today. He is more cut up and more jerky and powerless to express himself than ever."[34] With the insight de Glehn's letter provides, we get a glimpse of the man who sent this note to Mrs. Gardner on 5 April 1918: "Imagine the horrible news I got night before last—my charming widowed niece Rose-Marie was killed in the bombardment of Paris. I have no details—they are probably dreadful."[35] When Sargent moved close to the front to gather materials for his war epic, then, he carried with him a heavy burden of personal loss directly connected to the war.

Finally, in another and less traumatic manner, the artist's personal experience was relevant to his representation. Emily, the sister with whom he lived at the time, had, since autumn 1914, contributed to the war effort by wrapping the sort of "lint" or gauze bandages used in the blindfolds that protected the acutely sensitized eyes of gas victims.[36] That Sargent was aware of his sister's activity in this regard is apparent in a letter to Emily written during the anxious months that he was detained in the Austrian Tyrol by the war's outbreak: "I got a letter from Violet—ours must have crossed—she must be awfully distressed about Rose-Marie [whose husband had just been killed on the Western Front]—I can't think how she will spend the next few years. Alone in Paris would not be very pleasant. Violet says a lot of neighbors make bandages at the flat for the Red Cross, which is a clue to your phrase 'we make things.' "[37]

The overt connections between *Gassed* (fig. 123) and *Synagogue* are principally visual. Sargent's sketches (fig. 124) for the final version of *Synagogue,* using a blindfolded man as a model, are virtually identical to sketches of blindfolded sol-

Fig. 123

Top: John Singer Sargent, *Gassed,* 1918–19. Oil on canvas, 7 ft. 7 in. x 20 ft. 1/2 in. (231 x 611.1 cm). Imperial War Museum, London

Fig. 124

Left: John Singer Sargent, *Study for Synagogue,* from sketchbook of studies, c. 1916–19. Graphite on off-white wove paper, 10 1/8 x 7 9/16 in. (25.7 x 19.2 cm). Fogg Art Museum, Harvard University Art Museums, Gift of Mrs. Francis Ormond, 1937.7.28 folio 5 recto

Fig. 125

Right: John Singer Sargent, *Six Head Studies for Gassed,* 1918–19. Charcoal and stump on beige laid paper, 18 5/8 x 24 1/8 in. (47.3 x 61.3 cm). Corcoran Gallery of Art, Washington, D.C., Gift of Emily Sargent and Violet Sargent Ormond, 49.106

diers (fig. 125) preparatory to *Gassed*. In the finished paintings there is a striking compositional similarity between the blindfolded soldier with the raised canteen located to the right of center in the foreground and the figure of the allegorical Synagogue. Though Sargent's art suggests an abiding interest in themes of veiling and visuality, concealment and revelation, *Synagogue, Gassed,* and the studies for them are the only works in which Sargent painted *blindfolded* people. The general ubiquity of the blindfold by 1918 as a signifier of war wounds—and especially gassing—thus linked these two paintings. When, in 1919, Sargent sent Otto Fleischner the official descriptions of *Synagogue* and *Church,* he (Sargent) referred not to Synagogue's "blindfold" but to the "bandage round her eyes."[38]

In comparing *Synagogue* and *Gassed,* it is the synchronicity of creation that is most critical. Sargent completed *Gassed* sometime in March 1919; in the same month he invited Fox to help with a trial installation of *Synagogue* as well as *Church,* and he unveiled that pair six months later, in October 1919.[39] The linkage between *Gassed* and *Synagogue,* however, may have been conceptual and emotional as well as chronological and visual, influencing the way Sargent understood and executed the two paintings. In terms of his art historical sources, surely Sargent was familiar with the Cumaean sibyl's association with Roman wars and predictions of war; his literary and artistic contemporaries acknowledged and exploited this sibylline connection in their own art. Elihu Vedder used for his *Cumaean Sibyl* (1875–76) the features of Jane Jackson, a freedwoman whose portrait he had sketched in New York during the Civil War. In an inscription across the bottom of his drawing Vedder labeled the image: "*Jane Jackson—War-Time* (1863)." Sargent may have seen Vedder's finished sibyl at the Paris Exposition in 1878.[40] Three years after Sargent completed *Synagogue,* in a poem that expressed T. S. Eliot's sense of the personal and cultural suffocation wrought by war as well as the failure of the Judeo-Christian past to sustain the present, Eliot (another expatriate American in London) would preface his apocalyptic *Waste Land* with the Cumaean sibyl's anguished yearning: "I want to die."[41]

The technology and chemistry of modern warfare, too, suggested possible connections between *Synagogue* and *Gassed*. For while mustard gas was not always fatal, many of its victims died gruesomely within two weeks of exposure.[42] Did the artist consider affective similarities between the young victims of mustard gas who knew their ends might be horribly near and a Synagogue who, as described in Renan's account (an account consistent with Christian theology and popular culture at least as early as the Middle Ages), shared a similar terrifying knowledge of destiny? Further, in the library murals, did the similarity in the disposition of Christ's dead body laid out over the knees of Church and the disposition of Synagogue's body signify a joint sacrificial enterprise as well as a common passing of the material, the institutional, the external? Neither Sargent nor any of

his audiences had anything to say on this matter. Though contemporaries specu-
lated about the possible relation between World War I and Sargent's *Gog and
Magog* (originally called *Armageddon;* installed in 1916 but completed, too early for
the influence, in 1911), no written evidence documents observed connections
between *Synagogue* and the war or between *Synagogue* and *Gassed.* While this was
not a connection contemporary audiences noted, it was perhaps an emotional
link the artist *felt*—and observers did comment on the affective depth of *Syna-
gogue* and the comparative "shallowness" of *Church.* If the visual similarities be-
tween the studies for *Gassed* and the studies for *Synagogue* and the simultaneity of
production can be taken as indicators, the Renan-derived narrative of *Triumph of
Religion* would remain essentially the same (with the Jewish institution yielding, if
only temporarily, to a similarly moribund Christian one), but the emotive capac-
ity of and the possibility for empathetic identification with *Synagogue* would be
significantly expanded. Sargent's own war experiences, then, might account at
least in part for the greater emotional proximity in *Synagogue,* noted by Rabbi
Gold in 1919 and by numerous critics and art historians thereafter.[43] Yet another
factor (this one, too, as we will see, intimately related to Sargent's wartime expe-
rience) must be considered—and that is the different media of the principal
sources for this pair of images. *Synagogue*'s major source was a fresco painting,
Church's a stone sculpture.

CHURCH, SYNAGOGUE, AND THE END OF CIVILIZATION

One year into the war, by October 1915, Sargent had decided to make *Synagogue*
and *Church* a more prominent part of his mural program, moving them from dec-
orative relief accents on the upper walls or ceiling to the east wall. The events of
the war surely influenced his composition of *Church* and its meaning as they did
that of *Synagogue*—and may even have provided the initial impetus for inclusion
of the pair in the cycle. Both contemporary evidence and recent interpreters have
pointed out the role of damaged cathedrals and churches as "symbolic pieces of
ruined public architecture," as emblems of the collision between war and religion
and between war and art.[44] Sargent could not have escaped familiarity with this
trope, so common to newspaper accounts and artists' representations of the war.
In the fall of 1917 when, due to the press of another engagement, Sargent regret-
fully missed French officer Paul Azan's lecture series, "The Warfare of Today," at
the Lowell Institute, he gratefully received from Otto Fleischner a number of the
lieutenant colonel's books—and, if the surviving correspondence gives an accu-
rate sense of the matter, he read them with great interest.[45] Some months later the
book that published the Lowell lectures for 1917 included Azan's own pho-

tographs of ruined churches and cathedrals, shots generally taken earlier, in 1914.[46] Edmund Gosse, one of Sargent's close literary acquaintances, wrote of Henry James's encounter with the horrible cultural power of the willful targeting of cathedrals. Gosse described James looking out over the English Channel toward the sounds of battle: "The anguish of his execration became almost the howl of some animal, of a lion of the forest with the arrow in his flank, when the Germans wrecked Rheims cathedral."[47]

The first bombardment of Reims cathedral occurred early in the war on 18 and 19 September 1914. The damage to the cathedral was catastrophic (fig. 126). Gosse's claim that the shelling had "wrecked" it was scarcely hyperbolic. Barr Ferree, writing a short time later, maintained that "no other episode of the Great War has accomplished such complete destruction of so great a work of art."[48] Maurice Eschapasse recounts that "in 1914 Rheims was the first victim of modern warfare and came within a hair's breadth of complete destruction."[49] Sauerländer reports "enormous damage" to the "sculpture on the ambulatory chapels, on the upper storeys of the transept, on the left doorway of the west [façade], on the rose window storey of the west façade, and the side portions of the sculpture on the interior west wall."[50] Over the four years of the war, the bombardment of Reims did not represent a single episode but an event of continuous duration. A few assaults were particularly destructive of life (the total number of civilians killed in the shellings exceeds 712) and art; in some months, however, attacks were an almost daily occurrence.[51] Bombardments and major fires in September 1914 and between April and October 1918 were especially destructive. In September 1914 damage to the west façade was extensive; in response, that façade was sandbagged to protect the sculptures from further damage.

Both of Sargent's own written descriptions of *Synagogue, Church,* and their sources refer the reader first to the famous sculptures at Reims cathedral.[52] There the two figures appeared on the south transept façade, on the rose window story. Though Synagogue survived the war, the figure of Church was "mutilated" in 1917 and completely destroyed in the seige of 12 September to 5 October 1918.[53] (Both Church and Synagogue have since been replaced at Reims by copies.) Sargent would have been somewhere along the French or Belgian fronts at the time of Church's demolition (late September the artist spent in the war hospital tent). In his classic work (1919) on Reims cathedral, Paul Vitry reproduced large photographic plates of the cathedral's architecture and sculpture, including Church and Synagogue (fig. 127), as they had appeared before the devastation of the war. In the prefatory pages to the plates, he described the war's damage in detail and illustrated his text with photographs of what was left of Church (fig. 128) when the shelling was over and of Church's head as reconstructed from fragments (fig. 129).[54] There is a more than passing resemblance, in

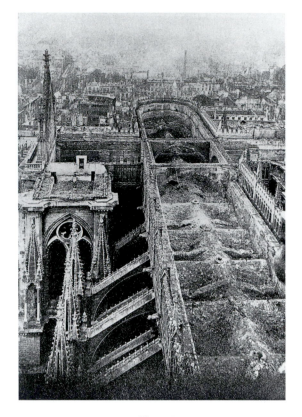

Fig. 126

Damage to Reims cathedral, September 1914. From Paul Vitry, *La Cathédrale de Reims: Architecture et sculpture* (Paris: Libraire Centrale des Beaux-Arts, 1919), vol. 1

Fig. 127

Opposite, top: Church and Synagogue, Reims cathedral. From Paul Vitry, *La Cathédrale de Reims: Architecture et sculpture* (Paris: Libraire Centrale des Beaux-Arts, 1919), vol. 2

Fig. 128

Opposite, bottom left: Fragment of Church recovered from the debris, 1918. From Paul Vitry, *La Cathédrale de Reims: Architecture et sculpture* (Paris: Libraire Centrale des Beaux-Arts, 1919), vol. 1

Fig. 129

Opposite, bottom right: Church, reconstructed head, 1918. From Paul Vitry, *La Cathédrale de Reims: Architecture et sculpture* (Paris: Libraire Centrale des Beaux-Arts, 1919), vol. 2

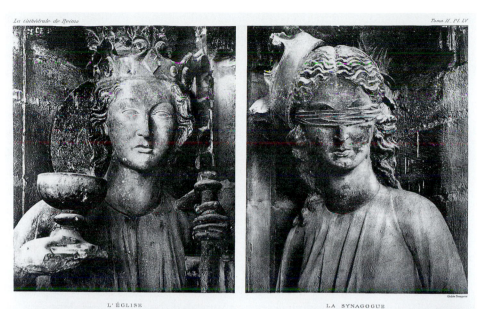

La cathédrale de Reims Tome II. Pl. LV

L'ÉGLISE LA SYNAGOGUE

Étage de la rose Façade méridionale du transept

position and in gaze, between the head of Sargent's *Church* and the head of the same figure at Reims, strikingly the very portion that could be resurrected from the debris.

 Though we have no direct evidence of Sargent's knowledge of Reims's fate, his intense interest in culture and its high artifacts would suggest that he would have paid attention to, perhaps participated in, the outcry among artists and arts organizations that attended the destruction at Reims, beginning in September 1914. Maurice Landrieux's 1920 book on the bombardment of Reims in-

cluded an appendix of thirty-seven separate predominately European "Protests by Learned and Other Societies and Authors," including short excerpts from statements issued by Auguste Rodin, the Académie des Beaux-Arts, two prominent French rabbis, the Royal Institute of British Architects, and a petition signed by three hundred British artists and writers (unfortunately not individually identified in the text). We have, furthermore, these facts: one friend of Sargent's (Gosse) published the anguished expression over Reims of another (James); Sargent explicitly indicated that Reims was a principal source for *Church* (and *Synagogue*); and the artist was in relative physical proximity to the incident at the time it occurred. It seems unlikely that Sargent would have remained unaware of the war's devastating impact on this art. Sylvester Baxter noted *Church*'s "stiff, solid, statuesque" pose, and another critic described the "neutral and gray tones" of Sargent's paintings as the artist's way of emphasizing the sculptural sources: these artistic masterworks "at Reims, Paris and elsewhere" the war had placed at risk.[55]

In August of 1918 Sargent painted *Ruined Cathedral, Arras* (fig. 130), an "empty landscape" that nonetheless communicated the sort of war drama he believed worthy of representation.[56] Arras, like Malines, Louvain, Ypres, Senlis, Soissons, the Somme, and, most of all, Reims, became a signifier of war's devastation of art and piety. In *Ruined Cathedral, Arras* Sargent invited the beholder to stand with him in the ruins amid the rubble at the altar end of the cathedral. Locating ourselves architecturally with respect to the fragmentary nave and the standing entry wall at liturgical west, we assume the usual perspective of the parish priest or of a communicant returning to the pew after receiving the host. This positioning of artist and viewer emphasizes the extent and degree of destruction and the precariousness of the remaining structure, the pattern of light in the foreground and middle ground of the painting indicating that the apse of the building, the eucharistic sanctuary, has been fully demolished. The beholder is surrounded by debris—toppled columns and shattered capitals. The desolation of the situation is augmented by the now headless (and therefore sightless) sculptural remains of a draped prophet or evangelist that stands with its back toward us, this side of the crossing. While Catholicism's associations for Sargent before the war and in the first years of the conflagration were most frequently to the "primitive" religious experience (see fig. 79) of the European "peasantry," as in Frazer, here Catholicism and the institution of the church lie in ruins.[57] Like the metaphorical destruction of *Synagogue*, the Church is here literally destroyed.

Not more than a month after painting *Ruined Cathedral* Sargent witnessed the scene that provided the subject for *Gassed*. In May 1919 he exhibited both *Gassed* and *Ruined Cathedral, Arras*. Critical response was consistent with the interpretation of *Ruined Cathedral*, especially, as an image representing civilization's end: "An extraordinary sense of the dignity of human suffering permeates the

various groups into which the composition [of *Gassed*] has been split up. The same spirit of beauty in destruction is to be found in his 'Cathedral of Arras in August, 1918,' in which the shattered edifice has been endowed with much of that grandeur of departed glory which clings about the relics of ancient Greece."[58] Many contemporary critics treated the ruins of war as emblematic of the ruins of "ancient Greece" and its "departed glory." On the one hand, this approach established a sort of aesthetic viability, a more or less sanitized "beauty in destruction," for these remains. On the other hand, this artistic and sometimes even picturesque recapitulation of the wreckage occurred in the context of active debate in France and Belgium over whether to discourage restoration in order to let the ruins stand as lasting monuments to human barbarity and brutality.[59] Regardless of a particular structure's actual fate in terms of reconstruction, paintings, drawings, and photographs captured a permanent record of civilization's destruction and destructiveness.

As John Thomas has argued persuasively, *Gassed*, like *Ruined Cathedral, Arras,* communicates a strong apocalyptic sense, with references as various as the obvious notation of Pieter Brueghel's *Parable of the Blind* (1568) and the somewhat less explicit citation of Tintoretto's *Crucifixion* (1565) in the Scuola di San Rocco (the parallel, noted by Elaine Kilmurray and David Fraser Jenkins, is between the guy ropes of the unseen hospital tent that lies just outside the picture plane to the right and the ropes that support the cross in the Tintoretto).[60] Two lines of blindfolded men move toward the hospital tent but see their geographical destination no more than we do. Two of the sighted orderlies guiding the men look back or to the side. Only the orderly leading the more distant group looks forward—and his features are rendered so indistinctly as to belie his gaze.[61] A game of soccer is played in the distance; two teams (one suited in blue and white, the other in red and white) are seen in the interstices between the bodies of the foreground line of standing men. The ball is suspended in the air a bit below the level of the moon, in the large gap framed by the wretching soldier who turns aside and the man in front of him, whose prominent rifle butt points directly at the red ball. Though the game, as many have remarked, introduced a contrasting note of ordinariness into the image, it also suggested (like the ever-threatening war planes in the distant sky) the interminability of competition and conflict. Life itself was a struggle of opposing forces, a rehearsal for combat.[62] In this sense, too, *Gassed* resembles *Ruined Cathedral*. Both represent the seemingly endless duration of war. *Ruined Cathedral* accomplishes this in its empty, timeless stillness. *Gassed* produces a similar effect in the somber and deliberate rhythm of the image, in the countless bodies, like the rubble of the cathedral (or Sargent's *Hell* [fig. 31]), strewn across the landscape before and behind those who march upright. The time of day, as well, with its eerie suspension between sunset and moonrise, underscores this content.

Not just for Sargent, but for Western culture more generally, World War I challenged the ideology of progress, shaking the earlier optimistic and evolutionary narrative it suggested to its foundations. Though many continued to think progress *might* be possible, belief in its inevitability largely disappeared with the war. As war historian Paul Fussell maintains: "The Great War was more ironic than any before or since. It was a hideous embarrassment to the prevailing Meliorist myth which had dominated public consciousness for a century. It reversed the Idea of Progress. The day after the British entered the war Henry James wrote to a friend: 'The plunge of civilization into this abyss of blood and darkness . . . is a thing that . . . gives away the whole long age during which we have supposed the world to be, with whatever abatement, gradually bettering.' "[63]

Sargent, then, found himself trying to complete a mural cycle based on a widely accepted public cultural and religious philosophy at precisely the historical moment when that philosophy was called seriously into question. Before the war, the sort of progressive movement Sargent imagined from a superstitious and materialistic exterior universe to the self-determining person acting from a "kingdom within" was one many could confidently endorse. In this scheme, enlightened individuals, operating from the perspective of subjective experience, could be counted on to behave morally and generously; it was not the content of

Fig. 130

Opposite: John Singer Sargent, *Ruined Cathedral, Arras,* 1918. Oil on canvas, 22 x 28 in. (55.8 x 71.1 cm). Private collection, courtesy of Adelson Galleries, Inc., New York

Fig. 131

John Singer Sargent, *Thou Shalt Not Steal,* 1918. Watercolor on paper, 20 x 13 1/4 in. (50.8 x 33.6 cm). Imperial War Museum, London

moral law that Sargent's cycle dismissed but the external structures that authorized and monitored it. Morality was a matter of self-control, not deference to institutions, codes, hierarchies.[64] The war, however, introduced an element of ambiguity, a kind of moral enervation threatening and challenging assumptions about the degree to which codes of ethics could actually be internalized. In a 1918 watercolor, *Thou Shalt Not Steal* (fig. 131), Sargent painted his acknowledgment of this wartime ambiguity.[65] And, while the precise content of the Reverend Dr. Thomas Van Ness's hesitation to endorse the spiritual condition of contemporary humanity is not entirely clear, he may have had the war and its lessons in mind when he rationalized Sermon on the Mount's incompletion in

1925: perhaps the time was not yet right for "this masterpiece, this central dominating conception." Perhaps humanity had not yet gained the requisite degree of spiritual maturity to "give proper expression to the Voice in religion when, freed from tradition, form, ceremony, dogma, it speaks forth the divine will and purpose."[66] If the late nineteenth century had been an age of religious doubt, commented Boston's Episcopal bishop Charles D. Williams (in words singularly and ironically suited to the war's introduction of chemical weapons), the postwar years were an age of "disillusionment," the "bitter fruit of the shattering experience of the world war with its poisonous aftermath."[67]

The "ends" represented in *Gassed* were personal as well as cosmic—and on a personal level the desolation meant both individual annihilation and, perhaps even more terrifying though somewhat less imminently final, the cessation of generativity. For, in addition to burning men's lungs and subsequently causing recurring respiratory illness if not death, mustard gas damaged or destroyed genitalia. Though downplayed in much of the literature, as John Thomas points out, the biological effects of the gas were horrifying:

The symptoms of mustard gas poisoning generally took two-to-three hours to be felt, and began with irritation of the eyes, resulting in conjunctivitis. Next, the nose would run with mucous, as with a heavy cold, which would be followed by nausea and vomiting. Finally, the eyelids would swell, causing complete closure of the palpebral fissure. This process might take as long as twenty-four hours, and be accompanied by pus running down the cheek. The vocal chords were also immobilised, to a greater or lesser extent, and a severe burning in the throat created an excessive thirst. Any areas of the skin exposed to the gas—or, worse still, the liquid that produced the gas—would be badly burned, causing a red/purple effect. Often the genitals were severely damaged by burning, and one theory for the occurrence of burning in non-exposed areas was the presence of hair and with it sebum, which was said to aggravate the destructive effects of the chemical. In the second twenty-four hours, blisters would form, the ears might swell, the genitals might be entirely destroyed, and the victim would cough up shreds of necrosed mucous membrane. . . . In essence, mustard gas killed by destroying the respiratory tracts, by causing acute septic bronchi-pneumonia, with emphysema and other complications. Death was known to have occurred between two and ten days.[68]

Having both witnessed gassed men returning from attack and having spent time in a hospital tent full of the victims of mustard gas, Sargent was surely aware of the dire effects on young men's bodies of this chemical weapon. He just as surely understood its implications in terms of a literal inertia and reproductive stagnation, the loss of vitality in contemporary civilization.

The particular sort of destruction represented in *Ruined Cathedral, Arras* and at Reims cathedral as well, while perhaps less insistently signifying human mortality, must have had an immediate personal reality for Sargent in the fall of 1918. It had been only a few short months since his niece Rose-Marie had become a casualty of war. The manner and place of death, furthermore, intimately linked her to this painted scene of destruction: she died in a Catholic church (Saint-Gervais) during the bombing of Paris. In this sense, Sargent's own most intense experiences of the war might account for the disproportionate stylistic distancing of *Church* (like *Ruined Cathedral* and in contrast to *Synagogue*) and the almost strained hieratic visual vocabulary the artist employed in the Christian panel. The possibility of this connection becomes stronger when Sargent's depiction of Church's face is juxtaposed not just with the head of Church at Reims but also with his representations of Rose-Marie. Like *Synagogue, Church* underwent significant changes between the first sketches in 1915 and the finished version in 1919. The circumstances of Sargent's personal war experiences may have contributed to the somber distancing of *Church*—as they did to the relative proximity of *Synagogue.*

In *Triumph,* the institutional *Church* Sargent imagined was, like Reims and like Saint-Gervais, Roman Catholic—she was garbed as a nun (a fact that did not escape the Boston critics), and she held eucharistic symbols in their Roman Church aspect.[69] In the same impressionistic manner in which he borrowed Coventry Patmore's features for Ezekiel (though with a much less light-hearted tone and a more stylized touch), Sargent used Rose-Marie's features for the face of *Church,* combining her "wide-set eyes and retroussé nose" with a position of the head suggested by the demolished sculpture at Reims (compare figs. 119–22 with figs. 127, 129 and 18).[70] He thus connected the tragedy of his young niece's death with the institution of the church and with the building (Saint-Gervais) in which she literally died.

The library painting is a funerary image for Rose-Marie and, through its connections to the sculpture at Reims, for Western culture.[71] Church's blue-gray vestment and the garment of the dead Christ are draped from a single piece of fabric; this joining of the youthful Church to the equally youthful but lifeless body of the Christian Savior is most obvious at Church's left knee and just above and to the proper right of Christ's right hand. The gold edging of Church's drapery also continues in a line of accent over Christ's left knee and around his legs. The personal associations of death, the Eucharist, the "demise" of institutional Christianity (especially in the medieval Catholic expression Sargent painted), and Rose-Marie contributed to the final configuration of Sargent's *Church.* These associations account, in part, for the unseeing "sculptural" stare that led Downes to call her "solemn and enigmatic" and to note her "inscrutable countenance."[72]

These meanings (*Synagogue* in relation to *Gassed* and to the *Cumaean Sibyl* and *Church* in relation to Reims and to Rose-Marie) complicate the two paintings' presence in *Triumph of Religion* and perhaps begin to explain their disjunction with respect to the rest of the cycle. No longer a "simple" medieval opposition fading into the background "behind" Sermon, each now contained disarmingly personal references that unbalanced the images' conventional symbolic usage and accounted for stylistic and representational inconsistencies and ambiguities. From Sargent's perspective, the attack on the paintings thus must have had an essentially hidden and powerful private resonance. The war, despite its devastating impact, did not lead Sargent to abandon *Triumph of Religion*. Despite his wartime experiences and in silent testimony to them, he completed *Synagogue* and *Church*. The war did, however, likely contribute to the effect on Sargent of the *Synagogue* controversy; to a large degree the progressive momentum of the cycle's optimistic public content had already been arrested even before October 1919.

PRIVACY, PUBLICITY, AND THE SELF CONCEALED

We turn now to the third theme of *Synagogue* and *Church* outlined in this chapter's introduction. The opposition and relation of concealment and revelation was a subject explicitly raised in both the story of the Cumaean sibyl and in Sargent's Renaissance and medieval sources for *Synagogue* and *Church*. In the Concordance window at St. Denis, for example, to which Sargent had earlier turned for medievalisms in his *Dogma of the Redemption,* the full Latin inscription translated: "What Moses veils, the doctrine of Christ reveals."[73] On the east wall of the Special Collections Hall, the relationship between Sargent's Jehovah of *Israel and the Law* and his proposed Jesus of Sermon on the Mount would accentuate continuities and diminish the oppositional elements of the medieval typology that Cosimo Rosselli had pursued in his pairing of *Giving of the Law* and *Sermon on the Mount* in the Sistine Chapel. But Sargent's revision did not altogether abandon the typological construct. His paintings would, in fact, imply the casting off of Jehovah's concealing, sheltering, and protecting veil in the Jesus of Sermon below. The modernity of Sargent's conception resided not in the contrast between concealment and revelation but in the privatizing and interiorizing content of the revelation, and in the way revelation doubled back into its presumed opposite, concealment. The two qualities, Sargent seemed to say, might be intimately related. The content of the sort of revelation the artist recommended was ultimately written on, concealed in, the individual heart.

The theme of concealment and revelation, however, did not emerge for Sargent in relation to the Boston Public Library murals, but reiterated in that

project a set of interests that ran visually and consistently throughout his oeuvre.[74] The artist's lifelong investment in this subject, in his professional and personal lives, informed both the content of *Triumph of Religion* as a whole and Sargent's reaction to the *Synagogue* controversy. Renan's historical theology, resting as it did on the conviction that the essence of religion had been hidden beneath a veneer, that all "creeds" and "symbols" were "disguises," must have had a particular appeal for Sargent.[75]

Somewhat ironically for an artist whose work critics and historians consistently described as "realist," "naturalist," "materialist" (Cortissoz once called him the "type of materialism triumphant"), Sargent was interested, at the Boston Public Library, in throwing off the "materialism" in religion that he believed concealed an authentic, internally generated and thus "private" spirituality.[76] As we have seen, it was not morality as signified in the Ten Commandments or the precepts of the Church (or even religious behavior per se) that Sargent wished to discard, but the external forms of morality's mediation and enforcement: law, doctrine, and institution. This privatization of religion from a political, communal, and cultural perspective here also meant the privacy of religion from the perspective of the individual. While not rejecting religious behavior, Sargent endorsed a position of noninterference with respect to individual expression and choice. In this scheme, the individual was the ideal unit of relation, and self-containment constituted the ideal alignment from which to approach the world.

While distance and detachment are not necessary counterparts of this essentially political position, Sargent's particular sort of expatriation, his early childhood and youth organized around not just leisurely travel but a rather intense schedule of sightseeing, educated him in a particular version of the art of seeing that might best be labeled spectatorship.[77] People moved in and out of his life with some frequency. Richard Ormond has commented on the degree to which Sargent and Vernon Lee were "detached in the main from the society of their contemporaries and literally spoon-fed on European culture."[78] A contemporary critic drew a similar conclusion: "Born in Florence of American parents, educated in Italy and Germany, a student at the Florence Academy and with Carolus Duran in Paris, it is not difficult to perceive that Sargent's point of view must inevitably be that of an unattached observer. Utterly without local bias or permanent background, he remained all his life an onlooker."[79] Sargent himself was often quoted by contemporaries as insisting: "I chronicle, others may judge."[80]

More than many, Sargent was a self carefully guarded, taking the precise measure of what to reveal and what to conceal. His explicit interest in the idea of concealment (and perhaps even a sense of private amusement over this exercise of control) extended even to his personal correspondence. Here, when some aspect of his own commitments and especially of his affection or esteem for someone

Fig. 132

John Singer Sargent, *Fumée d'Ambre Gris,* 1880. Oil on canvas, 54 3/4 x 35 11/16 in. (139.1 x 90.7 cm). Sterling and Francine Clark Art Institute, Williamstown, Massachusetts

Fig. 133

John Singer Sargent, *Mrs. Gardner in White,* 1922. Watercolor on paper, 16 3/4 x 12 1/2 in. (42.6 x 31.8 cm). Isabella Stewart Gardner Museum, Boston, P11e13

had become apparent to the correspondent, he repeated with some frequency a favorite expression: "Further concealment is useless."[81] Sargent's reputation for personal reticence was not simply a fiction of his critics and biographers, but a source of frustration for his friends—and even his family on occasion. Not only did he say relatively little in his letters, but only the most diligent could read his atrocious script. Jacomb-Hood maintained that the artist's "words and letters are indicated . . . in a few impressionist strokes, and have to be guessed at, rather than read."[82] Even his sister Emily, to whom he was perhaps closer in life than to anyone, confided to Thomas Fox two weeks after her brother's death, "I dare say

you know that John never told me anything hardly of his plans about his work."[83]

While never solipsistic, Sargent's detachment had ideological as well as personal dimensions; his disengagement informed his perspective on human relations, on politics, on religion, and on art. In 1891, at the age of thirty-four, as he contemplated Violet's marriage to Francis Ormond, he expressed his anxiety for his sister and her "passions." Though he himself maintained many long-term, warm, and considerate friendships, he told Lucia Fairchild that he considered intensity and permanence inconsistent. Marriages that started and stayed on the even ground of mutual respect and affection, he believed, had a much greater chance of success than those where the intensity of initial emotion, of love, could only lead, when passion inevitably diminished, to contempt and hate.[84] Speaking, on another occasion, to Fairchild, Sargent cautioned her against obvious partisanship in politics or religion. Such attachments so severely compromised aesthetic vision that they constituted "suicide" to art. This choice of words, by which Sargent seems to have meant that art "kills itself" in particularizing its politics or its religion, seems oddly self-referential. As far as his art was concerned, at any rate, Sargent apparently made a position of not taking a position.[85] As one familiar with public controversy himself and having witnessed his friends' (Henry James, Edmund Gosse, and Edwin Abbey, for example) experiences with similar "invasions," a public debate played out in newspapers was exactly the opposite of what Sargent intended for his mural cycle about the ideal of spiritual privacy. Perhaps it should come as no surprise that Sargent's apotheosis of private subjectivity should manifest itself at just the time that T. J. Jackson Lears equates with the "emergence of new ways to invade privacy—and new justification for the invasion."[86]

An artist who firmly believed that images spoke best for themselves, Sargent modeled the sort of personal detachment and interiority he recommended in the subjects he selected for his art and in the way he posed many who sat to him for portraits. In some of his paintings even the appearance of community could be strangely deceptive. *Cashmere*'s (1908) solemn procession of children was not a group of girls bound by some single enigmatic purpose but one girl (Rose-Marie's sister, Reine Ormond) who appeared in seven different poses.[87] Disengagement of the sort that made space for privacy and the reliance on the self, on interiority, that accompanied and in part constituted that quality, Sargent represented in numerous paintings and in numerous ways. In images like *Fumée d'Ambre Gris* (1880; fig. 132), *Sally Fairchild* (1890; Terra Museum of American Art, Chicago), *Frieze of Prophets* (1895), and *Reclining Figure* (c. 1908; private collection), veils contained individuals, isolated them, cut selves off from the outside (or the outside from them), allowing or even necessitating recourse to inner resources and suggesting hiddenness and secrecy as the flip side of interior discern-

Fig. 134

Opposite top: John Singer Sargent, *Sketch of Draped Figures on the Ground,* for *David Enters Saul's Camp at Night (Amsterdam Bible),* n.d. Graphite on paper, 9 7/8 x 14 in. (25 x 35.5 cm). Museum of Fine Arts, Boston, The Sargent Collection, Gift of Miss Emily Sargent and Mrs. Violet Ormond in memory of their brother, John Singer Sargent, 28.949

Fig. 135

Opposite, middle: John Singer Sargent, *Bedouins in a Tent,* 1906. Watercolor on paper, 12 x 18 in. (30.5 x 45.7 cm). Private collection, courtesy of Adelson Galleries, Inc., New York

Fig. 136

Opposite, bottom: John Singer Sargent, *Bailleul Tents,* 1918. Watercolor on paper, 13 1/4 x 20 3/4 in. (34 x 52.5 cm). Museum of Fine Arts, Boston, The Hayden Collection, Charles Henry Hayden Fund, 21.139

Fig. 137

Above: John Singer Sargent, *Interior of a Hospital Tent,* 1918. Watercolor on paper, 15 1/2 x 20 3/4 in. (39.4 x 52.7 cm). Imperial War Museum, London

ment.[88] Costumes operated as tents or hoods or shrouds or cocoons as, for example, in *Mrs. Gardner in White* (1922; fig. 133) and the illustrations and sketches for the Amsterdam Bible (fig. 134).[89] Tents—Bedouin tents (fig. 135), camping tents, army tents (fig. 136), hospital tents (fig. 137) (all these of a sort Sargent himself occupied at one time or another)—sheltered and protected, marking in an obvious

fashion the sometimes all too insubstantial boundary between interior and exterior. Fragments of architecture focused on doors, windows, courtyards, and loggias led viewers into distant spaces defined by ever decreasing apertures of sight. Umbrellas filtered light, suggested a kind of membrane between the individual and the world. Even Sargent's painting of Madame Gautreau, that "peacock woman," Vernon Lee called her (accentuating the element of public display evident in the person and the painting), delighted in the barrier the woman presented to the world: the pale lavender and rose-colored cosmetics with which she painted herself.[90] Often these recurring motifs functioned in ways that were interchangeable: mosquito netting could be a veil and a veil could be a tent. For his rendering of *Handmaid of the Lord* (fig. 11), Sargent queried his Catholic friend, poet Alice Meynell, for her assistance in finding, among the many titles of the mother of Jesus, those that represented protected interiority:

I am trying to do a Madonna and wish to introduce several of her appellations and among them some that I do not find in the Litany of the Blessed Virgin. For instance, is not "Hortus Inclusius" one of them; and where is it to be found?—and is it orthodox? And is there not one corresponding to the French "Vase d'Election"? I should be grateful if you can tell me where these names that seem not to be contained in the ritual are to be found and if you know of any others carrying the same sort of ideas I should be glad as they might suit my purpose.[91]

In one of the few of his own paintings that Sargent ever admitted to admiring, *The Hermit* (1908; fig. 138), a figure appears in an outdoor setting so dappled by the pattern of represented light that the title subject of the painting is virtually invisible.[92] Sargent gave the picture an Italian name *Il Solitario,* and he continued to think this label a more accurate representation of the image's significance even after he assented to its translation when the Metropolitan Museum of Art purchased the painting in 1911. " 'Hermit' is alright," the artist wrote to Metropolitan director Edward Robinson before adding a note of hesitation: "I wish there were another simple word that did not bring with it any Christian association, and that rather suggested quietness or pantheism; but it might seem affected, and at any rate I can't think of it."[93] Erica Hirschler accurately notes that *Hermit* provided Sargent with a sort of spiritual and artistic respite from the difficult intellectual labor of the library. According to Hirschler: "In *The Hermit* Sargent left his books behind, responding instead to the divinity and peace he found in nature."[94]

Where *Hermit* complements rather than contrasts with *Triumph of Religion,* however, is in its focus on the individual and on unmediated spiritual experience. *Hermit* thus provides insight into *Triumph*'s content: *Hermit*'s interior communion occurs in "quietness" in a setting that conceals the solitary believer at

Fig. 138

John Singer Sargent, *The Hermit (Il Solitario)*, 1908. Oil on canvas, 37 3/4 x 38 in.
(95.9 x 96.5 cm). The Metropolitan Museum of Art, New York, Rogers Fund, 1911

the moment of expanded spiritual awareness. Disengaged from the Christian triumphalism inherent in *Triumph*'s evolutionary narrative and iconographical sources, unconstrained by institutional parameters and expectations, in large part this painting said, without all the fanfare and attention, what Sargent wanted the library murals to say. Significantly, the library panel from which *Hermit* offered the most immediate respite, in terms of the chronology of Sargent's oeuvre, was the central lunette for the east wall, *Israel and the Law*.[95] Sargent's thoughts, then, must simultaneously have been directed toward Sermon on the Mount, for *Israel and the Law* was designed, in meaning and composition, to lead the beholder's eye and mind to the keynote of the cycle.[96] In its content, in fact, *Hermit* closely repli-

cated the artist's stated intentions for Sermon on the Mount. *Hermit* was, perhaps, the closest Sargent would ever come to completing that final panel.

Sargent maintained his own privacy by presenting only one public face to the world: his art. He did not allow interviews, he discouraged biographers, he kept no diaries except financial account books and appointment calendars. "The language of painting," said his friend Henry James, is "the tongue in which, exclusively, Mr. Sargent expresses himself."[97] In his pictures, of course, the focus was generally on someone else. Many years earlier Sargent had suggested to Vernon Lee that "a subject is something not always in the way"; he would likely have been pleased with Kenyon Cox's description of *Hermit* as "the most accomplished transcript of the actual appearance of nature that has yet been produced."[98] But some things in this carefully contrived painting about concealment and revelation were not actually what they seemed. The two lively gazelles to the left of the hermit, for example, the artist painted from a single product of a taxidermist's skill, and "the solitary one" was himself an artist, an Italian landscape painter, friend and sometime model of Sargent's in Purtud, Ambrogio Raffele.[99]

While his attempted departure from portraiture had multiple motives, an important aspect was Sargent's desire to elude the demands sitters made on his time and patience. As early as 1903 he had firmly established a reputation for diligently avoiding the public spotlight. In that year a columnist for the *Evening Transcript* suggested, albeit mildly, that the Boston public ought properly to have been provided with more notice of Sargent's arrival in the United States to install the second set of library panels:

Mr. Sargent is one of the most retiring of men outside the pale of the recluse, and as he had not announced his departure from England, merely advising a few friends here that he was coming over at this time, he appeared surprised to learn that he was expected by the public and that the cable had chronicled his sailing. Mr. Sargent shuns the interview as he does the bad painting, and his difficulties were added to by efforts to photograph him while he was on the pier at New York. He would have liked to escape, but that was not possible, and the camera had several records of him in company with Mr. Beckwith and Alfred von Glehn in the pier shed.[100]

In 1921 *Vanity Fair* (probably unknowingly) conflated the person of the artist with the subject of the painting here under consideration, calling Sargent "a recluse and a hermit of the most determined order."[101] While this description was hardly accurate with respect to the private Sargent who generally lived and traveled in the company of family and friends, it certainly fit the public persona he cultivated. It cannot be sheer coincidence that Sargent painted a fellow artist as *Hermit* (and afterward uncharacteristically admitted to liking the painting) in pre-

cisely those years in which he was evermore carefully guarding his own privacy to the extent that critics labeled *him* a "recluse," a "sphinx," a "hermit." Given that Sargent was also known, among close friends, for his well-developed sense of humor, the artist may even have entertained the idea of *Hermit* as a witty and self-aware response to earlier critics' application of the title and its synonyms in his own case. Carter Ratcliff, in his 1982 book on Sargent, protested that "it would go too far to claim this [painting] as a covert self-portrait"; perhaps he is right.[102] But Sargent's construction of his own identity as a well-concealed self implies that *Hermit* presents, if not a kind of figurative self-portrait, then at least an analog for the painter's self. Of *Hermit* Cox remarked, "One fancies that one sees the essential John Sargent working for himself alone without regard to external demands, and doing what he really cares most to do."[103] Some of the painter's friends apparently came to believe that the activity of painting itself was, for Sargent, synonymous with being. After the artist's death, Vernon Lee wrote: "More and more it has seemed to me that Sargent's life was absorbed in his painting; and the summing up of a would-be biographer must, I think, be: *he painted.* To some of us he seemed occasionally to paint to the exclusion of living."[104]

Shortly after the Metropolitan acquired *Hermit,* Kenyon Cox wrote to Edwin Blashfield of the painting's attraction—but also of the problems its technique presented to an artist (like Cox) for whom clarity of form was paramount:

Have you seen Sargent's *Hermit* in the Metropolitan Museum? It is the most successful piece of pure impressionism I have ever seen, and a capital example of what modern methods gain and lose for art. It is amazingly like nature, and the hermit is as inconspicuous a part of nature as if the picture were intended for an illustration of protective coloring! You have to hunt for him. In other words, Sargent has realized with extraordinary skill just that condition of things which convinced me, the last time I tried to paint a figure out of doors, that I did not want to paint nature as it really looks.[105]

Cox's celebration of Sargent's "impressionist" technique was also a complaint about his representation of the subject: "You have to hunt for him."[106] In this work Sargent's technique (his sense of color and shadow, his attention to uniform surface texture and character, his interest in the quality of light at a particular moment in time), like a veil or blindfold, concealed the object/subject that he painted. Despite his insistence that a subject not "get in the way," Sargent's interest in this image was not this "particular moment" as potentially interchangeable with any other, but the way the light at this particular moment blinded the beholder and shielded the figure in the landscape, a landscape Cox called "a bit of rough wood interior under intense sunlight . . . studied for its brilliancy rather than for its warmth."[107] And yet, this concealment, wrought by attention to

Fig. 139

John Singer Sargent, *Valley of Mar Seba, Palestine,* **c. 1905–6. Oil on canvas, 27 1/2 x 38 1/2 in. (69.9 x 97.8 cm). Private collection, courtesy of Adelson Galleries, Inc., New York**

"brilliancy," was also about revelation (to the beholder as well as the hermit); not seeing and seeing were here rather intimately connected. Looking harder, the observer enjoyed the discovery more.[108]

As we have seen, veils, draperies, and tents (as recurring images in Sargent's oeuvre)—and even blindfolds and blinding light—can be construed as both barriers and shelters, protecting the internal as well as shutting out what is external, and thus accenting the sort of privacy and interiority in experience that Sargent desired. Two additional details in the painting under consideration merit attention in this regard. First, the bowl of water next to the hermit, reiterating in its reflectiveness the similar quality of the hermit's eyes, and, second, the deer who head deeper into the recesses of the forest and its "rough wood interior." These are recesses, however, that the viewer is never allowed to reach. Sargent's painting invites us in, it explicitly raises for us the subject of interiority and then, in surface texture, square format, and reduction of tonal variation, it denies us access to these inner spaces and to the content of the hermit's vision. In Sargent's art we see people seeing within, and we frequently get a glimpse of mood or tone, but this artist's paintings steadfastly refuse to let us trespass on someone else's privacy.[109]

In his review of *Hermit* when it was exhibited at the New English Art Club, Lawrence Binyon judged this work to be

a piece of extraordinarily brilliant execution. The first impression is that of actual blinding sunlight and shadow among the eucalyptus stems of a southern forest; one is there in the hot atmosphere; the dazzling effect on the brain, the coming headache are admirably suggested. It is only after some time that you make out in the tangle of lights the forms of two deer and of a naked hermit reclining among the rocks. If to represent the sensations of the eye with the utmost possible vividness and completeness be the master aim of art, then this is among the final masterpieces; but what is the effect on our minds? Beyond admiration of miraculous skill it is quite null.[110]

Binyon stood in awe of Sargent's expertise with respect to recapitulating visual appearances on canvas, but he felt deflected from any deeper meanings, turned back on his own devices by the painting's visual character. A similar sort of disequilibrium characterized, for example, Sargent's swirling *Valley of Mar Seba, Palestine* (c. 1905–6; fig. 139), his *Bringing Down Marble from the Quarries to Carrara* (1911; Metropolitan Museum of Art, New York), and his *Mountain Sheepfold in the Tyrol* (1914–15; private collection).

PATTERNS, STENCILS, AND STRATEGIC CAMOUFLAGE

Edwin Blashfield later described *Hermit* as "a half naked man, and deer and trees and dead leaves . . . mixed in a manner which nature accomplishes and military and naval camouflage tries to imitate and use."[111] While this painting preceded the onset of the First World War by six years, it is as much about camouflage as Sargent's *Camouflaged Tanks* (fig. 140) of 1918. Charles Merrill Mount documented Sargent's exposure in 1915 to Abbott Handerson Thayer's work on camouflage, a subject Thayer called "protective" or "concealing" coloration. Thayer's book of 1909 examined the natural application of camouflage, the "laws of disguise through color and pattern."[112] Not only did Sargent indicate in his art his direct interest in this "military" subject, he also read artist Solomon J. Solomon's *Strategic Camouflage,* a book on aerial camouflage and strategic "concealment" in the war. Sargent would certainly have agreed with Solomon's description of camouflage as the "application of art to war."[113] That Sargent admired Solomon's work as an artist as well as a writer is suggested in his almost simultaneous appropriation of Solomon's *Ajax and Cassandra* (1886) as one principal resource for his *Death and Victory* mural at Harvard.[114] Perhaps Sargent discerned that sight is always a bit about camouflage—about seeking out and

Fig. 140
John Singer Sargent, *Camouflaged Tanks, Berles-au-Bois,* 1918. Watercolor on paper, 13 1/4 x 21 in. (33.7 x 53.3 cm). Imperial War Museum, London

Fig. 141
John Singer Sargent, *Passing of Souls into Heaven* (detail), pre-installation photograph showing Lincrusta Walton tacked to canvas, 1916. Oil and gilded or painted Lincrustra Walton on canvas. Trustees of the Boston Public Library

selecting from a web of options the shape that the beholder wants.[115] Not a few contemporary critics recognized Sargent's penchant for remarking this aspect of vision, noting "the variety and significance of touch by which he defines the texture and condition of most opposing things—how a contour becomes confused and full of mystery as it sweeps into the background and again reappears sharp and 'telling'—obedient to the laws of light upon an object, as Light itself obeying Nature's laws."[116]

Though this aspect of his artistic career has been little studied, long before the war, Sargent had developed and sustained an intense interest in pattern and decoration. This ornamental phenomenon could itself be described as a sort of camouflage, and, as the phrasing of Thayer's book indicated, these were interpretive terms available to Sargent and his contemporaries. Sargent's fascination with pattern led to his own extensive collection of laces and velvets and textiles. William Henry Fox commented on Sargent's somewhat unusual attraction to the Brooklyn Museum's substantial acquisitions in "Italian textiles and embroideries," explaining to his readers that the artist owned many similar things himself, and Martin Birnbaum described both his friend's collection of fabrics and his engagement with the patterning activity of stenciling.[117] This interest Sargent pursued in the representation of pattern and in the design of the ornamentation and moldings at the Boston Public Library (see, for example, the borders of *Hell* and *Passing of Souls into Heaven*, the trim of the garments worn by the figures in *Frieze of Angels*, the pattern of the dress worn by *Madonna of Sorrows*, and the veil of the Temple that swathes the figure of *Synagogue*). Sargent also produced literal textiles for the library in the tapestries (figs. 32 and 33) that covered the empty shrines for *Synagogue* and *Church* between 1916 and 1919 and he capitalized, in the execution of *Triumph*, on the textural qualities inherent in certain fabrics.[118] Coburn described the 1916 installation in this way: "For seven months after his arrival in Boston, in May, 1916, Mr. Sargent worked daily on the scaffolding, modelling and gilding every least bit of ornament, repainting whole passages of his panels, attaching to them yards of ribbed corduroy [Thomas Fox called the fabric Lincrusta Walton], so applied as to make the diffusion of light more interesting than from flat surfaces."[119] In a pre-installation photograph (fig. 141) of *Passing of Souls into Heaven*, the Lincrusta Walton and the tacks that held it in place at that stage of the process are visible. A New York critic noted that anyone privileged enough to have occupied a place on the scaffolding during the installation would have seen these

bits of heavily ribbed material, a fabric of commerce used for the walls of heavily furnished rooms, and would have noticed that this material was pasted here and there on the decorations and gilded or painted as the design required, the strongly marked ribs running sometimes in one direction, sometimes in another, according to the desired effect of light

Fig. 142
John Singer Sargent with Thomas A. Fox (American, 1864–1946), *Cranes*, n.d. Water-
color on grasscloth, 67 x 35 in. (170.2 x 88.9 cm). Private collection

on color, and especially on gold which seen on flat surfaces has almost the value of black. As the canvas on which the lunettes are painted, although very heavy, is comparatively smooth, the enlivening contrast of textures thus obtained plays an important part in the whole effect.[120]

Sargent also enjoyed and experimented with this fascination independent of any connection to a specific project. Over the last thirty years of his life—and throughout almost the entire duration of his public library labors—he collected and restored far more patterns and stencils than he ever used in a finished work. For the way in which they indicate the extent of the artist's concern with the visual mechanisms of revelation and concealment, a set of design experiments Sargent conducted with Thomas Fox is of special interest. His routine here was not to create new stencil patterns but to reproduce established designs (like his Japanese *Cranes;* fig. 142), to extract from surviving fragments the principles that allowed their reconstruction, and to exploit the medium's inherent formal possibilities.[121] Clearly Sargent was attracted to repeated pattern for its permission to manipulate design elements in such a way as to make them appear and disappear; he occasionally worked and reworked a single stencil in terms of the properties of color and the texture of ground, allowing now one element, now another, to "show." In a brief unpublished essay, written around the time Thomas Fox apparently exhibited some of Sargent's stencils at the Museum of Fine Arts, Boston, the architect described his friend's engagement with this art form:

The idea of reproducing to a reasonable degree the patterns, colors and textures of what might be called Classic Textiles, by means of stencils, was suggested by John S. Sargent who as a diversion spent a few of the hours set aside from his serious work of painting, in restoring and reproducing several of the best known but well-worn examples of Italian brocade and also one Japanese silk [fig. 142]. Sargent's interest in such materials and their color and designs is shown by their application, in theory at least, in many of his decorations and once in a while in his other work, in the nature of backgrounds or accessories. Many sketches and memoranda also prove his fondness for noting or working out the intricacies of involved and handsome repeats. . . . An interesting phase of the work is noting the effect of the use of different tones or colors for the same pattern, which opens a broad field for the study of relative color values and their juxtaposition.[122]

PAINTING PRIVACY IN PUBLIC

There is a sense in which, as John Davis suggests, the Boston Public Library murals were the "antithesis" in style and content of Sargent's work in portraiture and

genre painting where, ultimately, he represented enlivened visual experience.[123] A critic for the *Saturday Review* noted this disjunction with astonishment in 1894 when Sargent exhibited the panels for the north wall at the Royal Academy prior to installation: "We are too much startled to comprehend at once how the realistic painter of so many mundane portraits has suddenly become the illustrator of Ezekiel."[124] What were the artist's contemporaries to make of his exchange of the visible universe for the intellectual and symbolic? Some feared he had abandoned the source of his talent for something riskier and less secure, embarking on a new course for which he was singularly ill-suited; others heralded the awakening of skills too long neglected and wondered why he had previously hidden his intellectual and imaginative gifts.[125] But all agreed that this was something different.[126] Two of the pictorial labels most frequently applied to Sargent's art, "impressionism" and "realism," were both, outside France at any rate, "thought [by some] to derive from a kind of crass artistic materialism: what you see is what you get."[127] So the artist was, in this important sense, going against his own history in painting spirituality. Perhaps *Triumph of Religion* even represented a kind of protest ("what a surprise to the community!") against the consistent characterization, the "typing," of his work as "materialistic."[128]

And yet, there are also significant continuities between the public library murals and the rest of his oeuvre. Consistently the only sort of interiority Sargent was willing to display in public was actually a bid for personal privacy. Presented, in the geographical wanderings of his childhood, with the possibility of approaching life as the consummate tourist, a studied detachment was the public stance with respect to the world that Sargent selected and cultivated. This stance he reiterated over and over again throughout the course of his career in the art he produced.[129] From this position he conceived *Triumph of Religion;* from this position he approached his formal depictions of contemporaries. Indeed, outside the library, Sargent's portraits do not depict people who invite us into the fullness of their lives but people who judiciously and often theatrically present one or several aspects of themselves to us. In this sense the portraits themselves walk the line between individual and type. Sargent's subjects, like Sargent himself, surely had rich inner experiences and intimate relations (as most of Sargent's pictures lead us to believe), but, in these images at any rate, they do not invite us to share them. In her dissertation in preparation, Leigh Culver reaches similar conclusions. In Sargent's portraits, solicitation and diversion go hand in hand. Of *Mrs. Carl Meyer and Her Children* (1896; private collection), Culver writes: "Even as chosen aspects of the Meyers's bodies and belongings are offered to us for viewing, even as our visual consumption of the image is encouraged, it is also, simultaneously, denied. In fact, it could be argued that the painting itself is about reading, looking, and the frustration of those activities. . . . Only the Meyers themselves have full access to viewing and knowing the environment they inhabit."[130]

Sargent's pictures are highly self-aware but highly filtered representations of personality. Though many suggest a self at home, the viewer gains only partial admittance. Perhaps this was a function of the "sort of protective network of repressions" that Sargent's nephew, Guillaume Francis Ormond, believed his uncle maintained.[131] Perhaps it reflected a conviction of the privacy of individual subjectivity, suggested, as well, in Walter Pater's description of the self in modernity as "the individual in his isolation, each mind keeping as a solitary prisoner its own dream of a world."[132] When Sargent painted Henry James, W. Graham Robertson judged the painting "fine," but felt it lacked "a certain something." This deeper significance, he suspected, Sargent did not deny or abolish but deliberately held back: "Yet this [certain lack of something] should not have been so. . . . [James's] portrait by Sargent, one of the few men who really knew him, should have supplied a clue to the true Henry James that no one else could have found: perhaps the artist intentionally withheld it."[133] Perhaps Sargent had figured out how to accomplish in paint a skill he had admired in Henry James's writing years before: "O for Henry James's faculty of saying something so cautiously that you only know what he meant the next day."[134]

My principal interest in this book concerns what Sargent had to say in public about privacy and its visual and spiritual operation. Sargent's disposition toward privacy, we have seen, reflected a general attitude toward life and its appropriate arrangement. Beyond suggesting the persistence, in Sargent's oeuvre, of themes of concealment, artistic camouflage, performance, deflection, and disguise, this book pursues neither the particular content of Sargent's privacy nor that of his sitters and models. Trevor Fairbrother has raised the question of Sargent's sexuality as a possible motive for the depth and pervasiveness of the artist's desire to assert and protect a personal, interior, inviolable domain. The English legislature, beginning in 1885 just as Sargent was gravitating toward residence in that country, criminalized homosexual activity—presumably that practiced by bisexuals as well. Fairbrother's sophisticated visual argument, based in part on a series of erotically charged male nude studies for the Boston Public Library, is compelling. Taken as a whole, however, the known evidence regarding Sargent's sexual orientation is suggestive but inconclusive.[135] What does clearly emerge from scholarly engagement of Sargent's life and art is the extent to which, especially where intimate relations were concerned, Sargent drew a careful, psychologically fortified and consistently maintained boundary between public and private.

Not infrequently, Sargent's art accomplished its deflection of the intrusive or exposing eye not just in what it refused to divulge but also in its construal of the figurative subject as object. W. Graham Robertson's coat, for example, *was,* as Sargent claimed, "the picture"; the sitter simply had to wear it even in the sweltering summer weather.[136] The fact the Lord Ribblesdale receded "behind

his outfit" apparently did not bother the artist.[137] But the distinction to be observed was a fine one—and Sargent abandoned a decision to include a particularly magnificent carpet of Isabella Stewart Gardner's as the backdrop for his portrait of Ada Rehan when the carpet threatened to completely conceal the individual and steal the show.[138]

When attention to costume and "decorative ensemble" did not sufficiently deflect the viewer's gaze, the sitter's interior mental and emotional privacy might also be guarded in a portrait's theatrical preoccupation with contorted poses or gestures.[139] In genre painting and in portraiture, the artist's attention to color, light, and brilliantly facile surface functioned as ways of asserting privacy, of occupying the beholder with what appeared on the "skin" of the canvas.[140] In the fifty years or so following the artist's death, this distancing and often stylized aesthetic was much criticized. But Sargent came to rely on artistic distance and used it with a purpose in the public representation of private religion at the Boston library.

Camouflage, pattern, veiling, subjectivity: I am not suggesting that these nouns all represent the same thing—or even that they functioned in the same manner—but that they are all related in the consideration of Sargent's oeuvre and that, for this artist, they all had to do in some significant way with privacy, as social behavior and as intellectual conviction. Not surprisingly, then, at the Boston Public Library Sargent recommended a sort of spirituality that, while it had other cadences too, could be offered as a synonym for privatization. *Triumph of Religion,* as Sargent conceived it, was to have represented not only the privatization of modern religion but also the artist's clear plea for the superiority of privacy in religion (as in life in general). Like *Hermit,* the library cycle, with Sermon on the Mount as its capstone, would have privileged a space of self-contained, self-reflective interiority, cut off from and elevated above the intrusions of everyday public life—yet simultaneously connected as, in the moment of illumination, il solitario melded with the forest interior.[141] In the privacy of subjective experience, Sargent's hermit was neither Titian's *Saint Jerome in the Desert,* nor Washington Allston's *Elijah in the Wilderness.* Sargent's claim to "pantheism" in relation to his painting was a telling comment from one who generally said so little. Here the ultimate experience of subjectivity was also the experience of the private self-in-relation. The self-contained subject was part of a spiritually inflected universe. The visionary one experienced integration not with the saints of institutional religion but with the fabric or pattern of a divinely infused nature.

And yet, while Sargent steadfastly resisted the authoritarianism of the institutional church, he nonetheless succumbed in Boston to an "authoritarian scheme of values" represented by high culture and high art.[142] As Albert Boime has argued, Sargent "created for himself a world based on art, an extra-refined environment that evaded the philistinism and crassness of modern life."[143] This was

the principal currency of Sargent's personal and professional life, this was the lens through which he observed religion. In constructing his Boston cycle from the perspective of iconography, as he claimed he did, Sargent acknowledged an external authority he understood as aesthetically transcendent and ideally timeless and universal. His Boston audiences in 1919 said otherwise. In response to controversy, Sargent would assert the authority of the source, which, while it provided a powerful visual vocabulary with deep contemporary cultural and personal resonance, also represented its own kind of authoritarianism and censorship of other registers or patterns of organizing experience.

In the end, the truncation of Sargent's library mural cycle canceled the "local" Protestantism of his idea. Many soon would forget—and many never knew—that the artist had not finished his decoration. In its arrested form, Sargent Hall is a room without focus, or, more accurately, a room with an unintended focus. *Dogma of the Redemption,* with its high-relief Crucifix and its position at the top of the main staircase, claims the largest share of the viewer's attention. Circumventing Sargent's carefully orchestrated ritual movement, the incomplete cycle manifests a High Church aesthetic. Abbreviation turned Sargent Hall into a "Catholic" chapel.[144] Contemporary critics, including one rather aptly named Preserved Smith, strained to make sense of this "Catholicism": "Probably the Catholic tone of the whole is due more to artistic reasons than to anything else; for, as Winckelmann pointed out long ago, Protestantism is the religion of merchants and Catholicism the religion of artists. But it would almost seem as if Boston's great mural decorations vividly represent the present reaction against Puritanism, those in the library a Catholic reaction, those in the Art Museum a Hellenistic or pagan reaction."[145]

Smith was not entirely off the mark; *Triumph of Religion* did reject "Puritanism" in its mythic recapitulation as a culturally inhibited, authoritarian, and religious hierarchical position (what Vernon Lee had called "unhealthy Puritanism"). But Sargent's scheme also embraced Puritanism of Lee's more advanced sort, the Puritanism of internalized ethical constraints or conscience.[146] *Triumph of Religion,* then, represented Boston's triumph as well as Sargent's. In this cycle, a "freethinking" artist told a story about progressive spiritual liberation. Contrary to the impression created by the truncated cycle, Sargent's completed scheme, with its narrative and stylistic emphasis on *Frieze of Prophets* and Sermon on the Mount, would have disclosed a Protestant preference for the more historical and experiential and less symbolic and doctrinal. It would have urged on old Puritan and new pluralist Boston an interiorized and subjective, reputedly universal, religion of the heart. That the artist understood this story in terms of Christian scripture and iconography (an iconography with an intensely though not intentionally invoked anti-Jewish past) finally undid his message. Figuratively speaking, it was Sargent who wore the cultural blindfold.

THE MANY PUBLICS OF

SARGENT'S *PROPHETS*

לא תרצח
לא תנאף
לא תגנב
לא תענה
לא תחמד

אנכי יהוה
לא יהיה
לא תשא
זכור את
כבד את

⊕

Every public library ought to have a few pictures. These, of course, cannot be sectarian, but there is no good reason why some of them should not be religious. All of them should appeal to something high and noble in human life. The Sargent and Abbey paintings in the Boston Public Library suggest an entirely unobjectionable range of pictures suitable for any public library. The Holy Grail, and the fine row of prophets, are in fact, reproduced in framed photographs in many a public library.

—WILLIAM E. BARTON, *"The Library as a Minister in the Field of Religious Art" (1910)*

*

A work of art embraces a dynamic continuum of historical relations—involving the artist, the patron, the object, its audiences, its location in time and space, and its mobility (over time and space) in the original and in a variety of imitative forms. For Sargent's *Triumph of Religion,* the preceding chapters have examined, to one degree or another, all but the last of these variables. This chapter turns now to the reiteration in reproduction of *Triumph of Religion* and its constituent parts—especially *Frieze of Prophets*—and to the consequent multiplication of the murals' publics. In practice, the cultural work of interpretation is a collaborative venture, animated, over time, in the conduct of numerous individuals and groups, viewing art in reproduction as well as in the original. Interpretation thus largely takes place as part of a multivocal, if not always instantaneously collective, "public" conversation. Those who purchased, displayed, and performed reproductions of Sargent's *Frieze of Prophets* shaped and reshaped the images' significance, appropriating, modifying, and sometimes contradicting, in varying aspects and to varying degrees, the declared intentions of the artist and the published descriptions provided by the Boston Public Library. The murals' reiteration began well before the public *Synagogue* debate and generally continued independently of it (despite Rose Kohler's appeal to Jewish religious educators to boycott reproductions of *Frieze* because of Sargent's christological arrangement of the prophets). Reproduction in new contexts outside Sargent Hall thus by no means represented a deliberate strategy for salvaging the original's reputation and reestablishing esteem for it in new media and new locations. My purpose here is twofold: first (though not necessarily in this order), to consider the proliferation of audiences, contexts, and interpretive possibilities that attended piecemeal reproduction of *Triumph of Religion;* and, second, to chart patterns of reception for reproductions of *Triumph* between 1895 and the present.

While late-twentieth-century classification of Sargent positions him, first and foremost, as a high society portrait painter, J. Walker McSpadden, writing two years before Sargent's death, maintained that his popular appeal rested on *Triumph of Religion:* "The foundation of Sargent's popular fame was laid in 1890, when he received a commission to decorate a hall in the Boston Public Library. The 'Frieze of Prophets' . . . carried the name of Sargent into every corner of the United States. There were few parlors so humble as to be denied their 'Hosea' and no art store or print shop dared to run out of stock in them."[1] Some catalogues of art reproductions offered prints of selected Sargent portraits, but almost all offered *Frieze of Prophets* (or visual quotations from it)—and, of all the artist's works, many catalogues offered his prophets exclusively.

This is a different Sargent than we have been willing to consider for some time. Ironically, and for a significant number of years, Sargent's popular reputa-

tion derived from precisely those images the artist had hoped would frame lasting high cultural enthusiasm for his work.[2] Beginning as early as 1916 and accelerating after the artist's death, however, the esteem in which aesthetic elites held Sargent's entire oeuvre—and especially his murals—declined sharply. By 1941 Martin Birnbaum, looking back over the preceding fifteen years, noted what he described as an "almost deliberate conspiracy to dwarf [Sargent], to belittle his accomplishment and falsify his true position in his epoch."[3] Sargent's reputation did not begin its slow ascent to recovery until the mid-1950s, and, even when his portraits and watercolors had reclaimed a place in the art historical literature, high culture critics continued to view his murals as a waste of time.[4] Strikingly, it was at the lowest ebb of *Triumph*'s high artistic reputation, in the early 1950s, that requests to the library for rights to reproduce images from the cycle peaked. Clearly some audiences continued to find the images attractive.

Attempts to categorize specific types of reproduction and communities of use raise once again the issue of the "unsteady adjacency" of two important pairs of terms: public and private; sacred and secular. For purposes of this chapter, it is worth recalling this book's definition of "public" in terms of degree of accessibility and collectivity. For example, the Boston Public Library, with respect to accessibility, was relatively more public than the library of the Jewish Community Center in Rochester, New York, where a large-scale reproduction of Sargent's *Frieze of Prophets* was installed in 1938. But the Jewish Community Center library was hardly inaccessible, and, in terms of collectivity, its range of social exchange engaged moderately large groups of people as well as individuals. The installations of Sargent's prophets in both institutions, then, were "public," though in varying degrees. In general, and with important exceptions, the move from original to reproduction did not represent a move from public to private, but from one public to another.

Though large numbers of spectators visited the library to see the murals for themselves, it was principally through the mass-mediated culture of newspapers and magazines that many beyond Boston came to know Sargent's *Triumph of Religion*. With each new installation of panels—and sometimes between installations—the major Boston and New York papers devoted special picture sections to reproductions of the paintings, generally accompanied by explanatory captions.[5] In 1913 the "Christmas number" of the *New York Times* included a large folded full-color insert with the north wall portion of *Frieze* printed at the top and the west and east wall panels beneath. Heading an extended descriptive essay that named *Frieze* as the choice of many for the "most important part of the whole series of paintings" (though only the 1895 and 1903 installations could be seen in Boston at this time), a diagram demonstrated "How to Frame 'The Prophets' Effectively" (i.e., how to secure their proper order of display).[6] That people actually followed

Fig. 143

Reproduction of Sargent's Hosea from *Frieze of Prophets* in a specially manufac-
tured frame. Private collection

these and similar sets of instruction is suggested by such artifacts as the small-scale black-and-white reproduction of *Frieze* that the Reverend Sheldon Christian (d. 1997), a Unitarian minister in Brunswick, Maine, displayed in his home. Christian assembled, glued to a cardboard backing, and framed in sequence the reproductions he had purchased of *Frieze*'s "separate" panels.

The media of mass-art reproduction (in *Triumph*'s case, art prints like Christian's, postcards, newspapers, and popular periodicals, for example) further complicate notions of "public" and "private" reception. When Charles Moore, in 1929, called Sargent's Hosea (fig. 143) an "idol of the household," he signaled the figure's use in the relative privacy of the domestic sphere. The image, however, was one already defined, even in "private," by its "public" recognizability, and it was this feature of widespread (presumably public *and* private) assent that led Moore to label it an "idol."[7] By 1910 *Frieze* had achieved sufficiently wide popular recognition that *Ladies' Home Journal,* in an article with no illustrations, could advise readers planning Christmas pageants for "secular and Sunday schools" to pattern the headdress of the central magus after the costume of Sargent's Hosea.[8] Mechanical reproduction and dissemination, on the one hand, thus supplied Sargent with a kind of public "brand name" status; on the other hand, different individuals and groups selected different images from his library cycle and, even when selecting the same image, used their selections in different ways and chose different formats or croppings. When reception of reproductions is factored into the account, the plurality, partiality, and dynamism of *Frieze*'s publics are even more obvious than when attention is focused only on the original.

With respect to the relation of secular and sacred, the same sort of interdependent and fluid adjacency applies. The Rochester Jewish Community Center library was not the sacred space of a synagogue, but it was religiously affiliated, and the possibility that some individuals used that library's resources in a devotional manner cannot be dismissed. The Chicago synagogue (Temple Sholom) that considered Sargent's prophets as possible models for stained-glass windows seems to fall more obviously into the category sacred, at least until the windows' proposed location in the structure's social hall (rather than a worship space) is known. For purposes of this chapter, however, both the adaptations of *Frieze* at the Rochester community center library and the proposed windows at the Chicago synagogue will be considered "religious." Here "religious" uses will include the devotional, the educational, and the social when these occur within institutions that understand their primary function as largely "religious" or when they are affiliated with particular religious traditions or denominations.

Considered in relation to its reception over roughly one hundred years (1895–1998), John Singer Sargent's *Frieze of Prophets* offers an opportunity to study the mass-mediated dissemination and reinvention of a significant set of fine

arts images in reproduction. Following discussion of some more general aspects of this subject, two sorts of evidence will be introduced: first, the results of the statistical analysis of a body of correspondence (dated 1895 to 1965) concerning reproduction rights for *Triumph of Religion;* and, second, description, in some detail, of four specific examples of use. Three of these examples deal with replications initially performed or installed between 1913 and 1938; three of the four had a continuing presence of some sort into the 1970s; and two are still in use as this book goes to press.

REPRODUCTIONS: IN GENERAL

In the original, Sargent's *Triumph of Religion* was an ambitious and sophisticated mural project but, especially in its incomplete state, a dense and even bewildering one. Over time, perhaps parts of *Triumph* were especially susceptible to reproduction and reinterpretation precisely because the whole seemed so opaque. What *could* be read with facility were the high seriousness of the endeavor and the religious subject matter. In situ, the prophets were an essential part of a larger and largely secularized narrative structure. They found their place as the most immediate precursors in kind to Sermon on the Mount's Jesus, himself the epitome of the unmediated mode of experience that Sargent recommended as the basis for contemporary American culture. Outside of their conceptual significance in Sargent's planned program on the progress of Western (American) civilization and outside their material position in the truncated cycle, however, Sargent's prophets, in particular, traced a new set of trajectories of their own. The question of the visual coherence and integrity of the library hall was irrelevant in this new and unquestionably different set of contexts. Despite controversy, incompletion, and changes in aesthetic climate, *Triumph of Religion* thrived in disassembly and dissemination, creating new audiences the artist hardly imagined.

Even before the murals lost their place in the art historical and critical literatures, new and growing popular constituencies moved into view. Mass-mediated reproduction began in earnest immediately following the first installation. As early as 1896 Boston publishing company Curtis and Cameron offered reproductions of *Frieze* in multiple sizes and various fractions of the whole. Over the years prints and photographs of *Frieze* and its components have been available through the library itself, the popular press, and numerous commercial establishments. It could be purchased in its entirety, flattened out as though it covered only one wall instead of three surfaces (fig. 144); in sections of three (fig. 146), divided by west, north, and east wall, or five, with the north wall counting as three separate panels; and by individual prophet, full figure (fig. 145) or

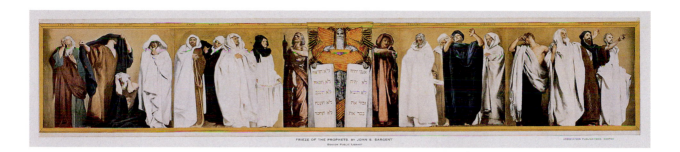

Fig. 144

Reproduction of Sargent's *Frieze of Prophets*. Association Publications, Boston.
Trustees of the Boston Public Library

Fig. 145

Postcard reproduction of Sargent's Isaiah. Trustees of the Boston Public Library

A SELECTION OF THISTLE PRINTS SUITABLE FOR SCHOOLS

Fig. 146

"A Selection of Thistle Prints Suitable for Schools." From sales brochure, Detroit Publishing Company, Detroit, Michigan, 1930. Library of the National Museum of American Art and the National Portrait Gallery, Smithsonian Institution, Washington, D.C.

Fig. 147

Reproduction of cropped version of Sargent's Isaiah. Cosmos Pictures Company, New York. Library of the National Museum of American Art and the National Portrait Gallery, Smithsonian Institution, Washington, D.C.

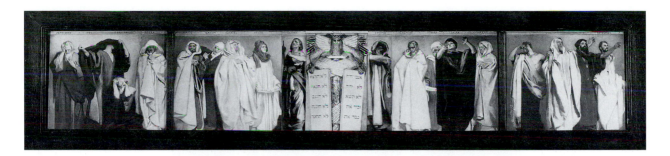

Fig. 148

Reproduction of Sargent's *Frieze of Prophets* in a specially manufactured frame. Cosmos Pictures Company, New York. Private collection

Fig. 149

Selection of fine-art reproductions with seven from Sargent's *Frieze of Prophets* across the top row. From sales catalogue, Perry Pictures Company, Boston, 1927. Trustees of the Boston Public Library

Fig. 150

Selection of fine-art reproductions with Sargent's *Frieze of Prophets* in the second register from the bottom, the third image from the left. From *Art for Schools: Descriptive Catalogue,* Elson Art Publication Company, Belmont, Massachusetts, September 1924. Library of the National Museum of American Art and the National Portrait Gallery, Smithsonian Institution, Washington, D.C.

cropped (fig. 147). The earliest versions were halftone reproductions from photographs or steel engravings. These first black-and-white images were soon followed by prints in a brown or "sepia tone," resembling "expensive art photographs," and then by "natural" color pictures.[9] In 1948 the library sold hand-colored photographs of *Frieze of Prophets* in five panels. From the beginning, almost all reproductions were retouched to delineate features and drapery with greater precision. Color reproductions generally ignored the gilding but otherwise displayed a brighter palette by comparison with the original. Several firms manufactured special frames to showcase either an individual prophet (fig. 143) or the trisegmented spread of the whole frieze (fig. 148). In addition to Curtis and

Cameron's Copley Prints, Sargent's *Frieze* was marketed by, for example, Perry Pictures Company (fig. 149), University Prints, Thistle Prints, Cosmos Pictures Company, Elson Art Publication Company (fig. 150), the Detroit Publishing Company, the Horace K. Turner Company, and Taber-Prang Art Company. Mass marketing of reproductions received a boost in May 1913 when arts professionals and other experts polled by the American Federation of Art's Committee on Art in the Public Schools named two Boston Public Library decorations, Edwin Austin Abbey's *Quest and Achievement of the Holy Grail* and Sargent's *Frieze of Prophets,* as the two finest examples of the art of American mural painting.[10]

Agents of widely varied institutions hailed particular parts of the decoration as indicative of the strength of their own divergent convictions. Select panels of this unfinished and hotly contested cycle appealed to some of the very constituencies that found the 1919 installation problematic. Protestant, Catholic, and Jewish concerns (houses of worship, seminaries, publishing houses, and educational and social organizations, for example) requested permission to reproduce fragments of the series as book and encyclopedia illustrations, in religious educational and periodical literature, on the covers of church bulletins, in ecclesiastical stained glass, on calendars, in wall decorations, and in public pageantry. In the context of the increasing pluralism of American religion and, even more, the new acknowledgment of a pluralism that had long existed, piecemeal reiteration allowed different audiences to pick and choose from a literal catalogue of pictures, to endorse or reject the overtly Christian frame of Sargent's progressive evolutionary theme, and to avoid the confusing spatial and narrative organization of the unfinished room. Different groups not only required Sargent's images to serve new purposes, they also remade the medium of representation to suit their own needs, presenting the murals as dramatic performances, chapel windows, easel paintings, and "documentary" encyclopedia illustrations (in historical entries on "prophets," for example).[11]

REPRODUCTIONS: NEW MEDIA FOR EDUCATION

While halftone mechanical reproduction was by no means the only "new" medium in which parts of *Triumph* appeared, the technological innovation was especially significant in creating and responding to the popularity of Sargent's images. In fact, the 1895 timing of the completion of *Triumph of Religion*'s first phase could hardly have been more fortuitous in terms of both the readiness of an art publishing industry founded on newly available methods of mass reproduction *and* the new pictorial initiatives in public and religious education that created ready markets for them. The technology of halftone visual reproduction (per-

fected in 1888) transformed possibilities for pictorial education.[12] In 1900 psychologist, child development theorist, and university president G. Stanley Hall marveled at the way pictures had "multiplied more within the last ten years than in all the previous history of mankind." In a series of "secular" articles (interestingly titled "The Ministry of Pictures") he laid out his thoughts on this visual expansion's revolutionary implications for "teaching geography, history, science, language, literature, art, and religion": "The daily press, advertisements, posters, scientific literature, the popular lecture, decoration, and now the kinetograph, not to speak of the coming colored photography, have all contributed to what is probably slowly coming to be a new mode of pictorial thought. From the kindergarten up through the grammar and high schools to the university lecture room, we are gradually developing what perhaps we may call a picture age."[13]

The greatest value of the new visual technologies, according to Hall, was their democratic availability and their consequent potential for the universal education of taste. The new "picture age" he described he located at a point of advanced ("modern urban") achievement on his own evolutionary blueprint for human culture. For Hall, the "eye-minded type of cranium" was clearly "superior" to the "ear-minded type of thought and culture." Hall's ideas, along with the work of Henry Turner Bailey (in the public schools), Albert Edward Bailey (in liberal Protestant religious education), and others, contributed to the visual ideology of what some called the picture study movement in public and religious education. For this group of widely influential educators, many of them employed, at least during the first decade of the twentieth century, in the Boston public school system, "seeing [was] not only believing but also understanding." Simply knowing something was insufficient; to be valuable, knowledge had to penetrate "deeper than memory and become more or less incorporated in conduct, character, and achievement."[14] Hall's summary comments reflected the thinking of many picture study professionals (and, coincidentally, paralleled the sort of education Sargent planned to recommend in Sermon on the Mount). Though children needed some knowledge of all "classes of pictures," Hall maintained,

those that leave the most indelible impress, and that shape, form, and mold mind, heart, and will, are those that touch human nature in the largest and broadest way. . . . The most important ministry of pictures, then, is the education of the heart,—in teaching the young to love, fear, scorn, admire those things most worthy of being loved, feared, scorned, admired. Just in proportion, therefore, as education widens its scope, as it is now so rapidly doing, so as to reach not merely the memory and intellect, but the will and especially the heart that is larger and deeper than all the other human powers, the function of pictures is certainly to increase.[15]

When Hall and his colleagues talked about "pictures," they meant fine-art reproductions, "such high titles as 'The Aurora,' 'The Gleaners,' 'The Prophets' "; these were the sorts of images that elevated, refined, shaped "conduct, character, and achievement." [16] For some, reproductions required a degree of defensive posture by comparison with originals. In a series of articles on "Picture Study in the Boston Public Schools," James Frederick Hopkins, director of drawing for the metropolitan school system, recommended Sargent's *Prophets* as one of nine reproductions in the "modern series" of images he compiled for the city school curriculum. Hopkins explicitly discouraged teachers from trying to collect original works because of their expense and because of rapidly changing standards of taste and aesthetic value. Most important, for Hopkins, was the fact that, as the teacher's own taste "advanced in true appreciation," "she" might regret her choices. Reproductions of images presumably selected by those with a higher level of "taste-training" were thus a safer bet. Furthermore, "children in the Boston schools are fortunate in being able, now and then, to view an original of the reproduction which they study in the classroom. . . . the Boston child has something to look to in the first and last examples [in Hopkins's curriculum] chosen for this month. 'Caritas,' by Abbott Thayer, hangs in the Art Museum, and Mr. Sargent's 'Prophets' are just across the street, as part of the magnificent decorative scheme of the stately Public Library." [17] Most picture study educators, however, rarely mentioned "originals." For these individuals, reproductions represented some distinct advantages, freeing art from the "guilty association of wealth and privilege" and offering a truly democratic alternative, one that, because of contemporary readings of its photographic medium, did not forfeit "aesthetic quality or power to frugality." [18]

The words of experts like Hall and Henry Turner Bailey appeared often in the pages of *Perry Magazine* (as well as *School Arts Magazine,* which Bailey edited). *Perry Magazine,* its promotional blurb maintained, was "devoted largely to showing teachers and parents how to use pictures in the school and home" as well as how to distribute prints by loan through the public library system. [19] Given the magazine's Boston location and its avid promotion of the work of Sargent (fig. 151), Abbey, and Puvis at the Boston Public Library, it is likely that Perry Pictures as well as Curtis and Cameron supplied many of the images the Boston library loaned to area public schools. For *Perry Magazine* was, of course, a very clever marketing tool of the Perry Pictures Company; though it welcomed advertisements from competing firms, the periodical was illustrated almost exclusively with images from the company's own catalogues. The magazine, furthermore, provided tips for using the pictures in home, school, library, and church, constructing curricula and study aids that depended on purchase of the prints.

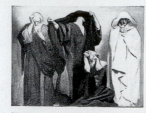
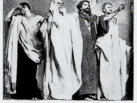
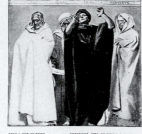

92 The Perry Magazine.

Next to Joshua, on the right of the central panel, is the figure of Jeremiah, who seems overcome with grief, standing as if alone and apart from all human sympathy. The most impressive figure of this panel is that of Isaiah. With upraised hands and backward turned head, the sad mouth seems uttering the question, "Oh Lord, how long?" The sad eyes are full of reverence, but are sorrowful with despair. Behind him stands Jonah with a scroll in his hand, bearing the one word, Jehovah. Finishing this panel, to the extreme right, is the grim face and figure of Habakkuk.

his stern dark face brought out in relief against the light color surrounding it.

Farther still to the left, on the side wall, are represented the prophets of despair, with one prophet of hope, Hosea, as a gracious and distinct relief. The figures of Zephaniah, Joel and Obadiah are strongly dramatic in their representation. The bowed head and distressed face of the aged Zephaniah, the covered head and gesture of despair of Joel, and the utter hopelessness of the figure of Obadiah stand in strong contrast to the grand and quiet figure of Hosea, clothed in simple, pure white, and delineated with masterly skill. This is claimed to be Mr. Sargent's favorite figure.

We cannot help feeling a sense of relief as we turn to the last panel on the right, and facing the one on the left which contains the figure of Hosea. Here we have the three prophets of hope—Haggai, Malachi and Zechariah, with only one prophet of despair, Micah. As the prophets of despair predicted woe to Israel, so these great prophets of hope are predicting the Messiah. Mr. Sargent's painting of "The Teachings of Christ" is to be placed on the side wall of the hall toward which the prophets of hope are turning, and will complete the grand conception of which this frieze is but a part.

Fig. 151

Reproductions of Sargent's *Frieze of Prophets*. From Marie A. Moore, "Great Artists and Their Paintings," *Perry Magazine* 4, no. 3 (November 1901), 92. Trustees of the Boston Public Library

Adopting a definition of the sectarian that paralleled the one assigned by Sargent and Abbey (i.e., nonpreferential, interdenominational Protestantism), the liberal Protestant Religious Education Association (REA, founded 1903) generally endorsed what it perceived as a growing public sentiment to let the church and family teach "sectarian" religion while the public schools "devote themselves to those forms of truth which are universal, and those principles of morality and religion about which there can be no controversy."[20] (Many would have agreed that such "universal" principles existed.) Still, the linkage within the picture study movement between professionals in "secular" public education and their counterparts in "sacred" religious education (especially in the REA) was very close.[21] Hall and Henry Bailey, for example, wrote for, spoke to, and would likely have

seen themselves as part of both domains.[22] In addition to its materials for public school use, Perry marketed numerous materials for religious education, its "Perry Pictures Lessons System" for Sunday schools, for example. For his articles on "Picture Study in the Boston Public Schools," Hopkins recommended a "Christmas Series" as well as a "Modern Series." Christmas, according to Hopkins, "is a time when everything suggests the old, old story: the message of peace, hope, and promise, to which almost all the world, at least once a year, stops to listen. There will be certain sections of many cities where a particular series of pictures outlined could not be wisely introduced, but there are many others in the wide field from which to choose; and if the thought of the Christ Child cannot be accepted, the spirit of the gift-giving season can be as happily treated with other examples."[23] In a climate conducive to ever greater awareness that religious pluralism characterized the experience of students in the public schools, the picture study movement allowed the mostly liberal Protestant educators, who supported the separation of church and state and rejected sectarian religion in the schools, to promote the inculcation of "nonsectarian" values in picture study.

Long before the late nineteenth century, American Protestants used pictures for a variety of religious purposes, including religious education. The widespread promotion of fine arts images as part of the Protestant religious agenda, however, awaited both the invention of halftone technology and concurrent innovations in the psychology of child and human development (influenced largely, again, by the thinking of G. Stanley Hall).[24] By including a Department of Religious Art in its early organizational structure, the REA and its founders institutionalized the promotion of picture study in religious education. Sharing experts with the "secular" exponents of the picture study movement and endorsing similar educational strategies (though to more explicitly Christian ends), the REA's progressive agenda merged respect for cultural formation with its mission of religious education.[25] Though it privileged religious subjects and recent figurative works (with Sargent's *Frieze* appealing on both counts), the REA acknowledged the religious educational contributions of "practically all artistic products, religious and otherwise."[26] In Sargent, in fact, schools public and religious could annex an attractive combination of high culture and religion.

REPRODUCTIONS: PATTERNS OF RECEPTION

The Department of Rare Books and Manuscripts at the Boston Public Library retains over 150 letters, written over a period of almost seven decades, requesting permission to reproduce portions of *Triumph* in a number of different media and formats. Statistical analysis of this admittedly somewhat arbitrary sample provides

a sense of the wide range of religious and secular organizations and individuals in-
volved, of the image preferences they expressed, and of continuity and change
over time in both image selection and petitioners.[27] Perhaps the most striking
trend that emerges from this material is the dramatic shift in primary and sec-
ondary publics for *Frieze* that began around the time of Sargent's death. Up until
1925 requests from artistic and religious domains were rather evenly balanced
with the early years leaning toward the aesthetic sphere; after 1925 a rapidly in-
creasing proportion of requests (85 percent overall) came from religious institu-
tions or from individuals intending religious uses. Thus, while Sargent did not
imagine sectarian religious roles for the public mural panels that constituted his
Triumph of Religion (including *Frieze of Prophets*), over time a shift in domain from
the aesthetic to the religious attended the cycle's reiteration in a variety of media
outside the library's walls.[28]

From the beginning, *Frieze of Prophets* (or some portion thereof) was
most frequently requested by all groups. Despite the tensions produced by *Syna-
gogue, Frieze of Prophets* never lost its currency even among Jewish constituencies
(Kohler's address to the Fifth Triennial Convention of the National Council of
Jewish Women notwithstanding). Protestants, Jews, interdenominational organi-
zations, and secular concerns preferred *Frieze* over any other panel or set of pan-
els. Requests for Sargent's *Prophets* constituted 71 percent of overall queries from
religious groups; an even higher percentage of secular organizations (89 percent)
preferred *Prophets* to all others. Catholics too admired *Prophets* but added *Madonna
of Sorrows* and *Handmaid of the Lord* to their set of desired pictures. Conversely,
Synagogue and *Church* attracted neither a religious nor a secular following.[29]

Of the permissions letters retained by the Boston Public Library, almost
four-fifths concern publication in newspapers, magazines, books, encyclopedias,
and ephemeral religious educational and devotional materials (like worship bul-
letins or Christmas cards). Some 19 percent, however, represent requests to locate
large reproductions from *Frieze of Prophets* in a permanent or temporary exhibi-
tion of some kind (Sargent's Moses in a "display of religious pictures" organized
by a chaplain at the Pentagon for Easter 1955, for example, or stained-glass ren-
derings of individual figures for a church sanctuary or auditorium).[30] New local
cultures of display and performance, then, took shape within the larger frame of
mass mediation, extending and transforming the authority of the original.[31]

Through at least 1903 and the introduction of a photomechanical repro-
duction of Sargent's *Dogma of the Redemption,* Curtis and Cameron (who had of-
fices across the street from the library and also published the library's *Handbook*)
offered a fairly representative selection of images from *Triumph* (including *Astarte*
and *Moloch* from the north ceiling and the large north wall lunette of *Israelites Op-
pressed* as well as a range of options for figures from *Frieze*).[32] *Frieze of Prophets*

seems to have emerged rather early on as a favorite, however, and most compet-ing companies soon listed only reproductions of *Frieze* and its various parts and configurations. Early in the twentieth century, for example, though University Prints included six Sargent portraits and genre paintings in its American art series, of Sargent's murals, it listed only *Frieze of Prophets*—and it offered in five separate prints all five panels of that work.

The obvious influence of marketing strategies aside, a number of qualities associated with *Frieze of Prophets* seemed to contribute to its extraordinary popu-larity. Some meanings transferred directly from the original or were consistent with meanings already connected with *Frieze* in situ. In almost all iterations, for example, reproductions of *Frieze* retained certain abstract qualities associated with the artist, his subject (the prophets), and the Boston Public Library. These in-cluded democracy, individualism, modernity, cultured achievement, and the ex-altation of education (for discussion of these qualities in relation to the original, see chapter 4). Among the most important factors, according to those who wrote about *Frieze*'s attraction, was its combination of legibility (its "prominent and eas-ily intelligible" style) with "gravity and dignity" (communicated in its subject).[33] The visual rhetoric of Sargent's *Frieze of Prophets,* painted in a manner that might be called heroic or idealistic naturalism, was consistent with the preferences ex-pressed by the influential (mostly) liberal Protestant professionals who directed art education in, for example, the city of Boston and the state of Massachusetts.[34] Many would have agreed with Sargent and with the artist's early critics that *Frieze* was the only finished part of *Triumph* that did not represent the vestiges of earlier religious expressions. This was the case, moreover, in terms of subject as well as manner or style. Subject matter was, in all cases of the educational use of art re-productions at any rate, among the most critical of factors. G. Stanley Hall in-sisted: "Teachers do not realize how much more important, not only for children but for every one who has not a special artistic training, the subject-matter of a picture is than its execution, style, or technique. The good picture, from an educational point of view, is either like a sermon, teaching a great moral truth, or like a poem, idealizing some important aspect of life. It must palpitate with human interest."[35]

Many apparently agreed that Sargent's Hebrew prophets "palpitat[ed] with human interest." Unlike the other completed portions of the cycle, Sargent's prophets illustrated human experience and lived biblical history rather than doctrine, dogma, or abstract thought. For liberal Protestants and Jews, the prophets represented twentieth-century concerns with the social and ethical re-sponsibilities of religious individuals and with the psychology of inspiration. Writing in 1927 about "American Preaching" over the first twenty-five years of the twentieth century, Ozora Davis commented on the

modern discovery of the mission and message of the Old Testament prophet. With clearness and force it is seen that these great characters were not wizards foretelling events like soothsayers; they were patriots and statesmen, rebuking the sins of their times and defining policies that were surely the will of God. The Hebrew prophet has re-entered the Christian pulpit, not with a grotesque foretelling of dates and dispensations, but with a veritable word from God to a generation bewildered from carnage and drenched in blood and tears. The pulpit has been elevated and ransomed by this discovery and now speaks to its generation with a word of prophecy made more sure.[36]

The dissemination of the murals in reproduction allowed audiences to extract *Frieze of Prophets* from its location in Sargent Hall to focus on the artist's "modern" and "democratic" accomplishment.

Returning to the statistical evidence discussed earlier in this section, overall numbers of permissions requests by religious organizations and individuals peaked in the 1940s and 1950s; *Frieze* was especially popular between 1945 and 1955. By this time (and though art critical opinion would soon begin to reverse its course), two or three decades had passed since Sargent's work had attracted positive interest in aesthetic circles and among elite critics. By the 1950s contemporary arts professionals would have dissented strongly with those (educators at Edward Lee McClain High School in Greenfield, Ohio, included) who labeled *Frieze* "great art." But the large popular readership of Cynthia Pearl Maus's widely promoted series of anthologies on biblical religion and art would have heartily endorsed her classification of the panels as great *religious* art.[37] The climax of a sustained initiative by the institutional Protestant establishment in the United States (beginning around 1880) to seek rapprochement between fine art and religion was likely responsible for Sargent's continuing appeal in the religious domain.[38]

By the mid-1940s, however, some in the liberal Protestant church (including Alfred H. Barr, Jr., a devout Presbyterian and son of a minister as well as a widely influential modernist art professional) began to object loudly to both the style of heroic naturalism and to the "reprehensible custom of collecting art via the printing press." "Original works of art" (rather than reproductions) and works in a modern "abstract" style were now construed as necessities of "authentic" religion and "authentic" democracy.[39] During the decade of the 1950s, Barr, as president of the National Council of Churches Commission on Art, and his highly educated and religiously like-minded colleagues (Perry T. Rathbone, Charles Rufus Morey, George Heard Hamilton, and Paul Tillich) expressed their dismay at the "banality and saccharine vulgarity of most Christian art, especially protestant Christian art in this country."[40] Sargent was not one of the commission's specific targets, but the style of his art did generally locate him in relation to

works that earned the group's scorn. As an antidote to the deleterious effects on American culture and politics of the liberal Protestant aesthetic that accounted for Sargent's popularity in reproduction, the commission urged a new taste culture for "modern" liberal Protestantism. But clergy and intellectuals (like Barr) registered the new preferences long before the average parishioner was inclined to accept nonfigurative images and modernist styles. Accustomed as they were to using pictures in religious education, Sunday school teachers and youth leaders were not likely to easily relinquish their art prints either. The desire to rid the churches of "cheap reproductions" came much later—and was less universally successful—than the turn-of-the-century movement, originating in Boston, to dispose of collections of reproductions in museums. In the churches the impulse was slow to catch on, and it seems to have had only a moderate impact (if any) on images used with youth and children.

Over time and as an artifact in replication, Sargent's *Frieze* navigated a range of interpretive spaces and audiences. His prophets could define, for example, appropriate aesthetic and didactic adornment in a public high school, the performance of evangelical Christian formation in a national YWCA pageant, the dissemination of Jewish culture and religion in a Jewish Community Center library, and the retrieval of visual and material heritage in an urban congregation of the liberal Protestant United Church of Christ. I have selected for extended discussion here four uses of *Frieze:* two of them from Sargent's lifetime when instances were more evenly distributed between secular and religious domains, and two from after the artist's death when the image in reproduction had essentially become "religious." These selections register some ways that different publics adapted reproductions of *Frieze* to suit their own situations. In no case can we be certain that the reproductions recalled, for any specific viewer, an encounter with an "original" once seen—and in most cases this is unlikely. While each of these new local cultures sought some of the same meanings in Sargent's prophets, each differed significantly from the others and from the pattern set at the Boston Public Library.

REPRODUCTIONS:
THE PUBLIC HIGH SCHOOL ART GALLERY

The American Federation of Art's campaign to display the "best American art" (including the highly ranked *Frieze*) in public schools was clearly successful in some measure.[41] Sometime between 1915 when the Edward Lee McClain High School opened and 1918 when the first catalogue of its "art gallery of 165 masterpieces" was produced, the public high school in the Greenfield, Ohio, town of

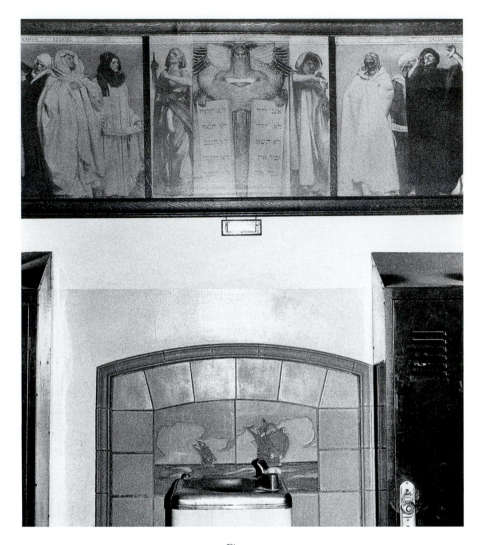

Fig. 152

Reproductions of Sargent's *Frieze of Prophets*. Copley Prints, Curtis and Cameron, Boston. Displayed over Rookwood tile drinking fountain, second-floor corridor, Edward Lee McClain High School, Greenfield, Ohio

Fig. 153

Opposite, top: Reproductions of Sargent's *Frieze of Prophets*. Copley Prints, Curtis and Cameron, Boston. Second-floor corridor, Edward Lee McClain High School, Greenfield, Ohio

Fig. 154

Opposite, bottom: Library, with Vesper Lincoln George (American, 1865–1934), *The Melting Pot*, Edward Lee McClain High School, Greenfield, Ohio

five thousand residents acquired a gift of reproductions of "great masterpieces of ancient and modern art," both painting and sculpture.[42] The new school building (with an interior decoration including Rookwood tiles [fig. 152] and punctuated by glazed polychrome pictorial panels on the exterior) had been funded by Edward Lee McClain, a wealthy, local self-made businessman. Lulu Johnson McClain, his wife, worked with Theodore M. Dillaway, an advocate for the picture

study movement and then director of art in the Boston Public Schools, to select the art; she also contributed the reproductions for display. In this context, and though the catalogue text mentions the donors' leadership in the Greenfield Methodist Church, *Frieze* was classified and appreciated in terms both secular and aesthetic. Chosen for their status as "great art," their educational value, and their inspiration to "purer morals and broader and better citizenship," the reproductions were deemed "peculiarly appropriate for schoolroom decoration" because they could be "readily correlated with school work."[43] The catalogue text characterized *Frieze* as an "illustration" of the "monotheistic and spiritual principles of the Jewish religion" and provided information designed to "render [all of] these works more readily accessible" to the "average school pupil." For this audience, and in fact in almost all reproductions of Sargent's *Prophets,* English characters replaced the artist's Hebrew inscriptions, presumably making the picture more intelligible to adolescents as well as to the general public. In the process of reworking the inscriptions, the cornice line and moldings of the original were also simplified and severely reduced.

The catalogue for this permanent display (it is still in place) explicitly identified the images with Sargent, with the Boston Public Library, and (in translating the inscription on Daniel's scroll for the reader: "And they that be wise shall shine") with the library's sacralization of public education and human achievement. The *Frieze* panels (in three separate sections representing the Boston library's north wall and the north ends of the west and east walls; fig. 153) appeared with numerous works by other artists. All of McClain High School's reproductions of paintings were Copley Prints and Medici Prints installed in the hallways, staircases, and common spaces of the school by Curtis and Cameron of Boston. Three large original murals (e.g., fig. 154) by Boston painter Vesper Lincoln George completed the building interior's secular "art motive."[44] George described his Greenfield murals in terms consistent with notions about the relation of education, culture, and immigration that pertained at the Boston Public Library. This is perhaps not surprising given that he painted them in Boston and exhibited each of the three large canvases at the Boston Art Club (an institution frequented occasionally by Sargent and located just a block from the library) prior to installation in Greenfield (see discussion of George's murals in chapter 4). Describing the pictures to a local newspaper reporter, George had this to say: "Taking the three paintings together, they make a pleasing sequence. [In *The Melting Pot*] the immigrants come to this country and this means all of us—for are we not all immigrants or the descendants of immigrants—and they go to our public schools [the *Apotheosis of Education*] which are, after all, the real crucible, the real melting pot, and they become Americanized; and lastly, 'The Pageant of Prosper-

ity' symbolizes the ideal citizenship. The family, and the prosperity that comes of labor and thrift."[45]

The Boston connection was strong and carried through all the "expert" personnel involved in acquisition: George, Dillaway, Curtis and Cameron, and P. P. Caproni Brothers who produced and installed the statuary casts. Greenfield thus acknowledged Boston's authority as cultural arbiter; it called on the Eastern city for advice on refining public taste in Ohio. Interestingly, the Sargent reproductions at McClain High School were placed directly across the second-floor corridor from fifteen hand-colored panels of Edwin Austin Abbey's *Quest and Achievement of the Holy Grail* and immediately adjacent to the six lunettes of John White Alexander's *Evolution of the Book* from the Library of Congress. Not only were all three sets of works reproduced from library murals and directly associated with education, but the American Federation of Art ranked the three highest in its list of mural decorations for public schools; some combination of these three often appeared on the same page or on adjacent pages of commercial catalogues of "school art."

In 1998 Greenfield, Ohio, is still a rural farming community with a per capita income below the state average; the town is located a significant distance from any major interstate highway and sixty-five miles from a major urban area. In terms of religious affiliation, the population is predominantly Christian, but with a fairly wide range of denominations and expressions within Christianity. Only two Jewish families currently have children in the high school. Principal and alumnus Dan Strain (class of 1974) describes Greenfield's citizens as "conservative" and "stable"; most families of the town's small African American minority have lived in Greenfield for three or four generations. The school forms the cultural, social, and geographical hub of Greenfield; the public institution's art shows, theatrical productions, and concerts contribute substantially to the town's cultural life.[46]

Teachers of Latin, English literature, world history, and both elementary school and high school art use the school's "gallery" in instruction. One teacher commented, however, that Abbey's *Holy Grail* is now used more frequently than Sargent's *Prophets,* in large part because the hand-colored Abbey reproductions have deteriorated less over time than the black-and-white prints of Sargent's *Frieze* but also because the Abbeys (which appear in their full sequence) retain the original's narrative structure while the Sargents stand alone.[47] McClain High School integrates the artwork on campus into the institution's ritual as well as its academic life. Only alumni and faculty are allowed to use the wide marble staircase that ascends from the entry level to the second floor beneath Vesper George's *Apotheosis of Education.* Graduating seniors descend those stairs for the first time in a cere-

mony held a week before graduation. Strain described the event for a reporter from the *Cincinnati Enquirer:* " 'That night, parents take pictures and shoot videos of their kids walking down the stairs. Boys walk down the side where Mr. McClain's picture hangs; the girls come down the other side, past Mrs. McClain's painting. We have to pass the Kleenex that night.' . . . Senior Nathan Barr, a member of the student council, said his peers are mindful of their surroundings. 'Our high school is special, and the students respect its artwork,' he said. 'Even students who aren't so respectful have enough sense not to bother it.' "[48]

REPRODUCTIONS: THE YWCA PAGEANT

Despite words to the contrary from the artist and his high culture critics, many audiences interpreted *Frieze* in an explicitly religious institutional fashion and even reintroduced the sorts of devotional elements that Sargent implied his treatment of the subject was meant to suppress. On 12 April 1913, in Richmond, Virginia, at the Fourth Biennial Convention of the National Young Women's Christian Association (YWCA), nineteen young women from Lynchburg performed Sargent's *Frieze of Prophets* as part of an elaborate outdoor pageant with six hundred (some sources claimed eight or nine hundred) participants and five thousand to six thousand spectators.[49] If practices in this case matched those of similar contemporary events, many of the youthful actors for the YWCA's "Ministering of the Gift" had been recruited through local parishes and public libraries as well as YWCA membership.[50] Here a reiteration of a fragment of Sargent's *Triumph of Religion* was staged in an entirely new arena—outdoors in a public park—as part of a national evangelical Christian gathering of youth leaders. Most processional performers came from Richmond, but some girls who played more substantial roles traveled from as far away as Pittsburgh and Cleveland. The pageant was written by Helen Thoburn of the national YWCA offices in New York and directed by Boston's Lotta Clark, secretary of the American Pageant Association.[51] Perhaps Thoburn had seen Sargent's *Frieze* in situ before she decided sometime prior to February 1913 to incorporate it in her pageant's climax. In early March Clark sent Thoburn a "colored picture" of the murals to share with other pageant leaders; the YWCA's Louise Brooks sent Clark photographs of Richmond's Joseph Bryan Park.[52] Whether or not Thoburn was directly acquainted with *Triumph,* it is unlikely that any of the participants in the pageant's "living representation" had ever been to the Boston Public Library.[53] Had they made the trip in 1913 they would have seen only the north and south wall murals of the "Jewish" and "Christian" ends; the east and west walls remained blank until the 1916 and 1919 installations.

While Thoburn said that she composed the pageant "especially for visu-
alizing the [Young Women's Christian] Association and its potentialities," the
enactment had devotional as well as educational and community building aspects.
The program for the pageant, distributed to all in attendance, included on its
front cover two interpretive epigrams that established the character of the event as
one of shared Christian ministry and worship. The schedule for the full conven-
tion, too, was structured according to a framework of daily devotions, scripture
readings, and prayer. The script for the play described the scene including the
tableaux of the Sargent painting as suggestive of the YWCA's Bible study con-
ceived as the "spiritual life underlying the whole."[54] Thoburn's directions for the
performance clarified her specific use of *Frieze:*

The chorus sings "How lovely are the messengers that publish the gospel of peace," from
Mendelssohn's St. Paul, as nineteen girls enter from the left, representing the prophets as
depicted in the Sargent frieze in the Boston Public Library. They group themselves in the
order as shown in the frieze. From the right, enter at the same time girls in choral robes,
carrying over their arms Christmas wreaths with long red streamers. As they sing softly
one verse of "Silent Night," to indicate the transition from the Old to New Testament,
the prophets assume the actual attitudes of the figures in the frieze, so that those to the left
are pointing forward to the Christmas singing.

 As the music dies away, the choral singers suddenly raise their wreaths in tri-
umph, all in the group of prophets look toward them, and the choral singers, accompa-
nied by orchestra and chorus, sing the first and second verses of "Joy to the World,"
indicating the expanding power of Christ's life.[55]

While the evolutionary coding of the public library murals would be-
come problematic in 1919 in Boston, in 1913 the YWCA recognized and appro-
priated Sargent's visual assertion of the "progress" from Judaism to Christianity,
leaving behind the secular implications of the painter's subjectivity-driven
agenda. In writing the pageant, not only did Helen Thoburn acknowledge
Sargent's cultural evolutionary content, she made it carry the full significance of
the scene, drawing the audience's attention, in three studied stages, to the object
of the prophets' interest. First, the nineteen young women from Lynchburg took
their appropriate places in the order designated by Sargent's painting; then they
assumed the gestures of the artist's figures; and, finally, all of them turned their
gaze "forward" toward the carolers representing the advent of Jesus. "The Minis-
tering of the Gift" thus annexed Sargent's *Frieze* and reworked it visually and dra-
matically to foreground the explicitly Christian triumphalist theme Thoburn
desired and to celebrate the missionary concerns of the YWCA.

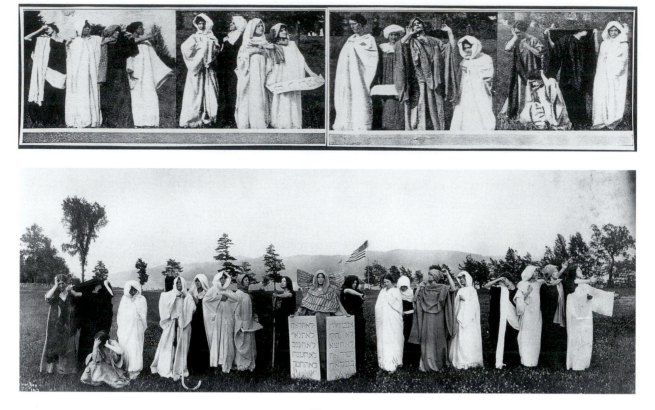

Fig. 155

Photo assemblage of figural groupings from "Ministering of the Gift" pageant, Richmond, Virginia, 1913. From *Good Housekeeping Magazine* 57, no. 2 (August 1913)

Fig. 156

"Frieze of Prophets" in "Ministering of the Gift" pageant, YMCA Conference Center, Silver Bay, New York, 1913. Collection of Barbara T. Martin

From the beginning the YWCA wanted a permanent visual record of the performance and arranged to have it filmed as well as photographed.[56] And, though the actual Richmond performance was forced indoors (under cover of a large arena) by rain, the images that document the pageant were all shot outdoors at rehearsals or reenactments. In an article published a few months after the convention, *Good Housekeeping Magazine* printed a grouping of Richmond pageant photographs (fig. 155). Magazine staff charged with the task of layout apparently did not know or chose to ignore the content of Sargent's original sequencing, despite the fact that Thoburn's pageant had noted and accentuated his gestural vo-

cabulary. Another photograph (fig. 156), this one taken at a second full-scale presentation of the YWCA pageant, retained the visual rhythms and sweep of Thoburn's tableaux. This second performance took place on 25 June 1913 at the Silver Bay Conference Center of the Young Men's Christian Association (YMCA) on the shores of Lake George, New York. The American flag's visible presence in the upstate New York staging area was entirely consistent with the sense of Christian citizenship that informed the YWCA script. As an interdenominational training site and conference center, Silver Bay hosted frequent national and regional gatherings of the YMCA, YWCA, Christian missionary groups, Boy Scouts of America, and a broad spectrum of evangelical Protestant churches and organizations.[57]

In the YWCA pageant, Sargent's *Frieze* was literally dislocated from the larger narrative program of which it was a part, from its architectural setting, and from its particular urban geography—indeed from any specific geography since the play was designed to be repeated elsewhere. In the process of reiteration from mural to pageant, the "image" not only underwent a complete shift in gender, it also lost, among other things, its pronounced framing devices, its inscription of Hebrew names, and its gilt ground, moving from the low illumination of the library hall interior to daylight in the natural surrounds of a gently rolling open field. The young women who "were" the prophets perhaps most completely appropriated the work—made it their own—and in the ritual reenactment of the pageant at other times and locations participants both familiarized the object (Sargent's *Prophets*) and sacralized the spaces of the eminently movable Christian performance.

REPRODUCTIONS:
THE JEWISH COMMUNITY CENTER LIBRARY

Like Helen Thoburn, Tobias Roth and Charles W. Markus had religious and cultural formation in mind when they sought permission to reproduce *Frieze* "photographically" and "use it as a mural in our library."[58] Unlike Thoburn, Markus and Roth were interested in *Jewish* formation. The library in question was located in the new Andrews Street building of the Jewish Young Men's and Young Women's Association in Rochester, New York (now the Jewish Community Center, or JCC; fig. 157). The main objective of the Jewish center movement as a whole, and of its local Rochester expression, according to Louis C. Kraft, one of the movement's national leaders, was to provide for the "development of a consciously Jewish life, properly integrated in the life of the commu-

Fig. 157

**Photographic reproductions of Sargent's *Frieze of Prophets*. Jewish Community
Center library, Rochester, New York**

nity at large."[59] The center movement was vocal in its support of such common
American values as democracy and personal freedom. Its primary mission, how-
ever, concerned Jewish identity and Jewish citizenship; it hoped to "inspire" its
members "with the idealism that is their spiritual heritage as Jews" and to "con-
tribute toward the perpetuation and development of Jewish life in America."[60]
The popularity of Sargent's *Frieze* in contexts both explicitly Jewish and Christ-
ian indicates that, at least for these audiences, and regardless of the expectant ges-
tures of the three final figures on the public library's east wall panel, the image
(coming as it did from a public and secular source) was sufficiently neutral to ac-
commodate divergent religious readings. What served as Christian devotional art
in one setting could serve Jewish audiences in another.[61]

In 1937 and 1938, at the time of their correspondence with librarian Mil-
ton Lord, Markus, the murals' donor, was a chief purchasing agent at Eastman

Kodak in Rochester and Roth was executive secretary of the city's JCC. The area to be filled, Markus told Lord, was thirty feet eight inches wide and forty inches high at the center, tapering off at the ends with the slope of a gently vaulted ceiling.[62] The available space remade Sargent's *Frieze* as a shape that approximated a truncated lunette, framed by free-floating corbels. The Rochester library was designed for individual and group study and for small meetings. Its principal patrons were youths but the room served all ages. In this move from one library to another, Sargent's *Frieze*—in large-scale photographic reproduction—kept the association with education, scholarship, and books that pertained in Boston, but in Rochester it occupied a space that asserted a specifically Jewish American culture and the vitality of this culture in the twentieth-century United States.

Historically libraries, as resources for cultural renewal, stood near the heart of the JCC movement.[63] Between 1924 and 1929 one leader in the center movement wrote: "A library is regarded as an essential facility in a Jewish Center. It is generally a reference and reading room . . . with a good Jewish collection of books and periodicals. . . . The library should be so designed as to give it a non-institutional appearance, and to provide for comfort and quiet. It should be located where it is readily accessible since its use should be encouraged."[64] Several years earlier, Mordecai Kaplan, describing the ideal Jewish center for the readers of *American Hebrew,* recommended the inclusion of "books and pictures . . . such as deal with Jewish themes" and an atmosphere "pervaded by a spirit of piety and reverence."[65] With its stuffed leather chairs, its sofas, its walls lined with books, and its casual organization of furniture, the Rochester library did in fact assume a distinctly less formal and somewhat more domestic appearance than its Boston public counterpart. The JCC library was, nevertheless, not a space that invited rambunctious behavior. In this room of quiet contemplation and study, as in the Boston Public Library, Sargent's "heroes of Jewish antiquity," in attitudes of interior self-reflection and communication with the divine, became a source of inspiration for the Jewish American present.[66]

Unlike Thoburn's reiteration in performance, the sepia-and-white Rochester reproduction disconnected the image from the original's evolutionary assertions. The architecture of the Rochester room, interestingly, contained and negated the gestures of the Prophets of Hope. In Boston the architectural framing and a horizontal language of gesture and color maintain the friezelike quality and the subtle but insistent movement across the surface that, as early as 1895, established the vacant east wall as the visual focus of the cycle. On Andrews Street the three final figures to the spectator's right appear cramped, the space around them too small to embrace their responsive activity. Their gesticulation intercepted in

the reproductive flattening of the surface of Sargent's *Frieze* (from three walls to one), they stare into a dim corner instead of facing out as in Boston toward a large and comparatively light, open area. This interruption in Rochester of Boston's gestural choreography and the corresponding dissipation of horizontal movement produced by the vertical seams between photographic segments turn the viewer's attention back to Moses at the center. The modified spatial geometry of the room, however, moderates the effect of this redirection, inadvertently creating the illusion that Moses is somewhat shorter than the prophets at the extremes. The absence in Rochester of Boston's relief elements and substantial framing devices (including the heavy gilt cornice that in Boston appears almost to rest on Moses' head yet easily clears the heads of the other figures) contributes to the relative diminution of the Rochester Moses. But until the JCC sold the Andrews Street building in 1972, the Rochester *Frieze* represented a meaningful part of the library's cultural and religious content as well as, to many of its patrons, a "beautiful piece [of art] on the wall."[67]

<div align="center">

REPRODUCTIONS:

THE LORD CHAPEL AT CENTER CHURCH, HARTFORD

</div>

Though it is now a congregation of the liberal Protestant United Church of Christ (Congregational), Center Church, Hartford, dates its presence in the Connecticut city back to the early-seventeenth-century founding pastor, Thomas Hooker. Located in downtown Hartford, across the street from the Wadsworth Atheneum, the church's ministries embrace an increasingly diverse urban congregation. In 1990 Jeri Bothamley, then director of Christian education at Center Church, wanted to renovate the parish house chapel for use in children's worship. In order to implement a recent decision with respect to children and communion services, the congregation had need of a space in which children could be invited to receive the sacrament. The parish house location of the chapel placed it in close proximity to rooms accommodating other educational and social ministerial functions. For the chapel's "new" decorations, Bothamley turned, first, to the congregation's attic. There she found a number of suitable objects, including a plaster cast of singing boys (a P. P. Caproni Brothers cast of Luca della Robbia's *Cantoria*), a representation of Hebrew prophets in a large, segmented, dark oak frame (a complete set of 1896 Curtis and Cameron sepia prints of Sargent's *Frieze*), and a long, rectangular oak trestle table. The addition of reproductions of several works by Edward Hicks and Horace Pippin, as well as a stained-glass window of the Good Shepherd (purchased by Bothamley in a Michigan antique store), completed the room's aesthetic renovation.

Fig. 158

Reproductions of Sargent's *Frieze of Prophets*, 1896. Copley Prints, Curtis and Cameron, Boston. Hand-colored, c. 1990, by Jeri Bothamley. Lord Chapel, Center Church, Hartford, Connecticut

Of all the instances of reproduction I have considered here, this is the only one in which the image (Sargent's *Frieze*) was selected, at least in its current iteration, neither principally for its specific subject matter nor because of the identity and prestige of the artist. Not surprisingly, in fact, given the virtual oblivion of *Triumph of Religion* in the art critical and historical literature in 1990, Bothamley was unable to identify the artist or the location of the original. Of course Edward F. Harrison, church librarian from 1884 to 1898 and the individual who likely acquired the Curtis and Cameron reproduction for the congregation, surely knew the artist's identity and *Frieze*'s Boston home. Harrison probably purchased the Sargent print and the Luca della Robbia cast from their respective catalogues at about the same time in 1896. In 1990, however, the Center Church *Frieze* was chosen, alternatively, for its decorative capacity, because it

was "the right shape, the right kind of frame [i.e., it matched the proportions and finish of the trestle table that some speculated had served the congregation in earlier communion services], and the right kind of art [i.e., figurative and generally biblical subject]."[68] When the picture was positioned on the back wall of the parish house chapel (fig. 158), several church members felt that the image was too dark and that this quality was exacerbated by its placement in a dim corner of a room with no windows. The director of Christian education, an artist herself, responded by hand-coloring the faded hundred-year-old print with red, blue, and yellow oil washes, brightened by touches of metallic gold.

In 1998 the chapel continues to be used for children's communion services on Sunday mornings, and this was the group of worshippers the church had in mind when it redecorated the space in 1990. In the children's chapel of this prominent Hartford church, Sargent's *Frieze* represents an aesthetic the congregation judges appropriate for its children (the "right kind of art"); it also gains additional status as a congregational heirloom, a "treasure" retrieved from the attic and restored for use by a congregation that places significant value on its own heritage and substantial longevity in the city. No longer "modern," or even identifiable, Sargent's frieze is yet associated with the religious and devotional education of children—and, importantly, with the church's own "antique" material past. In addition to the Sunday morning gatherings of Center Church's children, another group now uses the parish house chapel. On Sunday evenings the room accommodates the Bible study and worship of a Spanish-speaking congregation of the Disciples of Christ (Iglesia Cristiana, Discípulos de Cristo). This expansion of the Lord Chapel's ministries suggests new interpretive dimensions for this reproduction of *Frieze of Prophets.*

"PRIVACY" AFTER ALL

Art, in order to be religious, declared Walter Sargent, of the Boston Public Schools, in the pages of *Perry Magazine,* "must do more than deal with religious subjects."[69] The Boston educator's remarks on the divorce of religious subject from religious content implied that the "more" he required of religious art had to do with some quality invested in the object itself, likely by virtue of the artist's piety or conviction. As *Triumph of Religion* demonstrated, however, artistic motive was easily separated from interpretation and use. In each of the particular cases examined here, audiences participated in negotiating meaning. But in creating a series of diverse afterlives—some religious and some secular—for Sargent's prophets, each of the new publics that coalesced around reproductions of the

Boston Public Library murals enriched and complicated the visual and cultural grammar of the "original."

Curiously, perhaps even ironically, the central ideal of egalitarian subjectivity that Sargent claimed for *Triumph of Religion* constituted an implicit, though in all likelihood unintentional invitation to invest *Triumph* with just these sorts of new personal and cultural meanings. *Triumph* presumably left enlightened beholders free to discover their own "private" interpretations. In 1899 Henry Turner Bailey, writing on the picture study movement for *Perry Magazine,* wondered: "Yet, after all, is the initial thought of the artist so important to our enjoyment of the picture? Perhaps the artist saw in his picture all everybody else has seen and much besides; the probability is that he did. It is safe to assume that all great pictures are *full* of thought and feeling. . . . [But] the ultimate question is, 'What does the picture say to me?' " If, from Sargent's perspective, *Triumph* exalted the privatization of religion, from Bailey's, the privatization of art was a similarly logical step: "While no scripture is of private interpretation, in one sense; in another its only true interpretation is a private one. So it is with a great work of art. We may read about it and be told about it, we may learn its history and appreciate its technical qualities, but we shall not know *it* until it has spoken to each of us directly, until it has brought to our spirit a personal message too tender for words."[70]

REPRESENTING

RELIGIOUS PLURALISM

IN PUBLIC

⊕

Pluralism, for our purposes, can simply be defined as the coex-
istence and social interaction of people with very different be-
liefs, values and lifestyles. This state of affairs is indeed generally
associated with modernity, but it does not necessarily lead to
secularization, as is most clearly shown by America, a "lead so-
ciety" (to use Talcott Parsons's term) both for modernity and
for pluralism. Rather, the effects of pluralism are more subtle,
but nonetheless of great importance: pluralism influences not so
much *what* people believe as *how* they believe.

—PETER L. BERGER, *"Protestantism and the Quest for
Certainty" (1998)*

✳

Despite the noninstitutional character of Sargent's religious beliefs, he was not entirely without them. His *Triumph of Religion,* as he had planned to complete it, would depict his public conviction that, for himself and for modern Americans, religion was a subjective, private affair, a "habit of the heart." Sargent's mural cycle, thus conceived, would chart a progressive ideational evolution for religion with the "great inwardizations" of Sermon on the Mount's subjective spirituality (privileging the consent of the individual rather than the consensus of the whole) as its pinnacle. This privatization of religion, a historical tendency accelerated in the United States by the official separation of church and state, represented not the extinguishing of the religious impulse, nor the divorce of religion and culture, nor the disappearance of religious expression from the public sphere, but the assignment of religion to a domain of individual volition and disposition. The claim being made in *Triumph of Religion* was not that contemporary religion should happen only in private, where it was not visibly or collectively accessible (Sargent was, after all, painting religion in public; his "more personal relation" was expressed in the midst of a crowd), but that religious decision-making and faith were ultimately subjective and private matters. This was a perspective suited, in 1890, not only to Sargent but also to a large number of Americans and Western Europeans within the church as well as without and especially to the liberal Protestant majority in the northeastern United States. It is a content, in fact, officially endorsed in the United States in the 1990s.[1]

This combination of religious freedom, individualism, and privacy had a long American history, beginning with early Puritan colonists as well as with the Enlightenment thinkers whose works informed the founding of the republic. John Locke, for example, claimed in 1689 that the "true and saving Religion consists in the inward persuasion of the Mind."[2] Thomas Jefferson's famous 1802 letter to the Baptists of Danbury, Connecticut, the letter in which he wrote of the "wall of separation between Church and State," also asserted his conviction that "religion is a matter which lies solely between man and his God."[3] By the late nineteenth century there was widespread liberal agreement that the "inner spiritual life" was the "domain of sovereign individuality."[4] In 1890 it must have seemed to Sargent that his timing was impeccable. His theme was innovative enough to appear risky or at least adventuresome (his "surprise to the community"), but also sufficiently representative of the attitudes of many (in terms of current reactions to Renan and his other literary sources) to be seen as accurate, objective, and even true. Combining a number of contemporary ideas (the evolution of religion, the progress of civilization, the subjectivity of modern religion), Sargent the artist-scholar would present a progressive but popular late-nineteenth-century public philosophy of religion. The philosophy Sargent outlined moved from materialism to spirituality, from objective to subjective, but

also—and this was a critical addition consistent with but not necessarily inherent in the first two—from diversity to unity and universalism, a position Sargent supposed all could embrace. He began with plurality and worked toward a unity he predicated on the privacy of individual conscience and imagination. The 1895 library *Handbook* outlined the course it expected *Triumph* to follow, from the "Confusion" of the pagan idols, to the "Conventionality" of institutional Christianity on the south wall, to the ultimate "Unity" that would be represented in the central panel on the east wall. Sargent did not dispute this characterization— and it was one that others subsequently picked up, refined, and reiterated.[5] Prominent contemporaries would link the possibility of a workable public religion in the United States to a similarly liberal, progressive, and universalizing theory of religion—and this despite the fact that, from the time of the nation's founding, "religion in the United States has typically expressed not the culture of the society as a whole but the subcultures of its many constituents."[6] For Sargent, this universalizing theory of religion was to be expressed (and even, in part, achieved) with reference to the purportedly universal and timeless significance of high artistic culture.

In the late nineteenth century, intellectuals and liberal religious congregants on both sides of the Atlantic voiced the often anxious opinion that modernity might necessarily be accompanied by a decline in religion. By the 1950s and 1960s, sociologists of religion assumed and had documented this decline, a phenomenon they called "secularization." In the 1990s, however, the scholarly literatures of the history and sociology of religion have overturned the presumption that modernity—and especially modernity in the United States—automatically defeats religious experience and expression. The "new paradigm" for the sociological study of religion in the United States, according to R. Stephen Warner's already classic article, "begins with theoretical reflection on a fact of U.S. religious history highly inconvenient to secularization theory: the proportion of the population enrolled in churches grew hugely throughout the 19th century and the first half of the 20th century, which, by any measure, were times of rapid modernization. . . . One [even] naive glance at the numbers is bound to give the impression that, in the experience of the United States, societal modernization went hand in hand with religious mobilization."[7] Polls charting levels of religious belief and observance in the United States have consistently yielded figures substantially higher than intellectuals, especially, might have imagined. For example, a Gallup poll conducted in 1997 indicated that respondents who claimed "belief in God" numbered 96 percent, compared to 95 percent in 1947.[8] The outcome predicted (and then rejected) by Rabbi Henry Raphael Gold in 1919, that the progressive evolution of religion in the modern world might lead it right out of religion and into science, has not necessarily matched the course of events.

What modernity *has* produced, as the polls suggest and almost all agree, is *pluralism* in belief and culture, again especially in the United States and here due largely to substantial immigrant populations and to a political philosophy that rests on religious and social freedoms.[9] Though his timing may have seemed impeccable in 1890, by 1919 almost three decades had passed. Sargent had aged from thirty-four to sixty-three. Both he and the world had passed through the Great War, an event of "savage disillusion" that seemed to render progress itself obsolete.[10] Furthermore, the accelerated pace of large-scale immigration had dramatically altered both the perception and the reality of American demographics. In *Triumph of Religion,* though parts of his idea (e.g., the arguments for freedom and privacy) would remain compelling, Sargent was now asserting a progressive unification that was no longer tenable at just the point in time when the fact of its untenability became apparent.

The years during which Sargent worked on his public library mural cycle represent a key period in terms of inaugurating a perceptual shift from the notion of an American "people" or *public* (singular) as a collection of citizens in a predominantly Protestant and certainly Christian monoculture to an emerging sense of the pluralism and multiculturalism of American *publics* (plural). In a recent essay on church-state relations, historian Robert T. Handy settled on the years between 1880 and 1920 as the meaningful chronological frame for concerns regarding the "increasing pluriformity of religious life" in the United States.[11] This was the same "pluriformity" that George Santayana, in 1913, observed working to "break" the "shell of Christendom."[12] *Triumph of Religion* and the responses to it that have been discussed in the pages of this book can be numbered among the many and various attempts to mediate between Protestant hegemony and a changing American culture. As Handy demonstrates, though new fissures appeared and old ones expanded, the period supported a consensus of sorts: "the illusion that Christendom was still intact persisted, yet the underlying tension was increasing."[13] From the perspective of the later twentieth century, as Frances FitzGerald suggests, both centripetal and centrifugal tendencies are at work. The symbolic mechanism of accommodation to American life is no longer "a melting pot but a centrifuge that spun [people] around and distributed them out again across the landscape according to new principles."[14] *Triumph,* even as Sargent conceived it, straddled the cultural gap between other new and old worlds than the United States and Europe. His visual documentation of privatization, his interest in new biblical criticism, and his engagement of the historical study of religious ideation aligned him with those who looked forward into the twentieth century. His commitment to discerning the unitive progressive culmination of religion's "triumph," conversely, suggested allegiance to a now dated worldview.

The *Synagogue* controversy expressed a critical and very "modern" set of involvements regarding public education, pluralism, visual expression, and religious experience. While issues concerning religious pluralism and the role of the state had been raised much earlier with respect to public education in the United States, public education was one of the first fields on which late-nineteenth- and early-twentieth-century skirmishes over American identity and the ownership of American culture were fought. Protestants were loathe to relinquish control of the public system of schools (and libraries, and literatures) that they had shaped.[15] Protestant support for "complete" separation of church and state in the public schools was, in fact, a direct, though less than generous, response to increasing pluralism in American religious expression. In the final two decades of the nineteenth century, Protestants were ultimately willing to yield ground only to prevent Catholics, Jews, and others from seizing it. As Robert H. Keller, Jr., notes, for example, "not until American Catholicism began to grow in size did 'strict separation' become a Protestant constitutional doctrine."[16]

In 1890 many expressed surprise that Sargent (as a freethinking individual with a reputation for high society portraits) would paint religion; few thought it unusual that he would paint nonsectarian religion in the public library. It was, in other words, the person and not the place that represented the puzzle. By 1919 the situation had reversed itself, and it was the institution and its public educational mission that generated concern and perplexity regarding a mural cycle that multiple publics now read as sectarian. It would be just one year later that the American Civil Liberties Union (ACLU) would be founded, on a platform Sargent, philosophically at least, could have endorsed. The ACLU pledged to protect each citizen's "inherent right to freedom of expression, belief, and association, to procedural fairness, to equal treatment before the law, to privacy."[17] In 1925, the year of Sargent's death, the organization's first major case, the Scopes trial, would involve the relation of religious content and public education in the United States. Sargent's mural cycle and its conception of religion engaged key late-nineteenth- and early-twentieth-century American ideas about public religion and public education. In particular, it paralleled attempts on the part of the Protestant establishment to formulate a workable public and "universal" religion that could be taught in the nation's schools and, significantly, the failure of these attempts.

The Boston Public Library was not a schoolhouse in the Boston public school system; the murals on Sargent Hall's east wall were privately, not publicly, funded. Readings of their significance in 1919 were hampered by the absence of the keynote panel, by Sargent's inability or unwillingness to share his "private" intentions, and by his culturally elitist insensitivity to the local political and social

implications of his selections. In terms of ideas about the progress of civilization and its foundations, he had painted a widely shared public philosophy of religion. He established a sharp contrast between the religion of institutions and the enlightened spirituality of the subjective self. He styled religion as a body of cultural knowledge and recommended study, not belief, as the activity appropriate to this space. In the course of expressing his idea, he would manipulate a conventional medieval iconography (Synagogue and Church) in the direction of mitigating the stereotype and collapsing the allegorical contrast between two (as he saw them both) obsolete institutions.

As a late-nineteenth- and early-twentieth-century narrative program, Sargent's *Triumph of Religion,* intent on demonstrating religious history as a move from diversity to unity, suggested that the representation of religious content in the pluralistic United States could be navigated only by turning inward, by making religion private. Today, by comparison, rather than living in a culture in which religion must become ever more private in order to tolerate pluralism, we occupy a place in time and space in which pluralism (including religious pluralism) is becoming ever more public. The new visual accessibility of pluralism can be attributed to several recent phenomena. These include, but are not limited to, first, the social transformations attending what sociologists are calling the "new immigration." Between 1966 and 1990 nearly as many people immigrated to the United States as did between 1890 and 1914. The situation in terms of numbers of newcomers, then, is very similar to that of Sargent's Boston. The new immigration, however, is even more heterogeneous in terms of race, ethnicity, religion, and language than that of the century past.[18] Historian Diane Winston observes: "We no longer live in a Christian nation, or even a Judeo-Christian one. As *The New York Times Magazine* reported in December, the United States is now home to 800,000 Hindus (compared with 70,000 in 1977) and to as many Muslims as Presbyterians. The numbers of Sikhs, Jains, Buddhists, Eastern Orthodox, and Baha'i in this country are also increasing."[19] Not only are the numbers of belief systems to which people subscribe expanding, but more and more people have adopted what Winston calls "trans-religiosity," "blending . . . beliefs, mythologies, and practices from varying traditions . . . without feeling any contradictions."[20]

Second, American culture owes the publicness of contemporary pluralism to the civil rights movement and its attendant focus on issues of ethnicity and race relations. Here, significantly, much of the movement's leadership either represented established (generally Christian) religious bodies or created new initiatives (like the Black Muslims) in American religion. Third, within liberal Protestantism itself, as well as outside it, the changing roles of women and homosexuals in the religious community have produced publicly visible denominational fissures. Even within the so-called mainstream, then, an increasing array of

options is displayed. Fourth, the public visibility of pluralism is the product of the factors already noted, in combination with the mass mediation of culture and its tendency to "subject to the persistent gaze of publicity" so much that was formerly "private."[21] Technologies of mediation complicate definitional categories, rendering "public" and "private" as increasingly elastic terms. For example, into which category should we place the World Wide Web? As a new arena of social interaction, it is a place, or site, where many people meet to display and exchange information; it is thus both accessible and collective—yet it is also used in the privacy of one's own study, or family room, or bedroom, and it offers at least the illusion of anonymity.

For historians and interpreters of American visual culture it is especially significant that pluralism has become more public in terms of its *visual* accessibility. One outcome of the increasing visual accessibility of pluralism is its tendency to challenge the "taken-for-grantedness" of individual values and beliefs—not *what* people believe, but *how* they believe.[22] Because no one expression can be taken to stand for the whole (for one unifying or universal religion), religious expression itself undergoes a sort of emancipation. The public display of religions (plural) thus gains the potential to contribute to the sense of cultural diversity rather than reinforcing the hegemony of any one group. This possibility is unlikely to yield rapid acceptance—or even necessarily toleration—of differences, but religious pluralism is no longer something we do, in large part, in private.[23]

Granting as an essential feature of his position significant local/regional, rural/urban variation in the extent and particularity of religious pluralism, Warner argues that in the United States religion itself is configured as a "social space for cultural pluralism." The more and more frequent public expression of plural religions on television, in movies, in the newspapers (with many major papers recently hiring religion reporters and establishing religion pages), and on the Internet supports his claim.[24] Recent religious architecture, too, contributes to this sense. In Montgomery County, Maryland, on a principal commuter artery into Washington, D.C., a stretch of road less than ten miles long is now home to almost three dozen religious congregations, including, among others, houses of worship for Hindus, Muslims, Buddhists, Jews, Catholics, and Protestants and liturgies spoken in Spanish, Chinese, Korean, Vietnamese, and Ukrainian languages as well as English and Hebrew. Especially striking, in terms of visual presence and accessibility, is the constellation of buildings at the busy intersection of New Hampshire Avenue (recently widened to four lanes) and Norwood Road (fig. 159).[25] Here, in a location passed daily not only by commuters but by hundreds of children and youths on their way to nearby elementary and high schools, adherents of three different religious groups have constructed buildings that express their different subcultures and beliefs. Appearing in immediate and

obvious proximity to one another, the white, turquoise, and gold architecture of the Ukrainian Orthodox cathedral is set off against the minaret and copper dome of the Muslim Community Center's mosque, and both contrast with the understated modernism of the adjacent congregation of the Protestant Disciples of Christ. Not only is pluralism more immediately apparent in the visual stimuli of everyday life, but consciousness of the potential for overtly religious works of art to have a pluriformity of audiences is expanded by such display.

What ethicist Robin W. Lovin calls the "encumbered self" and psychologist Kenneth J. Gergen the "saturated self" reflects the increasing complexity and pluriformity of what is visibly present to us, the "relational realities" in proximity to which we define ourselves and conduct our daily lives: "The multiple encumbrances that complicate the experience of individuals yield an even wider range of possibilities for society." [26] Social anthropologist Simon Coleman and art historian John Elsner identify the experience of "ritualized browsing" among adherents of different religious beliefs in the late twentieth century. Like museums or shopping malls, in an increasingly pluralistic culture and open market economy (and even within a single religious tradition) religious sites offer the potential for improvisation and accommodation to personal interpretations, expanding and reconfiguring in the process, the boundaries of expectation. [27]

Multiple publics, representing a variety of usually cultural educational motives, visit Sargent Hall today. For many, however, the recent history of the room has complicated attempts at understanding. In the early 1970s the Dartmouth Street entrance to the library was closed, effectively circumventing entry to the room along the intended axis leading in and up from Copley Square. Twenty years later, in the early 1990s, the gallery, filled with filing cabinets and dust, was used as a storage area. Among arts professionals, nonetheless, *Triumph of Religion* had begun in the 1970s a slow ascent to recovery of its positive reputation; this aesthetic recuperation began two decades later for the murals than for Sargent's portraits and watercolors. Again, the nature of requests for permission to reproduce the public library murals documents this shift, with most queries between 1973 and 1984 coming from within the artistic domain. [28] As part of the centennial restoration of the McKim, Mead and White building, the main "ceremonial" Dartmouth Street doors reopened in May 1994. [29]

In Sargent Hall, according to a survey of docents and visitors conducted in 1998, the principal concerns (for this group of forty-six respondents at least) related to the dilapidated condition of the murals, the empty panel, and the modified and inadequate lighting of the room. [30] Tours, predominantly educational groups of many ages and backgrounds (including English as a Second Language classes and literacy programs), generally enter the room from the main stairway, look first at the north end with its pagan gods and Hebrew prophets, and leave

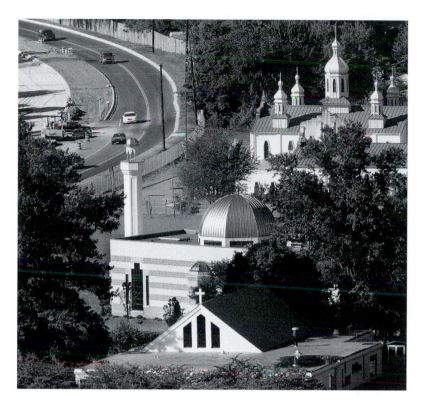

Fig. 159

"A Place for Those Who Pray: Along Montgomery's 'Highway to Heaven,' Diverse Acts of Faith," ***Washington Post*** **(3 August 1997): B1**

through the door at the south end, beneath Crucifix. To many the room reads as a medieval chapel. Docents and visitors resolve the presence of this sort of historically "sacred" space in a "secular" public library in a variety of thoughtful ways, in relation, for example, to the artist's scholarly interest in medieval religion and culture and to their sense of his accurate categorization of religion as a body of knowledge (rather than a community of faith) and thus a subject appropriate to a library. Some comment on Sargent Hall's adjacency to the Cheverus Room. Although the room was the Music Library when Sargent planned and executed the murals (and until 1975), the anachronistic connection seems relevant to the room's impact as "chapel" since Jean Louis Lefebvre de Cheverus (1768–1836) was the first Roman Catholic bishop of Boston.

As part of the larger, comprehensive centennial project already underway, *Triumph of Religion* is itself scheduled for cleaning and restoration. In a now more openly and multifold pluralist context, the renewed visibility of the murals will almost certainly foster productive discussion of past and present roles of religious images in public places and in popular imagination.

ABBREVIATIONS

AAA Archives of American Art, Smithsonian Institution, Washington, D.C.

AJHS American Jewish Historical Society, Waltham, Mass.

BA Boston Athenaeum, John Singer Sargent-Thomas A. Fox Papers

BL Bancroft Library, University of California, Berkeley

BPLc Boston Public Library, Corporation Office

BPLf Boston Public Library, Fine Arts Clippings Files

BPLr Boston Public Library, Rare Books and Manuscripts

CC Colby College, Waterville, Maine, Special Collections, Miller Library

CEE Congregation Emanu-El of the City of New York, Archives

DCL Dartmouth College Library, Hanover, N.H.

HL Houghton Library, Harvard University, Cambridge

ISGM Isabella Stewart Gardner Museum, Boston

LC Library of Congress, Washington, D.C.

MCC Massachusetts Council of Churches, Boston

MHSpc Private collection on deposit with the Massachusetts Historical Society, Boston

MMA The Metropolitan Museum of Art, New York, Archives

NMAA/NPG Library, National Museum of American Art/National Portrait Gallery, Smithsonian Institution, Washington, D.C., Vertical Files

SUL Syracuse University Library, Syracuse, N.Y.

YWCA Young Women's Christian Association, New York, National Archives

INTRODUCTION

1 For current investigation of Sargent's work as a muralist, see Mary Crawford Volk, "Sargent in Public," in *John Singer Sargent,* ed. Elaine Kilmurray and Richard Ormond, exh. cat. (London: Tate Gallery; Princeton: Princeton University Press, 1998), 44–58; and Jane Dini, "Public Bodies: Form and Identity in the Work of John Singer Sargent," Ph.D. diss., University of California, Santa Barbara, 1998. My own work on this subject includes: Sally M. Promey, " 'Triumphant Religion' in Public Places: John Singer Sargent and the Boston Public Library Murals," in *New Dimensions in American Religious History,* ed. Jay P. Dolan and James P. Wind (Grand Rapids, Mich.: Eerdmans, 1993), 3–27; Sally M. Promey, "The Afterlives of Sargent's *Prophets*," *Art Journal* 57, no. 1 (Spring 1998): 31–44; and Sally M. Promey, "Sargent's Truncated *Triumph*: Art and Religion at the Boston Public Library, 1890–1925," *Art Bulletin* 79, no. 2 (June 1997): 217–50. For earlier, groundbreaking scholarship on *Triumph of Religion,* see Trevor Fairbrother, *John Singer Sargent and America* (New York: Garland, 1986), 208–78 (cited as *Sargent and America*); Trevor Fairbrother, *John Singer Sargent* (New York: Harry N. Abrams, 1994), 83–91 (cited as *Sargent*); Martha Kingsbury, "John Singer Sargent: Aspects of His Work," Ph.D. diss., Harvard University, 1969; eadem, "Sargent's Murals in the Boston Public Library," *Winterthur Portfolio* 11 (1976): 153–72; and Doreen Bolger Burke, "Astarte: Sargent's Study for *The Pagan Gods* Mural in the Boston Public Library," in *Fenway Court 1976* (Boston: Trustees of the Isabella Stewart Gardner Museum, 1977), 8–19. See also Derrick Randall Cartwright, "Reading Rooms: Interpreting the American Public Library Mural, 1890–1930," Ph.D. diss., University of Michigan, 1994, esp. 145–58.

2 "A Sargent Year," *Literary Digest* 53, no. 11 (9 Sept. 1916): 608. See also "Boston Acquires Another Sargent," 19 Dec. 1925, unidentified newspaper clipping, NMAA/NPG: "For years he had worked on the idea [of Sermon on the Mount] . . . as he cherished the thought that this painting would be his masterpiece"; and Royal Cortissoz, "A National Monument of Art: The Congressional Library at Washington," *Harper's Weekly* 39 (28 Dec. 1895): 1240–41: in the hyperbolic opinion of this contemporary, "The Boston Public Library will stand forever as the first and most splendid achievement of American art working under the conditions of our civic life." See further, Richard Ormond, "Sargent's Art," in *John Singer Sargent,* ed. Elaine Kilmurray and Richard Ormond, exh. cat. (London: Tate Gallery; Princeton: Princeton University Press, 1998), 23–43.

3 See, for example, Jon Butler, *Awash in a Sea of Faith: The Christianizing of the American People* (Cambridge: Harvard University Press, 1990); Nathan O. Hatch, *The Democratization of American Christianity* (New Haven: Yale University Press, 1989); and James H. Hutson, *Religion and the Founding of the American Republic,* exh. cat. (Washington, D.C.: Library of Congress, 1998).

4 R. Stephen Warner, "Work in Progress toward a New Paradigm for the Sociological Study of Religion in the United States," *American Journal of Sociology* 98, no. 5 (Mar. 1993): 1058–64; Robert T. Handy, "Changing Contexts of Church-State Relations in America, 1880–1920," in *Caring for the Commonweal: Education for Religion and Public Life,* ed. Parker J. Palmer, Barbara G. Wheeler, and James W. Fowler (Macon, Ga.: Mercer University Press, 1990); and William R. Hutchison, "Protestantism as Establishment," in *Between the Times: The Travail of the Protestant Establishment in America, 1900–1960,* ed. William R. Hutchison (Cambridge: Cambridge University Press, 1989), 3–18.

5 E. V. Lucas, *Edwin Austin Abbey, Royal Academician: The Record of His Life and Work* (London: Methuen and Company, 1921), 2:360.

6 George Santayana, "The Intellectual Temper of the Age," in *Winds of Doctrine: Studies in Contemporary Opinion* (New York: Charles Scribner's Sons, 1913), 1.

7 A more general, comprehensive, and broadly historical treatment of this subject forms the content of a book-length manuscript in progress, "The Public Display of Religion."

8 John F. Wilson, "The Public as a Problem," in *Caring for the Commonweal,* 13.

9 Ibid., 11–22; Stanley I. Benn and Gerald F. Gaus, "The Public and the Private: Concepts and Action," in *Public and Private in Social Life,* ed. Stanley I. Benn and Gerald F. Gaus (London: Croom Helm, 1983), 3–27; and Jeff Weintraub and Krishan Kumar, eds., *Public and Private in Thought and Practice: Perspectives on a Grand Dichotomy* (Chicago: University of Chicago Press, 1997).

10 Jeff Weintraub, "The Theory and Politics of the Public/Private Distinction," in *Public and Private in Thought and Practice,* 1–3.

11 Ibid., 2.

12 Ibid., 6; and Allan Silver, " 'Two Different Sorts of Commerce'— Friendship and Strangership in Civil Society," in *Public and Private in Thought and Practice,* 45.

13 Weintraub, "Public/Private Distinction," 4–5. Trevor Fairbrother first suggested the potential fruitfulness of considering Sargent's oeuvre in relation to privacy; see Trevor Fairbrother, "Sargent's Genre Paintings and the Issues of Suppression and Privacy," in *American Art around 1900,* ed. Doreen Bolger and Nicolai Cikovsky, Jr. (Washington, D.C.: National Gallery of Art, 1990), 28–49.

14 Wilson, "Public as a Problem," 15; Benn and Gaus, "The Public and the Private," 20–21.

15 Wilson, "Public as a Problem," 22.

16 Robert A. White, "Religion and Media in the Construction of Cultures," in *Rethinking Media, Religion, and Culture,* ed. Stewart M. Hoover and Knut Lundby (Thousand Oaks, Calif.: Sage Publications, 1997), 40, see also 45.

17 Ernest F. Fenollosa, *Mural Painting in the Boston Public Library* (Boston: Curtis and Cameron, 1896), 6–10, 27–28. See also Robin W. Lovin, "Beyond the Pursuit of Happiness: Religion and Public Discourse in Liberalism's Fourth Century," in *Caring for the Commonweal,* 47, and Warner, "Work in Progress," 1044–93.

18 The intellectual history of progressive schemes of cultural evolution and the European genre of triumphal cycles (including, for example, James Barry's *Progress of Human Culture,* 1777–83, at the Royal Society of Arts, and Richard Westmacott's *Progress of Civilization,*

1847–51, above the main entrance to the British Museum, both of which Sargent had undoubtedly seen) form a significant backdrop to Sargent's enterprise. For a discussion of Sargent's public library mural cycle in terms of the ubiquitous late-nineteenth-century theme of the progress of Western civilization, see Promey " 'Triumphant Religion' in Public Places," 3–27.

19 Joseph Walker McSpadden, *Famous Sculptors of America* (New York: Dodd, Mead and Company, 1927), 92.

20 This constellation approximates Baxandall's notion of a museum exhibition as a "field in which at least three distinct terms are independently in play—makers of objects, exhibitors of made objects, and viewers of exhibited made objects"; Michael Baxandall, "Exhibiting Intention: Some Preconditions of the Visual Display of Culturally Purposeful Objects," in *Exhibiting Cultures: The Poetics and Politics of Museum Display,* ed. Ivan Karp and Steven D. Lavine (Washington, D.C.: Smithsonian Institution Press, 1991), 36.

CHAPTER 1: THE SUBJECTIVITY OF MODERN RELIGION

1 Some of the early material in this chapter appeared in a similar form in Promey, "Sargent's Truncated *Triumph*," 4–6; and Promey, " 'Triumphant Religion' in Public Places."

2 A verbal agreement was reached in May 1890, and the trustees characterized the nature of the agreement as a "verbal contract" in November of that year; see "Extracts from the Records of the Board of Trustees, Relating to John S. Sargent and His Contract for Mural Paintings for the Central Library Building," compiled 22 June 1922, BPLr, Ms Bos Li B180.

3 John Singer Sargent to Ralph Curtis, 18 Nov. 1890, BA; Charles F. McKim to Samuel A. B. Abbott, 9 May 1890, BPLr, Ms Bos Li B18b.2; Charles F. McKim to Samuel A. B. Abbott, 3 Nov. 1890, BPLr, Ms Bos Li B18a.2; and McKim, Mead and White to Boston Public Library Trustees, 5 June 1893, BPLr, Ms Bos Li B18a.2. See also Fairbrother, *Sargent and America,* 212–15; and Stanley Olson, *John Singer Sargent: His Portrait* (New York: St. Martin's Press, 1986), 163–68.

4 In his Museum of Fine Arts murals, Sargent would later personify this ideal and assign the three figures of the visual arts a key role in the program.

5 On Sargent's selection of space in the library, see Thomas A. Fox, "Collections and Recollections," BA; and Thomas A. Fox, untitled typescript on Sargent Hall, n.d., 8, BA.

6 "Contract between John Singer Sargent and Trustees of the Boston Public Library," 18 Jan. 1893, BPLr, Ms Bos Li B18a.1.

7 Ibid.

8 Sargent to Curtis, 18 Nov. 1890, BA. Ralph's father, Daniel Sargent Curtis, was a cousin of Fitzwilliam Sargent, the artist's father. Sargent also corresponded with Ralph's mother, Ariana Wormeley Curtis.

9 Sargent to Herbert Putnam, [May 1895], BPLr, Ms 1320.2; and Herbert Small, comp., *Handbook of the New Public Library in Boston* (Boston: Curtis and Cameron, 1895), 52.

10 Sargent to Putnam, [May 1895], BPLr.

11 Sargent to Charles F. McKim, 28 Sept. 1893, BPLr, Ms Am 562.

12 Ibid.

13 "Contract between John Singer Sargent and Committee of Citizens," 5 Dec. 1895, BPLr, Ms Bos Li B18a.1.

14 Ralph Curtis to Isabella Stewart Gardner, 16 July [1915], ISGM; and Ralph Curtis to Isabella Stewart Gardner, 2 July [1910], ISGM.

15 Sargent's only mural experience prior to this had been the assistance he provided his teacher, Carolus-Duran, with a ceiling painting now at the Louvre. Sargent to Josiah H. Benton, 29 Apr. 1914, typescript, BPLr, Ms Bos Li B18a.7. Though he dedicated a substantial amount of time to the cycle, working for significant periods intensely and exclusively on the murals, over the course of the project Sargent failed to meet the deadlines indicated in his contracts. Furthermore, as his thinking and his work schedule changed over time, the order in which he completed and installed individual panels began to deviate from the priorities set out in the second agreement. The 1916 installation would include parts of both contracts—and thus some images that had been scheduled for completion in 1897. The east and west lunettes installed in 1916 represented the negotiable images of the second contract—whereas the essential large east wall panels, images that contractually were to have been delivered as early as 1901, still remained to be completed. On the one hand, it took Sargent an inordinately long time to "finish" *Triumph of Religion;* the library trustees, on more than one occasion, expressed their annoyance about delays. In terms of the demands on his time, Sargent began the mural cycle just as the market for his portraits in America and England was taking off, and he tried to sustain his work on the murals through the peak of his portrait career. In 1907 he "gave up" portraiture because it was intrusive—in terms of time commitments and in terms of the complaints of sitters—and because it interrupted his work in mural and landscape painting. On the other hand, the library got more than it bargained for—and less: Sargent ultimately painted all six of the contractually negotiable lunettes, and he decorated the three central bays of the ceiling without additional compensation simply because he believed it necessary to his design—but he never completed the final painting, the cycle's "keynote" and "triumph."

16 The quotations in this paragraph are taken from Sargent's own description of this installation in Sargent to Putnam, [May 1895], BPLr.

17 For correspondence relevant to the installation, see Sargent to Boston Public Library, 21 Nov. 1902, Autograph File, HL.

18 Herbert Small, comp., *Handbook of the Library of Congress* (Boston: Curtis and Cameron, 1901), 72, see also 71–75.

19 See, e.g., "Sargent, the Artist," *Boston Globe,* 1 Feb. 1903, 29. Sargent's audiences might have been somewhat less surprised had they known that he was working on a set of biblical illustrations for the aborted Amsterdam Bible at just about the same time; see Lucas, *Edwin Austin Abbey,* 2:288, 292, 303–5. Sargent showed four of these illustrations in an exhibition of his work at Copley Hall, Boston, in 1899; "Catalogue of Paintings and Sketches by John S. Sargent, R.A.," Copley Hall, Boston, 20 Feb.–13 Mar. 1899, NMAA/NPG.

20 Evan Charteris, *John Sargent* (New York: Charles Scribner's Sons, 1927), 2–3; Olson, *Sargent,* 274–75.

21 Stanley Olson, "On the Question of Sargent's Nationality," in *John Singer Sargent,* ed. Patricia Hills, exh. cat. (New York: Harry N. Abrams, 1986), 17.

22 Charteris, *Sargent,* 4–5.

23 Lucia Fairchild, Diary, 8 Aug. 1891, 6, DCL.

24 American Cathedral in Paris (Holy Trinity Episcopal Church), Cathedral Register. Stanley Olson sets the date for the actual wedding at 17 Aug. 1891; Olson, *Sargent,* 169–71. Sargent's name appears one other time in cathedral records; on 5 Nov. 1899 he is listed as the godfather of Sylvia Curtis (registered as the daughter of "Mr. and Mrs. Ralph Curtis

of Boston") in the record of her christening. The artist was not present at the church, however, and someone else stood in for him. Despite the fact that Ralph Curtis was highly critical of the institutional church and its clergy, Sylvia was confirmed in the same congregation in 1916. I am grateful to Mary Kergall for her thorough and thoughtful assistance with research at the American Cathedral in Paris.

25 Telephone interview with Richard Merrill, archivist at Trinity Church, Boston, 6 Nov. 1997; telephone interview with Betty Hughes Morris, archivist at Church of the Advent, Boston, 20 Nov. 1997.

26 Vernon Lee (the pen name selected by Sargent's childhood friend Violet Paget) made this comment in a letter written to her mother in June 1881; Irene Cooper Willis, ed., *Vernon Lee's Letters* (London: privately printed, 1937), 63. A small number of inconsistencies in the record make me hesitate to describe Sargent as *fully* "emancipated" from religious conviction.

First, he and his family made use of at least the ritual services of the church in rare times of personal crisis. The memorial service for his mother, for example, was held at St. James, Westminster ("Canon Witherspoon's church where moms used to go"); Sargent to Mary Hunter, [Jan. 1906], AAA, reel D169, fr. 260. When Sargent died, Anglican services were held at Westminster Abbey and, concurrently, the Cowley Fathers sang a requiem mass at Boston's Church of St. John the Evangelist (Episcopal). Isabella Stewart Gardner, after her break with the rector of Church of the Advent, attended and supported St. John's. Prior to her death in 1924, Gardner had arranged for a requiem mass to be said in perpetuity by the Cowley Fathers each year in the private chapel at Fenway Court on the occasion of her birthday. Given the closeness of her relationships with both Sargent and the Cowley Fathers, it is likely that Gardner, in the years immediately before she died, also arranged the future requiem mass for Sargent. The Church of St. John the Evangelist, furthermore, sustained significant connections to the arts and to artists in Boston, and it was a congregation with a reputation for welcoming those without active religious connections elsewhere; telephone interview with Brother Eldridge Pendleton, archivist, Society of St. John the Evangelist, Cambridge, Mass., 29 July 1998. On Gardner's connections with St. John's and the Cowley Fathers, see Douglass Shand-Tucci, *The Art of Scandal: The Life and Times of Isabella Stewart Gardner* (New York: HarperCollins, 1997).

Second, some of the conversations that most clearly suggest Sargent's "liberation" took place with self-described agnostics: he may have tailored his message to fit his sense of their expectations. And third, there is Lucia Fairchild's report that Sargent, unlike other men present, appeared to participate in prayers at Dennis Bunker's wedding (Fairchild, Diary, 1890, 1, DCL). Finally, a letter from Emily Sargent to Isabella Stewart Gardner (5 Mar. 1920, ISGM) relays Emily's plan to attend, with her brother, a "Bible reading by Copeland" at Mrs. Livingston Cushing's on the following Sunday. To be held in the afternoon by a known "reader," the event was likely as much literary as religious, but some religious motive cannot be ruled out.

27 Nicola D'Inverno, "The REAL John Singer Sargent, as His Valet Saw Him: Painter Was Freethinker in Religion," *Boston Sunday Advertiser,* 7 Feb. 1926, 3.

28 Richard Ormond, *John Singer Sargent: Paintings, Drawings, Watercolors* (New York: Harper and Row, 1970), 89.

29 Martin Birnbaum, *John Singer Sargent* (New York: William E. Rudge's Sons, 1941), 36; Sargent to Charles Martin Loeffler, 8 Mar. [1917], Charles Martin Loeffler Papers, Box 3, LC.

30 Sargent to Charles Martin Loeffler, 26 Dec. [1921], Loeffler Papers, Box 3, LC.

31 Thomas A. Fox typescript of G. P. Jacomb-Hood, "John Sargent" (an article published in *Cornhill Magazine* [July–Dec. 1925]): 5, MHSpc.

32 Sargent to Mary Hunter, 22 Oct. [1916], AAA, reel D169, frs. 318–20. Mary Hunter's 1898 Christmas gift of a Bible to Moore, the writer claimed, influenced his decision to write a life of Christ. Moore also suggested that part of his intention was to best Renan in "rais[ing] Jesus into some sort of manhood"; see George Moore, *The Brook Kerith* (New York: Macmillan Company, 1916); and Lawrence Gilman, "The Book of the Month: Mary Hunter's Bible," *North American Review* 204 (Dec. 1916): 931–37.

33 Fairchild, Diary, 1890, 4–5, DCL; Anna Bonus Kingsford and Edward Maitland, *The Perfect Way, or, The Finding of Christ* (London: Field and Tuer, 1890); the book was first published in London in 1882 and appeared in New York and Boston editions in 1882 and 1900.

34 Initially Sargent may have envisioned his project as a sort of freely interpreted visual catalogue of one of the library's special collections. For a contemporary description of the Ticknor collection, see Lindsay Swift, "The New Public Library in Boston: Its Ideals and Working Conditions," *Century Magazine* 51, no. 1 (Nov. 1895): 268. Sargent had a significant history with Spanish subjects (for example, *El Jaleo,* 1882, and *La Carmencita,* 1890) and Spanish culture; see Nicolai Cikovsky, Jr., "*El Jaleo* in the Cult of Spain," and Mary Crawford Volk, "Sargent, Spain, and El Jaleo," in Mary Crawford Volk, *John Singer Sargent's El Jaleo,* exh. cat. (Washington, D.C.: National Gallery of Art, 1992).

35 "The Public Library at Boston," *Boston Evening Transcript,* 10 May 1893, 6. Much of this article was quoted from the *London Art Journal.* During the years in which Sargent worked on *Triumph of Religion* and on both sides of the Atlantic, the evolution of religion was a subject of intense scholarly and popular interest. In addition to Renan's books, see, e.g., A. Eustace Haydon's contemporary overview of the subject, "History of Religions," in Gerald Birney Smith, ed., *Religious Thought in the Last Quarter Century* (Chicago: University of Chicago Press, 1927), 140–47; Allan Menzies, *History of Religion* (London: John Murray, 1895); Lyman Abbott, *The Evolution of Christianity* (1892; New York: Johnson Reprint Corporation, 1969); and Edward Caird, *The Evolution of Religion* (Glasgow: James Maclehose and Sons, 1893). Caird's treatment used some of the same terms noted by Sargent, but Caird described disjunction as well as continuity between subjectivity and spirituality (which he opposed not to materialism but to "objectivity"). He also maintained a more positive sense of religious institutions than did Renan, placed significantly less emphasis on the Hebrew prophets and Sermon on the Mount, and described a greater discontinuity between Judaism and Christianity.

36 "Shrine": McSpadden, *Famous Sculptors,* 92; "Mecca": Small, *Handbook,* 51; "Valhalla": T[homas] R[ussell] Sullivan, "The New Building of the Boston Public Library," *Scribner's Magazine* 19, no. 1 (Jan. 1896): 85.

37 Marc Simpson, "Sargent and His Critics," in *Uncanny Spectacle: The Public Career of the Young John Singer Sargent,* exh. cat. (New Haven and London: Yale University Press, 1997), 32, also 31, 39, 67; and Sarah Burns, *Inventing the Modern Artist: Art and Culture in Gilded Age America* (New Haven: Yale University Press, 1996), 63.

38 Early and late in his career, in both England and America, Sargent was criticized for his facile "French" technique; see, for example, "The Decline of Art: Royal Academy and Grosvenor Gallery," *Blackwood's*

Edinburgh Magazine 138 (July 1885): 17; [Harry Quilter], "Royal Academy," *Spectator,* 59 (May 1886): 580–81; and Forbes Watson, "John Singer Sargent," *Arts* 7, no. 5 (May 1925): 243.

39 Sargent to Vernon Lee, [1884], CC.

40 Watson, "John Singer Sargent," 245. In a letter to Mariana Griswold Van Rensselaer dated Dec. 1890, Sargent lamented (in relation to perceptions of shallowness or superficiality in his work): "very few writers give me credit for insides, so to speak"; quoted in Charteris, *Sargent,* 110. See also Sargent to Charles Fairchild, 1 Feb. 1891, BA; and Sargent to Mrs. Charles Fairchild, 6 Mar. 1892, BA. For contemporary acclaim regarding the intellectual success of the cycle, see, e.g., "The Artists on Sargent's Paintings," *Boston Evening Transcript,* 10 June 1895, 4; and Frederick William Coburn, "Sargent Decorations in the Boston Public Library," *American Magazine of Art* 8, no. 4 (Feb. 1917): 129–30. See also Kingsbury, "John Singer Sargent," 101, 174; and Fairbrother, *Sargent and America,* 242.

41 Thomas A. Fox, "John S. Sargent, 1856–1925: The Man and Something of His Work," typescript, 30, BA.

42 On the course of Sargent's career, see Ormond, "Sargent's Art," 14–15, 26–28; also Ormond, "Biographical Sketch," in *John Singer Sargent,* ed. Elaine Kilmurray and Richard Ormond, exh. cat. (London: Tate Gallery; Princeton: Princeton University Press, 1998), 8. On Sargent's desire to be free of portraiture's "intrusions," see Sargent to Mrs. Curtis, 13 June 1907, BA; and Edward Robinson to Josiah Benton, 22 May 1914, BPLr, Ms Bos Li B18a.7.

43 Burns, *Inventing the Modern Artist,* 324.

44 Fox, "John S. Sargent," 58, BA.

45 Gutzon Borglum, "John Singer Sargent—Artist," *The Delineator,* Feb. 1923, 15, italics added.

46 Edwin Howland Blashfield, "Mural Painting in America," *Scribner's Magazine* 54 (Sept. 1913): 353, italics added.

47 Fenollosa, *Mural Painting,* 21.

48 Sylvester Baxter in *Handbook of the Boston Public Library and Its Mural Decorations* (Boston: Association Publications, 1920), 44–45.

49 "Artists on Sargent's Paintings."

50 Sargent to Mrs. Charles Fairchild, 6 Mar. 1892, BA.

51 Elaine Kilmurray provides an excellent "Chronology of Travels," in Warren Adelson et al., *Sargent Abroad: Figures and Landscapes* (New York: Abbeville Press, 1997), 237–42. Sargent's correspondence with Mrs. Curtis (BA) provides significant details regarding his excursions.

52 Sargent to Charles Fairchild, 1 Feb. [1891], BA.

53 Sylvester Baxter, "John Singer Sargent's Decorations for the Boston Public Library," *Harper's Weekly* 39 (1 June 1895): 509, see also 506–7.

54 E[van] C[harteris], typescript, [c. 1925], BA. See also Charteris, *Sargent,* 231.

55 Thomas A. Fox, "As Sargent Goes to Rest," *Boston Evening Transcript,* 24 Apr. 1925.

56 The list of books from the estate sale includes a volume on book collecting; *Catalogue of the Library of the Late John Singer Sargent, R. A.,* sale cat., Christie, Manson and Woods, London, 29 July 1925, 11.

57 See, e.g., Sargent to Vernon Lee, 23 Apr. 1870, CC; Sargent to Ralph Curtis, Jan. 1912, BA; and Sargent to Mrs. Curtis, 1907, BA. Lists of Sargent's books note many items with inscriptions from family and friends; see, e.g., *Catalogue of the Library.*

58 R. I. L. to "Tometal" [Thomas A. Fox], 12 July 1918, BA.

59 Birnbaum, *Sargent,* 36; and Elizabeth Oustinoff, "The Critical Response," in Adelson et al., *Sargent Abroad,* 232.

60 Sargent to Charles Martin Loeffler, 10 Feb. 1923, Loeffler Papers, Box 3, LC. That Strettell's book was received as illustrative of "primitive" religious expression is reflected in the criticism of the time. Royal Cortissoz, e.g., referred to one of Sargent's pictures for the book as "a quaint image of the Madonna such as Southern peasants worship"; Royal Cortissoz, "John S. Sargent," *Scribner's Magazine* 34, no. 5 (Nov. 1903): 520.

61 Lists provide substantial valuable information, but even as lists they are not complete. Sargent mentions in his correspondence owning books that do not appear on any of the lists, and some extant assemblies of Sargent's books, containing many items that can be confidently assigned to the artist on the basis of independent evidence, were never tabulated.

62 In addition, though some books are inscribed with dates, it is not always clear when Sargent acquired a specific item. Further complicating matters, he consulted libraries other than his own, and, as his correspondence indicates, he often exchanged books on a temporary basis with friends. He also kept scrapbooks of clipped excerpts—mostly visual but also textual—of things he found interesting. One such scrapbook survives in the collections of the Metropolitan Museum of Art.

63 R. H. Ives Gammell, "The Mural Decorations of John Singer Sargent," typescript, [c. 1962], 18–19, collection of Elizabeth Ives Hunter.

64 Sargent to McKim, 28 Sept. 1893, BPLr.

65 In the secondary literature, Trevor Fairbrother first noted the connection to Renan; see Fairbrother, *Sargent and America,* 274 n. 44; and Fairbrother, *Sargent,* 86.

66 Sargent to Curtis, 18 Nov. 1890, BA.

67 Dora Bierer, "Renan and His Interpreters: A Study in French Intellectual Warfare," *Journal of Modern History* 25, no. 4 (Dec. 1953): 381. See also Albert Schweitzer, *The Quest for the Historical Jesus* (1906; New York: Macmillan Company, 1957), 188; and G. Stanley Hall, *Jesus, the Christ, in the Light of Psychology* (New York: Doubleday, Page and Company), 1:132.

68 Owen Chadwick, *The Secularization of the European Mind in the Nineteenth Century* (Cambridge: Cambridge University Press, 1975), 219.

69 Bierer, "Renan and His Interpreters," 381, 381 n. 24. See also Jaroslav Pelikan, *Jesus through the Centuries: His Place in the History of Culture* (New York: Perennial Library, 1985), 199. New editions of *Life of Jesus* continued to be published with some frequency into the twentieth century.

70 Fairchild, Diary, 8 Aug. 1891, 6, DCL.

71 Henry James as quoted in Stephen Wilson, *Ideology and Experience: Antisemitism in France at the Time of the Dreyfus Affair* (East Brunswick, N.J.: Fairleigh Dickinson University Press, 1982), 470, from Henry James, *Parisian Sketches: Letters to the New York Tribune, 1875–76* (New York, 1961), p. 125, entry dated 27 May 1876. Leon Edel, *Henry James: A Life* (New York: Harper and Row, 1985), 487, see also 189.

72 Sargent to Henry James, [28 Feb. 1892], Henry James, Jr., Papers, HL, bMS AM 1094 (397). A note to Fairchild written a week later specified that the artist was hard at work on the designs for the library; Sargent to Charles Fairchild, 6 Mar. 1892, BA.

73 John Ormond to Sally Promey, 13 Nov. 1997.

74 *Catalogue of the Library,* 12; Sargent to Mrs. William Franklin Hughes, 1 Nov. 1922, BPLr, Ms Bos Li B18b.

75 Fairchild, Diary, 8 Aug. 1891, 6, DCL.

76 Ernest Renan, *Life of Jesus,* trans. Charles Edwin Wilbour (New York: Carleton Publisher, 1864), 104; Renan, *History of the People of Israel,* trans. Joseph Henry Allen and Elizabeth Wormeley Latimer (Boston: Roberts Brothers, 1895), 5:356.

77 Emile Zola, *Le Roman expérimental* (Paris, 1893), 70, as quoted in Bierer, "Renan and His Interpreters," 381 n. 21.

78 Bierer, "Renan and His Interpreters," 382. Though initially intending a priestly vocation, Renan had left the seminary and the Catholic Church in 1845, long before the publication of *Life of Jesus.* In the years immediately surrounding the book's appearance, however, he was suspended from lecturing (1862) at the Collège de France and denied his stipend there (1864) by the agitation of clerical groups.

79 Ibid., 382, 383 n. 30.

80 *Guardian* (1878), 778, as quoted in Chadwick, *Secularization of the European Mind,* 157.

81 Bierer, "Renan and His Interpreters," 384.

82 Renan, *Life of Jesus,* 51. For Renan, "God" came close to being synonymous with "Progress"; see Michael Paul Driskel, *Representing Belief: Religion, Art, and Society in Nineteenth-Century France* (University Park: Pennsylvania State University Press, 1992), 49–50, 169–70.

83 Renan, *History of the People of Israel,* 2:ix, 403; see also Renan, *History of the People of Israel,* 1:xi. Renan's original wording of the phrase quoted in my text described "l'entrée de la morale dans la religion"; see Ernest Renan, *Histoire du Peuple d'Israël* (Paris: Calmann Lévy, 1893), 2:i.

 From Renan's Christian perspective at least, the yoking together of these two subjects displayed an internal logic: the biblical account of the Sermon on the Mount (Matt. 5–7) includes Jesus' statement that he came not to "destroy but to fulfill" the Law and the prophets (Matt. 5:17, King James Version). Sargent's original title for *Frieze of Prophets* was *The Law and the Prophets*—thus underscoring the relationship of *Frieze* to the biblical Sermon. Two of the religious subjects discussed by Sargent and Fairchild in 1891 were the Hebrew prophets and the Sermon on the Mount; Fairchild, Diary, 8 Aug. 1891, 6, 8, DCL.

84 Renan, *History,* 5:356; in the original, "Jésus, le dernier des prophètes, met le sceau à l'œuvre d'Israël"; Renan, *Histoire,* 5:415. See also Renan, *History,* 1:viii.

85 Renan, *Life of Jesus,* 397; in French, "Quelles que puissent être les transformations du dogme, Jésus restera en religion le créateur du sentiment pur; le Sermon sur la montagne ne sera pas dépassé"; Renan, *Vie de Jésus* (Paris: Michel Lévy Frères, 1863), 447.

86 Renan, *Life of Jesus,* 187 (italics added). In Sargent's copy of this text, Renan's words read, "Mais plus heureux encore, nous dirait Jésus, celui qui, degagé de toute illusion, reproduirait en lui-même l'apparition céleste, et, sans rêve millénaire, sans paradis chimérique, sans signes dans le ciel, par la droiture de sa volonté et la poésie de son âme, saurait de nouveau créer en son cœur le vrai royaume de Dieu!"; Renan, *Vie,* 194. See also Renan, *History,* 5:359.

87 This passage from Renan's 1862 inaugural lecture at the Collège de France is quoted in Francis Espinasse, *Life of Ernest Renan* (London: Walter Scott, 1895), 95.

88 Renan, *Life of Jesus,* 111; "Un culte pur, une religion sans prêtres et sans pratiques extérieures, reposant toute sur les sentiments du cœur, sur l'imitation de Dieu, sur le rapport immédiat de la conscience avec le Père céleste"; Renan, *Vie,* 85–86.

89 Renan, *Life of Jesus,* 55, also 59, 62. The quotation in the original French reads, "Défenseurs de l'ancien esprit démocratique, ennemis des riches, opposés à toute organisation politique"; Renan, *Vie,* 7.

90 Renan, *Life of Jesus,* 103–4, see also 83, 107, 113–14. "Jésus n'a pas de visions; Dieu ne lui parle pas comme à quelqu'un hors de lui; Dieu est en lui; il se sent avec Dieu, et il tire de son cœur ce qu'il dit de son Père. Il vit au sein Dieu par une communication de tous les instants . . . Jésus n'énonce pas un moment l'idée sacrilége qu'il soit Dieu. Il se croit en rapport direct avec Dieu, il se croit fils de Dieu. La plus haute conscience de Dieu qui ait existé au sein de l'humanité a été celle de Jésus"; Renan, *Vie,* 75, also 74, 76.

91 See, for example, Sargent to McKim, 28 Sept. 1893, BPLr; Sargent to Josiah H. Benton, 8 Oct. 1915, BPLr, Ms Bos Li B18a.11; and Sargent to Thomas A. Fox, 12 May 1918, BA.

92 Sargent to McKim, 28 Sept. 1893, BPLr; and "Sargent, the Artist, Arrives," interview in the *Boston Globe,* 19 Jan. 1903, 4.

93 Robinson to Benton, 22 May 1914, BPLr. On Sargent's sequential design, see interview in "Sargent, the Artist, Arrives."

94 In 1903 a reporter reiterated Sargent's intention that Sermon, the "final and most important feature," would "occupy the long wall above the staircase . . . the largest part of the work"; "The Sargent Mural Paintings for the Public Library," *Boston Evening Transcript,* 19 Jan. 1903, 10.

95 Sargent to Benton, 8 Oct. 1915, BPLr. For balance and punctuation, Sargent designed elaborate bookcases for the west wall opposite *Synagogue* and *Church.* See also Fox and Gale to Josiah H. Benton, 30 Oct. 1915, MHSpc; Sargent to Fox and Gale, 29 Dec. 1915, MHSpc; and John W. Elliot (for the Trustees of the Sargent Fund) to Fox and Gale, 18 Apr. 1916, MHSpc.

96 Sargent to Benton, 8 Oct. 1915, BPLr.

97 A number of sketches now at the Museum of Fine Arts, Boston, show the artist working out representational possibilities for the figure of Synagogue. In these early sketches, a more feminine and youthful Synagogue exhibits small, "pretty" features and a more commanding pose and posture than in the final version.

98 On the library's labeling, see Frank H. Chase, *Boston Public Library: A Handbook to the Library Building, Its Mural Decorations, and Its Collections* (Boston: Association Publications, 1926), 40; on contemporary associations of the word *medieval,* see Sargent to Otto Fleischner, [9 Jan. 1917], typescript, BPLf; J. B. Bullen, *The Myth of the Renaissance in Nineteenth-Century Writing* (Oxford: Oxford University Press, 1994); Hilary Fraser, *The Victorians and Renaissance Italy* (Oxford: Blackwell Publishers, 1992); Chadwick, *Secularization of the European Mind,* 193; T. J. Jackson Lears, *No Place of Grace: Antimodernism and the Transformation of American Culture* (1981; rev. ed., Chicago: University of Chicago Press, 1994), 184–88.

99 Renan, *Life of Jesus,* 366; "Ses symboles ne sont pas des dogmes arrêtés, mais des images susceptibles d'interprétations indéfinies. On chercherait vainement une proposition théologique dans l'Evangile. Toutes les professions de foi sont des travestissements de l'idée de Jésus"; Renan, *Vie,* 446.

100 W[illiam] H[owe] D[ownes], "Two New Panels by Sargent," *Boston Evening Transcript,* 6 Oct. 1919, 16.

101 George Santayana to Mrs. Frederick Winslow, 16 Nov. 1922, in *The Letters of George Santayana,* ed. Daniel Cory (London: Constable and Company, 1955), 199.

102 See, e.g., Caird, *Evolution of Religion,* 2:302–6.

103 Renan's wife was the niece of painter Ary Scheffer, and the French author's son, Ary Renan, was an artist too. On Ernest Renan's relationship to art, see "Death of M. Renan," *London Times,* 3 Oct. 1892, 6; "Ernest Renan Is Dead," *New York Times,* 3 Oct. 1892, 1:1–2; and "Noble Dead of the Week: England and France Mourn Their Great Losses [Tennyson and Renan]," *New York Times,* 7 Oct. 1892, 1:1. See also Chadwick, *Secularization of the European Mind,* 248.

104 James C. Livingston, *Modern Christian Thought: From the Enlightenment to Vatican II* (New York: Macmillan Company, 1971), 27–28.

105 For a number of Enlightenment thinkers, Voltaire included, dogma was "ignorance which pretends to be truth"; Ernst Cassier, *The Philosophy of the Enlightenment* (Princeton: Princeton University Press, 1951), 161, see also 134, 188.

106 John Ormond to Sally Promey, 2 Feb. 1998; Chadwick, *Secularization of the European Mind,* 244–48.

107 Ernest J. Simmons, *Introduction to Tolstoy's Writings* (Chicago: University of Chicago Press, 1968), 94–97, 108, 110–11; and Warren S. Kissinger, *Sermon on the Mount: A History of Interpretation and Bibliography* (Metuchen, N.J.: Scarecrow Press, 1975), 52–56.

108 Lears, *No Place of Grace,* xii, xix, 17, 193–96, 222.

109 On William James and changing notions of objectivity and subjectivity, see Gerald L. Bruns, "Loose Talk about Religion from William James," *Critical Inquiry* 11, no. 2 (Dec. 1984), 304–10.

110 On James's position, see Klaus Bruhn Jensen, *The Social Semiotics of Mass Communication* (London: Sage Publications, 1995), 32–33.

111 Charteris, *Sargent,* 249–51.

112 In a brief essay written in response to Sargent's *Pagan Gods,* Lee commented on Renan's writing: "When all the exegetic learning of Renan may have grown obsolete, his [imaginative] visions of patriarchs and prophets will still remain as art"; Vernon Lee, "Imagination in Modern Art," *Fortnightly Review* 68 (1 Oct. 1897): 517. Renan's use of "imagination" and "poetry" occasionally earned him the disdain of other scholars; see, e.g., Schweitzer, *Quest for the Historical Jesus.*

113 Martha Kingsbury first brought consideration of Sargent's historicist and progressive stylistic agenda into the scholarly arena; see Kingsbury, "John Singer Sargent," 184; and eadem, "Sargent's Murals," 153.

114 Sargent to Putnam, [May 1895], BPLr. See also typescript copy of same, BPLr, Ms Bos Li B18f; and Sargent, "Argument[?] of Decoration," [1893], BPLr, Ms Am 563. For another perspective on late-nineteenth-century perceptions of a desired "evolution" from material to spiritual, see Kathleen Pyne, *Art and the Higher Life: Painting and Evolutionary Thought in Late-Nineteenth-Century America* (Austin: University of Texas Press, 1996).

115 Bullen, *Myth of the Renaissance,* 1, 17. At a time when the American discipline of art history was taking shape, Sargent could assume that stylistic periodization was becoming fixed in the public mind. See, for example, Craig Hugh Smyth and Peter M. Lukehart, eds., *The Early Years of Art History in the United States* (Princeton: Princeton University Press, 1993); and Fraser, *Victorians and Renaissance Italy.*

116 Sargent to Putnam, [May 1895], BPLr; and Sargent, "Argument[?] of Decoration," [1893], BPLr.

117 Driskel, *Representing Belief,* 4–7.

118 Ibid., 6–8.

119 Ibid., 165–66.

120 That contemporaries in New York and Boston saw this stylistic tendency as "unconventional" by comparison to the more formulaic style of, for example, Moses is attested to in the criticism of the time; see, for example, " 'The Prophets' by Sargent, Added Greatly to His Fame," *New York Times,* 7 Dec. 1913, 10:4.

121 Driskel, *Representing Belief,* 169–70. Despite the fact that Renan was not generally attracted to the naturalist aesthetic, certainly not before 1870, others promoted his emphasis on history as movement, as a process of becoming, as justification for naturalism in art; Driskel, *Representing Belief,* 170; and Ernest Renan, "Religious Art," in *Studies in Religious History* (New York: Scribner and Welford 1887), 367–79, esp. 376–77.

122 Driskel, *Representing Belief,* 252.

123 Renan, *History,* 1:xx; "Moïse, à la distance où il est, fait l'effet d'un cippe informe, comme les statues de sel de la femme de Loth"; Renan, *Histoire,* 1:xviii. See also Renan, *Life of Jesus,* 55.

124 See Sargent to Putnam, [May 1895], BPLr.

125 Ibid. Sargent must have completed this study between 1892 and 1894, sometime before he decided to execute this prophet in relief; Sargent to Samuel Abbott, 18 Jan. [1895], BPLr, Ms Am 564, outlines this decision.

126 Sargent to Charles F. McKim, [1892], BPLr, Ms 1320.3. The library, for its part, underscored the stylistic distinction of Moses and encouraged contemporary audiences to assign significance to Sargent's manner of treatment; Small, *Handbook of the New Public Library,* 60. See also Fenollosa, *Mural Painting,* 26; and Sylvester Baxter, "The Development of Religion from Early Beliefs: Wall and Ceiling Decorations in the Upper Staircase Hall, by John Singer Sargent, R.A., an Interpretation," [1903], BPLr, Ms Bos Li B18a.1, 28. Sargent initially planned to group Debora and Joshua with Moses but subsequently substituted Elijah for Debora; see Sargent to Charles F. McKim, 9 Dec. 1891, BA.

127 Small, *Handbook of the New Public Library,* 60. R. H. Ives Gammell later tried to account for the naturalism of the *Frieze* by claiming that Sargent painted the prophets first, before any other sections of the north wall, and before he had realized the merits of a more tightly contained style; Gammell, "John Singer Sargent: Boston Public Library Decorations," in *John Singer Sargent Studies for the Boston Public Library Decorations,* ed. Elizabeth Ives Hunter, exh. brochure (Boston: St. Botolph Club, 1988), 3–4. In fact, the prophets were the last segment of the north wall to reach completion (Sargent to Ralph Curtis, [1894], BA), and, though Sargent seemed later to regret certain aspects of their execution and public reception, their naturalism was a deliberate part of the artist's stylistic program.

128 *Art Journal* (1894): 210–11, as quoted in Ormond, *Sargent,* 90.

129 "John Singer Sargent's Second Wall Painting in the Library," unidentified newspaper clipping, [1903], BPLf. See also Sylvester Baxter, "Sargent's 'Redemption' in the Boston Public Library," *Century Magazine* 66, no. 1 (May 1903), 131; Russell Sturgis, "Sargent's New Wall Painting as Seen by the Decorative Architect [Sturgis] and the Portrait Painter [Frank Fowler]," *Scribner's Magazine* 34 (July–Dec. 1903): 766; Frank Fowler, "Sargent's New Wall Painting as Seen by the Decorative Architect [Sturgis] and the Portrait Painter [Frank Fowler]," *Scribner's Magazine* 34 (July–Dec. 1903): 767; and "Sargent's New

Decorations in the Boston Library," *New York Times Magazine,* 24 Dec. 1916, 14.

130 Christian Brinton, "Sargent and His Art," *Munsey's Magazine* 36, no. 3 (Dec. 1906): 274.

131 Sturgis, "Sargent's New Wall Painting," 766.

132 Henry Van Dyke, *The Gospel for an Age of Doubt* (New York: Macmillan Company, 1919), 130–32.

133 Hall, *Jesus, the Christ,* 1:13.

134 See, e.g., Malcolm Warner, *The Victorians: British Painting, 1837–1901,* exh. cat. (Washington, D.C.: National Gallery of Art, 1997), 32; and John Christian, ed., *The Last Romantics: The Romantic Tradition in British Art, Burne-Jones to Stanley Spencer* (London: Lund Humphries, 1989). In her dissertation in progress at the University of Pennsylvania, "Performing Identities in the Art of John Singer Sargent," Leigh Culver examines Sargent's significant connections to the Pre-Raphaelite Brotherhood and to later-nineteenth-century British aesthetes.

135 For contemporary recognition of Sargent's need, in the lunettes, to keep his "free realism" within bounds, see "Sargent's New Decorations in the Boston Library," *New York Times Magazine,* 14.

136 Trevor Fairbrother, "A Private Album: John Singer Sargent's Drawings of Nude Male Models," *Arts Magazine* 56, no. 4 (Dec. 1981), 77–78, notes these connections to "popular Bible illustration." Sargent was, by this time, well acquainted himself with contemporary Bible illustration. Not only had he produced a set of pictures for the abandoned Amsterdam Bible project (illustrations that adopt the same conventions of containment as those in his south ceiling), he had also helped broker the Brooklyn Museum's purchase of James Tissot's *Life of Christ,* the influence of which can be seen, especially, in the Virgin of Sargent's *Annunciation,* one of the *Joyful Mysteries,* on the east side of the south ceiling vault.

137 Forbes Watson, "Sargent—Boston—and Art," *Arts and Decoration* 7 (Feb. 1917): 196; Sargent to Otto Fleischner, [1917], BPLf. On relations to commercial illustration, see also Gammell, "Mural Decorations," 55.

138 Sargent to McKim, [1892], BPLr. Sargent also once referred to his "vulgar and realistic" signature style in a letter to an acquaintance he described as a "devotee of a more spiritual school"; Sargent to Miss Violet Maxse, Wed. [1897], SUL.

139 William A. Coffin, "Sargent and His Painting," *Century Magazine* 52, no. 2 (June 1896): 163–78.

140 Baxter, "Sargent's 'Redemption,' " 129.

141 Samuel Isham, *History of American Painting* (1905; rev. ed., New York: Macmillan Company, 1936), 549, see also 548; and "J. S. Sargent in New York," *Boston Evening Transcript,* 19 Jan. 1903, 10. Both Sylvester Baxter, "Master Murals," *The Independent* 89, no. 3554 (15 Jan. 1917), 108; and Baxter in *Handbook* (1920), 40–41, 63, emphasize the anticipated "freedom of treatment" in Sermon. Baxter also indicated that Sargent had explicitly "authorized" this expectation.

142 Fowler, "Sargent's New Wall Painting," 768; see also Charles Moore, *Life and Time of Charles Follen McKim* (Boston: Houghton Mifflin, 1929), 77–78.

143 Cox, "Mural Painting in France and America" (1917), reprinted in Kenyon Cox, *What Is Painting? "Winslow Homer" and Other Essays* (New York: Norton 1988), 361–62; and "Head of Christ, by John Singer Sargent," *Museum of Fine Arts Bulletin* 23, no. 140 (Dec. 1925): 70.

144 Coffin, "Sargent and His Painting," 169–71. See also Sturgis, "Sargent's New Wall Painting," 766–67; Pauline King, *American Mural Painting* (Boston: Noyes, Platt and Company, 1901), 139; and Fowler, "Sargent's New Wall Painting," 768.

145 Royal Cortissoz, "In the Field of Art," *Scribner's Magazine* 75, no. 3 (Mar. 1924): 352.

146 Baxter, "Sargent's 'Redemption,' " 129.

147 "John Singer Sargent's Second Wall Painting in the Library," [1903], BPLf.

CHAPTER 2: RITUAL PERFORMANCES

1 See, for example, Sullivan, "New Building of the Boston Public Library," 84–85.

2 See, e.g., *El Jaleo* (1882), *Ellen Terry* (1889), and *Charles Stewart, Sixth Marquess of Londonderry, Carrying the Great Sword of State at the Coronation of King Edward VII, Aug. 1902* (1904). The "pageant" reference is Thomas Fox's, typescript, 9, BA. Leigh Culver, "Performing Identities," considers the theme of performance in relation to both Sargent's artistic practice and the social identities of his sitters. Culver's chapter on Ellen Terry locates Sargent within an immediate social milieu "obsessed with performance." Dini's "Public Bodies" demonstrates Sargent's studied attention, in his murals at the Museum of Fine Arts, to the choreography of classical ballet and modern dance. For other recent scholarship on Sargent and performance, see Ormond, "Sargent's Art," 25–28; and Albert Boime, "Sargent in Paris and London: A Portrait of the Artist as Dorian Gray," in *John Singer Sargent,* ed. Patricia Hills, exh. cat. (New York: Harry N. Abrams, 1986), 75–109.

3 Vernon Lee's letters of the 1880s and early 1890s identify a cast of theatrical personalities (Oscar Wilde, Sarah Bernhardt, Ellen Terry, Henry Irving, the Comyns Carrs, Edouard Pailleron, etc.) in Sargent's social circle; see Willis, *Vernon Lee's Letters.* Walford Graham Robertson (himself a designer of staged interiors) discusses a range of Sargent's activities in this context; Robertson, *Time Was* (London: Hamish Hamilton, 1931). Six years after Sargent's death, artist and muralist Thomas Hart Benton referred disparagingly to *Triumph's* theatricality; to Benton, Sargent Hall seemed a "bag full of Paris Opera and Empire Theatre prophets in red and gold relief"; Benton as quoted in "More Murals," *New York Times,* 25 Jan. 1931, 12:6.

4 Gammell, "Mural Decorations," 19.

5 For a description of Sargent's participation in the design of these textile hangings, see ibid., 47–49; note the presence of the curtains in the 1916 photograph (fig. 2) of the interior of the hall. Over the space reserved for *Synagogue,* the artist hung a cloth that literally reiterated the Temple veil of the finished painting, though the fabric curtain added the seven-branched candlestick to the winged cherubim of the painting. At the south end of the east wall, over the space held for *Church,* a central motif of the tapestry was the eagle, associated with the Resurrection, the Ascension, and, perhaps most significant in this context, the Gospels (through the eagle's connection with John the Evangelist). The stag (the "hart" of Psalm 41), linked by the early church fathers to both Christ and Christians, accompanied the eagle in Sargent's design.

6 A. J. Philpott, "Doubt Vandals Spotted Murals," *Boston Globe,* 22 Feb. 1924, 1–2.

7 *Handbook* (1920), 42.

8 William H. Jordy, *American Buildings and Their Architects: Progressive and Academic Ideals at the Turn of the Century* (Garden City, N.Y.: Dou-

bleday and Company, 1972), 364, recognizes Sargent Hall as a space for prefatory activity.

9 *Handbook* (1895), 51; *Handbook* (1926), 38.

10 *Handbook* (1895), 49.

11 Leonard Folgarait, "Revolution as Ritual: Diego Rivera's National Palace Mural," *Oxford Art Journal* 14, no. 1 (1991): 18.

12 In "Sargent's New Decorations in the Boston Library," for example, a New York critic referred to the "attentive pilgrims" who came to see the 1895 and 1903 installations (*New York Times Magazine,* 14). See also Fenollosa, *Mural Painting,* 6.

13 Sargent to McKim, 9 Dec. 1891, BA; Sargent to Benton, 8 Oct. 1915, BPLr; Fox and Gale to Sargent, 17 Dec. 1915, MHSpc; Sargent to Fox and Gale, 29 Dec. 1915, MHSpc; and Sargent to Fox and Gale, 26 Feb. 1916, MHSpc.

14 Sargent to McKim, 9 Dec. 1891, BA.

15 "Sargent's New Decorations in the Boston Library," 14.

16 Catherine Bell, *Ritual Theory, Ritual Practice* (Oxford: Oxford University Press, 1992), 74. See also Simon Coleman and John Elsner, "Performing Pilgrimage: Walsingham and the Ritual Construction of Irony," in Felicia Hughes-Freeland, ed., *Ritual, Performance, Media* (London and New York: Routledge, 1998), 48; and White, "Religion and Media," 52–53. My thanks to Jennifer Krzyminski for many fruitful conversations on this subject.

17 See Carol Duncan, *Civilizing Rituals: Inside Public Art Museums* (London and New York: Routledge, 1995).

18 After Sargent's death, the model was exhibited at the Royal Academy and elsewhere before some of its constituent parts were shipped, some years later, to Harvard University Art Museums. See Fox, untitled typescript, 17–18, BA.

19 The Copley Plaza opened for business in Aug. 1912.

20 The McKim, Mead and White building also had a north door (now no longer navigable), but that door did not constitute a principal point of entry. The McKim building had multiple architectural sources (library, temple, palazzo; see Jordy, *American Buildings,* 33–44). The Johnson addition visually appropriated the Renaissance palazzo's function as an urban fortress rather than the status as a palace (here a "palace of the people") that interested McKim.

21 *King's Handbook of Boston* (Cambridge: Moses King, 1881), 115.

22 Wrote the *Boston Evening Transcript:* "The Boston Public Library occupies one of the finest sites in New Boston as the Back Bay district may fitly be called. Trinity Church, Old South Church and the Boston Art Club are immediately contiguous; on the other side is the Boston Museum of Fine Arts"; "Public Library at Boston." Peter W. Williams has reached conclusions similar to my own regarding the orchestration and significance of space in the Boston Public Library and at Copley Square; Williams, "In Pursuit of the American Sacred," 7, paper delivered at Religion and Public Space conference, Center for the Study of American Religion, Princeton University, May 1996.

23 Mariana Griswold Van Rensselaer, "The New Public Library in Boston: Its Artistic Aspects," *Century Magazine* 51, no. 1 (Nov. 1895): 261–62; Sullivan, "New Building of the Boston Public Library," 83.

24 Sullivan, "New Building of the Boston Public Library," 84.

25 Ibid., 85.

26 Puvis titled his painting *Les Muses Inspiratrices Acclament le Génie, Messager de Lumière.* To enter Bates Hall from the landing, the library patron traversed a space bounded by two sets of double doors separated by the width of an interior stairwell corridor/landing, with stairs, for staff use only, descending on either side into the lower levels of the library.

27 Sullivan, "New Building of the Boston Public Library," 90.

28 *Handbook* (1895), 46–48, describes the decoration of the Venetian lobby by Boston painter Joseph Lindon Smith.

29 Three doors and an elevator as well as the staircase provided access, and people saw the room in different ways at different times—but the staircase was the one principal and usual point of entry.

30 Fox, untitled typescript, 2, BA.

31 "Unveil New Sargent Panels Today," *Boston Globe,* 21 Dec. 1916.

32 After the 1916 installation: "Mr. Sargent to show his interest in the library . . . approved a complete set of photographs which have been copyrighted for the benefit of the Boston Public Library Employee's Association, and also a descriptive pamphlet by Sylvester Baxter, which has also been copyrighted for the benefit of the association"; "Unveil New Sargent Panels Today." See also Sylvester Baxter, "Master Murals," 106–8; and "Christianity in Mural Decorations," *American Review of Reviews* 55, no. 3 (Mar. 1917): 303–4.

33 Quoted in Cartwright, "Reading Rooms," 173 n. 108. The article in question appeared as Baxter, "John Singer Sargent's Decorations," 506–7, 509. Sargent was content to have Baxter (in the case of the library) and Thomas Fox (in the case of the museum) assume from him the role of telling people what his murals meant.

34 Gammell, "Mural Decorations," 27–30.

35 See Sargent's comments on polychrome sculpture in Sargent to [William Sergeant] Kendall, 18 Nov. [?], SUL.

36 "Art and Artists," *Boston Globe,* 25 Jan. 1903, 31; Gammell, "Mural Decorations," 33–34.

37 The library's 1926 *Handbook* (58) labels the institution's special collections its "rarest treasures." On the tendency of most visitors to begin their reading of Sargent Hall at the north end, see Philpott, "Doubt Vandals Spotted Murals."

38 Sargent to McKim, 9 Dec. 1891, BA; and Sargent to Charles F. McKim, 25 Dec. 1891, BA.

39 "As for the central place for Moses and his attendant Joshua and Debora, it is highly important that it should be in slight relief, as it not only gives him prominence, but will act as a sort of pedestal for the important central group above"; Sargent to McKim, 9 Dec. 1891, BA.

40 From Sargent's 1895 description of north end, Sargent to Putnam, [May 1895], BPLr; see also Sargent, "Argument[?] of Decoration," 1893, BPLr.

41 Agnes Carr, "Artist Sargent Had Poor Opinion of His Own Mural of Prophets in Boston Public Library," *Boston Traveler,* 19 Sept. 1933, 23.

42 In an early oil study (fig. 30), Sargent separated the individual figures of the prophets.

43 Because some representations of Neith in two dimensions (including Sargent's own sketch and the image in the Book of the Dead papyrus at the British Museum) arrange the goddess's body with toes on the left and fingers on the right, it is possible that Sargent simply copied this arrangement and was not aware of the myth that specified the orientation of her body with toes at the east and fingers at the west (Neith swallows the sun on the west at night and gives birth to it on the east in the morning). The Louvre Book of the Dead image, which the artist

may also have seen, shows Neith's fingers at left and her toes at right. See George Hart, *Egyptian Myths* (London: Trustees of the British Museum, 1990), 14; and T. G. H. James, *Egyptian Painting and Drawing in the British Museum* (London: Trustees of the British Museum, 1985), 48.

44 Gammell, "Mural Decorations," 10.

45 The west panel of *Frieze of Prophets* does not organize a similar pull westward. See Coffin, "Sargent and His Painting," 171, for contemporary recognition and analysis of Sargent's careful use of color. For Sargent's consideration of gesture and pose in Joel and in the Prophets of Hope, see Harvard University Art Museums, 1937.7.32, fols. 1r and 1v, 2r and 2v, and 3r (Joel); and 10v, 11r and 11v, and 12r (Prophets of Hope).

46 "Sargent's New Decorations in the Boston Library," *New York Times Magazine,* 14.

47 Sargent to Benton, 8 Oct. 1915, BPLr; also Sargent to Fox and Gale, 29 Dec. 1915, MHSpc; Fox and Gale to Sargent, 17 Dec. 1915, MHSpc; and Sargent to Fox and Gale, 26 Feb. 1916, MHSpc.

48 For an interpretation of the story of Gog and Magog, see Renan, *History,* 2:328–29; on the internal chronology of the east wall lunettes, see *Handbook* (1920), 77–90.

49 In his nearly contemporary role (c. 1899) as consultant in aspects of the decoration (the suspended gilded and painted wood crucifix, in particular) of the Roman Catholic Westminster Cathedral, Sargent considered a similar configuration in a ritual religious space; Winefride de L'Hôpital, *Westminster Cathedral and Its Architect* (New York: Dodd, Mead and Company, 1919), 1:129–31, 228–29, pl. 19; see also this work's second volume (433–39) for Sargent's tangential involvement in other comparable projects.

50 "John Singer Sargent's Second Wall Painting in the Library," [1903], BPLf.

51 Contemporaries frequently noted the location of one Prophet of Hope on the west among the Prophets of Mourning and one Prophet of Mourning on the east among the Prophets of Hope.

52 Mary Crawford Volk cites an entry in William White's diary regarding a conversation with Sargent (in the presence of Santayana) about the primitive "idolatry" represented by Madonnas like those Sargent depicts; see Volk, "Sargent in Public," 53; see also Watson, "Sargent—Boston—and Art," 196.

53 See, e.g., George Santayana to Martin Birnbaum, 12 Oct. 1945, with its reference to the sense Santayana and Sargent shared of the "impure wealth of Spanish art, passion in black velvet and seven gold daggers," and Santayana to Mrs. Frederick Winslow, 19 Mar. 1923, in *Letters of George Santayana,* 201–2, 355–56.

54 I am grateful to Elizabeth Ives Hunter for sharing this visual material with me. See also Gammell, "Mural Decorations," 45.

55 Thomas Van Ness, "Sargent and the Unfinished Panel," *Boston Sunday Herald,* 22 Nov. 1925, C9.

56 Watson, "Sargent—Boston—and Art," 196–97.

57 *Handbook* (1920), 88–89.

58 Baxter, "Master Murals," 108.

59 "Sargent's New Decorations in the Boston Library," *New York Times Magazine,* 14. See also Gammell's astute comparison of the later images (the west wall lunettes especially, but also *Church*) to the "empty prettiness" of commercial art ("Mural Decorations," 42–44, 61). *Passing of Souls into Heaven* he likens to an "Easter card."

60 The artist indicated his intention to most fully articulate the decoration of the east wall in a letter of 1915; Sargent to Benton, 8 Oct. 1915, BPLr.

61 Sargent to Fox and Gale, 29 Dec. [1915], MHSpc.

62 *Handbook* (1920), 78: "Of all the subjects, this is the most plastic in treatment. Indeed, it frankly simulates a sculptured group, and this is wrought into a noble unity."

63 Edward W. Forbes to Thomas A. Fox, 13 Dec. 1933, MHSpc: Sargent's bronzes were generally executed after the fact "as a demonstration . . . that it could be put in the round."

64 "Of the six new lunettes, three are devoted to Hebrew subjects and three to Christian. Perhaps the most complete composition of the six is the central lunette of the Hebraic series, the one symbolizing [Israel and] the Law. This is a symmetrical design, very simple in color arrangement, and treated almost as if it were a group of sculpture"; Watson, "Sargent—Boston—and Art," 196. Sylvester Baxter was more enthusiastic: "It seems safe to say that 'The Law' will be recognized as the masterpiece of the whole decorative sequence [of lunettes]"; Baxter, "Master Murals," 108.

65 Though the newspaper account as a whole deals most particularly with the Museum of Fine Arts murals, this reference is specific to both the "later library paintings" and the "first ones at the museum"; "The Art Museum's Sargent Murals," *Boston Evening Transcript,* 4 Nov. 1925, 7.

66 *Israel and the Law* is the only lunette (in the final version) with a gilded inscription around its perimeter; an earlier version of *Judgment* had one too, but it was covered over in the final installation of that lunette.

67 In 1896 Fenollosa acknowledged that the north ceiling's heaviness "may have been designed to throw back into retirement this end wall as a whole, when the more brilliant side shall have been completed"; Fenollosa, *Mural Painting,* 27.

68 Sargent to Benton, 8 Oct. 1915, BPLr.

69 In 1896 William Coffin noted the darkness of the north end; he understood this low illumination as an intentional feature of the decoration; Coffin, "Sargent and His Painting," 167. Ives Gammell discusses at some length the "modernity" of Sargent's deliberate use of electric lighting, in combination with the natural light, to achieve the effect he desired in the library gallery: "Sargent was quick to perceive the potentialities of a system whereby lights of any desired strength could be safely and cheaply placed in any desired relationship to the painted areas. . . . the situation made possible the then quite novel idea of heightening dramatic effect by utilizing the glint of raised and gilded surfaces applied to the paintings . . . he had hit upon a devise capable of intensifying the emotional mood he wished to convey" (Gammell, "Mural Decorations," 27–30).

70 A number of letters, written between 1914 and 1917, attest to Sargent's careful calculation of the lighting in the special collections gallery. In particular, they indicate his desire for more illumination in the center of the room and his interest in reflected as well as direct light. See, e.g., Josiah H. Benton to Sargent, 10 Nov. 1914, BPLr, Ms Bos Li B18a.7; Sargent to Benton, 19 Mar. 1915, BPLr, Ms Bos Li B18a.7; Benton to Sargent, 19 Apr. 1915, BPLr, Ms Bos Li B18a.7; Sargent to Benton, 21 Nov. 1916, BPLr, Ms Bos Li B18a.7; and Sargent Gallery Memorandum, [1917], BPLr, Ms Bos Li B18b.1.

71 Sullivan, "New Building of the Boston Public Library," 93.

72 Estelle M. Hurll, "Sargent's Redemption: The New Mural Decoration in the Boston Public Library," *Congregationalist and Christian World,* 7 Mar. 1903, 351.

73 Coleman and Elsner, "Performing Pilgrimage," 49.

74 Sylvester Baxter, "The Judaic Development," 1895, reprinted from *Harper's Magazine* in "Description of the Mural Decorations in the Public Library of the City of Boston" (Boston: Trustees of the Public Library, 1907), 24, BPLr, Ms Bos Li B18a.

75 Coleman and Elsner, "Performing Pilgrimage," 58.

76 Ibid., 49; Duncan, *Civilizing Rituals,* 7–20, esp. 13.

77 Coleman and Elsner, "Performing Pilgrimage," 48, 54.

CHAPTER 3: CULTURAL SELECTIONS

1 As Gammell noted of the "magnitude of the artist's intellectual *tour de force*": "It is fascinating whatever it means. But we feel instinctively that the value of all this is increased by the profundity of the meaning behind it, even though we may not care to investigate that meaning"; Gammell, "Mural Decorations," 25–26.

2 In an interview with Gutzon Borglum, Sargent spelled out an aspect of his preference for mural painting: "You can study on and on, and crowd your life into it"; Borglum, "John Singer Sargent—Artist," 15. The contrast between "study" and "attack" is Sargent's, as recorded in the Borglum article. On Sargent and collecting, see, for example, Sargent to Mrs. Curtis, 21 Aug. [1913], BA.

3 Susan Stewart, *On Longing: Narratives of the Miniature, the Gigantic, the Souvenir, the Collection* (Baltimore: Johns Hopkins University Press, 1984), 162. On Sargent and collecting, see, e.g., Emily Sargent to Thomas A. Fox, 15 May 1925, MHSpc; Sargent to Isabella Stewart Gardner, 29 Aug. 1895, ISGM; and Sargent to Isabella Stewart Gardner, 17 Mar. 1920, ISGM. Sargent's insurance coverage, as well as the correspondence between Thomas Fox and Emily Sargent after the artist's death, indicates that he accumulated a surprising amount of "stuff" in Boston as well as London. The insurance policy on the materials he kept in the Pope Studio Building ("John Singer Sargent, Memorandum of Insurance," [14 May 1918], MHSpc) includes a paragraph insuring: "Furniture and furnishings of every description, useful and ornamental, family wearing apparel, jewelry and watches, musical instruments, gas and electric attachments, traveling, military and society equipments and appurtenances, china, crockery and glassware, plate and plated ware, mirrors, carpets, curtains, draperies, tapestries, printed books, printed music, pictures, paintings and engravings, including frames, sculpture, bronzes, statuary, bric-a-brac, curiosities, collections, ornaments and works of art, typewriting, scientific, professional and all other articles for use and recreation, all contained in and on brick, stone, and iron building, situate Nos. 219/223 Columbus Avenue, Boston, Mass."

4 Stewart, *On Longing,* 161.

5 Ibid., 159.

6 That "pastiche" is a term Sargent himself might have sanctioned is clear in his use of it in his own correspondence where he contrasts its polygenic character with the faithful copy of a single source or a "genuine translation" of an original; see Sargent to Daniel Sargent Curtis, 20 Oct. [19??], BA; and Sargent to Vernon Lee, [1884], CC.

7 Gammell, "Mural Decorations," 12; Sargent to editor of *Jewish Advocate,* 23 Oct. 1919, 1. Sargent's letter, written on 21 Oct., appeared in the *Jewish Advocate* two days later.

8 On the British Museum objects, see Karl Baedeker, *London and Its Environs* (Leipzig: Karl Baedeker Publishers, 1923), 326–58, esp. 341–44.

9 On Sargent's Egyptian travel, see Charteris, *Sargent,* 114; and Karl Baedeker, *Egypt and the Sudan* (Leipzig: Karl Baedeker Publishers, 1929), 234–355.

10 Sargent, "Argument[?] of Decoration," 1893, BPLr. The Seti I version (fig. 70), for example, he might have consulted in his copy of Georges Perrot's and Charles Chipiez's first volume on ancient art in Egypt. Sargent's ownership of these volumes is documented in the estate sale catalogue, *Catalogue of the Library,* 11.

11 *Helps to the Study of the Bible* (London: Oxford University Press, [1880]), pl. 46. Sargent's copy of this text is in the collection of the Boston Public Library. Photographs of both British Museum bas-reliefs, the lion and the eagle-headed deity, appear in Richard David Barnett, *Assyrian Palace Reliefs* (London: Batchworth Press, n.d.), pls. 93 and 8, respectively.

12 Baedeker, *London and Its Environs,* 344; and Edward Verrall Lucas, *A Wanderer in London* (London: Methuen and Company, 1907), 224. See also Karl Baedeker, *Paris and Environs* (Leipzig: Karl Baedeker Publishers, 1913), 164.

13 On Milton, see Sargent to Lee, 23 Apr. 1870, CC (Sargent's copy of *Paradise Lost* was a gift from Emily). On literary and artistic sources for the pagan gods, in particular, see Kingsbury, "Sargent's Murals," 153–72; and Burke, "Astarte," 8–19.

14 *Handbook* (1920), 49; and Mary Crawford Volk's recent substantive treatment of these (and other) images in the catalogue entries on the Boston Public Library murals in *John Singer Sargent,* ed. Elaine Kilmurray and Richard Ormond, exh. cat. (London: Tate Gallery; Princeton: Princeton University Press, 1998), 177–207. While Sargent collected from the other side of the Atlantic all of the objects he represented, his audiences in Boston could see many similar works of art, verifying the artist's scholarship, just across the street from the library at the Museum of Fine Arts. For example, a statue of the lion-headed goddess Pasht, who stands to the left in the north wall lunette, just in front of the sphinx, could be seen on display in the Egyptian Collection, immediately off the main entrance hall on the first level of the Boston museum; *King's Handbook of Boston,* 114; see map of museum on inside front cover of *Handbook of the Museum of Fine Arts Boston* (Boston: Museum of Fine Arts, 1907). The cast collection of the museum included, furthermore, examples of relief sculpture from the temple at Karnak; "The Museum of Fine Arts, Boston," *American Architect and Building News* 8, no. 253 (30 Oct. 1880): 208.

15 Sargent, "Argument[?] of Decoration," 1893, BPLr.

16 See Volk, "Study for an Angel in the *Frieze of Angels,*" catalogue entry in *John Singer Sargent,* 195.

17 The addition of an angel was the source of some negative criticism. Estelle Hurll wrote: "There are eight in all, and in this number Mr. Sargent has made a somewhat surprising departure from the traditional standard. The seven angels of the Apocalypse (Rev. 8:2 and 5:1), the seven 'archangels' of ecclesiastical tradition have so long figured in sacred art that the lover of ancient things resents the intrusion of an eighth! But here is a case where the artist evidently valued the symmetry of his design above traditional symbolism"; Hurll, "Sargent's Redemption," 351.

18 See, e.g., Adolphe Napoleon Didron, *Christian Iconography* (1851; New York: Frederick Ungar Publishing Company, 1965), 1:130, figs. 111, 126; 2: figs. 137, 144. With the library murals as well as his consul-

tation at Westminster Cathedral, Sargent was drawn to certain aspects of Gothic Revival. He did not, however, like Boston Gothic Revivalist Ralph Adams Cram, and he said as much: see Sargent to Isabella Stewart Gardner, 31 [Oct.] 1919, ISGM; and Sargent to Otto Fleischner, Nov. 1919, BPLf. On his attraction to the polychrome sculpture of the Middle Ages, see Sargent to Kendall, 18 Nov. [?], SUL.

19 Karl Baedeker, *Italy: Handbook for Travellers: Central Italy and Rome* (Leipzig: Karl Baedeker Publisher, 1900), 318. For Sargent's description of consulting Baedeker while sightseeing at Orvieto, see Sargent to Vernon Lee, [1884?], CC.

20 Tancred Borenius, "The Rediscovery of the Primitives," *Quarterly Review* (London) 239 (Apr. 1923): 258–70. Sargent first mentioned Pinturicchio with respect to the library in 1891. In her dissertation in progress ("John Singer Sargent and Italy: A 'Modern Old Master' and the American Renaissance") at the Institute of Fine Arts at New York University, Stephanie Herdrich is expanding what we know of Sargent's connections with Italian art and ideas.

21 Fogg Art Museum, Harvard University Art Museums, 1937.7.1.

22 Charteris, *Sargent,* 242–43.

23 Vernon Lee, *The Sentimental Traveler: Notes on Places* (London: John Lane, 1907), 7, 10–11. Richard Ormond, "John Singer Sargent and Vernon Lee," *Colby Library Quarterly* 10, no. 3 (Sept. 1970), 156–57, first drew attention to Lee's words on this subject.

24 Lee, *Sentimental Traveler,* 13–14.

25 Richard H. Broadhead, introduction to Nathaniel Hawthorne, *The Marble Faun* (1860; New York: Penguin Books, 1990), xii.

26 On the Sargent family's customary use of Murray's handbooks for travelers, see Fitzwilliam's letter of Oct. 1870 to George Bemis, quoted and described in Stephen D. Rubin, *John Singer Sargent's Alpine Sketch Books: A Young Artist's Perspective,* exh. cat. (New York: Metropolitan Museum of Art, 1991), 15.

27 Charteris, *Sargent,* 241. On the critical role of guidebooks in the nineteenth century and on Murray's guides in particular, see Fraser, *Victorians and Renaissance Italy,* 50. Murray's was the principal guidebook used by English travelers between 1840 and the mid-1870s when translations of Baedeker's superseded them. On Murray's, see also Francis Marion Crawford, *Ave Roma Immortalis* (New York and London: Macmillan Company, 1906), 514.

28 John Murray, *Handbook of Rome and Its Environs* (London: John Murray, 1873), 232, 234.

29 Baedeker, *Italy,* 323–24.

30 Edwin Blashfield, "John Singer Sargent—Recollections," *North American Review* 220, no. 827 (June–Aug. 1925): 642. The 1877 Carolus-Duran mural was called *Triumph of the Marie de' Medici.*

31 Bernard Berenson, *Italian Painters of the Renaissance,* quoted in Vincenzo Golzio, "Raphael and His Critics," in *Complete Work of Raphael* (New York: Reynal and Company, 1969), 637. During the years of Sargent's work at the Boston library, Kenyon Cox described the paintings in the Stanza della Segnatura as "Raphael's greatest triumphs—the most perfect pieces of monumental decoration in the world"; Cox, "Raphael," in *Artist and Public and Other Essays on Art Subjects* (London: George Allen and Unwin, 1914), 117. So famous and beloved was Raphael and so admired the Stanza della Segnatura, that references to the room and its paintings animate other murals in the Boston Public Library. Puvis's *Muses of Inspiration* drew on Raphael's *Parnassus;* Brian Petrie, *Puvis de Chavannes* (Hants, England: Ashgate, 1997), 145. Some-

what later, Sargent more than glanced in the direction of the *Parnassus* when he was at work on his own *Apollo and the Muses* at the Museum of Fine Arts.

32 On Sargent's attraction to both Raphael and Ingres, see Charteris, *Sargent,* 195, 247–48; also Olson, *Sargent,* 245, 251. On Ingres's great admiration for Raphael, see Golzio, "Raphael and His Critics," 628–29. Golzio is a good source for the historiography of the reception of Raphael.

33 Fairchild, "Diary of Visit to Louvre with John S. Sargent," 2–3, DCL. Paul Delaroche's Hemicycle (1837–41), a huge semicircular mural in the Ecole des Beaux-Arts, celebrated the "artists of every age" and owed a debt to both Ingres and Raphael; see Francis Haskell, *Rediscoveries in Art* (Ithaca, N.Y.: Cornell University Press, 1976), 9. See also Robert Rosenblum, *Jean-Auguste-Dominique Ingres* (New York: Harry N. Abrams, 1990), 100–101; Michael Paul Driskel, "Eclecticism and Ideology in the July Monarchy: Jules-Claude Ziegler's Vision of Christianity at the Madeleine," *Arts Magazine* 56, no. 9 (May 1982), 127; and idem, *Representing Belief,* 22, 114 (on Victor Orsel's judgment of the *Disputation* as the highest expression of Christian art).

34 René Schneider titled the painting "Triomphe de la Foi," in René Schneider, *Rome: Complexité et harmonie* (Paris: Librairie Hachette et Cie, 1908), 225. There was also a sense in which the entire body of Raphael's work for the Stanze came to be thought of as a "Triumph of the Church." See, for example, Edward Hutton, *Rome* (London: Methuen and Company, 1926), 229. This usage continued into the later twentieth century; in 1963 M. Donati maintained: "In reality the work deals . . . with the Exaltation of the Holy Sacrament, or Triumph of the Christian Religion, carried out on earth by the Church Militant and in heaven by the Church Triumphant"; G. Colonna and M. Donati, *Les Musées du Vatican* (Novara, Italy: Istituto Geografico de Agostini, 1963), 103 ["En réalité, il s'agit plutôt de l'Exaltation du Saint Sacrement ou Triomphe de la Religion chrétienne, représentée sur la terre par l'Eglise militante et au ciel par l'Eglise Triomphante"]. The title *Triumph of Religion* for Raphael's work is still in use in the 1990s in such a popular-cultural source as the autumn 1995 trade catalogue (p. 15) for an American jigsaw puzzle company called Bits and Pieces. This title is used for the 3,000-piece puzzle of this image, produced by "the Renaissance fresco painter at the height of his powers." The same page of the ad offers picture-puzzle reproductions of the Sistine Chapel ceiling, Botticelli's *Primavera,* and Leonardo Da Vinci's *Last Supper.*

35 The Reverend William Ingraham Kip, in his *Christmas Holydays in Rome* (New York: D. Appleton and Company, 1846), referred to Overbeck's work at the time of its exhibition in Rome as the "Triumph of Religion *Over* the Arts," 180, italics added.

36 Keith Andrews, *The Nazarenes: A Brotherhood of German Painters in Rome* (London: Oxford University Press, 1964), 68–69.

37 Ibid., 72–85; William Vaughn, *German Romantic Painting* (New Haven: Yale University Press, 1980), 163–91. Ingres and Overbeck apparently held each other in high esteem; Andrews, *Nazarenes,* 74–75. See also Ulrich Pietsch, "Italien als Vorbild: Johann Friedrich Overbeck und Raffael," in Andres Blühm and Gerhard Gerkens, eds., *Johann Friedrich Overbeck (1789–1869),* exh. cat. (Lübeck-Behnhaus: Museum für Kunst und Kulturgeschichte der Hansestadt, 1989), 44–53, esp. 51; and Andres Blühm, " 'Herr vergieb ihnen, sie wissen nicht was sie thun': Overbeck und seine Kritiker," in Andres Blühm and Gerhard Gerkens, eds., *Johann Friedrich Overbeck (1789–1869),* 63–79, esp. 68–69, and catalogue entries 148–151. For further discussion of Overbeck's influence in France and England, see Fraser, *Victorians and Renaissance Italy,* 93–94.

38 Luisa Becherucci, "Raphael and Painting," in *Complete Works of Raphael*, 88, see also 9–198.

39 John Shearman interprets the *Disputa* as "an ideal elucidation of one of the Mysteries of the Sacrament by the practice of theology which is the titular Faculty on the vault above"; Shearman, "The Vatican Stanze: Functions and Decoration," *Proceedings of the British Academy* 57 (1973): 380.

40 Cox, "Raphael," 117.

41 Frederick Hartt, *History of Italian Renaissance Art* (New York: Harry N. Abrams, 1969), 460–61; Edward Hutton noted that "the Host, as the symbol and summit of our religion, is naturally the centre to which every line leads, to which every thought tends"; Hutton, *Rome*, 225. See also *Guida delle Gallerie di Pittura*, vol. 5 in the series *Musei e Gallerie Pontificie* (Rome: Prima Edizione Vaticana, 1925), 99–100.

42 Becherucci, "Raphael and Painting," 90.

43 On the Vatican's atmosphere of "churchmanship," see Crawford, *Roma*, 514–16.

44 "Boston Acquires Another Sargent."

45 Bullen, *Myth of the Renaissance*, 158–59, 251–55, 275, 286–87; Fraser, *Victorians and Renaissance Italy*, 9.

46 Driskel, *Representing Belief*, 257–58.

47 Shearman, "The Vatican Stanze," 369–429, esp. 379–80. By 1914 Ernesto Begni's amply illustrated and institutionally sanctioned book on Vatican art, written for a popular rather than an academic audience, would identify the Stanza della Segnatura as the "private library of Julius II"; Begni, *The Vatican: Its History—Its Treasures* (New York: Letters and Arts Publishing Company, 1914), 137.

48 Hartt, *Italian Renaissance Art*, 461.

49 Tabernacle and window treatments from Michelangelo's Laurentian Library in Florence may have suggested to Sargent the framing designs for his east wall "shrines" and the bookcases on the west wall.

50 Murray, *Handbook of Rome*, 250–51. See also Hutton, *Rome*, 203–6; and Crawford, *Roma*, 522. On the importance of Pinturicchio for American artists, see Edwin H. Blashfield, *Mural Painting in America* (New York: Charles Scribner's Sons, 1914), 275.

51 Hall of the Guards paintings had been covered over between 1868 and 1897. Hutton, *Rome*, 203; and Ernst Steinmann, *Pinturicchio* (Bielefeld and Leipzig: Verlag von Velhagen und Klasing, 1898). For Sargent's first mention of Pinturicchio with respect to the library murals, see Sargent to McKim, 25 Dec. 1891, BA.

52 Fenollosa, *Mural Painting*, 28; Pauline King also compared *Triumph* to Michelangelo's Sistine Chapel in her *American Mural Painting*, 124.

53 Fenollosa, *Mural Painting*, 23. On the Museum of Fine Arts, see Benjamin Ives Gilman, *Manual of Italian Renaissance Sculpture as Illustrated in the Collection of Casts at the Museum of Fine Arts, Boston* (Boston: Museum of Fine Arts, 1904), xiv.

54 Coburn, "Sargent Decorations in the Boston Public Library," 129.

55 Since 1903 Sargent had been the occasional houseguest of Gardner, staying in what is now the MacKnight Room on the first level and painting in the Gothic Room upstairs.

56 Borenius, "Rediscovery of the Primitives"; Leopold David Ettlinger, *The Sistine Chapel before Michelangelo: Religious Imagery and Papal Primacy* (London: Oxford University Press, 1965), 1–2.

57 Sargent to Mrs. Curtis, [Sept. 1907], BA.

58 Murray, *Handbook of Rome and Its Environs*, 204; see also Baedeker, *Italy*, 318.

59 Murray, *Handbook of Rome and Its Environs*, 204. Murray's reference is to Luigi Lanzi's *History of Painting in Italy from the Period of the Revival to the End of the Eighteenth Century* (1828).

60 For a contemporary acknowledgment of this pairing of Moses and Crucifix, see "Sargent's New Decorations in the Boston Library," *New York Times Magazine*, 14.

61 Charles Seymour, Jr., *Michelangelo: The Sistine Chapel Ceiling* (New York: W. W. Norton, 1972), esp. 83.

62 Ettlinger, *Sistine Chapel*, 89, 100; Seymour, *Michelangelo*, 83, 95.

63 Walter Pater, *The Renaissance: Studies in Art and Poetry* (1873; London: Macmillan and Company, 1925), xii.

64 *Authorized Daily Prayer Book of the United Hebrew Congregations of the British Empire* (London: Spottiswoode, 1904), 148. Sargent's copy of this book, in the Rare Books and Manuscripts Division of the Boston Public Library, includes his emendations or marks (including turned-down pages) in a number of places (96, 146, 147, 148); the inscription for the outer perimeter of the lunette, the words read at recitation of the Law, Sargent marked out on p. 147. My thanks to Sharon Gerstel, Adam Cohen, and Robert Fradkin for help in translating Hebrew inscriptions.

65 Baxter missed this emendation when he noted the content of Sargent's inscriptions in *Handbook* (1920), 78.

66 Hans Wolfgang Singer, *Julius Schnorr von Carolsfeld* (Bielefeld and Leipzig: Verlag von Belhagen und Klasing, 1911), 87. On Schnorr's considerable influence in London, see Vaughn, *German Romantic Painting*, 181–83. Mary Crawford Volk suggests a visual connection between Augustus Saint-Gaudens's Adams Memorial (1890–91) and Sargent's Jehovah. See Mary Crawford Volk, entry for "Cartoon Study for *Israel and the Law* Lunette," in *John Singer Sargent*, ed. Elaine Kilmurray and Richard Ormond, exh. cat. (London: Tate Gallery; Princeton: Princeton University Press, 1998), 200.

67 Renan, *History*, 3:413. "La façon dont un chrétien pieux parle à Dieu n'aurait pas de tels accents de tendresse, si, derrière le Dieu en trois personnes, il n'y avait un Dieu plus tangible, qui a porté sa tribu dans son sein comme une nourrice, l'a caressée, lui a parlé comme à un enfant"; Renan, *Histoire*, 3:506–7.

68 Baxter in *Handbook* (1920), 78–79.

69 For Pater, Michelangelo's art was characterized by a combination of sweetness and strength, power and tenderness; see Pater, "The Poetry of Michelangelo" (1871), in Pater, *Renaissance*, 73–97. For Pater, Michelangelo would never be claimed by the "new Catholicism" that, "fixing itself in frozen orthodoxy," supplanted the Renaissance. On the other hand, Michelangelo's art did embrace certain medievalisms.

70 Charteris, *Sargent*, 155.

71 No intermediaries, that is, excepting the words on the scroll and in the "air."

72 Renan emphasized precisely this aspect of Jeremiah's prophecy; see Renan, *History*, 3:331.

73 Sargent introduced an evolutionary and historical thrust to the Catholic triumphalism and typological thinking of the Vatican Stanze and the Sistine Chapel; he conflated two grand thematic structures of contemporary art: "Progress of Civilization" with "Triumph of Religion."

74 Ettlinger, *Sistine Chapel,* 89–90.

75 Gerald Friedlander, *Jewish Sources of the Sermon on the Mount* (1911; New York: Ktav Publishing House, 1969), x, xxxvii.

76 Kissinger, *Sermon on the Mount,* 40–42.

77 Lyman Abbott, *A Dictionary of Religious Knowledge for Popular and Professional Use* (New York: Harper and Brothers, 1875), s.v. "Sermon on the Mount," 863. Shirley Jackson Case, writing in 1927 on the effects of the scholarly quest for the historical Jesus, remarked that literary, critical, and historical analysis of the biblical texts tended to produce a Jesus who was neither the "adorable Christ of faith" nor the Jesus of "christological dogma," but one who "is discovered to have been a teacher of moral and spiritual idealism such as one meets in the Sermon on the Mount"; Shirley Jackson Case, "The Life of Jesus," in Smith, *Religious Thought in the Last Quarter Century,* 26–27, 34–35.

78 Hall, *Jesus, the Christ,* 2:471.

79 Ibid., 1:xiv.

80 Fairchild, Diary, 1891 (England), 8, DCL.

81 "Sargent, the Artist, Arrives."

82 Ibid.; and Baxter, "Master Murals," 108.

83 In addition, one drawing at Harvard University Art Museums and two at the Metropolitan Museum of Art have been identified as sketches for Sermon. All three are distinctly related to each other but more likely represent a mythological or Shakespearean scene than the biblical one Sargent intended for the library.

84 Abbott, *Dictionary,* 863. Sargent's *Hills of Galilee* (1905–6; Brooklyn Museum of Art) is one likely source for the landscape of Sermon on the Mount, as it appears in the extant sketches.

85 Anna Jameson, *History of Our Lord as Exemplified in Works of Art* (London: Longmans, Green, and Company, 1890), 1:319–20; and Allen Staley, " 'Art Is upon the Town!': The Grosvenor Gallery Winter Exhibitions," in *The Grosvenor Gallery: A Palace of Art in Victorian England,* ed. Susan P. Casteras and Colleen Denney (New Haven: Yale Center for British Art, 1996), 59–74. Sargent's work also appeared at the Grosvenor in the same half decade.

86 I am grateful to John Clift and Helen Sherwin of Trinity Church for assistance with the historical titles of Trinity's windows.

87 Liberal Protestant minister Henry Ward Beecher described Sermon on the Mount in terms consistent with Sargent's premessianic intentions; see his *Life of Jesus the Christ* (New York: J. B. Ford and Company, 1871), 235.

88 I am grateful to Virginia C. Raguin for calling my attention to these windows.

89 Jameson, *History of Our Lord,* 1:318.

90 See Renan, *History,* 3:397, idem, *Histoire,* 3:486 ("la personnification du peuple").

91 On the Reformation origins of the motif, see Carl C. Christensen, *Art and the Reformation in Germany* (Athens: Ohio University Press; Detroit: Wayne State University Press, 1979), 207; for discussion of the motif in the United States, see David Morgan, *Protestants and Pictures: Religion, Visual Culture, and the Age of American Mass Production* (Oxford: Oxford University Press, 1999), ch. 5. Cf. Jameson, *History of Our Lord,* 1:329.

92 Matthew 19:13–15; Mark 10:13–16; Luke 18:9–14.

93 Matthew 18:1–5; Mark 9:33–37; Luke 9:46–48.

94 Lears, *No Place of Grace,* 146; see Lears for contradictions within and implications of these two alternatives (144–49).

95 G. Stanley Hall, "The Ministry of Pictures," part 4, *Perry Magazine* 2, no. 9 (May 1900): 387.

96 Walter Pater's *The Renaissance: Studies in Art and Poetry,* read and favorably remarked by Sargent as early as 1881, concluded with a similarly explicit paean to the unmediated aesthetic awareness of the "children of the world"; Pater, *Renaissance,* 238. Ormond, "John Singer Sargent and Vernon Lee," 168, documents Sargent's reading of Pater. Years later, in 1912, Sargent would give Pater's *Plato and Platonism* (1910) to his nephew Jean-Louis Ormond as a Christmas gift.

97 Lears, *No Place of Grace,* 17, 50, 196, 222.

98 Renan, *Life of Jesus,* 184–87. "La religion naissante fut ainsi à beaucoup d'égards un mouvement de femmes et d'enfants. Ces derniers faisaient autour de Jésus comme une jeune garde pour l'inauguration de son innocente royauté . . . C'était l'enfance, en effet, dans sa divine spontanéité, dans ses naïfs éblouissements de joie, qui prenait possession de la terre"; Renan, *Vie,* 191–92.

99 Renan, *Life of Jesus,* 187, as quoted in chap. 1 of this book. Mary Crawford Volk ("Sargent in Public," 55) has recently made the intriguing suggestion that, though Sargent himself never said as much, *Triumph of Religion* in the context of the Boston Public Library, signifies the relationship of "words" to the ultimate "Word," Jesus. Based on the available evidence this seems probable only in a particular and, from the perspective of Christian scripture and tradition, particularly unorthodox way. Jesus himself becomes for Sargent the ultimate "Word," not as God-man but as the supreme model of interior discernment, of knowledge and wisdom internalized, of the "spiritualization," as Fenollosa insisted, of a material world. Anna Jameson's words (*History of Our Lord,* 1:318) regarding the Jesus of Sermon on the Mount may have attracted Sargent's eye: "When Christ is not only the heavenly Teacher, but in the act of teaching men on earth—not merely the 'light of the world,' but occupied in enlightening the world, then the Spiritual Word becomes visible in form."

100 Pater, quoted from a letter written in 1884 to Vernon Lee, in Carolyn Williams, *Transfigured World: Walter Pater's Aesthetic Historicism* (Ithaca, N.Y.: Cornell University Press, 1989), 170.

CHAPTER 4: EDUCATION FOR DEMOCRACY

1 Cassier, *Philosophy of the Enlightenment,* 134.

2 James George Frazer, *The Golden Bough: A Study in Magic and Religion,* part 1: *The Magic Art and the Evolution of Kings* (London: Macmillan and Company, 1963), 1:xii.

3 The sort of "archaic" institutional belief system within which Sargent cast his *Madonna of Sorrows* (fig. 12) can be seen in his *Confession* (1914; unlocated), which includes a very similar image at the left margin, and in his illustrations for Alma Strettell's *Spanish and Italian Folk Songs* (London and New York: Macmillan and Company, 1887). See also Van Ness, "Sargent and the Unfinished Panel."

4 Morgan, *Protestants and Pictures,* chap. 8.

5 Josiah H. Benton, *The Working of the Boston Public Library* (Boston: Rockwell and Churchill Press, 1914), 60.

6 Richard Shiff, "Originality," in *Critical Terms for Art History,* ed. Robert S. Nelson and Richard Shiff (Chicago: University of Chicago Press, 1996), 104. That this notion of "individualized" experience and education represented a way of thinking available to Sargent's audiences

is clear in contemporary conversations about introduction of the elective system at Harvard University. Though the notion of elective education began to come into currency after the War of 1812, it reached its culmination under Charles Eliot's Harvard presidency (Sargent painted Eliot's portrait in 1907). See Warren A. Nord, *Religion and American Education* (Chapel Hill: University of North Carolina Press, 1995), 81; and Ronald Story, *Forging of an Aristocracy: Harvard and the Boston Upper Class, 1800–1870* (Middletown, Conn.: Wesleyan University Press, 1980), 20.

7 For an excellent treatment of the visual cultural impulse called the American Renaissance, see Richard Guy Wilson, Dianne H. Pilgrim, and Richard N. Murray, *The American Renaissance, 1876–1917,* exh. cat. (New York: Brooklyn Museum, 1979).

8 Sylvester Baxter, "Master Murals," 106.

9 This was a decision he had made by 1893 before any images were installed and just after he signed the first contract. For a critical reading that emphasized the educative function of mural painting, see Blashfield, *Mural Painting in America,* 5.

10 Cox, "Raphael," 116. Cox designated the four walls of the Stanza della Segnatura Raphael's greatest "triumphs."

11 Benton, *Working of the Boston Public Library,* title page, 59. See also Horace G. Wadlin, *The Public Library of the City of Boston: A History* (Boston: Boston Public Library, 1911), 56.

12 Blashfield, *Mural Painting in America,* table of contents, 5, 8.

13 Coburn, "Sargent Decorations," 129; Van Rensselaer, "New Public Library in Boston," 262. Sargent was hardly alone in painting (here cultural) literacy, education, and religion on a library's walls. See Cartwright, "Reading Rooms." At the New York Public Library (and some years later), for example, Edward Lamming would picture Moses as the representative of an early stage in the technology of distributing the printed word.

14 Walter Muir Whitehill, *Boston Public Library: A Centennial History* (Cambridge: Harvard University Press, 1956), 147–48; "Copley Square: A Brief Description of Its History" (Boston: State Street Trust Company, 1941), 5–6.

15 On "intellectual" Boston and "commercial" New York, see Simon J. Bronner, "Reading Consumer Culture," in *Consuming Visions: Accumulation and Display of Goods in America, 1880–1920,* ed. Simon J. Bronner (New York: W. W. Norton and Company, 1989), 15; Mona Domosh, *Invented Cities: The Creation of Landscape in Nineteenth-Century New York and Boston* (New Haven: Yale University Press, 1996), 114–19; *King's Handbook;* E. Digby Baltzell, *Puritan Boston and Quaker Philadelphia* (New York: Free Press, 1979), 246–47; and Broadhead, introduction to Hawthorne, *Marble Faun,* xiv. Intellectual pursuits here qualified as "spiritual"; their opposite was material and commercial.

16 *King's Handbook,* 107, 123. See also Wadlin, *Public Library,* 4, on Boston's superiority with respect to education and culture.

17 Story, *Forging of an Aristocracy,* xiii, 7; see also Henry May, *The End of American Innocence: A Study of the First Years of Our Own Time, 1912–1917* (New York: Alfred A. Knopf, 1959), 52, 63.

18 May, *End of American Innocence,* 30, 39.

19 The motto was inscribed in Latin on the seal produced by Saint-Gaudens for the façade above the main entry. See Whitehill, *Boston Public Library,* 159–60.

20 Story, *Forging of an Aristocracy,* xii–xiii.

21 Ibid., xiii, 8–9, 174–75.

22 Paul DiMaggio, "Classification in Art," *American Sociological Review* 52, no. 4 (Aug. 1987): 446.

23 Abigail A. Van Slyck, *Free to All: Carnegie Libraries and American Culture, 1890–1920* (Chicago: University of Chicago Press, 1995), 67, also 66. The library's architectural references both flattered its moneyed supporters with explicit allusions to the wealthy patrons of Italian Renaissance culture *and* connected its readers with liberal humanist values of individualism and selfhood current in contemporary cultural and historical understandings of the fifteenth and early sixteenth centuries in Italy.

24 Arthur Mann, *Yankee Reformers in the Urban Age* (Cambridge: Harvard University Press, 1954), 3–7: Back Bay was mainly upper-class Protestant. Immigrants, especially Italian Catholics and Jews, tended to live in the North, West, and South Ends.

25 Frederic Cople Jaher, "Nineteenth-Century Elites in Boston and New York," *Journal of Social History* 6, no. 1 (Fall 1972): 32–77. See also Betty G. Farrell, *Elite Families: Class and Power in Nineteenth-Century Boston* (Albany: State University of New York Press, 1993), 25–31.

26 Walter Muir Whitehill, *Boston: A Topographical History* (Cambridge: Harvard University Press, 1968), 159.

27 See Benton, *Working of the Boston Public Library,* 62–63.

28 If the facial features of figures represented in the building's murals are taken as indicators, immigrant Boston could read on the library's walls the triumph of Western civilization scripted by race as well as class to signify the superiority of Anglo-European culture.

29 Subscription list, 1895, BPLr, Ms Bos Li B18a.3.

30 On liminality, see Victor Turner, *The Ritual Process: Structure and Anti-Structure* (Ithaca, N.Y.: Cornell University Press, 1969), esp. 94–130; on cultural liminality, see Duncan, *Civilizing Rituals,* 13.

31 See sample Perry Pictures reproductions with descriptive text, BPLf. See also Marie A. Moore, "Great Artists and Their Paintings," *Perry Magazine* 4, no. 3 (Nov. 1901): 91.

32 Jonathan Freedman, "Jews and the Making of Middlebrow American Culture," *Chronicle of Higher Education,* 18 Sept. 1998, B4.

33 See, e.g., *King's Handbook,* 107, 123; Wadlin, *Public Library;* Benton, *Working of the Boston Public Library;* as well as Henry James, *The Bostonians* (1886); and William Dean Howells, "Hazard of New Fortunes" (1890). See also Baltzell, *Puritan Boston and Quaker Philadelphia,* 246–334.

34 Van Slyck, *Free to All,* 70.

35 On this "collective mission" of the American Tract Society, the American Sunday School Union, and the American Bible Society to promote the "spread of English and evangelical literacy," see Morgan, *Protestants and Pictures,* chap. 5.

36 Benton, *Working of the Boston Public Library,* 59.

37 Wadlin, *Public Library,* 28, also 45–46, 97–98.

38 "Copley Square," 6.

39 "In the New Library," *Boston Evening Transcript,* 11 Mar. 1895, 4; and Whitehill, *Boston Public Library,* 80–82.

40 Story, *Forging of an Aristocracy,* 167, 174; and Lears, *No Place of Grace,* 98–114.

41 Henry James to William James, 29 Oct. 1888, as quoted in Simpson, "Sargent and His Critics," 43.

42 *King's Handbook,* 112, establishes the connection of Puritanism and individual freedom in Boston's late-nineteenth-century sense of history and self.

43 The "DAB" to which Baltzell referred was the *Dictionary of American Biography*. Baltzell, *Puritan Boston and Quaker Philadelphia*, 308, see also 319. The Boston clubs with which Sargent associated underscore this elite connection: St. Botolph's, the Tavern Club, and the Saturday Club.

44 Story, *Forging of an Aristocracy*, 176–77; Baltzell, *Puritan Boston and Quaker Philadelphia*, 364.

45 See, for example, Sargent to Isabella Stewart Gardner, 31 May [1918], ISGM; and Sargent to Fox, 12 May 1918, BA. For evidence of the contemporary use of this expression in Boston, see, for example, Arlo Bates, "A Challenge to Boston's Culture," *Boston Evening Transcript*, 15 June 1907, 3:3.

46 "Notes on J. S. Sargent by His Nephew, F. G. Ormond," c. 1956, BA. Though David McKibbin's notations on this manuscript name Sargent's nephew "Francis Guillaume," in correspondence Sargent called him Guillaume, and family sources record his name as Guillaume Francis Ormond.

47 Frederick W. Coburn, "John Singer Sargent, Bostonian: Anecdotes of an American Portrait Painter Returned to His Ancestral New England," *New York Times Magazine*, 28 Oct. 1923, 8.

48 Sargent to Mary Hunter, 24 Apr. [1919], AAA, rel D169, frs. 1342–44.

49 Charteris, *Sargent*, 2–3. See also Olson, *Sargent*, 274–77. Curtis referred to the greater Boston area as "Puritan land"; Ralph Curtis to Isabella Stewart Gardner, 27 Sept. [?], ISGM.

50 Vernon Lee, "John Singer Sargent: In Memoriam" (13 Aug. 1925), in Charteris, *Sargent*, 249. Emily Sargent wrote to Vernon Lee (who was Violet Sargent's godmother) to express her appreciation for this memorial essay: "Violet and I think it wonderfully perfect"; Emily Sargent to Vernon Lee, 15 Aug. 1925, CC; and Emily Sargent to Vernon Lee, 9 Sept. 1925, CC.

51 Lee, "In Memoriam," 235–36.

52 Vernon Lee, *Gospels of Anarchy and Other Contemporary Studies* (New York: Brentano's; London: T. Fisher Unwin, 1909), 32–33.

53 Fitzwilliam Sargent's regard for religion was not dissimilar. When he wrote to a relative explaining his decisions with respect to his children's religious education (as quoted in chap. 1 of this book), he made it clear that he felt it useful to know, broadly speaking, the content of the catechism and what it meant to him personally, but that inculcation of the prescribed orthodox form left him cold.

54 I am grateful to Gretchen Buggeln, historian of American religious architecture, and to an anonymous reader of my manuscript for insights in this regard. On "secular puritanism," see Baltzell, *Puritan Boston and Quaker Philadelphia*, 282.

55 Story, *Forging of an Aristocracy*, 13–17; see also Benton, *Working of the Boston Public Library*; and Wadlin, *Public Library*.

56 Robert F. Dalzell, Jr., *Enterprising Elite: The Boston Associates and the World They Made* (Cambridge: Harvard University Press, 1987), 153. Business and economic historian Dalzell identifies Ticknor as the "foremost American man of letters of his generation." While Ticknor must surely share this honor with others, he was Smith Professor of Modern Languages at Harvard for sixteen years (1819–35). He amassed a significant collection of Spanish and Portuguese literature that he later donated to the public library, and he wrote a monumental treatise on that subject. See Dalzell, *Enterprising Elite*, 152–55; and Wadlin, *Public Library*, 126–28.

57 T. R. Sullivan, *Passages from the Journal of Thomas Russell Sullivan, 1891–1903* (New York: Houghton Mifflin, 1917), 133–34. This was the reception at which Fox met Sargent.

58 Whitehill, *Boston Public Library*, 168–69.

59 Fairbrother, *Sargent and America*, 268 n. 20; Walter Muir Whitehill, "The Making of an Architectural Masterpiece—The Boston Public Library," *American Art Journal* 2, no. 2 (Fall 1970), 33; and Whitehill, *Boston Public Library*, 149–56.

60 "Public Library at Boston." The *Boston Evening Transcript*, Independent Republican in politics, quoted this article from the *London Art Journal* where it was first published. *King's Handbook* (263–64) described the *Evening Transcript* as a "literary paper," the "favorite afternoon paper, particularly in refined Boston and suburban homes." King noted, further, the "quiet and dignified tone of the editorial page, and the absence in the paper of any thing which appeals to the popular craving for sensationalism."

61 "In the New Library." On this dynamic, see also Van Slyck, *Free to All*, 66–67; and Burns, *Inventing the Modern Artist*, 325, on the role of culture in "teaching the 'masses' to venerate a common set of American standards, values, and ideals."

62 Henry James, *The American Scene* (New York: Charles Scribner's Sons, 1946), 249–51, as quoted in Jordy, *American Buildings*, 354–56.

63 Lindsay Swift, "The Moving of the Boston Public Library," *Century Magazine* 50, no. 2 (June 1895), 318.

64 Swift, "New Public Library in Boston," 271.

65 Whitehill, *Boston Public Library*, 188–89.

66 In the late 1990s public libraries continue to function as places where many recent immigrants acquire skills and knowledge requisite to their own sense of successful citizenship; see, e.g., Blaine Harden, "Boroughful of Bookworms: Motivated Immigrants Make Queens Library Busiest in U.S.," *Washington Post*, 28 Apr. 1998, A1, A8.

67 John B. Orr, "The American System of Education," in Luther S. Luedtke, ed., *Making America: The Society and Culture of the United States* (Chapel Hill: University of North Carolina Press, 1992), 378–79; Nord, *Religion and American Education*, 75. The masthead of the *Jewish Advocate* in these years read "Americanism and Judaism," with the order of the nouns reversing sometime in 1921 as antisemitism in New England and the United States flared.

68 Mariana Griswold Van Rensselaer, "Places in New York," *Century Magazine* 53, no. 4 (Feb. 1897): 515–16.

69 Kenneth M. Ludmerer, "Genetics, Eugenics, and the Immigration Restriction Act of 1924," *Bulletin of the History of Medicine* 46, no. 1 (Jan.–Feb. 1972): 63.

70 "Mr. George's Mural Panel," *Boston Evening Transcript*, 24 Oct. 1919.

71 On the library's patronage, see, for example, Lilian Whiting, *Boston Days* (Boston: Little, Brown and Company, 1902), 424; Swift, "New Public Library in Boston: Its Ideals and Working Conditions," 271; and Whitehill, *Boston Public Library*, 80–82.

72 Mary Antin, *The Promised Land* (1912; Boston and New York: Houghton Mifflin Company, 1924), 340–43, see also 223–40. Antin completed this story in 1911; it appeared serially in 1911–12 and was first published as a book by Houghton Mifflin in 1912. When Antin wrote on Sargent Hall, only the north and south walls had been installed.

73 George Middleton, "Mary Antin's 'The Promised Land,'" *Bookman* (New York) 35, no. 4 (June 1912): 419–21.

74 Coburn, "Sargent Decorations in the Boston Public Library," 129.

75 Baltzell, *Puritan Boston and Quaker Philadelphia,* 282.

76 John Cournos, "John S. Sargent," *The Forum* 54 (Aug. 1915): 233.

77 See, e.g., Renan, *Life of Jesus,* 55; Renan, *History,* 5:353. See also Menzies, *History of Religion,* 191–94.

78 Renan, *History,* 2:397 ("un homme du peuple," 466). Further, Renan, *Life of Jesus,* 55, describes Moses and the Law, the "code of monotheism," as the ancient container of the "mighty germs of social equality and morality" (in Sargent's 1863 edition [6], "le code du monothéisme" and "de puissants germes d'égalité sociale et de moralité").

79 Sargent to Mrs. Hughes, 1 Nov. 1922, BPLr. The letter was published (with a few slight variations) in an article in the *Boston Traveler* on 19 Sept. 1933.

80 D. H. Meyer, "American Intellectuals and the Victorian Crisis of Faith," *American Quarterly* 27, no. 5 (Dec. 1975): 593.

81 Newman Smyth, "The New Old Testament," *Century Magazine* 50, no. 2 (June 1895): 300–301. Smyth recommends a religious evolutionary scenario (from materialism to spiritualism) very similar to Sargent's.

82 Gammell, "Mural Decorations," 20.

83 The entire series appeared between 22 Apr. and 22 July 1899. One of the two June issues included the material quoted here on Jeremiah; Lyman Abbott, "Hebrew Prophets and American Problems," *Outlook* 62, no. 7 (17 June 1899): 384–85. See, for Micah, Abbott, "Hebrew Prophets and American Problems," *Outlook* 62, no. 6 (10 June 1899): 660; for Malachi and Joel, Abbott, "Hebrew Prophets and American Problems," *Outlook* 62, no. 12 (22 July 1899): 660; for Isaiah, Abbott, "Hebrew Prophets and American Problems," *Outlook* 62, no. 4 (27 May 1899): 208; for Hosea, Abbott, "Hebrew Prophets and American Problems," *Outlook* 62, no. 1 (6 May 1899): 27; and for Ezekiel, Abbott, "Hebrew Prophets and American Problems," *Outlook* 62, no. 9 (1 July 1899): 518. On Abbott in Cambridge and Boston, see, for example, "Jottings," *Boston Evening Transcript,* 11 Mar. 1895, 4.

84 See Fairchild, Diary, Aug. 1891, 5–6, DCL. The windows were much published even by 1891; see Hilary Wayment, *The Stained Glass of the Church of St. Mary, Fairford, Gloucestershire* (London: Society of Antiquaries, 1984), ix, 5, fig. 5; and Lucas, *Edwin Austin Abbey,* 2:346, 371 (on the "famous Fairford windows").

85 Fairbrother, *Sargent,* 89, first mentioned the connection to Rodin's *Burghers.* On reception of the Rodin sculptural group, see Albert Elsen, *Rodin* (New York: Museum of Modern Art, 1963), 70, 73; Dominique Jarrassé, *Rodin: A Passion for Movement* (Paris: Terrail, 1992), 13–30; and Catherine Lampert, "Rodin and England," *Antique Collector* 57, no. 11 (Nov. 1986): 89–95. For an excellent and comprehensive study of *Burghers* and its reception, see Mary Jo McNamara, "Rodin's 'Burgher's of Calais,'" Ph.D. diss., Stanford University, 1983. Martin Birnbaum, *Sargent,* 16, associated Sargent with Rodin.

86 See Driskel, *Representing Belief,* 184–85.

87 Small, *Handbook of the Library of Congress,* 76.

88 Peter Arms Wick, comp., *Boston Public Library Handbook* (Boston: Associates of the Boston Public Library, 1977), 48.

89 Thomas Fox's papers include a typescript notation that Major George C. Roller, "who restores pictures for the R. A. [Royal Academy], says that he posed for some of the figures in the frieze of the prophets in the Boston Public Library"; Fox typescript, 22 Dec. 1925, BA. At least one author (Douglass Shand-Tucci, *Art of Scandal*) maintains that Sargent included a reference to Dennis Bunker. Bunker scholar Erica Hirschler found no direct evidence in the Bunker literature that would support Bunker's role as a model here. Hirschler hesitates to reject the possibility outright, however, because Ives Gammell, who had interviewed Bunker's family, believed that he appeared in *Frieze.* Telephone interview with Erica Hirschler, 2 Feb. 1998. Several letters of the early 1930s indicate that at least some at the time believed that poet Bliss Carman had also been a model; see Lorne Pierce to Thomas Fox, 13 Aug. 1931, MHSpc; and Thomas Fox to Lorne Pierce, 8 Sept. 1931, MHSpc. Fox discounted the possibility because *Frieze* was painted in England and Carman (incidentally an Episcopalian turned Unitarian) was in Boston at the time.

90 At least one other student of *Triumph* (Kate Diamond) has noted this resemblance.

91 Fenollosa, *Mural Painting,* 23. On the democratic individualism of Sargent's prophets, see King, *American Mural Painting,* 139.

92 Story, *Forging of an Aristocracy,* 7–8. Story maintains that "by 1850 approximately two-thirds of the wealthiest Bostonians were Unitarians: by 1870 the average Unitarian was thirteen times richer and twenty times more likely to be a businessman or lawyer than was a member of any other denomination." The Boston elite's attachment to Unitarianism continued well into the twentieth century (Story, *Forging of an Aristocracy,* 7, 172, 247); see also Carl Seaburg, *Boston Observed* (Boston: Beacon Press, 1971), 201–5.

93 Story, *Forging of an Aristocracy,* 162.

94 Benjamin P. Holbrook to Boston Public Library Trustees, 17 June 1903, BPLr, Ms Bos Li B18a.6.

95 Benton, *Working of the Boston Public Library,* 7; Wadlin, *Public Library,* 134–37.

96 For a similar description of the "modern" piety of progressive Protestant G. Stanley Hall (who explicitly acknowledged the influence of Renan on his thinking), see Morgan, *Protestants and Pictures,* chap. 8. In the United States many associated Renan's work with Protestantism. In contrast, most of his American detractors were Roman Catholic; Bierer, "Renan and His Interpreters," 383, 388. See publication notices with reviews of Renan's writings at the back of, e.g., Renan, *History,* vol. 5. See also Baltzell, *Puritan Boston and Quaker Philadelphia,* 282, 284.

97 The notation of Jesus' concern for physical health also calls to mind Sargent's relation to Emily, the sister in terms of whom he considered Sermon on the Mount in 1891. Emily had suffered a back injury as a child and, in connection with this sister as well as with his reputedly hypochondriacal mother, the painter lived in familial proximity to some degree of physical disability all his life.

98 Van Ness, "Sargent and the Unfinished Panel." The community Van Ness recalls Sargent imagining sounds a lot like the crowd the journalist at the *Boston Evening Transcript* had described on opening day at the new library ("In the New Library"). Cf. Van Ness's recapitulation of Sargent's description with the Sermon panel as indicated in the oil study for east wall (fig. 24).

99 Robert N. Bellah et al., *Habits of the Heart: Individualism and Commitment in American Life* (New York: Harper and Row, 1986), esp. vii.

100 On James in this regard, see Meyer, "American Intellectuals," 585. Either Sargent or his sister Emily owned a copy of William James's *Pluralistic Universe* (1912); Richard Ormond to Sally Promey, 16 Mar. 1998.

101 Lucas, *Edwin Austin Abbey,* 2:294.

102 Ibid., 385, 415.

103 Martin E. Marty, *Modern American Religion,* vol. 1, *The Irony of It All, 1893–1919* (Chicago: University of Chicago Press, 1986), 20.

104 Lucas, *Edwin Austin Abbey,* 2:385, 403, 415, 471–72. Fairbrother (*Sargent and America,* 275 n. 57) sees the influence of Harrisburg on Sargent's *Hell* and *Passing of Souls.*

CHAPTER 5: THE *SYNAGOGUE* CONTROVERSY

1 Frederick William Coburn, "In the World of Art," *Boston Sunday Herald,* 14 Sept. 1919, C4. The politically independent *Herald* was, according to *King's Handbook of Boston* (268–69), the "great popular newspaper of the city."

2 D[ownes], "Two New Panels By Sargent." The *Boston Evening Transcript,* in contrast to the *Herald,* was produced by an upper-class publishing institution (Story, *Forging of an Aristocracy,* 174–75). The medieval precedents cited by Downes included Reims, Strasbourg, Paris, and St. Seurin at Bordeaux. Lacking knowledge of Coburn's earlier comments, the *Literary Digest* ("Jews Offended by Mr. Sargent's 'Synagogue,' " 1 Nov. 1919, 31) suggested that Downes might bear responsibility for the controversy.

3 Coburn, "In the World of Art," C8. With early professional connections to the Society of Friends and the nonsectarian, nontheistic Ethical Culture schools, Coburn's own religious sympathies were likely liberal or even progressive. Downes was the Unitarian son of Connecticut Congregationalists.

4 This account of events is corroborated by the address written by Rabbi Edward N. Calish of Richmond, Va., for the yearbook of the Central Conference of American Rabbis in 1922. In that year Calish succeeded Leo Franklin as president of the conference which represented the rabbinic leadership of the Reform movement in American Judaism. *Proceedings of the Thirty-third Annual Convention of the Central Conference of American Rabbis* (Richmond: Old Dominion Press, 1922), 104.

5 [Alexander Brin], "Does Sargent Represent or Misrepresent the Synagogue," *Jewish Advocate,* 16 Oct. 1919.

6 "Jews to Ask Removal of Painting," unidentified newspaper clipping, MHSpc.

7 "Jews Offended," 31.

8 The reference to Eichler appeared in the 1 Nov. article in *Literary Digest* ("Jews Offended," 31). The petition was mentioned in the unidentified, undated clipping, "Jews to Ask Removal of Painting," MHSpc; internal references indicate a local Boston paper. The journalist interviewed Alexander Brin who discussed both the petition and the *Advocate*'s solicitation of an expert opinion from the New York art critic Brin had selected. On 19 Oct. 1919 the *New York Times* referred to the petition in its captions for a pictorial layout on Sargent's *Synagogue* and *Church* that appeared in the Sunday "Rotogravure Picture Section": "The Canvas Entitled 'The Synagogue' Is Now Under Sharp Criticism by Prominent Rabbis of Boston as an Affront to Judaism and as Poorly Conceived, and a Petition to the Mayor of Boston and the Trustees of the Library Is Being Circulated Asking Its Removal."

9 Sargent to the editor (21 Oct. 1919), printed in "Real Interpretation of 'The Synagogue' Missing in John Singer Sargent's Explanation," *Jewish Advocate,* 23 Oct. 1919, 1.

10 Ibid., 1, 5.

11 Gold was born in 1893 and immigrated to the United States from Poland at age fifteen. An orthodox rabbi, he held degrees from Jewish

Theological Seminary, Columbia University (A.B., 1915), and Harvard University (M.A., 1921). He was twenty-six when he came to Boston's Congregation Adath Jeshurun. For biographical information on Gold, see *Who's Who in American Jewry* (New York: Jewish Biographical Bureau, 1926), 201–2.

12 This letter, now in a private collection, is reproduced in Charteris, *Sargent,* 209; and in Olson, *Sargent,* 252. The letter itself provides only the day and month (24 Oct.). Although Charteris later recalled the year as 1921, the *Jewish Advocate* article and the course of events make the 1919 date that Olson assigned more plausible. Sargent's complaint was perhaps not quite as mean-spirited as it might initially appear. The appeal to the "good old times" was a stock phrase he used on other occasions and in reference to other groups as well. For example, during the execution of *Carnation, Lily, Lily, Rose,* Charteris (75) claims that, after a particularly exasperating session with the Barnard children who modeled for the painting, Sargent could be heard to mutter under his breath a longing for the "good old days of Herod," a reference, of course, to the Massacre of the Innocents.

13 "Real Interpretation," 1, 5.

14 "Jews to Ask Removal of Painting," MHSpc.

15 "Real Interpretation," 1, 5.

16 "Jews Offended," 30.

17 Leo Franklin and Felix Levy to Boston Public Library Board of Trustees (William F. Kenney, president), 5 Nov. 1919, BPLr, Ms Bos Li B180. See also *Proceedings of the Thirty-first Annual Convention of the Central Conference of American Rabbis* (Cincinnati: C. J. Krehbiel Co., 1920), 21–22.

18 Leo M. Franklin, "The Historical Background of the New Sargent Pictures," sermon given at Temple Beth El, Detroit, 16 Nov. 1919, 4–5, BPLr, Ms Bos Li B180. Franklin, who trained at Hebrew Union College, the principal educational institution of Reform Judaism, was president of the Central Conference of American Rabbis from 1919 to 1921. He devoted considerable time and energy to fostering amicable Jewish-Christian relations.

19 "Extracts from the Records of the Board of Trustees," BPLr.

20 Franklin, "Historical Background," 9, 12, BPLr.

21 Ibid., 14.

22 Louis Wolsey, "Bigotry and Nudity," *Jewish Review and Observer* (Cleveland), 5 Dec. 1919, BPLr, Ms Bos Li B180. The use of the word "corrupting" is Rabbi Wolsey's own. His article also appeared in the *American Israelite* (Cincinnati, Ohio) on 8 Jan. 1920.

23 Janet Simons Harris to Boston Mayor Andrew J. Peters, 26 Dec. 1919 (quotations from attached "Resolution" dated 19 Nov. 1919), copy BPLr, Ms Bos Li B18b.1. For another early formulation of the "un-American" charge, see "Jews Offended," 30.

24 "Jewish Girl's Medallion Refutes Sargent's 'Synagogue,' " *Jewish Advocate,* 15 July 1920, 3. See also "A Bas Relief by Rose Kohler," *New York Times,* 4 July 1920, 3:21 (a large illustration of Kohler's medallion accompanied this article). See *Who's Who in American Jewry,* 1926, 325–26, for a biography of Rose Kohler. At least one other artistic response to *Synagogue* was created; Jewish poet Louis L. Norman expressed his feelings in verse. See Franklin, "Historical Background," 15, BPLr; and this chapter's epigraph.

Following Sydney E. Ahlstrom (*Religious History of the American People* [New Haven: Yale University Press, 1972], 579), I previously ("Sargent's Truncated *Triumph,*" 234) identified Kaufmann Kohler as

son-in-law of Isaac Meyer Wise. This is inaccurate; Kohler married Johanna Einhorn, the daughter of another Reform pioneer, David Einhorn. "Kaufmann Kohler," *Encyclopaedia Judaica* (Jerusalem: Keler Publishers, 1972), 16:1142–43.

25 Her teachers had included Frank Duveneck, Cecelia Beaux, and William Zorach; "Rose Kohler," *Who's Who in American Jewry*, 1926, 325–26; "Miss Rose Kohler, Artist, Dies at 74," *New York Times*, 6 Oct. 1947, 21.

26 " 'The Spirit of the Synagogue' Medallion by Rose Kohler," marketing brochure, CEE; see also *Who's Who in American Jewry*, 1938–39, 551.

27 Thanks to Marcia Hertzman, archivist of Congregation Adath Israel, Louisville, Ky., for much assistance in documenting and trying to locate the original medallion. See Ora Spaid, "A Reporter Goes to Church: Synagogue Here Displays Medallion Answering Depiction as an Old Hag," *Louisville Courier-Journal*, 14 Sept. 1953, clipping file, Congregation Adath Israel. Ellen Smith, Jonathan Sarna, and Elka Deitsch provided indispensable help in locating one of the sculptor's twelve-inch bronze copies at Congregation Emanu-El of the City of New York.

28 Quoted in " 'Spirit of the Synagogue,' " brochure, CEE.

29 Rose Kohler, "Art as Related to Judaism," National Council of Jewish Women, 1922, 1, CEE. In this essay (12–13) Kohler also remarked on dramatic changes she observed between 1860 and 1922 in Jewish views with respect to art: "Though there still may be some objection to figures in Synagogue ornamentation [she cites her grandfather's earlier concerns on this subject], it is really remarkable what a change of view now exists among Jews everywhere regarding the utilization of art." Leo Franklin had also addressed this subject in his sermon of Nov. 1919 on the *Synagogue* controversy ("Historical Background," 3); the Reform rabbi attributed the dearth of art "in the Jewish spirit" to a "misconception of the Second Commandment."

30 Kohler, "Art as Related to Judaism," 12, CEE.

31 Rose Kohler, "Religious School Work," Records of the Fifth Triennial Convention of the National Council of Jewish Women, 1908, 115, CEE. Kohler discerned an aspect of Sargent's work that his Christian audiences did not see; even when he meant to indicate the holy books of Judaism, he assumed an organization of texts based on the Christian canon. In the Jewish canon the prophets appear in the middle; the Christian arrangement of texts places the prophets at the end of an "Old Testament," pointing the way to the messiah and accomplishing the transition between "old" and "new."

32 Franklin, "Historical Background," 8, BPLr.

33 Henry Raphael Gold, in "Panel Removal All a Matter of Law," *Jewish Advocate*, 2 Mar. 1922, 3. Cf. Kohler, "Religious School Work," 115, CEE; and Franklin, "Historical Background," 8, BPLr.

34 "Rabbi Gold Lectures to B. U. Theologians," *Jewish Advocate*, 24 Apr. 1924, 5B.

35 Israel G. Einstein, "The Judaic Beginnings of Christianity," *Jewish Advocate*, 17 Nov. 1921, 3.

36 The "Committee of Citizens," through its representatives, remained actively involved over time in the satisfactory execution of the 1895 contract; see Elliot to Fox and Gale, MHSpc.

37 Arthur D. Hill (corporation counsel) to William F. Kenney (president, board of trustees), 12 Apr. 1920, BPLr, Ms Bos Li B186.1. In the *Trinity* case (in relation to which Hill also acted as corporation counsel), the Massachusetts Supreme Court ruled that a memorial statue of Phillips Brooks by Augustus Saint-Gaudens (erected by contribution of and contract with a committee of citizens) could not be moved from its contractual location to make room for a new statue by Bela Pratt. The monument constituted a "charitable trust"; in a situation in which the specific terms of the contract had been fulfilled, alteration could not be made "upon consideration of policy and convenience." See transcription of "Charles W. Eliot and others *vs.* Trinity Church and others," 21 Jan. 1919–1 Apr. 1919, in BPLr, Ms Bos Li B186.1.

38 Library trustees as quoted in "Jews Offended."

39 Leo M. Franklin to William F. Kenney, 28 Apr. 1920, BPLr, Ms Bos Li 186.1. See also "Extracts from the Records of the Board of Trustees," 6, BPLr. In early May Charles Francis Dorr Belden, the director of the library from 1917 to 1931, sent Augustus Hemenway a copy of Hill's opinion. Hemenway responded: "It would seem very clear that the matter now rests in Mr. Sargent's hands and that the decorations cannot be removed"; Belden to Hemenway, 3 May 1920 and Hemenway to Belden, 4 May 1920, BPLr, Ms Bos Li B180.

40 House No. 1131, 20 Jan. 1922, copy, BPLr, Ms Bos Li B180.

41 Massachusetts Federation of Churches letterhead, MCC; "Program of the Annual Meeting of the Massachusetts Federation of Churches," 1908 and 1910, MCC. Catholic adherents were invited to join the federation but declined; see Harry Levi, *The Great Adventure* (Boston: Temple Israel, 1929), 85. See also Constitution and By-laws, Greater Boston Federation of Churches, as amended up to 1 Nov. 1921, MCC; and Constitution and By-laws of the Massachusetts Federation of Churches, revised Apr. 1919, MCC. The quotation in the text is taken from Rose S. Klein, "John Singer Sargent's Painting—'The Synagogue,' " 6, typescript collation of newspaper clippings relative to the controversy, AJHS.

42 Klein, "John Singer Sargent's Painting," 6–7, AJHS.

43 Ibid., 6.

44 Trustees records, BPLc, vol. 11, 386–87. Alexander Mann was a member of the board of trustees from 1908 to 1923 and president of the board from 1920 to 1923; Arthur Connolly was a board member from 1916 to 1932 and president from 1923 to 1924; and Louis Kirstein was a member of the board from 1919 to 1942 and its president in 1924–25, 1928–29, 1931–32, 1936–37, and 1941–42.

45 See letterhead of Greater Boston Federation of Churches, 1919 and 1920, MCC.

46 The Jewish Coleman Silbert was a Boston attorney active in a number of fraternal and philanthropic organizations.

47 Minutes of "Hearing before the Joint Judiciary Committee In re Removal of Sargent's Synagogue," 27 Feb. 1922, BPLr, Ms Bos Li B180. Murray probably attended the hearing as a representative of the city law department; see Charles F. D. Belden to Arthur D. Hill, 21 Feb. 1922, BPLr, Ms Bos Li B180; and Hill to Belden, 24 Feb. 1922, BPLr, Ms Bos Li B180.

48 The list of speakers included Silbert, Murray, Goldberg, Gold, Levi, Scudder, Richards, Representative Martin Lomasney (a prominent West End Catholic layperson), Francis Slattery (also speaking as a Catholic), Representatives Adlow, Lancaster, Conroy, Dwyer, Hume, and Finkelstein, Louis Hurwich (representing the city's Jewish schools), Rabbi David M. Shohet, and City Assistant Corporation Counsel Samuel Silverman. An administrator for the West End Young Men's Christian Association registered that group's support for Silbert's bill; the Amos Lodge of B'nai B'rith was also represented. On the religious affiliations of speakers, see "Silbert's Bill Adopted by the Senate," *Jewish Advocate*, 8 June 1922, 5.

49 *Proceedings of the Thirty-third Annual Confer-
ence of American Rabbis,* 105; and *Proceedings of the Thirty-first Annual Con-
vention of the Central Conference of American Rabbis,* 21–22.

50 Minutes of "Hearing," BPLr.

51 Ibid.

52 On 31 May 1922, before the bill came before the state Senate,
B'nai B'rith sent a statement in its support to the members of the legisla-
ture. See Klein, "John Singer Sargent's Painting," 8, AJHS.

53 "Pass Bill to Seize Sargent's 'Synagogue,' " *American Art News* 20,
no. 35 (10 June 1922):4.

54 Otto Fleischner to Isabella Stewart Gardner, 7 June 1922, ISGM.
No record of a letter or call from Gardner survives, but her degree of es-
teem and affection for Sargent at this time would suggest that she did re-
spond in his defense. A series of letters from Sargent to Otto Fleischner
(BPLr and BPLf) indicates the intimacy of the acquaintance between
artist and librarian, a man whom Whitehill (*Boston Public Library,* 186)
described as a "native of Bohemia." Fleischner had been, first, the su-
pervisor of special collections and then, beginning in 1900, assistant li-
brarian.

55 Augustus Hemenway to Channing H. Cox, 8 June 1922, BPLr. In
the Jewish press in the same year, political advertisements advocating
the reelection of the Republican Cox noted that Cox "made possible
the passage of the so-called 'Sargent-Bill,' which calls for the removal
from our Public Library of the painting known as 'The Synagogue' be-
cause of its offensiveness to the Jewish people"; see "Re-elect Lodge
and Cox: They Kept Faith with Us; Let Us Keep Faith with Them!"
Jewish Advocate, 1 Nov. 1922. The election occurred just after the passage
of the initial legislation and before its repeal. Seven months later Cox
appointed the highly qualified Silbert, a practicing attorney, to the posi-
tion of public administrator of Suffolk County (see notice in *Jewish Ad-
vocate,* 26 July 1923). Boston Jews had begun to organize politically in
1905 and by 1922 had significant political power in the city and state.
Elihu Stone, who placed the campaign ads in the *Jewish Advocate,* was, at
this time, chairman of the Republican State Committee Auxiliary. See
William Braverman, "The Emergence of a Unified Community,
1880–1917," in Jonathan D. Sarna and Ellen Smith, eds., *The Jews of
Boston* (Boston: Combined Jewish Philanthropies of Greater Boston,
1995), 84–88.

56 For a list of those who spoke at the hearing, see "Silbert's Bill
Adopted by the Senate," 1, 5; see also Klein, "John Singer Sargent's
Painting," 8, AJHS.

57 "Silbert's Bill Adopted by the Senate," 1, 5; and Minutes of
"Hearing," BPLr.

58 James Garfield Moses to librarian, 14 June 1922, BPLr, Ms Bos Li
B186.2. The controversy did not, then, pit Jew against Christian.

59 Lincoln Kirstein, *Mosaic: Memoirs* (New York: Farrar, Straus and
Giroux, 1994), 26–27; see also Nicholas Fox Weber, *Patron Saints: Five
Rebels Who Opened America to a New Art, 1928–1943* (New York: Alfred
A. Knopf, 1992), 10–13, 19. In the final analysis, the *Synagogue* contro-
versy had as much to do with class and culture as with race or religion.
The upper-class, generally assimilated Jews among Sargent's supporters,
patrons, and friends (Louis Kirstein and Philip Sassoon, e.g.), would find
nothing objectionable in his elite monocultural assemblage in Boston.

60 Sargent to Mr. Fayon[?], 23 Nov. 1919, Feinberg Collection,
AAA, reel D10, fr. 1438.

61 "Pass Bill to Seize Sargent's 'Synagogue,' " 4.

62 Minutes of the Boston Art Commission, 1922, 43, Boston Art
Commission Papers, AAA, reel 3136.

63 *Proceedings of the Thirty-third Annual Convention,* 105.

64 "Pass Bill to Seize Sargent's 'Synagogue,' " 4. See also "Governor
Signs Law to Take 'Synagogue': Massachusetts Senate Follows House in
Passing Bill for Removal of Sargent Mural, But It May Be Held Void,"
16 June 1922, unidentified newspaper clipping, BPLf.

65 The court's decision was reported in "John Singer Sargent Dies
during Sleep," *Boston Herald,* 16 Apr. 1925, 1, 6.

66 Arthur D. Hill to Thomas A. Fox, 21 Oct. 1922, MHSpc; and Hill
to Fox, 30 Oct. 1922, MHSpc.

67 Payson Smith to Arthur T. Connolly, 21 Nov. 1923, BPLr, Ms
Bos Li B18b.2.

68 "Recommendations of the Commissioner of Education," as re-
ported in House 151, Jan. 1924, BPLr, Ms Bos Li B18b.2.

69 On 6 Dec. 1923 a newspaper article reported that the "Sargent
Painting Dispute [Had Been] Renewed"; Klein, "John Singer Sargent's
Painting," 11, AJHS.

70 Arthur D. Hill to Thomas A. Fox, 15 Mar. 1924, MHSpc.

71 House Bill 1398, copy enclosed in Hill to Fox, 15 Mar. 1924,
MHSpc.

72 Commonwealth of Massachusetts, chap. 220 of the Acts of 1924,
10 Apr. 1924 BPLr, Ms Bos Li B18b.2.

73 "John Singer Sargent," unidentified newspaper clipping, dated
Feb. 1924, BPLf. See also "Seek Vandal in Picture Inking," *Boston Her-
ald,* 22 Feb. 1924, 1; "Clean Ink from 'The Synagogue,' " *Boston Herald,*
23 Feb. 1924; and Philpott, "Doubt Vandals Spotted Mural." The latter
article argued that wet rain gear inadvertently splattered the panel. This
was not the first physical attack on a Sargent painting. His portrait of
Henry James had been slashed in 1914 in an attack aimed neither at
James nor Sargent; see "Suffragette Butchery of Art," *Literary Digest* 4,
no. 24 (13 June 1914): 1434.

74 "Ink," *Library Life* (Boston Public Library), 15 Mar. 1924, BPLr,
Ms Bos Li B18b.2. See also Herbert E. Thompson to Charles F. D.
Belden, 25 Feb. 1924, BPLr, Ms Bos Li B180.

75 Fox, "John S. Sargent," 48–49, BA.

76 Frederick Coburn, "John Singer Sargent Is Sphinx of Modern
Celebrities," *Boston Herald,* [1922?], ISGM Sargent Clippings File; see
also Coburn, "John Singer Sargent, Bostonian," 8.

77 Sargent to Sally Fairchild, 2 Jan. [1898], BA. Further evidence of
his disinclination to enter into argument or to acknowledge criticism
can be found in Sargent to Otto Fleischner, Sat. [1917?], BPLf; and Sar-
gent to Otto Fleischner, Sun. [1917?], BPLf.

78 Sargent to Julian Alden Weir, 7 May 1916, Harold B. Lee Library,
Brigham Young University, Provo, Utah. I am grateful to Marian War-
dle for calling this letter to my attention.

79 Sargent to William Rothenstein, 6 Dec. 1901, as quoted in
Rothenstein, *Men and Memories: A History of the Arts, 1872–1922* (New
York: Tudor Publishing Company, 1939), 2:8. See also "Sargent, the
Artist, Arrives."

80 "Pass Bill to Seize Sargent's 'Synagogue,' " 4.

81 C. Lewis Hind, "Sargent: Cable Correspondence from London,"
Outlook 139, no. 17 (29 Apr. 1925): 648.

82 Simpson, "Sargent and His Critics," esp. 31, 32, 39, 67.

83 Henry McBride, "The Silent Sargent," *New York Herald Tribune*, 11 Dec. 1921, as quoted in Oustinoff, "Critical Response," 232.

84 Sargent to H. F. Jenkins, Esq., 28 Jan. 1917, BA.

85 Sargent to Little, Brown and Company, 18 Feb. 1921, BA.

86 Sargent to Mrs. Fuller[?] Maitland, Friday [n.d.], SUL; see also Sargent to George Henschel, Tuesday [n.d.], AAA, reel D10, fr. 1459. The practice of disposing of letters after acknowledging them accounts for the dearth of surviving letters *to* Sargent *from* other individuals. Fortunately the recipients of Sargent's letters generally did not follow the same practice.

87 Fox, untitled typescript, 53, BA.

88 Unidentified clipping from a New York newspaper, BA.

89 See Sargent to Mary Hunter, 31 Oct. 1917, AAA, reel D169, frs. 321–23; Charteris, *Sargent*, 157; and Blashfield, "John Singer Sargent—Recollections," 645. For a good summary of this decision, see Olson, *Sargent*, 227–28.

90 Sargent to Miss Violet Maxse, Wednesday [n.d.], SUL.

91 "John Singer Sargent, Master of Portraits and Mural Decoration," *Boston Evening Transcript*, 15 Apr. 1925, 1:10.

92 See, for example, Charles E. L. Wingate, "Boston Letter," *Critic*, 27 July 1895, 61; M. H. Morgan (Classics Department, Harvard University) to Boston Public Library, 6 May 1903; Horace Wadlin (librarian) to Sargent, 16 May 1903; Sargent to Horace Wadlin, 17 May [1903], all three letters at BPLr, Ms Bos LI B18a.6; and "Sargent's Pictures in the Boston Library" (editorial), *Boston Sacred Heart Review*, 16 May 1903, BPLr.

93 Rabbi Charles Fleischer to Otto Fleischner, 13 Feb. 1903, BPLr, Ms Bos Li B18a.5.

94 Sargent to Thomas A. Fox, Friday [1903], BA.

95 "Sargent's Panel of 'The Church,'" *Boston Evening Transcript*, 16 Oct. 1919, 20; and "Changes in Sargent's Panel," *Boston Evening Transcript*, 17 Oct. 1919.

96 Dini, "Public Bodies," 115–118. Like *Synagogue*, Gautreau is completely swathed in fabric, with no hint of her earlier "exposure."

97 Sargent could have referred to his edition of *Helps to the Study of the Bible*, pl. 121, for an illustration of this figure.

98 "Real Interpretation."

99 Silbert as quoted in "John Singer Sargent Dies during Sleep."

100 The first quotation is from Fox, untitled typescript, 5, BA; and the second is from "Unveil New Sargent Panels Today," BPLf.

101 Simpson, "Sargent and His Critics," 57–59, 68.

102 "Silbert's Bill Adopted by the Senate," 1.

103 Frederick Coburn as quoted in "Pass Bill to Seize Sargent's 'Synagogue,'" 4.

104 D[ownes], "Two New Panels by Sargent,"; *Handbook* (1926), 55–58; "John Singer Sargent's Second Wall Painting in the Library"; and Baxter, "Sargent's 'Redemption,'" 131.

105 Sargent to Evan Charteris, 24 Oct. 1919, in Charteris, *Sargent*, 209.

106 Charles Belden to Rilla E. Jackman, 12 July 1924, BPLr, Ms Bos Li B180.

107 Violet Oakley, "An Address on the Work of John Singer Sargent," delivered to the Philadelphia Art Alliance, 27 Apr. 1925, BPLr,

Ms Bos Li B18b.4. Oakley repeated this address at the opening of the "Grand Central Exhibition" in Atlanta on 16 May 1925.

108 Sargent to Fox, 12 May 1918, BA. In this letter Sargent indicated that he was still at work on the east wall and that he was thinking of the three paintings (Sermon, *Synagogue,* and *Church*) in relation to one another. He wrote: "I think you had the exact measures taken of the Library big panel, with border, and of the panels inside the shrines—if so I wish you could send these to me here [at his Tite Street, London, home]. If I am left here, I may go on with these—and I should like to have the other photos that [Havelock] Pierce was doing."

109 Fairbrother, *Sargent and America,* 230; and Fox, untitled typescript, 10, BA. Fox would later contradict this assessment; Thomas A. Fox to Charles Belden, 9 Mar. 1931, BPLr, Ms Bos Li B186.3. Though earlier editions of the library's *Handbook* acknowledged the cycle's incompletion, the 1977 edition made no mention of Sermon on the Mount and suggested that the 1919 installation completed the cycle.

110 According to the terms of the 1895 contract with the "Committee of Citizens," Sargent was to be paid in three five-thousand-dollar installments. The amount decided by the court in 1926, then, represented the final payment of the three and not the full amount of the 1895 contract as I mistakenly suggested elsewhere; see Promey, "Sargent's Truncated *Triumph*," 238; "Library Given Old Funds to Preserve Sargent Paintings: Public Subscription of $5,000. Raised Twenty Years Ago to Complete Murals Disposed of by Judge Pierce," *Boston Evening Transcript,* 5 Nov. 1926; and "$5,000. Sargent Fund for Care of Murals," *Chicago Evening Post,* 16 Nov. 1926. See also Boston Public Library documentation (including newspaper clippings) in BPLr, Ms Bos Li B18b.3; and Arthur D. Hill to Thomas A. Fox, 27 Oct. 1925, MHSpc. Hill's office apparently initiated the petition to the state Supreme Court. Hill also sought the advice of Augustus Hemenway and Holker Abbot.

111 Sargent to Benton, 8 Oct. 1915, BPLr; Sargent to Fox, 12 May 1918, BA.

112 Fox to Belden, 9 Mar. 1931, BPLr. Ralph Curtis, Martin Birnbaum, Gutzon Borglum, and Walter Tittle, for example, agreed with Fox on this matter.

113 On Sargent's desire that the cycle be "seen and judged as a unified whole," see, e.g., Fox, untitled typescript, BA.

114 The west wall lunettes were the last major images completed for the 1916 installation. On the order of execution of the images installed in 1916, see Sargent to Benton, 29 Apr. 1914, BPLr.

115 See, for example, Charles H. Caffin, *The Story of American Painting* (New York: Frederick A. Stokes Company, 1907), 323; Watson, "Sargent—Boston—and Art," 195; and "Mural Painting in This Country since 1898," *Scribner's Magazine* 40, no. 5 (Nov. 1906): 637–40. I am indebted to Richard Murray for observations along this line; see also Erica Hirschler, "A Quest for the Holy Grail: Edwin Austin Abbey's Murals for the Boston Public Library," *Studies in Medievalism* 6 (1994): 36, 46.

116 In 1925 Forbes Watson ("John Singer Sargent," 243) commented emphatically: "The most adventurous contemporary art is far removed in its aims from the work of John Singer Sargent."

117 See, e.g., Ann Douglas, *The Feminization of American Culture* (New York: Avon Books, 1977); David Morgan, *Visual Piety: A History and Theory of Popular Religious Images* (Berkeley: University of California Press, 1998); and John S. Cornell, "What Is a Religious Painting? German Modernism, 1870–1914," *Nineteenth-Century Contexts* 14, no. 2 (1990): 128–29.

118 Kate P. Hampton, "The Face of Christ in Art," *Outlook* 61, no. 13 (1 Apr. 1899): 735–48 (I am grateful to Kristin Schwain for bringing this article to my attention). On Sargent and Tissot, see Barbara Dayer Gallati, "Controlling the Medium: The Marketing of John Singer Sargent's Watercolors," in *Masters of Color and Light: Homer, Sargent, and the American Watercolor Movement,* ed. Linda S. Ferber and Barbara Dayer Gallati, exh. cat. (New York: Brooklyn Museum of Art, 1998), 132–37. In the United States, Tissot's carefully researched illustrations were understood in relation to "scientific" scholarship on the historical Jesus. The Brooklyn Museum purchased the images by public subscription in 1900. Sargent remarked on their literary, religious, and scholarly character but emphasized the "aesthetic standpoint" as the most significant; William Henry Fox, "John Singer Sargent and the Brooklyn Museum," *Brooklyn Museum Quarterly,* July 1925, 112. See also Edith Coues, "Tissot's 'Life of Christ,' " *Century Magazine* 51, no. 2 (Dec. 1895): 289–302.

119 Here Frank V. Du Mond's *Christ and the Adulteress,* in particular, was praised for its "distinctly Jewish type both in face and attitude" and for its perceived attack on "dogmatic" orthodoxy; William Griffith, "Christ as Modern American Artists See Him," *Craftsman* 10, no. 3 (June 1906): 292; see also R. N. C., "New Conceptions of the Christ," *Brush and Pencil* 17, no. 4 (Apr. 1906): 148–57.

120 Volk, "Sargent in Public," 53–54.

121 On Sybil Sassoon's hands, see Fairbrother, *Sargent and America,* 276 n. 61; on Philip's call, see "Sargent Dies in His Sleep," *Boston Evening Transcript,* 15 Apr. 1925, 1.

122 For an excellent discussion of the Wertheimer portraits, see Kathleen Adler, "Portraits of the Wertheimer Family," in Linda Nochlin and Tamar Garb, eds., *The Jew in the Text: Modernity and the Construction of Identity* (London: Thames and Hudson, 1995), 83–96.

123 "Wills Nine Sargent's to British Nation," *Art News,* 13 Jan. 1923, BPLf; and Charles Aitken, "Mr. Asher Wertheimer's Benefaction," *Burlington Magazine* 29, no. 161 (Aug. 1916): 216–20.

124 "Wertheimer Portraits Discussed in House of Commons," *Jewish Advocate,* 5 Apr. 1923. The portrait of Asher Wertheimer (1898) had been exhibited in Boston at Copley Hall in 1899.

125 Hind, "Sargent: Cable Correspondence," 648. See also "Wertheimer Portraits Discussed in House of Commons"; Rothenstein, *Men and Memories,* 1:195, 2:35–36; Adler, "Portraits of the Wertheimer Family," 83–96; Olson, *Sargent,* 259–60; and Fairbrother, *Sargent and America,* 276 n. 61.

126 John Higham, *Send These to Me: Immigrants in Urban America* (1975; rev. ed., Baltimore: Johns Hopkins University Press, 1984), 99–100; David A. Gerber, "Anti-Semitism and Jewish-Gentile Relations in American Historiography and the American Past," in David A. Gerber, ed., *Anti-Semitism in American History* (Urbana: University of Illinois Press, 1986), 4–7; and Benny Kraut, "A Wary Collaboration: Jews, Catholics, and the Protestant Goodwill Movement," in *Between the Times,* ed. Hutchinson, 195–6.

127 Sargent to Charteris, in Charteris, *Sargent,* 209. See also Fairbrother, *Sargent and America,* 276 n. 61; and Olson, *Sargent,* 208–9, 258–59. Sargent's position was not unique; it was a classic restatement of a relatively constant theme in nineteenth-century American Christianity. See Jonathan D. Sarna, "The 'Mythical Jew' and the 'Jew Next Door' in Nineteenth-Century America," in Gerber, *Anti-Semitism in American History,* 57–78.

128 Wilson, *Ideology and Experience,* 468–72, 475, 512–13. On the range of interpretations, historical and contemporary, of Renan's work in this regard and on his repudiation of aspects of his own thought, see Bierer, "Renan and His Interpreters," 375–80; Michèle C. Cone, "Vampires, Viruses, and Lucien Rebatet: Anti-Semitic Art Criticism during Vichy," in Nochlin and Garb, *Jew in the Text,* 177–78; Adrian Rifkin, "Parvenu or Palimpsest: Some Tracings of the Jew in Modern France," in Nochlin and Garb, *Jew in the Text,* 280; Susan Rubin Suleiman, "The Jew in Jean-Paul Sartre's *Réflexions sur la question juive:* An Exercise in Historical Reading," in Nochlin and Garb, *Jew in the Text,* 214; and Robert Singerman, "The Jew as Racial Alien: The Genetic Component of American Anti-Semitism," in Gerber, *Anti-Semitism in American History,* 104.

129 Susannah Heschel, *Abraham Geiger and the Jewish Jesus* (Chicago: University of Chicago Press, 1998), 127–63, 226–27.

130 Wilson, *Ideology and Experience,* 470–72.

131 "La race, comme nous l'entendons, nous autres, historiens, est donc quelque chose qui se fait et se défait. L'étude de la race est capitale pour le savant qui s'occupe de l'histoire de l'humanité. Elle n'a pas d'application en politique. La conscience instinctive qui a présidé à la confection de la carte d'Europe n'a tenu aucun compte de la race, et les premières nations de l'Europe sont des nations de sang essentiellement mélangé"; Ernest Renan, *Qu'est-ce qu'une nation et autres écrits politiques* (Paris: Imprimerie Nationale, 1996), 234. See also Ivan Hannaford, *Race: The History of an Idea in the West* (Baltimore: Johns Hopkins University Press, 1996), 303. As early as *Life of Jesus,* though Renan organized much of his thinking around the idea of race, he recognized some of the difficulties inherent in racial categories. In the book's first chapter, in a note appended to the statement "to the Semitic race belongs the glory of having produced the religion of humanity," Renan qualified his usage: "This word [Semitic] simply designates here those nations which speak or have spoken one of the languages called Semitic. Such a designation is very defective; but it is one of those words like 'Gothic architecture' and 'Arabic numerals' which we must preserve in order to be understood even after the error which they imply has been demonstrated"; Renan, *Life of Jesus,* 54; and in the French original "C'est la race sémitique qui a la gloire d'avoir fait la religion de l'humanité"; and in Renan's note: "ce mot désigne simplement ici les peuples qui parlent ou ont parlé une des langues qu'on appelle sémitiques. Une telle désignation est tout à fait défectueuse; mais c'est un de ces mots, comme 'architecture gothique,' 'chiffres arabes,' qu'il faut conserver pour s'entendre, même après qu'on a démontré l'erreur qu'ils impliquent"; Renan, *Vie,* 5–6.

132 Bierer, "Renan and His Interpreters," 375.

133 Edel, *Henry James,* 188–89.

134 Ibid., 484–87.

135 Bierer, "Renan and His Interpreters," 378.

136 Evan Charteris, "John Sargent: An Appreciation," 1925, typescript, BA.

137 Karl Beckson, *London in the 1890s: A Cultural History* (New York: W. W. Norton and Company, 1992), 278; Wilson, *Ideology and Experience,* 474.

138 Heschel, *Abraham Geiger,* 127, 148–50.

139 Gerber, "Anti-Semitism and Jewish-Gentile Relations," 21, 22, 27, 29. For a contemporary contextual description and summary of the controversy through 1922, see *Proceedings of the Thirty-third Annual Convention of the Central Conference of American Rabbis,* 104–5.

140 Coburn, quoted in "Pass Bill to Seize Sargent's 'Synagogue,' " 4.

141 Gerber, "Anti-Semitism and Jewish-Gentile Relations," 24; Leon A. Jick, "From Margin to Mainstream, 1917–1967," in Sarna and Smith, *Jews of Boston,* 94–95; Marcia Graham Synnott, *The Half-Opened Door: Discrimination and Admissions at Harvard, Yale, and Princeton, 1900–1970* (Westport, Conn.: Greenwood Press, 1979); Louis Joughin and Edmund M. Morgan, *The Legacy of Sacco and Vanzetti* (Princeton: Princeton University Press, 1976); and Albert Lee, *Henry Ford and the Jews* (New York: Stein and Day, 1980). Louis Kirstein, who supported Sargent at the public library, opposed Abbott Lowell on discriminatory admissions at Harvard and on the Sacco and Vanzetti case. After Sacco's execution, Kirstein hired Sacco's son as a family chauffeur; see Lincoln Kirstein, *Quarry: A Collection in Lieu of Memoirs* (Pasadena, Calif.: Twelvetree Press, 1986), 35.

142 Sargent to Mary Hunter, 15 Oct. 1919, AAA, reel D169, frs. 362–64. That Sargent entertained classist sensibilities in combination with his general democratic inclinations is much easier to document than his specific position on race.

143 Gerber, "Anti-Semitism and Jewish-Gentile Relations," 24. For population statistics, see Colin Holmes, *Anti-Semitism in British Society, 1876–1939* (New York: Holmes and Meier Publishers, 1979), 3; and Sarna and Smith, *Jews of Boston,* app. A, 329.

144 Arthur Mann, "Immigration to Acculturation," in Luedtke, *Making America,* 69.

145 Singerman, "Jew as Racial Alien," 114. At one point the league considered changing its name to the Eugenic Immigration League. Beginning in 1912 Harvard's president Abbott Lawrence Lowell was national vice-president of the organization for a time; Marcia Graham Synnott, "Anti-Semitism and American Universities: Did Quotas Follow the Jews?" in Holmes *Anti-Semitism in American History,* 238. See also Barbara Solomon, *Ancestors and Immigrants: A Changing New England Tradition* (Cambridge: Harvard University Press, 1956).

146 Mann, "Immigration to Acculturation," 74.

147 Henry Samuel Levinson, *The Religious Investigations of William James* (Chapel Hill: University of North Carolina Press, 1981), 5.

148 Singerman, "Jew as Racial Alien," 116; and Ludmerer, "Genetics," 59–81.

149 Higham, *Send These to Me,* 54. See also Mann, "Immigration to Acculturation," 74–75.

150 It is important to note here that Jews, too, occasionally opposed the new immigrants as social and economic threats; Higham, *Send These to Me,* 105.

151 Sander Gilman comments in this regard on perceptions of the "swarthiness" of Jews, *The Jew's Body* (New York and London: Routledge, 1991), 171–73.

152 Higham, *Send These to Me,* 46, see also 45–47. This is not to say that color was insignificant—simply that a sort of color indeterminacy emerged from late-nineteenth-century assessments of Jewishness; see Tamar Garb, "Modernity, Identity, Textuality," in Nochlin and Garb, *Jew in the Text,* 22, 25; and Bryan Cheyette, "Neither Black nor White: The Figure of 'the Jew' in Imperial British Literature," in Nochlin and Garb, *Jew in the Text,* 31, 39.

153 Gail Bederman, *Manliness and Civilization: A Cultural History of Gender and Race in the United States, 1880–1917* (Chicago: University of Chicago Press, 1995), 28. It was only with the modern period that Jewishness had become a matter of race rather than religion; see Garb, "Modernity, Identity, Textuality"; and Ludmerer, "Genetics," 62–71.

154 Mann, "Immigration to Acculturation," 74–75.

155 Stanley Coben, "The Assault on Victorianism in the Twentieth Century," *American Quarterly* 27, no. 5 (Dec. 1975): 610–13.

156 Benton, *Working of the Boston Public Library,* 40.

157 Ibid., 23, 40–41, 59; and Wadlin, *Public Library,* 56, 115.

158 "Real Interpretation," 1.

159 "Why the Bible Should Not Be Read in the Public Schools" (New York: Central Conference of American Rabbis, 1922); and Eugene Lipman, "The Conference Considers Relations between Religion and the State," in Bertram Wallace Korn, ed., *Retrospect and Prospect: Essays in Commemoration of the Seventy-fifth Anniversary of the Founding of the Central Conference of American Rabbis, 1889–1964* (New York: Central Conference of American Rabbis, 1965), 114–15. Lipman (118) mentions the *Synagogue* controversy as "an interesting merger of the church-state problem and antagonism to Judaism."

160 See, for example, "Attendance at Christmas Exercises Optional: Position of Mr. Hurwich Heeded—Jewish Children Need Not Participate," *Jewish Advocate,* 16 Dec. 1920, 1; and "Religion in Our Public Schools," *Jewish Advocate,* 1 Jan. 1920, 4.

161 Kraut, "Wary Collaboration," 193–230, esp. 195, 208.

162 Coffin, "Sargent and His Painting," 172. Erica Hirschler notes the use of racial terms in contemporary interpretations of Edwin Austin Abbey's *Quest of the Holy Grail;* see Hirschler, "Quest for the Holy Grail," 47.

163 Brinton, "Sargent and His Art," 284. Comparing Sargent's portraits of Jews with Rembrandt's portraits of Jews, Brinton asserted (283) that "as a painter of Semitic types [Sargent] has scarcely had an equal since the day their greatest interpreter lived and suffered in the garrets and pot-houses of Amsterdam." See also Leila Mechlin, "The Sargent Exhibition," *American Magazine of Art* 15, no. 4 (Apr. 1924): 172–73.

164 Frederick W. Coburn, "Sargent's War Epic," *American Magazine of Art* 14 (Jan. 1923): 6. As Jane Dini ("Public Bodies," 161–65) demonstrates, the homogeneity of Sargent's soldiers was visually consistent with Harvard president Abbott Lawrence Lowell's restrictive, assimilationist agenda. Lowell commissioned the two Widener paintings in 1922 as a World War I memorial. On the distinctive and opposing politics of race and immigration held by the two Harvard presidents whose portraits Sargent painted (*Abbott Lawrence Lowell,* 1923 and *Charles William Eliot,* 1907), see Dini, "Public Bodies"; and Synnott, *Half-Opened Door,* 26–57.

165 Larry C. Miller, "William James and Ethnic Thought," *American Quarterly* 31, no. 4 (Fall 1979): 533–55, esp. 536.

166 Kraut, "Wary Collaboration," 200.

167 Ibid., 196.

168 Leo Franklin, Harry Levi, Kaufmann Kohler, Henry Gold, and Doremus Scudder were all strong advocates for Jewish-Christian cooperation.

169 The Federal Council (with links to the Federation of Churches at the state or regional and local levels) was founded in 1908 and represented, by 1920, "thirty-one [Protestant] denominations, 149,000 Protestant churches, and 19,500,000 members"; "Churches Flay Anti-Semitic Movement," *Jewish Advocate,* 9 Dec. 1920, 1. See also *American Jewish Yearbook* 23 (1921–22); and Robert A. Schneider, "Voice of Many Waters: Church Federation in the Twentieth Century," in Hutchison, *Between the Times,* 95–121.

170 Kraut, "Wary Collaboration," 203.

171 Arthur Mann, ed., *Growth and Achievement: Temple Israel, 1854–1954* (Cambridge, Mass.: Riverside Press, 1954), 91–92. See also Levi, *Great Adventure,* esp. 85; and Harry Levi, "Judaism," in *Fifty Years of Boston: A Memorial Volume* (Boston: Tercentenary Committee, 1932), 617–25. So popular was Levi's preaching during these years that non-Jews as well as Jews filled Temple Israel's pews.

172 See, for example, Charteris, *Sargent,* 252; Coffin, "Sargent and His Painting," 169; Olson, *Sargent,* 69. Sargent was dismayed when he feared dancer Carmencita was losing her distinctive "Spanishness"; Sargent to Miss Violet Maxse, Friday, n.d., SUL. Birnbaum (*Sargent,* 33) mentioned that the artist kept a scrapbook of "aboriginal types," and Sargent was much taken with the performances of Ruth Draper, an "interpretive artist" whose repertoire included a range of ethnic "types." Sargent sketched Draper at least three times, once as herself and the other two times as different "types."

173 Watson, "John Singer Sargent," 245. Watson further noted that the artist "could also bring out with extraordinary clarity the accentuated characteristics of those sitters who, having marked peculiarities, attracted him most." Kathleen Adler argues that Sargent was given to excess not just in his Jewish portraits but in portraiture in general; see Adler, "Portraits of the Wertheimer Family," 90, 94.

174 Celia Betsky, "Inside the Past: The Interior and the Colonial Revival in American Art and Literature, 1860–1914," in Alan Axelrod, ed., *Colonial Revival in America* (New York: W.W. Norton and Company, 1985), 266–67, 274–75; on the relation of colonial revival and immigration, see also William B. Rhoads, "The Colonial Revival and the Americanization of Immigrants," in Axelrod, *Colonial Revival,* 341–61.

175 Small, *Handbook of the New Library of Congress,* 25.

176 Sargent made similar modifications in the features and skin color of an African American model for the Museum of Fine Arts murals.

177 See Renan, *Life of Jesus,* 185. Sargent executed the sketch of Jesus with an infant (fig. 112) around 1914, after moving *Synagogue* and *Church* to the wall panels but before conceiving the pronounced architectural "shrines" that would help distinguish them from *Sermon.*

178 *Handbook* (1920), 82–83.

179 See Lears, *No Place of Grace,* 142–47, 188, see also 108, 115.

180 Charteris, *Sargent,* 218; to Gardner he wrote: "Each is interesting in himself, but united we will fall," 9 Sept. [1920], ISGM.

181 In the mid-1890s in the United States, the notion of racial typing was so widely accepted and so intimately connected to new academic disciplines in the social sciences that the decoration of the new Library of Congress included not only Blashfield's "progressive" *Evolution of Civilization* with "Judea" representing religion, but also a series of "ethnological heads ornamenting the keystones of the first-story . . . windows of the Entrance Pavilion"; Small, *Handbook of the New Library of Congress* 13–15. See also William A. Coffin, "The Decorations in the New Congressional Library," *Century Magazine* 53, no. 5 (Mar. 1897): 649–711, esp. 698; and Gertrude Lynch, "Racial and Ideal Types of Beauty," *Cosmopolitan* 38, no. 7 (Dec. 1904): 223–33, where the author notes that the "Jewish race, by its law of exclusion, has preserved its racial type almost in entirety, and the Hebrew beauty of today . . . might be a Ruth waiting for Boaz, an Esther, a Rachel or a Leah" (228).

182 Linda Nochlin, "Starting with the Self: Jewish Identity and Its Representation," in Nochlin and Garb, *Jew in the Text,* 13, 19.

183 Eichler as quoted in "Jews Offended," 30. A few years later Lincoln Kirstein claimed that Ben Shahn selected him (Kirstein) to represent a "Jewish ethnic type" in Diego Rivera's Rockefeller Center mural, largely on the basis of Kirstein's self-described "beak"; Kirstein, *Quarry,* 63.

184 Promey, "Sargent's Truncated *Triumph,*" 239–47.

185 Gilman, *Jew's Body,* 181.

186 John J. Appel, "Jews in American Caricature: 1820–1914," *American Jewish History* 71, no. 1 (Sept. 1981): 104, 110.

187 Appel, "Jews in American Caricature," 117. See Nochlin, "Starting with the Self," 13, 19.

188 Lisa Marcus, "May Jews Go to College?" paper delivered at the annual conference of the American Studies Association, Washington, D.C., Nov. 1997.

CHAPTER 6: SYNAGOGUE, CHURCH, AND THE SELF CONCEALED

1 Fox, untitled typescript, 9, BA.

2 Spaid, "Reporter Goes to Church"; John Ruskin, "Ariadne Fiorentina," 1872, as quoted in Seymour, *Michelangelo,* 162; H. W. Parke, *Sibyls and Sibylline Prophecy in Classical Antiquity,* ed. B. C. McGing (London and New York: Routledge, 1988), 71. Sargent had little use for Ruskin's linking of morality to art; Ormond, "Sargent and Vernon Lee," 169.

3 Kirstein, *Quarry,* 68; and idem, *Mosaic,* 26. Though he does not pursue this idea and though his reference remains general, Carter Ratcliff mentions connections between *Synagogue* and the Sistine Chapel; Carter Ratcliff, *John Singer Sargent* (New York: Abbeville Press, 1982), 144.

4 Sargent to Ben del Castillo, 20 June 1875, as quoted in Charteris, *Sargent,* 38.

5 Karen E. Quinn, "Elihu Vedder," in Theodore E. Stebbins et al., *The Lure of Italy: American Artists and the Italian Experience, 1760–1914,* exh. cat. (New York: Harry N. Abrams, 1992), 366. By 1860 Nathaniel Hawthorne, in *The Marble Faun,* assumed his readers' ability to identify as Cumaea the unnamed "Sibyl" that he mentioned in this novel set in Rome; Hawthorne, *Marble Faun,* 320. Sargent and Vernon Lee read Hawthorne's book in Rome in the late 1860s.

6 Sargent to Ben del Castillo, 23 May 1869, as quoted in Charteris, *Sargent,* 11–12.

7 It was Cumaea who accompanied Aeneas to hell (with the Golden Bough) to consult his father and back again. She was not only the priestess of Apollo but also of Diana "in her triple aspect [as Trivia] which included rule of the underworld"; Parke, *Sibyls and Sibylline Prophecy,* 80. Cumaea's books, consulted by the Roman Senate on occasions of extreme emergency, were supposed to have been burned in the Temple of Jupiter in 83 B.C.E. According to John La Farge, Justin called her the "most ancient of sibyls" and both La Farge and Anna Jameson note her Christian renown, as a "pagan" oracle with respect to predictions of a Virgin to come. John La Farge, *The Gospel Story in Art* (New York: Macmillan Company, 1913), 46; Jameson, *History of Our Lord,* 1:245–58. As Shearman notes in relation to Julius II's library ("Vatican Stanze," 382), Apollo sustained associations with libraries as well as with Cumaea; Cumaea was, furthermore, steward of the Sibylline books.

8 La Farge, *Gospel Story,* 21.

9 Ruskin faulted Michelangelo for giving his Cumaean sibyl only one book (apparently missing the three rolls, visible or implied, at her right side) when he thought she should have had nine or six or three. Elihu Vedder's *Cumaean Sibyl* (1875–76) carries three rolls as she strides grimly and resolutely toward Rome. See Quinn, "Elihu Vedder," 366. In *Triumph of Religion*, as *Synagogue*, Cumaea has no books but she decorates a library and, though her crown topples and her scepter has snapped in two, she clutches to her breast the upright and unbroken tablets of the Law.

10 Jameson, *History of Our Lord,* 1:246.

11 Parke, *Sibyls and Sibylline Prophecy,* 79.

12 Ibid., 93.

13 Hartt, *Italian Renaissance Art,* 449.

14 Jameson, *History of Our Lord,* 1:247. Jameson had high praise for Michelangelo's sibyls, in particular, and for their peculiar relation to his genius (253).

15 Hartt, *Italian Renaissance Art,* 449; La Farge, *Gospel Story,* 21, see also 19–62; Ruskin in Seymour, *Michelangelo,* 161–62; and Parke, *Sibyls and Sibylline Prophecy,* 79. Vernon Lee mentions statues of sibyls in the Roman house occupied by the Sargent family; Charteris, *Sargent,* 243–44.

16 Baxter, "Sargent's 'Redemption,' " 131, see also 129–34; and *Handbook* (1920), 56–57.

17 Somewhat closer to *Church*'s affective timbre was another source at Fenway Court: Giovanni Maria Mosca's *Madonna della Ruota della Carità* (1522). Sargent's *Church* takes almost as much from the idea and form of the pietà and various representations of the enthroned Madonna as from the conventional iconography of Ecclesia. The library's allegorical figure is, however, first and foremost Church; she rests on a throne inscribed with the names of the four greater prophets and surmounted by an arc of the four evangelist symbols.

18 Kirstein, *Mosaic,* 26.

19 "Pass Bill to Seize Sargent's 'Synagogue,' " 4.

20 Ibid., 27.

21 One sketch for *Church* (Museum of Fine Arts, Boston, 28.615) suggests that Sargent considered making her a more stylistically fitting counterpart to *Synagogue*. In this sketch, he depicted a mature female figure as *Church,* approximating the final representation of *Synagogue* more closely in age as well as style.

22 Gold, as quoted in "Real Interpretation," 5.

23 Fairbrother, *Sargent and America,* 255, 276 n. 61.

24 Adler, "Portraits of the Wertheimer Family," 86–88. See also Fairbrother, "Sargent's Genre Paintings," 29–49.

25 John Thomas, "*Gassed* and Its Detractors: Interpreting Sargent's Major War Painting," *Imperial War Museum Review,* no. 9 (Nov. 1994): 44; and Charteris, *Sargent,* 210–12.

26 During the month of August Sargent joined the Guards Division at Bavincourt to the south of Arras and painted scenes in and around Arras; in September he moved to the American Division at Ypres on the Belgian front.

27 Olson, *Sargent,* 258. Regulations prohibited artists from being present at the actual front.

28 Charteris, *Sargent,* 212.

29 Sargent to Isabella Stewart Gardner, 28 Dec. [1918], ISGM.

30 R. I. L. to "Tometal" [Thomas Fox], 12 July 1918, BA.

31 Charteris, *Sargent,* 214.

32 Charteris, *Sargent,* 217. See also Olson, *Sargent,* on the artist's participation in the war effort (247–48) and on this commission (258–61).

33 Charteris recalls that the bomb hit during Good Friday mass and that Rose-Marie and sixty-nine others perished at just the point in the service where the celebrant had read from the lectionary for the day: "Father into thy hands I commend my spirit" (*Sargent,* 210); in her essay in Adelson et al., *Sargent Abroad,* Elaine Kilmurray (certainly with Richard Ormond's assent) indicates her current understanding that Rose-Marie was attending a concert at the church. Rose-Marie's brother Guillaume was a church organist; see Violet Ormond to Julie Heyneman, 10 Nov. 1924, Correspondence and Papers of Julie H. Heyneman, BL.

34 Quoted in Patricia Hills, "Painted Diaries: Sargent's Late Subject Pictures," in *John Singer Sargent,* ed. Patricia Hills (New York: Harry N. Abrams, 1986), 206 n. 9; see also Elaine Kilmurray, "Traveling Companions," in Adelson et al., *Sargent Abroad,* 59. In 1913 Rose-Marie had married French art historian Robert André-Michel; he had preceded her in death when he was killed in the war in 1914. Kilmurray notes too that, during the war, Rose-Marie served as a nurse.

35 Sargent to Isabella Stewart Gardner, Friday [5 Apr. 1918], ISGM.

36 On Emily and the war, see Olson, *Sargent,* 247.

37 John Singer Sargent to Emily Sargent, 25 Oct. 1914, Ormond Collection, Sargent Papers, AAA, reel 1407, fr. 1457.

38 Sargent to Otto Fleischner, 4 Oct. 1919, BPLr, Mss Acc 2710(11).

39 Sargent to Thomas A. Fox, 24 Mar. 1919, BA. Sargent wrote this letter from his Tite Street, London, home; he arrived in Boston on 24 Apr. 1919, one month after the letter to Fox. Though the "trial" could not have taken place before 24 Apr., the two paintings were ready by late March.

40 On Vedder's sibyl, see Martha Banta, *Imaging American Women: Idea and Ideals in Cultural History* (New York: Columbia University Press, 1987), 149–51. Another image that may have influenced Sargent's conception of *Synagogue* was George Frederic Watts's *Hope* (1885–86). Watts exhibited this painting of a blindfolded female figure at the Grosvenor Gallery in 1886 where Sargent surely saw it. Watts presented a later version of the image to the Tate Gallery when it opened in 1897; see Warner, *Victorians,* 135–36, fig. 33. A number of critics noted that Sargent's "Old Testament" images "recalled" Watts's work; see, for example, Preserved Smith, "Sargent's New Mural Decorations," *Scribner's Magazine* 71, no. 3 (Mar. 1922): 379. Sargent surely also knew the blindfolded female figures (Justice and Fortune) from Abbey's Harrisburg murals.

41 Helen Vendler's "T. S. Eliot," *Time* 151, no. 22 (8 June 1998): 111–12, recalled this line to my attention. Eliot's poem, like Sargent's painting, represents a pastiche of elements from the past in a distanced style.

42 Thomas, "Gassed," 45.

43 Gold, quoted in "Real Interpretation," 1, 5. In addition to Gold, see, for example, Coburn, "In the World of Art," C8, which compares *Synagogue* and *Church* to Rembrandt and Botticelli (respectively) and notes the "superior allure of tragedy over comedy" and its tendency to "draw one away from the Church to the Synagogue"; and Fairbrother, *Sargent and America,* 255.

44 Paul Fussell, *The Great War and Modern Memory* (London: Oxford University Press, 1975), 40–41.

45 Sargent to Otto Fleischner, Sat. [Oct. 1917], BPLf; and Sargent to Otto Fleischner, Fri. [Oct. 1917], BPLf.

46 Paul Azan, *The Warfare of Today* (Boston: Houghton Mifflin Company, 1918), opp. 142, opp. 322. In July 1918, while Sargent was close by and engaged in the same occupation, American artist Ernest Peixotto produced a series of war paintings; in a contemporary article on his war landscapes, three out of five images reproduced depicted destroyed cathedrals or churches. See Adeline Adams, "Ernest Peixotto's War Landscapes," *American Magazine of Art* 12 (June 1921): 191–96.

47 Quoted in Modris Ekstein, *Rites of Spring: The Great War and the Birth of the Modern Age* (Boston: Houghton Mifflin, 1989), 209.

48 Barr Ferree, *The Bombardment of Reims* (New York: Leonard Scott Publication Company, 1917), 7. A few pages later he continued, "France—that noble treasure-house of architectural masterpieces—had no more noble building than this, so dear to the French people by reason of the supremacy of its art and as the coronation church of their kings, and once the emblem and the expression of their nationality" (16).

49 Maurice Eschapasse, *Reims Cathedral* (Paris: Caisse Nationale des Monuments Historiques, n.d.), 14. At this time Sargent was in Austria, detained from returning to England because the Austrian government now counted his traveling companions, British citizens Adrian and Marianne Stokes, as enemy aliens; Kilmurray, "Chronology of Travels," in Adelson et al., *Sargent Abroad,* 242. In November 1914 Sargent finally returned to London.

50 Willibald Sauerländer, *Gothic Sculpture in France, 1140–1270* (New York: Harry N. Abrams, 1970), 474.

51 Maurice Landrieux, *The Cathedral of Reims: The Story of a German Crime* (London: Kegan Paul, Trench, Trubner and Company, 1920), 24. Landrieux was bishop of Dijon and was archpriest of Reims cathedral from 1912 to 1916.

52 See Sargent to the editor of the *Jewish Advocate;* and Sargent to Charteris, 24 Oct. 1919, in Charteris, *Sargent,* 209. The two other specific sources that Sargent lists, Strasbourg and Notre-Dame de Paris, were cultural victims of earlier conflicts. The south transept of Strasbourg cathedral was severely damaged during the French Revolution. The figures of Synagogue and Church now in place on the south transept portals are nineteenth-century copies; the originals were removed to the Musée de l'Oeuvre Notre-Dame (Sauerländer, *Gothic Sculpture,* 442). In Paris, *Synagogue* appeared on the main portal. Though most figures had been restored before the First World War, the sculpture here was mutilated in 1793 and pillaged again in 1871 by the Communards; Baedeker, *Paris and Environs,* 274–75.

53 Sauerländer (*Gothic Sculpture,* 479) remarks on damage, as well, to a second and less famous set of representations of Synagogue and Church at Reims. This second pair, appearing on the north portal of the west façade, flanked the Crucifixion.

54 Paul Vitry, *La Cathédrale de Reims: Architecture et Sculpture* (Paris: Librairie Centrale des Beaux-Arts, 1919), 1:8, 14–18; 2:41–63, pls. 53–55.

55 Baxter in *Handbook* (1926), 57; A. J. Philpott, "Two Sargent Panels Unveiled at Library," *Boston Globe,* 6 Oct. 1919, Sargent Clippings File, ISGM.

56 Charteris, *Sargent,* 214; see also p. 212 where Tonks reports that Sargent "did a somewhat elaborate oil painting of the ruined Cathedral

and a great many water colours of surprising skill." Letters from Sargent to Mary Hunter dated 19 [Aug. 1918], 5 Sept. [1918], and [10 Oct. 1918] provide accounts of experiences in Arras and Ypres; see AAA, reel D169.

57 That the earlier images were understood in relation to ideas like Frazer's is indicated in the words of Adrian Stokes, Sargent's friend and sometime companion in the Tyrol. Of Sargent's *Tyrolese Interior,* e.g., Stokes maintained, "In an old castle—become farmhouse—he painted a family of peasants at their midday meal, and, in the deserted chapel, a wonderful crucifix—over a confessional—with spouts of blood from the wounds carved in solid wood; and many other things"; quoted in Richard Ormond, "In the Alps," in Adelson et al., *Sargent Abroad,* 79.

58 "The Royal Academy," *American Art News* 17, no. 33 (24 May 1919): 1.

59 On this debate, see Landrieux, *Cathedral of Reims,* 158–62. See also the epigraph to this chapter.

60 Thomas, "Gassed," 47; Richard Ormond, catalogue entry for *Gassed,* in *John Singer Sargent,* ed. Elaine Kilmurray and Richard Ormond, exh. cat. (London: Tate Gallery; Princeton: Princeton University Press, 1998), 263–66.

61 Thomas, "Gassed," 47.

62 Vernon Lee was among those who offered an optimistic interpretation of the inclusion of the soccer game: "Who else has ever expressed the tragedy of war as he has done in his group of gassed soldiers, its horror conveyed without contortion or grimace; and war's tragedy assigned a subordinate and transitory place in the order of things by that peaceful landscape and the game of football in the middle distance. This composition is as majestically serene as some antique frieze; while for the emotions of the beholder it is terrible, like a chapter of Tolstoi"; Lee in Charteris, *Sargent,* 254. Discussing *Gassed* with respect to her analysis of Sargent's Widener murals, Jane Dini considers sport in this painting as an aspect of military strategy for inducing teamwork and a necessary communal spirit, for substituting the worth of the common cause for the value of the individual. Individuals were dispensable, the unit had to survive; Dini, "Public Bodies," 168–72.

63 Fussell, *Great War,* 8, 24–35. See also W. Warren Wagar, *Good Tidings: The Belief in Progress from Darwin to Marcuse* (Bloomington: Indiana University Press, 1972), 148; and May, *End of American Innocence,* 393–94.

64 Cf. Bellah, *Habits of the Heart,* 222.

65 Perhaps there was also a bit of self-aware irony in the artist's decision to paint *this* commandment in particular. Over twenty years earlier he had found his own Moses criticized for a mistake in the Hebrew rendering of the eighth law. Writing to *The Critic* in July of 1895, Charles E. Wingate snidely opined that "any thief who is conversant with the Hebrew language can truthfully say, whenever he extracts a book from the Library shelves, that, according to the very language upon its walls, he finds no provision forbidding such an act." The mistake was quickly corrected; Charles E. Wingate, "Boston Letter," *The Critic,* 27 July 1895, 61.

66 Van Ness, "Sargent and the Unfinished Panel."

67 Charles D. Williams, *The Prophetic Ministry for Today* (New York: Macmillan Company, 1921), 157–63.

68 Thomas, "Gassed," 45.

69 See, for example, Smith, "Sargent's New Mural Decorations," 380; and "Pass Bill to Seize Sargent's 'Synagogue,'" 4.

70 This description of Rose-Marie's features is Richard Ormond's: catalogue entry for *Two Girls in White Dresses, Sargent,* 254. Assigning the features of persons known to the artist or culture was an established con-

vention of mural painting by this time. Sargent followed a pattern set by Michelangelo and Raphael and revived among his contemporaries, e.g., Carolus-Duran and Edwin Blashfield.

71 William Bouguereau's *La Vierge consolatrice* (1877), which visually resembled *Church,* was said to represent the artist's wife grieving over their dead son. Sargent likely saw the Bouguereau at the Salon of 1877 or at the Universal Exposition of 1878. See Driskel, *Representing Belief,* 232.

72 D[ownes], "Two New Panels by Sargent."

73 In Latin, "Quod Moyses velaf Christi doctrina revelat." Emile Mâle, *The Gothic Image: Religious Art in France of the Thirteenth Century* (1913; New York: Harper and Row, 1972), 171; Seymour (*Michelangelo,* 83) discusses this window in relation to typology in the Sistine Chapel.

74 Trevor Fairbrother's work represents the first significant interpretive study of the relation between concealment, revelation, and privacy in Sargent's art; Fairbrother, "Sargent's Genre Paintings," 47: "Being publicly known for images of other people was perhaps Sargent's best way of remaining private himself." On the synonymous use of "unveiling" and revelation among liberal Protestant audiences for *Triumph of Religion,* see Abbott, *Evolution of Christianity,* 256.

75 Renan, *Life of Jesus,* 366.

76 Cortissoz qualified this statement to a certain extent, adding, "but his is a materialism wonderfully refined by intelligence and taste"; Royal Cortissoz, "Books New and Old," *Atlantic Monthly Magazine* 93 (Mar. 1904): 413. On Sargent's "materialism," see also, for example, Cournos, "John S. Sargent," 233.

77 Olson, *Sargent,* 155.

78 Ormond, "Sargent and Vernon Lee," 157.

79 Brinton, "Sargent and His Art," 274.

80 Fox, untitled typescript, 29, BA.

81 So characteristic was this expression that Emily would include it in a letter to Vernon Lee several months after the artist's death: "As John would say, 'further concealment is useless' "; Emily Sargent to Vernon Lee, 9 Sept. 1925, CC. See also, e.g., Sargent to Thomas Fox, 24 Mar. 1919, BA.

82 Jacomb-Hood, "John Sargent," Fox typescript, MHSpc. In 1886 Sargent wrote to Vernon Lee, "The spirit moves me to write to you— inevitibly [sic] illegibly"; Sargent to Vernon Lee, [1886], CC. In 1912 he complained good-naturedly to Mary Hunter about a letter that had gone astray because the address could not be deciphered; it was returned to him some weeks later, but even the return address had puzzled the carrier: the artist's "J. Sargent" was mistaken for "Mr. Hazel" (and Sargent admitted that that was the way it appeared to him too); Sargent to Mary Hunter, [8 Jan. 1912], AAA, reel D169, fr. 263. Finally, for Christmas 1916 a friend sent him note paper with this heading printed across the top: "J. S. S. / SO HARD IT SEEMS THAT ONE MUST READ BE- CAUSE ANOTHER NEEDS MUST WRITE"; Sargent to Mary Hunter, 9 Jan. 1917, AAA, reel D169, fr. 295.

83 Emily Sargent to Thomas A. Fox, 3 May 1925, MHSpc. Sargent's nephew Guillaume Francis Ormond described Emily as John's "ever present and devoted companion" ("Notes on J. S. Sargent by His Nephew," BA); and Stanley Olson referred to her as the wife Sargent never had; Olson, *Sargent,* 198.

84 Fairchild, Diary, 1891, 4–5, DCL.

85 Ibid., 4. According to Fairchild, Sargent's words to her included his assertion that art and politics "can't live together." Henry James, in *The Tragic Muse,* a play Sargent had both read and seen performed in

Boston, also argued for the divorce of art from politics. For James, art was an imperishable "spiritual" resource in a transitory world; politics represented one aspect of that world that had to be resisted in order to produce art; see Viola Hopkins Winner, *Henry James and the Visual Arts* (Charlottesville: University of Virginia Press, 1970), 119–22. Ormond assigned Sargent's cosmopolitanism in art, his borrowing of ideas "from a variety of traditional and contemporary sources," to a similar unwillingness to commit himself to "any one all-embracing aesthetic credo"; Ormond, "Sargent and Vernon Lee," 159.

86 T. J. Jackson Lears, *Fables of Abundance: A Cultural History of Advertising in America* (New York: Basic Books, 1994), 137.

87 Dorothy Barnard posed for some of the draperies in this painting (now in a private collection), but it is Reine's face that appears in all figures for which facial features are legible; Richard Ormond, "In the Alps," 93.

88 Sargent was certainly not the only late-nineteenth-century artist fascinated with veils. The motif was seemingly ubiquitous and represented a range of impulses, variously sacred, secular, sexual, performative, or liminal.

89 Baxter reported, in 1895, that the shrouded Hosea was Sargent's personal favorite (Baxter, "Description of Mural Decorations," 29). If Malachi was indeed modeled after Sargent's own features, in regard to the subject at hand it is surely significant that Sargent paired Malachi with Joel, a prophet whose headdress almost completely obscures his face.

90 It was in large part this layer of colored powders and dyes between Virginie Gautreau and the outside world that fascinated Sargent and that sparked the controversy over the painting. For a brilliant analysis of this painting, see Susan Sidlauskas, "Painting Skin: Decay and Resistance in Sargent's *Madame X,*" paper presented at the annual conference of the College Art Association, New York, 1997.

91 Sargent to Alice Meynell, 5 Feb. [?], SUL. I am grateful to Leigh Culver for bringing this letter to my attention.

92 Walter Tittle, "My Memories of John Sargent," *Illustrated London News,* 25 Apr. 1925, 724. Though the article was written after Sargent's death, the Boston interview it described likely took place between 1917 and 1919; according to Tittle, Sargent called *The Hermit* "one of my most successful efforts" at painting "a landscape with a figure."

93 Sargent to Edward Robinson, 16 Mar. 1911, extract, MMA.

94 Erica Hirschler, "*The Hermit (Il Solitario),*" catalogue entry in Kilmurray and Ormond, *Sargent,* 251. See also discussion of *The Hermit* in Hills, "Painted Diaries," 193–95.

95 Here Sargent represented the heavily mantled Jehovah as a tent sheltering and nurturing the learning child Israel. This was the first east wall lunette that Sargent completed; he exhibited it at the Royal Academy in 1909. *Gog and Magog* he exhibited in 1911; *Messianic Era* he worked on in 1908 and 1909 but did not complete until later.

96 Gammell claims that *Israel and the Law* was Sargent's own favorite composition of all completed images at the library ("Mural Decorations," 43–44).

97 John L. Sweeney, ed., *The Painter's Eye: Notes and Essays on the Pictorial Arts by Henry James* (Cambridge: Harvard University Press, 1956), 220.

98 Cox, "Two Ways of Painting," in *Artist and Public,* 135. Cox contrasted Sargent's *Hermit* with Titian's *Jerome in the Desert.*

99 It is also likely Raffele's visage that appears in *Tramp* (c. 1906; Brooklyn Museum of Art) and *Artist in His Studio* (1904; Museum of Fine Arts, Boston).

100 "J. S. Sargent in New York." In 1902 Charles Caffin, too, had labeled Sargent a "recluse"; Charles H. Caffin, *Masters of American Paintings* (New York: Doubleday, Page and Company, 1902), as quoted in *Retrospective Exhibition of Important Works of John Singer Sargent* (New York: Grand Central Art Galleries, 1924), 9.

101 "We Nominate for the Hall of Fame: John Singer Sargent," *Vanity Fair* 15, no. 5 (Jan. 1921): 48.

102 Ratcliff, *Sargent,* 211.

103 Cox, "Two Ways of Painting," 134–35.

104 Lee in Charteris, *Sargent,* 254–55.

105 Kenyon Cox to Edwin Blashfield, 16 June 1911, in H. Wayne Morgan, ed., *An Artist of the American Renaissance: The Letters of Kenyon Cox, 1883–1919* (Kent, Ohio: Kent State University Press, 1995), 164–65.

106 Martha Banta discusses this painting in relation to a range of pictures that require the beholder to "hunt" for the subject(s); she thus highlights the exactly contemporary issue of a similar kind of pairing of publicity and intimacy; Banta, *Imaging American Women,* 222–29. See also Lears, *Fables of Abundance,* 137–38; and Alexander Nemerov, "Vanishing Americans: Abbott Handerson Thayer, Theodore Roosevelt, and the Attraction of Camouflage," *American Art* 11, no. 2 (Summer 1997): 50–81.

107 Cox, "Two Ways of Painting," 136.

108 For a fascinating discussion of the relation of vision to concealment and sight to blindness, see James Elkins, *The Object Stares Back: On the Nature of Seeing* (New York: Harcourt Brace and Company, 1996), 17–85, 201–35.

109 For insightful analysis of some significant visual qualities of this painting, see Hills, "Painted Diaries," 193; and Hirschler, "*The Hermit,*" 251. Kenyon Cox ("Two Ways of Painting," 136) remarked explicitly on the picture's unusual, "modern," and "exactly square" format.

110 Lawrence Binyon, "The New English Art Club," *Saturday Review* 107 (29 May 1909): 684.

111 Blashfield, "John Singer Sargent—Recollections," 648.

112 Charles Merrill Mount, *John Singer Sargent* (London: Cresset Press, 1957), 329–30. See also Nemerov, "Vanishing Americans"; and Banta, *Imaging American Women,* 225–26. That Sargent pursued a similar set of concerns in his artmaking as well as during the war is clear in such images as *Bed of a Glacial Torrent* (c. 1904; Diploma Collection of the Royal Watercolor Society, London); see Gallati, "Controlling the Medium," 125–26.

113 Solomon J. Solomon, *Strategic Camouflage* (London: John Murray, 1920), vi. See also Charteris, *Sargent,* 213.

114 For identification of this source, I am grateful to Jane Dini. Coincidentally, Rose Kohler, too, admired the Jewish Solomon's art and read and commented upon his book; Kohler, "Art as Related to Judaism," 1, CEE.

115 Elkins, *Object Stares Back,* 20–21, 41.

116 Frank Fowler, "An American in the Royal Academy," *Review of Reviews* 9 (June 1894): 688.

117 Fox, "Sargent and the Brooklyn Museum, 112–28; Birnbaum, *Sargent,* 15–16, 39. In 1900 Baldry had offered Sargent's "innate and instinctive feeling for decorative contrivance" as the rationale for the painter's "zeal" for his work at the Boston Public Library; A. L. Baldry, "The Art of John Singer Sargent, R.A.," part 2, *The Studio* 19 (15 Mar. 1900): 111. Donelson F. Hoopes was the first art historian to note Sargent's concern with patterns and stencils; see Hoopes, "John Singer Sargent and Decoration," *Antiques Magazine* 86, no. 5 (Nov. 1964): 588–91. This subject has not been pursued in the more recent literature.

118 Ives Gammell ("Mural Decorations," 47–48) reported:

Unfortunately nothing remains of either of the hangings, which were removed for the installation of the pictures, or of the designs Sargent made for them. I have only a blurred memory of these draperies, dyed or painted, as I dimly remember, in soft shades of blues, greens, and mulberry. The patterns seemed to me very fascinating at the time, of a pseudo-oriental character, vaguely recalling designs which Bakst made for the Russian Ballet. However, a good idea of the character of these patterns may be obtained from the voluminous drapery depicted in the panel representing The Synagogue. The great folds were painted from a silk on which Sargent had stenciled a design of his own inventing.

119 Coburn, "Sargent Decorations," 130; see also Fox, untitled typescript, 20, BA.

120 "Sargent's New Decorations in the Boston Library," *New York Times Magazine,* 14.

121 Eighty-nine stencils and partially executed designs survive in one private collection; another private collector retains several series of these designs. The handwriting of both Thomas Fox and John Sargent appears on the surviving materials—sometimes both wrote notes and instructions on a single item.

I am grateful to John B. Fox, Jr., for his generous sharing of his own expertise, including a recent original manuscript titled "A Few Informal Notes on John Singer Sargent's Interest in Stencils," March 1998. This manuscript informed my own discussion of Sargent's concern with pattern.

122 Thomas A. Fox, "Printed Grasscloth Panels Made from Stencils Prepared by and/or for John Singer Sargent," typescript exhibition checklist, including an unpublished essay by Thomas Fox, "Memoranda on the Reproduction and Restoration of Certain Important Fabrics by Means of Stencils," c. 1930, private collection. Sargent's interest in fabric pattern and design substantially modifies the implications of his demonstrated investment in the preservation of Whistler's Peacock Room and his maneuvering to create the conditions for Isabella Stewart Gardner or the Boston Public Library to acquire it. On 2 Nov. [1903] Sargent wrote to Gardner: "I have often thought that there ought to be an attempt to incorporate the peacock room into the library, but to my mind it would be much better to find a room there as near the right size as possible, so as not to change the arrangement of it. I don't see how anything but the three shutters and the large panel could be retained of it if it is transplanted into a large room, and I think it would be lost in Bates Hall [for which Whistler was to have provided a mural]. The committee rooms or trustees rooms or librarian's room are nearer the size. I advise you to consult McKim right away . . . and I will be delighted to help over here [in England]"; Sargent to Isabella Stewart Gardner, 2 Nov. [1903], ISGM. See also, e.g., Sargent to Isabella Stewart Gardner, 29 Aug. [1903], ISGM; and Sargent to Isabella Stewart Gardner, 28 June [1904], ISGM. See also Sargent's album and sketchbook, "Drawings of Ornaments and Stencils," with a series of photographs from the Alhambra, Granada; images of decorative tiles; sketches on graph paper for scale reproduction; and drawings of decora-

tive details from Palermo, Siena, and Rouen as well as the South Kensington Museum (one of Sargent's favorite sources for textile designs); Harvard University Art Museums, 1937.10. Thomas Fox also believed that Sargent's experimentation with pattern influenced the relation of solid and void in his painting, as, for example, in *Gassed* (fig. 123). See Fox, untitled typescript, 27, BA.

123 John Davis, *The Landscape of Belief: Encountering the Holy Land in Nineteenth-Century American Art and Culture* (Princeton: Princeton University Press, 1996), 215.

124 "The Royal Academy," *Saturday Review* (1894): 494, as quoted in Ratcliff, *Sargent*, 141. The critic's reference is to the book of Ezekiel; *Frieze of Prophets* was not included in the Royal Academy exhibition.

125 Regretting the time Sargent had devoted to painting portraits, John Cournos asked: "Has Sargent exchanged his genius for a mess of pottage? What would Sargent have been had he not given himself to promiscuous portraiture? What might he, with his powers, not have accomplished, if, from the very beginning, his art were the result of the impetus of ideas and not a surrender to the material considerations of a matter of fact world?"; Cournos, "John S. Sargent," 235–36.

126 Even as a boy, Sargent was reputed to have drawn "the record of what he saw"; Charteris, *Sargent*, 13. His visual reservoir included the "imaginary" realm only when he copied works of art by other artists: "to him paints were not for telling stories"; Vernon Lee, in Charteris, *Sargent*, 239.

127 Cornell, "What Is Religious Painting?" 129; Rose Kohler agreed: religious pictures that were too "realistic" were not "inspiring" because they had no "metaphysical" component; Kohler, "Religious School Work," 115, CEE.

128 Sargent to Ralph Curtis, 18 Nov. 1890, BA.

129 On Sargent's detachment, see Davis, *Landscape of Belief*, 214–17.

130 Culver, "Performing Identities."

131 "Notes on J. S. Sargent by His Nephew," BA.

132 Pater, *Renaissance*, 235.

133 Robertson, *Time Was*, 240.

134 Sargent to Lee, [1884], CC.

135 See, for example, Fairbrother, "Sargent's Genre Paintings"; idem, "A Private Album"; and idem, *Sargent*, esp. 83.

At least one of Sargent's contemporaries, in a written document just as inconclusive as the visual evidence, might have entertained these questions as well. In 1931, two years after Bliss Carman's death, Lorne Pierce, the poet's publisher, wrote to Thomas Fox to ask whether Fox had any knowledge of Carman serving as a model for Sargent's Hosea. Carman and his close friends always denied the possibility, Pierce admitted. He nonetheless seemed to remain convinced of the connection because of what he called the "Carman-Sargent affair," and he pursued Fox for further information about the level of intimacy between artist and poet. Fox replied that *Frieze* was painted in England and that he knew of no relation between Carman and Hosea (whose association with George Roller has been substantiated). See Mary Lewis (on behalf of Lorne Pierce) to Thomas Fox, 8 July 1931, MHSpc; Lorne Pierce to Thomas Fox, 13 Aug. 1931, MHSpc; and Thomas Fox to Lorne Pierce, 8 Sept. 1931, MHSpc.

136 Robertson, *Time Was*, 238.

137 Boime, "Sargent in Paris and London," 104.

138 Sargent to Isabella Stewart Gardner, 18 Aug. [1894], ISGM; and Sargent to Isabella Stewart Gardner, 27 Aug. [1894], ISGM.

139 Boime, "Sargent in Paris and London," 102; Robertson, *Time Was*, 236.

140 Gammell, "Mural Decorations," 16–17.

141 Cox, "Two Ways of Painting," 137.

142 Hawthorne, *Marble Faun*, xxvi; see also 334 where the old masters are a "tyrannous race."

143 Boime, "Sargent in Paris and London," 105.

144 In 1916, prior to the installation of the east wall images, a critic for *Vanity Fair* attempted an interpretation of *Triumph* in relation to the perceived centrality of Crucifix. In 1928 Hilaire Belloc proposed a similar reading. See "Sargent's Sculpture, The Crucifixion," *Vanity Fair*, Nov. 1916, 76; and Hilaire Belloc, *Many Cities* (London: Constable and Company, 1928), 84. See also, for example, Estelle Hurll's review of *Dogma* as "too Catholic," in Hurll, "Sargent's Redemption," 351–52.

145 Smith, "Sargent's New Mural Decorations," 380. The "present reaction against Puritanism" to which Smith refers rested on the work of cultural critics like Matthew Arnold whose thinking also formed part of the conceptual basis for the American Renaissance. According to Arnold (*Culture and Anarchy*, 1869), Americans should replace their Puritan "Hebraism" with a "more secular, more cosmopolitan view." Sargent's art was certainly more secular and more cosmopolitan, but, in part because it represented a somewhat later historical moment, its message was consistent with significant aspects of a modernized New England "Puritanism." See David C. Huntington, "The Quest for Unity: American Art between World's Fairs, 1876–1893," in *The Quest for Unity: American Art Between World's Fairs, 1876–1893*, exh. cat. (Detroit: Detroit Institute of Arts, 1983), 12; and Richard N. Murray, "Painting and Sculpture," in Wilson, Pilgrim, and Murray, *American Renaissance*, 159.

146 Lee, *Gospels of Anarchy*, 32–33.

CHAPTER 7: THE MANY PUBLICS OF SARGENT'S *PROPHETS*

1 Joseph Walker McSpadden, *Famous Painters of America* (New York: Dodd, Mead and Company, 1923), 287.

2 It was, in fact, within the context of their popular religious publication and their promotion by religious professionals that Sargent's Boston Public Library murals assumed the stature he sought for them. He would have been pleased to hear from a high culture critic in the 1950s the words uttered instead by religious educator Cynthia Pearl Maus: "Although most of John Singer Sargent's life was devoted to the painting of portraits, his murals represent his greatest undertaking in America and brought him his greatest fame"; Maus, *The Old Testament and the Fine Arts* (New York: Harper and Brothers, 1954), 182.

3 Birnbaum, *Sargent*, 23.

4 See, for example, Nelson Lansdale, "John Singer Sargent: His Private World," *American Artist* 28 (Nov. 1964): 60. For an excellent history of Sargent's artistic reputation, see Fairbrother, *Sargent*, 139–41.

5 "Boston Herald Rotogravure Section," *Boston Sunday Herald*, 7 Jan. 1917; "Sunday Picture Section," *New York Times*, 7 Dec. 1913.

6 " 'The Prophets,' by Sargent, Added Greatly to His Fame."

7 Moore, *Charles Follen McKim*, 80.

8 Florence Magill Wallace, "The Christmas Tableau," *Ladies' Home Journal* 27, no. 16 (1 Dec. 1910): 53. David McKibbin, *Sargent's Boston* (Boston: Museum of Fine Arts, 1956): 45–47, is the first "recent" art historian to mention reproductions of Sargent's prophets. Trevor Fair-

brother attended to popular appropriations of Sargent's murals; Fairbrother, *Sargent and America,* 240. Trudy Baltz noted the *Ladies' Home Journal* reference and connections to pageantry in "Pageantry and Mural Painting: Community Rituals in Allegorical Form," *Winterthur Portfolio* 15, no. 3 (Autumn 1980): 217, 222.

9 Copley Prints catalogue, Curtis and Cameron, Boston, 1902, 9, BPLf; Perry Pictures catalogue, Perry Pictures Company, Malden, Mass., 1927, 3, BPLf.

10 [Henry Turner Bailey], "Notable Attempt to Discover the Best American Art," *School Arts Magazine* 12 (May 1913): 562–68.

11 Especially in the 1940s and 1950s, secular encyclopedia manufacturers apparently assented to Sargent's claims with respect to his "living and realistic" style; they read his prophets as "historical fact" rather than as "art," selecting *Frieze of Prophets* or a panel or figure from it to illustrate informational entries on a range of subjects (none of them art related). Among others, *Compton's Pictured Encyclopedia* requested permission in 1952 to use Sargent's Moses in an entry on Moses as historical figure; *Nelson's Encyclopedia* asked in 1947 to use the entire frieze for an entry on the Bible; the French edition of *Grolier's Encyclopedia* in 1948 requested one panel for an entry on prophets; and in 1955 a children's encyclopedia titled *Our Wonderful World* asked permission to use two panels from *Frieze* for an entry on "Hebrew Religion."

12 See Morgan, *Protestants and Pictures,* chaps. 7, 8.

13 G. Stanley Hall, "The Ministry of Pictures," part 1, *Perry Magazine* 2, no. 6 (Feb. 1900): 243.

14 Ibid., 243–45.

15 Hall, "The Ministry of Pictures," part 4, 387–88.

16 Henry Turner Bailey, "The Picture Itself," *Perry Magazine* 1, no. 6 (June 1899): 169.

17 James Frederick Hopkins, "Picture Study in the Boston Public Schools," part 4, *Perry Magazine* 1, no. 4 (Mar.–Apr. 1899): 135–36. The same sort of potential for "refinement" that adhered to originals also characterized reproductions; for this reason, according to proponents, the pictures might have the most dramatic impact on children, the working class, and immigrants. See, e.g., E. M. S., "A New Work for Perry Pictures," *Perry Magazine* 2, no. 2 (Oct. 1899): 67–68; and Frederica Beard, *Pictures in Religious Education* (New York: George H. Doran Company, 1920), esp. 22–26, 31–33, 81, and 99–100.

18 Morgan, *Protestants and Pictures,* chap. 8; see Morgan's introductory chapter for a brilliant discussion of the retention of what Walter Benjamin called "aura" in the halftone reproduction and similar photomechanical media.

19 See, for example, the first Christmas issue, *Perry Magazine* 1, no. 3 (1898): 93.

20 Samuel Train Dutton, "The Religious and Ethical Influence of Public Schools," *Religious Education* 1, no. 2 (June 1906): 47.

21 As religious education adopted "scientific methods" (that is, as it came into alignment with contemporary child developmental theories), older ties between religious education and public education were reworked. Two important factors contributing to the early-twentieth-century professionalization of religious education were the scientific study of the Bible and the child study movement of G. Stanley Hall; see Theodore Gerald Soares, "Religious Education," in Smith, *Religious Thought in the Last Quarter Century,* 167–84.

22 The Religious Education Association held its annual conference in Boston in 1905.

23 James Frederick Hopkins, "Picture Study in the Boston Public Schools," part 2, *Perry Magazine* 1, no. 2 (Nov.–Dec. 1898): 37–39.

24 See Morgan, *Protestants and Pictures.*

25 Henry Turner Bailey, for example, spoke to the second annual convention of the REA in 1904.

26 Waldo S. Pratt, "The Field of Artistic Influences in Religious Education," *Proceedings of the Second Annual Convention,* 510, as quoted in Morgan, *Protestants and Pictures,* chap. 8.

27 Correspondence in the collection of BPLr, Ms Bos Li B18k–m. While this sample of letters is an arbitrary one, it provides a reasonable gauge of uses proposed by those who viewed their own intentions to be sufficiently official and formal as to require permission. The statistical data, furthermore, corroborate assessments formed on the basis of additional independent evidence.

28 Use in the secular domain continued (e.g., as illustrations for encyclopedia entries), but the images were generally used in this context as a tag for religion rather than art.

29 Only one request for *Synagogue* is documented in BPL records; this is a request for the allegorical pair of figures (*Synagogue* and *Church*) from a Lutheran, O. A. Dorn to BPL, 4 Oct., 1937, BPLr, Ms Bos Li B18m. The only other request for *Church* (in addition to Dorn's request for the pair) came from a Catholic institution. The fact that *Church* did not attract a significant Catholic following suggests that the difficulties Louis Kirstein remarked may have been shared by others.

30 Four inquiries regarding the use of images from *Triumph* in stained glass can be documented in library records. These requests came from Boston, Cincinnati, Bangor (Maine), and Chicago, and from a Catholic artist, two Protestant clergy, and a Jewish congregation. Three of the four expressed interest in *Prophets;* the Catholic artist wanted *Madonna of Sorrows* and *Handmaid of the Lord.* On the use of fine arts images, and especially those disseminated by various print companies, including Perry Pictures, in stained-glass design, see Helen Weis, "Those Old, Familiar Faces," *Stained Glass* 86, no. 3 (Fall 1991): 204–7, 216–18.
 The stained-glass requests, in particular, indicate that Sargent and the library were concerned about quality of reproduction: the Cincinnati request was denied because it proposed insufficient resemblance to the original (William Arthur Mottes to librarian, 10 Jan. 1928, BPLr, Ms Bos Li B18m.; and librarian to William Arthur Mottes, 31 Jan. 1928, BPLr, Ms Bos Li B18m); the Boston artist's credentials were to be checked with Sargent as the final authority; see "John Oster request to reproduce Sargent painting[s]," entry for 26 Oct. 1917, "Records of the Corporation, Public Library of the City of Boston," vol. 11, BPLc. Sargent's interest in, as well as evaluation and use of, print reproductions of his own work are documented in, e.g., Sargent to Mr. Johnson, 5 Dec. 1895, Century Company Records, Manuscripts and Archives Division, The New York Public Library, Astor, Lenox and Tilden Foundations (AAA, reel N8, fr. 282); Sargent to Putnam [May 1895], BPLr; and Sargent to Otto Fleischner, 5 Sept. 1917, BPLf. Sargent also wrote to Curtis and Cameron expressing approval of their reproductions of his library work: "I have pleasure in expressing my opinion of the excellence of your Copley Prints"; quoted in Copley Prints catalogue, Curtis and Cameron, Boston, 1907, LC.

31 William E. Austill to BPL, 1 Apr. 1955, BPLr, Ms Bos Li B18m. Clifford Geertz's notion of local "shapes of knowledge" and "frames of awareness" informs my examination of "local cultures" as modes of navigating and subverting "mass culture"; Geertz, *Local Knowledge* (New York: Basic Books, 1983), 4–6.

32 Copley Prints catalogue, Curtis and Cameron, Boston, 1903, 86–90, LC. There were documented occasions, however, when a visitor to the library wanted a reproduction of some other segment of *Triumph* and had to settle instead for prints from the widely reproduced *Frieze*. In 1908 one library visitor and postcard purchaser wanted to send his/her friend a card of Neith, the "Egyptian goddess" and "mother of the universe who appears calm and grand between the horrid Moloch and the enticing Astarte," but ended up purchasing Hosea because Neith was not available; see A. W. G. to Mr. Ruell Tolman, 2 July 1908, NMAA/NPG.

33 Moore, "Great Artists and Their Paintings," 91.

34 Morgan, *Protestants and Pictures,* chap. 8.

35 Hall, "Ministry of Pictures," part 4, 387.

36 Ozora S. Davis, "American Preaching," in Smith, *Religious Thought in the Last Quarter Century,* 204–5, see also 10–17.

37 See, e.g., Maus, *Old Testament and the Fine Arts;* Cynthia Pearl Maus to BPL, 28 Feb. 1951, BPLr, Ms Bos Li B18l; and Harper and Brothers to BPL, 15 Apr. 1954, BPLr, Ms Bos Li B18l.

38 Sally M. Promey, "Interchangeable Art: Warner Sallman and the Critics of Mass Culture," in *Icons of American Protestantism,* ed. David Morgan (New Haven: Yale University Press, 1996), 166–74; and Douglas Sloan, *Faith and Knowledge* (Louisville, Ky.: Westminster John Knox Press, 1994), 91–97, 201–3. On the late-nineteenth-century development of Protestantism's artistic (and devotional) commitments, see Morgan, *Protestants and Pictures,* chap. 8.

39 "*motive* Sales of Original Prints: A Price List," *motive* 18, no. 5 (Feb. 1958), 28.

40 Barr to Rathbone, 21 Mar. 1955, Alfred H. Barr, Jr. Papers, The Museum of Modern Art Archives, New York (AAA, reel 2180, fr. 329).

41 Ives Gammell recalled it from his schoolroom as well as his dentist's office; Gammell, "Mural Decorations," ii, 20, 40.

42 Grace Atkinson Blake, "Catalog of Pictures, Sculptures, and Other Works of Art in Edward Lee McClain High School" (Greenfield, Ohio: Greenfield Printing and Publishing Company, 1980), [5], 9. I am grateful to Richard Murray for calling my attention to the Greenfield art reproductions.

43 Ibid.

44 Ibid., 9, 21, 26.

45 "Vesper George Tells of the Conception of the Three Great Mural Paintings in McClain High School," *Greenfield Republican,* 20 Dec. 1920, 1.

46 Interview with Dan Strain, 30 Dec. 1997, McClain High School, Greenfield, Ohio.

47 Interviews with Dan Crusie, Kathy Rivas, and Dorothy Lynch, 30 Dec. 1997, McClain High School, Greenfield, Ohio.

48 " 'Our School Is Special . . .' McClain High School Carries Out Traditions, Style Set by Founder," *Cincinnati Enquirer,* 6 Feb. 1992, A1, A24. The idea that art should decorate public schools was fairly common in Cincinnati in the early twentieth century. A recent article documents the degree to which that city's schools were "slathered in art—statues, Rookwood fountains, gargoyles, clock towers, murals, tiled mansard roofs, stained glass windows, and Corinthian columns. The walls were a riot of owls, griffins, knights in armor, goddesses, patriots, and Columbus Sailing the Ocean Blue"; John Fleischman, "Decoration Days," *Ohio Magazine* 17, no. 8 (Nov. 1994): 43–46.

49 Helen Thoburn, "Pageants of Girlhood," *Good Housekeeping Magazine* 57, no. 2 (Aug. 1913), 228–31; "900 Girls Needed for the Pageant Processional," Apr. 1913, pageant flyer, YWCA; "Pageant to Show Work of Women," [5] Apr. 1913, unidentified Richmond newspaper clipping, YWCA; "Beautiful Pageant Transforms Gloom into Brightness," *Virginian,* 13 Apr. 1913; and "Beautiful Pageant Today Will Tell Story of YWCA's Work," *Newsleader,* 12 Apr. 1913.

50 See, e.g., Naima Prevots, *American Pageantry* (Ann Arbor: UMI Research Press, 1990), 14–15, 90, 92; and David Glassberg, *American Historical Pageantry* (Chapel Hill: University of North Carolina Press, 1990), 78.

51 The earliest report of the alternative title several sources claimed Sargent suggested for his Boston Public Library murals ("Pageant of Religion") came in 1914 on a picture study card designed as part of the "Mentor Reading Course" and illustrated by a Curtis and Cameron reproduction of Sargent's Hosea. In 1923 McSpadden, *Famous Painters* (288), used the title. And Fox reiterated its origin with the artist in a manuscript written after Sargent's death. The 1914 date suggests the intriguing possibility that Sargent may have heard about the Richmond pageant—or about its New York iterations.

52 Thoburn to Clark, 4 Mar. [1913], BPLr, Ms Acc 2709; Thoburn to Clark, 19 Feb. 1913, BPLr, Ms Am 1217; and Louise W. Brooks to Clark, 1 Mar. 1913, BPLr, Ms Am 1217.

53 Thoburn, "Pageants," 231.

54 Helen Thoburn, "The Ministering of the Gift," pageant script (New York: National Board of the YWCA, 1913), [5], 22; and "The Ministering of the Gift," 12 Apr. 1913, pageant program, YWCA.

55 Thoburn, "Ministering," 22.

56 H. Plimpton to Lotta Clark, 9 Apr. 1913, BPLr, Ms Am 1217; and "Pageant to Show Work of Women . . . 800 to Take Part . . . Motion Picture Company Will Reproduce and Exhibit Pageant in Country's Theatres," *Richmond Times-Dispatch,* 6 Apr. 1913.

57 *Silver Bay Association: A Pictorial History, 1900–1935* (Silver Bay, N.Y.: Silver Bay Association, 1992), vii, xii, 7, 33, 76.

58 Roth to Milton Lord, 2 Mar. 1938, BPLr, Ms Bos Li B18l.

59 Louis C. Kraft, *Development of the Jewish Community Center* (New York: National Association of Jewish Center Workers, 1967), 19–20.

60 Ibid., 225 (here Kraft reprinted a paper he had delivered in 1929).

61 The Rochester JCC did not represent an aberration in terms of the use of *Frieze* by Jewish individuals and groups; in addition, for example, Jewish periodicals and newspapers sought out reproductions of *Frieze*—and of Moses in particular—to illustrate Rosh Hashanah issues; a congregation on Lake Shore Drive in Chicago (Temple Sholom) turned to it for stained-glass patterns (though they ultimately selected another design), and a Minneapolis congregation wanted a plaster cast of it. See, for example, Norman D. Schwartz to librarian, 17 July 1997, BPLf; and front-page Rosh Hashanah layout, *Rochester Jewish Ledger,* 23 Sept. 1938, 1.

62 Markus to Lord, 2 Dec. 1937, BPLr, Ms Bos Li B18l.

63 Kraft, *Jewish Community Center,* 1–2, 7–9, 97; the last page cited here (97) reprints part of a 1924–29 compilation of recommendations for the ideal Jewish Community Center.

64 Ibid., 97.

65 Quoted in ibid., 40; this page is one of several that excerpts Mordecai Kaplan's 1918 essay, "Defining the Jewish Center."

66 Gold, in "Real Interpretation," 5.

67 Telephone interview with Herbert Roth, 28 Jan. 1998.

68 Interview with Jeri Bothamley, 22 Nov. 1997, Hartford, Conn.

69 Walter Sargent, "Art in the Sunday School," *Perry Magazine* 5, no. 1 (Sept. 1902): 50–53.

70 Henry Turner Bailey, "Picture Itself," 169–70.

EPILOGUE

1 On individualism, pluralism, and "privatism" in contemporary religious experience in the United States, see Bruce A. Greer and Wade Clark Roof, " 'Desperately Seeking Sheila': Locating Religious Privatism in American Society," *Journal for the Scientific Study of Religion* 31, no. 4 (1992): 346–52.

2 Quoted in Lovin, "Beyond the Pursuit of Happiness," 47.

3 Handy, "Changing Contexts of Church-State Relations," 30, 34.

4 Ibid., 37.

5 *Handbook* (1895), 52; Coffin, "Sargent and His Painting," 166. In these early uses of this progression, while the right variables were in place (confusion or chaos, convention, and unity), the order sometimes suggested that the critic believed the movement to be historical, so that the narrative ended with the south wall's conventionality. Perhaps the framing of the east wall's Sermon with *Synagogue* and *Church* was meant, in part, to clarify the appropriate ideological "chronology" of *Triumph*.

6 I am grateful to David Morgan for sharing with me his thoughts on G. Stanley Hall in this regard. Warner, "Work in Progress," 1047.

7 Warner, "Work in Progress," 1049. Finke and Stark assign this phenomenon to disestablishment and to the rise of an open market in religion in the United Sates; Roger Finke and Rodney Stark, *The Churching of America, 1776–1990* (New Brunswick, N.J.: Rutgers University Press, 1992).

8 See, e.g., Bill Broadway, "Poll Finds Americans 'As Churched as Ever': Beliefs in God Have Changed Little since 1947, But Faithful Sample More Forms of Spirituality," *Washington Post*, 31 May 1997, B7.

9 Peter L. Berger, "Protestantism and the Quest for Certainty," *Christian Century* 115, no. 23 (26 Aug.–2 Sept. 1998): 782.

10 May, *End of American Innocence*, 393–94.

11 Handy, "Changing Contexts of Church-State Relations," 27, 42.

12 Santayana, "Intellectual Temper of the Age," 1.

13 Handy, "Changing Contexts of Church-State Relations," 29.

14 Frances FitzGerald, *Cities on a Hill: A Journey through Contemporary American Cultures* (New York: Simon and Schuster, 1986), 16, as quoted in Warner, "Work in Progress," 1063; see also 1065.

15 See Robert W. Lynn, *Protestant Strategies in Education* (New York: Association Press, 1964). In the 1830s the movement for a system of tax-supported state schools assumed Protestant hegemony. Early conflicts about the content of religion in public education took place between liberals (like the Massachusetts Unitarian reformer Horace Mann) and conservatives *within* Protestantism; Nord, *Religion and American Education*, 71–73.

16 Robert H. Keller, Jr., *American Protestantism and United States Indian Policy, 1859–1882* (Lincoln: University of Nebraska Press, 1983), 214.

17 From an ACLU publication titled *Guardian of Liberty*, as quoted in Wayne Swanson, *The Christ Child Goes to Court* (Philadelphia: Temple University Press, 1990), 23–24.

18 Warner, "Work in Progress," 1061.

19 Diane Winston, "Campuses Are a Bellwether for Society's Religious Revival," *Chronicle of Higher Education*, 16 Jan. 1998, A60.

20 Ibid.

21 The quoted phrase belongs to Jean Bethke Elshtain, "The Displacement of Politics," in *Public and Private in Thought and Practice*, 167; see also Stewart M. Hoover, "Media and the Construction of the Religious Public Sphere," in *Rethinking Media, Religion, and Culture*, 283–97.

22 Berger, "Protestantism and the Quest for Certainty," 782.

23 "Inwardization" on its own does not necessarily lead to toleration. It can, in fact, produce the same fanaticism that Enlightenment thinkers who recommended privatization sought to avoid. But "inwardization" in combination with an increasingly visible, and therefore increasingly public, pluralism presents a suggestive set of possibilities.

24 Warner, "Work in Progress," 1058. And see Mark Silk, "Why Religion in the News?" *Religion in the News* 1, no. 1 (June 1998): 3. This increasing publicness of religion is not the result of religion in the United States entering the marketplace; it may be, rather, one result of its always having been there. See R. Laurence Moore, *Selling God: American Religion in the Marketplace of Culture* (New York: Oxford University Press, 1994).

25 Susan Levine, "A Place for Those Who Pray: Along Montgomery's 'Highway to Heaven,' Diverse Acts of Faith," *Washington Post*, 3 Aug. 1997, B1, B4–B5.

26 Lovin, "Beyond the Pursuit of Happiness," 60, see also 57–58; and Kenneth J. Gergen, *The Saturated Self: Dilemmas of Identity in Contemporary Life* (New York: Basic Books, 1991).

27 Coleman and Elsner, "Performing Pilgrimage," 46–47.

28 I am grateful to John Dorsey for making these uncatalogued records from the library's Norwood Storage Facility available to me.

29 See Jody Eldredge (coordinator of volunteers, Development Office, BPL), "BPL Tour Guide Program Statistics, 1994–1996," typescript.

30 The survey instrument (with slightly varying sets of questions for each of the two groups: docents and visitors) was designed by Sally Promey and Roger Fallot and administered by Jody Eldredge in winter and early spring 1998. A recent letter to the editor of the *Washington Post* offered a similar assessment of *Triumph*, linking Sargent's "vast tapestry" (as did a number of survey respondents) to Michelangelo's Sistine ceiling; see Arnold J. Rosenberg, "Boston Masterpiece," *Washington Post*, 16 June 1996, E8.

SELECTED BIBLIOGRAPHY

A partial list of manuscript collections can be found in the Abbreviations on p. 317. In addition to the archives named there, this book relied upon documents at the Museum of Modern Art Archives, New York; the New York Public Library; and the Museum of Fine Arts, Boston.

Abbott, Lyman. *A Dictionary of Religious Knowledge for Popular and Professional Use.* New York: Harper and Brothers, 1875.

————. *The Evolution of Christianity.* 1892. New York: Johnson Reprint Corporation, 1969.

————. "Hebrew Prophets and American Problems." *Outlook* 61, nos. 16–17 (22 Apr.–29 Apr. 1899): 915–19, 971–76. *Outlook* 62, nos. 1–12 (6 May–22 July 1899): 26–30, 208–14, 343–47, 381–86, 518–22, 570–77, 615–18, 660–65.

Adams, Adeline. "Ernest Peixotto's War Landscapes." *American Magazine of Art* 12 (June 1921): 191–96.

Adelson, Warren, et al. *Sargent Abroad: Figures and Landscapes.* With contributions by Donna Seldin Janis, Elaine Kilmurray, Richard Ormond, and Elizabeth Oustinoff. New York: Abbeville Press, 1997.

Ahlstrom, Sydney E. *Religious History of the American People.* New Haven: Yale University Press, 1972.

Aitken, Charles. "Mr. Asher Wertheimer's Benefaction." *Burlington Magazine* 29, no. 161 (Aug. 1916): 216–20.

Andrews, Keith. *The Nazarenes: A Brotherhood of German Painters in Rome.* London: Oxford University Press, 1964.

Antin, Mary. *The Promised Land.* 1912. Boston and New York: Houghton Mifflin Company, 1924.

Appel, John J. "Jews in American Caricature: 1820–1914." *American Jewish History* 71, no. 1 (Sept. 1981): 103–33.

Authorized Daily Prayer Book of the United Hebrew Congregations of the British Empire. London: Spottiswoode, 1904.

Azan, Paul. *The Warfare of Today.* Boston: Houghton Mifflin Company, 1918.

Baedeker, Karl. *Italy: Handbook for Travellers: Central Italy and Rome.* Leipzig: Karl Baedeker Publisher, 1900.

————. *Paris and Environs.* Leipzig: Karl Baedeker Publishers, 1913.

————. *London and Its Environs.* Leipzig: Karl Baedeker Publishers, 1923.

————. *Egypt and the Sudan.* Leipzig: Karl Baedeker Publishers, 1929.

Bailey, Henry Turner. "The Picture Itself." *Perry Magazine* 1, no. 6 (June 1899): 169–70.

[Bailey, Henry Turner]. "Notable Attempt to Discover the Best American Art." *School Arts Magazine* 12 (May 1913): 562–68.

Baldry, A. L. "The Art of John Singer Sargent, R.A." Part 2. *The Studio* 19 (15 Mar. 1900): 107–19.

Baltz, Trudy. "Pageantry and Mural Painting: Community Rituals in Allegorical Form." *Winterthur Portfolio* 15, no. 3 (Autumn 1980): 211–28.

Baltzell, E. Digby. *Puritan Boston and Quaker Philadelphia.* New York: Free Press, 1979.

Banta, Martha. *Imaging American Women: Idea and Ideals in Cultural History.* New York: Columbia University Press, 1987.

Barnett, Richard David. *Assyrian Palace Reliefs.* London: Batchworth Press, n.d.

Barton, William E. "The Library as a Minister in the Field of Religious Art." *Religious Education* 4, no. 6 (Feb. 1910): 594–614.

Baxter, Sylvester. "John Singer Sargent's Decorations for the Boston Public Library." *Harper's Weekly* 39 (1 June 1895): 506–7, 509.

————. "Sargent's 'Redemption' in the Boston Public Library." *Century Magazine* 66, no. 1 (May 1903): 129–34.

————. "Master Murals," *The Independent* 89, no. 3554 (15 Jan. 1917): 106–8.

Beard, Frederica. *Pictures in Religious Education.* New York: George H. Doran Company, 1920.

Becherucci, Luisa. "Raphael and Painting." In *Complete Work of Raphael.* New York: Reynal and Company, 1969.

Beckson, Karl. *London in the 1890s: A Cultural History.* New York: W. W. Norton and Company, 1992.

Bederman, Gail. *Manliness and Civilization: A Cultural History of Gender and Race in the United States, 1880–1917.* Chicago: University of Chicago Press, 1995.

Beecher, Henry Ward. *Life of Jesus the Christ.* New York: J. B. Ford and Company, 1871.

Begni, Ernesto. *The Vatican: Its History—Its Treasures.* New York: Letters and Arts Publishing Company, 1914.

Bell, Catherine. *Ritual Theory, Ritual Practice.* Oxford: Oxford University Press, 1992.

Bellah, Robert N., et al. *Habits of the Heart: Individualism and Commitment in American Life.* New York: Harper and Row, 1986.

Belloc, Hilaire. *Many Cities.* London: Constable and Company, 1928.

Benn, Stanley I., and Gerald F. Gaus, eds. *Public and Private in Social Life.* London: Croom Helm, 1983.

Benton, Josiah H. *The Working of the Boston Public Library.* Boston: Rockwell and Churchill Press, 1914.

Berger, Peter L. "Protestantism and the Quest for Certainty." *Christian Century* 115, no. 23 (26 Aug.–2 Sept. 1998): 782–85, 792–96.

Betsky, Celia. "Inside the Past: The Interior and the Colonial Revival in American Art and Literature, 1860–1914." In *The Colonial Revival in America,* ed. Alan Axelrod. New York: W. W. Norton and Company, 1985.

Bierer, Dora. "Renan and His Interpreters: A Study in French Intellectual Warfare." *Journal of Modern History* 25, no. 4 (Dec. 1953): 375–89.

Binyon, Lawrence. "The New English Art Club." *Saturday Review* 107 (29 May 1909): 684.

Birnbaum, Martin. *John Singer Sargent.* New York: William E. Rudge's Sons, 1941.

Blake, Grace Atkinson. "Catalog of Pictures, Sculptures, and Other Works of Art in Edward Lee McClain High School." Greenfield, Ohio: Greenfield Printing and Publishing Company, 1980.

Blashfield, Edwin Howland. "Mural Painting in America." *Scribner's Magazine* 54 (Sept. 1913): 353–65.

————. *Mural Painting in America.* New York: Charles Scribner's Sons, 1914.

————. "John Singer Sargent—Recollections." *North American Review* 220, no. 827 (June–Aug. 1925): 641–53.

Blühm, Andres, and Gerhard Gerkens, eds. *Johann Friedrich Overbeck (1789–1869)*. Exh. cat. Lübeck-Behnhaus: Museum für Kunst und Kulturgeschichte der Hansestadt, 1989.

Borenius, Tancred. "The Rediscovery of the Primitives." *Quarterly Review* (London) 239 (Apr. 1923): 258–70.

Borglum, Gutzon. "John Singer Sargent—Artist." *The Delineator*, Feb. 1923, 15, 106.

The Boston Public Library: A Handbook to the Library Building, Its Mural Decoration and Its Collections. Boston: Association Press, 1939.

Brinton, Christian. "Sargent and His Art." *Munsey's Magazine* 36, no. 3 (Dec. 1906): 265–84.

Bronner, Simon J. "Reading Consumer Culture." In *Consuming Visions: Accumulation and Display of Goods in America, 1880–1920*, ed. Simon J. Bronner. New York: W. W. Norton and Company, 1989.

Bruns, Gerald L. "Loose Talk about Religion from William James." *Critical Inquiry* 11, no. 2 (Dec. 1984): 299–316.

Bullen, J. B. *The Myth of the Renaissance in Nineteenth-Century Writing*. Oxford: Oxford University Press, 1994.

Burke, Doreen Bolger. "Astarte: Sargent's Study for *The Pagan Gods* Mural in the Boston Public Library." In *Fenway Court 1976*. Boston: Trustees of the Isabella Stewart Gardner Museum, 1977.

Burns, Sarah. *Inventing the Modern Artist: Art and Culture in Gilded Age America*. New Haven: Yale University Press, 1996.

Butler, Jon. *Awash in a Sea of Faith: The Christianizing of the American People*. Cambridge: Harvard University Press, 1990.

Caffin, Charles H. *Masters of American Paintings*. New York: Doubleday, Page and Company, 1902.

———. *The Story of American Painting*. New York: Frederick A. Stokes Company, 1907.

Caird, Edward. *The Evolution of Religion*. 2 vols. Glasgow: James Maclehose and Sons, 1893.

Cartwright, Derrick Randall. "Reading Rooms: Interpreting the American Public Library Mural, 1890–1930." Ph.D. diss., University of Michigan, 1994.

Cassier, Ernst. *The Philosophy of the Enlightenment*. Princeton: Princeton University Press, 1951.

Catalogue of the Library of the Late John Singer Sargent, R.A. Sale cat. London: Christie, Manson and Woods, 1925.

Chadwick, Owen. *The Secularization of the European Mind in the Nineteenth Century*. Cambridge: Cambridge University Press, 1975.

Charteris, Evan. *John Sargent*. New York: Charles Scribner's Sons, 1927.

Chase, Frank H., comp. *Boston Public Library: A Handbook to the Library Building, Its Mural Decorations, and Its Collections*. Boston: Association Publications, 1926.

Christensen, Carl C. *Art and the Reformation in Germany*. Athens: Ohio University Press; Detroit: Wayne State University Press, 1979.

Christian, John, ed. *The Last Romantics: The Romantic Tradition in British Art, Burne-Jones to Stanley Spencer*. London: Lund Humphries, 1989.

"Christianity in Mural Decorations." *American Review of Reviews* 55, no. 3 (Mar. 1917): 303–4.

Clement, Clara Erskine. "Later Religious Painting in America." *New England Magazine* 12, no. 2 (Apr. 1895): 130–54.

Coben, Stanley. "The Assault on Victorianism in the Twentieth Century." *American Quarterly* 27, no. 5 (Dec. 1975): 604–25.

Coburn, Frederick W[illiam]. "The Sargent Decorations in the Boston Public Library." *American Magazine of Art* 8, no. 4 (Feb. 1917): 129–36.

———. "Sargent's War Epic." *American Magazine of Art* 14, no. 1 (Jan. 1923): 3–6.

Coffin, William A. "Sargent and His Painting." *Century Magazine* 52, no. 2 (June 1896): 163–78.

———. "The Decorations in the New Congressional Library." *Century Magazine* 53, no. 5 (Mar. 1897): 694–711.

Coleman, Simon, and John Elsner. "Performing Pilgrimage: Walsingham and the Ritual Construction of Irony." In *Ritual, Performance, Media*, ed. Felicia Hughes-Freeland. London and New York: Routledge, 1998.

Colonna, G., and M. Donati. *Les Musées du Vatican*. Novara, Italy: Instituto Geografico de Agostini, 1963.

"Copley Square: A Brief Description of Its History." Boston: State Street Trust Company, 1941.

Cornell, John S. "What Is a Religious Painting? German Modernism, 1870–1914." *Nineteenth-Century Contexts* 14, no. 2 (1990): 115–73.

Cortissoz, Royal. "Mural Decoration in America." *Century Magazine* 51, no. 2 (Nov. 1895): 110–21.

———. "A National Monument of Art: The Congressional Library at Washington." *Harper's Weekly* 39 (28 Dec. 1895): 1240–41.

———. "John S. Sargent." *Scribner's Magazine* 34, no. 5 (Nov. 1903): 514–32.

———. "Books New and Old." *Atlantic Monthly Magazine* 93 (Mar. 1904): 402–14.

———. "In the Field of Art." *Scribner's Magazine* 75, no. 3 (Mar. 1924): 345–52. Reprinted as "Sargent: The Painter of Modern Tenseness, the Nature of His Genius." N.p.: n.p., n.d.

Cory, Daniel, ed. *Letters of George Santayana*. London: Constable and Company, 1955.

Coues, Edith. "Tissot's 'Life of Christ.'" *Century Magazine* 51, no. 2 (Dec. 1895): 289–302.

Cournos, John. "John S. Sargent." *The Forum* 54 (Aug. 1915): 232–36.

Cox, Kenyon. "Raphael." In *Artist and Public and Other Essays on Art Subjects*. London: George Allen and Unwin, 1914.

———. "Mural Painting in France and America." 1917. In *What Is Painting? "Winslow Homer" and Other Essays*. Reprint, New York: W. W. Norton and Company, 1988.

Crawford, Francis Marion. *Ave Roma Immortalis*. New York and London: Macmillan Company, 1906.

Culver, Leigh. "Performing Identities in the Art of John Singer Sargent." Ph.D. diss. in preparation, University of Pennsylvania.

Dalzell, Robert F., Jr. *Enterprising Elite: The Boston Associates and the World They Made*. Cambridge: Harvard University Press, 1987.

Davis, John. *The Landscape of Belief: Encountering the Holy Land in Nineteenth-Century American Art and Culture*. Princeton: Princeton University Press, 1996.

"The Decline of Art: Royal Academy and Grosvenor Gallery." *Blackwood's Edinburgh Magazine* 138 (July 1885): 1–25.

Didron, Adolphe Napoleon. *Christian Iconography*. 2 vols. 1851. Reprint, New York: Frederick Ungar Publishing Company, 1965.

DiMaggio, Paul. "Classification in Art." *American Sociological Review* 52, no. 4 (Aug. 1987): 440–55.

Dini, Jane. "Public Bodies: Form and Identity in the Work of John Singer Sargent." Ph.D. diss., University of California, Santa Barbara, 1998.

Domosh, Mona. *Invented Cities: The Creation of Landscape in Nineteenth-Century New York and Boston*. New Haven: Yale University Press, 1996.

Douglas, Ann. *The Feminization of American Culture*. New York: Avon Books, 1977.

Driskel, Michael Paul. "Eclecticism and Ideology in the July Monarchy:

Jules-Claude Ziegler's Vision of Christianity at the Madeleine." *Arts Magazine* 56, no. 9 (May 1982): 119–28.

———. *Representing Belief: Religion, Art, and Society in Nineteenth-Century France.* University Park: Pennsylvania State University Press, 1992.

Duncan, Carol. *Civilizing Rituals: Inside Public Art Museums.* London and New York: Routledge, 1995.

Dutton, Samuel Train. "The Religious and Ethical Influence of Public Schools." *Religious Education* 1, no. 2 (June 1906): 47–59.

Edel, Leon. *Henry James: A Life.* New York: Harper and Row, 1985.

Ekstein, Modris. *Rites of Spring: The Great War and the Birth of the Modern Age.* Boston: Houghton Mifflin, 1989.

Elkins, James. *The Object Stares Back: On the Nature of Seeing.* New York: Harcourt Brace and Company, 1996.

Elsen, Albert. *Rodin.* New York, Museum of Modern Art, 1963.

E. M. S. "A New Work for Perry Pictures." *Perry Magazine* 2, no. 2 (Oct. 1899): 67–68.

Encyclopedia Judaica. Jerusalem: Keler Publishers, 1972.

Eschapasse, Maurice. *Reims Cathedral.* Paris: Caisse Nationale des Monuments Historiques, n.d.

Espinasse, Francis. *Life of Ernest Renan.* London: Walter Scott, 1895.

Ettlinger, Leopold David. *The Sistine Chapel before Michelangelo: Religious Imagery and Papal Primacy.* London: Oxford University Press, 1965.

Fairbrother, Trevor. *John Singer Sargent and America.* Boston University, 1981. Outstanding Dissertations in the Fine Arts. New York: Garland, 1986.

———. "A Private Album: John Singer Sargent's Drawings of Nude Male Models." *Arts Magazine* 56, no. 4 (Dec. 1981): 70–79.

———. "Sargent's Genre Paintings and the Issues of Suppression and Privacy." In *American Art around 1900,* ed. Doreen Bolger and Nicolai Cikovsky, Jr. Washington, D.C.: National Gallery of Art, 1990.

———. *John Singer Sargent.* New York: Harry N. Abrams, 1994.

Farrell, Betty G. *Elite Families: Class and Power in Nineteenth-Century Boston.* Albany: State University of New York Press, 1993.

Fenollosa, Ernest F. *Mural Painting in the Boston Public Library.* Boston: Curtis and Cameron, 1896.

Ferree, Barr. *The Bombardment of Reims.* New York: Leonard Scott Publication Company, 1917.

Finke, Roger, and Rodney Stark. *The Churching of America.* New Brunswick, N.J.: Rutgers University Press, 1992.

FitzGerald, Frances. *Cities on a Hill: A Journey through Contemporary American Cultures.* New York: Simon and Schuster, 1986.

Fleischman, John. "Decoration Days." *Ohio Magazine* 17, no. 8 (Nov. 1994): 43–46.

Folgarait, Leonard. "Revolution as Ritual: Diego Rivera's National Palace Mural." *Oxford Art Journal* 14, no. 1 (1991): 18–33.

Fowler, Frank. "An American in the Royal Academy." *Review of Reviews* 9 (June 1894): 685–88.

———. "Sargent's New Wall Painting as Seen by the Decorative Architect and the Portrait Painter." *Scribner's Magazine* 34 (July–Dec. 1903): 767–68.

Fox, William Henry. "John Singer Sargent and the Brooklyn Museum." *Brooklyn Museum Quarterly,* July 1925, 112–18.

Franchot, Jenny. "Unseemly Commemoration: Religion, Fragments, and the Icon." *American Literary History* 9, no. 3 (Fall 1997): 502–21.

Fraser, Hilary. *The Victorians and Renaissance Italy.* Oxford: Blackwell Publishers, 1992.

Frazer, James George. *The Golden Bough: A Study in Magic and Religion.*

Part 1: *The Magic Art and the Evolution of Kings.* Vol. 1. London: Macmillan and Company, 1963.

Freedman, Jonathan. "Jews and the Making of Middlebrow American Culture." *Chronicle of Higher Education,* 18 Sept. 1998, B4.

Friedlander, Gerald. *Jewish Sources of the Sermon on the Mount.* 1911. Reprint, New York: Ktav Publishing House, 1969.

Fussell, Paul. *The Great War and Modern Memory.* London: Oxford University Press, 1975.

Gallati, Barbara Dayer. "Controlling the Medium: The Marketing of John Singer Sargent's Watercolors." In *Masters of Color and Light: Homer, Sargent and the American Watercolor Movement,* by Linda S. Ferber and Barbara Dayer Gallati. Exh. cat. New York: Brooklyn Museum of Art, 1998.

Gammell, R. H. Ives. "A Masterpiece Dishonored." *Classical America* 4 (1977): 47–53.

———. "John Singer Sargent: Boston Public Library Decorations." In *John Singer Sargent Studies for the Boston Public Library Decorations,* ed. Elizabeth Ives Hunter. Exh. brochure. Boston: St. Botolph Club, 1988.

Geertz, Clifford. *Local Knowledge.* New York: Basic Books, 1983.

Gerber, David A., ed. *Anti-Semitism in American History.* Urbana: University of Illinois Press, 1986.

Gergen, Kenneth J. *The Saturated Self: Dilemmas of Identity in Contemporary Life.* New York: Basic Books, 1991.

Gilman, Benjamin Ives. *Manual of Italian Renaissance Sculpture as Illustrated in the Collection of Casts at the Museum of Fine Arts, Boston.* Boston: Museum of Fine Arts, 1904.

Gilman, Lawrence. "The Book of the Month: Mary Hunter's Bible." *North American Review* 204 (Dec. 1916): 931–37.

Gilman, Sander. *The Jew's Body.* New York and London: Routledge, 1991.

Glassberg, David. *American Historical Pageantry.* Chapel Hill: University of North Carolina Press, 1990.

Glazer, Nathan. "Individualism and Equality in the United States." In *Making America: The Society and Culture of the United States,* ed. Luther S. Luedtke. Chapel Hill: University of North Carolina Press, 1992.

Golzio, Vincenzo. "Raphael and His Critics." In *Complete Work of Raphael.* New York: Reynal and Company, 1969.

Greer, Bruce A., and Wade Clark Roof. " 'Desperately Seeking Sheila': Locating Religious Privatism in American Society." *Journal for the Scientific Study of Religion* 31, no. 4 (1992): 346–52.

Griffith, William. "Christ as Modern American Artists See Him." *Craftsman* 10, no. 3 (June 1906): 286–99.

Guida delle Gallerie di Pittura. Vol. 5 of *Musei e Gallerie Pontificie.* Rome: Prima Edizione Vaticana, 1925.

Hall, G. Stanley. "The Ministry of Pictures." Part 1. *Perry Magazine* 2, no. 6 (February 1900): 243–45.

———. "The Ministry of Pictures." Part 4. *Perry Magazine* 2, no. 9 (May 1900): 387–88.

———. *Jesus, the Christ, in the Light of Psychology.* 2 vols. Garden City, N.Y.: Doubleday, Page and Company, 1917.

Hampton, Kate P. "The Face of Christ in Art." *Outlook* 61, no. 13 (1 Apr. 1899): 735–48.

Handbook of the Boston Public Library and Its Mural Decorations. Boston: Association Publications, 1916.

Handbook of the Boston Public Library and Its Mural Decorations. Boston: Association Publications, 1920.

Handbook of the Museum of Fine Arts Boston. Boston: Museum of Fine Arts, 1907.

Hannaford, Ivan. *Race: The History of an Idea in the West*. Baltimore: Johns Hopkins University Press, 1996.

Hart, George. *Egyptian Myths*. London: Trustees of the British Museum, 1990.

Hartt, Frederick. *History of Italian Renaissance Art*. New York: Harry N. Abrams, 1969.

Haskell, Francis. *Rediscoveries in Art*. Ithaca, N.Y.: Cornell University Press, 1976.

Hatch, Nathan O. *The Democratization of American Christianity*. New Haven: Yale University Press, 1989.

Hawthorne, Nathaniel. *The Marble Faun*. 1860. Introduction by Richard H. Broadhead. New York: Penguin Books, 1990.

"Head of Christ." *Museum of Fine Arts Bulletin* (Boston) 23, no. 140 (Dec. 1925): 69–70.

Helps to the Study of the Bible. London: Oxford University Press, [1880].

Herdrich, Stephanie. "John Singer Sargent and Italy: A Modern 'Old Master' and the American Renaissance." Ph.D. diss. in preparation, Institute of Fine Arts, New York University.

Heschel, Susannah. *Abraham Geiger and the Jewish Jesus*. Chicago: University of Chicago Press, 1998.

Higham, John. *Send These to Me: Immigrants in Urban America*. 1975. Rev. ed. Baltimore: Johns Hopkins University Press, 1984.

Hills, Patricia, ed. *John Singer Sargent*. With essays by Linda Ayres, Annette Blaugrund, Albert Boime, William H. Gerdts, Patricia Hills, Stanley Olson, and Gary A. Reynolds. Exh. cat. New York: Harry N. Abrams, 1986.

Hind, C. Lewis. "Sargent: Cable Correspondence from London." *Outlook* 139, no. 17 (29 Apr. 1925): 648–50.

Hirschler, Erica E. "A Quest for the Holy Grail: Edwin Austin Abbey's Murals for the Boston Public Library." *Studies in Medievalism* 6 (1994): 35–49.

Holmes, Colin. *Anti-Semitism in British Society, 1876–1939*. New York: Holmes and Meier Publishers, 1979.

Hoopes, Donelson F. *The Private World of John Singer Sargent*. Exh. cat. Washington, D.C.: Corcoran Gallery of Art, 1964.

———. "John Singer Sargent and Decoration." *Antiques Magazine* 86, no. 5 (Nov. 1964): 588–91.

Hoover, Stewart M., and Knut Lundby, eds. *Rethinking Media, Religion, and Culture*. Thousand Oaks, Calif.: Sage Publications, 1997.

Hopkins, James Frederick. "Picture Study in the Boston Public Schools." Part 2. *Perry Magazine* 1, no. 2 (Nov.–Dec. 1898): 36–43.

———. "Picture Study in the Boston Public Schools." Part 4. *Perry Magazine* 1, no. 4 (Mar.–Apr. 1899): 135–40.

Huntington, David C. "The Quest for Unity: American Art between World's Fairs, 1876–1893." In *The Quest for Unity: American Art between World's Fairs, 1876–1893*. Exh. cat. Detroit: Detroit Institute of Arts, 1983.

Hurll, Estelle M. "Sargent's Redemption: The New Mural Decoration in the Boston Public Library." *Congregationalist and Christian World*, 7 Mar. 1903, 351–52.

Hutchison, William R., ed. *Between the Times: The Travail of the Protestant Establishment in America, 1900–1960*. Cambridge: Cambridge University Press, 1989.

Hutson, James H. *Religion and the Founding of the American Republic*. Exh. cat. Washington, D.C.: Library of Congress, 1998.

Hutton, Edward. *Rome*. London: Methuen and Company, 1926.

Isham, Samuel. *History of American Painting*. 1905. Rev. ed. New York: Macmillan Company, 1936.

Jaher, Frederic Cople. "Nineteenth-Century Elites in Boston and New York." *Journal of Social History* 6, no. 1 (Fall 1972): 32–77.

James, Henry. *The American Scene*. New York: Charles Scribner's Sons, 1946.

James, T. G. H. *Egyptian Painting and Drawing in the British Museum*. London: Trustees of the British Museum, 1985.

Jameson, Anna. *History of Our Lord as Exemplified in Works of Art*. 2 vols. London: Longmans, Green, and Company, 1890.

Jarrassé, Dominique. *Rodin: A Passion for Movement*. Paris: Terrail, 1992.

Jensen, Klaus Bruhn. *The Social Semiotics of Mass Communication*. London: Sage Publications, 1995.

"Jews Offended by Mr. Sargent's 'Synagogue.' " *Literary Digest* 63, no. 5 (1 Nov. 1919): 31.

Jordy, William H. *American Buildings and Their Architects: Progressive and Academic Ideals at the Turn of the Century*. Garden City, N.Y.: Doubleday and Company, 1972.

Joughin, Louis, and Edmund M. Morgan. *The Legacy of Sacco and Vanzetti*. Princeton: Princeton University Press, 1976.

Karp, Ivan, and Steven D. Lavine, eds. *Exhibiting Cultures: The Poetics and Politics of Museum Display*. Washington, D.C.: Smithsonian Institution Press, 1991.

Keller, Robert H., Jr. *American Protestantism and United States Indian Policy, 1859–1882*. Lincoln: University of Nebraska Press, 1983.

Kilmurray, Elaine, and Richard Ormond, eds. *John Singer Sargent*. With essays by Richard Ormond and Mary Crawford Volk. Exh. cat. London: Tate Gallery; Princeton: Princeton University Press, 1998.

King, Pauline. *American Mural Painting*. Boston: Noyes, Platt and Company, 1901.

King's Handbook of Boston. Cambridge: Moses King, 1881.

Kingsbury, Martha. "John Singer Sargent: Aspects of His Work." Ph.D. diss., Harvard University, 1969.

———. "Sargent's Murals in the Boston Public Library." *Winterthur Portfolio* 11 (1976): 153–72.

Kingsford, Anna Bonus, and Edward Maitland. *The Perfect Way, or, The Finding of Christ*. London: Field and Tuer, 1890.

Kip, William Ingraham. *Christmas Holydays in Rome*. New York: D. Appleton and Company, 1846.

Kirstein, Lincoln. *Quarry: A Collection in Lieu of Memoirs*. Pasadena, Calif.: Twelvetree Press, 1986.

———. *Mosaic: Memoirs*. New York: Farrar, Straus and Giroux, 1994.

Kissinger, Warren S. *Sermon on the Mount: A History of Interpretation and Bibliography*. Metuchen, N.J.: Scarecrow Press, 1975.

Kohler, Rose. "Art as Related to Judaism." New York: National Council of Jewish Women, 1922.

———. "Religious School Work." Report of the Fifth Triennial Convention, 110–15. New York and Cincinnati: National Council of Jewish Women, 1908.

Korn, Bertram Wallace, ed. *Retrospect and Prospect: Essays in Commemoration of the Seventy-fifth Anniversary of the Founding of the Central Conference of American Rabbis, 1889–1964*. New York: Central Conference of American Rabbis, 1965.

Kraft, Louis C. *Development of the Jewish Community Center*. New York: National Association of Jewish Center Workers, 1967.

La Farge, John. *The Gospel Story in Art*. New York: Macmillan Company, 1913.

Lampert, Catherine. "Rodin and England." *Antique Collector* 57, no. 11 (Nov. 1986): 89–95.

Landrieux, Maurice. *The Cathedral of Reims: The Story of a German Crime*. London: Kegan Paul, Trench, Trubner and Company, 1920.

Lansdale, Nelson. "John Singer Sargent: His Private World." *American Artist* 28 (Nov. 1964): 58–63, 79–81.

Lears, T. J. Jackson. *No Place of Grace: Antimodernism and the Transformation*

of American Culture. 1981. Rev. ed. Chicago: University of Chicago Press, 1994.

———. *Fables of Abundance: A Cultural History of Advertising in America.* New York: Basic Books, 1994.

Lee, Albert. *Henry Ford and the Jews.* New York: Stein and Day, 1980.

Lee, Vernon. "Imagination in Modern Art." *Fortnightly Review* 68 (1 Oct. 1897): 513–21.

———. *The Sentimental Traveler: Notes on Places.* London: John Lane, 1907.

———. *Gospels of Anarchy and Other Contemporary Studies.* New York: Brentano's; London: T. Fisher Unwin, 1909.

Levi, Harry. *The Great Adventure.* Boston: Temple Israel, 1929.

———. "Judaism." In *Fifty Years of Boston: A Memorial Volume.* Boston: Tercentenary Committee, 1932.

Levinson, Henry Samuel. *The Religious Investigations of William James.* Chapel Hill: University of North Carolina Press, 1981.

L'Hôpital, Winefride de. *Westminster Cathedral and Its Architect.* 2 vols. New York: Dodd, Mead and Company, 1919.

Livingston, James C. *Modern Christian Thought: From the Enlightenment to Vatican II.* New York: Macmillan Company, 1971.

Lucas, Edward Verrall. *A Wanderer in London.* London: Methuen and Company, 1907.

———. *Edwin Austin Abbey, Royal Academician: The Record of His Life and Work.* 2 vols. London: Methuen and Company, 1921.

Ludmerer, Kenneth M. "Genetics, Eugenics, and the Immigration Restriction Act of 1924." *Bulletin of the History of Medicine* 46, no. 1 (Jan.–Feb. 1972): 59–81.

Lynch, Gertrude. "Racial and Ideal Types of Beauty." *Cosmopolitan* 38, no. 7 (Dec. 1904): 223–33.

Lynn, Robert W. *Protestant Strategies in Education.* New York: Association Press, 1964.

McKibbin, David. *Sargent's Boston.* Boston: Museum of Fine Arts, 1956.

McNamara, Mary Jo. "Rodin's 'Burghers of Calais.'" Ph.D. diss., Stanford University, 1983.

McSpadden, Joseph Walker. *Famous Painters of America.* New York: Dodd, Mead and Company, 1923.

———. *Famous Sculptors of America.* New York: Dodd, Mead and Company, 1927.

Mâle, Emile. *The Gothic Image: Religious Art in France of the Thirteenth Century.* 1913. Reprint, New York: Harper and Row, 1972.

Mann, Arthur. *Yankee Reformers in the Urban Age.* Cambridge: Harvard University Press, 1954.

———. "From Immigration to Acculturation." In *Making America: The Society and Culture of the United States,* ed. Luther S. Luedtke. Chapel Hill: University of North Carolina Press, 1992.

———, ed. *Growth and Achievement: Temple Israel, 1854–1954.* Cambridge, Mass.: Riverside Press, 1954.

Marty, Martin E. *Modern American Religion.* Vol. 1, *The Irony of It All, 1893–1919.* Chicago: University of Chicago Press, 1986.

Maus, Cynthia Pearl. *The Old Testament and the Fine Arts.* New York: Harper and Brothers, 1954.

May, Henry. *The End of American Innocence: A Study of the First Years of Our Own Time, 1912–1917.* New York: Alfred A. Knopf, 1959.

Mechlin, Leila. "The Sargent Exhibition." *American Magazine of Art* 15, no. 4 (Apr. 1924): 169–90.

Menzies, Allan. *History of Religion.* London: John Murray, 1895.

Meyer, D. H. "American Intellectuals and the Victorian Crisis of Faith." *American Quarterly* 27, no. 5 (Dec. 1975): 585–603.

Middleton, George. "Mary Antin's 'The Promised Land.'" *Bookman* (New York) 35, no. 4 (June 1912): 419–21.

Miller, Larry C. "William James and Ethnic Thought." *American Quarterly* 31, no. 4 (Fall 1979): 533–55.

Minchin, Hamilton. "Some Early Recollections of Sargent." *Contemporary Review* 127 (June 1925): 735–43.

Moore, Charles. *Life and Time of Charles Follen McKim.* Boston: Houghton Mifflin, 1929.

Moore, George. *The Brook Kerith.* New York: Macmillan Company, 1916.

Moore, Marie A. "Great Artists and Their Paintings." *Perry Magazine* 4, no. 3 (Nov. 1901): 91–96.

Moore, R. Laurence. *Selling God: American Religion in the Marketplace of Culture.* New York: Oxford University Press, 1994.

Morgan, David. *Visual Piety: A History and Theory of Popular Religious Images.* Berkeley: University of California Press, 1998.

———. *Protestants and Pictures: Religion, Visual Culture, and the Age of American Mass Production.* New York: Oxford University Press, 1999.

Morgan, H. Wayne, ed. *An Artist of the American Renaissance: The Letters of Kenyon Cox, 1883–1919.* Kent, Ohio: Kent State University Press, 1995.

"*motive* Sales of Original Prints: A Price List." *motive* 18, no. 5 (Feb. 1958): 28.

Mount, Charles Merrill. *John Singer Sargent.* London: Cresset Press, 1957.

"Mural Painting in This Country since 1898." *Scribner's Magazine* 40, no. 5 (Nov. 1906): 637–40.

Murray, John. *Handbook of Rome and Its Environs.* London: John Murray, 1873.

"The Museum of Fine Arts, Boston." *American Architect and Building News* 8, no. 253 (30 Oct. 1880): 205–18.

Nemerov, Alexander. "Vanishing Americans: Abbott Handerson Thayer, Theodore Roosevelt, and the Attraction of Camouflage." *American Art* 11, no. 2 (Summer 1997): 50–81.

Nochlin, Linda, and Tamar Garb, eds. *The Jew in the Text: Modernity and the Construction of Identity.* London: Thames and Hudson, 1995.

Nord, Warren A. *Religion and American Education.* Chapel Hill: University of North Carolina Press, 1995.

Olson, Stanley. *John Singer Sargent: His Portrait.* New York: St. Martin's Press, 1986.

Ormond, Richard. *John Singer Sargent: Paintings, Drawings, Watercolors.* New York: Harper and Row, 1970.

———. "John Singer Sargent and Vernon Lee." *Colby Library Quarterly* 10, no. 3 (Sept. 1970): 154–78.

Orr, John B. "The American System of Education." In *Making America: The Society and Culture of the United States,* ed. Luther S. Luedtke. Chapel Hill: University of North Carolina Press, 1992.

Palmer, Parker J., Barbara G. Wheeler, and James W. Fowler, eds. *Caring for the Commonweal: Education for Religion and Public Life.* Macon, Ga.: Mercer University Press, 1990.

Parke, H. W. *Sibyls and Sibylline Prophecy in Classical Antiquity.* Ed. B. C. McGing. London and New York: Routledge, 1988.

"Pass Bill to Seize Sargent's 'Synagogue.'" *American Art News* 20, no. 35 (10 June 1922): 4.

Pater, Walter. *The Renaissance: Studies in Art and Poetry.* 1873. Reprint, London: Macmillan and Company, 1925.

Pelikan, Jaroslav. *Jesus through the Centuries: His Place in the History of Culture.* New York: Perennial Library, 1985.

Petrie, Brian. *Puvis de Chavannes.* Hants, England: Ashgate, 1997.

Prevots, Naima. *American Pageantry.* Ann Arbor: UMI Research Press, 1990.

Proceedings of the Thirty-first Annual Convention of the Central Conference of American Rabbis. Cincinnati: C. J. Krehbiel Company, 1920.

Proceedings of the Thirty-third Annual Convention of the Central Conference of American Rabbis. Richmond, Va.: Old Dominion Press, 1922.

Promey, Sally M. " 'Triumphant Religion' in Public Places: John Singer Sargent and the Boston Public Library Murals." In *New Dimensions in American Religious History,* ed. Jay P. Dolan and James P. Wind. Grand Rapids, Mich.: Eerdmans, 1993.

———. "Interchangeable Art: Warner Sallman and the Critics of Mass Culture." In *Icons of American Protestantism,* ed. David Morgan. New Haven: Yale University Press, 1996.

———. "Sargent's Truncated *Triumph:* Art and Religion at the Boston Public Library, 1890–1925." *Art Bulletin* 79, no. 2 (June 1997): 217–50.

———. "The Afterlives of Sargent's *Prophets.*" *Art Journal* 57, no. 1 (Spring 1998): 31–44.

Pyne, Kathleen. *Art and the Higher Life: Painting and Evolutionary Thought in Late-Nineteenth-Century America.* Austin: University of Texas Press, 1996.

[Quilter, Harry]. "Royal Academy." *Spectator* 59 (May 1886): 580–81.

Quinn, Karen E. "Elihu Vedder." In *The Lure of Italy: American Artists and the Italian Experience, 1760–1914,* by Theodore E. Stebbins et al. Exh. cat. New York: Harry N. Abrams, 1992.

Ratcliff, Carter. *John Singer Sargent.* New York: Abbeville Press, 1982.

Reinhardt, Hans. *La Cathédrale de Reims.* Paris: Presses Universitaires de France, 1963.

Renan, Ernest. *Vie de Jésus.* Paris: Michel Lévy Frères, 1863.

———. *Life of Jesus.* Trans. Charles Edwin Wilbour. New York: Carleton Publisher, 1864.

———. "Religious Art." In *Studies in Religious History.* New York: Scribner and Welford, 1887.

———. *Histoire du Peuple D'Israël.* 5 vols. Paris: Calmann Lévy, 1893–95.

———. *History of the People of Israel.* Trans. Joseph Henry Allen and Elizabeth Wormeley Latimer. 5 vols. Boston: Roberts Brothers, 1888–96.

———. *Qu'est-ce qu'une Nation et autres écrits politiques.* 1896. Paris: Imprimerie Nationale, 1996.

Retrospective Exhibition of Important Works of John Singer Sargent. Exh. cat. New York: Grand Central Art Galleries, 1924.

Rhoads, William B. "The Colonial Revival and the Americanization of Immigrants." In *The Colonial Revival in America,* ed. Alan Axelrod. New York: W. W. Norton and Company, 1985.

R. N. C. "New Conceptions of the Christ." *Brush and Pencil* 17, no. 4 (Apr. 1906): 148–57.

Robertson, Walford Graham. *Time Was.* London: Hamish Hamilton, 1931.

Rosenblum, Robert. *Jean-Auguste-Dominique Ingres.* New York: Harry N. Abrams, 1990.

Rothenstein, William. *Men and Memories: A History of the Arts, 1872–1922.* 2 vols. New York: Tudor Publishing Company, 1939.

"The Royal Academy." *American Art News* 17, no. 33 (24 May 1919): 1.

Rubin, Stephen D. *John Singer Sargent's Alpine Sketch Books: A Young Artist's Perspective.* Exh. cat. New York: Metropolitan Museum of Art, 1991.

Santayana, George. "The Intellectual Temper of the Age." In *Winds of Doctrine: Studies in Contemporary Opinion.* New York: Charles Scribner's Sons, 1913.

"A Sargent Year." *Literary Digest* 53, no. 11 (9 Sept. 1916): 608–11.

Sargent, Walter. "Art in the Sunday School." *Perry Magazine* 5, no. 1 (Sept. 1902): 50–53.

"Sargent's Sculpture, the Crucifixion." *Vanity Fair* 7, no. 3 (Nov. 1916): 76.

Sarna, Jonathan D., and Ellen Smith, eds. *The Jews of Boston.* Boston: Combined Jewish Philanthropies of Greater Boston, 1995.

Sauerländer, Willibald. *Gothic Sculpture in France, 1140–1270.* New York: Harry N. Abrams, 1970.

Schneider, René. *Rome: Complexité et harmonie.* Paris: Librairie Hachette et Cie, 1908.

Schweitzer, Albert. *The Quest for the Historical Jesus.* 1906. Reprint, New York: Macmillan Company, 1957.

Seaburg, Carl. *Boston Observed.* Boston: Beacon Press, 1971.

Seymour, Charles, Jr. *Michelangelo: The Sistine Chapel Ceiling.* New York: W. W. Norton, 1972.

Shand-Tucci, Douglass. *The Art of Scandal: The Life and Times of Isabella Stewart Gardner.* New York: HarperCollins, 1997.

Shearman, John. "The Vatican Stanze: Functions and Decoration." *Proceedings of the British Academy* 57 (1973): 369–429.

Shiff, Richard. "Originality." In *Critical Terms for Art History,* ed. Robert S. Nelson and Richard Shiff. Chicago: University of Chicago Press, 1996.

Silk, Mark. "Why *Religion in the News?*" *Religion in the News* 1, no. 1 (June 1998): 3.

Silver Bay Association: A Pictorial History, 1900–1935. Silver Bay, N.Y.: Silver Bay Association, 1992.

Simmons, Ernest J. *Introduction to Tolstoy's Writings.* Chicago: University of Chicago Press, 1968.

Simpson, Marc, with Richard Ormond and H. Barbara Weinberg. *Uncanny Spectacle: The Public Career of the Young John Singer Sargent.* Exh. cat. New Haven and London: Yale University Press, 1997.

Singer, Hans Wolfgang. *Julius Schnorr von Carolsfeld.* Bielefeld and Leipzig: Verlag von Belhagen und Klasing, 1911.

Sloan, Douglas. *Faith and Knowledge.* Louisville, Ky.: Westminster John Knox Press, 1994.

Small, Herbert, comp. *Handbook of the New Public Library in Boston.* Boston: Curtis and Cameron, 1895.

———. *Handbook of the New Library of Congress.* Boston: Curtis and Cameron, 1901.

Smith, Gerald Birney, ed. *Religious Thought in the Last Quarter Century.* Chicago: University of Chicago Press, 1927.

Smith, Preserved. "Sargent's New Mural Decorations." *Scribner's Magazine* 71, no. 3 (Mar. 1922): 379–84.

Smyth, Craig Hugh, and Peter M. Lukehart, eds. *The Early Years of Art History in the United States.* Princeton: Princeton University Press, 1993.

Smyth, Newman. "The New Old Testament." *Century Magazine* 50, no. 2 (June 1895): 299–306.

Solomon, Barbara. *Ancestors and Immigrants: A Changing New England Tradition.* Cambridge: Harvard University Press, 1956.

Solomon, Solomon J. *Strategic Camouflage.* London: John Murray, 1920.

" 'The Spirit of the Synagogue' Medallion by Rose Kohler." Marketing brochure. Cincinnati: privately published, c. 1921.

Staley, Allen. " 'Art Is upon the Town!': The Grosvenor Gallery Winter Exhibitions." In *The Grosvenor Gallery: A Palace of Art in Victorian England,* ed. Susan P. Casteras and Colleen Denney. New Haven: Yale Center for British Art, 1996.

Steinmann, Ernst. *Pinturicchio.* Bielefeld and Leipzig: Verlag von Velhagen und Klasing, 1898.

Stewart, Susan. *On Longing: Narratives of the Miniature, the Gigantic, the Souvenir, the Collection.* Baltimore: Johns Hopkins University Press, 1984.

Story, Ronald. *Forging of an Aristocracy: Harvard and the Boston Upper Class, 1800–1870.* Middletown, Conn.: Wesleyan University Press, 1980.

Strettell, Alma. *Spanish and Italian Folk Songs.* London and New York: Macmillan and Company, 1887.

Sturgis, Russell. "Sargent's New Wall Painting as Seen by the Decorative Architect and the Portrait Painter." *Scribner's Magazine* 34 (July–Dec. 1903): 765–67.

"Suffragette Butchery of Art." *Literary Digest* 4, no. 24 (13 June 1914): 1434.

Sullivan, T[homas] R[ussell]. "The New Building of the Boston Public Library." *Scribner's Magazine* 19, no. 1 (Jan. 1896): 83–97.

————. *Passages from the Journal of Thomas Russell Sullivan, 1891–1903.* New York: Houghton Mifflin, 1917.

Swanson, Wayne. *The Christ Child Goes to Court.* Philadelphia: Temple University Press, 1990.

Sweeney, John L., ed. *The Painter's Eye: Notes and Essays on the Pictorial Arts by Henry James.* Cambridge: Harvard University Press, 1956.

Swift, Lindsay. "The Moving of the Boston Public Library." *Century Magazine* 50, no. 2 (June 1895), 318.

————. "The New Public Library in Boston: Its Ideals and Working Conditions." *Century Magazine* 51, no. 1 (Nov. 1895): 264–71.

Synnott, Marcia Graham. *The Half-Opened Door: Discrimination and Admissions at Harvard, Yale, and Princeton, 1900–1970.* Westport, Conn.: Greenwood Press, 1979.

Thoburn, Helen. "The Ministering of the Gift." Pageant program. New York: National Board of the Young Women's Christian Association, 1913.

————. "Pageants of Girlhood." *Good Housekeeping Magazine* 57, no. 2 (Aug. 1913): 228–31.

Thomas, John. "*Gassed* and Its Detractors: Interpreting Sargent's Major War Painting." *Imperial War Museum Review,* no. 9 (Nov. 1994): 42–50.

Tissot, James. *The Life of Our Saviour Jesus Christ.* 2 vols. London: Sampson Low, Marston and Company, 1897.

————. *The Old Testament.* 2 vols. Paris, London, and New York: M. De Brunoff, 1904.

Tittle, Walter. "My Memories of John Sargent." *Illustrated London News,* 25 Apr. 1925, 723–25.

Turner, Victor. *The Ritual Process: Structure and Anti-Structure.* Ithaca, N.Y.: Cornell University Press, 1969.

Van Dyke, Henry. *The Gospel for an Age of Doubt.* New York: Macmillan Company, 1919.

Van Rensselaer, Mariana Griswold. "The New Public Library in Boston: Its Artistic Aspects." *Century Magazine* 51, no. 1 (Nov. 1895): 260–64.

————. "Places in New York." *Century Magazine* 53, no. 4 (Feb. 1897): 501–16.

Van Slyck, Abigail A. *Free to All: Carnegie Libraries and American Culture, 1890–1920.* Chicago: University of Chicago Press, 1995.

Vaughn, William. *German Romantic Painting.* New Haven: Yale University Press, 1980.

Vitry, Paul. *La Cathédrale de Reims: Architecture et Sculpture.* 2 vols. Paris: Librairie Centrale des Beaux-Arts, 1919.

Volk, Mary Crawford. *John Singer Sargent's El Jaleo.* With essays by Nicolai Cikovsky, Jr., Warren Adelson, Elizabeth Oustinoff, and Mary Crawford Volk. Exh. cat. Washington, D.C.: National Gallery of Art, 1992.

————. "Sargent in Public." In *John Singer Sargent,* ed. Elaine Kilmurray and Richard Ormond. Exh. cat. London: Tate Gallery; Princeton: Princeton University Press, 1998.

Wadlin, Horace G. *The Public Library of the City of Boston: A History.* Boston: Boston Public Library, 1911.

Wagar, W. Warren. *Good Tidings: The Belief in Progress from Darwin to Marcuse.* Bloomington: Indiana University Press, 1972.

Wallace, Florence Magill. "The Christmas Tableau." *Ladies' Home Journal* 27, no. 16 (1 Dec. 1910): 53.

Warner, Malcolm. *The Victorians: British Painting, 1837–1901.* Exh. cat. Washington, D.C.: National Gallery of Art, 1997.

Warner, R. Stephen. "Work in Progress toward a New Paradigm for the Sociological Study of Religion in the United States." *American Journal of Sociology* 98, no. 5 (Mar. 1993): 1044–93.

Watson, Forbes. "Sargent—Boston—and Art." *Arts and Decoration* 7 (Feb. 1917): 194–97.

————. "John Singer Sargent." *Arts* 7, no. 5 (May 1925): 243–46.

Wayment, Hilary. *The Stained Glass of the Church of St. Mary, Fairford, Gloucestershire.* London: Society of Antiquaries, 1984.

"We Nominate for the Hall of Fame: John Singer Sargent." *Vanity Fair* 15, no. 5 (Jan. 1921): 48.

Weber, Nicholas Fox. *Patron Saints: Five Rebels Who Opened America to a New Art, 1928–1943.* New York: Alfred A. Knopf, 1992.

Weintraub, Jeff, and Krishan Kumar, eds. *Public and Private in Thought and Practice: Perspectives on a Grand Dichotomy.* Chicago: University of Chicago Press, 1997.

Weis, Helen. "Those Old, Familiar Faces." *Stained Glass* 86, no. 3 (Fall 1991): 204–7, 216–18.

Whitehill, Walter Muir. *Boston Public Library: A Centennial History.* Cambridge: Harvard University Press, 1956.

————. *Boston: A Topographical History.* Cambridge: Harvard University Press, 1968.

————. "The Making of an Architectural Masterpiece—The Boston Public Library." *American Art Journal* 2, no. 2 (Fall 1970): 13–35.

Whiting, Lilian. *Boston Days.* Boston: Little, Brown and Company, 1902.

Who's Who in American Jewry. New York: Jewish Biographical Bureau, 1926.

"Why the Bible Should Not Be Read in the Public Schools." New York: Central Conference of American Rabbis, 1922.

Wick, Peter Arms, comp. *Handbook to the Art and Architecture of the Boston Public Library.* Boston: Associates of the Boston Public Library, 1977.

Williams, Carolyn. *Transfigured World: Walter Pater's Aesthetic Historicism.* Ithaca, N.Y.: Cornell University Press, 1989.

Williams, Charles D. *The Prophetic Ministry for Today.* New York: Macmillan Company, 1921.

Willis, Irene Cooper, ed. *Vernon Lee's Letters.* London: privately printed, 1937.

Wilson, Richard Guy, Dianne H. Pilgrim, and Richard N. Murray. *The American Renaissance, 1876–1917.* Exh. cat. New York: Brooklyn Museum of Art, 1979.

Wilson, Stephen. *Ideology and Experience: Antisemitism in France at the Time of the Dreyfus Affair.* East Brunswick, N.J.: Fairleigh Dickinson University Press, 1982.

Wingate, Charles E. "Boston Letter." *The Critic,* 27 July 1895, 61.

Winner, Viola Hopkins. *Henry James and the Visual Arts.* Charlottesville: University of Virginia Press, 1970.

Winston, Diane. "Campuses Are a Bellwether for Society's Religious Revival." *Chronicle of Higher Education,* 16 Jan. 1998, A60.

INDEX

Unless otherwise identified, all works of art cited in the Index are by John Singer Sargent. Boston Public Library is abbreviated as BPL; *Triumph of Religion* is abbreviated as *Triumph;* Sermon on the Mount (biblical subject) is indicated by "Sermon (biblical)"; the unfinished panel of Sermon on the Mount for *Triumph of Religion* is indicated by "Sermon (*Triumph*)."

Abbey, Edwin Austin, 34, 105, 158, 172, 255, 286; *Quest and Achievement of the Holy Grail* (BPL murals), 13, 66, 76, 154, 163, 273, 283, 285, 295, 339n.162, fig. 44; *Reading of the Declaration of Independence,* 173; *Religion,* 172; and Sargent, 13, 172, 173; "Spirit of Religious Liberty," 172

Abbott, Lyman, 130, 171; *Dictionary of Religious Knowledge,* 130; *The Evolution of Christianity,* 320n.35; interpretation of Hebrew prophets (*Outlook* series), 165–66, 169, 333n.83; interpretation of Sermon (biblical), 130, 132

Abbott, Samuel, 105, 159, 166

abstraction, 54, 55, 89, 204–5, 290–91

Adam and Eve, 17, 232, 233

Adler, Kathleen, 235, 340n.173

Alexander, John White, *Evolution of the Book,* 295

Alexander VI, Pope, 116

Allen, Thomas, 190

Allston, Washington, *Elijah in the Wilderness,* 270

American Civil Liberties Union (ACLU), 311

American Federation of Art, 291, 295; Committee on Art in the Public Schools, 283

Americanization, 154–55, 161–62, 216–17, 219, 294

American Mural Movement, 150, 205

American Renaissance, 12, 129, 148, 345n.145

Amiens cathedral, 133

Amsterdam Bible, 257, 319n.19, 324n.136, fig. 134

André-Michel, Robert, 239, 341n.34

Antin, Mary, *The Promised Land,* 163–64, 332n.72

antisemitism, 176, 180, 183, 201, 203, 207–13, 216, 218, 271, 332n.67, 339n.159; Protocols of Zion, 213, 218; and Renan, 209–10, 338n.131; and Sargent, 207, 209, 210–11

Apis, 116

Apollo, 200, 230, 340n.7

archaeology, biblical, 205; and Renan, 51, 53

archaeology and *Triumph,* 33, 34, 37, 88, 102. *See also* ruined cathedrals

Arnold, Matthew, 345n.145

art, history of European: represented by *Triumph,* 107, 110, 111, 148, 186, 187, 204, 212; as source for *Triumph,* 81, 107, 129, 200, 201, 204, 228

art, public. *See* public art

art, religious, 54, 59, 60, 137, 205, 287, 290, 304, 314; religious representation in public places, 4, 5, 6–7, 9, 26–27, 30, 52, 146, 173, 176, 179–80, 192, 215, 216, 273, 308, 315, 331n.13. *See also* art and religion

art, styles or periods of. *See* American Renaissance; Assyrian art; Baroque art; Byzantine art; Egyptian art; Gothic Revival; medieval period; modernity, in art; naturalism; Nazarene; "primitive" art; Renaissance, the; Romanesque art; Symbolism

art and religion, 5, 11, 137, 164, 179, 183–84, 204, 211, 228, 274, 287, 290, 335n.29

assimilation, 161–62, 176, 219, 339n.164. *See also* Americanization; immigrants and immigration

Assyrian art, 32, 54, 107, 109

Astarte, 16, 81, 87, 89, 109, 347n.32, figs. 5, 48; and Diana of Ephesus, 200; and Madonnas, 89; reproductions of, 288; Sargent on, 89; sources for, 109

audience, 106, 152, 222, 314; and race, 217, 222; and ritual, 64. *See also* publics

audiences for *Triumph,* 4–5, 27, 56, 58, 65–66, 68, 76, 83, 102–3, 106, 111, 115, 127, 153, 173, 176, 205, 212, 215, 217–18, 230, 241, 271, 275, 319n.19, 327n.14, 330–31n.6; multiplicity of, 4, 6–7, 8, 9, 173, 214, 219, 274, 311, 314; for *Triumph* in reproduction, 274–75, 277, 278, 283, 291, 296, 304. *See also* publics for *Triumph;* viewers of *Triumph*

Azan, Paul, 242–43

Back Bay, 68, 152–53, 157, 202, 325n.22, 331n.24

Baedeker, Karl, travel guides of, 108, 111, 113, 328n.27

Bailey, Albert Edward, 284

Bailey, Henry Turner, 284–86, 305, 346n.25

Baltzell, E. Digby, 155, 157

Banta, Martha, 344n.106

Baptists, 169, 308

Barnard, Dorothy, 343n.87

Baroque art, 204; and *Triumph,* 60, 234

Barr, Alfred H., Jr., 290–91

Barr, Nathan, 296

Barry, James, *Progress of Human Culture,* 318n.18

Barton, William E., 273

Baxandall, Michael, 319n.20

Baxter, Sylvester, 33, 34, 61, 246; marriage to Lucia Millet, 77; on *Triumph,* 60, 61, 77, 79, 102, 131, 148, 170, 220–22, 246, 324n.141, 325nn. 32, 33, 326n.64

Beatitudes, 41, 130, 141

Beaux, Cecelia, 335n.25

Beckford, William, *Vathek,* 211

Bederman, Gail, 214

Beecher, Henry Ward, 165, 171, 330n.87

Belden, Charles, 202, 335n.39

Bell, Catherine, 67

Bellah, Robert, 172

Belloc, Hilaire, 211, 345n.144; *The Jews,* 211

Benjamin, Walter, 346n.18

Benton, Josiah H., 16, 43, 45, 66, 131, 147, 194, 215

Benton, Thomas Hart, 324n.3

Berger, Peter L., 307

Bernhardt, Sarah, 324n.3

Betsky, Celia, 220

biblical criticism, 37, 109, 205, 310; German, 39; Higher Biblical Criticism, 165; and *Triumph,* 37, 131, 132

Bierer, Dora, 37

Binyon, Lawrence, 263

Birnbaum, Martin, 35, 265, 275

Blashfield, Edwin, 32–33, 113, 149–50, 168, 261, 263; *Evolution of Civilization,* 27, 168, 340n.181

B'nai B'rith, 336n.52; American Jewish Committee of, 213; Amos Lodge of, 187, 335n.48; Anti-Defamation League of, 181, 187, 213

Boime, Albert, 270

Bolton, Charles Knowles, 197

bookcases by Sargent, 66, 92, 322n.95, 329n.49

Borglum, Gutzon, 32, 327n.2

Boston: and anglomania, 155; and class, 8, 151–55, 158, 169, 331n.24, 336n.59; and culture, 31, 69, 151–55, 157, 169, 173, 176, 270, 294–95, 336n.59; and education, 215, 216, 284, 289; and immigration, 8, 151–55, 160, 213, 312, 331nn. 24, 28; and race, 155,

Tonks, Henry, 236
Toqueville, Alexis de, 172
Trinity, 126, 169, 233; in *Triumph*, 17, 88, 110, fig. 10
Trinity Church, 28, 69, 101, 133–37, 185–86, 188, 206, 325n.22
"triumph," in Western art, 113, 318–19n.18, 328n.34, 329n.73
triumphalism, 115; Catholic, 329n.73; Christian, 4, 179, 184, 187, 209, 212, 228, 234, 259, 297, 328n.34; Protestant, 216
Triumph of Religion: color in, 67, 68, 79, 83, 86–87, 93, 267, 301; condition and restoration of, 78–79, 202, 314–15; and *Disputa* (Raphael), 113, 129; iconography of, 77, 107, 123, 125, 126, 129, 137, 149, 198, 200, 225, 271; initial conceptions of, 15, 17–18, 35, 37–39, 40, 51, 64, 111, 113, 130, 185, 200, 204; order of completion, 16, 42, 77, 131, 185, 234, 319n.15, 323n.127, 337n.114, 343n.95; —, evolutionary pattern in, 11, 12, 30, 42, 68, 131, 202–3; original Spanish theme of, 15, 27, 30, 37; and Overbeck, 115; and Pinturicchio, 111, 328n.20, 329n.51; research of Sargent for, 34–35, 36, 66, 102, 106, 107–9, 131, 146, 327n.14; Sargent on, 8, 11–12, 15, 16, 31, 34, 50–51, 54, 59–60, 107, 130, 202–3; title of ("Pageant of Religion"), 64, 347n.51; title of (*Triumph*), 15, 106, 113, 115; travels of Sargent as background for, 34, 67, 107, 109–10, 146; unfinished status of, 201–3, 206–7, 271, 278, 283, 311, 319n.15, 337n.109. *See also* commission for *Triumph*; contracts for *Triumph*; evolution/progress as theme in *Triumph*; evolution/progress of religion as theme in *Triumph*; funding for *Triumph*; installations of *Triumph*; relief elements in *Triumph*; Sargent Hall; sources of *Triumph*, literary; sources of *Triumph*, visual
Triumph of Religion, components of. See Church; Crucifix, in *Triumph*; Dogma of the Redemption; Fall of Gog and Magog; Frieze of Angels; Frieze of Prophets; Glorious Mysteries of the Rosary; Handmaid of the Lord; Hell; Israel and the Law; Israelites Oppressed; Joyful Mysteries of the Rosary; Judgment; Last Judgment sequence; Madonna of Sorrows; Messianic Era; Pagan Gods; Passing of Souls into Heaven; Sermon on the Mount (*Triumph*);
Sorrowful Mysteries of the Rosary; Synagogue and Church; Synagogue
trustees of BPL, 4, 12, 13, 15–16, 147, 194, 229, 319nn. 2, 15, 335n.44; and Synagogue controversy, 177–80, 185–88, 190, 191, 206, 216
types, 214, 222, 338n.119, 340nn. 181, 183; and exoticism, 30, 219, 235; and Sargent, 219–20, 222, 235, 340n.172, 339n.163, 340n.172; stereotypes, 57, 212, 222–25, 229, 312; in *Triumph*, 217, 220
typology, 6, 123–25, 218, 232, 252, 329n.73, 343n.73

ultramontanism, 55
Unitarianism/Unitarians, 158, 169–70, 201, 205, 277, 333n.89, 334n.3, 348n.15; and Boston elite, 158, 169, 333n.92
United Church of Christ, 291, 302. *See also* Congregationalism/Congregationalists
universalism, 183, 271, 309
University Prints, 283, 289

Van Dyke, Henry, *The Gospel for an Age of Doubt*, 58–59
Van Ness, Thomas, 89, 171, 249
Van Rensselaer, Mariana Griswold, 161
Van Slyck, Abigail, 152
Vatican, the, 116, 117, 123, 126, 329nn. 47, 73; and Sargent, 111; and *Triumph*, 111, 129, 143. *See also* Raphael, and Vatican Logge; Raphael, and Vatican Stanze
Vedder, Elihu, *Cumaean Sibyl*, 241, 341n.9
viewers of *Triumph*, 43, 78, 148, 163, 271, 275; as participants in ritual, 64, 173; as spectators and participants, 61, 64, 102; as spectators of performance, 8, 64, 101. *See also* audiences for *Triumph*; patterns of movement in Sargent Hall; patterns of viewing in Sargent Hall
Virgil, 230–32
Vitry, Paul, 243
Volk, Mary Crawford, 206, 318n.1, 327n.14, 330n.99
Voltaire, 29, 40–41, 51, 52, 129, 146, 323n.105

Wadlin, Horace, 160–61
Wagner, Richard, 211
Warner, R. Stephen, 309, 313
Warren, Henry, *Christ's Sermon on the Mount* (after Rogers), 137, fig. 95
Warren, Samuel D., 15
Watson, Forbes, 92, 200
Watts, George Frederic, *Hope*, 341n.40
Weintraub, Jeff, 3, 6
Wertheimer, Asher, 207, 222, fig. 108
Wertheimer, Flora Joseph, 207
Westmacott, Richard, *Progress of Civilization*, 318–19n.18
Westminster Cathedral, 326n.49, 327–28n.18
Weston, J. J., 186
Whistler, James McNeill, Peacock Room, 344n.122
White, Robert A., 7
White, Stanford, 12, 105
White, William, 326.52
Whitehill, Walter Muir, 153
Wickhoff, Franz, 115
Widener Memorial Library, Sargent murals for, 156, 196–97, 204, 217, 263, 339n.164, 342n.62; *Death and Victory*, 217, 263; *Soldiers of the Nation*, 217
Wilde, Oscar, 324n.3
Williams, Charles D., 250
Williams, Peter W., 325n.22
Wilson, Woodrow, 161, 213
Wingate, Charles E., 342n.65
Winston, Diane, 312
Winthrop, John, 156
Wise, Isaac Meyer, 181, 335n.24
Wolsey, Louis, 180
World's Parliament of Religions, 173
World War I, 210, 242, 248–49, 310, 339n.164, 342n.52; and destruction of churches, 242–43; and Sargent, 9, 35, 156, 228, 236–39, 242, 246, 248, 250–52, 263, 310; and *Triumph*, 92, 242. *See also* mustard gas; ruined cathedrals

Young Men's Christian Association (YMCA), 189, 299, 335n.48
Young Men's Hebrew Association (YMHA), 181, 187
Young Women's Christian Association (YWCA), 291; pageant of, 296–99, 301, 304, figs. 155, 156
Young Women's Hebrew Association (YWHA), 181, 187

Zamaçoïs, Miguel, 227
Zechariah, 83, 86, fig. 9
Zola, Emile, 39–40, 211
Zorach, William, 335n.25

PHOTOGRAPHY CREDITS

Adelson Galleries, Inc., New York (figs. 119, 122, 130, 135, 139)

American Antiquarian Society, Worcester, Mass. (fig. 95)

Nancy Andrews, Courtesy of *The Washington Post* (fig. 159)

Archivio Fotografico, Musei Vaticani, Rome (figs. 74–75, 77, 80–82, 84, 117)

© 1999 Artists Rights Society (ARS), New York/ADAGP, Paris, Bruno Jarret (fig. 100)

Campus Photo Services, University of Maryland, photo Thai Nguyen (figs. 38, 40–41, 53, 59, 68–70, 72–73, 87, 89, 97–98, 126–29, 144, 148)

© Richard Cheek (figs. 42, 45–46)

The Corcoran Gallery of Art, Washington, D.C. (fig. 125)

© The Frick Collection, New York (fig. 91)

Michael Hager (fig. 157)

Hirshhorn Museum and Sculpture Garden, Smithsonian Institution, Washington, D.C. (fig. 64)

Imperial War Museum, London (figs. 123, 131, 137, 140)

Isabella Stewart Gardner Museum, Boston (figs. 11–15, 54–55, 78, 133)

Bill Kipp (figs. 6, 7, 10, 49)

Library of Congress, Washington, D.C. (figs. 90, 99, 115)

Courtesy of Barbara T. Martin (fig. 156)

The Metropolitan Museum of Art, New York (figs. 57, 79, 106, 138)

David Morgan (figs. 85, 88, 96)

Museum of Fine Arts, Boston (figs. 34, 60, 65, 101, 105, 116, 118, 120–21, 134, 136)

National Academy, New York (fig. 102)

National Gallery of Art, Washington, D.C. (fig. 155)

National Museum of American Art/National Portrait Gallery Library, Smithsonian Institution, Washington, D.C. (figs. 145, 147, 150)

Photographic Services, Fogg Art Museum, Harvard University Art Museums, Cambridge, © President and Fellows of Harvard College, Harvard University (figs. 20–23, 30, 50–52, 58, 76, 86, 111, 114, 124); photo David Matthews (fig. 67); photo Rick Stafford (figs. 112–13)

Sally M. Promey (figs. 152–54, 158); and Catherine Hays (figs. 3, 35)

Sheldon Memorial Art Gallery, University of Nebraska–Lincoln (fig. 29)

Tate Gallery, London/Art Resource, New York (fig. 108)

Courtesy of Trinity Church, Boston (figs. 93–94)

Courtesy of the Trustees of the Boston Public Library (figs. 1–2, 4–5, 8–9, 16–19, 24–28, 31–33, 36–37, 39, 43–44, 47–48, 56, 61–63, 66, 71, 83, 92, 104, 107, 141, 143, 146, 149, 151)

© Sterling and Francine Clark Art Institute, Williamstown, Mass. (fig. 132)

Malcolm Varon Photography (fig. 103)

All rights reserved (figs. 109, 110, 142)